THE BIRTH OF GREEK ART

Roland Hampe · Erika Simon

THE BIRTH OF GREEK ART

From the Mycenaean to the Archaic Period

With 504 illustrations, 60 in colour

Foreword by John Boardman

Thames and Hudson

Errata: plate 49 appears upside down
 plate 331 appears reversed right to left.

First published in Great Britain in 1981
by Thames and Hudson Ltd, London

Copyright © 1980 by Office du Livre, Fribourg

Printed and bound in Switzerland

Table of Contents

Sculpture 233

Conclusion 283

Bibliography 285

Glossary 310

Index 314

Foreword

The modern world has learned about Greek art backwards. The Renaissance, the scholars and collectors of the seventeenth and eighteenth centuries, knew it mainly from the finds of Roman date on Italian soil, and they understood it as Greek in essence because the recognizable figures and scenes were explicable in terms of the Greek texts already known to them. But what was Greek in essence was only superficially Greek in style. There were many copies of good, Classical Greek works, accurate copies too, so far as we can judge, lacking only the master's original and finishing touch, but in the absence of any proper understanding of the development of the arts in antiquity they could not be recognized for what they were. On the Roman relief sarcophagi the Greek myths read in the poets, both Greek and Roman, could be identified, if not always accurately, but they appeared in styles very far removed in date and quality from those of Classical Greece.

The later eighteenth and early nineteenth centuries at last brought true Greek art to the eyes of western scholars and artists. Learned and acquisitive travellers to Greece and Turkey recorded and brought back sculptures of the Hellenistic and Classical periods, and when Lord Elgin salvaged the greatest of all such prizes, the marbles from the Acropolis at Athens, a puzzled but exultant audience came to recognize something of what they had lacked hitherto. At the same time the cemeteries of Etruria were being plundered, and although it took rather longer for the fine painted vases in the tombs to be understood as Greek, they soon added a new field of genuine Greek, Classical narrative art to the mythology depicted otherwise only on far later sarcophagi and gems.

Even so, the bulk of the finds were of the Classical period, of the fifth century BC and later. Some of the vases were earlier, of the sixth century, and gradually more sculptural works of this, the Archaic period, became known—the pedimental sculptures from the temple of Aphaea, now in Munich, and at the end of the century the splendid find on the Athenian Acropolis of the Archaic maidens overthrown by the Persians when they sacked the city in 480 BC. Archaic Greek art could at last be recognized as the cradle of the Classical, and it readily won hearts for its simple appeal, almost an antidote to those more cloying aspects of the Classical which had been exploited by the artists and writers of the nineteenth century.

But even this is not the end of the story; indeed, so far as this book is concerned, the story has yet to begin. In the mid-nineteenth century two other major and earlier periods of Greek art remained to be discovered, or seen for what they truly were. The arts of early Iron Age Greece, notably the Geometric and earlier Archaic of the ninth to seventh centuries BC, looked still foreign to western eyes, and only patient scholarship has thrust the study of the early development of Classical Greek art back to the beginning of the first millennium BC. The story seemed, to many it still seems, complete: an art of abstract Geometric pattern, gradually admitting figure decoration, quickened by the arts of the east, disciplining itself in the Archaic to reach full realization of expression and naturalism in the Classical, a heritage fostered by Rome and transmitted to the culture of the west in succeeding centuries.

At the same time, however, Greek soil promised and yielded yet greater surprises. Schliemann at Mycenae, then Evans at Knossos revealed the arts of the civilizations of the Greek Bronze Age, before 1200 BC, unintelligibly literate, and at first sight (even second) very far removed in spirit from that later sequence leading to the Classical. The divide seemed total— 'Dark Ages' of illiteracy, loss of population and palatial culture, followed by a true renaissance. Slowly, and mainly in the last fifty years, that divide has been bridged, and this is a major theme of this book. The discovery that the Mycenaeans spoke Greek, once their Linear B script had been deciphered by Ventris in 1952, encouraged closer observation of possible evidence for continuity of culture over the 'Dark Ages'. Greek names in Mycenaean texts, even divine names, encouraged scholars to seek continuity of cult practice through the 'Dark Ages'. In the ground, evidence was sought too for continuity of occupation in sites which appeared to have enjoyed a glorious Bronze Age past, then to have been abandoned, and only later reoccupied either because the advantages of the setting were still valued or, on religious sites, because they were recognized as places where, in the heroic past, gods and men had walked the earth together. At every point—linguistic, excavational, religious—the evidence is lacunose and capable of more than one interpretation. To the art historian, however, other possibilities are offered. If Mycenaean art, albeit a child of the certainly non-Greek Minoan of Bronze Age Crete, was in fact the product of Greeks, is it possible to discover in it those qualities which we admire in the later period, as it developed from the Geometric to the Classical? Even in matters so apparently subjective as these it is possible to reach a measure of agreement about those barely definable (but they must *be* defined) qualities of Mycenaean art which either survived or have left an essence still to be discovered in the later Greek. So, where most accounts of the arts of Greece deal with either the Bronze Age on its own, or that better charted later progress to the Classical, this book concentrates on the exploration of continuity between the two, setting the achievements of the last phase of the Bronze Age of Mycenaean Greece beside those of the later renascent Greece, and continuing the story

on into the early Archaic, where new influences from the non-Greek world begin to work their spell, sometimes quickening, sometimes hindering that progress to the Classical.

The authors are art historians, with a distinguished record of publication, mainly in the field of post-Bronze Age Greek art. That they are neither excavators nor specialists in Mycenaean archaeology, though it is well familiar to them, means that their approach is novel, and it is one securely based on scholarly practice in periods which are better documented and where the place of art in the historic record is more clearly defined. Their approach is also an optimistic one—but this is the way to present a case for continuity and it needs to be stated thus. Some readers may remain more impressed by differences than similarities, or find that the confrontation, genre by genre, of the works of the two eras serves more to point the contrast of approach and spirit in the artists who created them. But the congruity is striking too, and it is symptomatic of the progress achieved in the study of Greece that what had once seemed a void can now legitimately become the focus for such a study.

By treating the objects class by class—pottery, painting, metalwork, etc.—and not period by period, the common factors of material and technique are the better observed; also, of course, the loss of some techniques, notably in jewellery and gem-engraving, until new sources of inspiration were available, and the total loss of some art forms, such as the fresco murals or inlaid metalwork. The castle at Mycenae and the village that was Athens of the eighth and seventh centuries BC, were very different places in terms of wealth, not perhaps so different in terms of outlook, and in both Greek was spoken in an environment which has surely done much to shape Greek culture in all periods. The authors look for these common factors in the riches that the excavations of the last hundred and fifty years have given us.

In January 1981 Roland Hampe died, in his seventy-third year: an imaginative scholar, an admired teacher, a friendly man. With Erika Simon, his collaborator in other works, he has offered a book to please, interest and challenge.

John Boardman

Introduction

When in 1876 Heinrich Schliemann discovered Grave Circle A at Mycenae, with its great treasures, he was convinced that he had found a new world—and rightly so. Since that time many new Mycenaean sites have been excavated and much research has been done, yet Schliemann's finds in the shaft graves have never been overshadowed, for his excavation did indeed reach the centre of the Mycenaean world. In the 1950s archaeologists discovered Grave Circle B, a little earlier in date, below the citadel of Mycenae—that is, outside the fortification wall; as a result of this piece of good luck Schliemann's work could be supplemented in many ways.

In the first years of the twentieth century Sir Arthur Evans discovered another 'new world', the Minoan, at Knossos in Crete. It was soon realized that this culture had exerted an extremely strong influence on the Greek mainland. Evans concluded that the Peloponnese was dependent on Crete politically as well, and that it was even occupied for a time by the Minoans. We now know that the reverse was true: around 1450 BC, about a century after the shaft graves, Knossos came under Mycenaean rule. In the same century the Mycenaeans developed from the Cretan script, the so-called Linear A, a script that was better suited to their own language. From the decipherment of this syllabic script, the so-called Linear B, we now know that the Mycenaeans spoke an early form of Greek, and so are to be regarded as ancestors of the Greeks. Their art was an overture to that of the Greeks, in which one can already make out motifs that were to recur later.

We shall here attempt to demonstrate this point by examples chosen from different branches of art. The period to be dealt with extends from about 1600 BC beyond the end of the Mycenaean world (c. 1100 BC) into the so-called Dark Ages, through the Geometric and down to the end of the Orientalizing period (c. 600 BC).

Special attention has been paid to the quality of the illustrations. We should like to thank the Greek authorities for permitting new photographs to be taken of certain works of art. Initially J. Sakellarakis of Athens was to have taken part in writing this book, but unfortunately he was prevented from doing so by other commitments; nevertheless we thank him for making photographs available. Almost all the colour plates and some black-and-white pictures come from Sp. Tsavadaroglou of Athens, an outstanding man who has supported our work throughout in the most friendly and helpful way. His premature death is a great loss to archaeology.

For photographs we also thank the American Excavations in the Agora at Athens, the Ashmolean Museum, Oxford, the British Museum, London, the Archaeological Institutes of the Universities of Heidelberg and Würzburg and their photographers Ch. Pieterek and K. Oehrlein, the German Archaeological Institutes in Athens and Istanbul, the Metropolitan Museum in New York, the National Museums of Athens and Copenhagen, the Staatlichen Museen Stiftung Preussischer Kulturbesitz, Berlin, the Iraklion Museum, Crete, the Nicosia Museum, Cyprus, and the Römisch-Germanisches Zentralmuseum, Mainz. In addition the following people have assisted in the production of this book by providing photographs and information: C. Albiker (Ettlingen); J. Boardman (Oxford); Ch. Boulotes (Athens); H.A. Cahn (Basle); J. Caskey (Cincinnati); U. Gehrig (Berlin); M. Hirmer (Munich); H. Hoffmann (Hamburg); G. Hübner (Athens); K. Kilian (Athens); A. Lebessi (Iraklion); M. Maass (Munich); B. Otto (Karlsruhe/Innsbruck); I. Pini (Marburg); A.C. Renfrew (British Excavations on Melos); N. Schimmel (New York); B. Seidel-Borell (Heidelberg); C.G. Styrenius (Stockholm); W. Taylour (England); P. Themelis (Delphi); C. Vermeule (Boston); K. De Vries (Philadelphia); E. Zwierlein-Diehl (Bonn); Deep gratitude is due to all those concerned, and, by no means last, we offer our thanks to J. Hirschen of the Office du Livre, Fribourg, for his personal participation and his patient concern in the publication of this book.

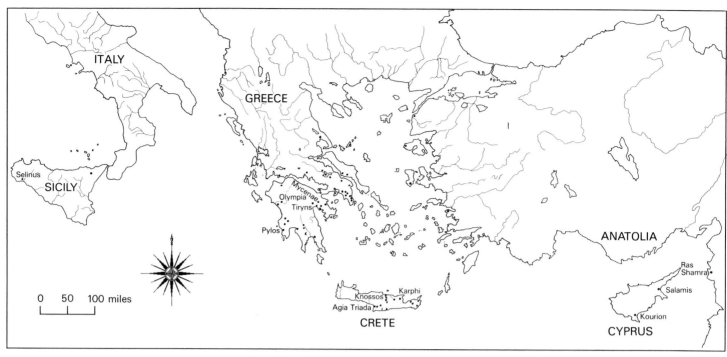

ITALY

GREECE

SICILY

Selinus

ANATOLIA

Mycenae
Olympia
Tiryns

Pylos

Ras
Shamra

Salamis

Kourion

CRETE

CYPRUS

Knossos
Karphi

Agia Triada

0 50 100 miles

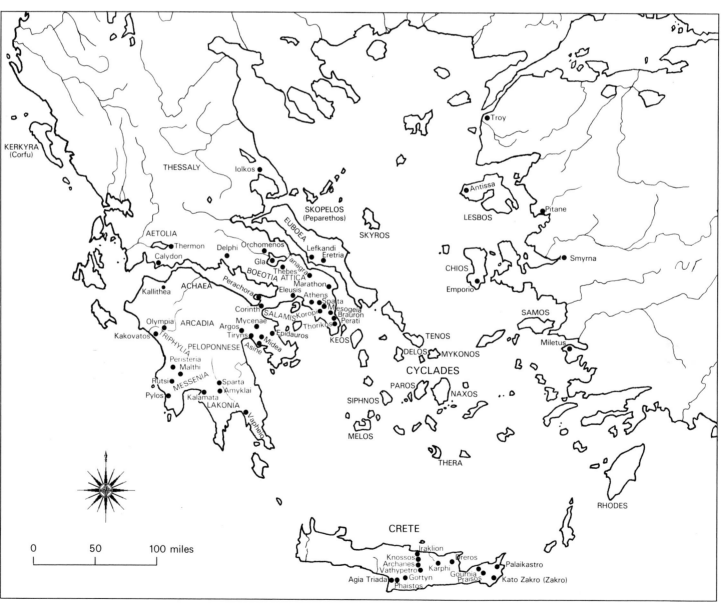

KERKYRA
(Corfu)

THESSALY

Iolkos

Troy

SKOPELOS
(Peparethos)

SKYROS

Antissa

Pitane

LESBOS

AETOLIA

EUBOEA

Thermon
Calydon
Delphi

Orchomenos
Gla
Thebes
Tanagra
BOEOTIA

ATTICA

Lefkandi
Eretria

CHIOS

Smyrna

Marathon

Emporio

ACHAEA

Perachora

Eleusis
Athens
Sparta
Mesogeia
Brauron
Perati

Kallithea

Corinth
SALAMIS
Koropi

Olympia
ARCADIA

Argos
Mycenae
Tiryns

Epidauros
Midea
Thorikos
KEOS

SAMOS

Kakovatos

TRIPHYLIA

Asine

TENOS

Miletus

PELOPONNESE

DELOS
MYKONOS

Peristeria
Malthi

CYCLADES

Rutsi
Pylos
MESSENIA

Sparta
Amyklai
Kalamata
LAKONIA

PAROS

NAXOS

SIPHNOS

Vapheio

MELOS

THERA

RHODES

CRETE

Iraklion

Knossos
Archanes
Vathypetro
Agia Triada
Phaistos

Dreros
Karphi
Gortyn
Gournia
Praisos

Palaikastro

Kato Zakro (Zakro)

0 50 100 miles

Architecture and Painting

Mycenaean Palaces

Mycenaean palaces are all built according to the same fundamental concept without, however, being rigidly schematic. Only meagre remains can be discovered of structures from the Early Mycenaean period, for these were later altered and enlarged. We have a clearer idea only of Late Mycenaean designs, based of course for the most part simply on the ground-plans and those parts of the lower storey that have been preserved.

The kernel of the palace is the megaron. At Mycenae this room measures 12.96 by 11.5 m, at Tiryns 11.9 by 9.7 m and at 1-2, 7 Pylos 12.9 by 11.2 m. In the middle lies the great circular hearth, which is enclosed by a raised and stuccoed rim. The diameter of this hearth is 3.7 m at Mycenae, c. 3.3 m at Tiryns and 4.02 m at Pylos. The stucco on the rim was decorated with patterns, for instance one of red and black flames or another of spirals, and was continually renewed.

The hearth was surrounded by wooden columns of Minoan form, in other words columns which tapered downwards. At Pylos, near one of the columns, is a low stuccoed table for offerings; a similar one was found at Mycenae. The wooden columns stood on stone bases. Although these columns were burned, the floor around them was renewed many times and so preserved their impression. Thus in the megaron at Pylos we find traces of 32 flutes, in another 44 and from the huge columns in the propylon the outline of 64 flutes: miniature 343 examples in ivory can provide a general idea of their appearance. On top of the columns rested the timberwork, but what this looked like in detail has not yet been explained. An opening in the middle of the room must have served to let the smoke out; at Pylos a clay pipe, which was surely used as a chimney, has been found. Such pipes for letting out the smoke were probably adopted in other Mycenaean palaces too. The upper storey was designed with this characteristic in mind, as is 1 shown in the reconstruction of Pylos.

On the right-hand side-wall was the throne of the ruler, or Anax. In later times the title of Anax was applied to the gods, but in the Homeric epics it was used for the ruler Agamemnon and occasionally even for other lords, as well as the gods. In the Mycenaean period this title was reserved for the ruler in each of the governmental and administrative spheres, as we learn from Linear B tablets. Nevertheless, there is no indication that in Mycenaean palaces the Anax enjoyed any divine honours. His throne was made from some precious material (perhaps wood, gold and ivory). It perished together with the footstool in the fire or the plundering of the palace. At Pylos, near the site of the throne, is a hollow in the ground from which a channel ran to a second depression. One presumes that this was intended for libations by the ruler.

The floor was divided into squares and colourfully painted. At Pylos in the last renewal the lines near the entrance were irregularly drawn. The best-preserved painted squares, however, are those at Tiryns, for here the floor was covered 2 with a fine coat of stucco over the usual limestone surface. The decoration of the squares alternated between elaborate net patterns, pairs of dolphins and octopuses. The decoration at Pylos was simpler; there were various linear patterns and only in front of the throne was a square painted with a powerful octopus. The floor of the megaron at Mycenae was similarly decorated, but only meagre remains have been preserved.

In front of the megaron a vestibule and portico jutted out. At Tiryns, following the Cretan fashion, three doors led from 3-4 the vestibule into the portico. At Pylos the side-walls of the 5 vestibule were broken by two doors; at Tiryns only on one side by one door, which leads into a narrow corridor. At Tiryns and Pylos the megaron and the vestibule opened through wide, high doors into the portico; at Pylos this was supported by two 5 high wooden columns of Minoan type. This is the portico where, in the Homeric epics, the guests spent the night. Thus according to the *Odyssey* (III, 397) Telemachos and Peisistratos, the son of Nestor, slept in the portico: 'but Gerenian Nestor the horseman sent Telemachos, the dear son of godly Odysseus, to sleep on a corded bedstead in the echoing portico. And next to him Peisistratos of the good ash spear...' or (IV, 296): '...and Argive Helen told her handmaids to set up beds in the portico, to lay on them fine purple blankets with coverlets above and to spread fleecy cloaks on top of all...' Nestor and Menelaos, however, rested inside in the corner of the house.

From the portico at Tiryns two shallow red steps led into the main courtyard. The size of this courtyard depended on local factors. At Tiryns it was a spacious area, surrounded on three 3 sides by columns. At Mycenae and Pylos it was smaller; only Fig. 2 on one side (over Room 44) have traces of two columns Fig. 1 certainly been discovered. One assumes there were balconies above. At Mycenae the courtyard is limited by the precipitous terrain. At Tiryns and Pylos there is a smaller megaron in addition to the large one. The former is generally referred to as the 'Queen's Megaron'; there is, however, no certainty that in Mycenaean palaces a separate megaron was reserved for the queen.

The bathroom was often a standard feature in the palaces. The best-preserved room of this type is at Pylos (Room 43). A clay bath with a step in front was built into the room. In the 6 corner a stand, which carried two large vessels, probably for bath-water, was set into the wall. At Tiryns, however, a single slab of grey limestone was employed as flooring. It measures

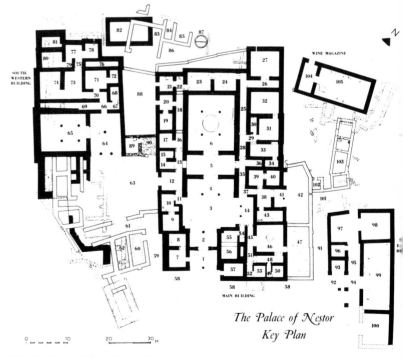

The Palace of Nestor
Key Plan

Fig. 1 Plan of the palace at Pylos.

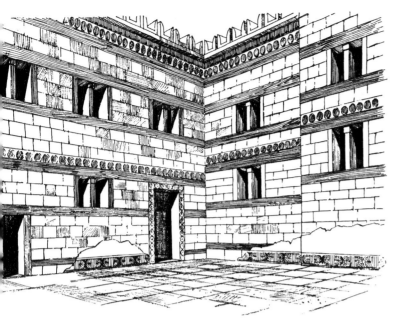

Fig. 2 Courtyard of the palace at Mycenae. Reconstruction by A.J.B. Wace.

Fig. 3 Plan of the palace at Mycenae.

over 3 by almost 4 m (70 cm thick) and weighs nearly twenty tons. On this were found fragments of a clay bath-tub. The walls were wood-panelled; by means of a slight inclination of the floor, the water was made to flow into a small courtyard and from there into the large main drain, which at the same time perhaps collected the rain water from the surrounding roofs.

The magazines are impressive; reached through long 7 narrow corridors and small doors, they served to store wine and oil. They were particularly well preserved at Pylos. Behind the megaron (6) were the oil store-rooms: in Room 23 seventeen storage vessels were embedded in the ground and sixteen in Room 24, while Room 27 served as a further oil magazine. The larger storage vessels were partly painted. Near by were smaller rooms in which smaller vases stood on shelves. In all many thousands of vessels of this type were found; they fell from the shelves in the great fire and were thus mostly broken.

Other rooms apparently contained the palace workshops. At Pylos there were workshops for repairing chariots and for leather- and metal-working, at Mycenae shops for ivory- and gold-working and for making finely painted votive tablets.

Occasionally the staircases which led to the upper storey, where the actual living-rooms and state chambers were located, have been preserved. At Pylos the level of the upper storey was about 3.25 m higher than the ground-floor. The walls of almost all these upper rooms were decorated with frescoes which fell down in the great fire that destroyed the building.

From the courtyard one passed through a propylon to the Fig. 3 outside. At Mycenae the propylon can still be traced; here the plan was altered and instead of a normal propylon, stairs were Fig. 4 constructed down the steep slope. At Pylos the propylaia were opposite the megaron; they took the form of a wall pierced by a gate with a column both in front and behind (Rooms 1 and 2). On one side of the entrance (Rooms 7 and 8) were the rooms of the guards, who had to watch over those who came and

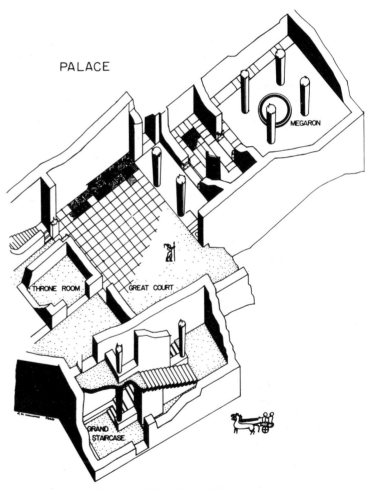

Fig. 4 Isometric drawing of the palace at Mycenae.

went; near by on wooden shelves was kept the archive of clay tablets, which have provided the basis for the decipherment of the Linear B script. Close by was a waiting-room (10) with a stuccoed bench which ran round the wall and on which visitors could sit until they were summoned. In the corner was a stand

with two large vessels which were probably kept full of wine, for in the adjacent rooms there stood hundreds of drinking vessels on wooden racks; the wine may have been intended to help the waiting visitors pass the time. One suspects that the rooms (55 and 56) in a tower-like building on the other side of the propylon served as accommodation for the guards. At Tiryns one passed first through a smaller propylon into the outer yard (12) and thence on to a large monumental propylon beyond (from 12 to 11).

3

The palaces were at first unfortified and this may still have been the case at the time of the shaft graves (1550-1450 BC). Over the years, however, they went through substantial alterations and were partly developed into fortresses. The palace of Pylos, in contrast, remained unfortified, despite the clear signs of danger elsewhere. In the thirteenth century men still felt so safe, so 'far away in a remote land' (*Odyssey*), that they did not consider it necessary to erect any bulwark. The obvious result was that the palace of Pylos was left defenceless before the enemy and that it perished in a great fire, never to be occupied again. The risk of fire was increased by the method of construction, for the most common building material was wood. Although square blocks of stone were employed on the exterior, the plastered rubble walls and the stucco were supported by vertical and horizontal wooden beams. Furthermore, the columns, doors and door-frames, panelling, ceilings and roofs were all of wood, which magnified the destructive effect of the great fire, which occurred between about 1210 and 1190 BC.

At Tiryns and Mycenae the first Cyclopean walls were built in *c.* 1375 and *c.* 1350 to 1340 BC respectively. At Tiryns the approach ramp was moved further to the east and from an open entrance the way now led through two fortified gateways (5 and 6), from which a possible attacker might be exposed to bombardment on both sides. Set back from both succeeding courtyards (11 and 12) were casemates, which were used to accommodate troops and store supplies. Casemates were constructed from roughly hewn, pointed stones which were leant against each other. On the outside, however, the Cyclopean wall was built from very lightly worked or completely unhewn rocks, skilfully fitted one to another, while the gaps were filled in with smaller stones and earth. The interior of these walls, which are *c.* 6 m thick, was packed with rubble and earth.

8

9

On the western side of the palace of Tiryns a stairway was constructed, flanked by high walls. Above, it led in through a strong tower, where a ditch was set, which one could have crossed only by means of a wooden drawbridge. It was originally believed that this exit was intended to (and did) serve as a means of ensuring the water supply in the event of a siege, so that sallies could be made to a source lying outside the town. However, it now seems more likely that this exit led to the near by harbour, for at that period the coastline ran much closer to the fortress. Towards the end of the thirteenth century the Lower City was also surrounded by a Cyclopean wall; it was not a refuge area, as had formerly been supposed, but in the Late Mycenaean period was densely populated. It is clear that the staff employed by the palace lived here, as well as the craftsmen. The division of labour and the specialization of jobs must have been taken to extremes, as we know from the Linear B tablets. There were bakers, cooks and stokers, unguent-boilers and libation-pourers, assistants, wood-cutters

Fig. 5

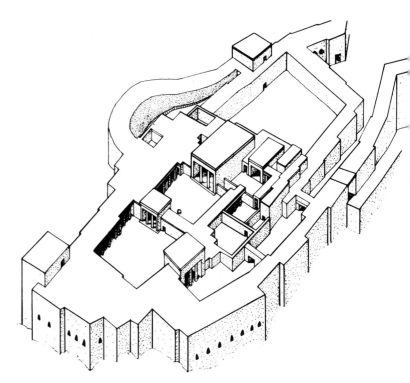

Fig. 5 View of the palace and fortifications at Tiryns. Reconstruction by the German excavation team at Tiryns.

and hunters. Among the craftsmen were tailors, fullers, tanners(?), potters and basket-makers; goldsmiths, smiths and armourers, bow-makers, harness-makers, cartwrights and carriage mechanics (?) are mentioned too, as are masons, carpenters, shipwrights, carriage drivers, stable boys, rowers and finally cleaners. Only the scribes, whom we know from their handwriting and finger-prints, receive no special mention as an individual profession. We do not even know what they were called.

At Mycenae the early palace was remodelled and enlarged and, as at Tiryns, was surrounded with a Cyclopean wall, though at the corners and in the towers the blocks were cut in a rectangular fashion. Finally the Cyclopean walls were taken far to the south and west, so that Grave Circle A was enclosed, and in the north-west the Lion Gate was built, protected by flanking towers and lofty walls.

10-11

62-3

When greater danger made itself felt toward the end of the thirteenth century, at Mycenae, Tiryns and on the Acropolis of Athens, the water supply was secured by means of an underground staircase leading to a well in an area outside the city. On the western side of the Lower City of Tiryns two covered stairways led to the exterior of the circuit wall, while at Mycenae an ingenious underground staircase was constructed in the north-eastern quarter of the city. Finally at Athens, where the whole Acropolis was surrounded with a Cyclopean wall in the thirteenth century (a part of it is still visible near the Propylaia), a staircase of stone and wood was made in a crevice 35.5 m deep under the north wall down to a well—an extraordinary feat of engineering, the results of which certainly did not last for long. In the end Mycenae and Tiryns perished around 1120 BC. The Acropolis of Athens, however, survived the storms and the Cyclopean walls were still standing at the time of the Persian invasion around 480 BC.

3

12

Fig. 6

Fig. 7

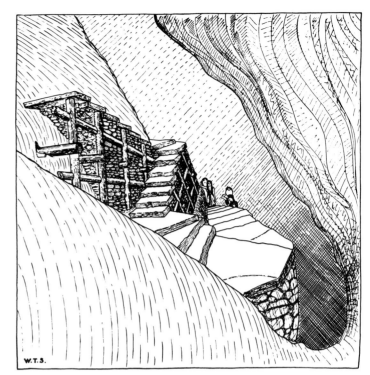

Fig. 7 Staircase to the well on the Acropolis of Athens.

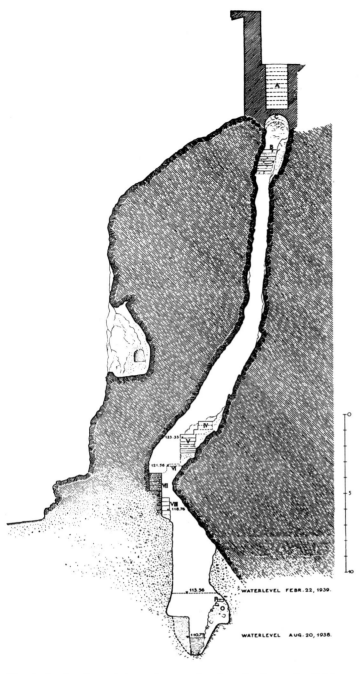

Fig. 6 Section through the underground well on the Acropolis of Athens. Reconstruction by O. Broneer.

Both of these halves are so similarly arranged that one must assume that they were occupied by two equally important persons. Although the living-rooms contain wall-paintings, they are not really palatial in character. The pottery found there is of Late Mycenaean date and the whole area might have served as a refuge for the population of neighbouring villages.

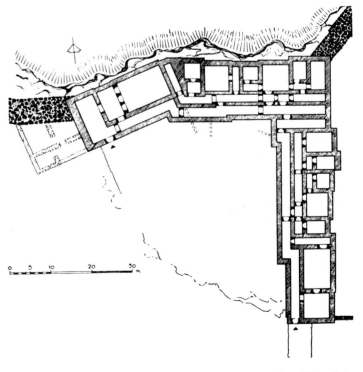

Fig. 8 Plan of the inhabited area of the fortress of Gla in the middle of the drained Lake Kopaïs.

The palace of Thebes is covered by the modern city, that of Orchomenos by a monastery. Only very small parts have so far been revealed; the same applies to the palace at Iolkos.

13 The fortress of Gla in the middle of the drained Lake Kopaïs is particularly remarkable. The dikes of the Minyans and the drainage system (*katabothrai*) with which they kept the swamp dry are famous. They fell into decay in the post-Mycenaean period and were first restored under Alexander the Great. The island of Gla reaches a height of 70 m and lies in the middle of the swamp area. Its stone walls enclose an area of *c.* 200,000 sq. m. They are built from more regular rectangular blocks than the Cyclopean walls of Mycenae and Tiryns, and are interrupted by four gates to which guard-rooms are connected. One half of the residential district abuts, in the north, the city wall, while the other half stretches southward.

Fig. 8

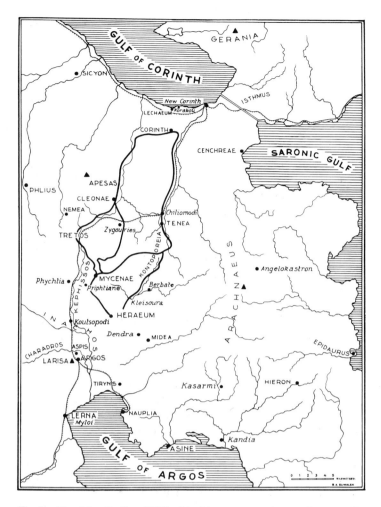

Fig. 9 Map (after Steffen, 1884) of the Mycenaean road system between the Gulf of Argos and that of Corinth.

There are other palaces with circuit walls, such as the fortified costal town of Asine, the mountain fortress of Midea, Malthi-Dorion in Messenia, Brauron and Thorikos in Attica. They are, however, less well preserved and cannot be discussed here. Finally we may mention the Cyclopean wall at the Isthmus of Corinth, erected in the early phase of the Late Mycenaean period; it was probably intended to secure the settlement of Kenchreai from the landward side.

The Mycenaean centres were connected with each other by a

Fig. 9 network of roads, as the plan shows. Running brooks were spanned by bridges, which were built in the manner of the

14 casemates: a Mycenaean bridge at Ligurió, over which the road to Epidauros still runs today.

Mycenaean Painting

Walls were decorated with paintings in all important rooms of Mycenaean palaces and in individual houses like that of the Oil-Merchant at Mycenae. The subjects of some of these paintings were ornamental, but most of them were figured.

Not only walls and ceilings were decorated, but also some floors were covered with durable patterns in coloured stucco.

The wall-painting was usually applied *al fresco*; indeed in the palace of Tiryns there are some areas of painting which show that the plaster was applied with a spatula and was still damp when the painting was done. In the palace of Pylos traces of additional painting with opaque colours have been discovered. Besides large-scale figured friezes and others on a miniature scale there were also purely ornamental ones. Paintings were often bounded by wooden beams, some horizontal, at eye level, and others vertical. This copious use of wood in the buildings led to their complete destruction in the great fire. The paintings fell from the walls, broke into pieces and were partially discoloured by the conflagration. Worse still, the paintings from the upper storey fell into the ground-level rooms and became intermingled with the remains of the paintings there. This has made the task of the excavators very difficult, especially when remains of the frescoes of an earlier phase of the palace already lay as debris under the renovated palace. Thus only a few coherent areas of painting survive, which are themselves reconstructed from fragments, and even they can only rarely be connected with particular places in the building.

The most important remains of frescoes come from the palaces of Knossos, Thebes, Mycenae, Tiryns and Pylos: smaller fragments were found at other places. These frescoes belong to various phases, from the early part of Late Mycenaean to the latest, but in spite of such differences in date they are basically homogeneous and show few signs of any real development. We shall, therefore, take them as a unity, while also glancing at the well-preserved frescoes from the island of Thera, for they give much help in gaining a proper impression of what Mycenaean wall-painting might have been like.

The motifs are largely taken over from the Minoan wall-painting of Crete, where painting was already fully developed, and only occasionally show any originality. Furthermore, the borrowed motifs were faithfully copied and not enlivened by fresh observations. A favourite theme of this type is the long procession of women, shown moving in both directions; unfortunately in no case is the goal, to which they were heading, preserved. The frieze of women from Thebes 15 has been reconstructed from many fragments. The women stepping along solemnly wear the Cretan festal costume: the Minoan flounced skirt with decorated borders and the Cretan jacket, tightly laced at the waist, over which the breasts are exposed. The hair is curled over the forehead and falls in long strands down the breast and back. Some of the women are drawn completely in profile, others turn their chests to the viewer. Some carry blooms, others various forms of pyxides or other vessels. One fragment of the great frieze of women from 16-17 Tiryns shows, according to a recent interpretation, a woman's hand holding in a cloth a female idol with raised arms. This procession may, therefore, have been moving toward a sacred place.

The examples from Thebes, Tiryns and Pylos are recon- 16-18 structions which have been put together from fragments of many figures. One head from the Tiryns frieze is preserved on 19 a fragment without any restoration, enabling us to appreciate better the details of line and style.

Hunting scenes play a large role in Mycenaean painting; but they have a character of their own. They do not display the

16

sensitive observation of nature and of rapid movement seen on the Cretan models. Instead the action takes place in a strictly ordered and stylized world. This is particularly striking on the Tiryns frieze, where two elegant women are on their way to the hunt—note especially the trees in the background. The left-hand tree is rigidly stylized; from the yellow trunk rises a wide yellow contour line which encloses the tree, so that the branches and leaves inside seem scarcely able to move any more. This same stylization recurs in the other trees, which are differently coloured.

20

The background is light blue, which contrasts with the red chariot and horse. Some other parts of the chariot are yellow, such as the wheel within its grey and blue frame. The ladies wear hunting dress—chitons with short sleeves. The one in front holds the reins; the other has her arm bent so that only the fist is visible; they stand rigidly upright and motionless. The horse moves at a gentle pace—in Mycenaean painting horses are only represented standing, moving quietly or sometimes racing along at a 'flying gallop'. The counterpart to the Tiryns frieze is the chariot parade from Pylos. A warrior with a boar's-tusk helmet and short-sleeved chiton stands on the chariot and holds the reins which are painted in white. A second warrior follows him on foot, a spear over his shoulder. The horse has the same quiet step as in the chariot scene with the two women from Tiryns. The background changes, as on the Cretan forerunners: neutral areas alternate with zones painted in various colours, each division being marked by vertical wavy lines.

21

The object of the hunt is shown in an excerpt from the Tiryns frieze. Three hounds chasing a boar, all in the 'flying gallop' pose, have broken into a thicket of white and red wavy plants. The hounds are spotted in various colours; the top one has red, the middle one blue and the lowest hound black spots. They wear red collars and have a wide red line along their stomachs. The boar has small eyes and large tusks and is painted yellow with brown stripes along its body. These are the colours of a young boar, though a fully grown animal is represented here. The rest of the hide is covered with little black lines. The hooves are black and there is a broad white line along the stomach. The animal runs straight on to two boar-spears, one of which is held by the red hand of a man, while the other is stuck in his forehead. Overlapping of figures drawn in profile is carefully avoided.

22

The counterpart from Pylos shows a man hunting a stag. He wears a short-sleeved belted chiton decorated with dots, but has no helmet. His hair flies to the rear as he bends right back at the hip to make his throw. A stag, at the 'flying gallop', looks back, not suspecting the hunter's presence, and so runs straight into his path. The background is neutral at this point and the variously coloured parts are again separated from each other by vertical wavy lines.

23

A part of the frieze at Tiryns shows a chariot team arriving at a gentle pace and a hunter in front holding a hound on a lead. A further extract depicts a herd of stags which are still standing quietly and looking around watchfully. The bodies of the animals are variously coloured and decorated with little rosettes. The sweeping contours of their necks are done with double lines. On this occasion overlaps are tolerated in order to give the impression of a herd.

24
25

Other fragments from Tiryns show a hunter carrying two hunting spears over his shoulder. Not only the drapery and arms but also the face are given definite contour lines. This is not, however, the rule, for on the face the contour is generally omitted; indeed, the fact that the painters had no firm rule is further shown by the fragments from Pylos. A further group of fragments from this site shows, above, a hunter with a spear, striding to the left in front of two hunting dogs, held on long leads. Below, men wearing leggings and carrying tripods move in the same direction. The context of the scene is not clear, though we may compare the striding hunter with the one from Tiryns: there is the same pose of the head and arms and the same puffed-out chest. The hunting dogs overlap here because a pack is represented.

26

27

The Mycenaean wall-painters attempted other themes such as warriors unharnessing or driving chariots, warriors running, men shooting bows and even battle scenes. At Pylos there are some on which the fight is at close quarters, where those on one side have helmets and short chitons, while the others wear animal skins draped round them and have loose, dishevelled hair. They kill each other with a spear-thrust at the genitals or with a sword-blow to the chest and fall forwards or backwards. Yet in all this violent action only profiles are shown and overlapping is avoided.

28

There are also, interspersed on a smaller scale, representations of architecture, as in Minoan wall-painting. In this respect the fresco fragments from the megaron at Mycenae are of particular interest. Here we see a house, almost symmetrical about its vertical axis, with a tower in the middle and slightly lower wings to the right and left. The tower and wings have flat roofs. They are coloured red with black, closely set cross parts. Beam ends over cross-beams appear in the wings above an opening filled by a Minoan column which rests on white rectangular blocks, while underneath is a chequer pattern. In the middle section, however, we see two large windows, one in the upper storey where a female head, turned to the right, is well preserved, and one in the lower storey with the back of the head of another spectator. Under these two storeys at least one more may be imagined. Above there appears, on a much larger scale, the legs and belted chiton of a falling figure. He wears the normal leggings and is usually regarded as a warrior, since only an event connected with war could plausibly be the cause of his fall. At the very top of the fragment over the yellow background, an area of red is still preserved: part of the stomach of a red animal at the 'flying gallop', probably a galloping horse pulling a chariot. Horse and falling warrior are on the same scale, but because of the fragmentary state of this piece we are unable to take the reconstruction any further. It is, nevertheless, clearly a characteristic of Mycenaean painting that the scale of the architecture, although consistent in itself, has no logical relation to the larger scale of the figures. Mycenaean painters and their public apparently took no exception to this anomaly.

29-30

The women depicted on a fragment from Mycenae, sitting in front of a verandah with garlands, are probably watching a celebration. The aperture of the window is painted blue, the architecture red and yellow, the women's sleeves yellow; the house and garlands are white. Another fragment from a private house at Mycenae shows three white demons carrying a pole on their shoulders.

32

33

Mighty animals like lions or mythical beasts frequently guard the place where the ruler sat enthroned. The decoration of the throne-room at Knossos is well known. It certainly dates

1 Throne-room of the megaron in the palace at Pylos. 13th century. 12.9 × 11.2 m. Reconstruction by P. de Jong.

2 Plan of the megaron in the palace at Tiryns, with circular hearth, throne, painted floor (reconstructed, cf. Pls. 39-40) and porches. 14th-13th century. Megaron: 11.9 × 9.7 m.

3 Plan of the Upper Citadel of the palace at Tiryns. 14th-13th century. 700 m².

4 Small propylon to the palace courtyard at Tiryns, with view of the megaron. 14th-13th century. Reconstruction by K. Müller.

5 Megaron portico at Pylos. 13th century. Reconstruction by P. de Jong.

6 Bathroom of the palace at Pylos. 13th century.

7 View of megaron (with circular hearth) and magazines of the palace at Pylos. 13th century. Megaron: 12.9 × 11.2 m.

8 Approach ramp and East Gate of the citadel at Tiryns. 14th century.

9 Casemates at Tiryns: view south. 14th century.

10 Plan of Grave Circle A at Mycenae. Graves: 16th century. Ring of orthostats: 14th century.

11 View of Grave Circle A and Lion Gate at Mycenae. Graves: 16th century. Ring of orthostats: 14th century. Drawing by A.J.B. Wace on the basis of old photographs and prints.

12 Cyclopean walls on the Acropolis of Athens (with view of the West Front of the Parthenon). 13th century.

13 Fortress of Gla in the middle of the drained Lake Kopaïs. 13th century. 200,000 m². Aerial photograph.

14 Mycenaean bridge near Ligurió (Argolid). 13th century.

15 Frieze of women, from Thebes. Fresco. C. 1400 BC. Life-size. Reconstruction by H. Reusch.

16 Detail from the great frieze of women: hand with idol, from Tiryns. Fresco. 13th century. Life-size. Reconstruction by Ch. Boulotes.

17 Mycenaean woman with small box from the great frieze of women, from Tiryns. Fresco. 13th century. Life-size. Reconstruction by G. Rodenwaldt.

18 Two Mycenaean women, from the frieze of women at Pylos. Fresco. 13th century. Reconstruction by P. de Jong.

19 Detail from the great frieze of women, from Tiryns. Fresco. 13th century. H. of detail 39 cm. National Museum, Athens.

20 Women driving to the hunt, from a frieze at Tiryns. Fresco. 13th century. National Museum, Athens.

21 Charioteer and warrior, from a frieze at Pylos. Fresco. 13th century. Reconstruction by P. de Jong.

22 Boar and hounds, from a frieze at Tiryns. Fresco. 13th century.

23 Stag hunt, from a frieze at Pylos. Fresco. 13th century.

24 Hunter and hound, a chariot behind, from a frieze at Tiryns. Fresco. 13th century. Reconstruction by G. Rodenwaldt.

25 Herd of stags, from a frieze at Tiryns. Fresco. 13th century. Reconstruction by G. Rodenwaldt.

26 Hunter, from a frieze at Tiryns. Fresco. 13th century. Reconstruction by G. Rodenwaldt.

27 Hunter and two hounds; below, men with tripods; from a frieze at Pylos. Fresco. 13th century. Reconstruction by P. de Jong.

28 Battle between men with short chitons and boar's-tusk helmets and men wearing animal skins, from a frieze at Pylos. Fresco. 13th century. Reconstruction by P. de Jong.

29-30 Falling warrior; above: a charriot; below: a building with a woman's head in the window; fragments of a fresco, from the megaron at Mycenae. 14th century (?). Left, drawing; right, watercolour from the original fragments (G. Rodenwaldt).

31 Singer with a five-stringed lyre on a rock and a large bird in flight, from the frieze in the megaron at Pylos. Fresco. 13th century. Reconstruction by P. de Jong. Cf. Pl. 35.

32 Women at window, from Mycenae. Fresco fragment. 14th century. W. 13.5 cm. National Museum, Athens.

33 Procession of demons carrying a pole on their shoulders, from Mycenae. Fresco fragment. 13th century. W. c. 11.5 cm. National Museum, Athens.

34 Frieze of doves, from Pylos. Fresco. 13th century. Reconstruction by P. de Jong.

35 Sequence of elements; right: the singer and bird (Pl. 31); below, much smaller: two groups of two men on camp-stools, sitting facing each other over a table. Left: on a larger scale: a standing bull; further left, separated by a vertical border: a lion and a reclining griffin; from a frieze in the megaron at Pylos. 13th century. Reconstruction by P. de Jong.

36 Violet-coloured griffin and brown lion, from the megaron at Pylos. Fresco. 13th century. Reconstruction by P. de Jong.

37 Ornamental frieze, from Tiryns with spirals and buds. Fresco. 13th century. Reconstruction by K. Müller.

38 Ornamental frieze with figure-of-eight shields. Fresco. 13th century. Reconstruction by K. Müller.

39-40 Painted floor, from the megaron at Tiryns (cf. Pl. 2): dolphins and octopus. Painted stucco. 13th century. Reconstruction by K. Müller.

41 Fragment of an ornamental frieze with figure-of-eight shields (cf. Pl. 38), from Mycenae. Fresco. 14th-13th century. National Museum, Athens.

42 Ornamental frieze with nautili from Pylos, above horses. Fresco. 13th century. Reconstruction by P. de Jong.

43 River with palm-trees, from Akrotiri on Thera (from the same room as Pls. 44-5). Miniature fresco. 1500 BC. H. 20 cm. National Museum, Athens.

44 Entry of the fleet, admiral's boat, from Akrotiri on Thera (from the same room as Pls. 43, 45). Miniature fresco. 1500 BC. H. 40 cm. National Museum, Athens.

45 Mycenaean warriors going on shore, from Akrotiri on Thera (from the same room as Pls. 43-4). Miniature fresco. 1500 BC. H. 40 cm. National Museum, Athens.

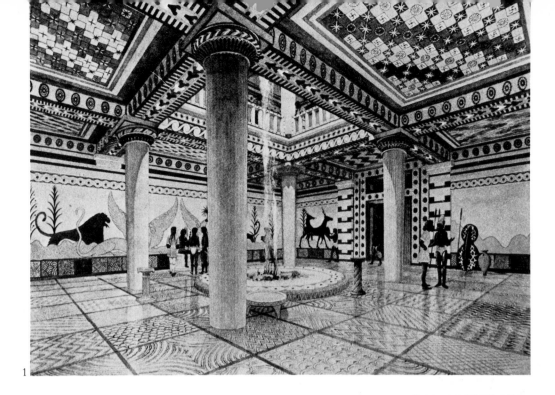

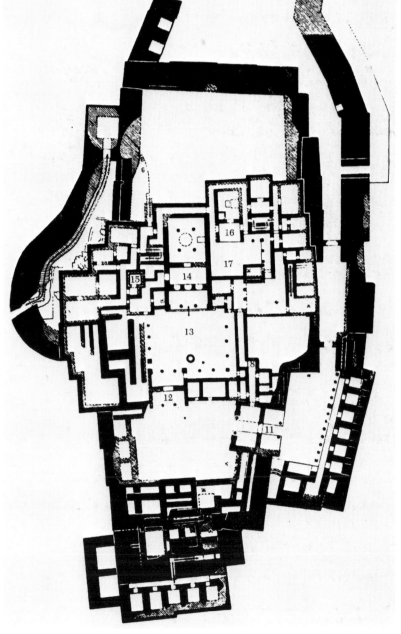

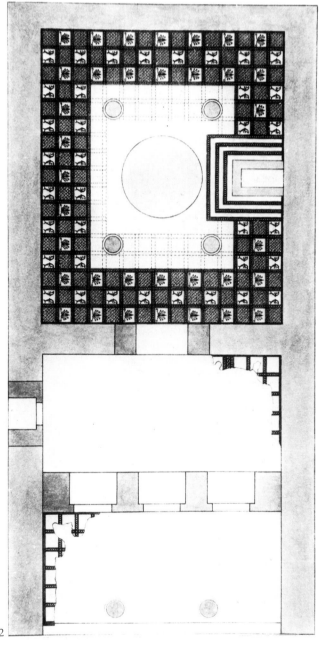

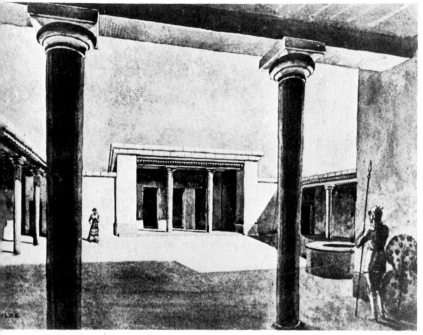

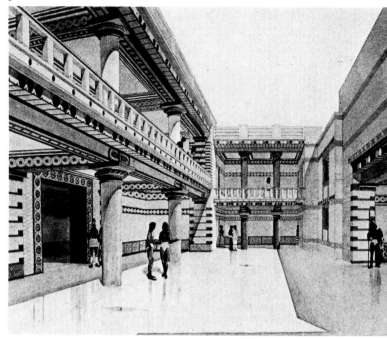

6▽

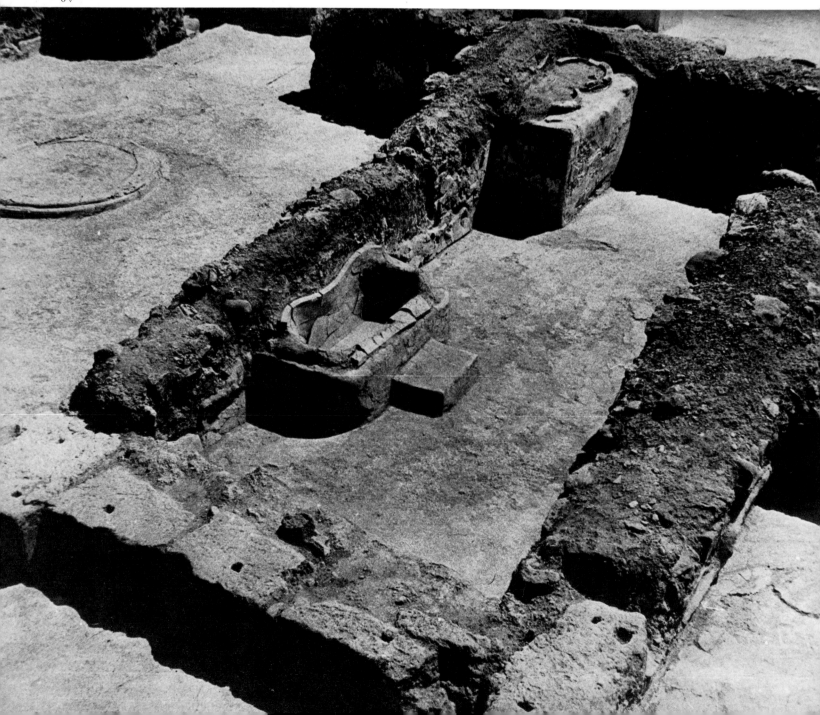

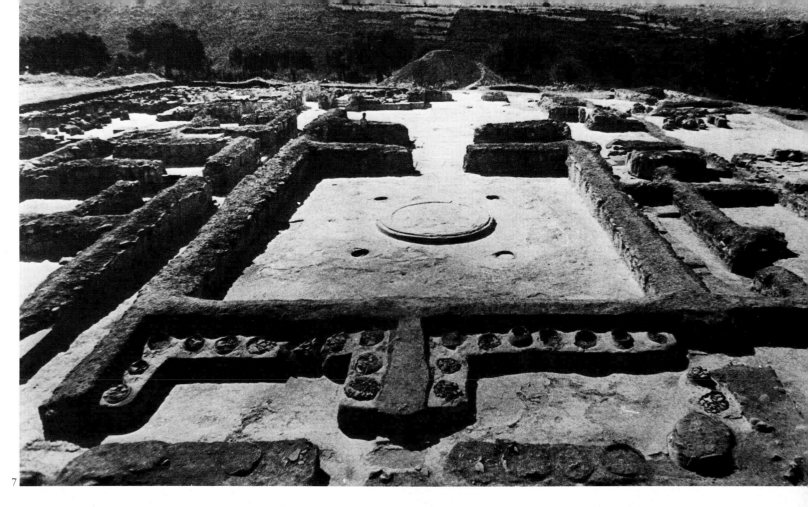

7

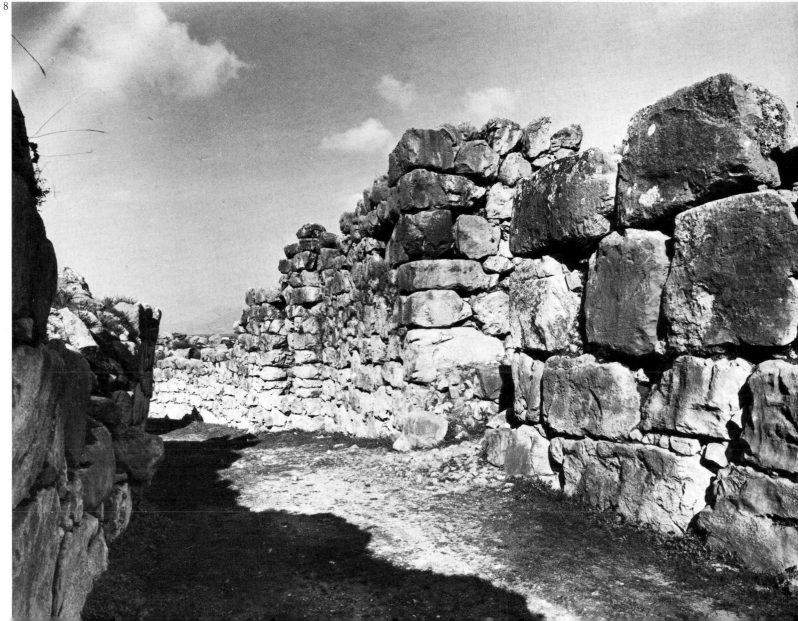

8

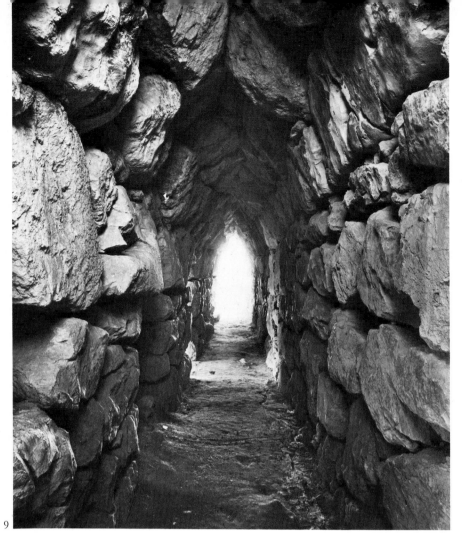

9

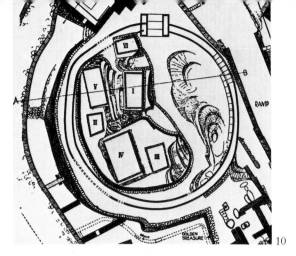

10

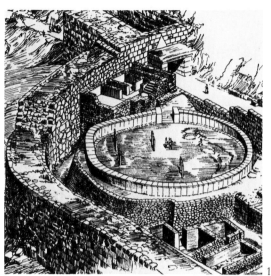

11

12

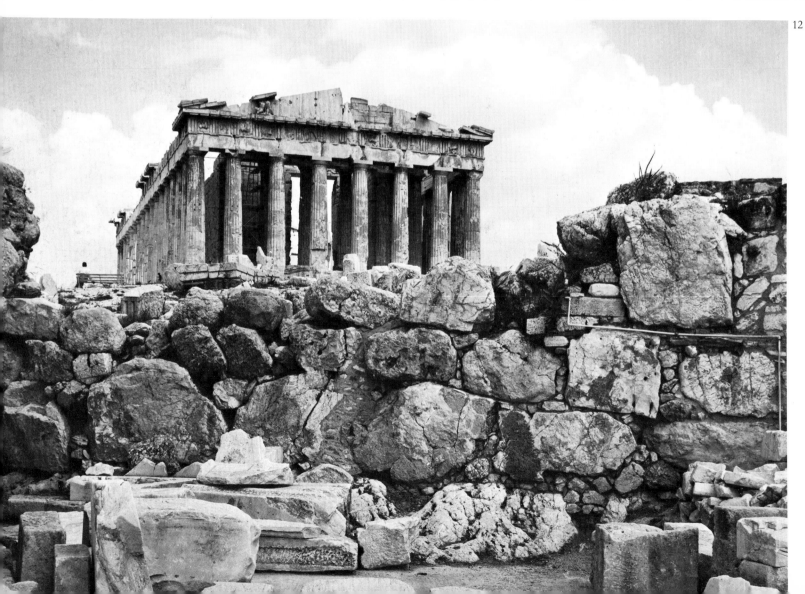

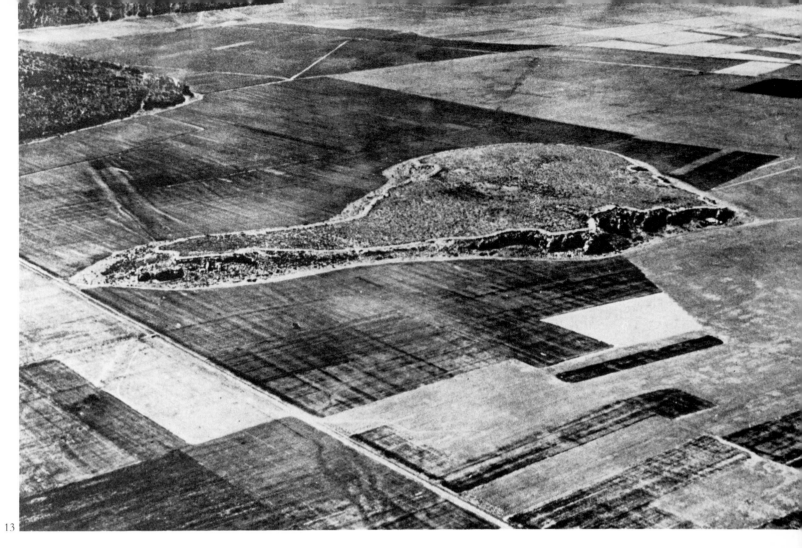

13

14

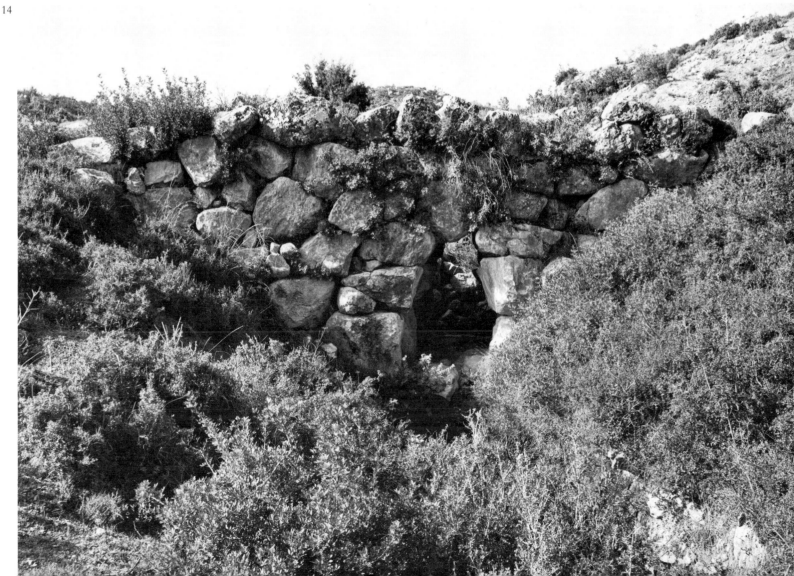

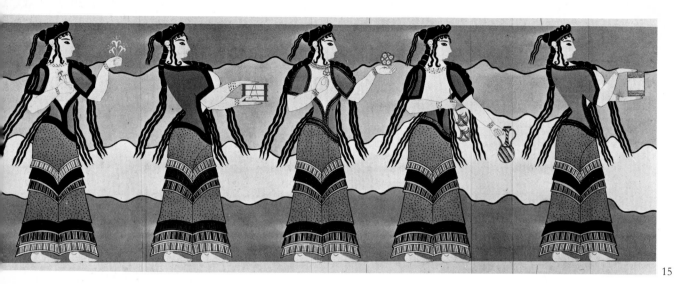

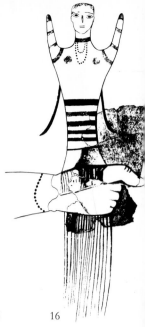

15

16

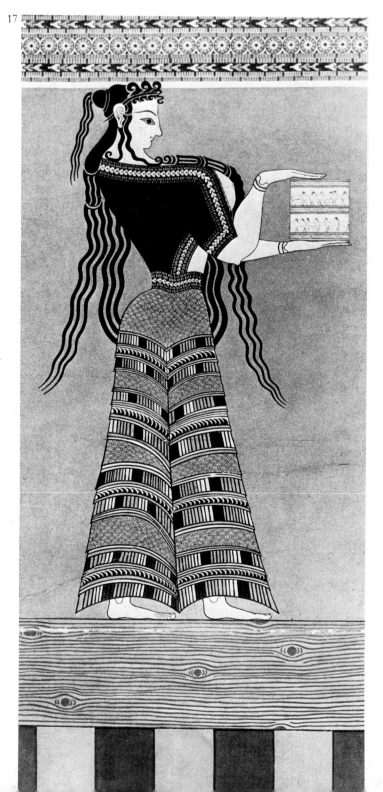

17

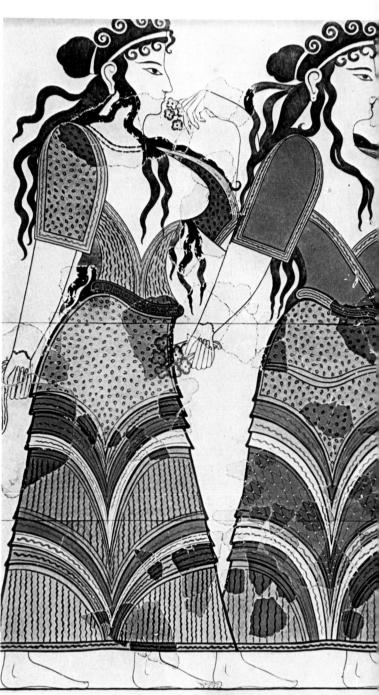

18

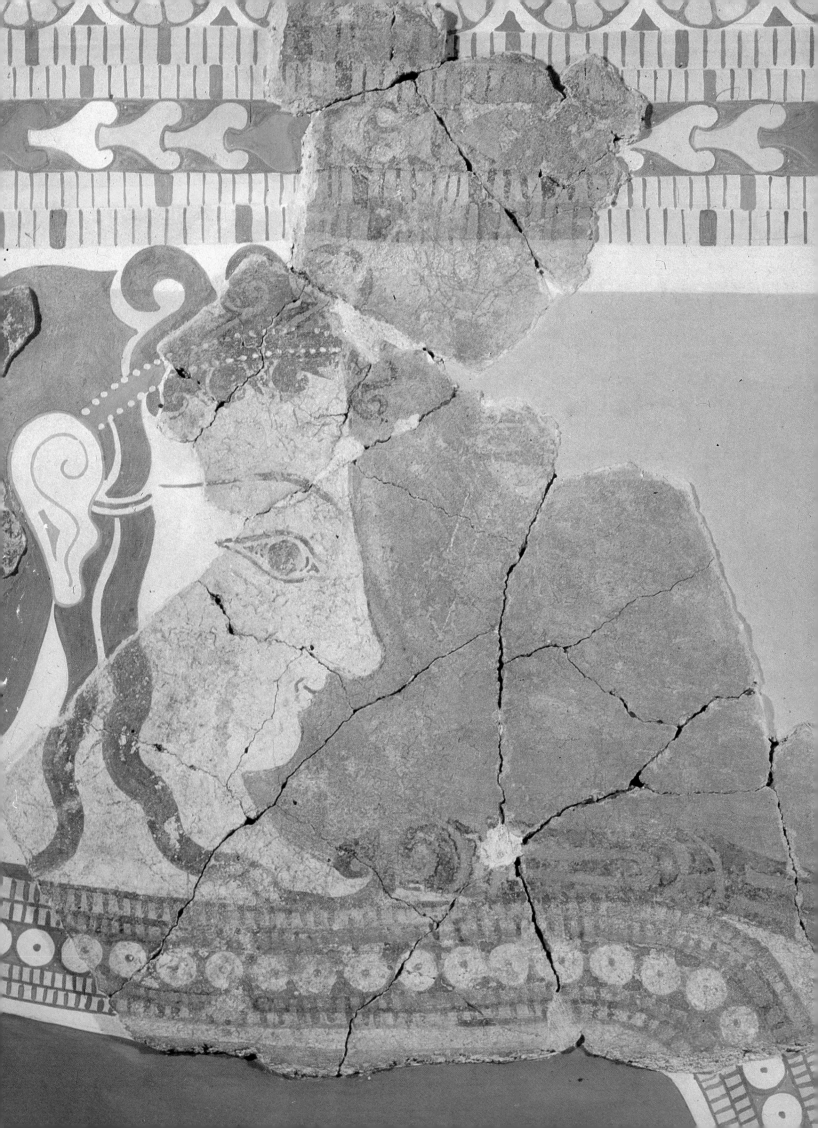

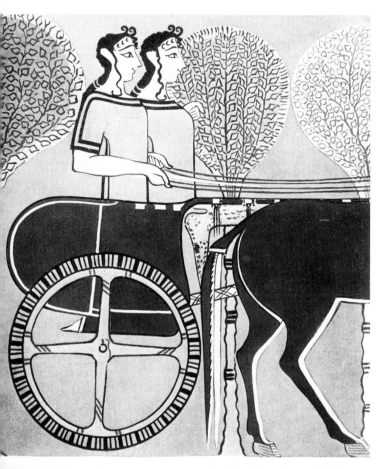

20

21

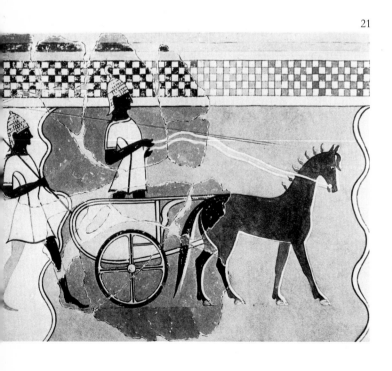

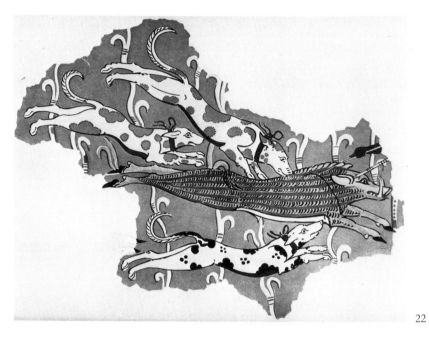

22

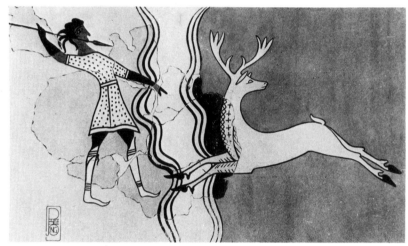

23

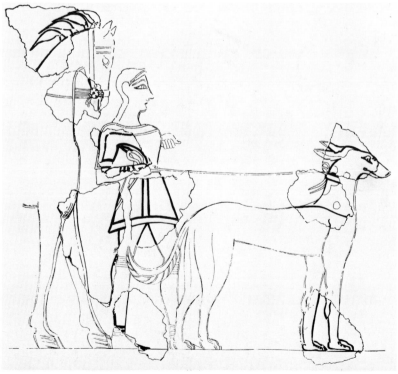

24

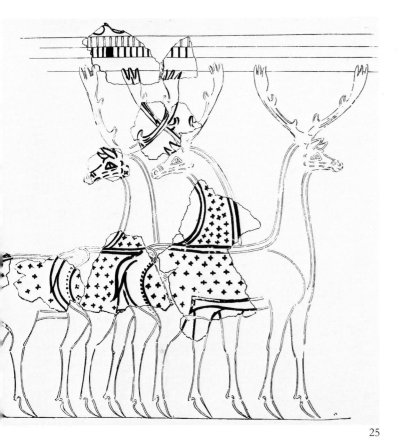

25

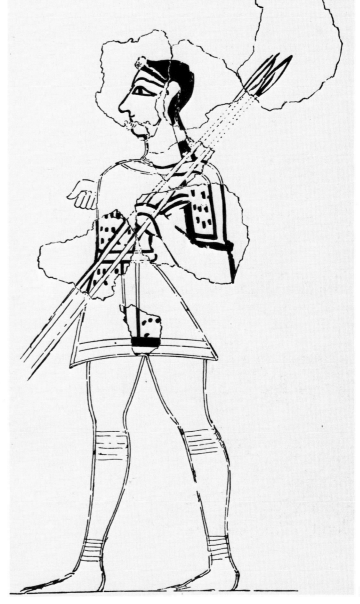

27

26

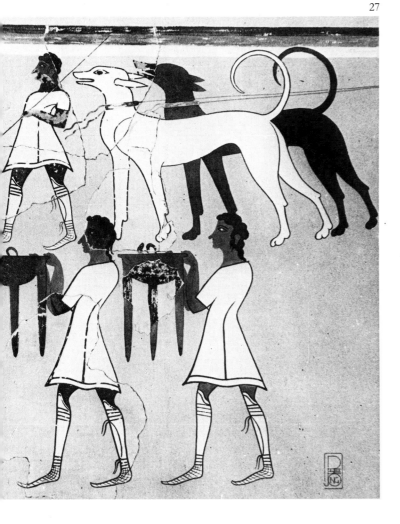

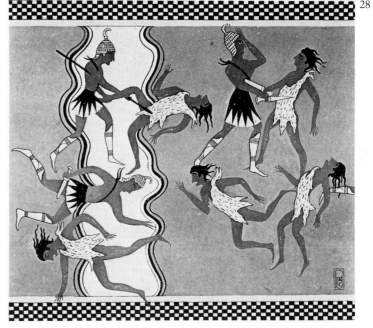

28

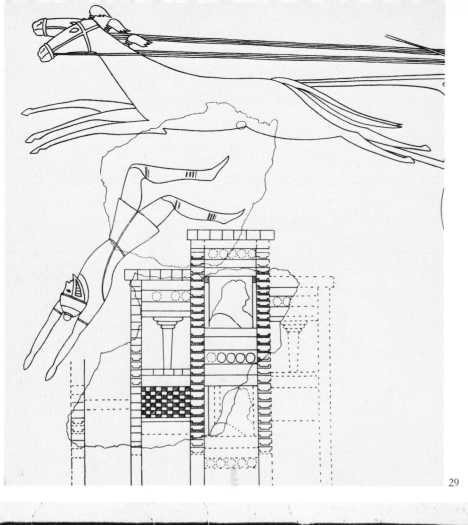

29

30

31▽

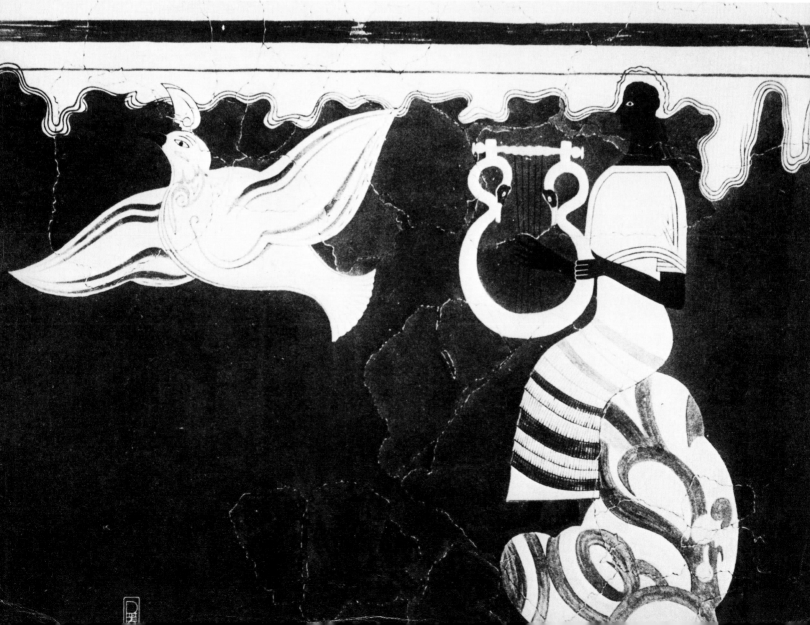

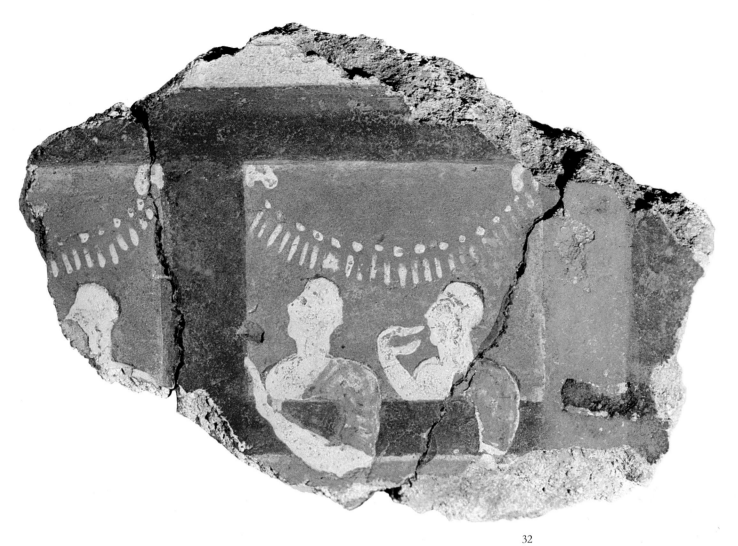

32

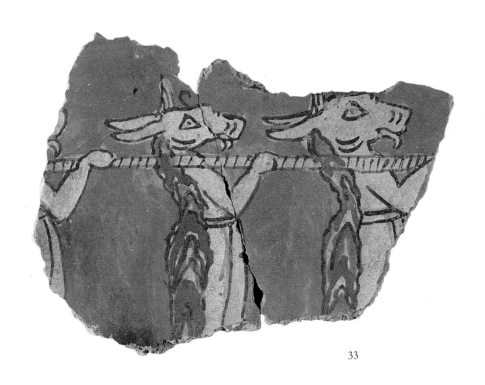

33

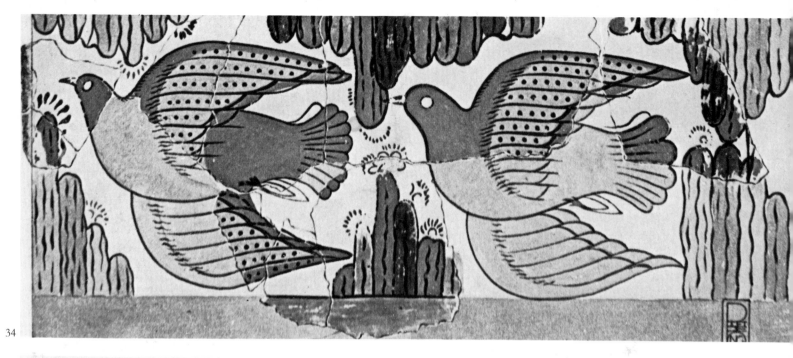

34

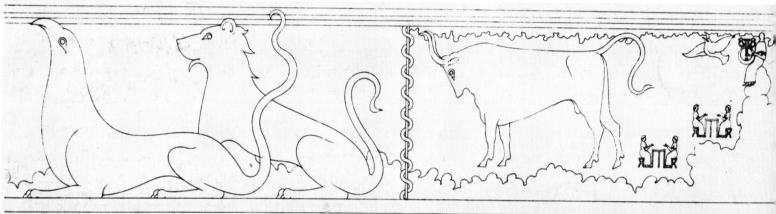

35

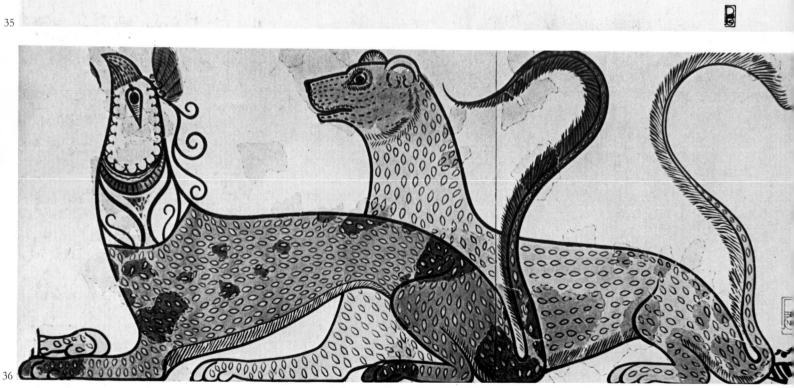

36

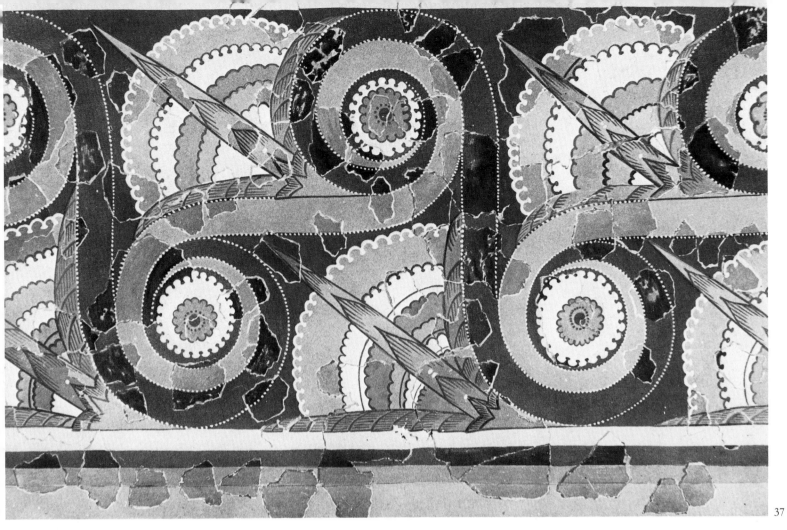

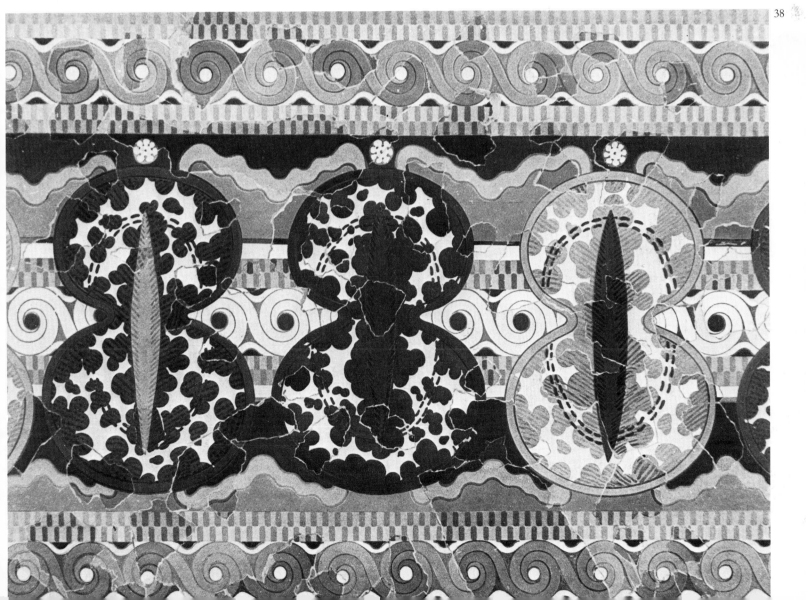

39

40

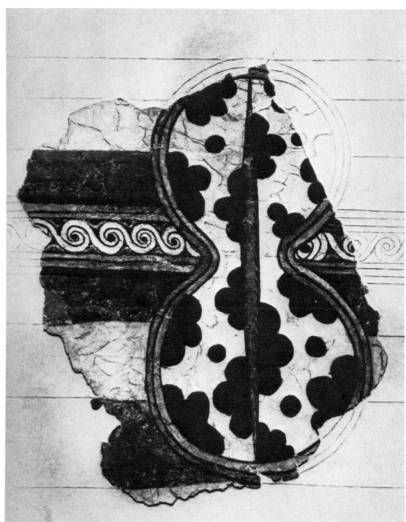

41

42▽

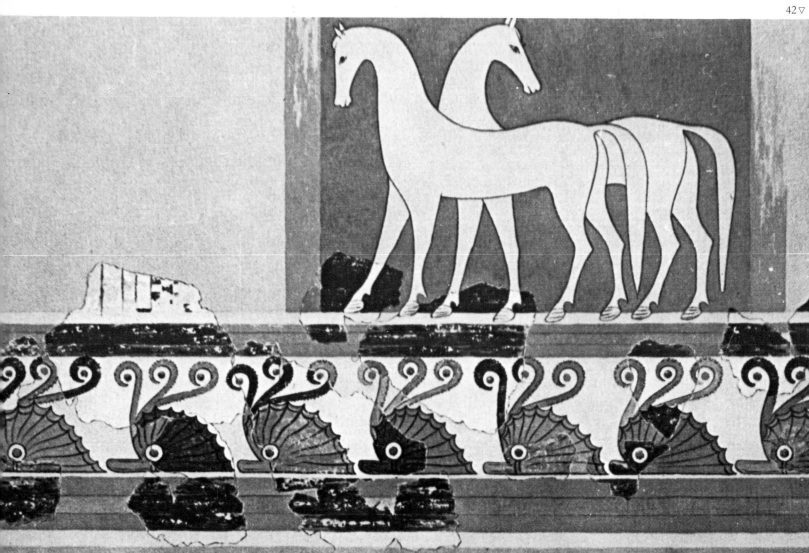

from the time of the Mycenaean overlordship, but the room is not a megaron with a circular hearth in the middle. On either side of the ruler's throne at Knossos, griffins lie between stylized blooms against a neutral background. How little of the frescoes was actually preserved on the walls is shown by a photograph taken during the excavation. Just as fragmentary 35-6 are the remains of a fresco with a griffin and a lion from Pylos, which belongs to a strange sequence of pictures. There a singer 31 sits on a multi-coloured outcrop of rock, playing on a five-stringed lyre. The arms of the instrument end at the top in swans' heads turned inwards. The singer has loose hair, falling down in long locks over the nape of his neck. In front of him a 34 powerful bird flies through the air; it may be a dove, since there are other such doves in a frieze of birds. Below, on a much smaller scale, in two places two men sit on camp-stools 35 opposite each other at a table. On the left there follows a large, quiet bull which is separated from the group of lion and griffin by a vertical border. We need larger connected passages, however, to understand the sense of such compositions, but we can at least appreciate the powerfully drawn head of the griffin with its curved beak and the lion's head with its lively eye and powerful jaws.

It is also worth glancing at the non-figured frescoes. Abstract forms found a place in ornamental borders; sometimes they 37 almost became themes in their own right like that from Tiryns. The ground is red; the spirals and bud-like points are done in light blue. The outer spirals are grey, the rosettes yellow and red on white, and the spandrels filled with white, light blue and yellow edged with red. It is the same pattern that is seen on the 51 ceiling of the side-chamber of the tholos tomb at Orchomenos, except that here the motif is conceived as a band but there as the covering for a whole surface. One must imagine the pattern from Orchomenos gaily painted. Such a continuous motif may originally have been a weaving pattern and, since it is chiefly met on ceilings, one might think that it was often used on canopies.

38 Another ornamental motif is that of large figure-of-eight shields. The high point of the use of these shields was in the sixteenth and fifteenth centuries, though they remained in sporadic use until the late phase of the Mycenaean period. The form survived on a large scale as a decorative pattern, and we find it on the walls of the palace of Knossos as well as Mycenae 41 and Tiryns; indeed, it probably occurred in every Mycenaean palace. In addition it is used as a decorative element on a miniature scale, for example on gold or ivory objects. Nevertheless, this motif always retained something of its original venerable quality.

Painted floors have also been preserved. In the megaron at 39-40 Tiryns the floor is divided into squares decorated with a scale pattern (perhaps to be thought of as waves) alternating with either two dolphins or an octopus. At Pylos there are friezes 42 with nautili. It is amazing, however, just how few marine motifs were adopted in Mycenaean art, even though from the sixteenth and fifteenth centuries onwards Mycenaean traders had already developed a large overseas market, which was further extended in the fourteenth and thirteenth centuries. Trade was carried westwards to Sicily, including the Aeolian island of Lipari, with southern Italy, the island of Procida and even Vivara. In the east the Mycenaeans traded with Syria and Egypt, had contact with Troy and Miletus, and founded trading posts at places such as Minet-al-Beida, the port of Ras

Shamra. Nevertheless, their pictorial art remained unaffected by these maritime adventures. The few marine motifs which they did use, such as dolphin, octopus and nautilus, were borrowed from Minoan art and did not increase in quantity.

An exception should be mentioned here, even though it is strictly speaking not a Mycenaean work, but rather one which stands within the orbit of Mycenaean influence. At Akrotiri on the island of Thera are three wall-paintings in the form of friezes, set in a room above window level. The one on the east 43 wall, only 20 cm high, shows by means of wavy lines a running river seen from above, beside which grow coconut-trees and other exotic plants. Colourful stones lying on the ground suggest a wilderness. Along the river bank race a winged griffin, a leopard and a deer; a water-bird preens its feathers on the bank and a duck takes off from the ground. The painting recalls Egyptianizing works such as the inlaid bronze dagger-blade from Shaft Grave V at Mycenae on which a leopard pounces on some wild ducks.

On the north and south walls, however,—the west wall is lost—the frieze is 40 cm high and shows another theme with different characters. Around a deep harbour are multi-storeyed houses, from which the heads of men and women look out, and naked men are approaching the shore in long columns. On a mountain peak we can see a lion following a herd of stags, and in another place a herd of cattle, goats and sheep, tended by shepherds. Into this busy bay sails a whole fleet of at least eight large and six small ships. One vessel has its sails hoisted; the others are being rowed. The admiral's boat is decorated 44 with garlands and, under a sun-shade, men sit opposite each other. Incidentally, each of the men on the left looking to the front has a boar's-tusk helmet, a typical Mycenaean piece of armour, hanging over his head. Dolphins play in the water around the ship which has lions and dolphins painted on its hull.

Elsewhere Mycenaean warriors can be seen disembarking 45 in military formation. They wear boar's-tusk helmets and carry the great rectangular tower shield, covered with spotted animal hide. Large swords hang in sheaths at their sides and in their right hands they hold enormous spears (or boat-poles).

This painting was done in about 1500 BC, after the earthquake which hit the island of Thera and before the great catastrophe of the eruption. One supposes that the owner of the house was the commander of the enterprise, the course of which he had painted in miniature frescoes in his house. Whether such an idea is correct or not, the frescoes show that in 1500 BC the island culture of Thera already had contact with the Mycenaean world. It is striking that on these paintings the landscape is also included, not only the immediate neighbour-hood, as in the river picture, but the wider surroundings as well. For in the foreground of the ship frieze are settlements with houses painted blue, yellow and red shown on top of one another; in the background is a rocky mountainous region with a sanctuary on its peak, and the flanks covered with wild animals or domestic herds. Except in the case of the deer and the animals in the herds, there is no overlapping—even the ships are set cleanly apart from each other. Furthermore, men, animals and ships are all drawn in profile and the scale of each is adjusted. This is no mythical event but a contemporary occurrence in which the adventure itself and the traditional formulae are happily combined.

Tholos Tombs

Besides shaft graves, which were common in the Early Mycenaean period, two other forms of burial began to be used, the chamber tomb and tholos tomb, which coexisted until the end of the Mycenaean epoch.

Chamber tombs were hewn out of the soft rock, though in exceptional circumstances they might also be sunk into the earth. They had a horizontal or slightly sloping approach passage *(dromos)*, which narrowed towards the door of the chamber. This dromos was closed with a packing of stones as a defence against tomb-robbers. Occasionally the façade was stuccoed and decorated with rosettes or geometrical ornaments. The size of the chambers varies and they may be roughly rectangular or oval in form. This type of grave often served as a family grave for generations; it was reserved mostly for wealthy families. Since the burial rites were basically the same in both chamber tombs and tholos tombs, we shall discuss the latter alone.

The tholos tombs were completely man-made and must have been built only for the foremost families of princely descent. However, one finds them spread throughout the whole Mycenaean world; at Mycenae itself, at Tiryns and Dendra, in the Argolid, the interior of Peleponnese, Lakonia, Messenia, Triphylia, Attica, in central Greece, for example at Orchomenos, and in Thessaly, up the western side of Greece and the Ionian islands and down to Zákynthos, as well as on the Aegean islands—sometimes even as far afield as Crete and Anatolia.

This form of burial first became popular towards the end of the sixteenth century, though some examples are perhaps a little earlier. As with the chamber tombs, there was an approach passage cut into the earth, but the tomb chamber itself was given a walled dome. These towering domes were not constructed with vertically set stones, but height was achieved rather by projecting each horizontal layer inwards from a certain level. These projecting stones, the backs of which were not visible, were weighted behind with other stones and packed with soil. A very effective waterproof coating of mud was laid over the top. The dome was closed with a round slab.

The weight of the mass of stones over the doorway was a problem. To solve it a relieving triangle was left over the lintel. The dromos varied in length; its side-walls and dome were constructed according to local circumstances and with varying degrees of care—most care perhaps being taken in the late phase at Mycenae.

Among the tholos tombs found at Mycenae the Treasury of Atreus is particularly striking. The dromos is constructed completely in isodomic fashion, and some of the stones used are very large. The largest is in fact 6 m long and 1.25 m high. The dromos has a length of more than 30 m; it runs almost exactly from west to east and begins with a forecourt which was closed with Cyclopean blocks. At the other end is the façade of the tomb, which is 10.5 m high and, like the dromos, 6 m wide. The doorway is 5.4 m high and somewhat norrower at the top (2.45 m) than below (2.7 m). Two enormous lintel stones have been placed over the doorway, one of which weighs almost 120 tons. They must have been raised on earth ramps. The depth of the entrance way is 5.4 m.

The façade was embellished with a pair of half-columns of green stone, which had capitals; to the rear a red stone was used. The fragments of the half-columns are scattered among various museums. The motif of beam ends with spirals on top, however, should belong to them. The ornamentation of the upper part of the façade is not known with any certainty. The forms of decoration used, for example on the half-columns of the tomb of Atreus, give the impression that the surface is covered with metal. It is, therefore, quite possible that Mycenaean art actually used metal architectural ornaments which were nailed on to wood.

The domed room itself has a height of 13.4 m with a diameter at the base of 14.6 m. It is built completely of conglomerate. To the right of the entrance an interior door, with lintel and relieving triangle, leads to a subsidiary room. Unexpectedly the walls of this room, which measures *c.* 6 m in length, are completely undecorated, as if it were a chamber tomb. It is thought that this room was never fully finished.

On all sides of the rising walls of the dome are holes for fastening metal ornaments of bronze or gilded bronze, so that the whole room—the largest surviving dome before the Pantheon in Rome—would have given the impression of the starry heavens.

The tholos tomb at Orchomenos was of similar splendour. Here the side-chamber was finished and was given a richly decorated ceiling. In order to get the right impression one must imagine the rosettes, spirals and spandrel patterns all painted with colours in the manner of wall-paintings. Pausanias saw the building still intact in the second century AD.

The Treasury of Atreus and the tholos tomb at Orchomenos had large doors with two wings that could be closed. Their dating is disputed. Wace supposed that the Lion Gate and the tomb of Atreus belonged to the same stage of development and were erected by the same king in *c.* 1330 BC. Mylonas, however, suggests a later date, *c.* 1250 BC. The dating of tholos tombs is a particularly difficult problem, especially since the graves have been plundered and one can rely only on the style of the decorations.

Carved Grave Stelai

Over a series of shaft graves, which were uncovered by Schliemann and have been called Grave Circle A, were erected stelai, six without ornamentation and eleven decorated with designs in low relief. The supposition that the undecorated stelai stood over the graves of women and those with relief carving only over the graves of men has not been substantiated by the finds. Over the shaft graves of the second Grave Circle, which were excavated after the last war, four more stelai were found, two of them carved.

One of the carved stelai from Grave Circle A is illustrated here: it is 1.33 m high and 1.06 m wide. Two rectangular panels were selected as picture zones. The upper one carries a spiral motif, one that had a long history in the Aegean and was taken over by the Mycenaeans. The lower panel shows a figured scene in addition to space-filling spirals. A man armed with a sword rides in a chariot drawn by an animal at the 'flying gallop'. In front of the chariot is a second man carrying a short

sword in his hand. The abstract ornament is simple and striking, whereas the figures are awkward. Indeed the tail of the stallion pulling the chariot looks rather like a bull's. These stelai may have been covered with stucco and painted, although there is no firm evidence for such an idea; or else perhaps adequate tools for stone carving had not yet been developed. In any case the Mycenaeans were evidently not satisfied with this form of representation, for the carved stelai of the shaft graves have no successors.

53 In the National Museum at Athens is a grave stele from Mycenae. Originally it was decorated with geometrical patterns carved with a chisel, as can still be seen in the upper right-hand corner. Later, however, a layer of stucco with painting was placed on top. The frame is red; in the upper picture area warriors are shown striding to the right, while in the lower zone deer stand one behind the other. The painted zones are alternately blue and yellow.

The Agia Triada Sarcophagus

54-6 It ought first to be explained why the following monument, the Agia Triada sarcophagus, is included in this study. It is true that it is a piece of Late Minoan art, but it belongs to a time when Minoan culture and art were already under Mycenaean influence. It is an almost perfectly preserved example of the sort of fresco painting which so strongly influenced Mycenaean painting. The sarcophagus is of limestone, 1.37 m long, and comes from a chamber tomb near the palace of Agia Triada in south-central Crete.

The interpretation of its paintings has caused scholars great difficulty, because they drew on the cult of the dead for its iconography and sought a continuous and consistent interpretation. In more recent times, however, its scenes have been associated with the cult of Zeus, particularly Zeus Velchanos, who was worshipped at Agia Triada, Phaistos and Gortyn. Classical coins of Phaistos show him as a youthful god sitting in the branches of his sacred willow. To interpret the sarcophagus we may turn to a hymn to Zeus which was first cut on stone at Palaikastro in eastern Crete as late as the third century AD, but which had already been composed in the Hellenistic period and indeed goes back to much older rites. In it Zeus is addressed as the 'Greatest Kouros' (youth)—he was worshipped as an unbearded man—who was to come each year to Dikte in order to enjoy the singing and music, and was to enter (literally, jump) into the beds and storage vessels, herds, crops, towns, ships, young citizens and Themis, the goddess of statutes and law. A similar cult has been suggested for the young Zeus Velchanos.

55 On the sarcophagus stands a small, young figure behind a stepped altar and in front of a sacred building near a large tree. His arms are wrapped in drapery, of which the lower part has been restored. The garment is white and has the same type of pattern as that of the three gift-bringers before him. Made of hide, it may have had a pointed hem at the bottom so that the feet could be seen. The interpretation of the figure as a corpse emerging from the ground, like a mummy, was based largely on the false restoration. So the god, or at all events his young priest, stands next to his strongly stylized sacred tree to receive gifts.

The people who bring these gifts are set against a greyish-blue ground, which unites them into a group of three. They project forward into the white background of the god and back into the cult ceremony with the double axes. They bring first the model of a ship, then a grey flecked calf and finally a brown flecked one. Ivory pyxides in the form of ships survive from the Mycenaean era in Crete: they served as containers for bloodless offerings. In the case of the two calves, which are represented in the formal pose of the 'flying gallop', one ought to ask oneself whether they are meant to be rhyta in the form of bulls, though among the surviving rhyta only quietly standing bulls are to be found, or living animals. If the latter is intended, one wonders why the painter employed the formula of the 'flying gallop' here. The question is, however, not yet soluble. To the left stand two golden double axes on tapering pillars. On each axe is perched a golden bird, which may be considered a typical cult symbol of Zeus.

Between the pillars on a stool stands a large grey (silver) vessel, into which a woman in a hide skirt is pouring something from a grey and yellow (silver and gold) bucket. A second woman in an elegant Cretan dress is bringing two more similar buckets on a wooden pole carried over her shoulder. A musician in a long garment, playing a kithara, follows her. This scene is turned away from the god and the gift-bringers.

On the other side women move in a procession to the right 56 against a yellow background. Four women, of whom only the lower parts survive, are led by a fifth who stretches out her hands in a cult gesture—the upper part of her body is also missing, apart from the hands. There follows another scene on a white ground. On a yellow sacrificial table—it may be thought of as being made of bronze—a slaughtered bull lies with crossed legs, fastened to the table with crossing red ropes. He has a grey spotted skin and his head and tail are yellow. The slaughtered animal lies on the table in a manner which recalls a number of gems. The blood runs into a bucket which stands under its head. Two goats, one yellow and one grey, lie under the sacrificial table. Behind, however, steps a man, leaning far back, blowing on a pair of pipes, one straight and one curved. Such pipes, similar to the so-called 'Phrygian auloi', were still in use in the Roman period.

Finally, on the right, against a grey background, stands a priestess wearing a hide skirt and holding her hands out over an altar. The libation jug, of typical Creto-Mycenaean form, and the offering-basket full of fruit show the kind of gifts she has brought. A golden double axe, this time with a blue bird above, and a sanctuary close the scene. The sanctuary is crowned with four pairs of sacred horns and contains a sacred tree.

On one end of the sarcophagus a chariot with a pair of 54 goddesses in it is pulled by winged griffins, while up in the left-hand corner a bird is perched. On the other end two goddesses ride in a chariot pulled by goats (the modern Greek *agrimia*), the last examples of which may still be found in the White Mountains of Crete. Above are remains of a procession of men. The series of rosettes which frame the scene has a pattern often employed in Mycenaean decoration both vertically and horizontally.

Since pipe and string music were played together at a sacrifice, these scenes with musicians must be closely related. 55-6 The question remains what the women are pouring from their buckets into the krater-like vessel between the columns. It is

46 So-called Treasury of Atreus at Mycenae: horizontal section, cross section and plan. According to Wace *c.* 1330 BC; according to Mylonas *c.* 1250 BC. Drawing by A.J.B. Wace.

47 Inner room of the so-called Treasury of Atreus at Mycenae (cf. Pl. 46). H. 13.4 m, D. at base 14.6 m. Engraving after Dodwell.

48 Dromos of the tholos tomb (cf. Pls. 46-7). L. over 30 m, W. 6 m.

49 Capital of a half-column from the entrance to the tholos tomb (cf. Pls. 46-8, 50). Green stone. Engraving after Dodwell. British Museum, London.

50 Façade of the tholos tomb in Pls. 46 to 48 (cf. Pl. 49). H. 10.5 m. Reconstruction (in upper part still rather hypothetical) by A.J.B. Wace.

51 Part of the roof of the side-chamber of the tholos tomb at Orchomenos, *in situ.* Fine grained greenish limestone. 14th-13th century. Whole ceiling 3.7 × 2.7 m.

52 Sculpted stele, from Grave Circle A at Mycenae. Limestone. 16th century. H. 1.33 m, W. 1.06 m. National Museum, Athens.

53 Re-used grave stele, from Mycenae: the original ornamental relief was later covered with stucco and painted. 13th-12th century. National Museum, Athens.

54 End panel of the sarcophagus (Pls. 55-6); pair of goddesses in a chariot pulled by griffins. *C.* 1400 BC. Museum, Iraklion.

55 Long side of the sarcophagus: wine (?) being poured from buckets into a vessel between columns with double axes; kithara-player (to left); procession of gift-bringers (to right) and a young god in front of his temple; from Agia Triada. Limestone, painted fresco. *C.* 1400 BC. L. 1.37 m. Museum, Iraklion.

56 Second long side of the sarcophagus of Pl. 55: procession of five women (only partly preserved); slaughtered bull on an offering-table; below: two goats; behind: a man playing on a pair of pipes; on the right: a priestess at an altar and a tree sanctuary. Museum, Iraklion.

57 Short side of a sarcophagus: women mourning. Terracotta. 13th-12th century. H. 48 cm. Badisches Landesmuseum, Karlsruhe.

58 Long side of a sarcophagus; women mourning from Tanagra. Terracotta. 12th century. L. 1.07 m, H. 61-8 cm (the dead were buried in a crouching position). Irene and Peter Ludwig Collection, on loan to the Staatliche Kunstsammlungen, Kassel.

59 Detail of Pl. 58: mourning women with one large eye.

60 Long side of a sarcophagus: four women worshipping at a column, from Tanagra. Terracotta. 13th-12th century. Museum, Thebes.

61 Second long side of the sarcophagus of Pl. 60: sphinx and woman worshipping at a column.

62 Lion Gate at Mycenae from inside. Conglomerate. According to the new excavation results of G. Mylonas and Sp. Jacovides *c.* 1250 BC. Interior H. 3.1 m, W. at base 3 m.

63 Lion Gate at Mycenae. The relief (H. over 3 m) shows two lions on either side of the column of Hera—their heads, now lost, would originally have been turned outwards. The relief is of limestone. *C.* 1250 BC.

64 Miniature representation of the façade of a sanctuary, from Shaft Grave IV at Mycenae. Gold sheet. 16th century.

65 Shrine in the central courtyard at Knossos. 16th century. Reconstruction by A. Evans.

66 Frieze of half-rosettes, from the north-west gate of the later palace at Knossos. Green limestone. *C.* 1500. H. 19 cm. Museum, Iraklion.

67 Rhyton, from the palace at Kato Zakro (eastern Crete), with a tripartite shrine on a mountain peak. Steatite, originally covered in gold leaf. *C.* 1500. H. 31 cm. Museum, Iraklion.

68-9 Sanctuary on the rhyton of Pl. 67 in a linear drawing and in attempted perspective by Joseph W. Shaw and G. Bianco.

70 Goddess with boar's-tusk helmet, carrying a griffin, from the cult centre at Mycenae. Fresco. 13th century. Museum, Nauplion.

71 Upper part of an idol with raised arms, from the 'Temple' at Mycenae. Terracotta. Latter half of 13th century. Museum, Nauplion.

72-3 Two idols, from the 'Temple' at Mycenae. Terracotta. Latter half of 13th century. H. *c.* 60 cm. Museum, Nauplion.

74 Coiled snake, from the 'Temple' at Mycenae, in which nearly as many such snakes as idols were found. Terracotta. Latter half of 13th century. D. 28 cm. Museum, Nauplion.

75 Elegant woman with necklace in her right hand, from the cult centre at Mycenae. Fresco. 13th century. H. of fragment 53 cm; the woman was life-size. National Museum, Athens.

76 Stone bench with representation of a seated goddess who holds in either hand a sheaf of red barley (?), from the cult centre at Mycenae. Fresco. 13th century. About half life-size. Museum, Nauplion.

77 Athena with large figure-of-eight shield at a concave altar, flanked by two worshippers, from the cult centre at Mycenae. Painted stuccoed plaque in fresco technique. 13th century. H. 12 cm, W. 19 cm. National Museum, Athens.

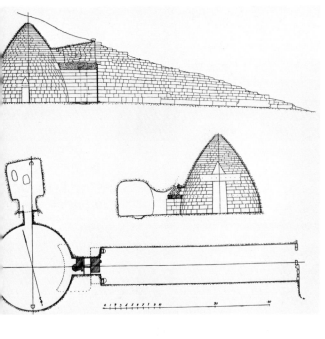

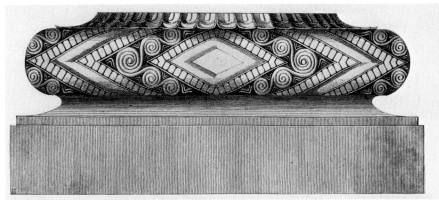

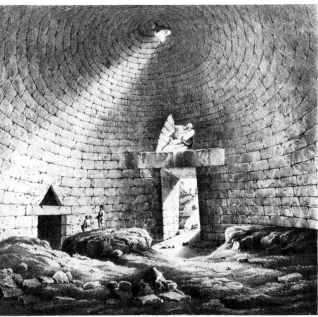

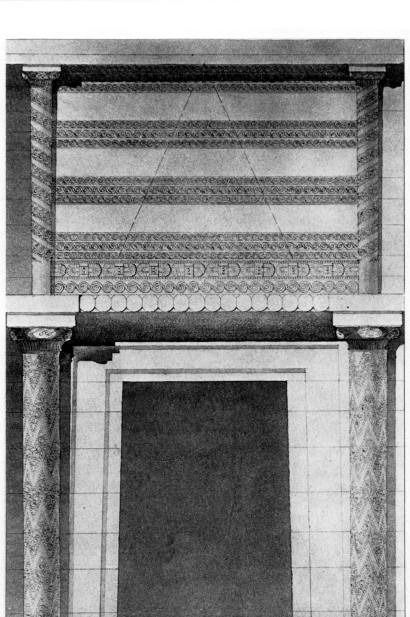

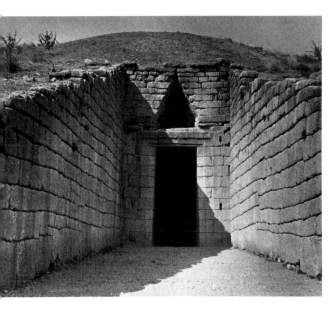

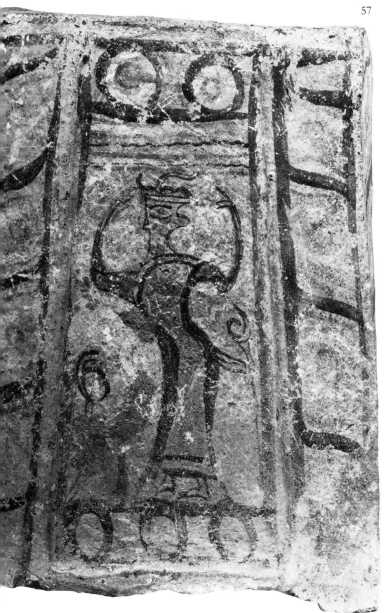

57

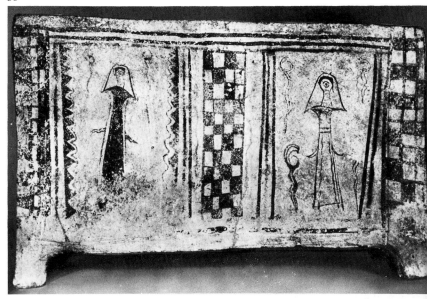

58

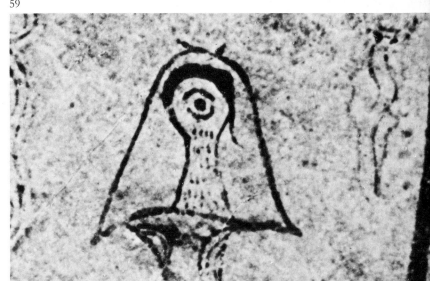

59

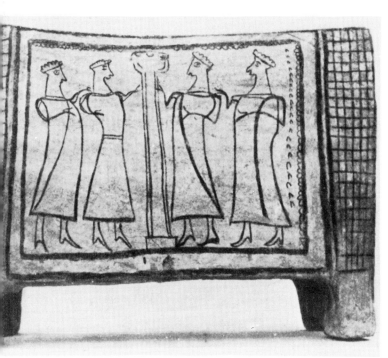

60

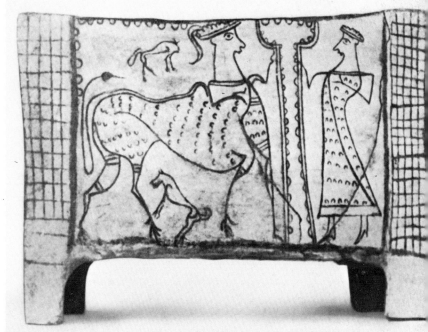

61

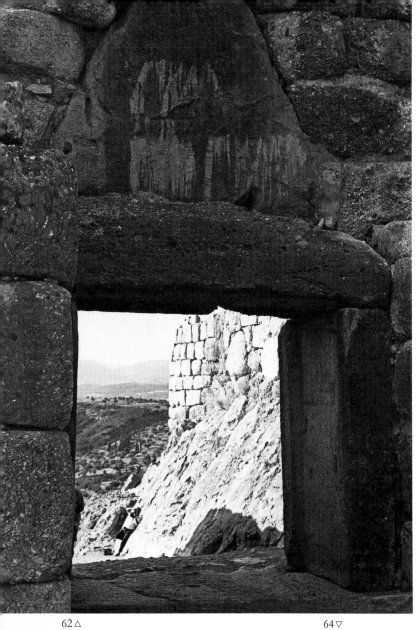

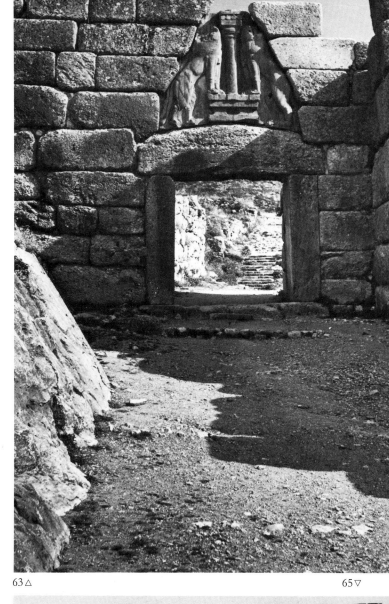

62△

63△

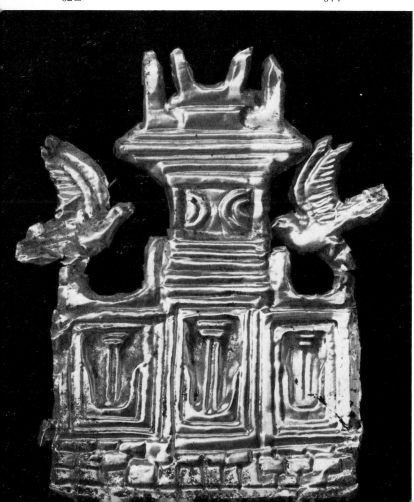

64▽

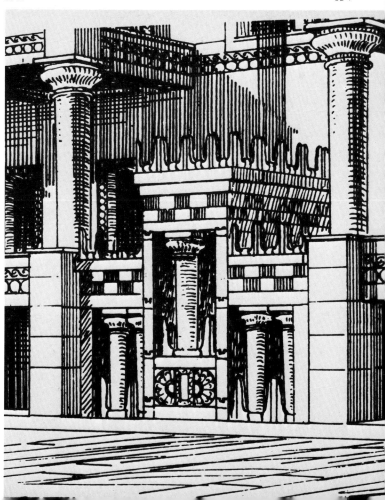

65▽

66

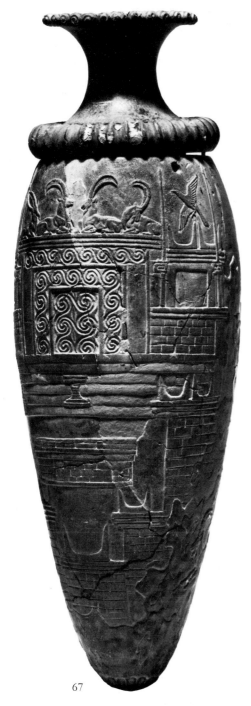

67

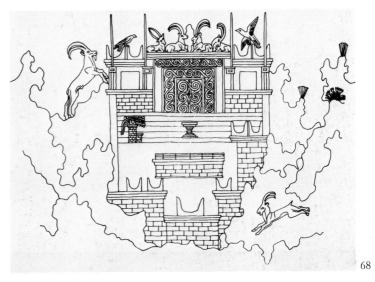

68

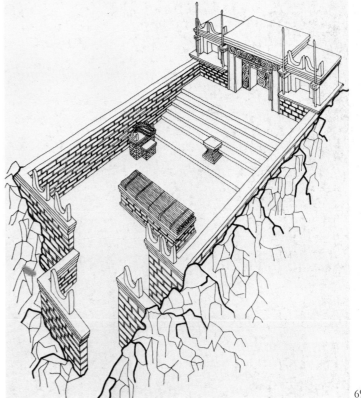

69

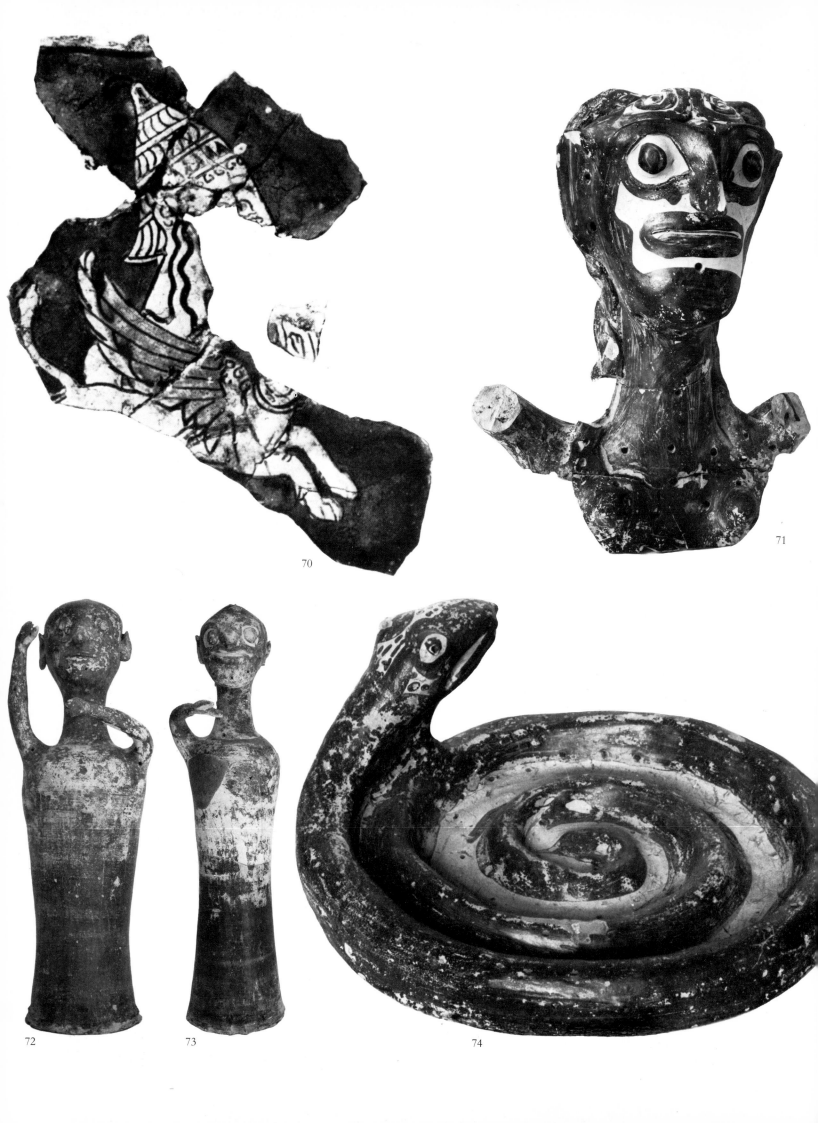

70

71

72

73

74

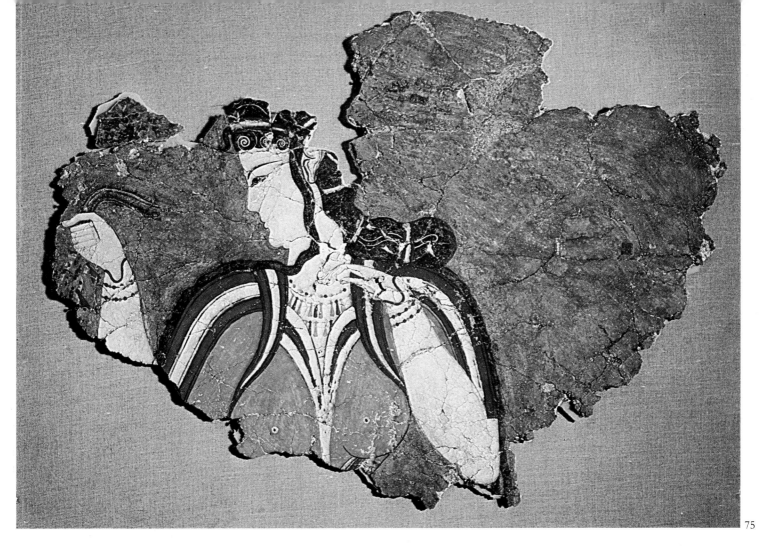

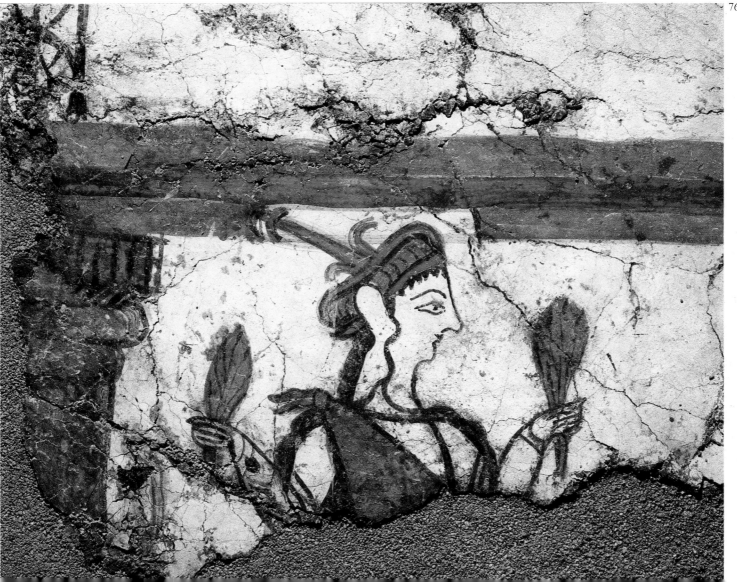

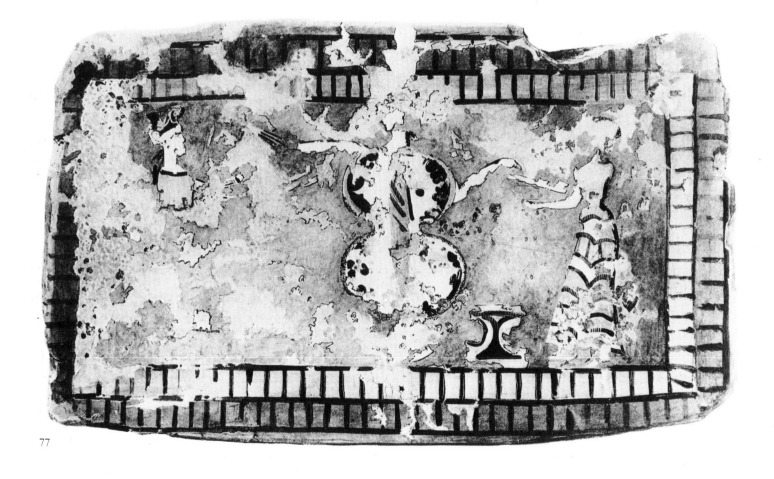

77

generally thought that it is the blood of the slaughtered animal. Yet the vessel under the offering-table which catches the blood looks different from the buckets out of which the liquid is being poured; it has therefore been suggested that the liquid is wine which the women mixed with water. One would rather suppose, however, that on this occasion the wine for the libation was unmixed and that it was offered to the participants in the ceremony, especially since a libation jug for wine hangs over one altar. It may be added that the palace of Agia Triada has yielded fragments of wall-painting which agree in particular details with the representations on the Agia Triada sarcophagus. The same pole carrying the same buckets occurs among these fragments, only borne by a man, and the buckets can scarcely be filled with sacrificial blood in this case. Nor is blood to be thought of as being in the krater, since no part of an animal killed according to chthonic rite in Homeric and later Greece might be consumed; it was taboo, and so the blood was poured into a trench in the ground. Animals killed for chthonic blood offerings did not occur in the cult of later immortal Olympians, but the Cretan Zeus, a vegetation god, was clearly mortal. His grave was to be seen on Crete.

Mycenaean Sarcophagi

In the Late Minoan period on Crete, after the destruction of the palaces, the dead were usually buried in clay sarcophagi. Sometimes clay bath-tubs were used, sometimes specially manufactured rectangular sarcophagi which could be closed with a clay lid. They were occasionally furnished with ornamental decoration and sometimes even painted with figured scenes. One can see from them how Minoan painting gradually sank to a derivative style.

Until recently it was held that the burial of the dead in such clay sarcophagi was not customary on the Greek mainland. But in 1956, when an airport was built between Schimatari and the ancient Tanagra, a series of Late Mycenaean clay sarcophagi was discovered. The first ones to be found were offered on the international art market, whence they reached various museums in Europe and America, but the later ones found their place in the museum of Thebes. An official publication is long overdue, for as yet only provisional accounts of individual pieces are available.

When they are painted with figures, these sarcophagi chiefly show women mourners. Some still represent the last offshoots of the Minoan style, as Mycenaean painting adopted it, while others display abstract forms which suggests a breakdown in Mycenaean painting. The sarcophagus in the museum of Karlsruhe is 57 offered here as an example. The short side shows, as do the long ones, women mourners with their hands raised to their heads. Rudimentary Minoan dress and pose are still recognizable. 58-9 Another clay sarcophagus shows women mourning, not with their heads and bodies in profile, as was customary in Minoan and Mycenaean painting, but frontally with only one eye. 60-1 A further example from Tanagra, now in the museum of Thebes, shows two representations of the old pillar cult. An Archaic epic poem, the *Phoronis*, which dealt with the foundation myths of the Argolid, relates in three verses (Fr. 4, Kinkel) that Kallithoe, the priestess of Argive Hera, first decorated the high column of the goddess:

Kallithoe, key-guarding priestess of the Olympian queen, Hera of Argos, who with fillets and tassels
First adorned the high column of the Mistress.

The Argive Heraion possessed a catalogue of the priestesses of Hera which extended back to the earliest times, and in the Argolid the years were reckoned by reference to these priestesses. Mycenaean sculpture provides many examples of this sort of column worship. In Thebes Dionysos was at first also worshipped as a column, and it was on the column that the mask of the god was later placed.

Thus one side of the sarcophagus in Thebes shows four women taking part in a column cult. They stand opposite each other in pairs, the nearest woman touching the sacred column while the one behind puts a hand on her shoulder to remain in magical contact with the column. On the other side of the sarcophagus the column is decorated. A woman approaches from the right and touches it. From the left, however, comes a strange monster. One would at first take it for a centaur with a human head, but is does not have a horse's hooves, but rather those of a lion, while the tail is no horse's tail either but again that of a lion, curled up high, in the way this is usually represented in art. It is in fact a sphinx which is also worshipping the sacred column by touching it. The tendrils swinging out behind her head are customary on early sphinxes. Finally, two small animals, perhaps dogs, are shown moving below and above.

The Lion Gate at Mycenae

The Lion Gate was built in the Late Mycenaean period, when 62-3 the circuit wall at Mycenae was enlarged to the south and west, making it necessary to enclose the old royal graves and raise 10-11 their level. It is protected on either side by a projecting bastion, so that an outer courtyard is formed. Here the walls were not Cyclopean but of carefully hewn blocks of conglomerate, which seem to have inspired more confidence in such an exposed position. The two-doored gate was roughly square, with a height of 3.1 m and a width of just under 3 m, though it tapered somewhat toward the top. It could be secured on the inside by a strong cross-bar. Over the lintel, slightly arched at the top, is a relieving triangle. It contains, fitting the arching of the lintel below, the Lion relief.

Two lions stand heraldically opposite each other and place 63 their forepaws on two altars, on which there rests a column of Minoan type, in other words one that tapers downwards. The column carries a capital and on top of that two horizontal slabs, between which the beam ends are visible. The heads of the lions have broken off. They looked straight out and were secured by metal dowels in the shoulders; perhaps they were done in a softer material which allowed more precise working. At any rate they are now lost.

The column on the altars represents the sacred image of Hera, who was worshipped in aniconic form as a column and who, as we know from Homer, was the chief goddess of the Mycenaeans. The lions, who looked out over the land, served to protect the gate and the city. They also show that the city, and the king who ruled it, stood under the protection of the goddess Hera. The Lion relief is the sole monumental piece of Mycenaean sculpture which has come down to us.

Shrines

64, 315 In 1876, Schliemann found five small sheets of gold decorated in relief, which were all embossed over the same mould, in Shaft Graves III and IV at Mycenae. These sheets are 7.5 cm high and 6.9 cm wide. In 1906 another similarly worked gold relief found at Volos was published: it is a little bigger, measuring 8.2 cm by 7.5 cm. Long ago it was realized that these gold sheets represent shrines, since similar buildings are commonly known in Minoan Crete. There we find, with slight variations, a base with three niches above, in which stand sacred horns and behind them one (or two) Minoan columns. Over both the outer sections were sacred horns, on each of which, on the gold reliefs, sits a bird, looking toward the middle. On the higher middle section is a half-rosette, a motif which in Minoan and Mycenaean art often symbolizes the

66, 344 sacredness of a place. Above the half-rosette the central part is also crowned with sacred horns.

Sir Arthur Evans noted these tripartite shrines on the
65 famous Miniature Fresco from the palace of Knossos. There the motif of the half-rosette appeared in the lower part of the middle section. The painting helped in the reconstruction of the shrine in the central courtyard at Knossos. In the excavations at Vathypetro in central Crete Marinatos uncovered the foundations of such a tripartite cult building. It turned out that, as the representations had already suggested, this was really a cult façade, which served as the background for sacred rituals, rather than an actual building. Finally, at
67 Kato Zakro in eastern Crete excavators found a steatite relief rhyton, which was originally covered with a very fine gold-foil so that it would look like a gold vessel. On one of the rocky
68-9 peaks rises, exactly depicted in miniature, a tripartite Cretan shrine, which Joseph W. Shaw and G. Bianco have reproduced in a linear sketch and in an attempted perspective drawing.

The lower enclosure walls of the sacred precinct (temenos) are decorated with sacred horns. The entrance was probably at the bottom right. Inside one comes first on a wide centrally placed altar, on which wood for a sacrifice lies ready. Then, further to the left, is a small altar wreathed with fillets, while towards the middle again a portable altar stands on the lowest step of a flight of stairs. These stairs lead up to the tripartite shrine, which seems a rather shallow structure: the cult ceremonies would have been performed in front of it. The shrine is decorated only with four (wooden) poles, as is usual in Minoan art.

On the roof of the central building lie, in heraldic arrangement, two large and two smaller wild goats, while a bird is perched on the pair of sacred horns on the left; another bird, its wings still fluttering, is landing on the right-hand pair of horns. A wild goat is moving up to the left side of the sanctuary, while another is running at the 'flying gallop' towards the entrance at the lower right.

One is reminded of a description by Arrian (Periplus, 21) of the sanctuary of Achilles on the island of Leuke in the Black Sea, where it is said that goats came to the altars of the hero and that sea-birds daily sprinkled and cleaned the temple.

It is possible that Cretan tripartite shrines were also adopted on the Mycenaean mainland—the gold sheets and a wall-painting from Pylos with the same motif could be taken as evidence of this—but more tangible remains have not been found there.

The Cult Centre at Mycenae

At Mycenae various scholars excavated a building complex on the west slope which has been interpreted as a cult centre. From there a processional street leads to the summit of the hill where the palace was situated. More altars, which were probably sacred to various gods and goddesses, stand on this street.

In the neighbouring houses were the remains of frescoes. One shows the head of a goddess, with a boar's-tusk helmet, 70 carrying a winged griffin; another the upper part of a woman in Cretan dress, holding a precious necklace in her outstretched 75 hand. In yet another room, on a stone bench, was the picture 76 of a goddess, perhaps seated, holding in both hands what may be a bundle of red barley. On the wall above, on a larger scale, a goddess was walking along towards another female figure.

The most remarkable feature, however, is a room which its excavator, Lord William Taylour, called the 'Temple'. Here one sees on the ground a hearth and against one side-wall benches of varying height. In the corner, on one of these benches, stood a fairly large idol. Other idols of this type were uncovered in a small room, reached by a staircase. In the upper room a rock wall was partly covered over, so that the visitor could not look at the bare rock.

The idols are of clay; the lower part was wheel-made, but 72-3 the breast, arms and head were hand-made. The small holes in the breast and neck can scarcely have been intended to aid drying, for A. Winter has shown that clay is itself so porous that such drying holes are unnecessary. The holes, therefore, probably served as a means of fastening some sort of jewellery. Near the idols were snakes, coiled into a ring, the head raised in 74 the middle or at the edge. A complete arsenal of such idols was stored here.

Lord William Taylour did not hesitate to interpret these idols as gods, or predominantly as goddesses. Both their drapery and their faces are covered with a dark brown or black 71 gloss slip, but they do have some light coloured patches. Their size ranges up to about 60 cm in height. The arms are stretched out (not simply raised), and some even seem to hold the shaft of what may have been a double axe. The expression of these idols is occasionally screwed up into a smile, but in most cases it is grim and terrifying, as if these were demonic creatures.

Mylonas has doubted their divine nature, accepting only the warrior goddess Athena, who was recognized many years ago on a limestone plaque covered with stucco and paint. The 77 goddess stands in the middle of this plaque, almost covered by a great figure-of-eight shield; her arms and head are painted white and at her side is a portable altar; a worshipper in Mycenaean dress approaches from the right and left.

We shall return later, in the chapter on Sculpture, to the question whether the idols from Mycenae represent gods or demons.

The Shrine at Eleusis

At Eleusis archeologists uncovered a sacred precinct, which enclosed a building, on the eastern slope. The temenos wall is only partly preserved, but can be made out roughly. The building is a megaron in antis; it leads to a platform from which, to the right and left, four steps lead down. Between the pair of steps one imagines two wooden columns. Inside on the central axis a column base is preserved and another can be inferred. The walls are only partly preserved, but they can be reconstructed with confidence. They are formed from two rows of unworked stones, which are laid in mortar and are c. 60 cm thick. The upper part of the building was probably constructed from sun-dried mud bricks. The walls were decorated with fresco paintings, as is indicated by the fragment of a painted human eye.

From the sherds which were also found there it can be deduced that this building was erected approximately in the fifteenth century BC. It was extended somewhat later by outbuildings. The edifice is very interesting since over it, on the same spot, the later phases of the sanctuary of Demeter were erected, including the great Telesteria, supported by pillars, put up in the sixth and fifth centuries BC. Indeed shrines rarely change their site and one may therefore conclude that this was the earliest temple of Demeter. Fragments found immediately above it seem to indicate that it was still in use in the Geometric period.

According to the Homeric Hymn to Demeter (lines 297-8) King Keleos built at the command of the goddess Demeter 'a rich temple and altar on the jutting hill'. Aristotle reports (FGH

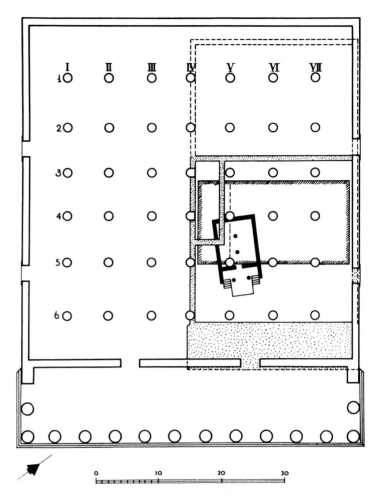

Fig. 11 Plan of the megaron of Demeter and later Telesteria at Eleusis.

II, fr. 282) that the Eleusinia, the oldest rituals in Greece, were founded in the reign of King Pandion of Athens. That was in c. 1300. Herodotos (IX, 97) explains that Ionians transplanted the cult of the Eleusinian Demeter to Asia Minor. Long before the eighth century BC Philistos, a forerunner of Neleus, erected a temple to Demeter Eleusinia on mount Mykale. Miletus was colonized by Ionians around the middle of the eleventh century and it was their leader, the son of King Kodros, who introduced the cult of Eleusinian Demeter into Ionia. Kodros reigned in Athens in c. 1050 BC.

The number of believers in the cult of Eleusinian Demeter grew greatly in Athens and all over Greece, as is evident from a comparison of the small Mycenaean temple with the grand Telesterion of the Classical period.

It is not size, however, that makes the Mycenaean building so important, but the fact that on this occasion the house of a god was erected not in the palace, and not together with many other gods (as at Mycenae), but on its own for one deity alone—and also that it was surrounded by its own temenos wall. This form of building was to become the forerunner of the Greek temple. That, however, was still a long way off; for after the collapse of the Mycenaean world Greece, which hitherto had been held together linguistically and culturally in a sort of koine, broke up into its various parts, lost its maritime connections and became extremely poor. It was thus many centuries before the concept of a Greek temple was actually brought to fruition.

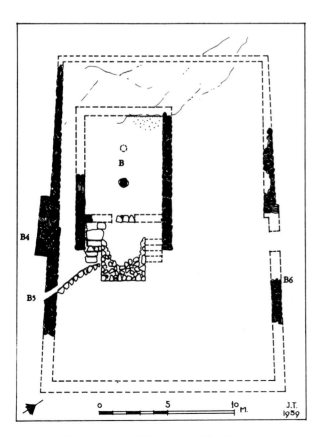

Fig. 10 Plan of the megaron of Demeter at Eleusis.

51

Building in the Geometric Period

As a result of this poverty and fragmentation only very few remains of buildings from the next centuries have come down to us. In such a period of austerity buildings lacked solidity and were often made of perishable materials. They have for the most part been destroyed by later construction. Only isolated fragments of walls or terraces have been preserved, together with a few fragments of the foundations of houses, still only partially excavated or insufficiently published. As a result any judgment as to whether such structures are still Mycenaean or already from the next period is inevitably controversial.

In the following pages we have selected only a few of the Fig. 12 better preserved examples. At Perachora were found the foundations of the temple of Hera Limenia, which may be dated to the eighth century BC. It is a simple rectangular building (9.5 by 5.6 m), the upper part probably of panel work and mud brick, which lay on a stone socle of roughly hewn, irregular stones. The main entrance was on the north side and a further entrance on the long western one. In the doorways a thin layer of decayed and carbonized wood rested on a clay layer, which suggests that there was an inset wooden door-frame. Inside was a rectangular hearth for offerings, of which three rim stones are still preserved. They were originally inscribed stelai which carried spits; the fourth is a later replacement. South of the hearth are two small stone socles, which, along with two more, can be reconstructed as an oval and may have served as supports for benches. The building no

doubt originally had a thatched roof, which was replaced by a tiled one during the seventh century, and was surrounded by a rectangular temenos wall.

At Dreros (Crete) the foundations of a rectangular temple of Fig. Apollo (10.8/9 by 7.2 m) were excavated. It lay on a rocky hillside, with the entrance to the north. The walls were of rectangularly hewn stones, which were set without mortar. The thickness of the wall at the entrance with its careful exterior finish is 1.1 to 1.2 m, on the other sides only 70 cm. Inside is a rectangular hearth for offerings and in front of this a stone socle for a round wooden support, while at the rear in the right-hand corner is a cult bench. Near by stands a stone chest which once probably had a wooden lid; it contained remains of offerings and some goats' horns. On the bench probably stood the bronze cult statues and in front an offering-table. The building was erected some time in the second half of the eighth century. It probably had a continuous ridged roof supported by posts and a small court with flagstones in front.

At Asine, on a terrace outside the town, was a temple of Fig. Apollo Pythaeus. It is perhaps the same one that is mentioned by Pausanias (II, 36, 5) which was spared when the town was destroyed by the Argives in the second half of the eighth century BC. The foundations measure 4.3 by 9.6 m and the entrance is in the south. The walls of quarry-faced stone are preserved up to a height of c. 60 cm. The width of the rear wall is 1 m, that of the other walls 80 cm. Ante-room and main room are separated by a partition wall 20 to 30 cm thick. On three sides of the main room runs a 30 cm-wide stone socle.

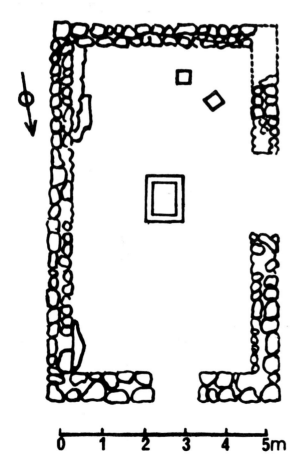

Fig. 12 Plan of the temple of Hera Limenia at Perachora.

Fig. 13 Plan of the temple of Apollo at Dreros.

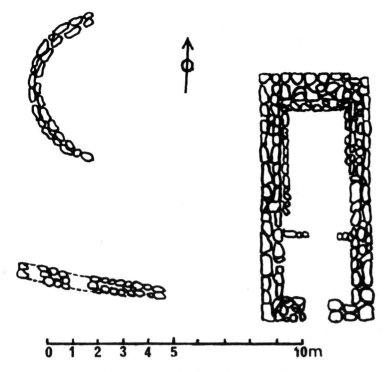

Fig. 14 Plan of the temple of Apollo Pythaeus at Asine.

The door is 1.2 m wide and the threshold consists of ten small stones. Outside remains of the pavement have survived.

At Perachora and Dreros we find a single-roomed *oikos*, at Asine a double-roomed one. Next comes the house at Emporio (Chios) which has a porch with two columns in antis. The left-hand long side of the so-called Megaron Hall abuts the inside of the Acropolis wall, with which it is bonded at the front, though at the rear it breaks away. The building must be contemporary with the Acropolis wall and belong in the late eighth century. The absence of an altar and votive offerings suggests a stately residence, perhaps that of the prince of the town. The measurements (at the back) are 18.25 by 6.4 m. The porch faces south. The front wall is 60 cm thick and up to 50 cm of its height are preserved. Only the corners and the free-standing right-hand anta-wall are set with roughly orthogonal blocks. Mud bricks were not employed and the entrance door had a threshold consisting of a single stone. In the porch were two column-bases, of which one had a circular contour, 60 cm in diameter. Inside three column-bases originally stood along the central axis.

Another house at Emporio, the 'Lower Megaron', which also probably belongs in the eighth century, measures 12.5 by 7 m. The exterior walls, so far as they are preserved, are 60 cm, the front ones only 45 cm thick. They are of quarry-faced stone with smoothed fronts; mud bricks were not used. The flat porch was supported by two columns. The bases for the two columns inside, which lay on the long axis, were still found *in situ*. Between them were the remains of a rectangular hearth. In the doorway lay bedding stones for a threshold, while inside there was a thick layer of mud as well as the upper half of a custom-made chimney of clay. All this suggests either a flat roof or a simple sloping one.

Fig. 15 The cella of the oldest temple of Hera on Samos was at first dated by Buschor roughly in the eighth century, but later scholars placed it around the turn from the ninth to the eighth

or at the beginning of the eighth century. It measures 6.75 by 33.5 m. It was an elongated building with central supports. The distance from post to post measures on average 2.45 m. These posts carried the ridge of a saddle-roof. The base for the cult statue was found inside towards the back, a little to the right of the central axis. If it is certain that Sub-Geometric sherds were found in its foundations, this building may belong to the end rather than to the beginning of the eighth century.

Under the foundations of the cella of the temple of Apollo at Thermon were the remains of a rectangular building (B) with a Fig. 16 porch, a main room, and a lateral room at the back; they measure respectively 8.15, 9.13 and 2.2 m in length. The exterior walls were of quarry-faced stones set in clay. These

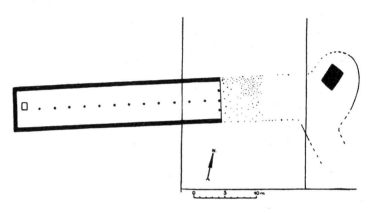

Fig. 15 Plan of the earliest Heraion on Samos.

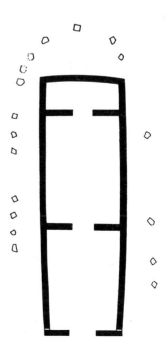

Fig. 16 Plan of the earliest temple of Apollo at Thermon.

53

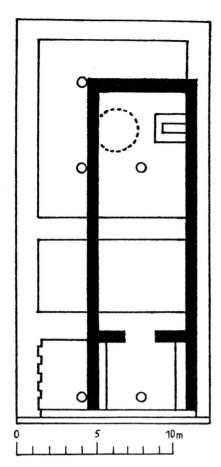

Fig. 17 Plan of 'anta-building' in the Mycenaean megaron at Tiryns.

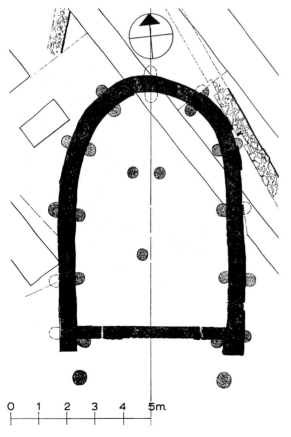

Fig. 18 Plan of Daphnephorion at Eretria.

walls, with the exception of that on the entrance side, are not straight but slightly convex, so that they lean inwards. In the clay floor no bases for interior columns were found. The oval flags laid in an oval circuit round the building—there must originally have been more of them—were for a long time considered to be supports for a colonnade. Recently, however, the interpretation has prevailed that they carried posts, sloping towards the roof, which served to support the outward thrust of a saddle-roof.

The building has been dated to the Proto-Geometric period on the basis of sherds found in it. However, the sherds were studied at a time when our knowledge of the Proto-Geometric period was still imperfect, and it now seems quite possible that the pottery is not Proto-Geometric proper but rather from the eighth century BC.

It is also very difficult to date the so-called 'anta-building' in the citadel of Tiryns. This structure was built inside the great Mycenaean palace megaron, which is substantially larger. The long eastern side rests on the remains of the stone flooring of the previous building, while the long western side stands on the stone floor. In fact the right-hand series of Mycenaean column-bases became the central row of its much narrower successor.

The building measures 6.9 by 20.9 m. The entrance is on the south side as in its Mycenaean predecessor. The walls are 50 to 60 cm thick, only half as wide as the Mycenaean ones, but their technique scarcely differs from that used in the older structure. Around the side-walls of the porch runs a bench, as in the Mycenaean megaron. This 'anta-building' was first taken for a temple of Hera because of the offerings found in a *bothros* twenty-two metres to the east and outside the citadel—offerings which can be dated back to the middle of the eighth century BC. The ground-level of this 'anta-building' is, however, the same as that of the Mycenaean megaron. The megaron must, therefore, have stood until the eighth century, then been razed to the ground in a fire and shortly afterwards replaced by the 'anta-building'. Both interpretations are rather dubious and so we must leave the Tiryns 'anta-building' out of consideration for the time being.

In addition to rectangular buildings, apsidal structures were also very popular, for example that at Antissa (Lesbos). This building is dated by sherds found there to the ninth or tenth centuries. In the eighth century a slightly narrower apsidal or oval building was erected which measures 17.25 by 5.5 m. The walls are mostly constructed from small, irregularly broken stones arranged without order; at the apse the wall still stands 1.85 m high. The side-walls bow outwards slightly, while the front wall, only a little of which is preserved, is set at an angle. The remains of one anta are preserved at the end of the north wall; there was a second one on the south wall. The inside is segmented by subsidiary walls, which in part run diagonally. Bases for interior columns have not been found. The central hearth in the second building and the long period of use suggest that it had a cult purpose. In the second building a hesitant attempt at a rectangular plan can be detected.

A special case is the apsidal house at Eretria of which the foundations were excavated by Swiss archaeologists. The horse-shoe-shaped socle wall and the little walls at the front had no load to carry for the whole structure rested on the clay bases, which were distributed inside and outside the socle. These bases had a diameter of *c.* 45 cm, whereas the pair in

front of the house were *c.* 50 cm in diameter. The bases served as supports for wooden posts which had to carry the weight of the walls and roof. The façade, however, rested on two rectangular pillars.

P. Auberson has made a model of this peculiar building. We can see the vertical posts and the horizontal poles, which were bound together. In this connection it has rightly been pointed out that in Homer the carpenters were also shipwrights. This skeleton, made up of side-walls, roof and a sloping front roof, was covered with twigs, perhaps of laurel. We are dealing here with a temple to Apollo Daphnephoros, which reproduces features of the oldest temple to Apollo at Delphi. It is said that Apollo, after killing the dragon Python, brought laurel from the valley of Tempe in order to purify himself. Pausanias states (X, 5, 9): 'The oldest temple was made of laurel and the branches brought from the valley of Tempe; this temple must have had the form of a hut.'

The hut at Eretria was, therefore, a reconstruction that echoed a mythical prototype. It was built in the eighth century, but was not in use for long; it was replaced by a temple one hundred feet long with an apse and central columns.

Urban Layouts

Urban layouts differ greatly according to the location of the site and its history.

In Crete, in a natural saddle high on Mount Dikte, lies the village of Karphi. The western part of the village was densely populated. One supposes that the native Cretan population retreated there before the invading Greeks. Rectangular rooms variously orientated lie closely packed together, but scarcely one right angle is to be found. The streets are paved but there is no plan, though they sometimes open into squares. The pottery found at Karphi is Sub-Minoan with a slight scattering of Proto-Geometric. In the north lies a larger courtyard with an altar in the middle and a cult bench along the south side. From Karphi come a number of Sub-Minoan idols, of which one is illustrated here. The survival of Minoan forms is clear in spite of all the incompetence in the modelling. The urban layout was evidently abandoned in the Early Geometric period.

The outlying part of the village in the east is different. The walls of the squat, long buildings meet at right angles. These

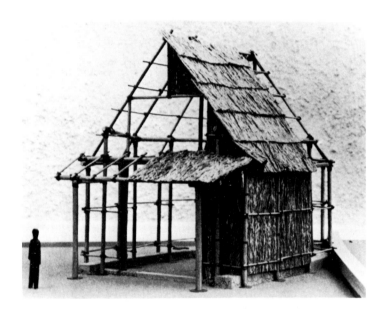

Fig. 19 Model of Daphnephorion at Eretria.

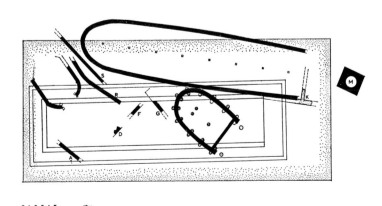

Fig. 20 Plan of Daphnephorion and 'Hundred-foot' temple at Eretria.

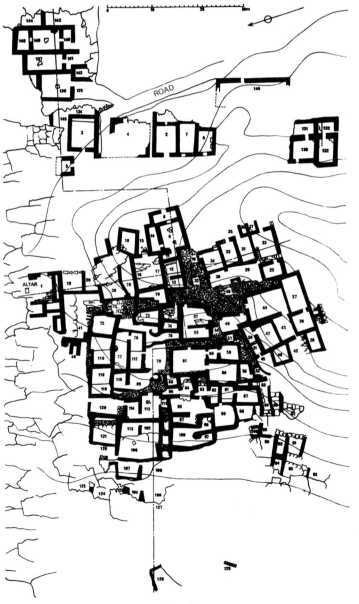

Fig. 21 Plan of the settlement at Karphi.

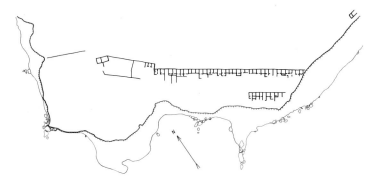

Fig. 22 Plan of the settlement at Vroulia.

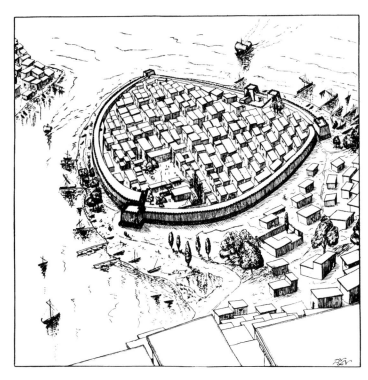

Fig. 23 Reconstructed plan of site at Old Smyrna.

buildings form a series of houses, all of which have entrances on the same side. The houses in both urban layouts, however, were flat-roofed, the rooms being stepped in terraces according to the terrain. In some rooms fragments of fired clay were found which probably came from chimneys.

Two principles of urban layout are found at Karphi. One is said to be Minoan, whereas the other must be ascribed to the invaders, who probably came from mainland Greece.

Fig. 22 The urban layout which has come to light at Vroulia on Rhodes is completely different: it may be dated around 700 BC. Abutting the city wall, which is almost 300 m in length and on the sea-side reaches from shore to shore, is a row of nearly rectangular rooms, each about 4.5 m wide. Some of them had a small ante-room in front; others faced on to a courtyard. Parallel to the main row of houses is a second one of ten houses, which was at least as long as the first. An open courtyard with two altars was probably the sanctuary and at the same time served as place of assembly. Vroulia is the earliest and best-preserved example of a rectilinear town plan, which may have been dictated by military considerations.

Fig. 23 Old Smyrna offers a different picture. From the Early Geometric period into the seventh century the city, which lies on a peninsula, must have had approximately the appearance shown in this reconstruction. The settlement was surrounded

Fig. 24 by a circuit wall, which enclosed an urban area of *c.* 35,000 sq. m. The wall was massive, measuring 4.75 m at the base, and was later strengthened even more. It consisted at the bottom of a steeply rising shell of rough stones set in clay, behind which was a wall of mud brick 2.1 m thick; these bricks were laid in layers of headers and binders and had a regular format of 51 by 30 by 13 cm. The upper part of the wall consisted of similar bricks.

Fig. 25 A bastion which juts out from this oldest fortification wall is still more carefully constructed. The lower revetment is the same, except that the stones are set not in clay but in a white clay mortar. Above it there rose a layer of blocks carefully cut with a stone saw, 20 and 31 cm high; they too were laid in an elaborate system of headers and binders. As in the Mycenaean period—for example in the Lion Gate—special care was taken when setting stones in bastions.

Fig. 26 An oval house, which we see here in a reconstruction, belongs to the Proto-Geometric period at Old Smyrna, *c.* 900 BC. The entrance lay on the short side. The walls were of mud bricks, measuring 51 by 30 by 12 cm, which were plastered on the outside. Even in the Late Geometric and Sub-Geometric periods oval houses were still the predominant form in Old Smyrna.

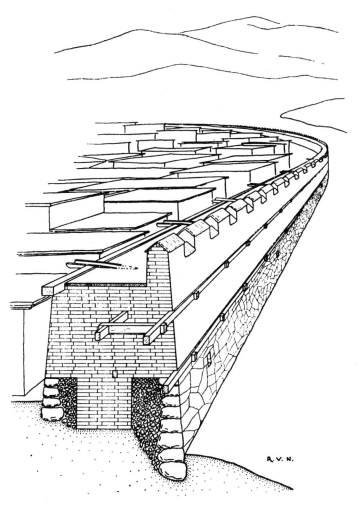

Fig. 24 Fortification system at Old Smyrna.

Fig. 25 Projecting bastion at Old Smyrna.

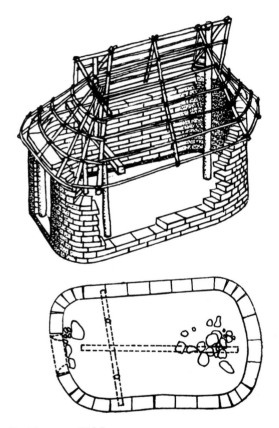

Fig. 26 Oval house at Old Smyrna.

House Models

Models of houses, too, reflect the variety of building techniques. One example is the clay round temple from Archanes (Crete) which reached the museum at Iraklion from the Giamalakis Collection. At the base it has a diameter of 14.2 cm; its maximum height is 18 cm. It is closed by a door with a chequered pattern. When one opens the door, one sees a goddess sitting inside with a polos on her head and her arms raised. On top of the roof lie a dog and two men, who are looking inside attentively through a round opening, the chimney. The men, who hug the contour of the roof, and the decoration are in part still Sub-Minoan, but in part they indicate what lies ahead. This little round temple is datable in the ninth century BC. Its design can be followed back into the Early Minoan period.

From Chaniale Tekke near Knossos comes the clay model of a rectangular house with a flat roof, which at its base measures 26.5 by 26.5 cm and has a height of 31 cm. It comes from the period of transition between the Late Geometric period and the Orientalizing style, *c.* 700 BC. The door is closed with a plaque, decorated with concentric circles and horizontal bands. Of the same width as the door is a small horizontal window above. Both are set in a projecting frame. The flat roof projects slightly over the walls; around it runs a ledge, and in the middle there is a chimney. Inside the floor has, on three sides, a low step; a horizontal shelf is set against one wall. The surface of the outside wall is divided into squares, which probably signifies large-scale isodomic masonry.

From the sanctuary of Hera Akraia at Perachora come several models of apsidal houses. The best preserved is Model A. To judge by their clay the models are Argive. They were offerings to the divinity who was worshipped in the temple and must have been made before the temple was destroyed in the middle of the eighth century. The plan of this building, which at the base measures 35.6 by 20.8 cm, is that of a squat apsidal house. The side with the entrance has a doorway which tapers towards the top; it rests on a raised threshold and over it are three square windows. A porch is set in front of the antae; it is supported on either side by twin columns on shared rectangular bases. In the upper part of the exterior walls a number of triangular windows are cut, as on the model from the Argive Heraion. The wall below is painted with a meander motif. The roof had a steep ridge with an open gable at the front and was hipped at the back; the original was probably of plaited straw.

From the Argive Heraion comes the clay model of a gabled house, 28.5 cm wide, with a porch; this is not an 'anta-building'. The roof overhangs the front and rear walls by only a few millimetres. On the side-walls vertical groups of strokes are painted; they represent the posts which served as props for the mud-brick wall. The flat-roofed porch was supported by rectangular pillars. In the upper part of the lateral walls are cut two triangular openings which probably served as holes for letting out smoke and ventilation generally; the gable front also has a large rectangular opening. The painting on the roof and lateral walls is partly Geometric and partly Orientalizing, suggesting a date of *c.* 700 BC.

The excavations at the Heraion on Samos yielded the limestone model of an oval house, about 20 cm long. The entrance is on the long side and the doorway is inset. The walls slope slightly inwards and there are no windows. The steep saddle-roof is hipped at both ends. The ridge beams, which are flat on top, jut out on one short side to make a small gable, under which is the smoke outlet.

Finally, models of corn granaries were found, chiefly in Attic graves. They are 5 to 12 cm, sometimes even 28 cm high, beehive-shaped, and have slits at the top; occasionally ladders are added. They last from the Early Geometric period

78 'Model' of a round temple with two men and a dog on the roof, from Archanes (Crete). Terracotta. 1100-1000 BC. H. of house 18 cm. Museum, Iraklion.

79 The round temple of Pl. 78, open (the door is removable); inside a goddess with raised arms.

80 'Model' of a house with gable and porch, from the Heraion at Argos. Terracotta (here in a drawing). C. 700 BC. H. 28.5 cm. National Museum, Athens.

81 'Model' of an apsidal house, from the sanctuary of Hera Akraia at Perachora near Corinth. Terracotta (here in a drawing). First half of 8th century. Base 35.6 × 20.8 cm. National Museum, Athens.

82 'Model' of a rectangular house with flat roof, from Chaniale Tekke near Knossos. Terracotta. C. 700 BC. Base 26.5 cm², H. 31 cm. Museum, Iraklion.

83 'Model' of an oval house with side entrance, from the Heraion on Samos. Limestone. 8th century. H. 13.5 cm. Museum, Vathy, Samos.

84 'Models' of five granaries on a single chest-shaped base, from the 'Grave of a Rich Athenian Lady' in the Agora of Athens. C. 850 BC. H. 25.3 cm. L. 44.5 cm. Agora Museum, Athens.

85 Plan of Heraion at Olympia. C. 600 BC. 18 × 50.01 m. A. Mallwitz's revised version of W. Dörpfeld's plan.

86 View of the ruins of the Heraion at Olympia.

87 Columns of the Heraion at Olympia. Limestone. H. 5.21 m.

88-9 Leaf moulding (Doric cyma) from an early wooden column, from the Heraion at Olympia, interior and exterior view. The ornament filled into the hollow channel under the capital. Bronze. 6th century. Museum, Olympia.

90 Circular akroterion, from the Heraion at Olympia. Terracotta. C. 600 BC. D. 2.31 m. Reconstruction after fragments in the Museum, Olympia.

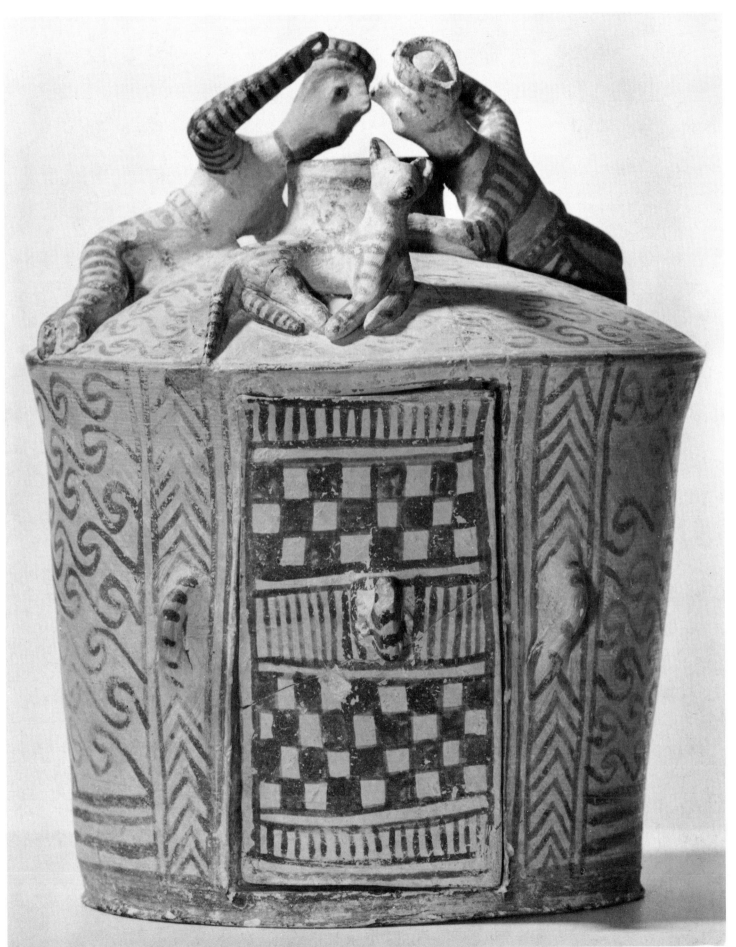

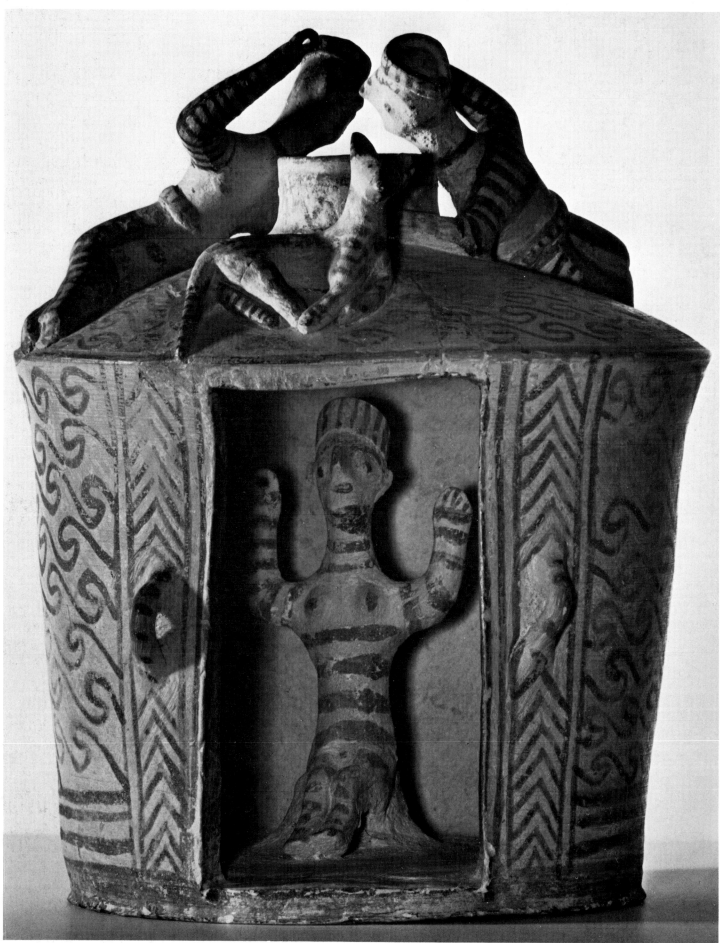

79

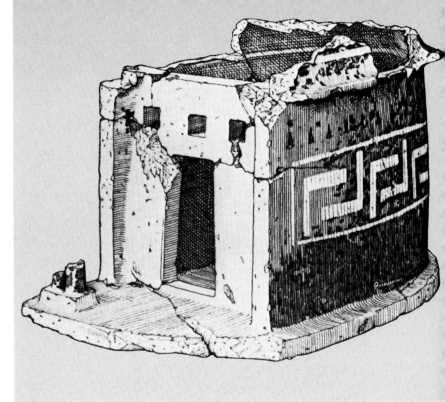

80 81

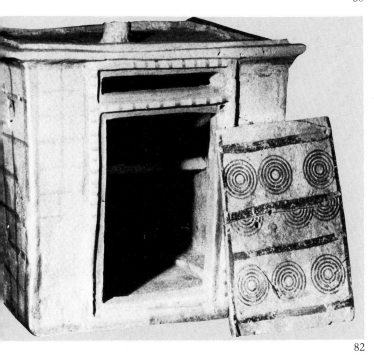

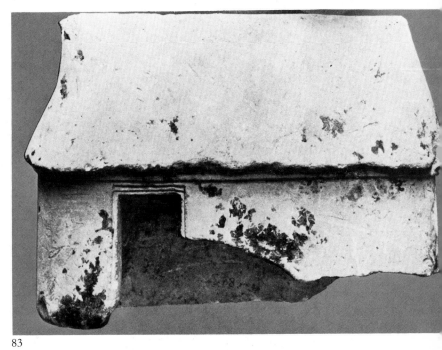

82 83

84

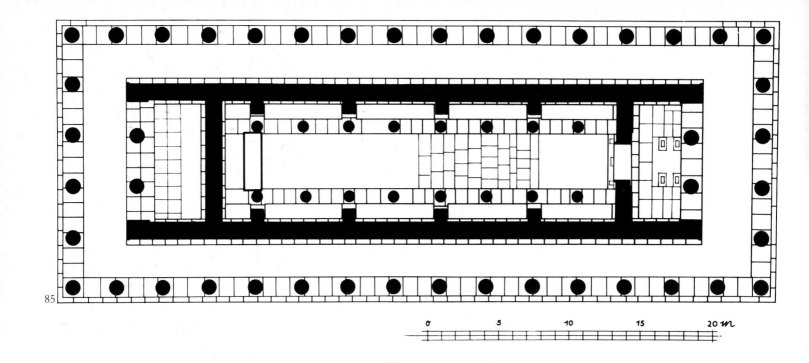

85

0 5 10 15 20 *m*

86

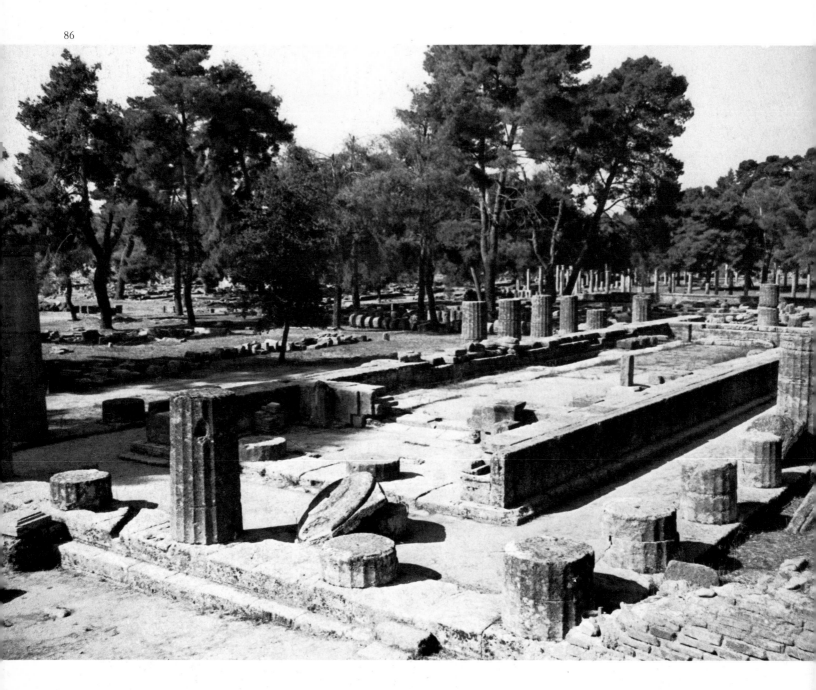

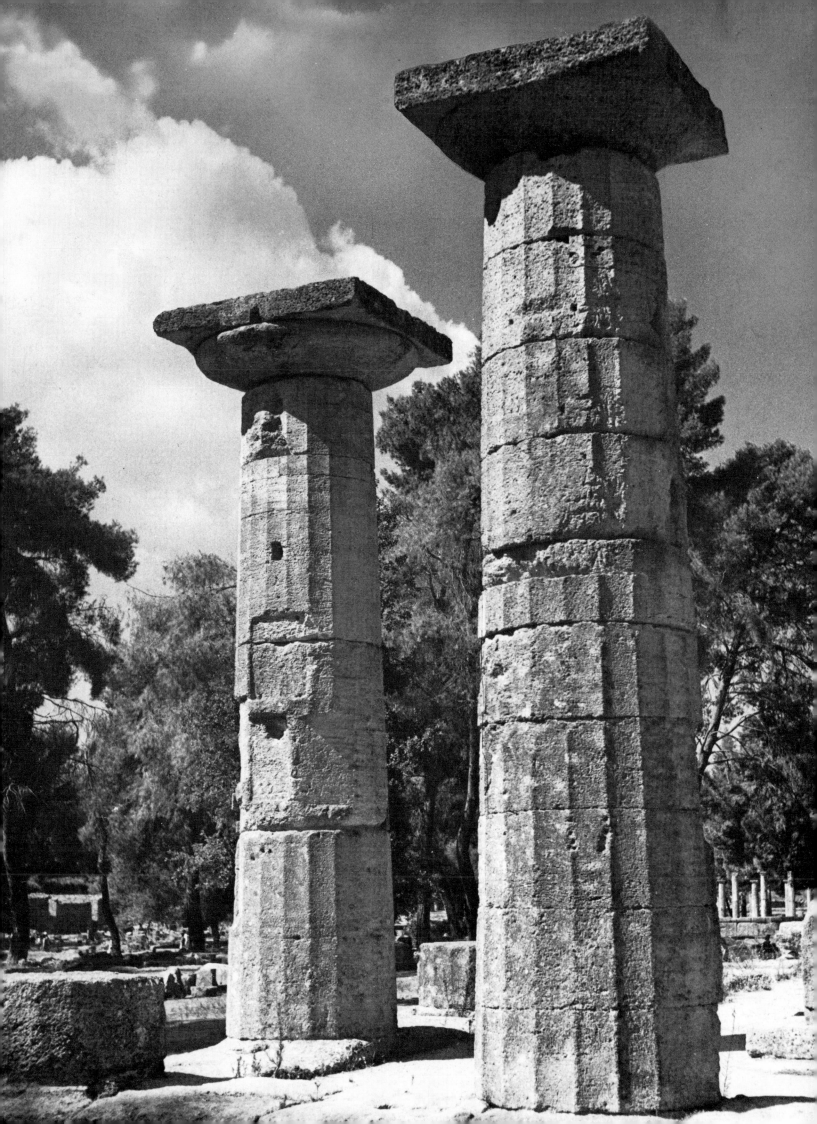

88 89

90

into Early Attic (seventh century); they are sometimes single, or else there are two or three of them on one base. Their meaning proved controversial—bells for the dead, child rattles and bee-hives were suggested—until the grave of a wealthy woman (c. 850 BC) was excavated in the Agora of Athens. Among other rich gifts this grave contained five such corn granaries on a single base. This gift was intended to signify that the deceased woman was the wife of a rich man who had an income from corn of over five hundred bushels.

Temples

Eighth- and seventh-century Greek temples are so poorly preserved that one does well to follow their development back from a more advanced period. As an example let us take the Heraion at Olympia, which was erected in one spurt around 600 BC or a little after. This is a particularly opportune specimen since its mixture of ancient and advanced features reflects the peculiarly unsettled state of temple architecture for over a century.

The building lies on the projecting slope of the hill of Kronos. In the east and partly in the north there was firm ground which needed to be cut away only a little to take the foundations of the cella and colonnade. In the south and west, however, the builders had to level up the ground with stones and broken blocks before they could lay the two-stepped stylobate, which measures 18 by 50.01 m; normally these have three steps.

The cella, with the pronaos in the east and the opisthodomos in the west, is very long, as was the Archaic fashion; the only entrance to it was through the pronaos, whereas the opisthodomos was accessible only from the outside. The latter had no rear door and was in fact a little wider than the pronaos, a peculiar feature which was avoided in later buildings. The cella lies almost in the centre of the colonnade; the distance between the pronaos and the east front is about 50 cm greater than at the west end and over 70 cm greater than on the long sides. The cella has a thick wall, which consists of a socle (1.03 m high and 1.18 m thick) of orthostats, on which mud bricks were laid. The high socle was intended to keep out the damp. This feature was retained in later temple architecture, even when the whole wall was of stone and it was no longer necessary to protect mud bricks against dampness. The mud-brick walls were, of course, plastered. To reinforce the walls buttresses were added inside, behind every other column; they were removed in the Hellenistic or Roman period. These wooden inner columns may have had two drums, which would allow the small stone capitals found in the excavations to be associated with them. The cella is divided into a nave 3.8 m wide and two side aisles 2.28 m wide. The door of the cella and the antae were overlaid with wood.

The stylobate lies 30 cm deeper than the cella and carries the columns of the peristasis, which has 6 by 16 columns (the corner columns being counted twice). The greatest surprise for the excavators were these columns of the peristyle. They are of stone but belong to very different periods, as is shown by their capitals. They vary from the Archaic type with their wide,

spreading echinus, through the centuries to those of the Roman period with their tight, steep contour. The solution to this riddle is offered by a remark of Pausanias (VI. 16, 1), who in the second century AD saw a column in the opisthodomos made of oak. Such wooden columns were, therefore, in the course of time replaced by stone ones. Furthermore, it seems that the wooden columns were covered with bronze decorations, for several fragments of bronze sheets with a leaf pattern have been found which fit in the hollows under the capitals. Ancient columns of other buildings imitated such patterns in stone.

The architrave and the frieze of metope and triglyph were apparently completely of wood. Wooden metopes could be painted or covered with embossed bronze sheets. It has therefore been suggested that the large bronze sheet with a griffin suckling its young, which comes from the time of the Heraion, might be a metope revetment from the temple.

The roof was covered with so-called Lakonian tiles. Over the gable was a circular disc of fired clay, 2.31 m in diameter, richly decorated with geometric patterns—a ceramic masterpiece. Indicative of future development is the way the 'triglyph problem' has been solved by contracting the span of the columns at the corner. There was much experiment with this, especially in Greek Sicily, but at the Heraion of Olympia a satisfactory result was found. Other advanced features are the orientation of the long walls to accord with the axes of the respective front columns and the correspondence of the inner and outer columns. One has the impression that size and proportion were important to the builders of this temple.

Painting from 800 to 600 BC

No evidence has come down to us of large-scale painting from the so-called 'Dark-Ages'. Indeed, we may ask ourselves whether wall-paintings did actually exist in the period from the eleventh to the eighth century BC.

We must concentrate, therefore, on paintings on flat rather than curved surfaces. Our first example is a little votive pinax in a private collection. It is only 7.6 to 7.7 cm high and its lower edge must have been 7.6 cm wide (the right-hand corner has been restored in plaster). It was painted on both front and back, but the painting on the back is severely rubbed. The pinax has a stem which is perforated at the top, so that it must have been meant to be suspended. It probably does not come from a grave, since grave-gifts of this type were not customary, but rather from a sanctuary; it was therefore a forerunner of the votive plaques of the seventh, sixth and fifth centuries which were offered to a divinity in a holy area on trees or elsewhere hung up by potters near their kilns in order to pacify the angry demons, who did mischief during the firing.

Our pinax dates from the middle of the eighth century BC. It is of Attic clay and is painted like Attic vases, certainly by a vase-painter, with the swastika, a motif often used by vase-painters in different variations. This swastika is hatched in an unusual manner, the empty spaces being filled with zigzag lines, and the whole design is framed. The scheme differs from vase-paintings too in that here the swastika is the sole theme. This design had no symbolic meaning in Greek art, as can be shown in many ways. The artist painted it because it appealed

to him and because he thought that it was bound to please the gods and demons.

92-4 Here we might turn to the catch-plates of two Boeotian fibulae from the second half of the eighth century, although they are engraved rather than painted. They show something new that occurred around this time in both painting and drawing. On the left side of a bow fibula in London a great
92 hero is portrayed. His head and shoulders are missing, but his belted waist and long legs are visible. With his left hand he is seizing a snake at the point where its many heads sprout, and with the sword in his right hand he is slashing at the monster. This is Herakles fighting the Hydra and, as is recorded in the legend, a crab is coming to the aid of the Hydra and biting the hero's heel. Water-birds fill the empty spaces and fish indicate that the sea is not far away. Under the snake's belly a little man is trying to cut through the monster with a serrated sickle: this is Iolaos, Herakles' friend. The hero's relative importance is brought out by the different scale of the two figures.

93, 149 On the fibula in Philadelphia the subject is the same but has been treated differently. The heroes face each other and are of the same size. On the left is Iolaos, cutting through the Hydra's body with his sickle. A snake's head is hissing near his face and behind him stand two spears. Herakles, identified by the crab, is fighting on the right.

While on the London version each episode is depicted consecutively as in an epic, on the Philadelphia fibula a uniform scene has been created which can be read at a single glance. It is a wild battle scene full of tension. There are no space-fillers: only dismembered pieces of the Hydra fill the empty spaces, and the whole representation is set in a proper frame.

In the eighth century figured scenes appear alongside geometric ornaments; in the second half of the century, representations of mythical themes begin, which give the scenes dramatic tension.

95 On one side of a large clay shield from Tiryns, which has a diameter of *c.* 40 cm, a furious battle is represented. In the middle strides an enormous warrior wearing a helmet with a tall crest. In his right hand he wields a sword; the baldric hangs over his shoulder. He seizes his opponent, an Amazon, by her helmet crest. She tries to restrain his arm and pushes against his right knee with her foot. From the left rushes a warrior, with his spear at the ready, and holding his massive shield, shown in profile, while from the right an Amazon hurries up with her wickerwork shield. Below lies a fallen warrior with a spear stuck in his back. Triangular filling ornaments jut into the picture. It is not certain whether the water-bird and fish behind the Amazon are filling ornaments or symbols of ill omen.

This is the oldest monumental painting—it dates from *c.* 700 BC—that we have with such a dominant central warrior figure, with such vigorous movements and with faces reserved, eyes indicated and mouths open—a group wholly filled with the heroic epic spirit.

96 On the inside is a centaur holding a pine-branch in each hand. On the end of the rear branch hangs a fawn with spotted skin, towards which the centaur is looking. A row of fawns or hinds is loosely spread over the picture zone: the rearmost animal suckles a young fawn. Below the belly of the centaur a stag with enormous antlers is to be seen. These animals are all drawn on a much smaller scale than the centaur.

The centaur's body is long and segmented by geometric patterns, which also spread over the torso and neck. The head is like a skull without flesh, while the hair is rendered with a single wide brush-stroke, from which a few wild hairs fly out. Below the waist the body becomes oddly thick, suggesting that it had human front legs, as was common with early centaurs, especially Cheiron. Should we see here Cheiron himself, who raised the hero Achilles?

An indication of the way painting was to develop is given by two vase-paintings showing the blinding of Polyphemos by Odysseus. One is on the neck of an early Attic amphora at Eleusis painted around 670 BC. Here the enormous Cyclops is seated, his body a black silhouette and only his face done in outline. His mouth is open and he is screaming with pain, for Odysseus and his comrades are driving a red-hot stake into his eye. The faces of the men are also in outline, but the body of the first is in white with a dark contour. Perhaps the artist intended in this way to distinguish the hero Odysseus. Scattered in the field are strongly stylized filling motifs, some completely new.

98 The other picture is on a slightly later krater from Argos. Here the giant lies on a couch of white and red boulders, whose contours are marked with double arcs. Odysseus and his companions approach. Two of them are completely preserved but of the third there is only a leg and an arm. They have to stretch in order to reach the Cyclops' eye with their stake. It has already struck his eye and he is putting his hand up in pain as blood pours down his face and neck. Here all the figures are drawn in outline and there are no filling ornaments: the painter had the courage to leave the field empty.

99-10 From Praisos in Crete comes a fragment of a plate which had a diameter of *c.* 35 cm. When the plate was hung on the wall, one would have seen the very carefully painted exterior.
99 A hero seems to be wrestling with a fish, while below is a white object shaped like a foot. The hero has a profusion of hair falling down his back and is armed with a sword. He grasps the fish-like monster with both arms, while his rear foot rests on its tail. He is drawn completely in outline. The drawing is fluid, expressing the slim body in an organic and articulated manner. The supple way in which the hero fits against the body of the fish recalls Minoan art. The body of the fish is completely in black-figure, in other words it is painted in black and enlivened with added white and incision. The foot below is white with a black contour.

One would like to see the hero as Peleus wrestling with Thetis, whose white foot is just visible, as she changes into a fish. Such a reconstruction is, however, not completely convincing and is not illustrated here. The inner side of the
100 plate is executed in another technique. The ground has a pinkish slip and on it, lightly drawn in outline, is a young rider reining in his horse. The silhouette is filled with a brownish colour. This plate may date from around 650 BC.

Here a work might be mentioned which does not strictly belong to the series of paintings on flat surfaces. It comes from
101 a very large vase, an amphora 1.22 m high overall. The picture on the neck, which is illustrated here, has a height of 27 cm. It shows the fight between Herakles and the centaur Nessos (the inscription reads Netos). Herakles jumps at him, putting his heel into the centaur's side, grasping him by the hair with one hand and holding his drawn sword in the other. The full-bearded centaur cannot turn his head back and touches the

hero's chin to plead for mercy. His horse's legs are already beginning to collapse. All parts of the drawing are in proportion and carefully articulated, but this is not what makes the picture so important. It is that one cannot examine and describe the scene in detail, for one's eye continuously slides from one detail to another. As a result of the tremendous impact of the attack the figures have been inseparably bonded into a single group. This is an important step for future developments and must have taken place in large-scale painting as well.

102 A picture of warriors facing each other in serried battle array decorates the shoulder of the so-called Chigi jug, a little Corinthian vessel only 26.2 cm high. It is covered with numerous miniature friezes, whose colourfulness and rarity suggest that they reflect large-scale models. From right and left come heavily armed warriors holding their spears ready to throw. The shield devices of those on the right are visible: a lion, a flying bird, the head of a bull, an eagle and a gorgoneion. On the left we see the patterned interiors of the shields. Towards the left appears a youth playing the double pipes (an oboe-like instrument), as was customary in the Spartan army.

E. Simon has observed that the spears of the warriors on the left are drawn behind their heads instead of in front of them. This is a form of representation common in low relief, such as coins, but not in painting. One concludes, therefore, that a relief work was this jug's model; it may have been an ivory and brightly painted. This example teaches us that not only large-scale paintings had an effect on development and served as models, but so too did works in precious materials on a miniature scale, such as a later Corinthian masterpiece, the chest of Kypselos, which was kept in the opisthodomos of the temple of Hera at Olympia.

103 A plate from Rhodes was painted around 630 BC; it has a diameter of 38.5 cm. The lower segment, marked off by a simple cable pattern, is filled with vertical tongues, but the upper scene is extraordinary for Rhodian art. It is the only representation of a mythological subject with the names of the characters included: Menelaos (Menelas) and Hektor (Ektor) are fighting over the body of the fallen Trojan Euphorbos. According to the *Iliad* (XVI, 806 ff.), Euphorbos had first wounded Patroklos. After Patroklos' death Euphorbos tried to get his armour, but was hindered by Menelaos, killed and then robbed of his own armour (XVII, 9 ff., 59 ff.). The shield which Menelaos won from Euphorbos was still displayed in the Heraion of Argos during Roman times.

The composition is arranged heraldically: from the triangle surrounded with volutes and palmettes, which dominates the upper part of the picture zone, and the pair of eyes with their brows, to the pose of both the warriors. However, on Hektor's shield we see a flying eagle, while on Menelaos' shield it is the spiral patterns on the inside that are revealed. Euphorbos too breaks the symmetry, for he lies with his head under Menelaos. Some filling ornaments are attached to the rim of the tondo, while others are freely disposed in the field. The polychromy of this piece is also unusual. The main colour of the three warriors is a reddish brown, but both the helmets on the left, the helmet crests and the short chitons are a golden brown. Some of the brush-strokes are fine, whereas others are wide and rougher, both in the figured parts and in the ornaments. All this gives the impression that the picture derives its main features from some large-scale painting.

Roughly contemporaneous with the Euphorbos plate is 104 another large one from Rhodes which also has a diameter of 38.5 cm. It shows a Gorgon in the role of 'Mistress of the Animals'. Some of the filling ornaments are the same as on the Euphorbos plate, but the style of the painting is rather different. Above all the Gorgon's head is done in outline with big eyes and widely opened mouth from which her tongue protrudes. On her forehead is a diadem, while her hair falls down on either side in long strands and passes into a full beard. The four wings link up and create the impression that the head could fly on its own.

The Gorgon wears a garment painted in black-brown gloss slip. Her narrow waist is girt by a belt and a very powerful thigh emerges from the split garment, which is furrowed with incisions to indicate the folds. In the manner of the 'Mistress of the Animals' she holds a water-bird by the neck in each hand. The outstretched leg, the arms and even the birds have filling ornaments on them. On the whole the design is not so balanced as that of the Euphorbos plate, but the folds of the Gorgon's garment point the way to future developments.

When we reach the last third of the seventh century BC, we can at last deal with actual monumental paintings, in the metopes from Calydon and Thermon. The plaques from Calydon are extremely fragmentary and probably a little earlier; those from Thermon are later and better preserved. The metopes of the temple of Apollo are 87 to 89 cm high, 105-8 99 cm wide and 6.5 to 7 cm thick. These plaques presuppose a fully developed system of triglyph friezes. They were inserted into the triglyphs from the side and were fixed above by means of two pins into the horizontal beams.

These metopes show traces of preliminary sketches incised in the clay, but the painters did not follow them slavishly. The picture area is framed on the right and left with a wide coloured stripe, on which are six rosettes one above the other. The pictures overlap this stripe in places. As for the subjects, some metopes are filled simply with a Gorgon mask, others 105 with mythological themes. There are representations of individuals such as a hunter returning home with his spoils, a boar and 106 a stag, which he carries over his shoulder on a wooden pole, or the self-contained picture of the two sisters. Furthermore there 107 are pictures like that of Perseus, who runs with the severed head of Medusa. Two pursuing Gorgons (not preserved) were 108 probably on an adjacent metope to complete the story.

Perseus has a pointed beard, no moustache and wears on his head, along with his sun hat, the cap of Hades which made him invisible. He moves at a fast pace and has the sack, the *kibisis*, with the head of the Gorgon Medusa in it, tucked under his arm. The long sword with which he cut off the monster's head hangs at his side. His short belted tunic is decorated with a large rosette and its hem with a cable pattern. He swings his arms wide and his feet project beyond the frame, though they still remain on the ground. The winged shoes, however, indicate that the flight from the pursuing Gorgons is through the air and over the sea. The pose of his legs and his arms, the front one bent up and the back one down, look ahead to the so-called 'knee-running' scheme, later used to depict rapid running or flying.

The metopes are the products of Corinthian potters, as is indicated by the style and the Corinthian alphabet, in which the 107, 110 inscription on the plaque with the women bending forward is written. The name Chelidon can be read on the right, the

91 Geometric votive plaque. Terracotta. Mid-8th century. H. 7.7 cm. Private collection.

92 Detail of a Boeotian bow fibula: Herakles fighting the Hydra. Bronze. Latter half of 8th century. Overall l. of fibula 20.4 cm. The detail shown here in a drawing is to the left of the central motif, a rosette. British Museum, London.

93 Boeotian catch-plate fibula (drawing): Herakles fighting the Hydra. Bronze. Last quarter of 8th century. H. of catch-plate 14 cm. University Museum, Philadelphia (detailed photograph Pl. 149).

94 Other side of catch-plate fibula in Pl. 93 (drawing): Herakles and the hind.

95 Outside of the shield: Achilles and Penthesilea on the battlefield, from Tiryns. Terracotta. C. 700 BC. D. c. 40 cm. Museum, Nauplion.

96 Inside of clay shield in Pl. 95: centaur (Cheiron?).

97 Picture of the neck of an Early Attic amphora: the blinding of Polyphemos. Terracotta. C. 670 BC. H. of detail c. 50 cm, overall h. of vase 142 cm. Museum, Eleusis.

98 Fragment of a krater, from Argos: the blinding of Polyphemos. Terracotta. Mid-7th century. Museum, Argos.

99 Fragment of a plate, from Praisos (Crete): hero fighting a fish-like animal (Peleus and Thetis?). Terracotta. Mid-7th century. D. originally c. 35 cm. Museum, Iraklion.

100 Inner side of plate in Pl. 99: young rider.

101 Picture on the neck of an Attic black-figured amphora: Herakles and the centaur Nessos. Nettos Painter. C. 600 BC. Overall h. 122 cm, H. of detail 27 cm. National Museum, Athens.

102 Shoulder frieze of a Proto-Corinthian jug (the 'Chigi jug'): opposing armies. Terracotta. C. 640 BC. Overall h. of jug 26.2 cm. Villa Giulia, Rome.

103 Rhodian plate: Menelaos and Hektor, between them the fallen Euphorbos. Terracotta. C. 630 BC. D. 38.5 cm. British Museum, London.

104 Rhodian plate: a Gorgon as 'Mistress of the Animals'. Terracotta. C. 630 BC. D. c. 38.5 cm. British Museum, London.

105 Metope, from the temple of Apollo at Thermon: Gorgoneion. Terracotta. C. 620 BC. H. 87-9 cm. National Museum, Athens.

106 Metope, from the temple of Apollo at Thermon: hunter with a bag. Terracotta. C. 620 BC. Original h. 87-9 cm. National Museum, Athens.

107 Metope, from the temple of Apollo at Thermon: the sisters Aedon and Chelidon, between them the boy Itys. Terracotta. C. 620 BC. Original h. 87-9 cm. National Museum, Athens.

108 Metope: Perseus with the head of Medusa, from the temple of Apollo at Thermon. Terracotta. C. 620 BC. Original h. 87-9 cm. National Museum, Athens.

109-10 Details of the metope in Pl. 107: head of Itys in the arms of Chelidon (drawing by H. Payne); head of Chelidon.

111 Tomb at Prinias (Crete). Limestone. Third quarter of 7th century. Reconstruction by A. Lebessi.

112 Grave stele: woman with wreath and bird, from Prinias (Crete). Limestone. Third quarter of 7th century. H. 48 cm. Museum, Iraklion.

113 Rolled-out frieze on a *krateriskos*, from the Heraion on Samos. Terracotta. Early 7th century. Museum, Vathy, Samos.

114 Fragments of an Attic krater; probably Herakles as an archer and centaur. Terracotta. Towards mid-7th century. National Museum, Athens.

115 Bronze sheet: Kaineus being driven into the ground by two centaurs, probably from a wooden chest. Mid-7th century. H. 22.5 cm. Museum, Olympia.

116 Large relief amphora, whose neck features the Wooden Horse, while the frieze on the body shows scenes from the Sack of Troy in metope-like panels. Terracotta. C. 670 BC. H. 13 cm. Museum, Mykonos.

117 Detail from the neck of the relief amphora in Pl. 116: front of the Wooden Horse with openings, from which the warriors look out.

118-20 Details from both friezes on the relief amphora in Pl. 116: Greek conquerors and Trojan mothers.

121 Medusa, beheaded and collapsing, from the amphora by the Nettos Painter (for the neck cf. Pl. 101). C. 600 BC. Copy of Drawing.

122 'Metope', from the relief amphora Pl. 116: Menelaos and Helen.

123 Fitting from a tripod leg: Clytemnestra killing Cassandra, from the Heraion at Argos. Bronze. Mid-7th century. H. (including panel above, not illustrated here) 46.3 cm. National Museum, Athens.

91

92

93

94

95

97

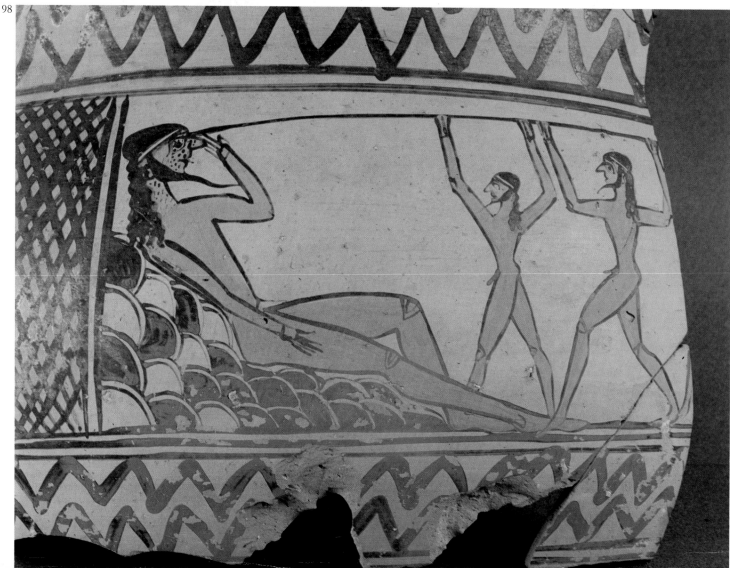

98

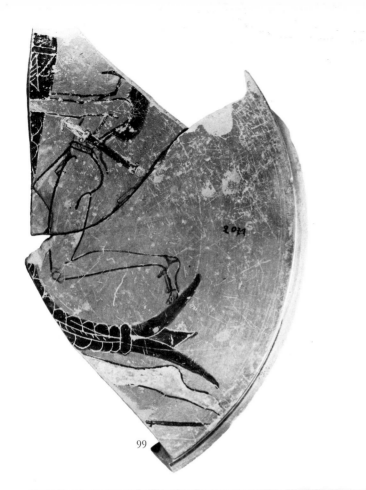

99

100

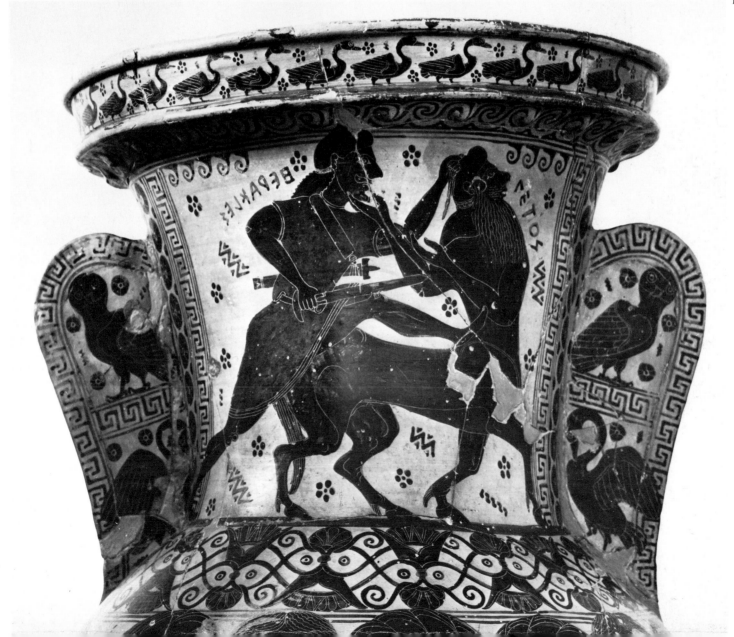

101

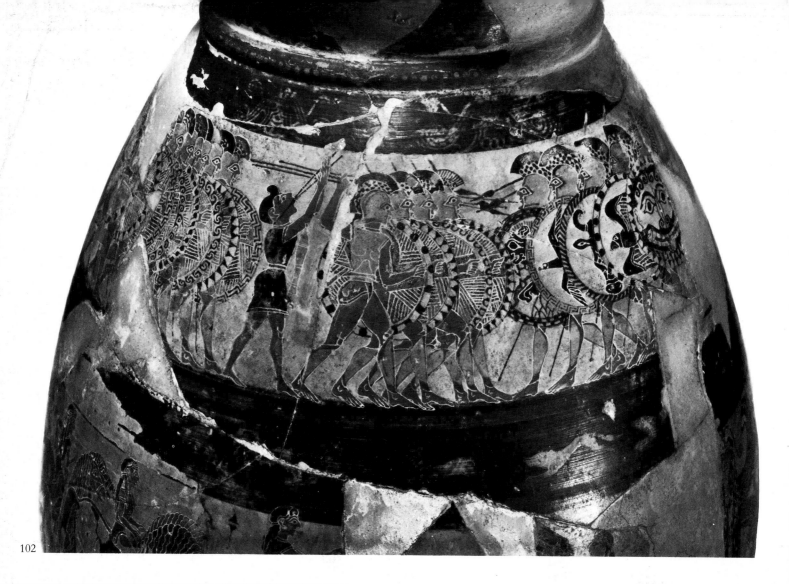

102

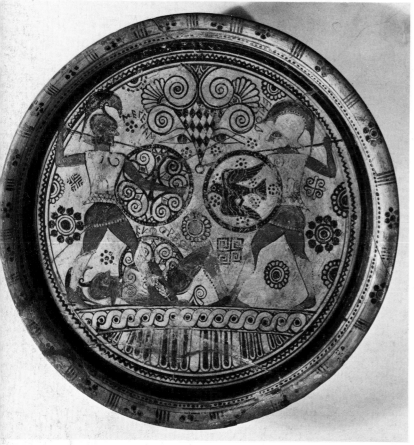

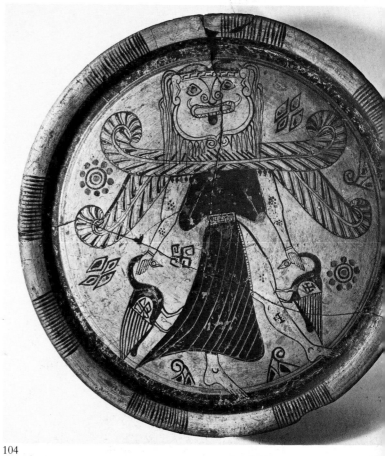

103 104

105

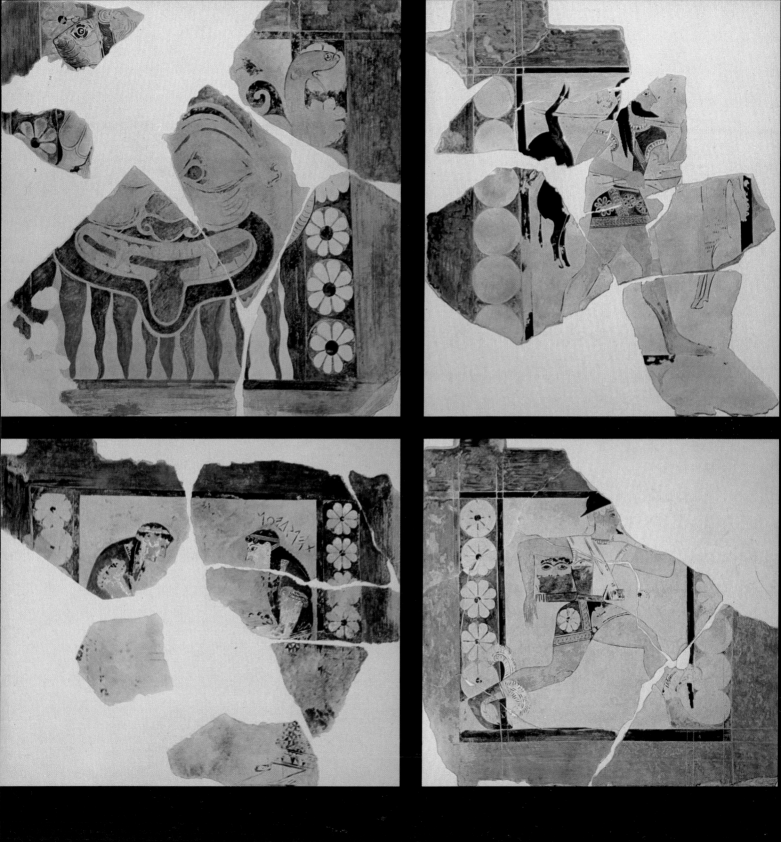

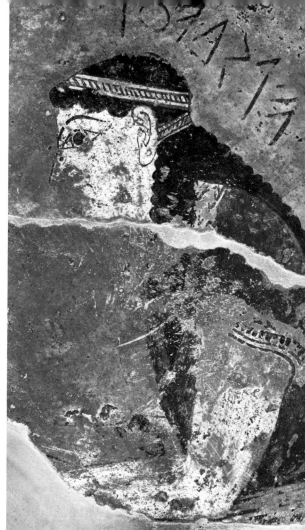

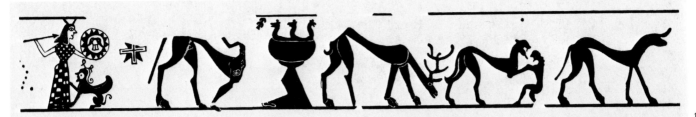

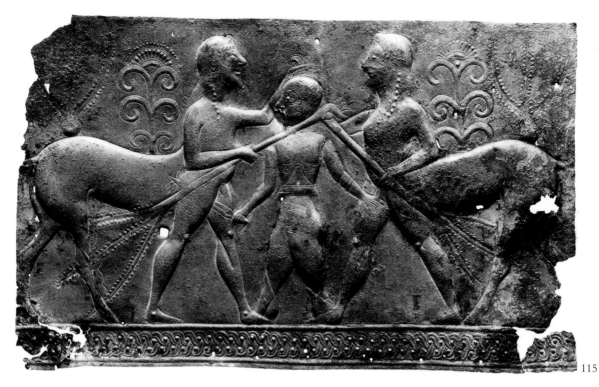

115

116

117

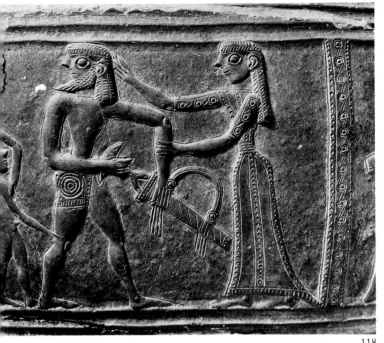 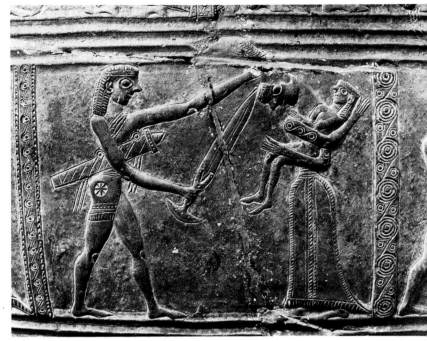

118 119

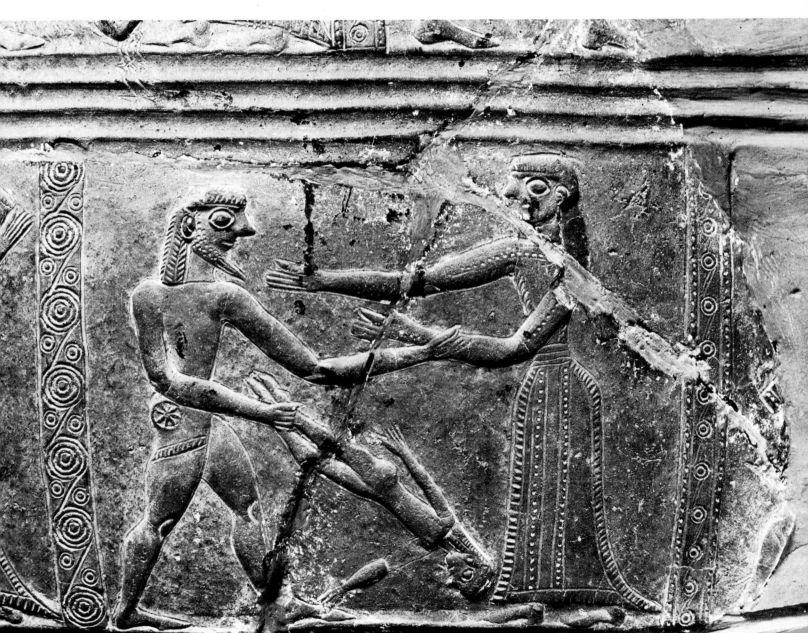

120

121

122

123

letters running from right to left. In order to understand the picture one has to know the myth, which has been handed down in various forms. Here it is based on the version in which King Pandion had two daughters, Prokne and Philomela. Prokne was married to Tereus of Thrace and had by him a son, Itys. She made her husband travel to Athens and bring back her sister. Tereus fell in love with Philomela, raped her and cut out her tongue so that she could not betray him. But somehow Philomela made the crime known to her sister. Prokne and Philomela therefore killed the son, Itys, and offered him as a dish to Tereus at a sacrificial feast. When Tereus discovered what he had eaten, he pursued his wife, his sword drawn. Zeus, however, changed him into a hoopoe, his wife into a nightingale (Aedon), who for ever after wept for her son Itys, and Philomela into a swallow (Chelidon). Here Aedon stands

110 on the left of the picture and her sister Chelidon on the right.
109 Between them the two women hold the slain Itys.

The range of colours is limited: black, white and red, the latter varying between reddish-brown and purple. The white is poorly preserved, for example on the face and arms of Chelidon and on the bindings and laces of Perseus' winged shoes. The rosettes too were often white. It should be made clear that by 'colours' we really mean different slips which fired to different colours. All these metopes—and this is new—are based on a formal composition which is balanced and indeed

105 carefully designed. This applies to the gorgoneion with the
108 serpents growing out of the side of the head and to the Perseus metope. Filling ornaments are completely lacking. It is a very carefully considered style, which excludes everything incidental and delibaretely aims at a monumental effect.

Only with some reservations can a group of sepulchral monuments be classed as painting. At Prinias, in Crete towards the middle of the seventh century the custom arose of erecting grave stelai for the dead. Only the outline of the dead person was engraved, frequently with double contour lines, on these

112 slabs. For the most part the figures are armed warriors or a woman with a spindle or a wreath in one hand and a little bird in the other. Little more than the contours of the figures are preserved. Certain slight remains of paint, however, indicate that these outlines were once filled with colour. This custom

111 lasted some decades. The slabs were evidently set in stone-built grave monuments, which they enlivened with their colour.

Mythological Representations

At the beginning of the so-called 'Dark Ages' there was no figured decoration but only geometric patterns. In the course of time figured motifs, such as running horses, occasionally occurred. It was only in the eighth century, though, that figured scenes became frequent, especially in Attic vase-painting. One finds the *prothesis* and *ekphora* of the dead for burial, ring dances, battles between warriors on land and on sea, friezes of animals and, from the middle of the century, scenes taken from

, 379 myth. A single plastic forerunner, the Lefkandi centaur, appears in the ninth century. Definite mythological forms had not yet been arrived at in the pictorial art of this period.

113 If we look at a *krateriskos* from the Heraion on Samos we see on the left a goddess with a polos on her head, holding a round shield and a raised spear. Facing her is a small crouching

sphinx. The goddess is probably Aphrodite or Pallas Athena. On the right of this group are fragments of a centaur, whose front legs are human. He raises his right arm to swing it back—the weapon is not preserved—and in front of him is part of the trunk of a pine-tree. His attack is probably aimed at a stag, grazing to the right of a cauldron that interrupts the scene. The cauldron has a conical foot and is decorated with

160, 164 griffins' heads, as was common on bronze cauldrons from the late eighth century into the sixth.

114 On the fragment of an Attic krater the attacker is probably Herakles. He is painted in the black-figure technique, in other words in black silhouette with incised detail, which was subsequently fired. On his back one can still see the end of his quiver. He has notched his arrow and stretched the great bow. Of his adversary a little is just visible— a long horse's tail and parts of its rear legs: it was surely a centaur and ought to be the centaur Nessos.

101 On a monumental amphora from the end of the century, in a fully formed representation of the subject, Herakles attacks the centaur Nessos with a sword. On the krater the hero has sideburns and a moustache, here by contrast only sideburns, for he is shaved around the mouth, as were warriors in Late Mycenaean scenes.

When and how did mythological themes burst into pictorial art and slowly supplant other motifs? In the course of the eighth century shrines began to be erected in the dromos of Mycenaean chamber and tholos tombs, where the dead were worshipped as heroes. One can go back as far as the year 776 BC when the Olympic Games, performed in honour of the hero Pelops, were newly founded. In the eighth century the hero Agamemnon was also honoured at Mycenae with a hero cult, while his brother Menelaos was worshipped at Therapne along with Helen, a goddess known in pre-Archaic times. Other heroes were honoured at other places. Even though we do not know the names of many of these heroes nowadays, we can be certain that they were not worshipped anonymously, but that each had his particular name, for interest in genealogy goes hand in hand with the oral tradition of epic poetry. In the eighth century the epic forms of particular myths must have gained such definite shape that they found expression in pictorial art as well.

The representation of myths at first had a purely illustrative character, but later the narrative content decreased and an interest in poetic and artistic form grew. Our earliest evidence for this is the fibula in Philadelphia, which doubtless still belongs to the Geometric style of the late eighth century. It is

149 often supposed that large-scale wall-painting dictates the development of the pictorial art. This may be true for later periods, but at this juncture leading artists were to be found in workshops such as those of bronze fibulae-makers, and the current does not seem to have passed from the large scale to

94 small. The back of the Philadelphia fibula shows a hunt. Since the other side bears a mythological theme, one would not normally suppose that here the theme was mythical too, for as a rule a mythological side is contrasted with a non-mythological one. The hunter, however, does not just kill the horned hind, but at the same time seizes her horn. On later representations of this legend, when it was included as one of the twelve Labours, the hind is usually left unharmed, because Herakles had to bring it alive to Eurystheus. In Euripides' *Herakles* (375), however, it is said that Herakles killed the golden horned

hind. Euripides must here have returned to an old version of the story.

115, 171 In 1937 a bronze sheet was found in Olympia which shows the Lapith king Kaineus in battle with the centaurs. The action occurs in an olive grove, for olive-trees grow over the backs of the centaurs and the twisted trunk of one such tree is visible in front of the rear leg of the left-hand centaur. According to the legend Kaineus was invulnerable to weapons. The centaurs, therefore, are grabbing him by the helmet crest and by the arm and hitting him with the tree-trunks, which they have torn out by the roots. Kaineus is stabbing his opponents in the genitals with a sword and defending himself resolutely. Nevertheless, 'he sinks', as Pindar (Snell ed., *Thren* VI, 8) reports, 'hit by fresh pine-trunks into the ground, splitting the earth with his upright foot'.

The bronze sheet dates from around the middle of the seventh century and may have belonged to the inlay of a wooden chest. It is the oldest definite representation of this legend. Whereas in later versions Kaineus threatens the centaurs with a drawn sword and they hold stone boulders over him, here he is being violently attacked and they are being stabbed. The execution of this sheet is minutely detailed and its composition is well thought out. How well the slim body of the Lapith leader contrasts with those of the massive centaurs! In early art boxers and wrestlers were regularly characterized as heavy and fat. What care the artist has lavished on the fine combed crest of the helmet or the little patterns on the armour and chiton! Even the greaves are carefully bordered with holes to attach the lining. Over the back of each centaur rises, like something strange, a stem with wide volutes and a bloom in the angle at the top. These growths have an upward thrust which contrasts with the sinking into the ground of the Lapith leader.

Representations of legends from the Trojan Cycle also 95 appear in the eighth century. On a shield from Tiryns a wild battle is raging. The main group is in the centre. The scale of importance makes the victor larger, while the figures who hurry to the scene, on the left a warrior and on the right an Amazon, are further differentiated, being smaller than the Amazon in the middle. The fallen figure is tiny.

The interpretation of the battle scene is uncertain even today, because the painter has not included any names. The more probable explanation is that Achilles and Penthesilea are represented here. Whoever favours Herakles and Andromache should not rely too much on the Amazon's girdle which the victor supposedly wishes to win. In the Late Geometric period such girdles are common not only for men but also for women and even animals, for example the fawn being suckled, are often similarly articulated. In later times, as on the Rhodian Euphorbos plate, in a scheme common since 700 BC, the duel over a fallen warrior was identified by including the names of the heroes concerned.

On an Attic jug made soon after the middle of the eighth century the shipwreck of Odysseus was depicted—here doubts over the interpretation may be dismissed. We have already 97-8 spoken of representations of the blinding of Polyphemos in the first half of the seventh century. In the late eighth and early seventh centuries the Wooden Horse was also represented pictorially. Around 670 this theme was depicted on the neck of 116-20 a relief pithos on Mykonos, accompanied by a complete cycle of 122 scenes from the Sack of Troy. The Wooden Horse is on wheels

and has rectangular openings in which the heads of the hidden 117 Greek heroes are to be seen. From the port-holes swords and shields are being passed out. Some heroes have already descended and are striding in full armour to the battle. On the 118- shoulder of the vessel, divided into metopes, is a series of terrible scenes in which the victors seize little children from their mothers and hurl them to their deaths or spit them on their swords. There is another scene where Menelaos with 122 drawn sword approaches Helen, who opens her veil so that he will stop, overcome by her beauty.

No less impressive is the mid-seventh-century bronze fitting 123 from a tripod leg from the Heraion at Argos. The scene in the upper field is too badly preserved to be interpreted precisely. A warrior is following a woman of peaceful intent—she is holding a spindle; below, however, are two upright and girdled female figures. The smaller one on the left, with a strange hair-style, is seizing the other by a lock of hair held over her forehead and stabbing her in the stomach with a drawn sword. Her head is completely framed by long locks to suggest her beauty, and she raises her hands high in horror. It is Cassandra, the most beautiful daughter of Priam (*Iliad*, XIII, 665), who was killed by Clytemnestra on the return of Agamemnon. No filling motifs have been used, while the hand on the lock of hair and the sword-tips are the only points of contact: both devices strengthen the effect.

The legend of Aedon and Chelidon, which has been passed 107, down in various forms, must belong to the very old stock of 110 myths, like other bird transformation stories.

The myth of Perseus is represented pictorially from the first half of the seventh century onwards. A beautiful ivory relief from the Heraion on Samos belongs to the second half of that 348 century. It probably served as the small side of a little box. It has a frieze of rectangular squares decorated with geometric patterns, on top. In the picture zone below, the figures are pressed together so closely that the background of the scene is scarcely visible. Perseus is turning his head away from the monster with the petrifying gaze, his face shown frontally. His pilos, or rather the hat of Hades which made him invisible, intrudes into the picture frame. His baldric runs diagonally over his chest. He has already drawn his sword and is stepping forward boldly to cut through the neck of the Gorgon Medusa. Athena, bare-headed, stands close behind him. Her hand, which touches his arm, lends him courage and strength. Medusa is already collapsing and her mighty head with its grimace is beginning to tilt as Perseus grabs it by one of the snakes which is growing out of the side. Her breast is scaly and one of her wings touches the upper border.

The metope from Thermon shows the next phase of the 108 adventure. The pursuing Gorgons on the succeeding metopes should be imagined as they are depicted on the Netos vase. We should probably also imagine the decapitated Medusa among the metopes. From the severed neck of Medusa on the Netos 121 vase blood flows, while one arm hangs down loosely and the other grips her trembling knee. The drapery falls to the rear; a vulture swoops down from above. Below, dolphins swim in the opposite direction from the pursuing Gorgons, thus emphasizing the speed of their movement.

An ivory comb from the sanctuary of Artemis Orthia at 357 Sparta (*c.* 620 BC) bears a carved representation of the Judgment of Paris. The interpretation of the scene was debated for a long time because one would normally have taken the

man on the throne at the left to be the bearded Zeus. Later it was interpreted as the Judgment of Paris because it was thought that the apple of Eris could be seen in his hand. But the apple does not belong to this scene. Paris is shown bearded, as is most often the case in the early period, and is here throned in judgment, while the supposed apple in his hand is actually the breast of Hera, who stands in front of him with a cuckoo on her arm. Athena follows her and, as is customary in the seventh century, does not wear a helmet. The third figure, Aphrodite, stands on the right, and is smaller because of the curvature of the frame. Her outstretched hand and that of Paris balance each other. Behind Aphrodite stands her sacred animal, the goose. The episode which led to the outbreak of the Trojan War is here represented very convincingly, though pressed into a very narrow space.

Yet other mythological scenes from before 600 BC. might be mentioned, but within the confines of this book these examples from a larger corpus must suffice.

Metalwork

Masks from Shaft Graves

124 For the visitor to the National Museum at Athens the world of the Achaeans is introduced by a golden mask full of sincerity and dignity: there is nothing like it among the Minoan works in the Iraklion Museum. Heinrich Schliemann, who excavated it, gave it the name of Agamemnon, the Homeric chieftain who destroyed Troy but on his return to Mycenae was murdered by his own wife. However, Agamemnon lived about two and a half centuries later than the prince whose face was covered by this mask found in Shaft Grave V. One may, therefore, regard him as one of Agamemnon's royal predecessors around 1500 BC.

The thick gold sheet has not been flattened out by a restorer but is preserved in its original state. The mask did not therefore fit the head but lay flat over the face of the dead man. Even the ears are added horizontally and widen the face which, in spite of the beard, long nose and high forehead, is in fact wider than it is long. The representation of the eyes is very strange, for the lids close in the middle of the almond-shaped eyes, even though the rims of the lids are also rendered plastically all around the eyes, as if they were open. It may be that the Mycenaean goldsmith was attempting the magical representation of a deceased person at one and the same time 'sleeping' and 'waking', although this is not certain. One should not suppose, however, that he simply made a mistake. We possess comparative material in the form of five further metal masks from Mycenae. These are artistically inferior to that of 'Agamemnon'. On each of them the eyes are either closed or open, instead of having this unique mixed form. Günter Kopcke explains it as an attempt to represent the eye conceptually. 'It is a picture language that explains itself in the way that concepts do... hence its unique plausibility and its spiritual power.' We have comparable things in modern art—one thinks of certain faces by Picasso.

125 With the 'Agamemnon' the Mycenaean artist improved upon an old-fashioned type, which is represented by three masks from the shaft graves, all very much alike. On them a single eyebrow arches over the closed eyes, the hair growing together at the area over the bridge of the nose. There are lashes on the lids, but no beard. The artist of the 'Agamemnon' doubtless knew this type, since the electrum mask from Grave Circle B at Mycenae is earlier. What he retained is the flat form, the hatching of the eyebrows, the length of the nose and the absence of hair on the head. However, he made not one eyebrow but two, gave the mouth thin lips instead of representing it simply as a slit, and added a moustache and beard—a veritable lion's mane. These changes may in part reflect an approach towards naturalism, but the representation of the eyes has nothing to do with such a concept. This phenomenon should warn us against speaking here of a portrait or of a death mask moulded over the face of the deceased.

124-5 We ought, however, to ask ourselves whether the common characteristics of the three flat masks just mentioned and of 'Agamemnon'—the almoned-shaped eyes and the long thin nose—may not be typical of a Mycenaean dynasty. One thinks of the facial characteristics which emerged over the generations in certain ruling families of later times, such as the Claudians or the Hapsburgs. This question is legitimate because for Mycenae two different and concurrent royal families are recorded—a peculiarity known from mythology for other Archaic princely residences as well—and because a second type of mask has in fact been uncovered in the shaft graves. It is represented by two examples from Schliemann's excavations, from Shaft Graves IV and V, i.e. from the same circle that yielded the so-called mask of Agamemnon. This second type has a spherical face, open round eyes that bulge out and a relatively short nose. It has been rightly attributed on stylistic grounds to another workshop than that from which came the specimens we discussed before. Did each of the princely families perhaps have its own workshop at Mycenae?

The hypothesis of two palace workshops for metal-working probably explains the differences between other objects from the shaft graves. There are copious references in scholarly literature to the stylistic disunity of the material from the shaft graves. This is generally explained by presuming that some of them were gifts from foreign princes and by referring to the allegedly semi-barbaric nature of Early Mycenae. Such an approach, however, prevents one from appreciating the surprising new development which has taken place here, a development with consequences for the future. It is impossible to imagine an Egyptian grave with masks as different as those that have been found in Shaft Graves IV and V. In contrast to the strongly established forms of Egypt and the rest of the Orient, variety reigned at Mycenae. We may therefore conclude that there was a measure of freedom even in the extremely conservative field of cult, a freedom absolutely unthinkable in the Orient. In spite of all the powerful restrictions, which naturally were also present in Greece during and after the Bronze Age, this freedom was never lost. It is apparent in another typically Hellenic principle, that of contest (agon), which spurred men to high achievement in many fields, such as athletics, poetry or the pictorial arts. Doubtless the two workshops at Mycenae vied with each other in a contest of this kind. The competition may indeed have created the particular form of the 'Agamemnon' mask.

Metal Vessels from Shaft Graves

There is a particularly rich inventory of metal vessels from the shaft graves at Mycenae. Three major groups can be differentiated:

1) Sturdy household vessels of copper, such as cauldrons, jugs and hydriae with forged handles. The considerable number of partial repairs speaks for long use. The connection with Middle Helladic forms (from the first half of the second millennium BC) is particularly strong.

2) Drinking vessels and other luxury pieces, such as cult vases, made of precious metals. Drinking vessels were part of the inalienable property of the dead and so followed them to the grave; cult vases were badges of their owners' priestly office. In this group some Minoan influence can be detected.

3) Drinking-bowls of thin gold leaf, some of them so thin that they could not have been used in practice. Like other offerings of fine gold-foil, they were made expressly for the cult of the dead.

The second group, to which belong the vases illustrated here, includes a series of important works of art. Let us begin with Shaft Grave IV, which contained the burials of three women and two men and was particularly rich in cult vessels. Among the offerings were three *rhyta*—vessels for libations—two of silver and one of gold. Two of these have the form of animal heads—lion and bull—while one is funnel-shaped. The latter and the bull's-head rhyton are of silver with gold trimmings, whereas the lion's-head one is completely of gold. The latter was, however, no more precious than others; on the contrary, silver was at that time considered more precious than gold. Until the Late Antique period the most exquisite works of ancient toreutics (the art of metal embossing) were also of silver, which after all was a metal particularly well suited to this technique. Thus in fineness of workmanship the two silver rhyta surpass the golden lion's head, which achieves its artistic power as a result of the feeling of energy that emanates from it. Nevertheless, the lion's-head rhyton is better preserved, for unlike gold silver is subject to corrosion.

All three were used as cult vessels. On top is an aperture for the libation, hidden on the crown of the animals' heads; below is another aperture—in the lower lip, in the lion's- and bull's-head rhyta—through which the liquid could be poured out. The funnel-shaped rhyton was also open at the bottom. On the animals' necks were closely fitting lids, now lost. The priest or other person officiating kept his finger on the lower orifice until the moment came for the offering to be made.

From Hittite texts we know that rhyta were often used to represent the sacred animal of the divinity who received the libation. The lion was an associate of goddesses such as the Oriental Aphrodite, the mother goddess Rhea or Hera, the chief goddess of Mycenae whose cult symbol, the column, is flanked by lions over the entrance. Thus the lion's-head rhyton may have served as an offering-vessel for Hera and one of the two women buried in Shaft Grave IV may have been a priestess of Hera. The bull, however, was an attribute of a male divinity such as Poseidon or Zeus, for whom the bull sacrifice on the Agia Triada sarcophagus was probably intended. The two animal's-head rhyta are doubtless a pair, because of details like the suspension loop on the neck, and they may in fact have once been used in the cult of the chief deities, Zeus and Hera. Nevertheless, they are the work of two different artists. One of them probably specialized in gold, the other in silver. From Linear B texts it is known that the professions of palace workers were highly differentiated, so that Emily Vermeule's attempt to ascribe to a single artist different types of object, for example stone reliefs and metal vases, is questionable from the outset.

The lion's-head was hammered out from a single thick sheet of gold and subsequently chased. The face consists of large smooth planes which meet at angles. A sharp edge also divides the face from the mane with its chased tufts which rise in inverted Vs up to the forehead. With this rather stereometric form are combined details which are more natural, such as the ears and the crevice for the muzzle; the eyes and nostrils are also lively in spite of the rigorous stylization. The work is rightly ascribed to a Mycenaean goldsmith who was brought up in the Helladic tradition.

In contrast, the silver bull's head stands so close to Minoan models that its artist surely must have had connections with Crete. The upper surface is badly corroded, but all the forms are soft and rounded, not angular like those of the lion. Inside the head was lined with a smooth internal sheet, such as one finds on the Vapheio cups. The ears are made separately of bronze and covered outside with silver and inside with gold. Thin gold leaf also covers the horns (which were once probably of wood), nostrils and muzzle, in other words those parts where there was no hair. Nevertheless, the artist was not purely concerned with realism, as the large golden rosette on the forehead shows. From Nestor's sacrifice in the *Odyssey* (III, 432-8) we know that the sacrificial beast's horns were gilded to please the divinity.

From a historical standpoint the silver funnel-shaped rhyton is one of the most interesting Mycenaean vessels. It is clear from the fragments that it too was once a marvellous piece of work. Its designer stands close to the art of miniature frescoes, such as are now best seen in the Ship Frieze from Thera. A 'Homeric' theme was represented, the battle for a city near the sea—the latter indicated by the stylized waves that cover the lower part of the narrowly tapering vessel. That they really are waves, not simply pattern work, is evident from the figures swimming among them. The attackers, who wield what may be clubs, could be seen on a minute fragment, now missing (not shown here). From Oriental parallels they ought to be the people with whom those who viewed the frieze identified themselves. They must have come over the sea. While the women on the city wall raise their arms in mourning, a chieftain tries to defend the city and the olive grove in front of it with slingers and bowmen, in other words with lightly armed troups. Behind the fighters two men with long lances are standing; they are probably 'officers' who are discussing the progress of the battle, as we may infer from their gestures. Whether they are carrying shields or cloaks is not clear, but the behaviour of the women shows that the battle is going badly for the besieged. The city wall is built of isodomic masonry, as are the walls on the miniature frieze from Thera. Since that frieze shows contemporary events, the relief on the silver rhyton also depicts a contemporary scene rather than a mythological one. When we called it 'Homeric' earlier, we were alluding to the historical background of Homer's epic.

Two small golden figure-of-eight shields flank the strap handle, which as usual tapers downwards. This shield form also came to be used in amulet form on cult vessels. The rim of the mouth of this rhyton is strengthened with bronze and decorated with gold. It must remain an open question to which divinity libations were poured from this special vase. Figure-of-eight shields and olive-trees as well as men in combat might make one think of Athena, the helper of heroes, who was highly venerated at Mycenae.

One of the finest drinking vessels which Schliemann found, a cup on a low foot, also comes from Shaft Grave IV. It is made of electrum, a natural mixture of silver and gold (cf. the electrum mask). Although the amount of gold is small, it hindered the corrosion of the vase, which consists of two thick sheets joined together. Scholars were uncertain whether this cup was made on Crete or on the Greek mainland, though most favour a Minoan origin. If one accepts the neat definition proposed by Emily Vermeule, who calls the Mycenaean 'a successful fusion of mainland and Minoan styles', the cup can be termed completely Mycenaean; what is more, there are arguments in favour of such a hypothesis. The general contour

124 Mask, from Shaft Grave V of Grave Circle A at Mycenae. Gold. *C.* 1500 BC. H. 26 cm. National Museum, Athens.

125 Mask, from Shaft Grave Gamma of Grave Circle B at Mycenae. Electrum. Mid-16th century. H. 21.5 cm. National Museum, Athens.

126 Lion's-head rhyton, from Shaft Grave IV of Grave Circle A at Mycenae. Gold. Latter half of 16th century. H. 20 cm. National Museum, Athens.

127 Bull's-head rhyton, from Shaft Grave IV of Grave Circle A at Mycenae. Silver with additions in gold. Latter half of 16th century. H., including horns, *c.* 30 cm. National Museum, Athens.

128 Cup with spiral decoration, from a tholos tomb near Peristeria. Gold. Early 15th century. H. 13.5 cm. Museum, Pylos.

129 Cup, from Shaft Grave IV of Grave Circle A at Mycenae. Electrum with inlays in gold and niello. Latter half of 16th century. H. 15.5 cm. National Museum, Athens.

130-1 Funnel-shaped rhyton with scenes from a siege, from Shaft Grave IV of Grave Circle A at Mycenae. Silver with additions in gold. Drawing of the preserved part and photograph of main fragment. Latter half of 16th century. Preserved h. 22.9 cm. National Museum, Athens.

132 Jug, from Shaft Grave V of Grave Circle A at Mycenae. Silver. *C.* 1500 BC. H. 34.5 cm. National Museum, Athens.

133 Kantharos, from Kalamata. Gold. *C.* 1500 BC. H. 9.7 cm. National Museum, Athens.

134-7 Cup with the 'idyllic' frieze: middle (Pl. 136); bull and cow left (Pls. 134-5): bull being led away with its left hind leg tied; right (Pl. 137): a second bull approaching; from the tholos tomb at Vapheio. Gold. Mid-15th century. H. 7.9 cm. National Museum, Athens.

138-40 Cup with the 'dramatic' frieze: middle (Pl. 139): a bull caught in a net; on either side: a bull fleeing (Pls. 138, 140); left: two men falling; from the tholos tomb at Vapheio. Gold. Mid-15th century. H. 7.9 cm. National Museum, Athens.

141 Household vessels: bowl, lamp and jug, from Chamber Tomb 2 at Dendra (Midea). Bronze. Latter half of 15th century. H. 14.3 cm (bowl), L. 10.6 cm (lamp), H. 20.5 cm (jug). National Museum, Athens.

142 Aegean gift-bearers with Minoan-Mycenaen metal vessels, in a grave in the Necropolis of Thebes, Egypt. Fresco. 15th century. Drawing.

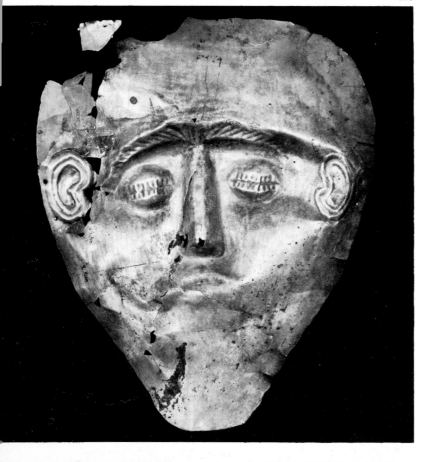

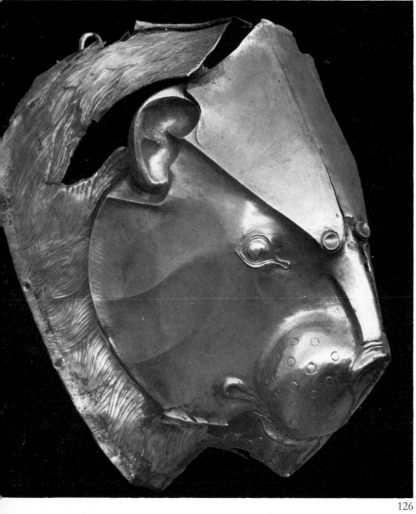

128

129

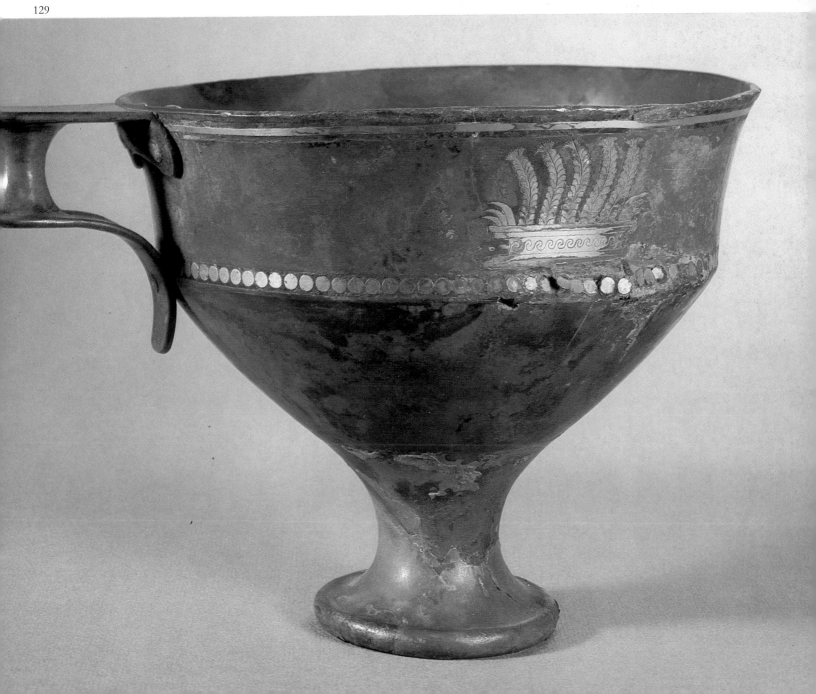

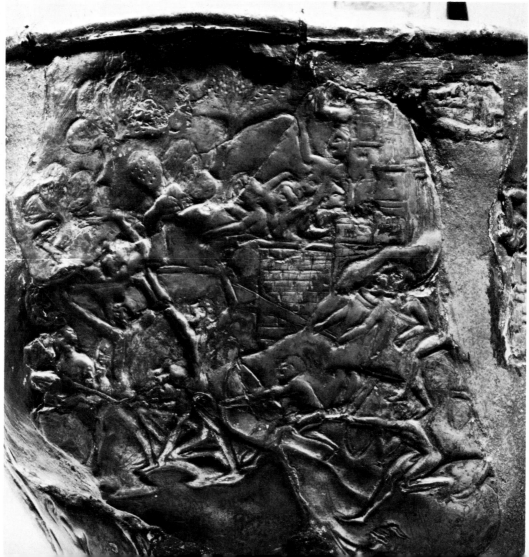

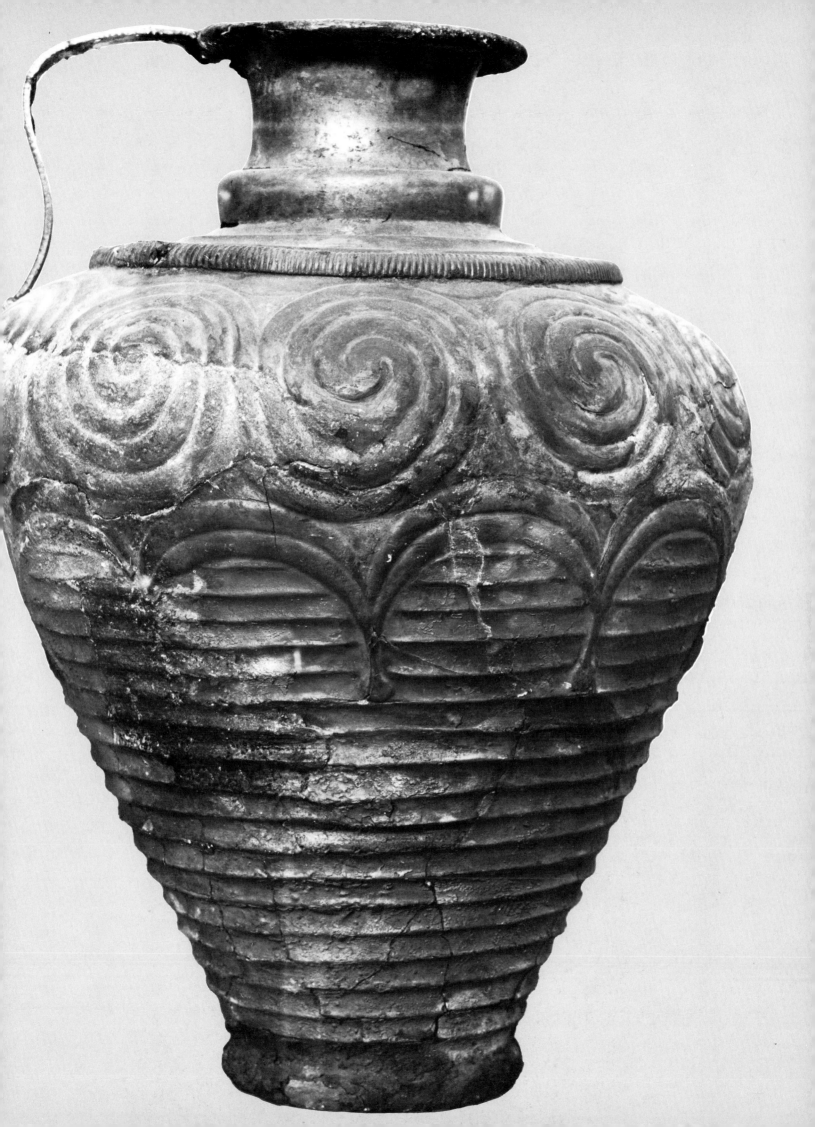

133

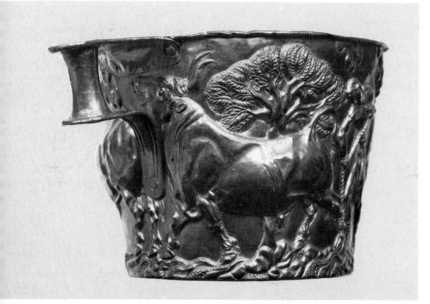

134

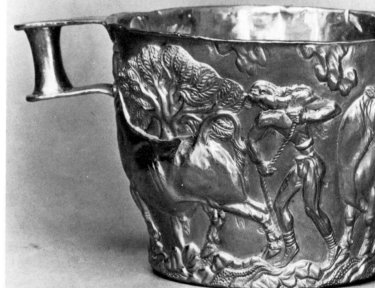

135

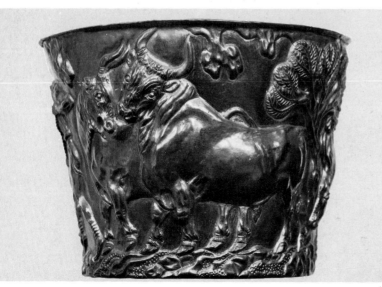

136

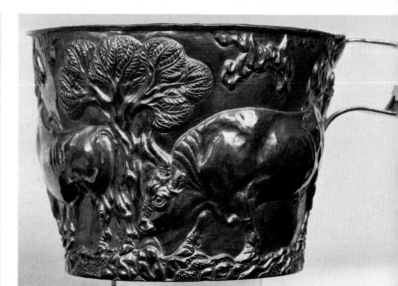

137

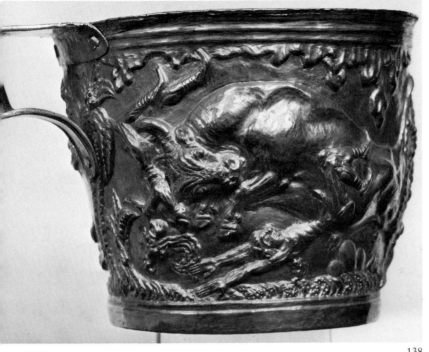
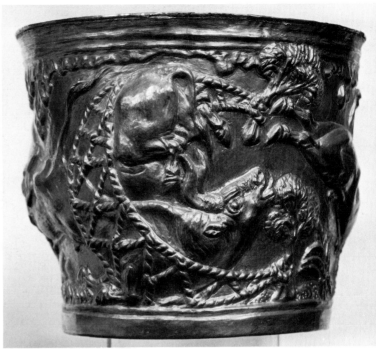

138 139

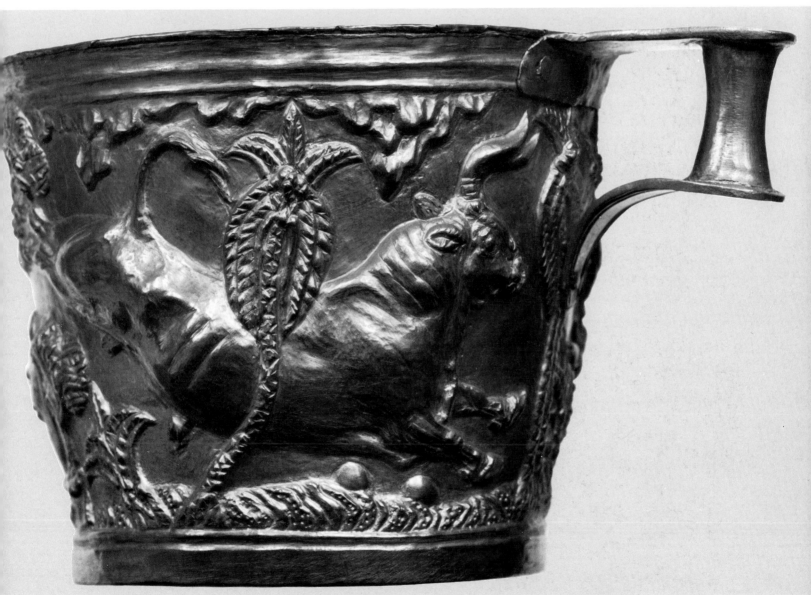

140

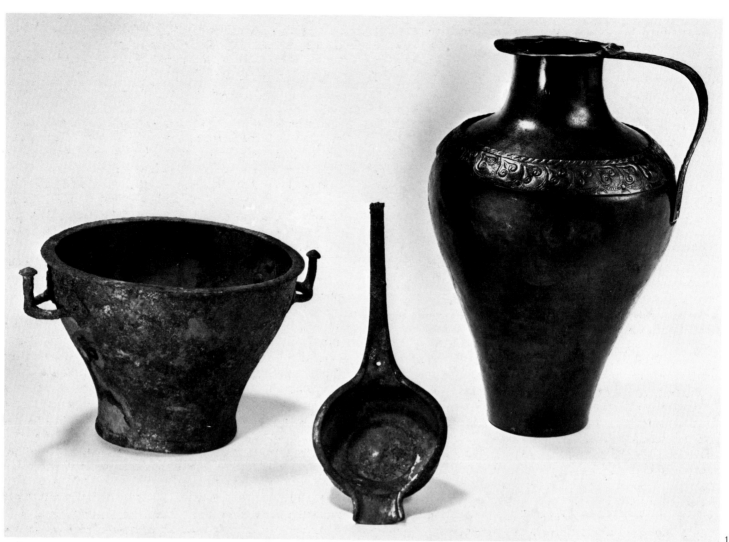

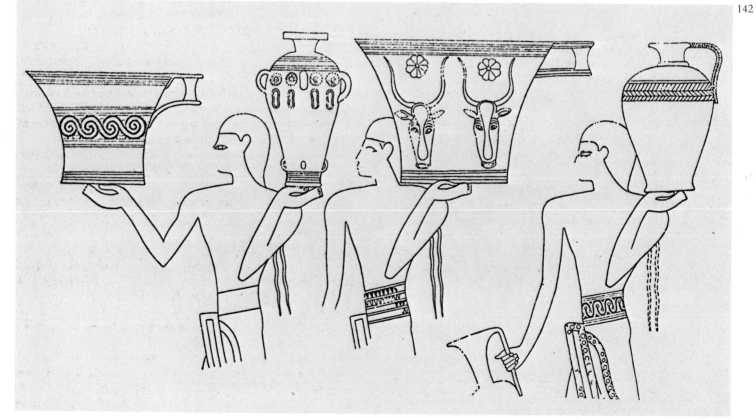

with its marked taper is also found on Crete, but the sharp angle between the body and the lip zone is typically Helladic. The enchanting motif, repeated three times on the lip, of branches growing from a concave altar—branches which seem to be moving in the wind—is rather Minoan in form. The inlay technique, however, is unknown on Crete, though it appears on a whole series of metal works from the Peleponnese: on vases and on weapons. The 'Vapheio handle', named after the famous cups from Vapheio, was admittedly of Cretan origin but this Middle Minoan invention had long been known on the mainland as well. The concave altar, which is decorated a little differently each time here, has predecessors on Crete, but it also occurs on the relief of the Lion Gate and in rather thinner form on the stuccoed plaque with the Palladion from Mycenae. Thus this electrum cup may have been made in a Mycenaean palace workshop soon after the middle of the sixteenth century. The concave altar is known to have been a sacred motif at Mycenae as well, so that the cup was probably used in cult ceremonies, like the rhyta. The lip is lined on top with a gold band, with gold discs below; these rest in a slightly recessed bedding of niello, a shiny blue or grey-black fusion of copper, silver and sulphur. The whole cup was also carefully patinated with this material, as has recently been suggested.

The silver jug from Shaft Grave V, whence the gold mask of 'Agamemnon' came, is certainly of Cretan origin. This vase, 34.5 cm high, made from two thick silver sheets, has a bronze companion-piece from Knossos. The seam on the shoulder is covered with a fillet which is notched and underlaid with bronze; the rim and foot-plate are also strengthened with bronze. The shoulder is decorated with thick spirals; bordering these is the typical Cretan pattern of double arcs and drops, which fuse with the horizontally fluted conical lower part. Just as the whole vase tapers downwards, so does the handle, which is fixed with three silver pins above and with one below.

A gold cup with two high handles, found in Shaft Grave IV, by contrast, has its companion parallels not on Crete but in Mycenaean Greece. We show here an example from Kalamai (Kalamata) in the south-western Peloponnese. We are dealing with a time-honoured form of kantharos, for the treasure of Tôd in Upper Egypt, a treasure which is surely of Aegean origin, contained a similar silver kantharos of c. 1900 BC. The sharp angle on the body of the Mycenaean specimen is, however, lacking on the Egyptian one. The decisively sharp carination in the outline is not a genuine toreutic feature, but comes from ceramics: it appears frequently on Middle Helladic pottery. One may be surprised that ceramics should have influenced metal-working, since the current generally flows the other way. But the kantharos was first produced in potters' workshops, as far back as the third millennium BC, before the adoption of the fast wheel. Perhaps already then it was a special vessel, just as later it was sacred to Dionysos and particular heroes. The golden Mycenaean specimens may have emulated those in clay because they were so ancient.

Gold Vessels from Tholos Tombs

In a tholos tomb near Peristeria, near ancient Pylos, Marinatos found a gold cup whose design is superior to that of an example from the shaft graves at Mycenae which is similarly decorated. A roll, stylized as a twisted band, divides the wall of the cup into two halves, which carry the same ornament: a three-storeyed net of spirals, a pattern with unending rapport. The vessel is made from a relatively thick gold sheet and has a strap handle; it may date from the early fifteenth century BC.

The tholos tomb at Vapheio, about seven kilometres south of Sparta near the Eurotas, was still partly undisturbed when Ch. Tsountas discovered it in 1888. This was a rare stroke of luck, since—in contrast to shaft or chamber tombs safely hidden in the earth or rock—most monumental tholoi had already been completely robbed in antiquity. Vapheio lies not far from ancient Amyklai, the centre of the Archaic Lakonian culture, and even nearer ancient Pharis or Pharai, where vassals of the king of Amyklai resided, until in the later part of the second millennium BC circumstances were fundamentally changed by the immigration of the Dorians. Lakonia is the region of the Greek mainland which lies nearest to Crete. Indeed it had a particularly strong connection with the culture and religion of Minoan Crete, and this remained the case even after the Dorian migration when Crete became Dorian. Hyakinthos, who was worshipped at Amyklai, was a cult figure similar to a Minoan vegetation god and the Lakonian Helen was originally a goddess closely connected with the Minoan tree cult. The lasting brilliance of her beauty originated in the fact that in myth she was also an Achaean princess, of whom Homer sang. It is not accidental, however, that the most beautiful women of Greek legend came from Lakonia, steeped as it was in Cretan influences, for in no other civilization of that time were women so important as in the Minoan.

The two golden cups from the Vapheio tholos, which date from the middle of the fifteenth century BC, are for us the most beautiful evidence of Minoan contacts with Lakonia. Whether they came as gifts from Crete or whether the Lakonian chieftains employed Cretan goldsmiths cannot be determined. Each cup seems to be the work of a different artist, but it is going too far to see one as Cretan and the other as Mycenaean, as was recently claimed. The similarities are stronger than the differences, which are the result less of different artistic homelands than of different artistic temperaments. In any case the design of both cups, which were conceived as companion parallels, is to be attributed to a single artist. He may have been a Cretan painter, since the arts of painting and metal-working were closely connected in other periods.

Both cups are decorated in high relief and are lined inside with a smooth sheet of gold, a technique which was still employed in the relief bowls of the Roman Empire. The chief motive of this technique must have been hygienic: the interior could be cleaned more easily. The bowls are one-handled, and their shape has given rise to the term 'Vapheio handle'. Whereas most Minoan and Mycenaean vases have one-piece strap handles, which taper downwards steadily, the Vapheio handle also has a strap form above and below, but in the middle there is a solid cylindrical element. In the shaft graves and later this form is reserved for single outstanding pieces. If one actually holds a vase with a Vapheio handle one will see how well it fits one's hand.

Both cups are decorated in relief with variations on a major Minoan theme, the bull. On both pieces the scene is the capture of bulls, either of wild ones or those raised in large paddocks, where they enjoyed a great deal of freedom, so that they might

take part in the bull sports or be led to sacrifice. On one cup the capture is dramatic, on the other idyllic. The dramatic version seems almost to burst the bounds of the picture even though it is in fact enclosed above and below by a thin horizontal band, which is lacking in the other cup. Furthermore, the bizarre landscape features, which jut into the picture zone from above in the Minoan–Mycenaean manner, appear on the first cup as a continuous whole and thereby serve as a further frame, while on the 'idyllic' companion parallel they are separated into individual sections. The central motif of the dramatic scene is a bull that has been caught in the net and is rolling wildly. Its bellowing has alarmed two other bulls, which flee in either direction, the right-hand one at the 'flying gallop' so typical of Cretan bulls. Apart from the two small olive-trees to which the net is fastened, tall and short palm-trees grow near by, while loose stones are scattered around. Both these elements are lacking in the idyllic landscape, in which only two olive-trees grow. The central motif is in this case the mating of bull and cow. The one, half covered by its partner, raises its tail and turns its head toward the other, just as animal mothers in Minoan art turn lovingly to their offspring. From the right comes a rival, a particularly mighty bull, who scents something. On the opposite side another bull, its rear legs tied, is bellowing as it is led away by a slim long-haired youth, who wears a typically Cretan skirt costume and high boots.

The bulls dominate both compositions to such an extent that at first one does not notice the human figures. This is particularly true of the dramatic scene, where two youths are in the greatest danger, it would seem, from the bull breaking away to the left. Both boys are tumbling head first to the ground—one is about to be gored by the bull's horns. How could anyone imagine that the famous Cretan bull sport is represented here? This is no sport; it is in deadly earnest. The reason why the movements of both youths are similar to those of bull-leapers is as follows: for this rare picture the artist used motifs which were familiar to him from the bull game frequently represented in Cretan art. The sport itself may have been conceived as an imitation of the actual capture of a bull. In any case in the eyes of a Greek it was surely mimetic, in other words the action imitated reality. The Greeks also considered the dance mimetic.

On the cup with the dramatic composition violence rules, but on the idyllic one the motif is cunning: a cow is set up as the lure and attracts the bulls' attention, so that men can catch them without too much effort. On one side a single young man has tamed the bull by cunning, whereas on the other side two men are in danger of succumbing to the bull. In Homer and early myth cunning is an attribute of gods and exceptional individuals—one thinks of Hermes, Perseus and Odysseus. The Bronze Age man who saw these two friezes may well have deduced that more is achieved by cunning than by force.

These two cups may be seen as personal drinking vessels of the royal couple from the Vapheio tholos. Pairs of cups with similar friezes are not known from graves in the Argolid, where we find either single cups or a whole group. Has the 'duality' of the Vapheio cups rather something to do with the fact that the Achaean women of Lakonia had more freedom than women did in the rest of Greece? Did the princesses there sit publicly with the princes at feasts? Perhaps one day a Linear B text or some other monument will give us the answers to such questions.

Bronze Vessels from the Argolid

The seats of the Achaean chiefs of the Argolid lay close to each other. On the east coast of the Argive plain was the acropolis of Midea (Dendra), the home of Herakles' mother, Alkmene. Here Greek and Swedish archaeologists have excavated fourteen chamber tombs, as well as a tholos. One of the largest, Chamber Tomb 2, with a dromos nearly 20 m long, was a cenotaph. The custom of honouring someone who died abroad with such a grave is known from Homeric epics. In the entrance to the chamber tomb was a trench in which were discovered thirty-five bronze vessels and utensils; three of them are illustrated here. These are items of household equipment like the copper vessels mentioned above from the shaft graves at Mycenae, which look clumsy and rather primitive when set against these elegant pieces. More than a century of development lies between them, since the cenotaph at Dendra was erected in the second half of the fifteenth century BC. The change in forms due to Cretan influences, which had first affected only luxury vases, can now be seen to have occurred also on items of daily use.

No counterpart to the jug is known from Crete, but other examples come from Mycenae, Asine and above all from Dendra. There, in Chamber Tomb 12, the famous tomb with the armour, a remarkably similar jug was discovered which may come from the same workshop. Two sheets of bronze were used for this vessel, which tapers downwards. The seam on the shoulder is covered with a moulded ornamental ring, which like the cast (or forged?) handle bears a vegetable pattern. The individual parts consist of heart-shaped leaves from which umbel grows. With a fine feeling for the shape of the vase they are set in an oblique row on the shoulder, while on the handle (not visible here) they appear in a vertical row.

The bowl (lekanis), which also tapers downwards, is equipped with moulded knob handles, a form which re-emerges in Greek art a thousand years later. The out-turned rim of the vessel, which is hammered from one piece, is carefully decorated with two rows of connected spirals (not visible here).

The small 'casserole' with a spout was plausibly explained by the excavator, Axel W. Persson, as a hand lamp. It has Middle Minoan forerunners in stone. In the hole at the beginning of the grip was a knob, as another specimen from the same grave shows. On it must have been the base of the wick-holder. Stone, bronze and terracotta lamps have been discovered in many Mycenaean graves.

Metal Vases with Inlays

In Egyptian Thebes, in the painted grave chambers of the treasurers and viziers of the Pharaohs of the fifteenth century BC several representations have been found of gift-bearers with typically Minoan–Mycenaean metal vessels. One shows jugs like the bronze jug from Dendra and cups with Vapheio handles mentioned above. The decoration of the vessels—spiral bands, rosettes, herring-bones and

tongues—should be thought of as embossed. One cup with Vapheio handles, on a larger scale than its carrier, shows bulls' heads; the originals were probably in inlaid work, as has been suggested. Silver cups with inlaid bulls' heads of gold and niello are indeed known. One has been found in a royal grave at Dendra, and a second at Enkomi on Cyprus. Each has only one knob handle, but the outline of the cup from Dendra belongs to the Mycenaean tradition, whereas the vessel from Enkomi looks like the hemispherical Cypriot clay bowls. Around the concave foot of the Enkomi cup runs a ring of niello; above it is the drop pattern of the silver jug from Shaft Grave V, here with a rosette in each arcade. The main decoration consists of six bulls' heads with their horns curving inward. Between each head are two lotus buds facing in opposite directions. On the upper rim are small gold discs set in niello, a miniature technique which recalls the decoration of the electrum cup from Mycenae. There are inlays in gold and niello on the bulls' heads and there are subtle variations between them. The piece was probably made in the Mycenaean tradition on Cyprus in the fourteenth century, if we follow the evidence of the other finds in the tomb. The Achaeans who settled this island came from Arcadia in the central Peleponnese. They must have brought the inlay technique from their Peloponnesian homeland, for there is no parallel to it on Crete. Whether the figures in the frescoes of Egyptian graves are meant to be Minoans or Mycenaeans cannot be determined, for the Egyptian painter did not try to identify exactly the people whom he called the Keftiu, but depicted only a general Aegean type.

The last of this spectacular series of Mycenaean metal vases that we can illustrate here is a thirteenth-century shallow silver cup from a chamber tomb at Mycenae. It used to be dated to the sixteenth century because of its gold and niello inlays, a technique first seen in the material from the shaft graves. Fragments of a comparable vessel, however, were found at Pylos, which was destroyed in about 1200 BC. The silver cup with inlaid boukrania from Enkomi can be dated in the fourteenth century. We must, therefore, be dealing with a common Mycenaean technique which was used over a long period and which survived in poetry down to Homer's time.

The technique was indeed made immortal by Homer's description of Achilles' shield in the eighteenth book of the *Iliad* (478 ff.). For what the divine smith Hephaistos adds to the shield is inlay work in the manner of Mycenaean daggers and vessels: 'In it he set a large vineyard heavy with clusters of grapes, beautiful and golden. The grapes on it were dark metal and around that a fence of tin' (561 ff.).

The vine branches were, therefore, inlaid in gold, the grapes were of niello, the posts of silver, the fence of tin and the ditch probably of tin with black stripes of niello. To many scholars' regret no poetry is preserved in the Linear B texts, but there are detailed descriptions of vessels and furniture, from which it is clear how much the owners respected details of material and technique.

The Mycenaean silver cup differs in its straight wall from the bulging contour of the fifteenth and fourteenth centuries. The Minoan influence is now almost gone. The middle of the thirteenth century, to which it belongs, was the time of the Trojan War. With this goes the decoration, of a type not known before this period: a so-called 'assembly of Archaic heads'. Twenty-one bearded heads, facing left, are inlaid in gold with details in niello. Similar heads, which must have belonged to a corresponding cup, were found at Pylos, as was mentioned above. On the piece from Mycenae some heads have fallen off. It is clear that the silversmith first cut out the outline—including the two golden branches on the lip and below the heads. The leaves of these branches are turned to the right in contrast to the heads, so that a balanced design is achieved. The men's half-length black hair falls down their necks in three strands; they have a beard but no moustache, a fashion also known from seventh-century works.

The Sceptre from Kourion on Cyprus

The sceptre of Pheidias' famous statue of Zeus at Olympia was 'decorated with every kind of metal', as Pausanias notes (V, 11, 1). Perhaps stimulated by the Homeric description of the shield we cited above, Pheidias therefore brought the Mycenaean technique back into favour. The shield of his Athena Parthenos, which showed the battle between the gods and the giants, probably was inlaid on the inside with gold, silver, niello and other metals. A golden sceptre from a grave at Kourion on Cyprus, dated to around 1100 BC, is a Late Mycenaean forerunner of Zeus' sceptre, except that it is crowned not with an eagle but with a pair of falcons, and the inlay work on it is not of 'every kind of metal' but of enamel. This technique, by which coloured glass is melted and poured into cloisons, which are here divided from each other by gold strips, occurs sporadically in the second half of the second millennium—another example is the armour of Tutankhamen. The enamel colours on the sceptre are dark blue, light violet and white. These colours are used for filling the rows of scales on the pommel and for the falcons' feathers. It is possible that the sceptre was already an heirloom before it was placed in the grave and that it was made in the thirteenth century, as Sinclair Hood suggests. At that time Cyprus was well known for metal inlay work, as is shown by the story in the *Iliad* (XI, 19 ff.) of Agamemnon's armour, which had been given to him by King Kinyras of Cyprus. It had twelve strips of gold, twenty of tin and ten of 'kyanos'. The three snakes which reared up on the neck of the armour were also of 'kyanos'. 'Kyanos' must have been dark blue in colour, as the word implies, but more than that we do not know. Hector W. Catling suggests with reference to Tutankhamen's armour that it was a dark blue enamel and that Agamemnon's was merely parade armour. However, in the eleventh book the king arms himself not for a parade but for battle. It seems more likely, therefore, that 'kyanos' should be seen here as niello, especially since this technique is also attested in Cyprus in the cup with bulls' heads.

Sub-Mycenaean and Geometric Bronze Pins

Except in Cyprus, metal artefacts are rare in the century either side of the turn of the millennium, the so-called 'Dark Ages'. This was when there was greater use of iron, a metal less suitable for use in works of art. Still, there do occur in graves,

99

143 Cup with bearded heads, from Chamber Tomb 24 at Mycenae. Silver with inlays in gold and niello. 13th century. H. 6 cm, D. 16.2 cm. National Museum, Athens.

144 Cup with boukrania, from Enkomi (Cyprus). Silver with inlays in gold and niello. 14th century. H. 6 cm, D. 15.7 cm. Cyprus Museum, Nicosia.

145 Sceptre, from Kourion (Cyprus). Gold with inlays of dark blue, light violet and white enamel on the pommel and on the pair of falcons on top. Probably 13th century. H. 16.5 cm. Cyprus Museum, Nicosia.

146 Sub-Mycenaean fibula. Bronze. 11th century. L. 9.8 cm. Antikenmuseum, University, Heidelberg.

147 A pair of Early Geometric dress-pins. Bronze. 9th century. L. 22.1 and 4.4 cm. Antikenmuseum, University, Heidelberg.

148 Upper section of the two dress-pins in Pl. 147.

149 Detail of the Boeotian catch-plate fibula in Pl. 93: Iolaos, the helper of Herakles, fighting the Hydra. Bronze, engraved. Last quarter of 8th century. University Museum, Philadelphia.

150 Detail of Boeotian catch-plate fibula, horse with birds and falling doe. Bronze, engraved. Last quarter of 8th century. D. at centre 6.9 cm. Antikenmuseum, University, Heidelberg.

151 Tripod, from Olympia. Bronze. Latter half of 9th century or soon after 776 BC, the year of the refounding of the Olympic Games. H. 65 cm. Museum, Olympia.

152 'Ridged leg tripod', from Olympia. Bronze. Third quarter of 8th century. Original h. over 2 m. Reconstruction by M. Maass (drawing). (cf. Pls. 154-5).

153 Hammered tripod. Copper reconstruction, after original fragments from Olympia, by M. Maass. H. 154.5 cm. Museum, Olympia. (Cf. Pl. 156).

154 Original leg of the tripod in Pl. 152; detail: upper part with modelled triangle which fitted on to the bowl. Bronze. Museum, Olympia.

155 Cross-section of the tripod leg in Pl. 152. Drawing.

156 Original leg of the tripod of which the copper reconstruction is shown in Pl. 153, detail. Bronze. Third quarter of 8th century. Museum, Olympia.

157-8 Fragment of 'ridged leg tripod': two panels: athletes; lions fighting; from Olympia. Bronze. Last quarter of 8th century. H. of complete fragment 46.7 cm. Museum, Olympia.

159 Fragment of a chased tripod leg, detail: representation of a griffin cauldron; from Olympia. Bronze. Early 7th century. Overall h. of fragment 78 cm. Museum, Olympia.

160 Protome cauldron with lion and griffins' heads and also two attachments, from Olympia. Bronze. Early 7th century. Reconstruction by H.-V. Herrmann (drawing).

161-2 Back and front view of a Greek copy of an Oriental cauldron attachment, from the Athenian Acropolis. Bronze. Early 7th century. Original h., including the broken-off bird's tail, c. 15 cm. National Museum, Athens.

163 Back view of a Greek imitation of an Oriental cauldron attachment. Bronze. Early 7th century. The bird's tail is broken off here too. H. approx. as the example in Pls. 161-2. Museum, Delphi.

164 Six griffin protomes from the same cauldron, mounted on the upper part of a bowl (added on in modern times). From a Samian workshop, exported in antiquity to Etruria. Bronze. Second quarter of 7th century. H. 19.5 cm-20 cm. Private collection, formerly in the Count Franz zu Erbach Collection.

165 One of the six Samian griffin protomes from Pl. 164. Bronze. Second quarter of 7th century.

166 Griffin cauldron on a rod tripod, from Salamis (Cyprus). Cauldron, attachments and protomes of bronze, rod tripod of iron. Probably later 7th century, in any case a special shape. H. with stand 1.25 m. Cyprus Museum, Nicosia.

167 Detail of upper part of the tondo in Pl. 168: frontal view of naked goddess of Oriental type, holding two lions by the ear. Bronze. C. 700 BC.

168 Tondo from the Idaean Cave. The lion's head in the centre is a cast from another tondo from the same cave (original not preserved). Bronze. C. 700 BC. D. 56 cm. Museum, Iraklion. (Cf. Pl. 167).

169 Cut-out sheet of the Kato Syme type (from Crete): youth with slain wild goat and bearded hunter. Bronze. Soon after 650 BC. H. 18 cm. Louvre, Paris.

170 Cut-out sheet: griffin with its young. Bronze. Drawing by R. Hampe. The square background suggests a base, probably of wood, on which the work was fastened. Perhaps a metope fitting or a door panel. Last third of 7th century. H. and W. 79.5 cm. Museum, Olympia.

171 Detail of Pl. 115: Kaineus and centaurs. Bronze. Mid-7th century. Museum, Olympia.

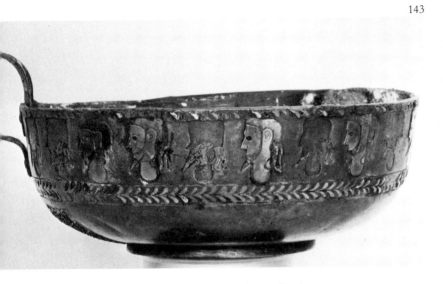

143

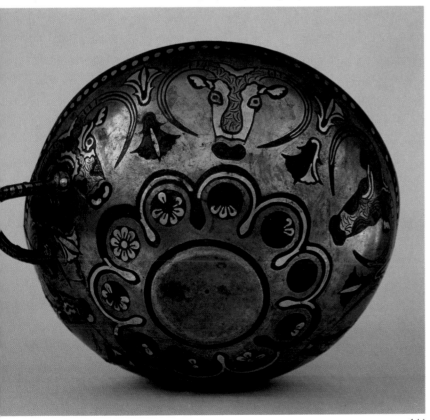

144

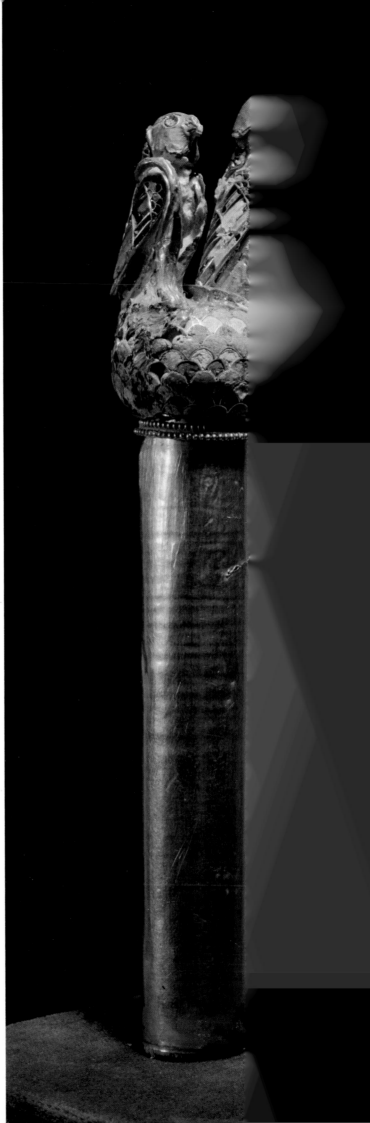

145

146

147

149

148

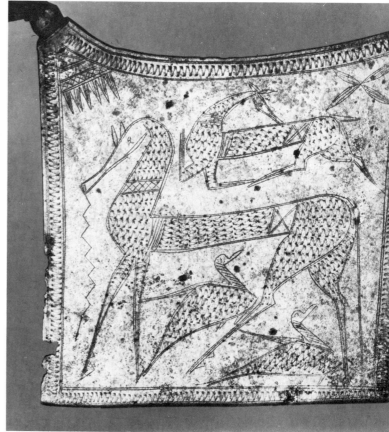

150

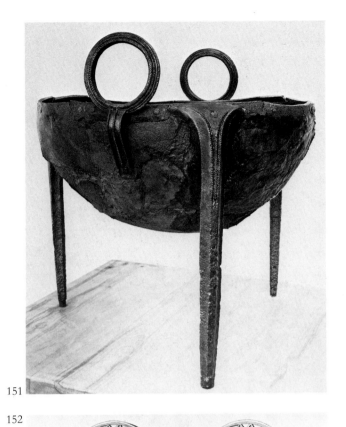

151

152

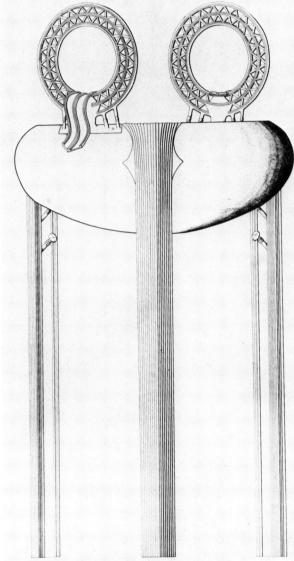

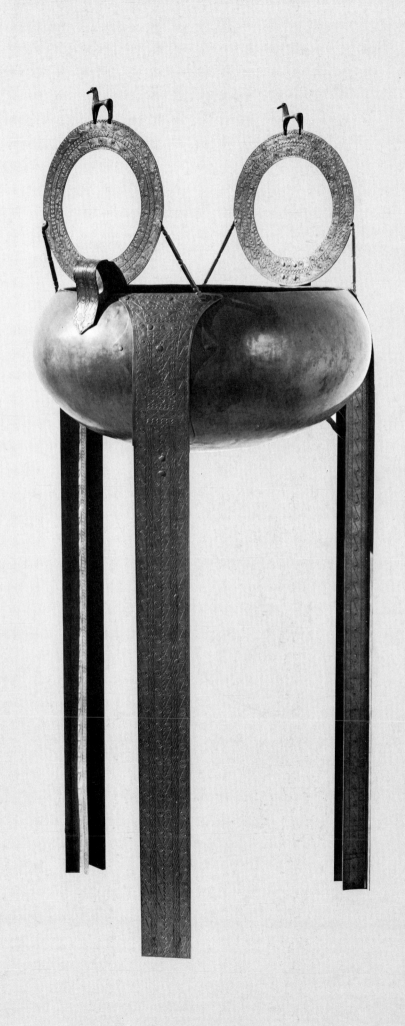

153 ▷

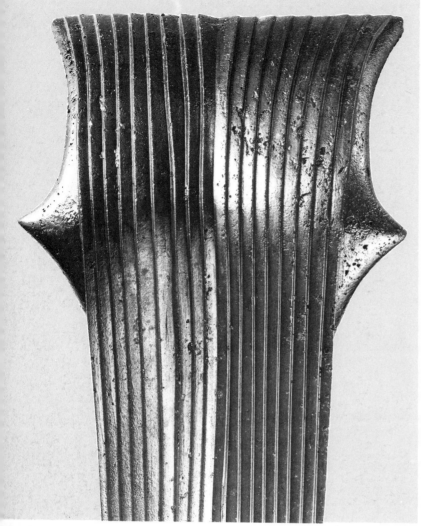

154

155

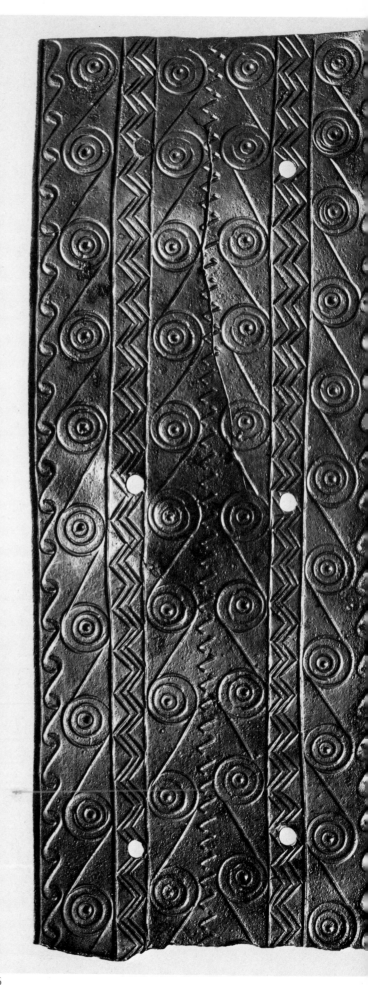

156

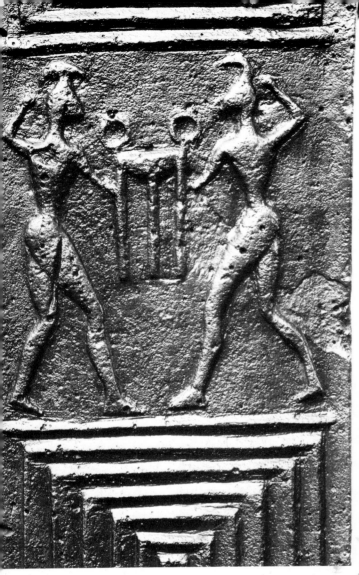

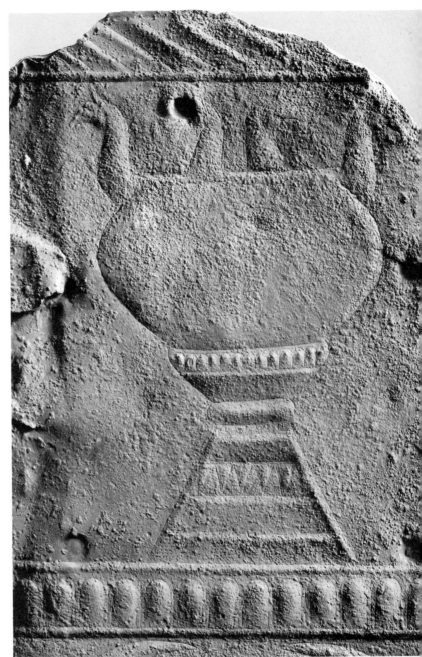

158 ▽

159

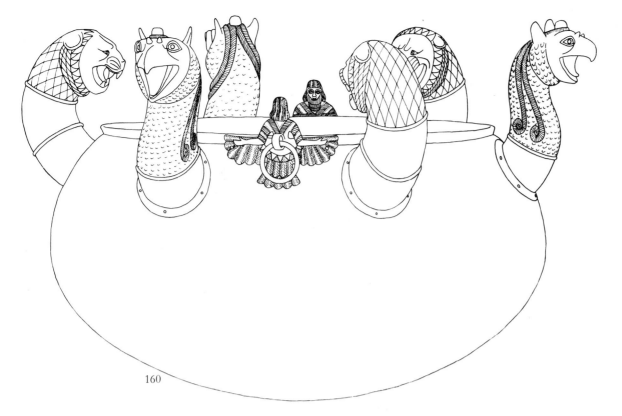

160

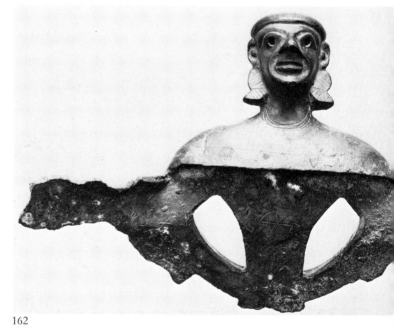

161 162

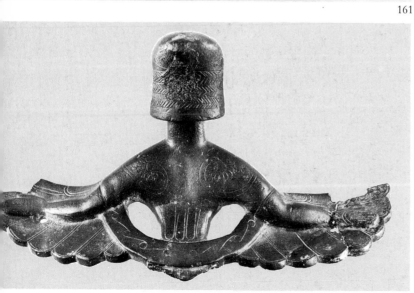

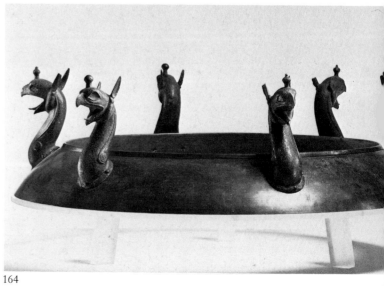

163 164

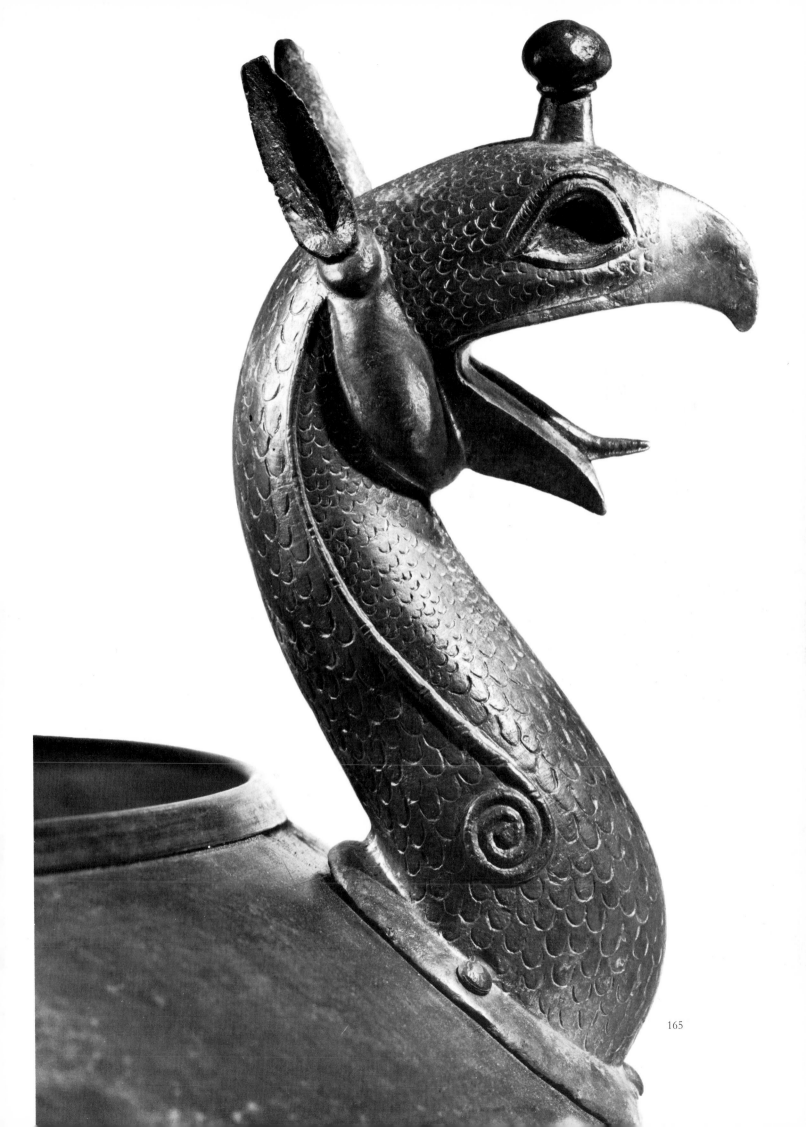

165

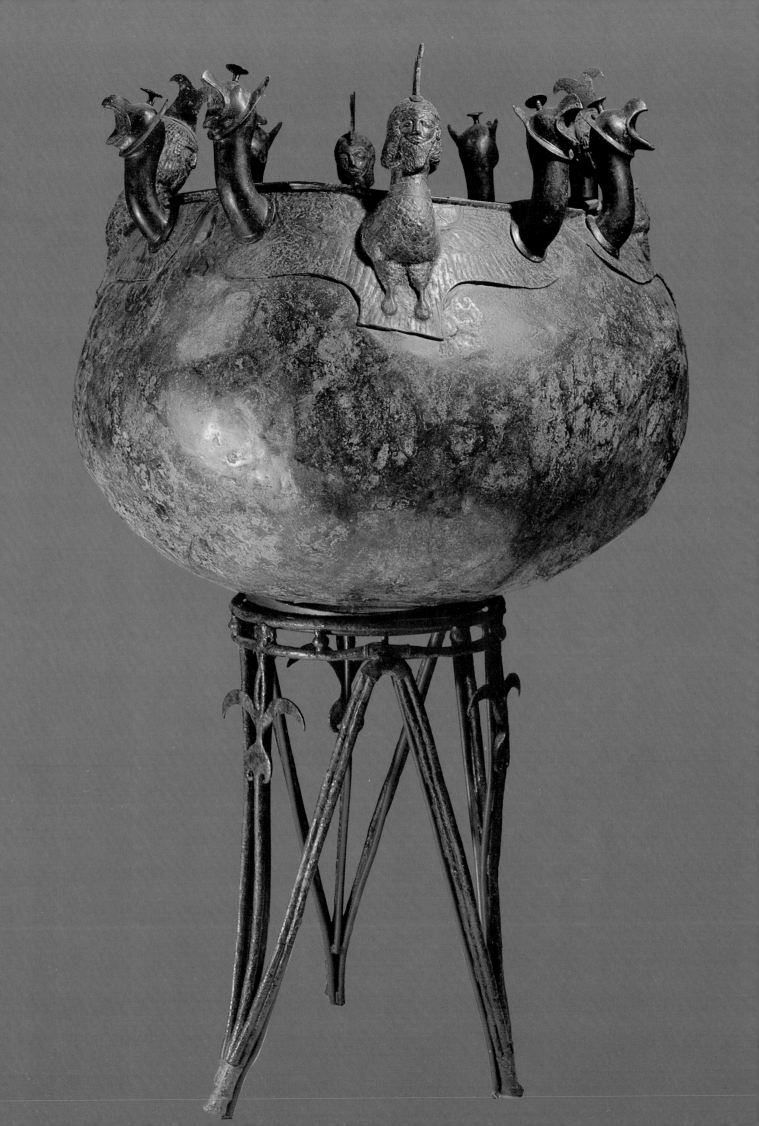

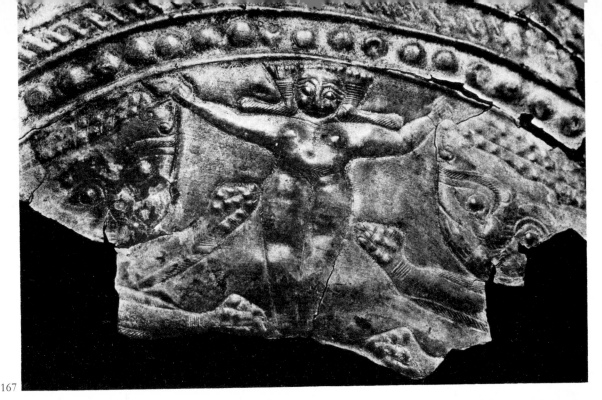

167

168

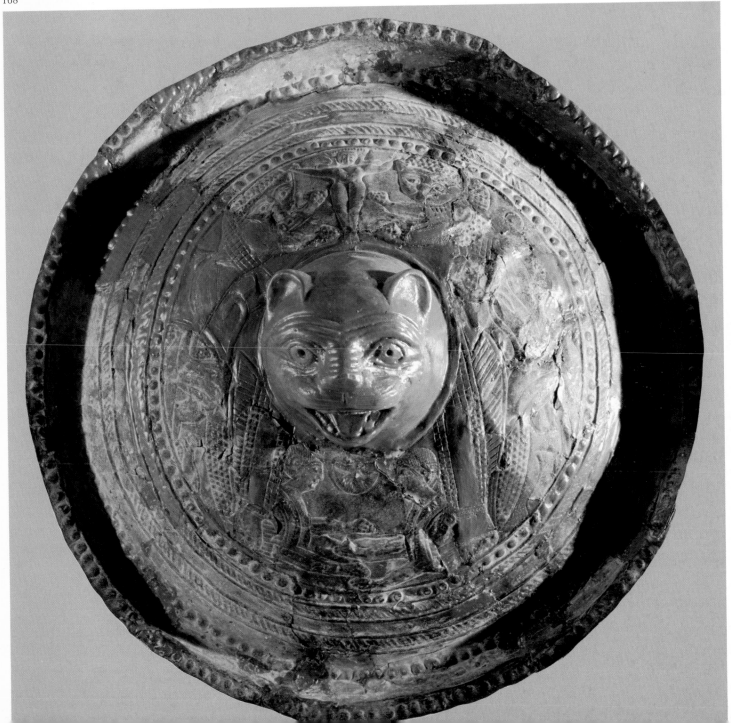

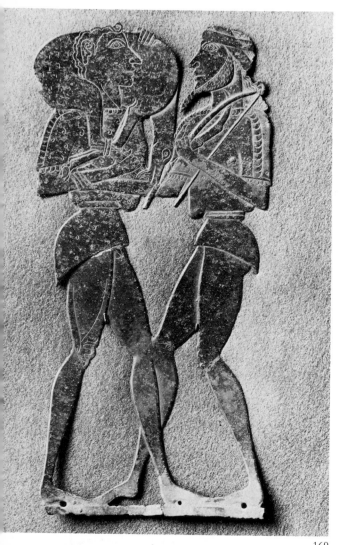

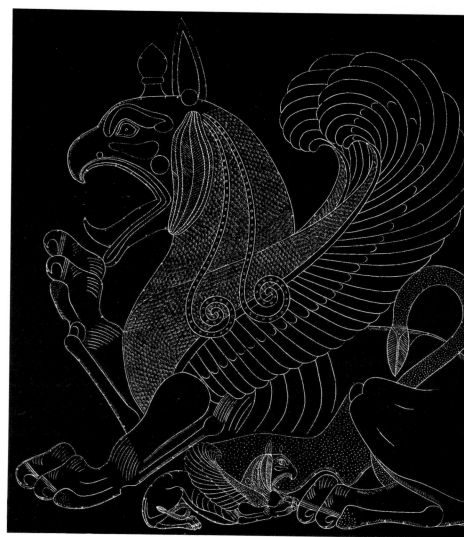

169 170

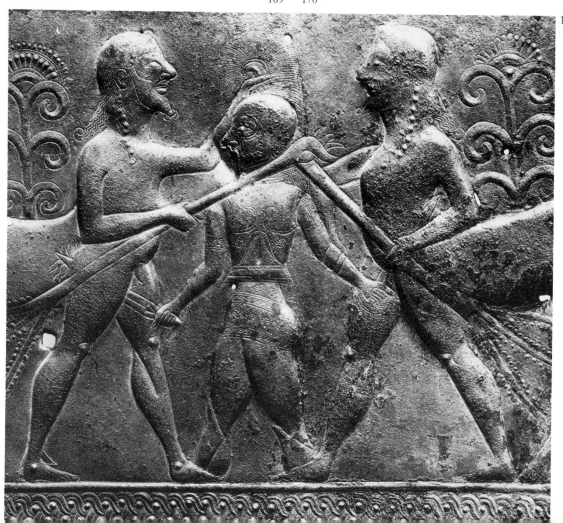

171

although rarely, bronze weapons and dress pins; the latter are mostly, though not exclusively, found in women's graves. At the transition from Late Mycenaean to Sub-Mycenaean, towards 1100 BC, two types of pin appear; during the 'Dark Ages' these develop and, along with pottery, provide important evidence of the continuity between the two millennia. The first type is a fibula in the form of a safety-pin. It is made from a single piece of bronze, which increased its durability and elasticity. The long bow and the catch for the pin are hammered flat; by contrast the spring and the pin are round and the piece between the catch and the bow is rectangular in section. It is a purely functional form, which however gave rise to the richly decorated fibulae of the Geometric period.

146

The second type, which first appears around 1100 BC, has an even longer history. This is the long drapery pin known from representations in Archaic and Classical art. It is used to hold the thick seamless woollen garment, the peplos, together at the shoulders. The Greeks considered the peplos to be a typically Dorian garment, so it is no surprise that these pins, which are found in women's graves close to the shoulder, first appear at the time of the Dorian invasion. This is why the Argolid, which was settled by the Dorians at this period, is richer in these pins than other parts of Greece. This type of pin thickens in the upper section until it is spherical in shape and at the top has a disc of the same diameter. As with the safety-pin, this form was also at first purely functional, but from the tenth century onwards a harmonious relation develops between the ball, the disc and the intermediate section. The pair of pins shown here from the ninth century BC are in the University Museum, Heidelberg: they represent the climax of this trend. The simple ball has become a biconical pearl, enclosed above and below by a fine ring. The disc terminates in a complicated knob; the section between is angular on the shorter pin and more rounded on the other. Below the pearl both pins have an angular section approximately as long as the upper section, before they merge into the rounded pin itself. These narrow surfaces are decorated with finely engraved zigzag lines. The varying lengths and the difference between the pin-heads, which do not, however, cast any doubt on the association of these two pieces, stem from the fact that the pin served a different function on either shoulder, for on one side the peplos was led round the body, while on the other the two seams met.

147-8

Late Geometric and Boeotian Fibulae

An important development in the form of the safety-pin, too, took place in the ninth century. The catch for the pin was now made into a wide plate which could carry an engraved design. These catch-plate fibulae were first used in Attica, where they were always small; in the eighth century they spread to nearby Boeotia and were greatly enlarged. The simple functional form developed into a display piece (*agalma*), which women wore only on special occasions; some of them were dedicated in a sanctuary. The fibula plates were usually decorated on both sides with peaceful or wild animals, ships, land or sea battles, and above all with the earliest representations of mythological subjects, which now established themselves firmly in Greek art (p. 82). The style of the individual engravings is so distinct that they can be attributed not only to particular workshops but even to individual masters. This is also true of the catch-plate fibula shown here, also in the University Museum, Heidelberg. Its engraver particularly loved representations of horses, of which we have several specimens with slight variations. The horse is always shown moving to the left and with its rear legs spread wider than the front ones. Two bands typical of Geometric art separate the back from the shoulders and from the hindquarters. A third band, which runs around the neck, could be the harness, especially since a halter hangs down from the bottle-shaped head. However, the same band occurs on the deer which is also to be seen in this picture above the horse's back, in a state of collapse. Two large water-birds between the rear legs and under the belly of the horse complete this remarkable collection of animals drawn from pasture, forest and marsh. On other catch-plates by the same engraver a lion attacks a fawn. This beast of prey, which pulls the fawn down, is something left to our imagination. Birds, horse and fawn are decorated over the whole of their bodies with zigzag lines, only the heads remaining free—even the birds' long necks are hatched. Most of the contours are given a pair of fine lines and only on the birds' heads and the horse's ears and hooves are these second lines lacking. The horse's long tail is also done with a double line, as is the zigzag pattern which frames the scene. Sureness and elegance of line make this engraver one of the greatest of Boeotian fibulae masters.

150

The fibula in Philadelphia with the battle between Herakles and the Hydra on one side and his adventure with the hind on the other was for a long time lost. The drawing was made when the fibula was still in a private collection. Recently it appeared in the University Museum, Philadelphia. The detailed photograph, reproduced here for the first time, of Iolaos from the Hydra scene shows how much more carefully the Boeotian engraver worked than the drawing indicated. Even on the rim there are zigzag lines, just as regular as those on the hero's body. Execution and composition prove that the craftsmen who made these metal ornaments in the late eighth century BC are to be reckoned among the leading artists of their time.

93-4
149

Geometric Tripods

In the eighteenth book of the *Iliad* Thetis goes to Hephaistos to ask for new arms for her son Achilles. She finds the divine smith engaged upon the manufacture of tripods (373 ff.). No other occupation was more suitable for Hephaistos in the eighth-century poet's imagination—for the age of Homer was the high point of the bronze tripod. The twenty examples that the god produces all at once are for the 'assembly of the gods'; one could hardly imagine the Olympians without these utensils, which filled the sanctuaries of the day in great numbers. Such tripods were in no way restricted to particular divinities like Apollo. In the eighth century the Panhellenic sanctuary of Olympia above all was full of tripods, as excavations have shown. They ranged in size from miniature ones up to monumental votive offerings larger than a man.

The tripod is a utensil that was revered from the Bronze Age onwards. One ought really to call it a tripod cauldron, since the most important part is the cauldron which is bonded

111

Fig. 27 A small clay tablet inscribed with Linear B signs, from Pylos (drawing). The text concerns two vase shapes, the tripod and the depas; for these cf. Pls. 207-8. National Museum, Athens.

on to the three legs. But already in the second millennium the Greeks called a cauldron with three legs and two carrying rings simply a tripod (τρίπους). We know this from the sensational find published in 1952 of a Linear B tablet at Pylos, which provided verification of the decipherment of the Mycenaean script. In addition the utensil known in the syllabic script as ti-ri-po is clearly reproduced in an ideogram which represents a tripod. The three feet are attached fairly far down the bowl, a feature which Proto-Geometric tenth-century clay and bronze examples share with thirteenth-century ones. The shape is functional: the tripod was a cooking vessel whose three legs stood over a fire. The development of this cooking pot into an *agalma*, a votive offering which would please the gods, took place during the ninth century. It is to the second half of this century that one of the few well-preserved tripods from Olympia is today generally attributed. Adolf Furtwängler, who first classified and dated the bronze finds at Olympia at the end of the last century, believed that none of the tripods found there were older than 776 BC, the traditional date of the foundation of the Olympic Games. In fact there is still no irrefutable evidence to contradict Furtwängler's thesis. At any rate one can say that this tripod is one of the earliest at Olympia; its form is already no longer purely functional but is on the way to becoming artistic. The three massive cast legs, which are divided by ribs and decorated with notches, reach to the rim of the basin. On the rim two cast ring handles are attached, which carry the same notch pattern as the legs. The hammered hemispherical basin is about half as high as the legs.

These proportions alter as time goes on. The legs become very much longer and more richly decorated; the handles become larger and approach a purely decorative form. Two tripods of this type from the third quarter of the eighth century are presented here in a new reconstruction by Michael Maass, one in a drawing, the other in a metal copy exhibited in the Olympia Museum. The original fragments were faithfully copied in each case. The first is a 'ridged leg tripod', whose cast legs have a central ridge from which the vertically fluted surface falls away on both sides like a roof. The top of the leg enfolds the rim of the bowl which curves inwards and bears a pair of triangles which are moulded to fit the curvature. The artist took into account the play of reflected light on the fluted legs, which seems to make the heavy utensil float in the air. The cast handles, trellised with zigzag patterns, which Maass assigns to this type of tripod, also contribute to the impression of lightness. On top of the handles there were often small bronze horses or men with horses; none of these are illustrated here.

The tripod reconstructed in metal belongs to the type with hammered legs. As the original fragment shows, these are richly decorated with different stamps, arranged into wave

patterns, tangentially linked circles and zigzags, all running vertically. The holes come from the rivets which held the bronze struts that served to strengthen the inside of the leg. The high circular handles, supported at the sides by thin props, bear the same stamped decoration. As Maass puts it, these handles were 'long straight strips of metal which were hammered until the ends overlapped and they formed a closed circle'. It is this phase of the work that Homer associates with Hephaistos in the verses of the *Iliad* we mentioned above. The tripods are complete except for their handles—Homer speaks, like the Linear B texts, of 'ears'—and it is with these the god is busy (XVIII, 378 ff.): 'Thus far were they finished, but the elaborately fashioned ears were not yet in place. These he was preparing, forging their rivets.'

The tripod with hammered handles and legs reached its climax around 750 BC. It is precisely to this period, towards the middle of the eighth century, that the *Iliad* is generally attributed. The poet describes the 'modern' tripod of his own time, the fashioning of which he knows from his own observation. Even the wheels, which Hephaistos fixed under the legs so that the tripod could run 'automatically', are not pure poetic fantasy. Wheels have been found on Geometric tripods on Ithaca. The custom of rolling metal stands, however, is older, for wheels are already found on bronze stands from Cyprus of the late second millennium.

The fragment of a 'ridged leg tripod' from the last quarter of the eighth century is added here because it is decorated with figures. The upper zone of the leg shows, close to the bowl, two men with one hand raised who seem to be starting to box with one another. With the other hand each grasps a tripod of our type, the prize for which this contest is fought. Each takes hold of it, sure of victory. The helmets on their heads do not belong to this battle, but are characteristic of Geometric representations of men. In the field below, two lions standing on their hind legs, their jaws open, attack each other. The ancient viewer, familiar with Homeric epics, understood the two lions as metaphors for the courage (*thymos*) with which the two men box for the tripod.

Seventh-Century Protome Cauldrons

Figured scenes appear not only on cast tripod legs, but also on embossed ones in their late phase. Indeed the greatest rival of the tripod cauldron, the cauldron with griffin protomes, appears as a decorative motif on a hammered leg. In the course of the seventh century it supersedes the tripod as the most splendid votive gift. The small relief picture shows only the most important elements: the conical stand with a knob and the griffins' heads, turned outwards, which tower over the basin's rim. As original finds show, some or all of these heads could also be turned inwards. Furthermore, the griffins could be replaced by lions, or there might even be a mixture of both. It is better, therefore, to speak of protome cauldrons than of griffin ones when referring to this category. As Herodotos tells us, the Greeks called them 'cauldrons of the Argive type' (IV, 152). It is possible that they were first displayed in the Heraion at Argos or at least were present in large numbers there. Nevertheless, very many pieces of protome cauldrons have

also been found on Samos, at Delphi, on the Acropolis of Athens and above all at Olympia.

In the early seventh century six protomes were normally combined with two attachments in the form of winged creatures, which carried ring handles in a loop at the back. Most of these attachments are Oriental in style; however, an attachment from the Athenian Acropolis dating from soon after 700 BC, has sharp clear forms that marks it as a Greek copy of an Oriental model. Other Greek bronze-founders, however, sought to imitate the softness and roundness of the Oriental style. The attachments no longer served any practical function, since the loops at the back are not bored and so could take no carrying ring. Finally they were completely omitted while the griffins remained—and indeed became larger for some time after the middle of the seventh century.

The Oriental origin of many of the attachments and the conical stands themselves has led some scholars to the idea that the griffin protomes may also have come from the Orient. In the light of the material from Olympia, however, Hans-Volkmar Herrmann concluded that even the earliest griffins found there are Greek work and that there is a continuous development from them down to the most recent specimens. The same was observed by Ulf Jantzen on Samos, where mis-cast examples of the oldest type of griffin's head were found. Workshops must, therefore, have existed on the island. To judge from the stylistic parallels, the six griffin protomes in a private collection, which belonged to a single cauldron, were also cast on Samos. They were acquired in the early nineteenth century by Count Franz zu Erbach in Rome; we are thus dealing with the first griffin cauldron to become known in modern times. The six heads were probably found in the tomb of an Etruscan prince, since the Etruscans gave protome cauldrons as special grave offerings. Each head was cast separately from a lost mould; they date from the second quarter of the seventh century. From the same Samian workshop come similar examples preserved in various collections. It seems that this type of griffin's head, because of its well-balanced proportions, was particularly popular. The spiral tendril which falls down from the ear emphasizes the curvature of the neck; the padded throat sack and the pointed ears which rise exactly above it balance and emphasize each other; the eyes, which were once inlaid with some brilliant material, and the forehead knob add to the effect of the whole. For the viewer of that time the forehead knob probably had a rather vegetable-like appearance similar to the spiral tendril. In the seventh century buds, blooms or fruit, too, often grow from the heads of sphinxes and other demonic creatures. The gaping beak and the alert, pointed ears suggest that the griffin was considered as a threatening watchman. The great bronze cauldrons guard the property of the gods, just as the griffin watches over the property of the princely dead in Etruscan graves.

That the griffin cauldron was Greek from the first is also clear from the fact that in the Orient no similar protome cauldrons have been found, but only attachments. Furthermore, in the Orient cauldrons were usually put on rod tripods, so that a very different outline was produced. Nevertheless, the conical stands are of Oriental origin, as was noted above, though they served another function there, for they seem to have been used as stands for incense-burners (*thymiateria*). The observation that the Greeks combined native and foreign elements in the same artefact is no longer without support, for

at Olympia embossed bronze representations of goddesses were put together from Greek and Oriental sheets (see p. 255).

In the year 1966 a griffin cauldron on an iron rod tripod was found at Salamis on Cyprus. It has eight protomes instead of the customary six, which sit partly on the wings of the attachments. Both features are unusual and the griffins' heads are particularly schematic. They cannot belong in the late eighth century BC, as the excavator Vassos Karageorghis suggests. The dating of the rich grave from which the cauldron comes rests on the pottery; on Cyprus this scarcely changed over a long period. The griffin type of cauldron from Salamis, however, is unthinkable before the end of the seventh century. The Cypriot find, therefore, provides no evidence where the type of protome cauldron originated around 700 BC.

Seventh-Century Bronze Sheets

In the last century many bronze dedications were found in the cult cave of Zeus on Mount Ida on Crete. Especially noteworthy are embossed and engraved tondi with plastic animal heads in the centre. They are taken for shield fittings. They are very small—the specimen illustrated here has a diameter of 56 cm—but shields of that size were used in the Orient. The lion's head in the centre is a restoration based on another votive disc from the same cave. The decoration in the outer part consists of concentric circles, knobs and simple guilloche. In the lower part of the inner circle lie two sphinxes, heraldically opposed, and between them hangs a bloom. In the upper part are two lions, which turn their broad heads frontally. A naked goddess stands between them and grasps them by the ears as a sign of their submission. The fulsome body visible in this frontal pose differs from the Greek ideal of beauty, which we know from Attic ivory figures and the stone relief from Gortyn. Furthermore, the sphinxes and lions, like the goddess's hair-style, do not look Greek. We are dealing either with tondi imported from the East or with works produced on Crete around 700 BC by immigrant Orientals.

Purely Cretan, however, is the seventh-century type of cut-out bronze sheets recently found in a sanctuary near Kato Syme in south-central Crete. Some single sheets of the same style, discovered earlier, like the one in the Louvre, may come from the same sanctuary, where cult was carried on continuously for over two thousand years, from the Middle Minoan period to the third century AD. The favourite theme of these Archaic sheets is that of wild goats (*agrimia*), killed by archers, being carried to sacrifice in the sanctuary. There, on a pebble floor, excavators discovered a hearth altar with a thick ash layer, in which were found horns of wild goats. Our group shows a man with a twisted beard holding a bow and a youth who has shouldered a freshly killed wild goat. His profile, with the long jutting nose and powerful lips, stands out strongly against the animal's dotted skin. His left hand holds its back and his right grips its legs, which are bound together in front of his chest, while the man on the right touches the youth's arm. Their eyes, which are at the same height, meet. One ought probably to think here of the Dorian–Cretan custom,

mentioned by various ancient authors, in which grown men pretended to steal youths from their homes in order that they might spend two months with them in the country. During this period they practised martial activities and the armed dance and above all learned to hunt. Their tall slim figures and long legs are emphasized by their short garments, while the springy step and slim waists are typical of seventh-century Cretan men. The group may have been made shortly after 650 BC. The heritage of the Minoan style is still felt.

Whereas this work shows a scene from contemporary life, a bronze sheet of the same period found at Olympia has a scene taken from legend. What object it once decorated cannot be determined, but to conclude from the holes it was fixed to a wooden backing. The two centaurs, who ram the invulnerable Kaineus into the ground, are represented as purely human in their foreparts. Their stocky proportions are very far from those of the Cretan group. We are dealing with the work of a typically Ionian master, though we cannot say precisely where his workshop lay. He loved the alternation of smooth reflecting surfaces and matt ones. For this reason he decorated the centaurs' bodies with fine dots, which would indicate hair, in order to leave between them the smooth surface of Kaineus' weapons. Figures and plants are partly embossed, partly engraved on the surface, whereby the impression of depth is achieved in spite of the flat relief. This impression is strengthened by the blooms and trees which grow behind the centaurs. Originally the artist probably intended to give Kaineus a shield on his left arm—he even drew the buckle there—but left it out in order to avoid too many overlaps, which would have made the picture unclear. Furthermore, he wanted to show the hero as *amphidexios*, in other words with two right hands: Kaineus holds in either hand a sword, with which he savagely wounds both centaurs.

From the same excavation campaign that produced the Kaineus relief came the monumental griffin reproduced here in a drawing by Roland Hampe. It consists of a cut-out bronze sheet with fine plastic relief work and precise engraving. Since the work, about 80 cm high, fits into a roughly square space, it may once have served as a metope attachment or as a door panel in an early wooden building at Olympia. Seventh-century Greeks imagined griffins both with a bird's body and with that of a lion. Here the artist opted for the second alternative because he wanted to show the monster suckling its young at the breast. Its body is just like its mother's with wings, forehead knob and pointed ears, but its beak is not open and its paw not raised; these two threatening gestures are reserved for the parents. Since the suckling beast of prey was particularly dangerous according to the ancient belief, as in reality, the maternal scene amplifies the griffin's threatening power. How was the young with its beak supposed to suckle at its mother's breast? This did not trouble the artist, who may have been active during the last third of the seventh century. Nevertheless, the griffin's head follows older models, though the stylization of the wings is typical of the 'Early Corinthian' phase. Corinth has also been proposed as the place where this sheet was produced.

Weapons

Mycenaean Swords and Daggers

The dead in the shaft graves were given a great many swords, nearly fifty. We do not know why. They do not seem to be weapons captured from the enemy, for they all belong to the same two types. The long type was used only for stabbing, whereas the rather shorter and broader type served as a slashing weapon. Perhaps such a large number of swords was placed in the grave because they were inalienable personal possessions.

172 On the island of Skopelos an extraordinarily long sword was found of which only the plated gold handle is preserved. It is finely decorated with spirals and loop patterns together with chains of double spirals, embossed in the gold. Of similar size must have been the sword which the Athenians under Kimon found in 475 BC together with a skeleton on the neighbouring island of Skyros—Skopelos is the ancient Peparethos—and from then on worshipped in the Theseion in the Agora as a relic of Theseus. The gold handle from Skopelos can be dated from its associated pottery in the fifteenth century BC.

Daggers decorated with different inlaid metals are among the most famous works of Mycenaean art. The technique is the same as that used for Mycenaean metal vases, the one which Homer describes for the shield of Achilles (*Iliad*, XVIII, 478 ff.). These daggers occur from the sixteenth century to the thirteenth at various Achaean centres, though the best pieces 173-6 come from the shaft graves at Mycenae. Only a few can be mentioned here. First is the bronze dagger-blade from Shaft 173 Grave V; the central gold panel is inlaid, and in this is engraved a pattern of spirals whose centres are filled with rosettes and emphasized with niello. The spirals, three across the width of the blade, become smaller towards the point. The division of labour in Mycenaean workshops has already been mentioned (see p. 86) and the goldsmith who made the inlays must have been a different craftsman from the bronzesmith who cut the spirals so carelessly.

174 Another dagger-blade from Shaft Grave V has on both sides leopards chasing wild ducks in an Egyptian-like landscape. The better preserved side is illustrated here. A leopard has pounced on and caught a duck in flight. Another duck, underneath it, tries to escape in the opposite direction over a winding stream, in which various fish can be seen swimming. Its desperate flutterings are, however, in vain; the leopard's hind paws have wounded it on the neck and red blood flows into the water. The theme is repeated with differences down towards the point of the blade—another leopard at the 'flying gallop' fails to catch its prey. The inlay is of gold and of various mixtures of gold and silver, which bring out the respective colours. The leopard's skin has a pattern of long strokes on the body and curved ones on the tail, emphasized by niello. The background was filled with black niello, except for the bends of the stream, which were originally a shiny silver colour. The leaves, stems, buds and seeds of the papyrus shine with gold. The scene is set in open country, though one assumes that man is not far away. Leopards were the hunting companions of the pharaohs and may also have been princely gifts for Achaean kings. We are probably dealing here with a leopard which had been trained to hunt, for it has caught two ducks at the same time.

175-6 The dagger from Shaft Grave IV is especially large and bears a different scene on either side; both, however, have a common theme, the lion. On one side men are involved, and on the other a lion hunts gazelle. It has caught one and is tearing at its neck with its teeth. Four more gazelle flee at the 'flying gallop', 176 becoming smaller towards the point. The second gazelle away from the lion is represented with the back of its head turned to the viewer—a particularly lively observation from nature. Under the animals is a ground-line done with a pattern of dots which is picked out with niello; so too are the shaggy fur and the spots on the shiny golden skin of the animals and other interior markings.

The other side, with its more colourful inlays, shows men 175 engaged in a lion hunt. They protect themselves with large shields, some of which are rectangular with a curved top, whereas others are in figure-of-eight shape. In the case of two hunters one can see the inside of their shields together with the straps by which they hang from the shoulder (they were not carried on the arm as were later shields). The foremost hunter has wounded the lion with his spear; a piece of the shaft is visible close to the shield, and its point comes out of the lion's flank below the tail. But the impetus of the leaping animal has knocked the hunter off balance and he is falling forward, his bent knee visible in front of the shield. The next hunter with the big figure-of-eight shield is thrusting his spear so that it enters the lion's forehead. His companion is about to do the same. Between him and the last remaining hunter, who is especially tall because of the width of the blade at that point, is a crouching archer aiming his bow at the lion. Towards the point two smaller lions are running away. As on the other side all the figures are shown moving independently. The inlays consist of various mixtures of gold and silver. On the figure-of-eight shield, seen from the side, niello is used to represent spots on the cow-hide.

Two daggers with inlay work were found among the offerings in a chamber tomb at Pylos, which may have belonged to a woman. The shorter dagger, on which by rare luck the gold-covered hilt is still preserved, is illustrated here. 177 Its theme is comparable to that with the leopards on the dagger-blade from Shaft Grave V. Leopards can also be seen here, but there are no wild ducks or Egyptianizing plants. Instead, rocks and shrubs fill the space between animals, which move even more supply than before. This suggests a rather later stylistic moment, probably soon after 1500 BC. It seems that the leopards are not in the wild but on some princely estate. The one represented next to the handle devours its prize, while the other in the middle sneaks up to get some of it too, and the third runs at a 'flying gallop' towards the point of the dagger. The animals are not in pure profile but are seen slightly from above; the head and neck of the right-hand one are seen completely from above. So it is that parts of the landscape are visible over the animals' backs. These should not be mistaken for clouds, but rather form part of the landscape, which in Minoan–Mycenaean art was shown enclosing the figures. Painters and metal-chasers follow this custom even when they are not representing the figures in 'bird's-eye' view.

A dagger-blade in the National Museum in Copenhagen 178 exemplifies a third style of decoration in which there are no landscapes, but only single items—here simple axes. We are not dealing with a later stage of development, since in Shaft Grave V there was a dagger decorated with single lily blooms. The place where the blade with the axes was discovered is important: it was found on the island of Thera long before the

excavations of Spyridon Marinatos. As with the miniature fresco with the Mycenaean warriors that was likewise discovered there, this dagger shows that the Greek mainland was in contact with the Cyclades.

Mycenaean Armour

It used to be thought that references to bronze armour in the Homeric epics, as in the adjectives 'bronze-clad' and 'well-greaved', had no basis in the Mycenaean world. They were usually dismissed as poetic inventions. Archaeological excavation has brought about a basic change in this respect. A complete set of armour, put together from single hammered 179 sections, was found in Chamber Tomb 12 at Dendra in the Argolid, a tomb which dates from the late fifteenth century. It consists of breast- and back-plates with a high neck-guard, shoulder-pieces and three wide bronze bands, front and back, to protect the trunk. As a result of this find other fragments from different places have been identified as parts of such armour. The panoply from Dendra is obviously not a first attempt, but belongs to an established tradition. How long this type of armour was in use cannot be said for sure. In any case the 'brazen chitons' which Homer attributes to the Achaeans should no longer be explained away. This armour is not that of the eighth century, which Homer could have seen, transferred back into the Mycenaean period, since Geometric armour reached only to the waist and not down to the thighs, chiton-like, as Mycenaean armour did.

179 The remains of a boar's-tusk helmet were also found in the same grave as the armour. There is a reconstruction of it in the museum at Nauplion. In the *Iliad* (X, 261 ff.) Homer describes such a piece as an ancient heirloom which had been passed down through many generations before Odysseus wore it. Boar's-tusk helmets were lined with leather and felt. Such components, however, dit not last for centuries and Homer's precise description of the rows of boars' tusks might, therefore, go back to an epic version from the Late Mycenaean period. From Linear B texts we know that at the time works of art were described in great detail.

The Homeric adjective 'well-greaved' is substantiated by a pair of bronze leg-greaves found at Kallithea (Achaea) and 181 now in the museum at Patras. They can be dated by associated finds to the early twelfth century BC. The bold pattern of two crossing bands, unknown in the repertoire of Mycenaean ornaments, may have been inspired by the ties of the felt leggings which then, as later, were worn for hunting and war. These greaves also have typological counterparts in Central Europe. Further fragments of bronze greaves were uncovered at Enkomi on Cyprus. They probably belonged to thirteenth-century Achaean emigrants. These examples all have rounded ends at the top of the knee, while a seventh-century greave from Olympia is more pointed.

Two types of shield were used in the shaft-grave period, i.e. 175 the sixteenth century. They appear for instance on a gold ring and—used together—on the dagger with the lion hunt. One type is the rectangular bowed shield with a curved upper edge; the other is a similarly bowed figure-of-eight shield which reached from the shoulders to the ankles. The second one was made of cow-hide with the patterned skin on the outside. An ivory relief from the Artemision on Delos shows a warrior 333 who carries a figure-of-eight shield and wears a boar's-tusk helmet. This form of shield was also used in Mycenaean art as a decorative motif, in miniature form on gold, ivory and pottery 130, 209 as well as on a large scale in monumental wall-paintings. Here 38 and on the inlaid dagger-blades it is clear that the surface of the 175 shield was of spotted cow-hide. Such shields were produced in Nubia until not long ago, as Heide Borchhardt has shown from specimens in the Leather Museum at Offenbach. The figure-of-eight shield survived into the first millennium as the 'Boeotian' shield. In Greek art it was regularly associated with 236 heavily armed heroes such as Ajax or Achilles, but in actual battle it was replaced by the round shield. Yet, figure-of-eight shields were regularly carried in religious contexts, for instance at the hoplitodromos races held to celebrate the battle of Plataea (479 BC). The shields which fell from heaven and were worshipped in the Regia in the Roman Forum, were likewise of this form.

From the neighbourhood of Knossos comes a bronze helmet 180 with a knob at the top and a cheek-piece with a double curve on the front edge: it dates from the second half of the fifteenth century. It was certainly made under Mycenaean influence. In surviving representations of helmets in Mycenaean art straight cheek-pieces alternate with curved ones. A bronze helmet fitting from a grave at Tiryns with Sub-Mycenaean 182 pottery in it (c. 1100 BC) still shows this Aegean form of cheek-piece.

Eighth- and Seventh-Century Armour

We have no other examples of metal armour from around the turn of the millennium. A grave at Argos of the second half of 183, 413 the eighth century, however, yields a well-preserved panoply. In contrast to the complicated Mycenaean armour the Geometric form consists of two shells: a breast-plate and a back- 414 plate with a short neck-guard. It tapers at the waist and then swings out again below. Breast and back muscles are clearly indicated in a severely stylized form. This representation of the forms of the body marks an important step for Greek art which is significant for the development of large-scale sculpture. The helmet that was found in the same grave has a high 'dome'. The 183 cheek-pieces are separately hammered and riveted on. 'Conical' 184 helmets of this type have also been uncovered at Olympia. In 380-4 the eighth and early seventh centuries they are frequently 397-9 depicted on statuettes and vase-paintings. During the seventh century they were replaced by various forms of helmets, of which the Corinthian one is an innovation, while the so-called Illyrian helmet can probably be seen as a modification of the Geometric 'conical' helmet. The angular cut-out for the face was retained, though the cheek-pieces are no longer riveted on, the whole object being made in one piece. This reveals the dominant influence of the Corinthian helmet, which remained the most important type of Greek helmet down to the fifth century BC.

Since armour used to be dedicated to Zeus at Olympia, there is a veritable armoury in the museum there. So it is not 185-6 surprising that the earliest Corinthian helmet of which we know was found at Olympia. It is still nearly 'Geometric', in other words its contour at the back of the neck does not follow

172 Handle and pommel of a ceremonial sword, from a shaft grave on the island of Skopelos. Gold-foil over bronze. *C.* 1500 BC. L. as preserved 24 cm. D. of the pommel 13.8 cm. National Museum, Athens.

173 Dagger-blade, from Shaft Grave V of Grave Circle A at Mycenae. Spiral pattern of gold and niello on bronze. 16th century. L. 24.3 cm. National Museum, Athens.

174 Dagger-blade: leopards chasing ducks in an Egyptian-like landscape, from Shaft Grave V of Grave Circle A at Mycenae. Inlays of gold and various alloys of gold and silver (electrum) as well as niello, on bronze. 16th century. L. 16.3 cm. National Museum, Athens.

175-6 Dagger-blade: men on a lion hunt; lions hunting gazelles, detail from each side, from Shaft Grave IV of Grave Circle A at Mycenae. Inlays of gold and various alloys of gold and silver (electrum) as well as niello, on bronze. 16th century. L. 23.8 cm. National Museum, Athens.

177 Dagger, from a tholos tomb near Pylos. The handle is of gold-foil over bronze, the inlays (leopards) as in Pls. 173-6. 15th century. L. 32 cm. National Museum, Athens.

178 Dagger-blade, from the island of Thera. Little axes of electrum, with niello, inlaid on bronze. 16th century. National Museum, Copenhagen.

179 Armour, from a chamber tomb at Dendra (Midea) in the Argolid, back view (the boar's-tusk helmet is reconstructed). Bronze. Late 15th century. H. at back 52 cm, in front 40 cm. Thickness of bronze plates 1 mm. Museum, Nauplion.

180 Helmet, from the neighbourhood of Knossos. Bronze. Latter half of 15th century. H. 38.6 cm. Museum, Iraklion.

181 Leg-greaves, from Kallithea (Achaea). Bronze. Early 12th century. L. 25.5 cm. Museum, Patras.

182 Helmet fitting, from Tiryns. Bronze. *C.* 1100 BC. H. 34 cm. Museum, Nauplion.

183 Armour and helmet, from a grave at Argos. Bronze. Last quarter of 8th century. Armour: H. 47.4 cm; total weight *c.* 3½ kg. Museum, Argos (the same armour in Pls. 413-14; cf. also Pl. 240).

184 Conical helmet, from Olympia. Bronze. *C.* 700 BC. Museum, Olympia.

185-6 Earliest Corinthian helmet, from Olympia. First half of 7th century. Museum, Olympia.

187-8 'Illyrian' helmet, from Olympia. Bronze. First half of 6th century. Museum, Olympia.

189 Cretan helmet with inscription 'Synenitos, son of Euklotas'. Bronze with embossed and engraved horse and engraved lion. Latter half of 7th century. H. 24.5 cm. Norbert Schimmel Collection, New York.

190-1 Detail of a Cretan helmet and drawing of motif on one side (the same motif is repeated on the other side): two youths with wings attached by straps to their chests and shoes, who grasp a pair of snakes by the neck. Bronze, embossed and engraved. Latter half of 7th century. Overall h. of helmet 21 cm. Norbert Schimmel Collection, New York.

192 Cretan mitra (groin-guard) with inscription 'Synenitos, son of Euklotas' (cf. Pl. 189). Bronze; both horse protomes are embossed and engraved. Latter half of 7th century. D. 24.2 cm. Norbert Schimmel Collection, New York.

193-4 'Girdle': warriors in a chariot and on foot, with Boeotian shields, from Arcadia. Bronze, embossed and engraved. Second quarter of 7th century. National Museum, Athens.

195 Back-piece of armour, from the Alpheios near Olympia. Bronze, embossed. The figured and ornamental decoration is engraved. Third quarter of 7th century. H. 40 cm, W. 36 cm. Museum, Olympia.

196 Drawing of armour in Pl. 195. The interpretation of the figured scene is still not certain. Left: perhaps Anios, the hero from Delos, who with two sons welcomes Apollo accompanied by the two Hyperboreans.

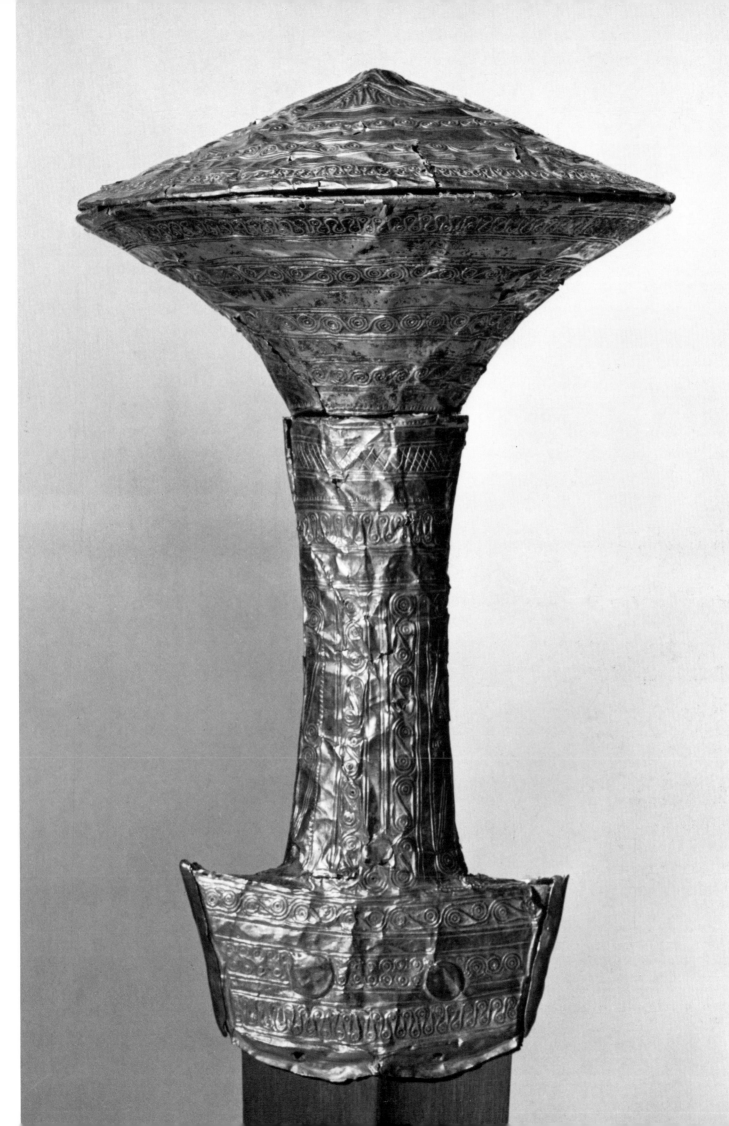

173

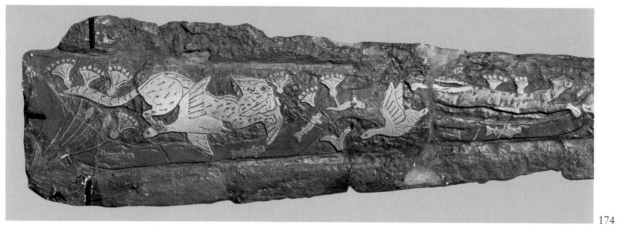

174

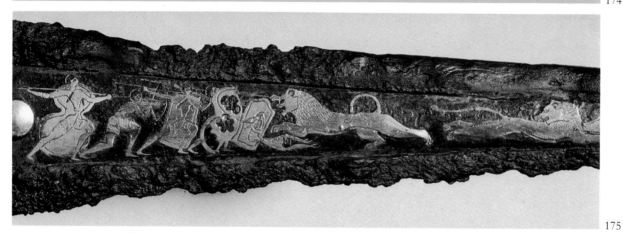

175

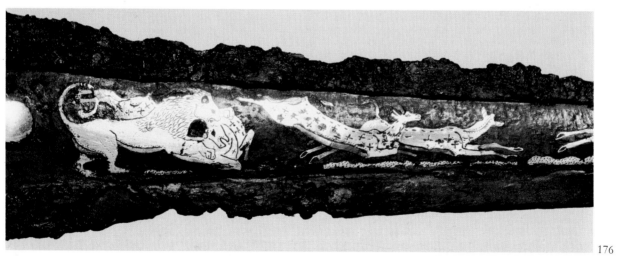

176

177

178

179

180

181

182

183

184

185

186

187 188

189 190

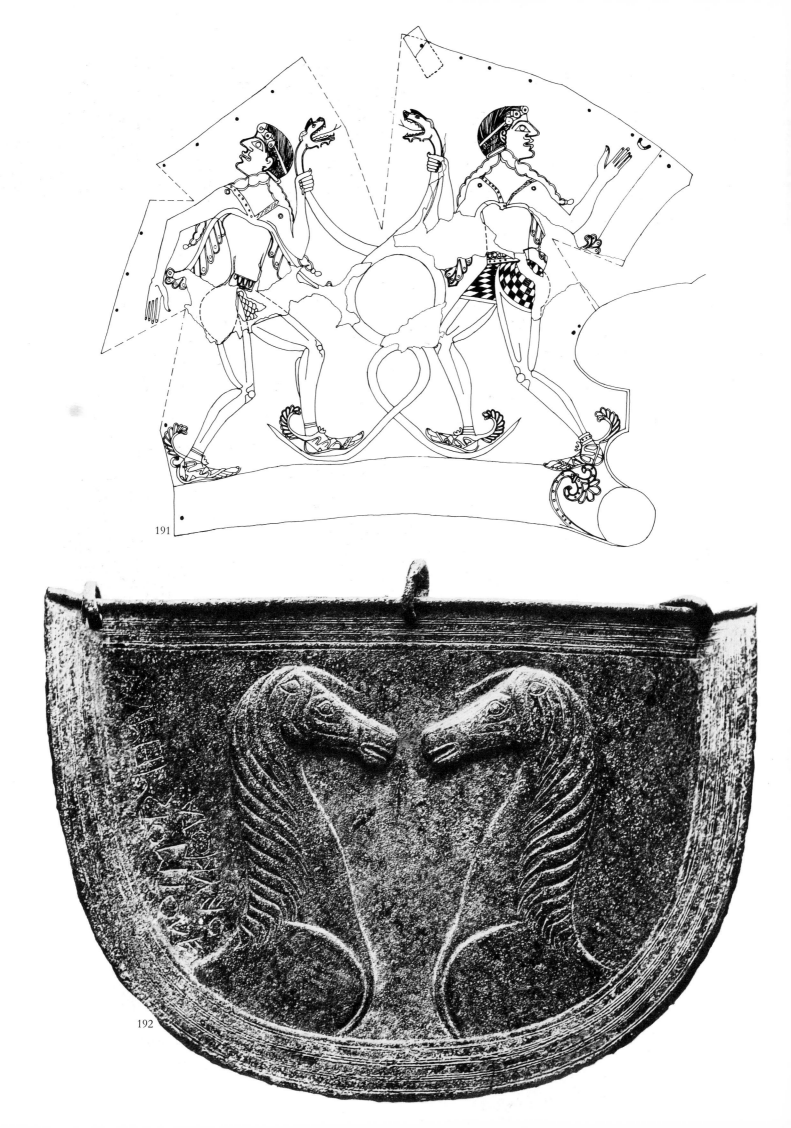

191

192

193 194

195

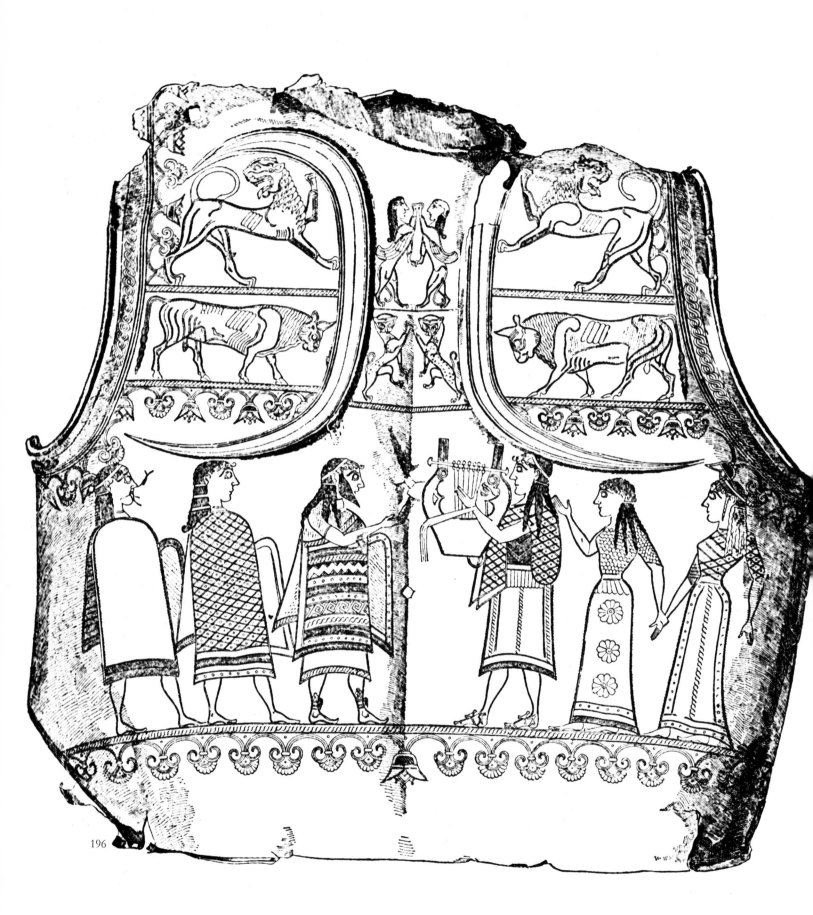

196

the shape of the head, as it does later. Furthermore, the nose-guard is still relatively short. To make such a helmet from a single thick sheet of bronze required great skill, because the bronze was not of the same thickness everywhere and it had to be particularly strong at the nose-piece. Inside was a lining of felt and/or leather. Only some of the helmets carried crests: they were not, therefore, a necessary part of the equipment. They were supposed to terrify the opponent—an aim which was also achieved by the mask-like face on the Corinthian helmet. The Illyrian type illustrated here is also from Olympia. It shows that in the first half of the sixth century a climax was reached in this kind of work. In the middle was a wide socket for the crest. The cheek-pieces were bent out by the dedicator to make the helmet useless—a custom which can be frequently observed. Even if they were bent back in antiquity, as is done in museums today, this would have destroyed the original tension on which the protection that the helmet gave largely depended.

A great deal of seventh-century Cretan bronze armour was found at Arkades in central Crete. It lay in large clay pithoi, in a building, which has been interpreted as the men's assembly-room. A large part of the find is in private hands, especially in the collection of Norbert Schimmel in New York. Only a few pieces from this group will be discussed. The helmet decorated with a horse on both sides is typically Cretan. It is put together from two halves; the seam runs from the neck to the forehead. In the double-bowed cheek-piece the Minoan helmet lives on in modified form; the cheek protection is not separately attached but made in one piece with the rest. A headband covers the seam over the eyes. The suggestion of a nose-guard also often appears in imitation of the Corinthian helmet, although in this case it is only vestigial. With the added headband the metal layers are doubled at this sensitive spot.

While Corinthian helmets are impressive simply because of their noble form, many Cretan ones excel in their embossed and engraved decoration. This was easier to execute in their case since they were made in two halves. The finest decorated example shows two winged youths, one on either side, grasping an intertwined pair of snakes by the neck. Each boy is simultaneously stepping with his winged shoes on the pointed tail of the reptile whose neck his companion is grasping. The snakes have tufts of hair and ears and they hiss threateningly, their fangs and forked tongues visible. Their subduers turn their heads away from the knot of snakes. A real impression of the work can be formed only from an examination of the original—no photograph up till now has been able to do it justice. The youths' wings do not grow out of their bodies in demonic fashion. Their breast-straps and winged sandals belong rather to the magical equipment which enabled them to grasp the snakes and keep them at bay. The youths are more robust in form than the figures on the cut-out sheets which were found not far from Arkades. The profiles, however, show a certain similarity, though in the case of the figures on the helmet all features, particularly the over-large mouth, have been made demonic. The double lines on the youths' hair and heads, and also on those of the snakes, add to the demonic effect. The artist who designed this helmet put creatures of Cretan demonic cult, perhaps the Kouretes, into a heraldic composition; this is very apt for the decoration of armour, but at the same time the scene is full of life, which is rare in blazons.

Next to the seam is written the name Neopolis. Further names can be found on other pieces of armour from Arkades, often with the addition of the father's name and the statement 'has captured (this piece)'. But in no case is it said in such inscriptions from whom the booty was taken, although this was the rule in the dedication of arms at places like Olympia. Nor, if they were considered as votive offerings, is the deity to whom the weapons were dedicated ever mentioned. Thus we cannot be dealing with normal pieces of booty or with simple votive offerings. They should probably be thought of as the equipment of armed dancers; their rich decoration might also point in this direction. As Xenophon tells us in the *Anabasis* (VI, 1) the Arcadians, from whom Arkades got its name, were very famous for their armed dances. Such dances had a mimetic character: mock fights were performed, including the 'disarming' of the 'conquered', who was in reality unharmed. The inscriptions may have related to episodes in dances of this kind. Since a whole series of Doric names is included in the inscriptions, one should probably associate them with the above-mentioned Doric–Cretan custom of pretending to carry off young boys (see p. 124). Their 'robbers' used to teach these boys to perform the armed dance.

Many so-called *mitrai* were found at Arkades. These half-moon-shaped bronze sheets, typical pieces of Cretan armour, served as protection for the groin. They are mostly decorated with a motif which is symmetrical about one axis. The two horses, depicted up to the shoulders and facing each other on a mitra in the Schimmel Collection, are very impressive. The long strands of hair are characteristic of the second half of the seventh century. What the complete horse looked like is shown by the helmet which originally belonged to the same set of armour. It carries the same inscription as the mitra with the horses' heads: 'Synenitos (has taken) it, the son of Euklotas'. Perhaps there was originally some body armour to go with this equipment, since the mitra is intended to hang from a belt or bronze breast-plate.

A bronze strap from Arcadia in the National Museum in Athens was described when published as a belt, but this attribution is not certain. It shows two four-wheeled chariots being driven to the right. Between them two hoplites with Boeotian shields are commencing a duel; the charioteer on the left also carries a Boeotian shield. In spite of careful incision the metal-chaser did not distinguish the right and left sides of his figures, since the shield ought to be carried on the left arm. This suggests a relatively early date, probably the second quarter of the seventh century, for this north-west Greek work.

Armour from Olympia

We have kept until the last the most beautiful of all the sets of armour preserved—unfortunately only a back-piece. It was fished out of the Alpheios near Olympia in 1870 and was acquired privately. Recently it passed to the Olympia Museum. Originally it must have belonged to a set of armour dedicated to Olympian Zeus: this is made clear by the square holes in the spine and in other places which surely come from the nails with which the armour, intended as an offering, was attached to a wooden pole. Certainly there cannot have been many pieces of

this sort that were so amply decorated. The few that have been preserved are as a rule decorated only on the breast-plate, even though this part was more difficult to do because of the modelling of the edge of the ribs. In contrast to the Cretan examples mentioned above, only the contours of the shoulder-blades are rendered plastically on the Olympian piece and the decoration itself is pure engraving. In the lower part there are six figures, arranged in two facing groups of three. The main figure is the kithara-player, who does not, however, occupy the middle because the spine runs down there. The two figures, one in front of him and one behind, have their right arms raised in greeting, indicating that they are honouring him. The kitharist has raised his left arm, not in greeting but only to hold the large instrument, helped by a band around his wrist. His right hand appears behind the kithara and holds the plektron, which is attached by a cord. In two-dimensional Greek art kithara-players are usually shown facing right. Maybe here the engraver wanted the figure to come from the right and so from the 'lucky' side. This direction and its meaning certainly played a more important role on armour, on which the right and left sides are of vital importance in nature, than in a free field. Both girls who follow the kithara-player from the right hold each other by the wrist in the manner of the ring dance. However, the three male figures on the left, a bearded man followed by two youths, are not dancing but are enveloped in their mantles.

The two main figures, the kithara-player and the bearded man, wear richly patterned garments and are usually called Zeus and Apollo; the scene is commonly interpreted as Apollo's entry to Olympos. But both in the Homeric hymn to Apollo and in art in such a scene Zeus is enthroned. Furthermore, his attributes, thunderbolt and/or sceptre, are strangely lacking. Nor can the two girls following the kitharist be Leto and Themis (or Artemis), for the motif of the ring dance is not suitable for them. However, we know from Cycladic religion and art that the two Hyperboreans, Arge and Opis, accompanied Apollo on his entry into the Delian sanctuary. It is surely they that are meant here. Since an expert like Paul Jacobsthal attributed this armour to an island workshop, the cult connection with Delos can certainly be adopted as an interpretation. Apollo's priest on Delos was his own son, Anios, the grandchild of Dionysos, whose sanctuary has been uncovered on the island. It is perhaps he who greets Apollo as he enters Delos.

Anios was the father of the island heroes Andros and Mykonos as well as of three daughters who could change everything they touched into wine, oil and cereals. These three Oinotropes, who once nourished the whole army of the Achaeans on the way to Troy, may have been represented on the missing breast-plate of the armour. One would also expect Artemis to be there, perhaps in a heraldic scheme as the 'Mistress of the Animals'; this would fit well with the fine lions and bulls on the shoulder-blades. The small panthers and sphinxes, arranged between the latter in mirror symmetry, and the ornament of palmettes and lotus buds under the bulls and under the figure frieze, are paralleled most closely on island vase-painting, as indeed are the girls' drapery and the styliza- 258 tion of the bulls' bodies. In style this belongs with the later 250- Proto-Corinthian of the third quarter of the seventh century BC.

Stone Vessels

Stone vessels have a very long history which goes back to the pre-ceramic period. In Egypt stone vases were made already in the fifth millennium BC. In Cyprus we meet them in the Early Neolithic, and in the third millennium they are found together with 'island idols' from the Cyclades. The latter are of dazzlingly white marble, while the exquisite stone vases from contemporary Early Minoan Crete are of varying colours and are veined. This technique was further developed on Crete in the Late Minoan period. We are dealing, therefore, partly with genuine ancient stone vessels and partly with ones imitating metal vases.

The Mycenaeans learned the working of stone vases from the Minoans. The oldest and most astonishing example dates 197 from the sixteenth century and comes from Grave Circle B at Mycenae. This vessel is 13.2 cm long, is made from rock crystal and has the form of a swimming duck looking back over its shoulder. The surfaces of the original crystal were not kept to but were rounded and adapted to the bird's organic form. One may wonder whether this piece is Cretan, but if one considers Mycenaean art to be a fusion of Helladic and Minoan elements (see p. 97) then it may be seen as a thoroughly Mycenaean work. The Greeks used many varieties of stone, occurring in different colours, for such vessels: alabaster, chlorite, serpentine, marble, poros, sandstone, slate, steatite and trachyte are all to be found. Only a few vases of certain Mycenaean origin 198 have been selected here: two round vases and a jug with a high neck. They date from *c.* 1500 BC. Both round vases have a short, separately attached neck, which has been lost. One comes from a chamber tomb at Mycenae, the other from the 'House of the Shields'. On the latter the light-coloured veins play the role of decoration, while the other has been given very pronounced torsion lines which follow a regular spiral. The jug, of yellowish horizontally rippled alabaster, is not really a stone form. It is the typical libation jug that we know from metal and clay versions and from the cult scene on the Agia 199- Triada sarcophagus.

A large carefully worked alabaster vessel with three attached handles belongs to the inventory of Shaft Grave IV. The volute handles tower high above the spouts and taper downwards. Three grooves are cut around the vase at its widest diameter. Here, as with the alabaster jug, a royal metal vessel has clearly been imitated. While we know to what use the jug was put, the function of this elegant and hybrid vessel is uncertain.

Lamps form one category of stone vessel or utensil. In addition to hand lamps of clay and bronze there were stone standard lamps, some with high feet and others with low ones. The oil was kept in a round hollow in the upper surface. Two 201 wicks lay opposite each other. The rim here consists of an overhang of large, thick leaves with two midribs, a forerunner of the Doric *cyma*.

While stone vessels temporarily died out with the end of Mycenaean culture, the marble lamp and basin with supporting figures survived to the Archaic period. The lamp from the sanctuary of Demeter Malophoros near Selinus was made in 202- the second half of the seventh century on one of the Greek 'marble islands', Naxos or Paros. It was hung up by three loops of rope. On the front a head is carved. It is difficult to decide whether it is male or female, but one would like to think the supporting figures of such marble basins were girls (*korai*). On our piece the hair, which spreads out on both sides, is divided into rectangular areas, and terminates at the bottom in points. The girl's irises are carved out without indication of the pupils. Around the forehead lies a garland with large volutes; it is probably to be thought of as metal. The nose juts out sharply. All this is characteristic of seventh-century Greek 436- sculpture.

Pottery

Mycenaean Clay Vessels and Terracottas

The basic criteria for the differentiation of Minoan (i.e. Cretan) and Mycenaean pottery styles were laid down by the Swedish scholar Arne Furumark in the early 1940s. Subsequent excavations have provided even further support for his classification, which here also may be taken as a guide-line for the few examples we have selected. By way of introduction, a word or two on terminology; 'Mycenaean' is the fusion of Helladic and Minoan elements to form a single style; Helladic is the style on the Greek mainland which was not influenced by Crete. In the Middle Helladic period, as one calls the first half of the second millennium BC, there were indeed contacts between the mainland and Crete, but they scarcely affected the two major styles of Middle Helladic pottery, matt-painted and 'Minyan' ware. The latter is called after the mythical king Minyas of Orchomenos. The vessels are solid and undecorated, with a grey, black or reddish slip, and often show sharp kinks in their contours. The commonly held view that this kind of profile is an imitation of metal vases is not correct. We are dealing rather with a genuine ceramic phenomenon closely connected with the rapidly rotating potter's wheel, in use since early in the second millennium. The place where this was invented is unknown, and perhaps cannot be located precisely, because even today in remote areas there are phases of transition between the slow and fast wheel. It is certain that Middle Helladic potters used the fast wheel, as their contemporaries did on Crete. With its help craftsmen in Cretan palace workshops, especially at Phaistos, produced the finest walled drinking vessels the world has ever seen. They are gaily painted with colourful earthen hues in the so-called Kamares style. Middle Helladic potters, on the contrary, used the fast rotating wheel to divide up the contour of their vessels and produce sharp profiles. The difference between Crete and the mainland is thus clearly expressed in the different use to which this technical innovation was put.

Furumark did not, as he emphasizes, take into account the purely technical aspects of the Mycenaean pottery which he analysed. This is a subject for further research, which, as the example above shows, could also profitably help to improve stylistic analysis.

On mainland Greece, perhaps in the Argolid, during the sixteenth century a ceramic invention was made whose significance cannot be overrated: the discovery of gloss slip. This decisively affected the surface of ancient pottery for two millennia, because even late Roman sigillata potters used much the same material. It is a natural product, but not simply one that can be found in nature like the earthen colours yellow, beige, dark red and white, with which Minoan potters painted their highly developed vessels. Gloss slip has rather to be produced by a systematic process from a specially prepared colloidal clay matter. This was levigated, i.e. by adding water the clay was freed of useless substances, which sank to the bottom. This probably was done in stepped washing basins, the flowing from one basin into the next until all the coarse ingredients were eliminated and only the fine colloidal gloss slip remained. On firing this became a shiny, brownish black or brownish red. One could use it both as a slip for the whole vessel and for the painting, which was basically more of a drawing than a painting. Since this technique involved a contrast between light and dark lines and/or areas, it imposed upon vase-painters a certain severity and conservatism. The linearity and formality of Mycenaean vase-painting, in contrast to the fluidity of Minoan paintings, probably also results from use of gloss slip.

Some of the few clay vessels found in the shaft graves at Mycenae still have Middle Helladic forms—they predominate in Grave Circle B found by Greek archaeologists at the foot of the citadel. One concludes that this circle began to be used slightly earlier, even though some of its burials are contemporary with the shaft graves found by Schliemann. The pottery of the latter is sometimes clearly influenced by Minoan vases, as for example in the case of a pear-shaped jug with a round spout from Shaft Grave VI with a contour that tapers towards the base. Around its maximum diameter runs a light stripe, framed on both sides by a thick dark band, which divides the decoration into two zones. The shoulder bears a necklace of tilted concentric semicircles, which consist of light, dark and dotted arcs. Under the middle stripe run spirals and above the foot is a branch with heart-shaped leaves of what appears to be ivy. The plastic ring on the shoulder is borrowed from metal vases. The jug from Shaft Grave I, the latest of those excavated by Schliemann, is slimmer and conical in form. It also has a collar round the neck, but on the body there grow from wavy vertical lines bunches of grass and various leaf motifs, a decorative mixture of lily and ivy.

Both jugs are important evidence of the state of early Mycenaean pottery in the second half of the sixteenth century. The decorative elements are borrowed from Crete, but they were formalized by the Mycenaeans. The use of axes, horizontal on the one vessel and vertical on the other, is more important for the Mycenaean potter than the impression of movement, especially of torsion, which Minoan decoration was able to convey. One might compare with the first jug the similarly shaped Minoan silver jug from Shaft Grave V. It also has on its lower part horizontal rings, which do not, however, dominate the middle of the vase but subside into an arcade pattern. On both vases running spirals are an important motif. On the clay jug they are on the lower part of the body, set between rings, whereas on the silver jug they roll free and swell in size over the 'breast' of the vessel. One cannot imagine a more different way of decorating such a jug. Nevertheless, it must be stressed that Mycenaean potters were successful in adapting Minoan forms. This achievement is very typical of the beginnings of Mycenaean Greek art. Later too, especially in the seventh century (cf. pp. 171), the Greeks were able to respond to foreign stimuli and to adjust what they learned to their own sense of form.

From Kakovatos in Triphylia, on the west coast of the Peloponnese, where a small Mycenaean citadel and several tholos tombs were excavated, comes an imposing (height 78 cm) storage vessel. We know its Mycenaean name from Linear B tablets: *di-pa*, that is to say *depas*—a general name for a vessel, used in Homer for drinking-cups. In archaeological terminology our vase would be called a *stamnos*. The number of its handles could vary, as the ideograms on the tablets show. Here there are three rows of three vertical handles, similar to the pithoi of Minoan palaces. One imagines at first that one is dealing with a Cretan vessel from the period soon after 1500 BC, with nautili, coral reefs and algi in the manner of the Cretan 'Marine style'. Doubtless the potter tried to copy

Minoan vases with marine motifs, but he failed to achieve the flow and rhythm of his models. The result is a rather confused and provincial-looking imitation. Kakovatos, whose ancient name is unknown, was not such a centre of Mycenaean culture as the Argolid.

208 A depas of the same form, but with three loop handles on the shoulder, was found in a chamber tomb in the harbour area
209 of Knossos. It is mentioned here, together with a jug from another grave in the same area, because both date from after 1450 BC, when the Achaeans already ruled in Knossos. Both are painted with a gloss slip, which the Cretan potters learned
208 from mainland works. The short neck of the stamnos is dark with reserved wavy bands, which anticipates the fluctuating character of the whole decoration. It consists of four helmets with curved neck- and cheek-pieces. The helmet itself has bands on which alternate patterns of rosettes, crescent-shaped boars' tusks and zigzags. The boars' tusks are a purely Mycenaean motif in this otherwise typically Knossian 'zoned helmet'. Even the straps with which it was fastened at the chin and the fluttering crest are depicted. The helmets lie horizontally and seem to float, surrounded by the so-called 'sand pattern' which follows their contours in broad sweeping curves. In its fine stippling this ornament seems like a colour print and recalls the older Minoan pottery which was not painted with gloss slip. In contrast to mainland potters the Cretans understood not only how to draw with gloss slip but also how to paint with it. The vase is decorated in the so-called 'Palace style', which is less formal here since it manages to retain much from its early phase, the 'Marine style'.

209 The other jug was not meant for everyday use but for cult purposes. Similar jugs are carried by the demons on the great
299 gold ring from Tiryns. Short spikes have been attached in hybrid style on the shoulder and in four vertical bands. The front of the neck is decorated with a small plastic version of a figure-of-eight shield, by this time already an ancient motif, which made this libation jug still more venerable. The painted decoration consists on the front of hanging blossoms, on the back of nautili. The gloss slip turned out red from the kiln while the same material on the depas is darker in colour.

211 This Cretan libation jug should be contrasted with a typical piece of everyday ware from the Argolid. It comes from a Mycenaean workshop which specialized in such striped jugs in the fourteenth century BC. They are frequently discovered in excavations as far afield as the western Peloponnese. Its elegant decoration combines both simplicity and finesse. The body of the jug has wide, vertical sweeping curves which alternate with groups of four narrower ones. The tapering of these patterns at both ends emphasizes the vessel's shape. The torsion, which has been recognized by scholars as typical Minoan decoration, is apparent here, but it has been somewhat tamed. At the foot and the neck are groups of horizontal rings. On the neck these are done with dark lines, while those on the foot are reserved in the brilliant brownish red slip. The same use of colours marks the earliest Proto-Corinthian pottery at the end of the eighth century BC.

210 One of the most popular large shapes between 1400 and 1200 BC was the krater—the one illustrated here is from the second half of the fourteenth century BC and was found at Enkomi on Cyprus. It is pear-shaped, with a strongly downward tapering contour. Flat handles serve as a transition between the shoulder and the short neck. Furumark calls the type Levanto-Mycenaean. It was thought at first that they were produced on Cyprus, but in the meantime specimens have come to light in the Argolid, especially at Tiryns, which can be ascribed to the same workshop as those found on Cyprus. Since the export of clay vases from Cyprus, which was only partly inhabited by Achaeans, to the motherland can hardly be considered plausible, the centre of production is now presumed to have been in the Argolid. The kraters are important evidence of the lively sea trade that was carried on between the Peloponnese and the Levant at this period, when the Mycenaeans ruled the eastern Mediterranean. The favourite decorative motif of this type of vessel is a team of horses drawing a chariot with a four-spoked wheel. Often two figures, one of whom holds the reins, stand on the chariot; sometimes there are even more. The horses step or stand; only in rare cases do they gallop. Often the two horses are abbreviated to one, as here, though it has been given two heads and eight legs. The eighth century Geometric grave kraters with chariots have led some people to associate these Mycenaean chariot scenes with funeral ceremonies. Although these kraters have only been found in graves on Cyprus, at Tiryns and other places in the Argolid they have been discovered in settlements, so that such a purely funerary interpretation is ruled out.

The two main sides of our krater were filled with a large octopus, a leitmotif of Minoan and Mycenaean decoration, but under one handle is a chariot scene. In front of the chariot stands a man in a long mantle with a balance in his hand. When the krater came to light in the Swedish excavations at Enkomi on Cyprus, Martin P. Nilsson, the historian of religion, interpreted this figure, by reference to the *Iliad* (XXII, 209 ff.), as Zeus with the balance of Fate. So the vessel was known as the 'Zeus krater' until Porphyrios Dikaios convincingly countered such an interpretation in his authoritative work on Enkomi.

The scene does not deal with a mythical subject but with an actual event, the weighing of copper ingots. Such an ingot is carried by the naked man below the chariot. It is drawn in outline, with strongly waisted sides, similar to a figure-of-eight shield, only more angular. The correspondence is not accidental, since the shield consists of a dried cow-hide and the ingot imitates such a skin because cow-hides were themselves a means of payment, like units of currency. Dikaios supposes that the ingot is to be loaded on the chariot, since on another krater of this type a figure carrying an ingot walks along the chariot. In any case, to Cypriot buyers of such kraters the weighing of copper must have been a familiar sight, for copper was the main source of the prosperity of Cyprus, the 'Copper Island'. The Argive potters thus took the Cypriot market into account when choosing the subjects with which they decorated their vases.

Until now we have not mentioned vases from Mycenaean Attica. In contrast to the noble graves in the Argolid the Attic cemeteries at Eleusis and Perati, excavated by Greek archaeologists, seem rather bourgeois. While the tombs at Eleusis date back to the Middle Helladic period and can be traced down into the thirteenth century, those at Perati belong essentially to the twelfth century. With the material from both excavations we can thus cover about six centuries. However, we shall discuss only one grave, from the neighbourhood of the village of Koropi in the fertile Mesogeia plain in central Attica. The 212-16

197 Duck-shaped vessel, from Grave Circle B at Mycenae. Rock-crystal. First half of 16th century. L. 13.2 cm. National Museum, Athens.

198 Libation jug and two globular oil-jars, from Mycenae; the attached mouths are lost. The jug is of alabaster, the stone of the other two vessels has not yet been identified. 15th century. National Museum, Athens.

199-200 Three-handled cult vessel, from Shaft Grave IV of Grave Circle A at Mycenae. Alabaster. 16th century. H. 24.3 cm. National Museum, Athens.

201 Lamp, from the Lion Tomb at Mycenae. Alabaster. 15th-14th century. National Museum, Athens.

202-3 Lamp, from the sanctuary of Demeter Malophoros near Selinus. Cycladic marble. Third quarter of 7th century. H. 7.2 cm, W. at front 21.7 cm. Museo Nazionale Archeologico, Palermo.

204 'Minyan' krater with sharp kinks and grooves on the high foot. Clay. First half of 16th century. National Museum, Athens.

205 Jug, from Shaft Grave VI of Grave Circle A at Mycenae. Clay. Latter half of 16th century. H. 36.5 cm. National Museum, Athens.

206 Jug, from Shaft Grave I of Grave Circle A at Mycenae. Clay. Towards 1500 BC. H. 35 cm. National Museum, Athens.

207 Storage vessel (depas), from Kakovatos (western Peloponnese), with provincial 'Marine style' decoration. Clay. 15th century. H. 78 cm. National Museum, Athens.

208 Storage vessel (depas), from the harbour area of Knossos. The painted gloss slip decoration consists of zoned helmets on their sides. Clay. Latter half of 15th century. H. 97 cm. Museum, Iraklion.

209 Libation jug, with spikes, from the harbour of Knossos. Clay. Latter half of 15th century. H. 49.5 cm. Museum, Iraklion.

210 Krater, the so-called Zeus krater. However, the scene shows not Zeus with the balance of Fate, but the weighing of copper ingots and a chariot. From Enkomi (Cyprus). On the two main sides a large octopus. Clay. Latter half of 14th century. H. 37.5 cm. Cyprus Museum, Nicosia.

211 Striped jug. Clay. 14th century. Museum, Nauplion.

212-16 Grave goods, from Koropi (Attica). Clay. Towards 1300 BC. Römisch-Germanisches Zentralmuseum, Mainz. In detail:
212 Amphora with spout. H. 33.3 cm.
213 Cup with low foot. H. 8.8 cm.
214 Cup with high foot. H. 19.4 cm.
215 Chariot team with chariot-box. H. 10.8 cm.
216 Chariot with charioteer. H. 11.4 cm.

217 Mycenaean figurines: idols and animals. Terracotta. 14th-13th century. National Museum, Athens.

218 Octopus stirrup-jar, from Perati (eastern Attica). Clay. 'Close style'. 12th century. H. 21.5 cm. National Museum, Athens.

219 Octopus stirrup-jar, from Pitane (Asia Minor). Clay. 'Close style'. 12th century. H. 20 cm. Museum, Istanbul.

220 Stirrup-jar, from Rhodes: view from above. Clay. 'Close style'. 12th century. H. 21.6 cm. British Museum, London.

221 Lekanis with four mourning women represented three-dimensionally on the rim, from Perati (eastern Attica). Clay. C. 1200 BC. H. 16.2 cm. National Museum, Athens.

222 Pyxis with cover. Clay. First half of 12th century. University Museum, Philadelphia.

197

198

199

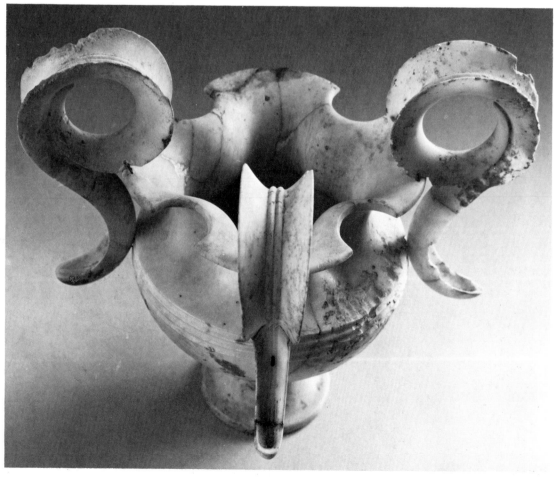

200

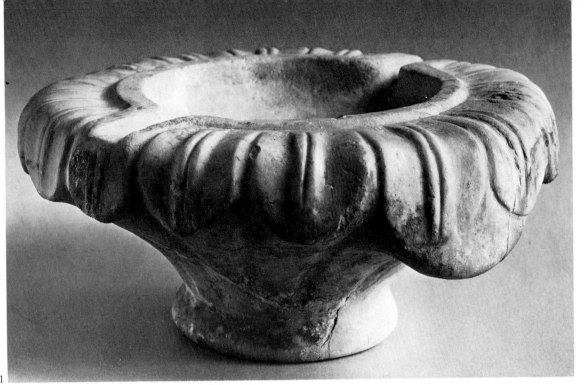

201

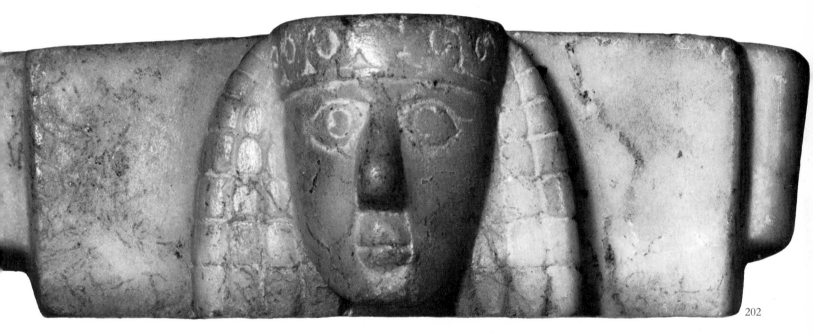

202

203

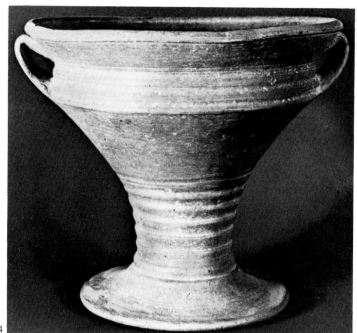

204

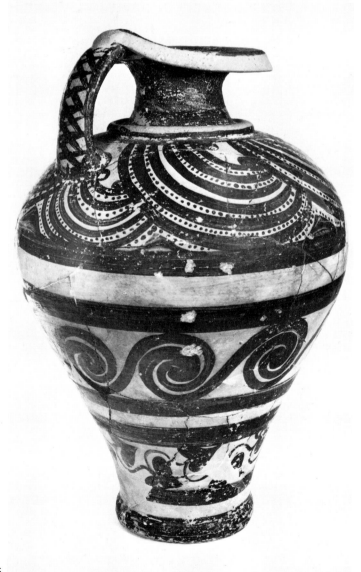

205

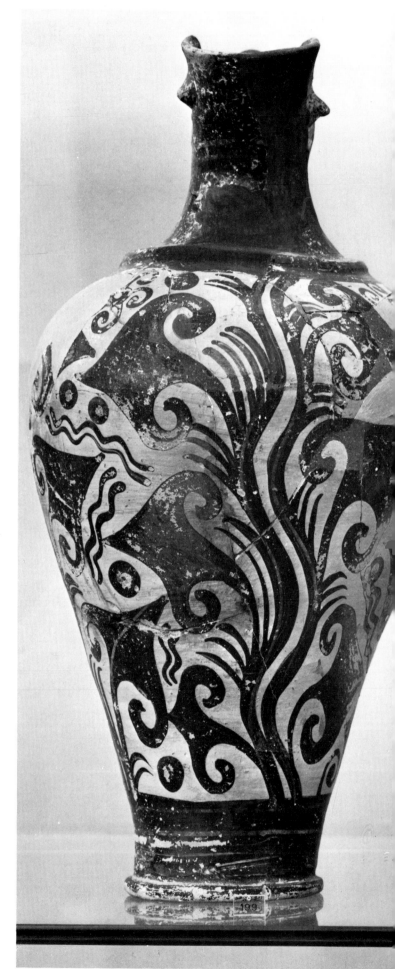

206

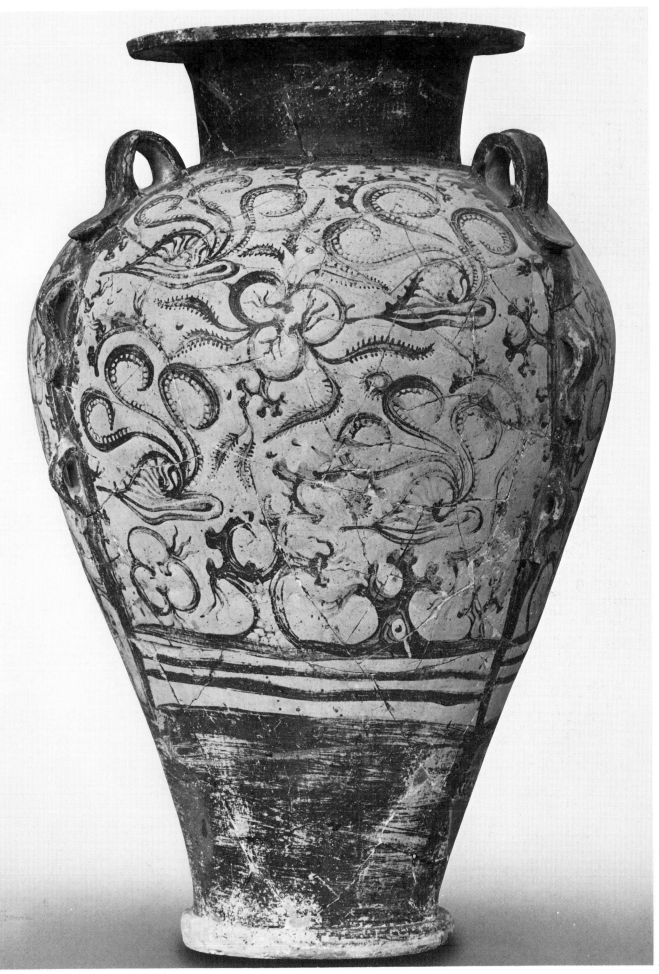

207

208

209

210

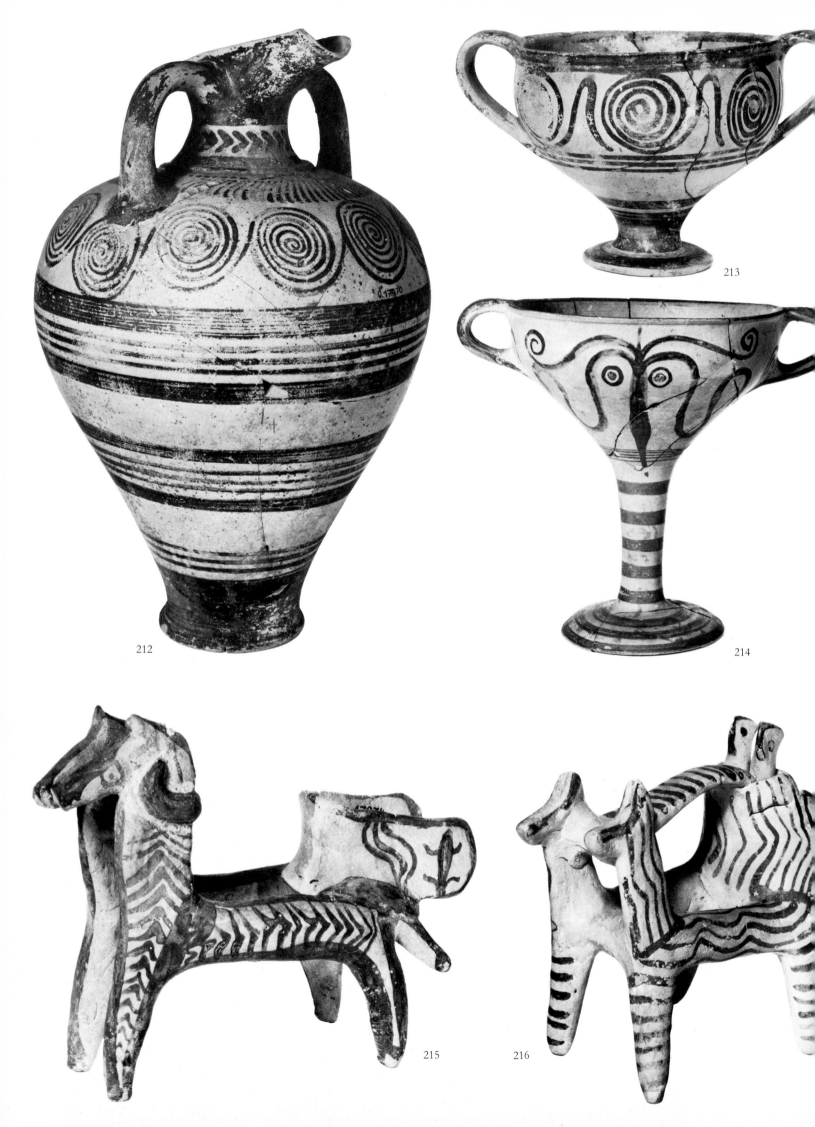

212

213

214

215 216

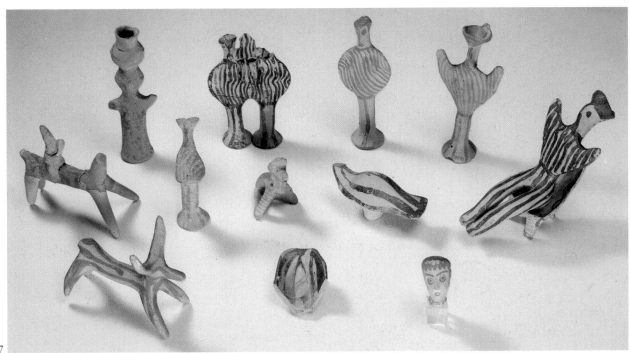

217

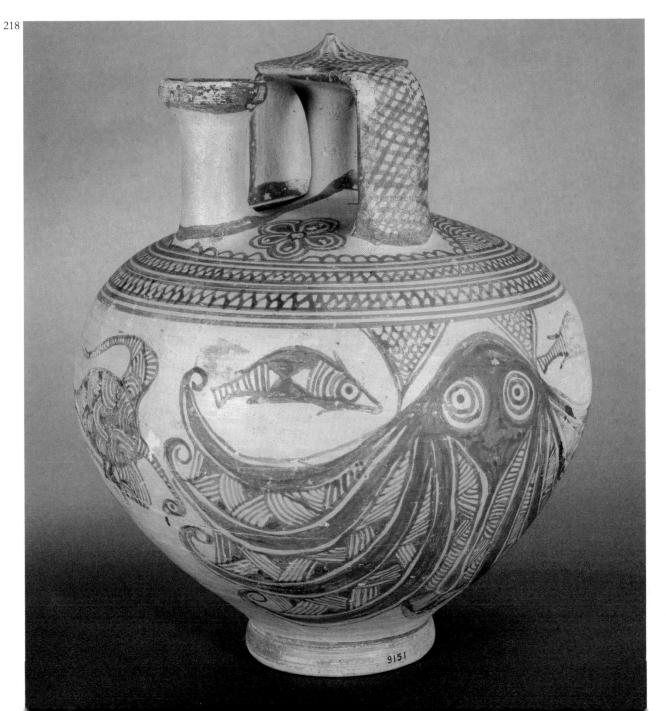

218

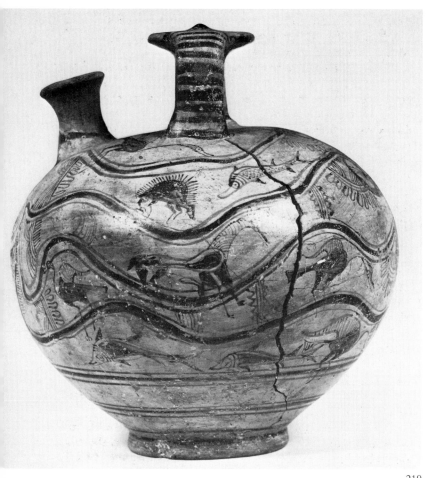

219 220

221 222

finds were long ago taken to Mainz. The grave should be dated to *c.* 1300 BC (Mycenaean III A/B) on the stylistic evidence of the pottery. Of the five ceramic offerings three are vessels and two terracotta groups, whose theme, that of chariots, corresponds with that on the series of chariot kraters just mentioned. The spouted amphora, the largest piece (height 33.3 cm), which tapers downwards, is very similar to the Early Mycenaean jug from Shaft Grave VI and the other vases we discussed, which indicates the homogeneity of Mycenaean forms over several centuries. As for the painting, running spirals appear on both. Here, however, they are set on the shoulder, have more turns and are more thinly drawn than on the jug mentioned earlier, whose painter worked with a wide, full brush, more in the manner of the Cretan models. The round handles near the spout are similar and the foot is also covered with gloss slip. The light surface of the body is divided up by a combination of broad and narrow rings.

Two double-handled cups, one on a low foot and the other on a high one, seem to be from the same 'service' as the amphora. One is also decorated with spirals; the other has an octopus on either side. The amphora may have contained wine or water, or else a mixture of the two, which was intended to be poured into the two drinking-cups. Cups predominate among offerings in Mycenaean graves. The type with spirals retained its form over a long period; the elegant high-footed cup, however, reached its climax in the fourteenth and thirteenth centuries, whereas at Perati it had by then nearly died out. The foot-plate and stem of the latter have horizontal rings. The octopus is placed with a sure decorative feeling, its tentacles reduced to four and rolled up like volutes. This animal, borrowed from Minoan art, already had nearly two hundred years of development behind it. The Mycenaean octopus differs from Cretan models by its vertical pose and rigid axial symmetry; it is more stylized. The octopus on the cup from Koropi belongs among those whose bodies are so narrow that there is no place for their eyes: they float alongside as two independent circular ornaments.

Rarer are the two terracotta chariots, especially since they are quite well preserved. On one only the chariot rail is indicated, resting at the rear on the rumps of the two horses. Two human figures stand next to each other in the chariot-box. From them the broad strap handle representing the reins stretches out to the horses' heads. The other chariot had separately attached wheels, as is shown by the axle which juts out at the sides, but here too the rail sits on the horses' rumps. The harness, however, is indicated on their heads. This chariot contains no figures: they may have been worked separately as on the *lekanis* we shall come to later. The horses bend their heads towards each other at an angle, as in later Greek representations. The other group lacks this remarkable observation from nature. On both, however, the number of legs is reduced from eight to four. Both are also painted with patterns: one with horizontal and vertical stripes and waves, the other with herring-bone patterns and, on the chariot rail, what may be plant motifs. An Attic land-owner might have been given these two attractive terracottas as grave goods, perhaps as tokens of his standing.

As the gloss slip painting of both chariot groups shows, they came from the same workshops as the pottery. Such a conclusion is supported by the existence of a combination of terracotta figurine and vessel, as on the bowl with the mourning women on the rim. Our coloured plate shows a whole assembly of terracotta figurines which are typical of Mycenaean sites. They start in the late fifteenth century and increase during the following century both in tombs and in settlements. At sites where the excavations are carefully controlled, such as Eleusis and Perati, female idols have been discovered mostly in the tombs of children. This has led Georgios Mylonas to the conclusion that they are to be explained as divine nurses (*kourotrophoi*) with whose help the dead children might find their destination. At any rate their function as amulets ought to be certain because of the small size of the figurines. One group is called 'Phi' idols, the other 'Psi' idols, because their contours look like these Greek letters. The Psi idols raise both arms in a gesture which is later characteristic of gods—and also of people praying. For this reason one hesitates between the two interpretations, and also because the headgear, the polos, was later used to identify both divine beings and people in the service of the gods. The woman on a throne with raised arms on the right of our illustration is most probably a divine figure because prayers are made standing. The two Phi idols combined into a group, holding a child between them, could also be divine kourotrophoi in Mylonas's sense. The rare idol with the large vessel on its head (called a 'Tau' idol because of the pose of the arms, which is like the Greek letter *tau*), can probably be taken for a serving figure.

In contrast to Greek terracottas of the first millennium, Mycenaean idols are also worked at the back—mostly there is only a long tress of hair down the back—and are painted with gloss slip. This comes from the fact that they are not mould-made but modelled free-hand, which also applies, of course, to the animals. A large bird, a monkey and two four-legged creatures—one a cow, the other with a fragmentary rider on its back—are to be seen in our illustration. The little head on the right in the foreground does not come from an ordinary idol, because these always have the very strongly stylized 'bird face'. It belonged to a figurine of high quality and shows just what the Mycenaean coroplast was capable of. If idols do not generally show such quality, this is the result not of a lack of ability but of difference of intention.

Perati, the site mentioned above, is the modern name for a hilly area on the eastern coast of Attica between Sounion and Marathon. In the Bronze Age this was the harbour of Athens whence journeys were undertaken to the Cyclades and Crete; this was long before Phaleron and Piraeus were developed. In the Late Mycenaean necropolis of Perati, the most frequently represented type of vessel is the stirrup-jar, a bulging container for perfume. In the Linear B texts it is called ka-ra-re-we: the underlying syllabic word was probably *chlareus*, since in the late lexicon of Hesychius chlaron is still the word for a jug. The form is not yet known from the shaft graves, but only from the 'House of the Oil-Merchant' at Mycenae. This shape with its closed false mouth and the spout set aymmetrically on the shoulder has also been found on Crete: indeed the finest of all stirrup-jars are the Minoan pieces decorated in the 'Marine style'. A remote copy of one is to be found in a jug from Perati that is three hundred years later. It is remarkable that at Perati the octopus, an ever-present motif in the Mycenaean period, is to be found only on oil-vessels of this form. The decoration of this chlareus is characteristic of the twelfth century and seems to have been invented in the south-eastern Aegean. In any

case, octopus stirrup-jars are rare in the Argolid, though they are common on Naxos (unpublished), Rhodes and the neighbouring islands and even as far afield as Asia Minor.

219 Next to the work from Perati we illustrate another jug which was found at Pitane, on the Aeolian coast of Anatolia. While the octopus on the Attic piece is still recognizable as a sea creature, on this vessel the tentacles have become mere 'landscape elements'. They spread over the whole vase and a whole assortment of animals play between them: a hedgehog, a horse, a bird and fish. Plant motifs also grow from the unduly long tentacles of the completely atrophied octopus, placed 218 centrally under the spout. By contrast on the stirrup-jar from Perati an octopus appears under each handle, whose tentacles encircle only half the vessel, leaving a narrow gap on both sides in which is a bird in flight. The creature visible in our illustration has a long neck and a hooked beak and is therefore probably meant to be a vulture. Two very natural-looking fish swim towards the octopus, which stares out with huge round eyes. These are rather Gorgon-like, in all likelihood intentionally so. In any case this pair of eyes may be considered as signs to ward off evil (*apotropaic* signs), a conception which still exists in Greece today. They probably protected the precious contents of the chlareus, the perfume, just as amulets protected people. The hatching between the octopus's tentacles and along its body on the Attic stirrup-jar are typical of the 'Close style', as a particular phase of Late Mycenaean vase-painting is called. 220 An excellent example of this style is a stirrup-jar from Rhodes, which is illustrated here seen from above in order to show the strange but practical construction of the spout.

One of the most important finds from the necropolis of 221 Perati is the bowl with four mourning women standing on the rim. It has only one counterpart there, which, however, lacks the little cups on the handles. The vase form itself, a lekanis, was already known centuries earlier, especially in bronze. The view that it contained water for washing has been challenged by Spyridon Iakovides, who found remains of food in a similar lekanis excavated at Perati. The dead were given a meal from such a bowl when they were buried; the little cups may have held sweetmeats. The bowl was decorated with mourning women because this was the last meal which the dead received. The figurines were fitted on to the rim with the help of small sticks. They are similar to Mycenaean clay idols and like them even wear poloi on their heads, but they lay both their hands on top of them in the gesture of mourning. Greek mythology has goddesses who mourn—one thinks of Thetis, with the choir of Nereids weeping for Patroklos (*Iliad*, XVIII, 37 ff.). Since the interpretation of Mycenaean idols found in graves is still uncertain, these mourning women cannot be identified precisely either. Their appearance is important, however, for they bear witness to the custom of mourning in the period around 1200 BC. The lekanis, a vessel of daily use, is here turned into a funerary gift by the addition of the three-dimensional women mourners. The same phenomenon recurs in Greek art five hundred years later.

Among everyday vessels are flat boxes (pyxides) for toilet articles. About a dozen of them have been preserved from the first half of the twelfth century, mostly found at Perati. Similar 222 to them is the pyxis of unknown provenance in the University Museum, Philadelphia. Its cylindrical lower part is completely covered by the lid. Only a thin ring on the base, which serves as a support for the lid, is visible. The slightly domed upper surface and the vertical wall of the lid are decorated with hanging and standing semicircles which are painted free-hand. On the top they are small and closely set, while on the sides they are grouped into metopes. The area between the semicircles is filled with gloss slip, which on the top takes the form of a dark wavy band, while on the sides each metope contains what appears to be the blade of a double axe. Whether this effect was intended or not is, however, debatable. More important to the potter in any case was the decorative contrast between light and shade, a contrast which returned in more organized form in the Proto-Geometric style. The form of the pyxis is basically timeless; indeed on Attic pyxides of the Classical period one occasionally finds the same perforation of the centre of the lid to take a metal handle.

The last Mycenaean vase in our series is the 'Warrior Vase' 223 from Mycenae, which Schliemann found in a house not far from the shaft-grave circle. It is a bell-shaped krater, a form which runs parallel to the pear-shaped one and indeed survives it. On bell-kraters bulls and birds are more popular than chariots, but in this case only the plastic bull's head flanked by painted birds remains. Since the same birds are found on vases of the 'Close style', the krater can be dated in the twelfth century; indeed it belongs at the very end of the series of figured Mycenaean vases. In contrast to the degenerated human figures on earlier vessels, these are more substantial. The development of vase-painting does not run in a straight line down to this very late example, fot its painter has looked beyond pottery to take fresco paintings as his model.

On both sides bearded warriors march in the same direction. They all have short cloaks with fringed hems, shields, greaves and sandals. The helmets, however, are different on either side, as is the movement of the right arm. On the one side the 224 warriors have horned helmets and their lances shouldered, on the other they have spiky helmets and raise their spears threateningly against the enemy on the other side. Between 223 them, beside one bow-shaped handle, stands a woman. She puts her hand—both hands are probably intended—to her head in a gesture of mourning. This indicates that the warriors with horned helmets are doomed, for the woman is lamenting them with a funeral dirge. Since the enemy is not marching towards them but attacking them form the rear, they were probably facing an ambush. The little bag-shaped objects on their lances have been variously interpreted as provisions bags or as slings. The latter is preferable, unless they are in fact standards identifying a certain division of the army. The flags of the Roman army were also lances with standards attached. As well as the reddish brown gloss slip the painter has used other colours to approximate those of the fresco whence he derived his inspiration. Thus the helmets and the fringed tunics are dotted with white and the interiors of the shields shine metallically.

Geometric Pottery

In no field of Greek art is the continuity between the second and first millennium so evident as in pottery. During the so-called 'Dark Ages', as scholars call the centuries between *c.* 1125 and 900 BC, certain forms like the stirrup-jar die out and vessels lose their typical Mycenaean outline which

tapered markedly towards the foot. Comparable phenomena, however, appear from time to time in later pottery. More important is what remains: above all the great invention of Mycenaean potters, gloss slip. It remains the same as in the half-millennium of Mycenaean production, sometimes fired a blackish brown, at other times a bright red, and occasionally flaking off too. This means that the types of kiln in which these vases were fired remained the same. They only change about 700 BC at Corinth (see p. 159).

The Mycenaean decorative motifs were, so to speak, filtered by painters of the Sub-Mycenaean style from 1100 BC onwards, so that all vegetable forms such as branches, leaves and blossoms slowly disappeared. Semicircles and circles remain, but they are now drawn with a compass and the triangles are no longer spherical but angular; generally there is a contrast between round and angular forms not only in the ornament but also in the contours of the vessels, a contrast which was never so strongly expressed in Greek pottery as it was in the so-called Proto-Geometric style between 1050 and 900 BC. One cannot connect its appearance directly with the Dorians, since these invading tribes from the north-west had a completely different pottery, fragments of which have recently been found at Tiryns. Furthermore, the purest expression of the Proto-Geometric style was at Athens, which was never occupied by the Dorians. It seems rather that in this style a constant Helladic factor, which was never totally hidden under the Mycenaean trimmings, once again came to the surface. We have seen that the mainland potters, in contrast to the Minoans, worked on strictly axial lines and that they drew their ornaments rather than painted them. From now on the decoration is, literally, constructed. It is certain that the Proto-Geometric style, like Late Mycenaean, became a Greek *koine* which spread from Thessaly over central Greece, the Peloponnese and Attica to Crete and Rhodes. Indeed one could call this *koine* the true Geometric style from which, only in certain places—above all at Athens, then on Euboea, in the Argolid and elsewhere—a special Geometric style developed that included figures and finally also plant ornaments; it dissolved at the end of the eighth century.

The German excavations in the Kerameikos at Athens yielded a complete sequence of Proto-Geometric pottery. 'Kerameikos' means potters' quarter, a designation which also includes the necropolis in front of the gates of Athens that remained in use into the Roman period. The Kerameikos potters produced not only clay vessels for the living and the dead, but also clay imitations of objects in other materials—especially for graves. Among the latter is the small box in the 225 form of a chest, modelled on a wooden one. It stands firmly on its four legs, which reach to the upper rim and are clearly distinguished from the body of the chest by triangular patterns. Its most important decorations are semicircles. Another frequently repeated ornament is the cross-hatched triangle. 226 This is the main decoration on the small amphora illustrated here. By contrast the double-handled drinking-cup next to it is almost totally covered with dark gloss slip. Only the handles are light and horizontally striped, as on the amphora; in addition a fine light stripe runs round the lip and the base. The cone of the foot and the roundness of the bowl fuse into a single artistic unity. One of the principles of Greek art, *palintropos harmonia* (harmony based on opposites), is expressed here in a particularly pure form.

Rhodes was an important centre of Late Mycenaean and 227 Geometric art. From that island comes a krater with concentric circles in its picture zone. One might be inclined to ascribe it to the Proto-Geometric style, with which also fit the dark crosses in the centre. The birds and stars in between, however, together with the whole form of the krater, which is taken over from Middle Geometric Attic models, indicate the second half of the ninth century. A typical East Greek motif is the ornament in the small reserved 'windows' beside the bow-shaped handles. Such handles already occured on Late Mycenaean kraters, but here they are connected with the rim by a stirrup; this form is the ancestor of the Corinthian or Column krater which appeared in the late seventh century BC. Thus, here too, we see a continuity extending over five hundred years. The plastic ridges at the top of the foot are of even earlier origin, for they reach back to the 'Minyan' kraters of the first 204 half of the second millennium, on which Helladic potters proudly left traces of the new invention, the fast wheel.

On other islands of the Aegean, as on Rhodes, the break with the Proto-Geometric tradition was not abrupt. An amphora from the island of Thera belongs already to the Late 228 Geometric style around the middle of the eighth century. Its clear and balanced ornamentation, however, still owes much to the early period of the Geometric style. One might compare, for example, the cross-hatched triangle on the shoulder with those on the Proto-Geometric amphora. The most important motif which entered in the ninth century is the meander, here in the popular hatched form. A peculiarity of Theran Geometric amphorae is the decoration of the front. Only the stripes run right around, because they were produced on the wheel. All the motifs between these bands—tangential circles, zigzags, triangles and meanders flanked by birds—are restricted to the front of the vase.

In works on Greek art one often finds illustrated as examples of Attic Geometric style the same vases, for example the famous grave amphora of the Dipylon workshop with the 235 laying out of the dead. In fact the percentage of excellent pottery was at the time very high in Athens—even the graves of poorer people as a rule contained clay offerings of quality. Not only large vases, which were probably bespoke pieces, but also small vessels are of astonishing precision. As an example let us look at the Middle Geometric miniature krater in the 229-30 National Museum at Athens. It has the same 'Helladic' ridges on the foot as the large specimens. The decoration of the wall consists of plastically rendered tongues rimmed with dark slip and decorated with chevrons, an old Attic Mycenaean motif. The chariot from Koropi already discussed, on which such a 215-16 series of chevrons is painted, recalls the plastic chariots on the so-called horse pyxides of the eighth century. Often there are 231-2 three or four horses, on whose heads the harness is indicated. The chariot itself is missing, since the naive method of putting it on the rump was out of the question for Attic Geometric artists. Furthermore, each horse now has four legs and the decoration is not spread over the entire body but emphasizes the chest. The horse pyxides, often found also in women's graves, are associated by contemporary scholars, probably rightly, with members of the cavalry class, to which the dead belonged. The lid and under part are perforated so that they can be hinged together or hung up; for this reason the underside is also decorated. These are among the most interesting Geometric compositions. Half a century before

223-4 'Warrior Vase'. Bell-shaped krater with warriors on both sides; those on one side shoulder lances and behind them stands a woman mourning; those on the other side have raised spears; on the bow-shaped handle a plastic bull's head, below them birds; from Mycenae. 12th century. H. *c.* 40 cm. National Museum, Athens.

225 Reproduction of a small wooden chest. Clay. *C.*1000 BC. H. 11.5 cm. Kerameikos Museum, Athens.

226 Proto-Geometric vases: amphora and cup. Clay. 11th-10th century. H. of amphora 13.8 cm, H. of cup 8.7 cm. University, Mainz.

227 Rhodian Geometric krater, from Kamiros. Clay. Towards 800 BC. H. 33.5 cm. Museum, Rhodes.

228 Theran Geometric amphora. Clay. 8th century. H. 51 cm. National Museum, Athens.

229-30 Attic Middle Geometric miniature krater with plastic ridges. Clay. Second half of 9th century. H. 12.2 cm. National Museum, Athens.

231-2 Attic Geometric 'horse pyxis' with a three-horse team on the lid: angled view from above and below. Clay. 750-735 BC. National Museum, Athens.

233 Attic Geometric kantharos. Clay. *C.*740 BC. H. with handle 19.6 cm. Museum Antiker Kleinkunst, Munich.

234 Attic Geometric tripod stand. Clay. *C.*740. H. 22.5 cm. Kerameikos Museum, Athens.

235 Detail from the 'Prothesis amphora'; main panel showing mourning scene. Clay. *C.* 760 BC. Overall h. 1.62 m. National Museum, Athens.

236 Attic Geometric neck-amphora: mourning, warriors. Clay. 750-735 BC. H. 54 cm. National Museum, Athens.

237 Attic Geometric jug, from the grave of the ivory figurines (cf. Pls. 393-6). Clay. 735-720 BC. National Museum, Athens.

238 Argive Geometric pyxis, from Asine. Clay. Latter half of 8th century. H. 20.5 cm, D. 40 cm. Museum, Nauplion.

239 Fragment of Argive Geometric krater: women performing ring dance and dancer leaping, from the Heraion at Argos. Clay. *C.*720 BC. National Museum, Athens.

240 Women performing ring dance on an Argive Geometric krater, from the grave containing the armour (Pl. 183). Clay. Last quarter of 8th century. Museum, Argos.

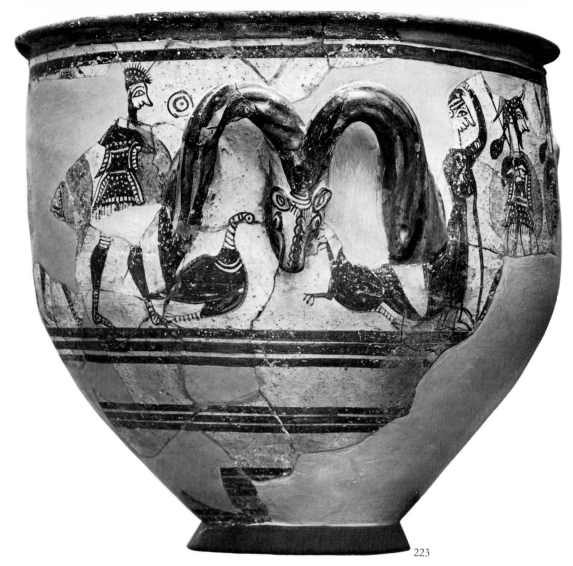

223

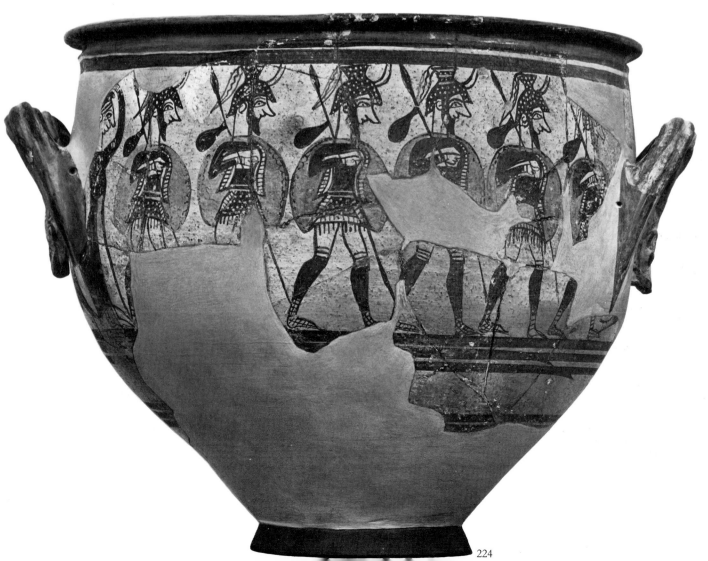

224

225

226

229 230

231 232

233

234

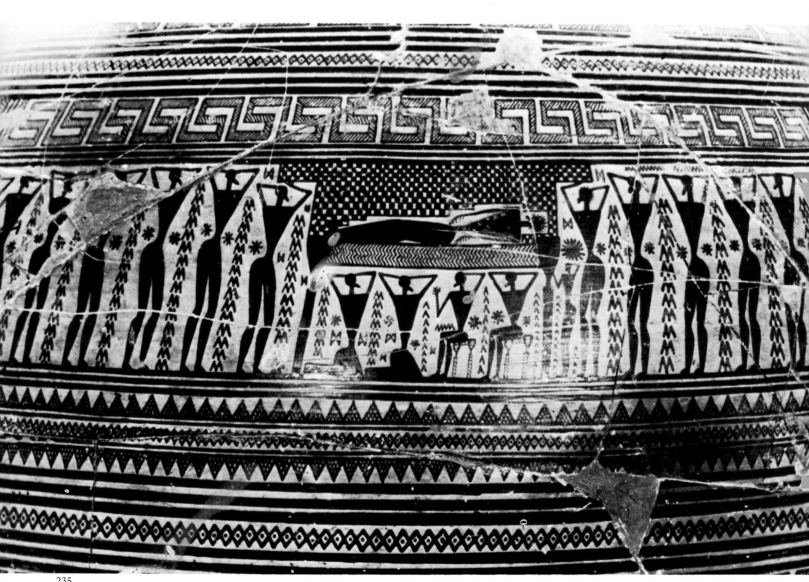

235

236 237

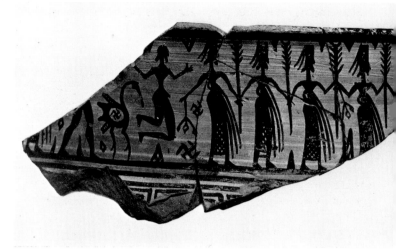

238 239

240

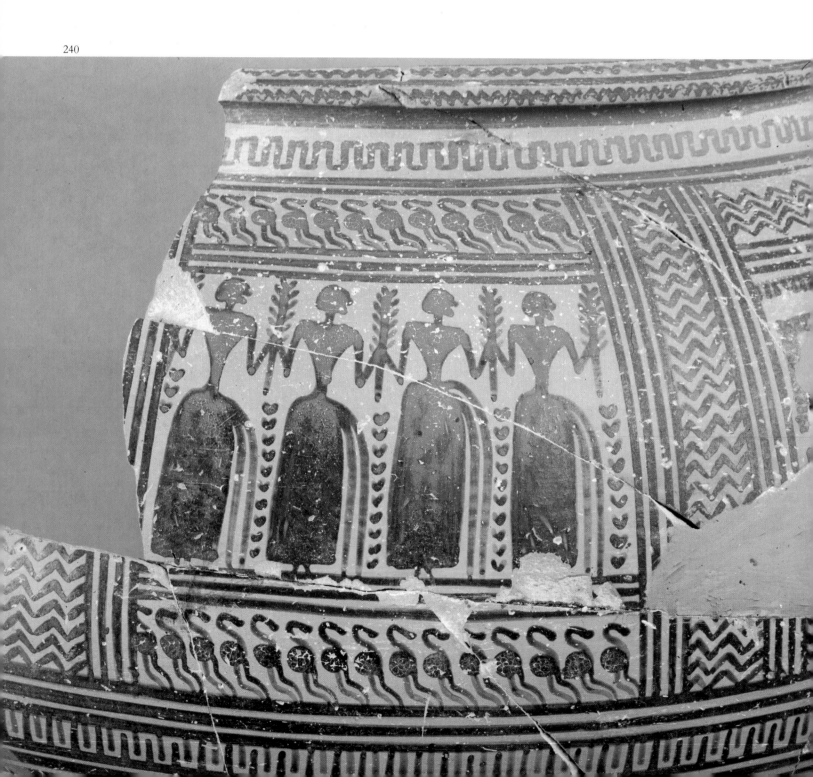

plant motifs crept back into vase-painting, there appeared on the bottom of these pyxides large rosettes with pointed oval leaves. The swastikas in the space between the panels, a reduced version of the filling ornaments in the metopes on the body of the same pyxis, help to bind the floral decoration into the Geometric frame. But nobody can doubt that here the artist has opened the door to new developments.

In the early eighth century there suddenly surfaced again, in the Athenian Kerameikos, a very old form of drinking vessel, the high-handled kantharos. Since there are no intermediate links in surviving Attic Geometric vase-painting, the impulse must have come from outside, perhaps from a metal kantharos which was stored for centuries in an Attic sanctuary of Dionysos. We have discussed golden kantharoi of the Mycenaean period. The example shown here may be dated shortly after the middle of the eighth century and in its strap-shaped handles clearly shows the influence of a metal model. A carefully hatched wavy band decorates the lip; on the body there is one of the metope friezes so popular in this period, with a leafy star in the centre flanked by swastikas.

Potters imitated not only metal vases but also bronze cauldron-stands. An especially fine example of a tripod stand from the Kerameikos has legs which are supported by rods that cross each other. The potter has cut them out of the conical wall and hatched them. The legs carry decorated panels like those on bronze tripods. The upper part of the stand spreads out slightly to take the bowl of the cauldron and is decorated with a carefully hatched zigzag band.

The 'Warrior Vase' from Mycenae and the vessels of its group were for several centuries the last vases to bear human figures. Apart from very few exceptions, representation of men begins again on Attic pottery in the early eighth century and reaches its peak in the first Late Geometric phase (c. 760-735 BC) with the Dipylon workshop. From the second half of this phase comes an amphora in the National Museum at Athens, not as big as the famous prothesis amphora but with the same theme: a corpse laid out on a bier and women mourning the deceased. They put both hands on their heads in the gesture of mourning taken over from the Mycenaeans; only the one who stands at the head of the bier has one hand stretched out towards the head of the body. That we are dealing with women is clear from the indication of their breasts, which are still missing on the large 'prothesis amphora'. This picture of human figures, for whose style there are no precedents, is a new creation of Geometric art. One could call it 'Homeric', since as in Homer stress is laid on breasts and limbs, that is to say those parts of the body with the help of which man breathes and moves. Drapery is left out because it would obscure what was important to the artist. Only the eye breaks the dark silhouette, an innovation on the way figures were depicted in the Dipylon workshop a generation earlier. The frieze below the prothesis shows marching warriors, of whom only the helmeted heads and the legs are visible; everything else is covered by a large shield, which has the Mycenaean figure-of-eight shape, stylized in the Geometric manner. Or rather, the silhouette of the shields and those of the warriors are fused together, as can be seen from the dagger that hangs in the middle. Each warrior holds two lances—in his hands, as one must suppose, since neither hands nor arms are to be seen. As has been correctly suggested, these warriors are the peers of the dead who pay him final honours in a funeral procession.

The neck of the vase is decorated with two different forms of meander: at the base of the handle a battlement meander and further down a multi-storeyed version, both of them hatched. Many narrow bands run around the egg-shaped body of the vase below the warrior frieze. A plastic snake creeps up each handle. They represent chthonic creatures and companions of the dead.

Certain workshops in the Kerameikos specialized in jugs for the cult of the dead. Some enormous amphorae and kraters were intended as grave-markers, others as grave-gifts. Our jug comes from the grave by the Dipylon Gate which contained the ivory figurines. The lid is particularly original: it fits exactly the contour of the round mouth and carries a jug with a high strap handle, on the lid of which a bird is perched. The gloss slip is well preserved on the lid, but on the mouth and body of the vase it has flaked off. The carpet-like pattern on the high neck and the egg-shaped body are harmoniously related to each other, for on both the same motifs recur: metopes with swastikas, cross-hatched triangles and chequer-board friezes, all closely packed. J. N. Coldstream dates the jug to between 735 and 720 BC. To the same era belong the ivory figures from this famous grave.

The Geometric pottery from Argos is also particularly fine. To appreciate it fully one has to go to the Argolid, for few vases have reached other museums. The Geometric potters of this area were worthy successors to the Mycenaeans. The tradition there was not interrupted, as is shown for example by the stirrup-jars with Proto-Geometric decoration. As at Athens, a great surge in vase production occurred in the middle of the eighth century. While the products of other workshops outside Athens are often so similar to the Attic pieces that they are easily confused, this is not the case with those from Argos. Form and decoration have their own character and the gloss slip is of particular quality. Close connections existed with neighbouring Corinth, which at that time was beginning to take over the leading role in vase production, a role it maintained throughout the seventh century. Argos has some vessel shapes in common with Corinth, one of which is the two-handled cylindrical pyxis. A fine Argive example of this shape was found at Asine, which was once a prince's estate. The slightly waisted body carries two typically Argive patterns: the step meander and the zigzag bands. The whole decoration has been carefully hatched with a multiple brush. This technique resulted in the precise hatching, which in comparison with Attic hatching is slightly shorter and of the same thickness as the framing lines. The step meander is flanked at each handle by a horse, the favourite motif of potters at 'horse-breeding Argos'. The rim of the flat lid and the lowest decorative band on the body show a row of tiny degenerated water-birds. This motif is repeated on the lid (not visible here).

A fragment of a krater shows a ring dance performed by women, who are holding each other's hands. Behind the last woman a dancer is depicted making a leap. Since such jumping dancers performed in pairs, as we know from the Homeric epics (cf. Odyssey, IV, 18 and elsewhere), the following figure, of whom only fragments remain, was probably his companion, followed by more women performing their ring dance. All the figures are moving to the right; the women carry branches between them, while some hold a second stem downwards. On their heads they wear high crowns (poloi). These figures are

157

'beautifully girdled women', as the three girdles that follow the billowing contour of the skirt suggest. Since poloi are crowns for gods or for humans in the service of gods, the women must be performing the ring dance as part of a religious rite. One might think, because of the find-spot in the Argive Heraion, of a festival of Hera, the greatest goddess of Argos associated 240 with the *polos*. Dancing women were indeed a favourite motif on Argive Geometric pottery. A fragment of a krater shows the gloss slip painted in Argive golden brown colour. The painter, who seems to have specialized in ring dances—several jugs with this motif have been attributed to him—belongs to the latest generation of Geometric artists in Argos. His style is disciplined but at the same time rather stagnant. That the four women with their twigs are meant to be dancers can only be realized by comparison with earlier representations, since they do not move but are planted almost next to each other like figures in folk embroidery. The water-birds in the friezes below and above are similarly frozen into a rigid pattern. The krater 183 was found in the grave in which the famous armour was discovered (Pls. 413, 414).

Seventh-Century Vases

The seventh century BC is generally referred to by archaeologists as the Orientalizing period. As in the Mycenaean era, strong influences again reached Greece from the Orient. Thus for the second time certain plant motifs (tree of life, rosettes), animals (bulls, lions) and mythical beasts (griffins, sphinxes) came from Oriental into Greek art. The manner and intensity of this borrowing varied in different parts of the country. It was particularly strong on Crete, as works in metal also show. In remote areas lived the 'real' Cretans (Eteo-cretans) who were descendants of the Minoan culture, while the rest of the island was essentially Doric. The attempt by a few modern scholars to attribute to seventh-century 'Daedalic' Crete an importance for the development of Greek art similar to that which it exercised in the second millennium does not seem to have succeeded. The leading role in the adaptation of Oriental models, at least so far as its rich store of pottery suggests, was doubtless played by Corinth. To the British archaeologist Humfry Payne we owe the recognition of the so-called Proto-Corinthian style from the last quarter of the eighth century to the last quarter of the seventh—and a plausible history of its development, which in turn created the chronological framework for other areas of Greece.

At Athens, as at Corinth, one can see signs of new development in the later eighth century. There is a type of 241 drinking-cup, offered in graves, which was inspired by metal cups of Phoenician origin. They have been found in the Athenian Kerameikos and at other sites. The Oriental models have interior friezes, and the clay cups imitate this decoration in the same place but in more modest form. On the example illustrated here, a piece in a private collection, there are three striding bulls. Their bodies are dark silhouettes; their heads, with the large eyes, are done in outline. It would not be fair to look back from here to the bulls on the Vapheio cups, but these Late Geometric bulls can stand comparison with the pictures on Late Mycenaean clay kraters. Our little cup was painted between 720 and 700 BC in Athens. At this period the filling

ornaments (mostly zigzags) become restless and begin to waver—a sign of the impending dissolution of Geometric ornamentation. In the succeeding Proto-Attic style, which is contemporary with Proto-Corinthian, the breakdown of the Geometric order still has its effect, though the Corinthian potters were astonishingly quick to find a well-defined new manner of expression. They exported pieces quite early to the west, for instance to Syracuse, the earliest Corinthian colony, founded in 733 BC, and to Etruria, whereas Attic potters in the seventh century worked only for their own consumption and for the needs of their immediate neighbours.

On a Proto-Attic jug in the Agora Museum, Athens, painted 242 about 700 BC, there still appears on one side the traditional hatched meander. Near by, in a free picture zone, grow two shrubs which are variations on the Oriental 'tree of life' motif. On the little tree on the left rosettes with alternately light and dark petals hang from long stems; on the volute-like branches of the right-hand tree buds are sprouting. Such well-formed plants were something new and unknown in Greece at this time. The motif of the two almost completely overlapping horses, however, is traditional, although the representation of the front legs seems new, for one leg is raised as if the animals wanted to show that they can move.

The two monumental cauldrons (*dinoi*) in the University of 243 Mainz Collection (only one of which is illustrated here) must come from a rich grave in the Athenian Kerameikos or in Attica. They were reconstructed by Roland Hampe in the 1950s. Their conical stands, which were potted separately, recall the bronze cauldrons with griffin protomes, while the two ring-handles on the rim remind one of tripod cauldrons. We are dealing with a transitional form between the tripod and the protome cauldron, a form which has not yet been found in metal. They belong, together with their painted decoration, to the time around 700 BC. On the handles there were probably plastic buds, as we know them from Oriental metal vessels, which have also been discovered in Greece. Around the rim runs a zone of differently sized studs surrounded by plastic snakes, which also recalls metal models. A painted frieze with hounds and vultures envelops the bodies of both dinoi. It makes one think of the first verses of the *Iliad* which say that those who fall before Troy will be given to the dogs as booty and to the birds to be devoured. In Archaic thought devouring by predators of those who fell in battle was thought of as the opposite of proper burial, for which these vases must in fact have been used, rather than for everyday purposes.

The high conical stand of the *dinos* shown here, which has 243-4 lozenge-shaped cuttings in it, is illustrated also with a reconstructed drawing. The painting is differentiated from that of the Late Geometric style by its large surfaces and its power of expression; the latter is especially clear in both the crouching sphinxes, which should perhaps be thought of as *keres* (demons of death). We stand here on the threshold of a new style. The row of warriors above is still Geometric in arrangement but not in execution. The plants with their hatching are still old-fashioned but rather advanced in the understanding of their vegetal quality. We are dealing with a painter who is called the Analatos Painter after the find-spot of one of his vases. The break-through was his.

In Boeotia, which borders on Attica, whence come finely 150 engraved Late Geometric fibulae, motifs that might go back to the Proto-Geometric period were still used on pottery in *c.* 700

247 BC. Thus a jug from Thebes in Würzburg is decorated all over with concentric circles. As in the Proto-Geometric period they are drawn with a compass, but as a result of their large number and their arrangement they seem to be rolling in contrast to the static circles of earlier centuries.

245-6 The painting on a Boeotian amphora of about a generation later is of a different type. Its shape is Urartian—the kingdom of Urartu lay by Lake Van in the area that later became Armenia—and was transmitted via the Cyclades and Euboea to Boeotia. The front carries the earliest certain representation 245 of the 'Mistress of the Animals' (Potnia Theron) in the first millennium BC., though forerunners are known from Minoan Crete. This heraldic picture from the conservative art of the Orient penetrated for a second time, like the griffins and sphinxes, to the Aegean world. The theme may first have been formulated on a lost Cycladic relief amphora, since the Boeotian picture indicates borrowing from relief pottery, especially in the frontal face of the goddess.

441 The Potnia Theron appears, as in the Minoan period, above mountain peaks which are indicated here by curving triangles 245 at her sides. Her arms turn into wings, with which she protects and rules the animals: the two birds, the two roaring lions and the snakes in the space at her sides, as well as the fish on her garment. Below her wings are a cow's head and part of its leg; these are animal offerings intended for the gods. The sacrificial 246 ritual was supervised by the goddess Artemis-Hekate, who is rightly seen depicted here. She is also related to the two snakes on the other sides which enclose a large flying bird of prey above a hare, filling the space diagonally; this re-emphasizes the realm that was under Potnia Theron's control.

The pottery workshops of Corinth were able to surpass those of other Greek states in the seventh century and dominate the export trade because of the following four achievements:

1) the shapes of their products, which were tried throughout many generations;

2) the production of a first-class gloss slip, which was achieved by the invention of the closed and adjustable kiln;

3) the combination of this gloss slip with incised drawing known as the black-figure technique;

4) the development of the miniature style which enabled tiny vessels—mostly for perfumed oil—to be decorated with multi-figured scenes.

252 The small round perfume vessel (*aryballos*) from the late eighth, and the drinking-cup (*skyphos* or *kotyle*) from the early seventh century are examples of the long tradition of shapes used by Corinthian potters in the transition from the Geometric to the Orientalizing style; both shapes are Corinthian inventions. To make the straight and curved lines on the rim of the drinking-bowl an instrument was used which can be traced back into the Geometric period: the multiple brush. The aryballos, which with its short foot and its small mouth-plate corresponds to the earliest aryballoi from Syracuse, founded in 733 BC, carries on its body fine stripes like the skyphos. On the shoulder it is decorated with tongues which lie around the neck like a rosette collar. The stripes are done with a brush on the rotating potter's wheel. By means of various operations in the kiln the lines became dark brown on the araybllos and partly reddish-brown on the skyphos. We met the same range of colours for the gloss slip on Mycenaean vases.

Even more characteristic of the transition to the Proto-Corinthian style is a large jug in the Martin-von-Wagner- 249 Museum at the University of Würzburg. The Sub-Geometric birds on the neck have deteriorated into a mere pattern. The body is boldly painted with a wavy band, which leaves far behind the manner of decoration which employed pure geometric patterns. Previously it was believed that jugs of this type were made in Magna Graecia (at Cumae), but since comparative material has been found in Greece, their Corinthian origin can no longer be doubted. The gloss slip of the stripes and the dots set between them has flaked off in places, a phenomenon which may be observed on other vases made by this technique.

A shy indication of incision appears on a fragmentary jug in 248 New York. The conical lower part—wide, flat and firm—had a long neck and handle, as is evident from numerous parallels. The main frieze shows a leaping horse, followed by a wolf; fish swim above and below. The most original motif is a bird with wings held high, standing before a protome cauldron. The lively griffins' heads on the cauldron seem to hold a dialogue with the bird. This is the typical form of the bronze cauldron in the Orientalizing period. The flat-bottomed jug is also sometimes taken for Cumaean; it ought, however, to be Corinthian, like the jug mentioned above.

Proto-Corinthian pottery is particularly rich in the variety of its jugs. From a tubular bellying jug with a round mouth and rotelles at the handle base, a so-called *olpe*, comes the 102 polychrome picture referred to above (p. 67). Here the decoration of the warriors' shields, the fineness of their profiles and the incision itself cannot be surpassed. Besides the warrior frieze there are two others: one with riders and a lion hunt, and the other showing tiny figures hunting a hare—remarkable evidence of Proto-Corinthian miniature painting.

Miniature pictures are also to be seen on an oil-vessel only 250 11.6 cm high. The plate on the mouth serves for wiping off the oil with one's hand. The vessel is wider than the earlier aryballoi, and is no longer rounded but pear-shaped. In technical terminology it is called a pointed aryballos; the Greeks seem to have called it a *lekythos* (little oil jug). On the main frieze of this vase, which dates from *c.* 630 BC, animals are depicted. On the handle side, not visible here, is a lion attacking a bull. This group stands opposite a group of three, two sphinxes crouching on either side of a goose. In the even smaller frieze below hounds are hunting a hare. Typical Proto-Corinthian dotted rosettes fill the space between them; except for these ornaments, the whole decoration is carefully incised.

On another jug, a large bellied vessel, it is clear that a metal 251 predecessor has exerted its influence—as for example, in the rotelles on top near the handle, the fluting, and the tongues on the shoulder. The colours, however, are quite traditional. Large ivory-coloured dot rosettes enliven the dark gloss slip at the rotelles, neck and shoulder-band. In addition to these colours and purple red, an apricot yellow is used, a very rare colour. On the shoulder each tongue in this colour is flanked by a black one and between each group there are always two purple red tongues.

The body of this vase, which belongs to Heidelberg University, is beautifully decorated all over with colourful scales. They were incised with the aid of compasses—the marks of the points are visible. The scales increase in size with

241 Attic Late Geometric drinking-cup with interior frieze: bulls. Clay. 720-700 BC. H. 5.5 cm. D. 13.3 cm. Erlenmeyer Collection, Basle.

242 Proto-Attic jug. Clay. *C.* 700 BC. H. 23 cm. Agora Museum, Athens.

243 Proto-Attic cauldron on a high stand pierced with lozenge-shaped design. Reconstruction with the help of the original fragments by R. Hampe. The buds on the handles of the tripod cauldron are hypothetical, but all else is certain. Clay. *C.* 700 BC. H. to rim 1.08 m. University, Mainz.

244 Rolled-out drawing of the scenes on the conical stand of the cauldron in Pl. 243: warriors marching and sphinxes squatting.

245 Detail of the main panel of the amphora in Pl. 246: 'Mistress of the Animals'.

246 Boeotian amphora, reverse. In the pictorial zone eagle and hare, on either side snakes (on the front, the goddess: Pl. 245). Clay. *C.* 680 BC. H. 87 cm. National Museum, Athens.

247 Boeotian Late Geometric jug, from Thebes. Clay. *C.* 700 BC. H. 50.8 cm. Martin-von-Wagner-Museum, University, Würzburg.

248 Lower part of a Proto-Corinthian flat-bottomed jug: bird and protome cauldron. Clay. *C.* 700 BC. Preserved H. 9.2 cm. Metropolitan Museum of Art, New York.

249 Proto-Corinthian jug. Clay. *C.* 700 BC. H. 33 cm. Martin-von-Wagner-Museum, University, Würzburg.

250 Proto-Corinthian oil vase (early form of lekythos) with animal frieze. Clay. *C.* 630 BC. H. 11.6 cm. Antikenmuseum, University, Heidelberg.

251 Proto-Corinthian jug with scale pattern. Clay. *C.* 620 BC. H. with handle 29.8 cm. Antikenmuseum, University, Heidelberg.

252 Proto-Corinthian vases: skyphos (drinking-cup) and aryballos (perfume container), both with striped decoration. Clay. The aryballos belongs in the last quarter of the 8th century, the skyphos in the first quarter of the 7th century. H. of skyphos 8.6 cm; H. of aryballos 6.7 cm. Martin-von-Wagner-Museum, University, Würzburg.

253-4 Cretan cauldron with three griffin protomes, from Arkades. Clay. Mid-7th century. H. 21 cm. Museum, Iraklion.

255-6 Cretan lion bowl. Clay imitation of an Oriental bowl for oil with leather bag attached. Mid-7th century. H. 4.3 cm; D. of the vessel 13.1 cm. Antikenmuseum, University, Heidelberg.

257 Early Corinthian pyxis with animal friezes. Last quarter of 7th century. H. 15.9 cm. Martin-von-Wagner-Museum, University, Würzburg.

258 Chiot chalice. Clay. Late 7th century. H. 15.8 cm. Martin-von-Wagner-Museum, University, Würzburg.

259 Attic black-figured jug: Hermes between sphinxes. Clay. *C.* 600 BC. H. 26 cm. British Museum, London.

260 Cycladic (Naxian) plate (without the heavily restored lower section): Bellerophon and Chimaera. Clay. Mid-7th century. D. 28 cm. Museum, Thasos.

261 Amphora in the 'Linear Island style'. Clay. Mid-7th century. H. 59 cm. Royal Palace, Stockholm.

241

242

244

243 245

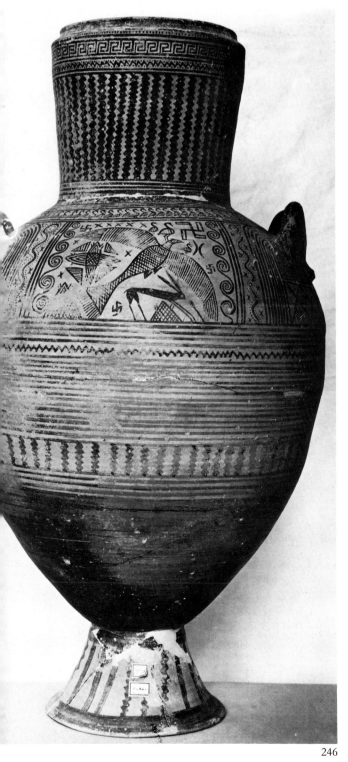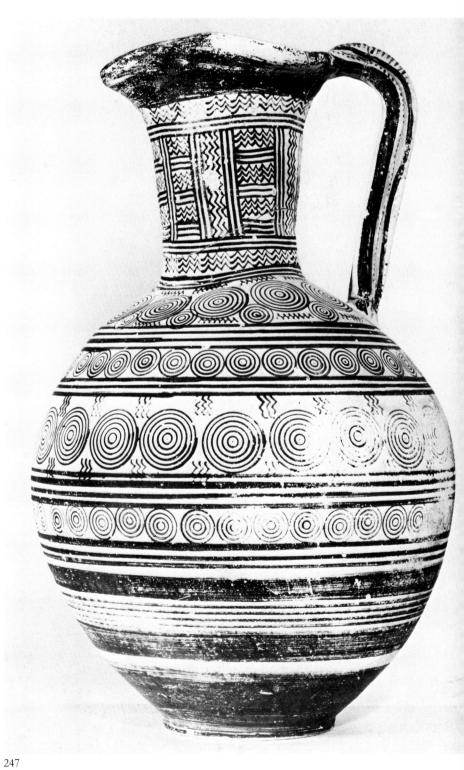

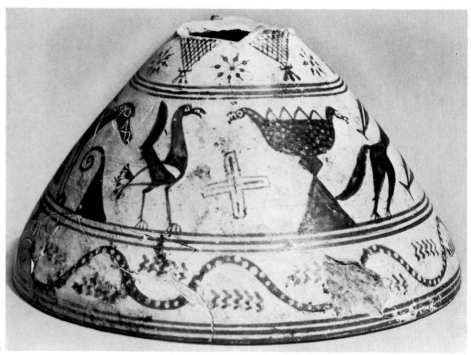

248

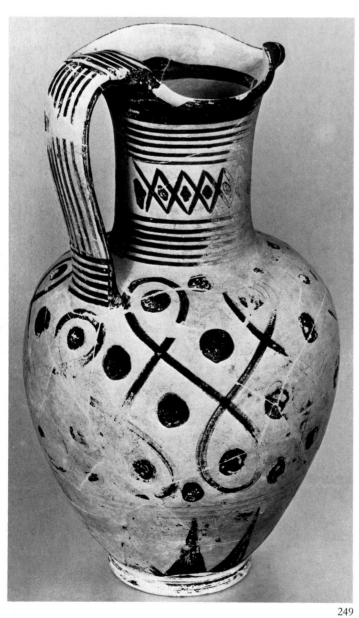

249 250

251

252

253

254

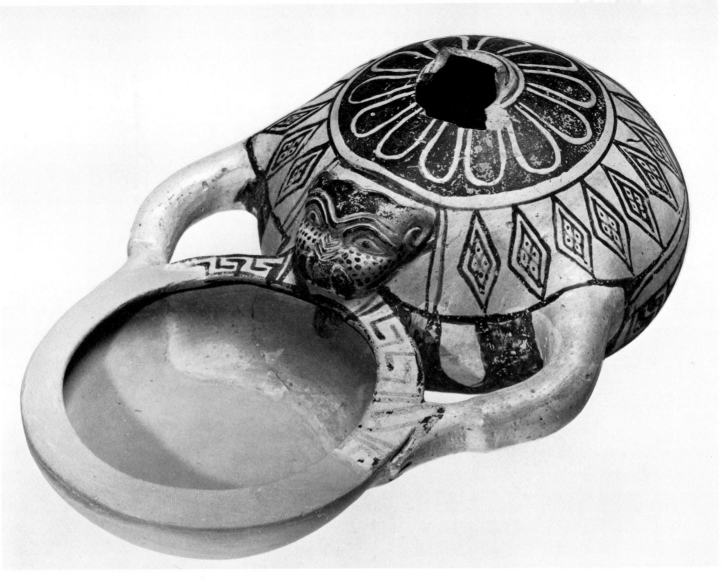

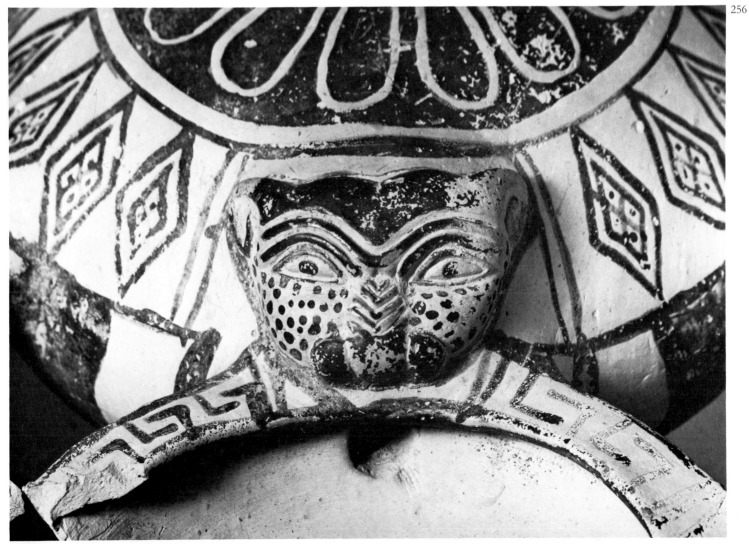

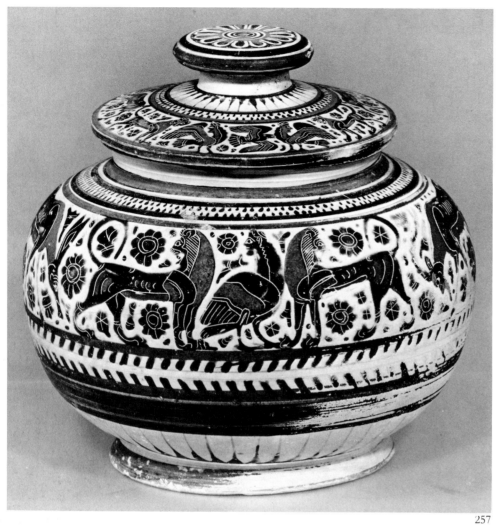

257

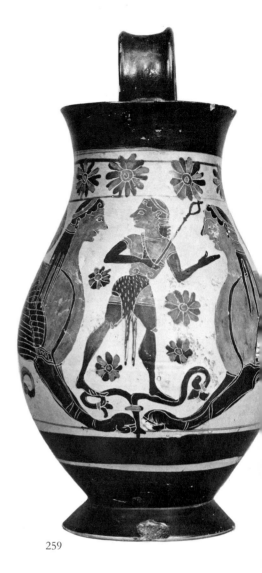

259

258

261

the swelling of the jug and diminish again as it tapers toward the foot. In addition there is a variously coloured diamond pattern. Vase-painters worked quickly, because the kiln had to be filled as fast as possible, but this decoration could only be done cautiously and carefully. The jug is a masterpiece of its type: it belongs to the transition from Proto-Corinthian to Early Corinthian, *c.* 620 BC.

257 This next step in the development of the Corinthian style is reached on the box (pyxis) with a lid. In the main frieze lions which are looking over their shoulders flank a bird with a human head, a siren. Other animals and monsters complete the circle. A similar animal frieze, but smaller, runs around the lid, while a large rosette decorates the knob. Instead of dot rosettes blooms, petals or buds are now incised in the gloss slip, which fill all the free space between the animals like a carpet. Form and decoration are harmoniously combined.

253-4 As we explained above (p. 113), contact with Oriental influence was particularly intense on Crete. The two vases chosen here are evidence of this. One is a bellied dinos, from which three plastic griffins' heads protrude. We are dealing with a successor of the bronze protome cauldron. It was used as an urn in the necropolis at Arkades in south-central Crete. The bird-like bodies of the griffins with their outstretched wings are painted on the wall of the vessel. To us such a combination of painting and sculpture seems rather baroque. The Cretan potter must have imitated an Oriental import; we know, for example, of a Persian gold bowl with plastic lions' heads which are carried on in engraved low relief on the wall. The animal heads in the centre of the bronze discs from the Idaean Cave ought also to be compared, for these are also continued partly in low relief. Completely different motifs are painted in the metopes between the griffins: a crowned sphinx whose wings are hatched like the griffins' wings, a crouching lion (not visible here), rosettes and birds. Large quarter-rosettes fill the remaining spaces. The very old Geometric motif of concentric circles is confined to the lower zone.

255-6 A vessel from the same period *c.*, 650 BC, which is in Heidelberg, can likewise be attributed on stylistic grounds to the potteries of Arkades. The lion's head, which encloses a flat bowl in its human arms, may be compared with Oriental steatite vessels. These end in a connecting plug to which an animal skin filled with oil could be attached. By squeezing the bag the oil flowed through the hole in the lion's mouth into the basin. A broad rim served to wipe the oil off one's hand, as with the lekythos. The Cretan potter has imitated the bag in clay. The width of the lion's head recalls the lions beside the naked goddess in the Oriental tondo from the Idaean Cave, but it is imbued with more tension and aggressiveness.

261 From the other Greek islands there are variations on the Orientalizing style. Humfry Payne called one the 'Linear Island style'. One of the finest specimens is in the Royal Palace at Stockholm. The form of the amphora is similar to the Boeotian specimen. The neck is decorated with geometric patterns, but a number of parallel horizontal bands run around the body. Between them is the picture zone, restricted to a single motif, a stag grazing. The painter dared to leave out all traditional filling ornaments and to fill the space provided with this animal alone. Diagonal lines also play a role, both on the back and front legs and on the bent head. In addition light and dark arcs (the gloss slip is a warm reddish brown) are disposed

thoughtfully and effectively. It is not yet clear with which Cycladic island this sensitive style is connected.

258 In any case Chios was certainly the home of the drinking vessels called 'Chiot chalices'. They were found on the island itself, on the coast of Asia Minor opposite, on the shores of the Black Sea and as far afield as Egypt and Etruria. From Etruria, probably from Vulci, comes the famous pair of chalices in Würzburg, the larger of which is illustrated here. Between the time of the egg-shell-thin Kamares cups (see p. 132) and the late seventh century no finer drinking vessels were made in the Aegean than these Chiot chalices. Their decoration belongs to the Orientalizing style, which in the Greek east goes on far into the sixth century. The Würzburg chalices are among the earliest pieces from *c.* 600 BC. They are totally black inside. There is no trace yet of the decoration of the interior with large white and purple painted flowers. On the outside only the foot and the fine handles are covered with gloss slip; otherwise light and dark, or rather ivory and reddish brown, are distributed equally over the surface. Below there are pointed leaves that enclose the chalice as if it were a flower. The convex handle zone, from which rises the steep wall, is emphasized on the side illustrated here by a complex plaited pattern. Vertical ornaments above the handles divide the decoration into two fields. On the opposite side wild goats are striding along; here different animals flank heraldically a central motif consisting of four spirals which may be thought of as plants. From the left a bull approaches; in front of it a small bird is perched with its head to the rear. A large goose—or is it meant to be an ostrich?—and a lion come from the right. One should note how carefully the eye of each species is differentiated. Semicircular and triangular filling motifs hang from above and below. The bull's black hide is broken up by characteristic reserved patterns, and the large bird's wings also have such stripes. Even the finest lines are reserved, not incised, in contrast to Corinthian and Athenian techniques.

260 An extremely painterly style appears on a plate uncovered by French archaeologists on Thasos, of which the main picture (without the segment depicting a dog running) is illustrated here. The ground-line is a sloping hatched meander. Standing on it to the left is the Chimaera—a hybrid creature, part lion, part goat and part snake—which turns all its three heads back towards its adversary. This is the young hero Bellerophon, who rides through the air on Pegasos. The height at which he is flying is indicated by the (partly preserved) bush of palmettes and volutes, on top of which is the flying horse. Its harness, which was given to this hero by Athena, is carefully depicted. The painter almost seems more interested in the harness with which the legendary beast was tamed than in the fight with the Chimaera, since Bellerophon holds the reins in his right hand while wielding his lance in his left. His head, the horse's and two of Chimaera's heads—the lion's and the goat's—are all done in outline, as are the snake's triangular head, seen from above, and its horizontally ridged stomach. This monster was named the Chimaera after its middle section, which consisted of the forepart of a goat growing from a lion's back. Pegasos' long, slightly bowed wings do not yet have the canonical sickle form that was common in Archaic art after the mid-seventh century BC. The plate must therefore have been made in the middle of the seventh century. It is, as John Boardman thinks, almost certainly Naxian which is related to the so-called Melian style, a style that has not been localized with certainty.

171

Since many 'Melian' vases were found on Delos, it is thought that one of the Cyclades was the centre of production—perhaps, as has recently been suggested again, in fact the island of Melos.

To conclude, let us look again at Athens. In the course of the seventh century pottery here developed to the climax represented by the Netos amphora, in which strong temperament is tamed by a strict language of form. The Netos Painter fulfills the tendencies of the ripe seventh century while also looking ahead to the sixth. The oinochoe in London comes from the hand of one of his contemporaries. It shows even more markedly the influence of Corinth on Attic workshops, which brought their outrageous fantasies within stricter bounds. Between two large sphinxes, which sit facing each other, a dainty Hermes with his messenger's staff steps on a tendril. We do not know what message he brings them, but it is made clear that communication with demonic creatures is not difficult for him. After the Early Corinthian model incised filling rosettes are deliberately put in the picture zone, while subtle incisions enliven the whole heraldic composition. This is the time when Attic exports first appear in Etruria, especially at Caere. From now on they compete with Corinthian pottery and during the sixth century go on to surpass it by far in the eyes of Etrurian purchasers as well as in our eyes.

Engraving

Mycenaean Gems and Gold Rings

Gem-engraving, like many branches of Mycenaean art, was derived from Crete, where it began in the third millennium under Oriental influences and reached its peak between 1700 and 1450 BC. The earliest gems found in mainland Greece come from the two grave circles at Mycenae, i.e. sixteenth century BC. Circle B, which is slightly earlier, produced only four examples; Circle A, excavated by Schliemann, twice that number, including five of gold. The gems from the earlier grave circle could be assigned to Cretan workshops, but the artistic origin of the gems and rings from Schliemann's excavation is still disputed; some authorities have held that they are Minoan products, others that they are partly Mycenaean. As will emerge from the descriptions of each piece, the arguments for the second opinion are the stronger. In no other find-group of Minoan and Mycenaean gems do motifs of hunting and fighting predominate as they do in the shaft graves of Circle A. Religious themes, such as are known from the chamber tombs of Mycenae or the richest find on the Greek mainland (the 43 gems from the tholos tomb at Vapheio) are totally absent from both grave circles; this is all the more surprising since the majority of the gems from Schliemann's grave circle belong to women's graves, not men's. If these objects were used as seals, one would have to conclude that this activity fell predominantly to women of the ruling families. But apparently in the early period of Mycenae gems and rings were in the main worn as ornaments, in contrast to Crete, where by this time people took great pleasure in seals. The custom of using seals was in fact closely linked with the use of writing, and the Mycenaeans of the shaft-grave era were still illiterate, whereas the Cretans already had their script, Linear A. As modern research has shown, the Achaeans developed the Mycenaean script (what is called Linear B) in the century after the shaft graves, or perhaps even earlier, before the conquest of Knossos (c. 1450 BC). Its basis was Linear A—still largely incomprehensible to us. Thus it is not by chance that from this period (even more so, subsequently) many seal impressions of Mycenaean origin have survived.

Naturally, even when they were used as seals, the gems were also ornaments. This becomes particularly clear from the gold rings, which, even when they were 'seals', on the whole give the 'correct' view not in impressions, but on the originals. This is especially recognizable in the action of the right hand of the human figures, for naturally the direction which the numerous animals face makes no difference. Where no other indication is given, the following descriptions are based on the originals; impressions are specified.

Alongside the gold rings, already attested by Schliemann's shaft graves, whose oval bezels were decorated like gems according to Minoan custom, Mycenaean engraving was on precious stones, partly found locally, partly imported. The gems were shaped into two main forms: amygdaloid (almond-shaped) or lentoid (lentil- or lens-shaped); the latter is more common. The decorated area was normally, as on a ring, more or less convex. Amygdaloids and lentoids are invariably pierced—the latter may have been worn by hanging them from a cord on the wrist (more rarely, on the neck); a good example of a lentoid gem may be seen on the Knossos fresco

with the Rhyton-bearers. When the edge of a round gem was not plain, as with a lens, but flat as on a modern coin, it is called discoid, but this form is virtually absent from Mycenaean gem-engraving. On the elliptical surfaces of gold rings and amygdaloid gems the scene is in general set transversely along the field, though with the latter the other orientation is also found. Circular and oval compositions predominate throughout. Even the three-sided prisms for the most part have round pictures, whose impressions cannot be distinguished from the lentoids. On the other hand the number of rectangular gem-pictures on flattened cylinder seals is small, though three gold examples, pierced through their length, came from Shaft Grave III.

The deceased with the electrum mask in Grave Circle B was 262 buried with a discoid amethyst showing a man's head in profile; the head, with its stringy hair and beard, is almost like a mask, as the neck is not visible. Despite the small scale—the stone is only about 1 cm in diameter—the pupil is clearly indicated; so also are the ear and a lock of hair which stands out from the close-cut fringe above the brow. The head was originally taken to be a portrait of the dead man, but later the objection was raised that the gem was too minute for the portrait of a prince; since the discoid form is not Mycenaean but Minoan, we have here an import from Crete, where similar men's heads are found on gems; the lock of hair on the brow is also typically Minoan.

Another grave in the earlier grave circle contained the skeleton of a girl, round whose neck was a necklace with nine components. Only the central stone—an amygdaloid 263 cornelian—bore a representation. This, too, can be identified as Minoan, since we know its style from numerous gems from Crete; we call this kind of decoration, with its preference for sketchy, abstract forms, talismanic. Such gems are engraved so deeply that they cannot often have been used as seals, but will have served as amulets. The designation is unfortunate, since it is certain that other gems besides these served as talismans, and we also know from later sources that the stone had even more of an amuletic character than what was engraved on it. Another imported piece of this kind came from the tholos tomb at Vapheio.

Gems in talismanic style with its simplified mode of representation are not the result of a later development but continued from c. 1700 BC to the middle of the millennium in Crete alongside those with naturalistic representations. The abstract element has a technical origin, for Minoan craftsmen used a limited range of tools to produce lines, circles or arcs on these mass-produced gems. Organic forms could hardly be represented in this way; instead, in addition to ornamental motifs, vases and plants were favoured. The gems seem to have some connection with the Minoan vegetation cult. This cornelian from the earlier grave circle shows a globular vase with two handles, and twigs, some of which are arranged like the crown of a palm. The palm played an important role in Minoan-Mycenaean cult; it may well be this tree that is depicted here. The motif may have seemed exotic to the Mycenaean princess whose jewels included this cornelian. Both the precious stone and the palm stemmed from the farthest limits of the world as these were known at the time.

Schliemann's Shaft Grave IV yielded two gold rings of 265- about the same size; like most Mycenaean rings they are not of solid gold but of thick sheet gold laid on a softer metal,

e.g. lead. The edges of the rings are set back and grooved; the bezel is an oval set along the knuckles, the scene being set transversely as usual. On one ring four men are shown in violent combat. In the middle a warrior with a boar's-tusk helmet makes a wide stride to thrust his dagger at his opponent; the latter has fallen on his knees and with his remaining strength brandishes his long sword; the upper part of his body is seen from behind, that of his attacker is in frontal view. Both wear the same kind of kilt; the kneeling figure, helmetless, has his hair bound up on his head. In contrast, his comrade is armed with a boar's-tusk helmet and a shield that is convex at the top; it almost covers him, and above it, as he retreats, he directs his spear at their common adversary. It is not clear whether the spear, on which there is an oblique bar like a pennant, continues above the kneeling figure. On many Minoan and Mycenaean gems, even where the setting is depicted, unrelated objects are shown in the background. They serve as a warning not to transfer our concepts of space to these compositions. Gem-engraving is a form of art which tends towards a heraldic arrangement of elements.

The fourth figure on the ring is a nude, bearded man seated on the ground. He has been interpreted as an opponent of the main figure, wounded and already disarmed; but this is not the only possible explanation, for his long beard and bald head mark him as an old man, in contrast to the young warriors, and for this reason it is hard to believe that previously he had been fighting in armour. His position behind the main figure might mean that he is on the same side as the latter, who has come to his aid. In that case the men kneeling and retreating could be taken as guards or tormentors of the aged man, whose son or young kinsman is avenging him. The fight takes place in a rocky landscape; in accordance with Minoan—Mycenaean artistic convention the rocks also project into the scene from the upper border, and they are even shown behind the old man, giving the impression of a glen or hollow. The owner of the ring may have taken this to be a specific event, probably something from his own family. We cannot identify the names, yet we must remember that the earliest Greek legends tell of maltreatment of an aged king by younger members of a royal house, and retaliation for it. One thinks of Laios, Oedipus and his sons. The tradition about the royal family of Aitolia is less well known than the Theban myths, but it is equally ancient. In this legend the aged king, Oineus, was ill-treated by his younger brother, Agrios, and finally avenged by a younger member of the family.

Since the gems from Grave Circle B, which is slightly earlier, are Cretan imports, one must ask whether the same is true of the Minoan-type ring as well. At that time Mycenae had no tradition of gem-engraving. On the other hand the numerous Minoan gems and seal impressions of the sixteenth century show few scenes of fighting and narrative elements, which in general are in evidence on the gold ring, but to a much lesser extent on Cretan gems. It is no accident that the description given above takes one close to myth. Can this new tendency in the Aegean in the area of Crete, be due to some Oriental, and not Minoan, influence? It seems that Oriental battle scenes are even less comparable, since in them more emphasis is laid on the victor as the principal figure. On the ring he is larger than his opponent, and is threatened by a long sword and a spear. The outcome is still in the balance. We are dealing with a battle scene which, to judge by representations of the following millennium, we can term typically Greek. This ring may therefore be regarded as a Mycenaean work—even if, as John Boardman assumes, it was made by a Cretan artist—the latter has succeeded in meeting the wish of his Achaean patron. It is reasonable to suppose that engravings were commissioned, since gems are among the most personal of all works of art.

Much the same is true of the counterpart, the hunting scene. It represents two stallions dashing past in a 'flying gallop', with a chariot on which are a driver and an archer aiming his arrow at an outsize stag. The latter speeds away, but turns its head back in an attitude like that of the lion wounded by an arrow on the discoid from Shaft Grave III. So the beast is already shot, though there is no arrow sticking in its side; this is omitted, like the pole and reins of the chariot. The artist has composed the three motifs on the ring—the stag, the stallions, and the chariot with the two men—in accordance with the rules of heraldry rather than those of spatial logic. This is one of the few representations of horses among the numerous animals in Minoan–Mycenaean engraving. They are present only on two seals, a lost lentoid from Crete and two cornelians from the tholos tomb at Vapheio mentioned above. Of these we here select the lentoid cornelian with a two-horse chariot. It was made about a century later than the ring from Shaft Grave IV, and shows advances in observation of the horse's body. In contrast the driver and the man with the spear are shown summarily. However, it represents clearly the thick pole, with bands round it, and, above, the series of loops (known from many pictures of chariots on Late Mycenaean vases) and the harness on the head, neck and chest of the horse which trots past. These many accessories make it clear how bold the artist of the gold ring was to leave them out, in order not to obscure the composition. His horses look like a first attempt, while his stag, a masterpiece of animal representation, is stylistically more developed than the suckling hind on a lentoid amethyst from Shaft Grave III. The stag is significantly larger than the horses, which are depicted in a way that brings out how fast the chariot moves through the undulating terrain, with a tree on the left and rocks above. Still more admirable is the accuracy of the shooting. Despite all the heraldic elements here too the narrative tendency shows through markedly.

Among the three gold flattened cylinder seals from Shaft Grave III which are worked in the same technique as the rings, one shows a man fighting a lion; we have here the scene on a dagger from Shaft Grave IV, compressed to a representation with two figures. The lion rears up and, clutching the man with its front claws, is about to bite his shoulder; the man, dressed only in a kilt, raises his dagger against it. As on the gold ring with the 'Battle in the Glen', the outcome is still undecided. The second seal bears only the representation of a wounded lion (mentioned above); the animal is collapsing on rocky ground and with its mouth is trying in vain to reach the arrow sticking in its flank. As John Boardman, one of the best judges of Bronze Age engraving, has observed, scenes with lions are even more popular in mainland Greece than in Crete. How Minoan and Mycenaean artists had the notion of portraying lions is an unsolved problem; the opportunity for observation from nature must have been limited (the Nemean Lion was a mythical creature). It is assumed that in Crete and Mycenae the lion was taken over from the art of the Orient and details from native large dogs added; this procedure can in fact be observed in Greek art of the first millennium BC. In both periods the

262 Discoid: head of a bearded man, from Shaft Grave Gamma of Grave Circle B at Mycenae. Amethyst. 16th century. D. 1 cm. National Museum, Athens.

263 'Talismanic' amygdaloid: vessel and twigs, from Shaft Grave Mu of Grave Circle B at Mycenae. Cornelian. 16th century. 1.75 × 1.4 cm. National Museum, Athens.

264 Lentoid: chariot and team, from the tholos tomb at Vapheio. Cornelian. 15th century. National Museum, Athens.

265 Ring: 'Battle in the Glen', from Shaft Grave IV of Grave Circle A at Mycenae. Gold. 16th century. Bezel 3.5 × 2.1 cm. National Museum, Athens.

266 Ring: stag hunt by chariot, from Shaft Grave IV of Grave Circle A at Mycenae. Gold. 16th century. Bezel 3.45 × 2.1 cm. National Museum, Athens.

267 Lentoid: suckling hind, from Shaft Grave III of Grave Circle A at Mycenae. Amethyst. 16th century. D. 1.8 cm. National Museum, Athens.

268 Flattened cylinder: wounded lion, from Shaft Grave III of Grave Circle A at Mycenae. Gold. 16th century. 2 × 1.5 cm. National Museum, Athens.

269 Flattened cylinder: man and lion fighting, from Shaft Grave III of Grave Circle A at Mycenae. Gold. 16th century. 2 × 1.5 cm. National Museum, Athens.

270 Flattened cylinder: duel, from Shaft Grave III of Grave Circle A at Mycenae. Gold. 16th century 1.8 × 1.2 cm. National Museum, Athens.

271-2 Lentoid: lion and bull, from the royal tholos tomb at Midea (Dendra) in the Argolid. Onyx (Pl. 272) and impression. C. 1400 BC. D. 4 cm. National Museum, Athens.

273 Lentoid: lion and bull, from the tholos tomb at Vapheio. Impression from an agate. 15th century. D. 2.81 cm. National Museum, Athens.

274 Lentoid: lion and bull, from the tholos tomb at Rutsi near Pylos. Impression from an agate. 15th century. D. 2.5 cm. National Museum, Athens.

275 Lentoid: woman offering lilies, from a tholos tomb at Rutsi near Pylos. Impression from a cornelian. 15th century. D. 1.7 cm. National Museum, Athens.

276 Ring: cult scene with women and children, from the Treasury of Mycenae. Gold. C. 1500 BC. Bezel 3.4 × 2.5 cm. National Museum, Athens.

277 Ring: enthroned figure and a griffin, from Chamber Tomb 91 at Mycenae. Gold. 15th century. Bezel 1.9 × 1.2 cm. National Museum, Athens.

278 Ring: sphinx, from Chamber Tomb 91 at Mycenae. Gold. 15th century. Bezel 2.1 × 1.1 cm. National Museum, Athens.

279 Ring: praying women in a sanctuary, from Chamber Tomb 91 at Mycenae. Gold. 15th century. Bezel 2.55 × 1.5 cm. National Museum, Athens.

280 Ring: vegetation cult, from Chamber Tomb 91 at Mycenae. Gold. 15th century. Bezel 3 × 1.8 cm. National Museum, Athens.

281 Ring: antithetically arranged griffins, from Chamber Tomb 68 at Mycenae. Electrum. 15th century. Bezel 3 × 1.7 cm. National Museum, Athens.

282 Ring: vegetation cult, from the tholos tomb at Vapheio. Gold. Minoan. 15th century. Bezel 2.15 × 1.38 cm. National Museum, Athens.

283-4 Amygdaloid: reclining lion, from the tholos tomb at Vapheio. Agate (Pl. 283) and impression. 15th century. 2.45 × 1.4 cm. National Museum, Athens.

285 Lentoid: priest and griffin, from the tholos tomb at Vapheio. Jasper. 15th century. D. 2.25 cm. National Museum, Athens.

286 Lentoid: woman riding on sea-monster, from the Lower City at Mycenae. Impression from an agate. 15th century. D. 2.7 cm. National Museum, Athens.

287-8 The ring of Nestor: bezel divided into four scenes by water-courses, dancing men and women, all with aniconic heads, engaged in the vegetation cult. In the left half, above: lion; below: griffin, the royal heraldic animals; below, in the middle: sea-monster (cf. Pl. 286). Right, above: butterflies with their chrysalises, important creatures in the Minoan cult, whose design confirms the genuineness of this piece; from Kakovatos. Gold. Minoan, 15th century. Bezel 3.3 × 2.1 cm. Ashmolean Museum, Oxford.

289 Lentoid: collapsing bull, from the tholos tomb at Vapheio. Jasper. 15th century. D. 1.85 cm. National Museum, Athens.

290 Lentoid: two reclining cattle, arranged heraldically, from the tholos tomb at Vapheio. Impression from an agate. 15th century. D. 2.25 cm. National Museum, Athens.

291 Lentoid: two reclining bulls, from the tholos tomb at Vapheio. Impression from an agate. 15th century. D. 2.23 cm. National Museum, Athens.

292 Lentoid: two reclining bulls and shrub, from a tholos tomb at Rutsi near Pylos. Impression from a sardonyx. 15th century. D. 2.8 cm. National Museum, Athens.

293 Lentoid: bull trying to lick its hind hoof, from the tholos tomb at Vapheio. Impression from a sardonyx. 15th century. D. 2 cm. National Museum, Athens.

294-5 Stirrup-jar: a bull trying to lick its hoof, from the 'House of the Oil-Merchant' at Mycenae; the sealed spout bears more impressions of the same amygdaloid seal, slightly damaged below (Pl. 295). 13th century. 2 × 1.5 cm. National Museum, Athens.

296 Lentoid: two demons with jugs at a cult place, from the tholos at Vapheio. Impression from an agate. 15th century. D. 1.95 cm. National Museum, Athens.

297 Amygdaloid: demon with jug, from the tholos tomb at Vapheio. Impression from an agate. 15th century. 1.89 × 1.3 cm. National Museum, Athens.

298 Lentoid: demon with two dead lions on a pole, from Crete, slightly damaged on the right. Honey-coloured cornelian. 14th century. D. 2 cm. Antikenabteilung, Staatliche Museen Preussischer Kulturbesitz, Berlin.

299 The large ring: procession of demons with jugs to an enthroned figure, from the 'Treasure of Tiryns'. Gold. C. 1400 BC. 5.7 × 3.5 cm. National Museum, Athens.

300 Ring: young man with ibex in a tree sanctuary, from Chamber Tomb 84 at Mycenae. Gold. 15th century. Bezel 3 × 1.95 cm. National Museum, Athens.

301-2 Prism with rounded faces: two reclining ibexes (Pl. 301); lion and ibex (Pl. 302), from a chamber tomb at Midea (Dendra) in the Argolid. Impression from an agate. C. 1400 BC. D. of both c. 2.4 cm. National Museum, Athens.

303 Seal impression: lion and bull, from the palace at Pylos. Clay. 13th century. D. 2.8 cm. National Museum, Athens.

304 Amygdaloid with setting: four-legged animal, from Melos. Cornelian. C. 600 BC, imitating Bronze Age seals. 1.95 × 1.23 cm. Antikenabteilung, Staatliche Museen Preussischer Kulturbesitz, Berlin.

262

263

264

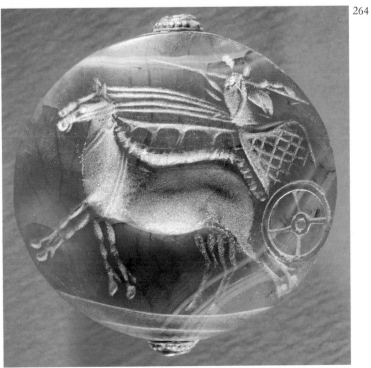

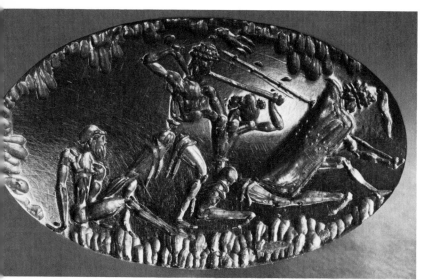
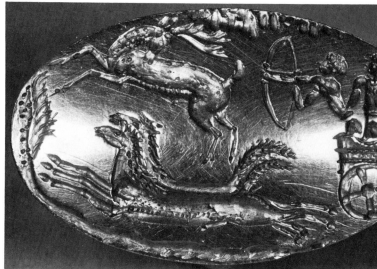

265 266

267 268

269

270

271

272

273

274

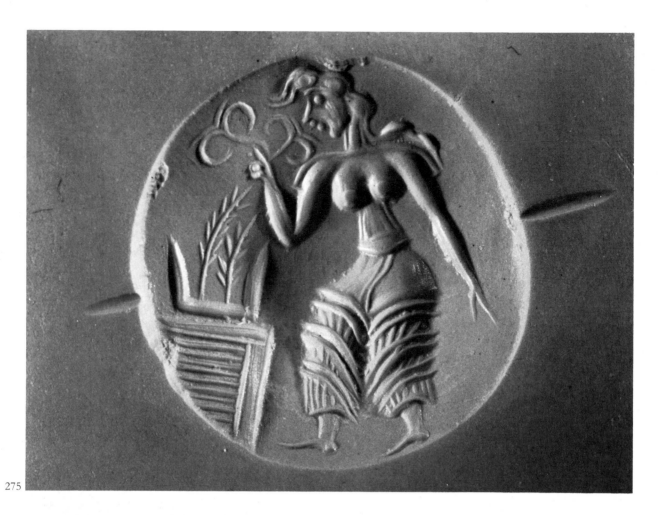

275

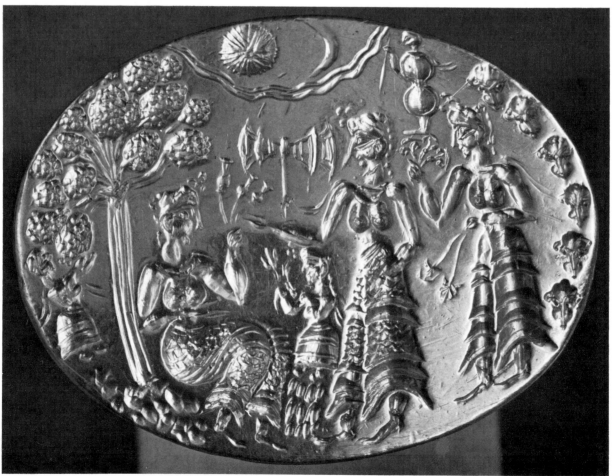

276

277

278

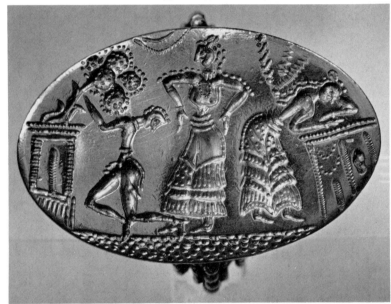

279

280

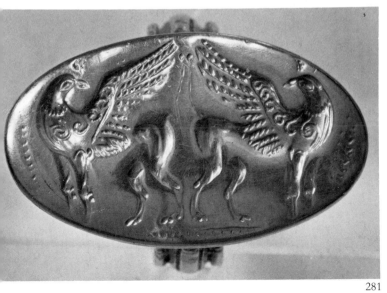

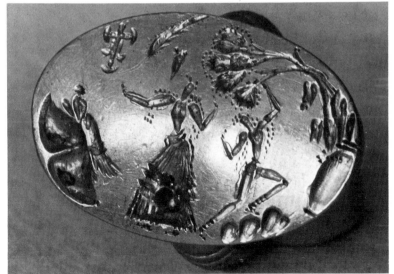

281

282

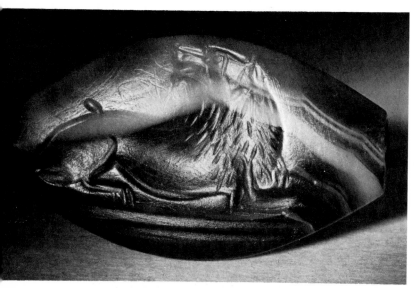

283 284

285 286

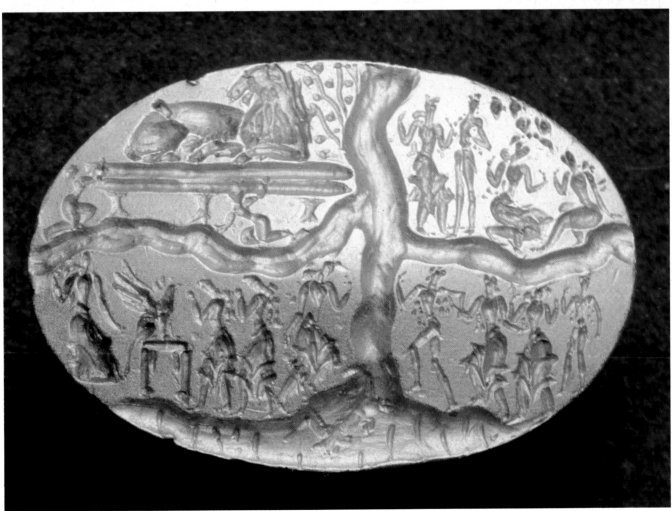

289

290

291

292

293

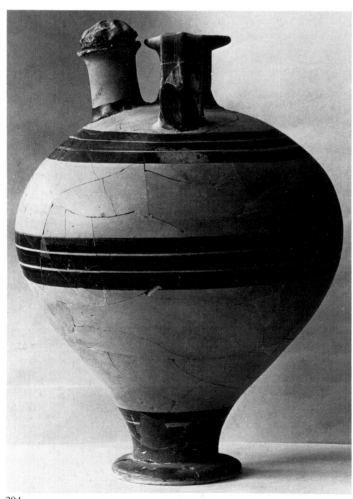

294

295

296 297 298

299

300

301

303

302

304

same 'errors' are found—for instance, in the form of the rump, and in the mane given to lionesses; however, Minoan—Mycenaean lions have no element of the hound. Even when strongly stylized they have a cat-like sinuosity, and it seems that the leading artists of the time studied wild cats rather than hounds in order to represent the attitude of the lion in a way that corresponded to nature. We suggested earlier, as regards 177 the leopards on Mycenaean dagger-blades, that the animals were kept in pens owned by princes; they were more suitable than hounds to make up for the inability to observe lions in nature.

The lions in the numerous groups in Mycenaean engraving showing them fighting bulls are portrayed in attitudes similar to those of trained leopards hunting in open country. A few 71-2 examples follow. One of the finest is on a lentoid onyx from the royal tholos tomb at Midea (Dendra) in the Argolid, of 73-4 around 1400 BC; it may be compared with two lentoid agates from Vapheio and Rutsi near Pylos—illustrated here from impressions, since the originals have many veins and since these gems can be regarded as seals even at this date. The bull is shown either in the Minoan scheme of the 'flying gallop', or in an attacking pose, with lowered head, or else collapsing, the head thrown up and the mouth open in a bellow. The bull's attitude shows far more variety than that of the lion—surely because here there was ample opportunity for observation from life; in each case the lion springs like a cat on to the bull's back and bites its neck. In two instances the lion's head is shown from above, as on the flattened cylinder from Shaft Grave III, which is an extremely common method of representation in Mycenaean art. It may be intentional that it recalls a hunter's trophy; dressed lions' skins may have existed as imports both in Crete and in the royal palaces of the mainland.

270 On the third flattened cylinder from Shaft Grave III a heavily-armed warrior is engaged in a duel with a youthful hero dressed only in a short Cretan kilt; the latter strides forward impetuously, his long hair flying in the wind, and thrusts his sword over the rim of the figure-of-eight shield into his adversary's neck. Here the issue of the fight is decided; the spear of the armoured man misses its target and flies into air. Beneath the spear the elongated object with transverse ribs looks like a sheath; it is simply placed in the empty background, in the heraldic manner described above. It is surprising that war-like themes decorated objects from shaft graves which were worn mainly by women; in this connection one might recall the Boeotian fibulae of the eight and seventh centuries BC, on the plates of which similar themes are found. The explanation surely is that in war men also fought to protect the women of their family; 'like Andromache, they had reason to fear the loss of their husbands, and therewith the loss of their freedom; these ideas are clearly reflected on the fibulae' (Roland Hampe).

Unless the gems, the gold rings and flattened cylinders had been found in the two grave circles at Mycenae, one would hardly have dated them all in the sixteenth century BC; the dating of Mycenaean gems purely by style is problematic, and in books on the subject the attribution often varies by centuries. The chronology worked out by Arne Furumark for pottery cannot be transferred without further ado to the other branches of art; in the next phase of Mycenaean art, in the fifteenth century, engraving differs from that of the shaft-grave period less by style than by its themes. This is less true of representations of combats between animals—dealt with above—than of religious themes, which now bulk much larger. It was mainly with the help of the gems and rings of this period that Martin P. Nilsson wrote his pioneering work on Minoan—Mycenaean religion.

A treasure found in a house in the citadel of Mycenae, near Schliemann's grave circle, can be dated to the transition from Late Helladic I to Late Helladic II; in style and in the type of objects the contents are not very different from those of the shaft graves. Of the two gold rings in the treasure (both stolen from graves during the Bronze Age and reburied) one is among the most famous Mycenaean works of art. It shows 276 a cult scene: two women crowned with lilies approach a goddess, similarly adorned and seated on rocks beneath a sacred tree; the small, regular stones in front of her represent the pebble floor of her sanctuary. The gesture of the leading woman's hand allows one to conclude that she has given the goddess the bunch of poppy-heads which the latter is holding in her hand; with both hands the second woman brings flowers—lilies and irises; all three wear Minoan—Mycenaean ceremonial dress, with flounced skirts and bare breasts, shown in frontal view. A lentoid cornelian from Rutsi near Pylos 275 illustrates the close connection between gold rings and gems; on it a woman similarly dressed approaches a place of sacrifice, bearing lilies (the impression shown here might well give the correct picture, since otherwise the woman making the offering would be left-handed). As with the representations of griffins discussed below, the carved stone is the more sensitive work, when contrasted with the gold ring: compare the women's profiles, hair and movements. Analogous themes occur in Mycenaean wall-painting. On the ring, as on some 276 gems, two childrens are set beside the goddess as her servants—two little girls in similar, though less elaborate, dress; one stands on the pebble floor and holds out a bunch of flowers to her, the other, behind the goddess, raises both hands to the tree, as if to pluck something from it. Since there is an array of small, plain round fruit, this may be a mulberry-tree; on an olive-tree the bole would be gnarled, not smooth, as it is here, and in Minoan—Mycenaean art its upper part would be stylized in a different way. The mulberry, which ripens earlier than all other fruit-trees, was a particular favourite among Greek children, according to later sources.

Though this ring surpasses other Mycenaean engraved works, it is not free from heraldic elements. Between the figures are set a double axe and an armed image (Palladion) with a figure-of-eight shield, and six frontal lions' heads are arranged round the right border; reference to the lion's-head rhyton from Shaft Grave IV allows us to interpret them as cult 126 vessels. Taken with the sacred sign of the double axe and the armed image they enhance the cult character of the scene. Above, over an undulating double line, two heavenly bodies—a large star and a crescent moon—belong partly to the heraldic element, partly to the landscape.

Among divinities in the later Greek pantheon the name 'Aphrodite in the Gardens' would best fit this goddess; there is evidence of her cult at Athens, where, above all other Greek cities, the cult tradition of the Mycenaean period was preserved in its purest and most complex form; that goddess, together with Athena (whose Palladion can be seen above right on the ring), had a secret ritual which can be proved to go back to the

Bronze Age. At the heart of the ritual were two little girls (Arrhephoroi), who on a particular night in summer went from the Acropolis by way of a Mycenaean stair to the sanctuary of 'Aphrodite in the Gardens' on the north slope of the Acropolis. Two little girls are set behind the goddess on the ring; the moon and star (the planet Venus?) show that it is night; and the mulberry with its ripe fruit indicates that it is summer, when the ritual took place (it was certainly not celebrated in Bronze Age Athens alone). Before their nocturnal journey, in which they carried secret objects—surely a fertility charm—the Arrhephoroi spent a period as cult servants of Athena and Aphrodite; it is the little girls' stay in the territory of the gods, not the extremely secret ritual, which forms the subject of the magical scene. On the Athenian Acropolis an olive was protected as a sacred tree, and it may be that on the citadel at Mycenae there was a mulberry; we shall meet it again on other tree-cult scenes on gold rings.

A great number of gems came to light in the chamber tombs (over a hundred in number) in the Lower City at Mycenae, which belonged to prosperous citizens. The finds extend over three centuries, from 1500 to 1200 BC. Here we pay special attention to Chamber Tomb 91, whose four gold rings Jannis Sakellarakis dates to the fifteenth century through associated finds; he attributes pairs of them to different workshops. Only one has a purely heraldic decoration—a reclining sphinx, wearing a diadem with a long tendril, which makes one think of the leaf-crowns of seventh-century sphinxes, and spreading its wings across the background. Above it on either side flutter the fine strips which in Minoan–Mycenaean art often indicate dedications or people engaged in a cult—e.g. the figures on the Agia Triada sarcophagus. The six small, slightly angular objects in front of the sphinx are too regular and isolated to be rocks and may be chrysalises of the butterfly, whose important role in Bronze Age art and religion is well known. The vertically ribbed ground-line beneath the sphinx (whose paws do not touch it) recurs on the ring with the female griffin—one of the arguments for attributing both rings to the same Mycenaean workshop; in addition, the details of the feathers are similar, though both the griffins' wings are to the rear, and only the upper edge of one of them is visible. By this means space is left in front of the griffin for an enthroned figure. This has been interpreted as male because of its simple, long garment; this is made more plausible by the lack of hair, and, furthermore, one would expect a stool if the figure on the throne was female.

The man holds the crouching griffin, with dugs, eagle's beak and tuft on the head, by means of a neck-band made up of flat pieces; this is not simply a heraldic scene but an event, which would surely have had some definite meaning for a Mycenaean. The combination of throne and griffin recalls the throne-room at Knossos or the griffin fresco at Pylos. The enthroned figure might be a Mycenaean ruler with such strength and intelligence that he can tame the dangerous monster so that it obeys him like a dog, it raises its head obediently, like the griffins in the throne-room at Knossos. A similar theme can be seen on an almost contemporary lentoid jasper from the Vapheio tholos tomb; but here the griffin-tamer is not enthroned but stands, wearing a stiff Minoan–Mycenaean priest's robe, beside the monster, which is also standing, and holds it by a thin cord; the forms on the gem are clearer and finer than those on the gold ring. The artist has ventured something rare in

engraving, bold overlapping of the animal by a human figure; it is far more common to see the complete outline of a griffin, and this may even be repeated in heraldic fashion, as on the electrum ring from Chamber Tomb 68 at Mycenae, where two standing griffins look back at each other in the same attitude as the one from Vapheio and fill the oval space with tautly drawn symmetry.

The two other gold rings from Chamber Tomb 91 at Mycenae (both from the same Mycenaean workshop) show cult scenes. On one two women are praying, facing each other on either side of the shrine; they wear flounced skirts and, in a typical Minoan–Mycenaean gesture of prayer, each shades her brow with one hand as if dazzled by the epiphany of a divinity. In contrast to the ring with the garden scene their bodies are boldly shown in profile—a method of representing the female body for which there is evidence from the fifteenth century onwards, and which was used frequently, though not invariably in the subsequent period. The composition is symmetrical, down to the vegetation behind the women—left, a cypress; right, branches growing out of rocks. Examination of the predella—more common on Mycenaean gems than on Minoan—shows the floor of the sanctuary, in which a cult building rises to the level of the women's eyes; as with the branches shown at the side, we have here the enclosure of a sacred tree, whose top is cut off by the upper border; a forecourt, in bird's-eye view, leads to this building through a gateway with half-open double doors, whose diminishing, step-like frame had its origin in Crete; from Crete, too, comes the tree cult, which is even more clearly indicated in the companion-piece.

In the predella of the latter ring small stones are shown, that is, a floor—not of slabs, as on the companion-piece—but of pebbles. On this ring the composition is not symmetrical as on its counterpart, yet the lateral figures and objects are connected to the female figure in the centre; she is thought of as dancing, as emerges clearly from a series of Minoan rings which show similar tree-cult scenes (a dance expressing grief, since she slaps her thighs with both hands, a gesture of sorrow known also from the Homeric poems—e.g. the *Hymn to Demeter* (245). The woman on the right, who wears a flounced skirt like the dancing figure, is also clearly a mourner, for she tearfully lays her arms on a small cult structure which occurs elsewhere as the architectural setting of a sacred tree. However, here the tree is missing; is this the reason for her sorrow? We are still far from understanding the Bronze Age vegetation cult, yet we know from later traditions about cults of this type, e.g. the festivals of Adonis or Attis, that violent manifestations of mourning and joy occured in succession. The absence of the tree, lamented with tears, may symbolize the death of the youthful vegetation god.

On the other hand, in the left part of the sanctuary can be seen a tree grasped by a young man who dances in ecstasy; it is questionable whether he wishes to uproot it, as many scholars have assumed, for the bending of the trunk might also be the result of shaking the fruit (which is arranged in a similar way to that in the garden scene, though far more stylized). Here again the subject might be the mulberry-tree (*morea*, in ancient Greek), which opens its buds with a sound in late spring, and is the first to bear ripe fruit in summer; when it is shaken, the buds burst and produce a real 'blood-bath'. This may have been an important element in the Minoan–Mycenaean vegetation

cult; even today it is a characteristic tree in Greece, found wild, half-wild and domesticated.

By comparison with other rings which show the ecstatic tree cult according to the Minoan concept, this gold ring is demonstrably a Mycenaean work. Leaving aside the objects from Phaistos and Archanes (south of Knossos), we here adduce only the gold ring with the same theme from the Vapheio tholos tomb, which from associated finds, e.g. the famous gold cups with the bulls, can be dated to the middle of the fifteenth century BC, that is, contemporary with the ring from Chamber Tomb 91 at Mycenae. The style is basically different, even though the female dancer in the middle and the ecstatic youth at the tree recur ; these figures have more free space above them and are gripped by swirling movement; beside them the dancers on the ring from Mycenae seem frozen. The Vapheio ring, like other objects from the tholos tomb (above all the bull cups), are convincingly classed with the very extensive Lakonian imports from Minoan Crete, and the fact that on it the tree grows from a pithos-like object should not be surprising for Crete, the island which was the classical home of the pithos. On the other hand the large figure-of-eight shield is a new motif, which is shown to be a cult object by the knotted cloth set upon it. Objects hang from the bole of the tree, which have been convincingly identified as butterfly chrysalises; they recur in other vegetation-cult scenes and are well suited to the mulberry-tree, whose delicate leaves are of course the food for larvae. A large chrysalis, a branch, and a double axe are shown in heraldic form above the head of the dancing woman.

A final, important difference between the Vapheio ring and the one from Mycenae is in the heads; on the latter they have strong features, whereas on the former they are small and smooth. If we had only the ring from Vapheio, we might assume that the artist, like many painters of our own time, had simplified the face into a disc, but these remarkable, non-representational heads recur on a whole series of Minoan rings and gems—frequently in cult scenes, so the omission of the features must have had religious reasons. Since we lack written sources, and since archaeologists have not yet examined this phenomenon closely, we can here only put forward conjectures. It is striking that these strange featureless figures are especially common among women and men in the vegetation cult—indeed, in scenes which also show butterflies and/or their chrysalises. For the Minoans, as Arthur Evans already assumed, the metamorphosis of the motionless chrysalis into the butterfly, and then back again, might have been a symbolic precedent for the cycle of existence, and so for the indestructibility of life. How well this conception fits what we think we know of the vegetation cult need not be stressed; thus, we may wonder whether the dancers in their ecstasy 'are beside themselves' (for that is what this expression means) and are copying the various stages of the birth of the butterfly. The mimetic nature of ancient dance is well known; in this case the aniconic heads might then indicate the remarkable changes of the insect: to chrysalis and then to butterfly. Perhaps these metamorphoses were expressed in the real world by larva-like masks, on the Vapheio ring the stages of chrysalis, death, and immobility were expressively accompanied by rituals of mourning. Did the Mycenaean, who represented the same theme with human heads, lack the capacity for ecstasy?

However this may be, it is certain that from the period of the shaft graves the Mycenaeans were familiar with gold butterflies

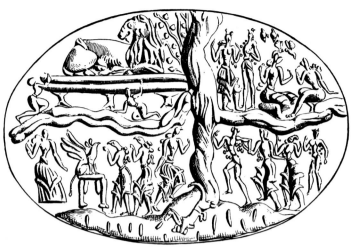

Fig. 28 Drawing, inaccurate in details, of the bezel of the ring of Nestor, Pl. 288. It is shown here reversed, in contrast to Evans's illustration, so that it corresponds with the original in Oxford.

as grave-gifts, and in isolated cases they also imported Minoan rings on which dancers with non-representational heads were combined with butterflies. The ring from Vapheio is not the only example; we can here add the so-called ring of Nestor, in Oxford, which takes its name from its find-spot, Kakovatos, believed by Wilhelm Dörpfeld to be Nestor's Pylos; the tholos tomb in which it was found shortly before Dörpfeld's excavation can be dated to the fifteenth century BC, like the one at Vapheio. Soon after it was published, the object was explained away as a forgery, but this was wrong, as Jannis Sakellarakis has shown; for in 1965, in a tholos tomb at Archanes in Crete, he found a gold ring with chrysalises and butterflies shaped and combined in a similar way to that of the insects on the ring, formerly thought to be Nestor's.

As Evans, the first to interpret the ring of Nestor, rightly saw, this complicated representation with its little figures can best be compared with miniature frescoes, and indeed he made an interesting attempt to translate the scene on the ring into a fresco of this kind. However, he could not know of the best-preserved example of this kind of decoration—the miniature frieze from Thera; had he known of it, he would not have taken the wavy bands which divide the bezel of the ring of Nestor into four parts for the branches of a tree. The frieze from Thera makes it clear that we have to do with streams of water; two brooks flow horizontally into a vertical one, whose lower part seems to run into a broad stretch water—a sea or swamp. These parts were engraved deeply, and their aqueous nature was perhaps stressed by a silver inlay. So the 'boughs' (above, left) do not spring from a tree but mark the edge of the shore, as on the Thera frieze. There are no stones or rocks, so that the areas between the brooks are meant to be meadows—a playground for the butterflies who, above, right, fly towards each other; above them can be seen two chrysalises, and, on the left, two human figures, facing each other and dancing, corresponding to the two butterflies. The faces of the man and the woman are aniconic, and close inspection shows that none of the numerous figures on the ring has a human face.

Evans, followed by Nilsson, was misled by the drawing into thinking that some of the women in the lower part of the ring

189

Fig. 28
287

of Nestor had griffins' heads, but on the original in Oxford one can see everywhere the same curious lack of features, generally surrounded by bead-like hair; so it is better to speak of 'butterfly-men' instead of 'griffin-men', that is, people who in the dance pass through the different stages in the life of this insect—for they are all dancers, apart from the two seated above, right; and they, too, are already caught by the rythm of the dance. The separate dance of the pair beside these last is echoed in the area below by the line-dance of two men and their women partners, which is continued in the area on the left—for on the other shore a woman dancer signals to them. The female figure (below, left) seems like a repetition of the dancing woman on the ring from Vapheio; she has a long dress, in contrast to the other women in the ring, whose flounced skirts are fastened up to the height of the calf. The two male figures in the upper part seem to be naked except for a short kilt, and so to be male; their remarkable contortions—going down on one knee—recall the dancing youths on the rings from Mycenae and Vapheio; so here too the subject seems to be a vegetation and not an animal cult, as some have thought because of the huge reclining lion on the left and the griffin below. Elsewhere in Minoan–Mycenaean art we know lions and griffins not as gods but as subordinates of divinities or of kings who may be their representatives. A number of seal-stones show that they served as heraldic animals; to take one of many examples, the lion lies in a similar way on an amygdaloid agate from Vapheio. The lion and griffin might also have a heraldic significance on the ring of Nestor, with the lion, representing the realm of a queen and/or goddess, as elsewhere, and the griffin that of a god and/or king; this means that the butterfly dance of the human pair takes place under the protection of the royal couple and also in honour of the divinities which the latter represent. The fact that the goddess is emphasized by her large lion, reclining above the ritual table, should cause no surprise in a Minoan work.

283-4

We are left with the remarkable short-legged animal with a long tail in the middle of the lower part of the scene. Evans and Nilsson interpreted it as a dog-like dragon, but they did not know the closest parallel for this monster, on a lentoid agate from the Lower City of Mycenae, which is almost contemporary. This splendid seal (illustrated here from an impression) shows a creature with similar short thick legs and long smooth tail; on the gem its head is like that of a griffin and it is ridden by a goddess. The horizontal line of 'scales' in the zone below indicates water, rather than rocks (the stone is damaged on the left); the animal looks like a combination of a lizard and a griffin, thus, a sort of water-griffin which survives in a modified form in the Greek *ketos*. From later myth one might identify the rider on the agate as a Nereid; a Mycenaean could surely give her a name, though we cannot guess it. On the ring of Nestor the mythical creature lives in, or guards, the waters by which the ritual dances take place.

286

In addition to the heraldic animals on the ring of Nestor—lion and griffin—the bull was most favoured on Mycenaean seals. From Grave Circle B comes a Middle Minoan lentoid sardonyx with a collapsing bull—a theme which hereafter constantly recurs in Mycenaean engraving. As an example we take here the lentoid jasper from the Vapheio tholos tomb: the subject is a sacrificial victim which has already been struck by the priest and collapses with a bellow, but the

289

artist has combined this motif (known from his own observation) with the lion to form a group of animals in combat. On the agate from Rutsi mentioned above the front part of this scheme is used, though the hind legs, overlapped by the huge lion, are shown in the 'flying gallop'. When compared with those from Vapheio, the animals are more strongly stylized, though the two tholoi are approximately contemporary (fifteenth century BC); so should one explain the two gems from Vapheio as Minoan and the one from Rutsi as Mycenaean? This might be correct in the present case, but should not be applied universally. The abstract decoration of talismanic stones—certainly from Minoan Crete—shows that on that island different styles of gem-engraving co-existed for centuries. Stylistic criteria are insufficient to pinpoint workshops in Crete or in mainland Greece, and in this respect researchers face great problems.

274

263

Like the Vapheio gold cups from the same grave, the gems from the same large find show bulls not only in dramatic action but also in a peaceful setting. The motif of two reclining bulls occurs twice; we illustrate here the impression of one of the two stones, and with it that of an agate from Rutsi. From their contexts the two lentoids are approximately contemporary and have the same theme, though it is reversed on one. The reclining bull, seen in side view, almost covers its companion, of which one can see only the back and the head, in rear view, but the relation between the groups and their setting is different; on the Rutsi gem the animals have so much more space that the engraver has added a bush—a realistic touch, in that they are trying to lie in the shade. The reclining bulls on the gem from Rutsi are closer to nature, but it is clear that the artist quite naturally took the animal group from the traditional mode of representation; it is so common in Mycenaean engraving that one might almost raise the question whether someone who wished to become a gem-engraver had to produce a companion-piece.

291-2

Another lentoid agate from Vapheio shows two cattle arranged differently, in a way that resembles modern playing-cards; it is an arrangement which recurs frequently and is used for other animals as well. The two beasts lie in opposite directions on an imaginary ground-line; placing in space, so important for the other groups, is here sacrificed in favour of a heraldic effect. This way of grouping animals, which is widespread, shows the limitation of a workshop tradition, but also the surprisingly high artistic level of these mass-produced gems; the first characteristic is typical of engraving in later periods, but the second one is not.

290

A particularly charming representation, inspired by Minoan art, is the cow looking backward, either suckling a calf or about to lick its hind hoof, as on a lentoid sardonyx from the Vapheio tholos; two centuries later this motif recurs on the clay sealing of a stirrup-jar from the 'House of the Oil-Merchant' at Mycenae. The seal is oval, made from a metal ring which was damaged in the lower part, but still re-used; the impressions are set close together and so represent a herd of cattle—a phenomenon that can be seen with other seals; they were intended for repeated use. A clay sealing with Linear B signs from the 'House of the Spinxes' at Mycenae—also of the thirteenth century BC—shows the close link between script and engraving which was discussed at the start.

293

294-5

Finally, the favourite animals of Minoan–Mycenaean gem-engravers were ibexes, which can still today be seen

in Crete. They are sometimes shown standing or lying confronted, sometimes side by side; like the bulls they can be attacked by lions, and they also accompany deities as subordinate figures, or are brought by humans to be sacrificed. The two reclining ibexes on a three-sided agate from a chamber tomb at Midea are particularly life-like (the impression is shown here); there is less overlap than with the bulls, and their horns are so ornamental that the artist has made them both face the same way. Another side of the prism is blank, and on the third a lion leaps upon an ibex.

A fifteenth-century gold ring from Chamber Tomb 84 at Mycenae shows a large ibex in a sacred precinct as a sacrificial victim; in front of it is a youth, dressed in a kilt, who prays before a cultivated tree; branches of the tree are set above the goat in heraldic fashion, which perhaps mark it as the property of the divinity (it was a good omen if the victim did not hesitate but, as here, came into the sanctuary of its own will). The type of youth shows that we have here a Minoan work, which anticipates the Cretan *à jour* bronze of the seventh century on which a youth brings an ibex for sacrifice; this metal sheet was a dedication in the sanctuary of Kato Syme, which according to later inscriptions belonged to Aphrodite and Hermes Dendrites (Hermes of the Tree); the scene of the gold ring takes place in a tree sanctuary.

A creature of which we would have only superficial knowledge without Minoan–Mycenaean gem-engraving belongs partly to the animal kingdom, partly to that of humans and gods. It is found also on frescoes and in works of ivory and bronze, but it leads its mysterious existence above all on gems; it appears in isolation or with its fellows, in the service of a deity, brought under control by one, or else taming or killing wild animals; it can even be an object of cult. This creature has correctly been described as a demon, since it corresponds to a surprising degree to the Platonic definition of the demonic as something intermediate between gods and men, but in the Bronze Age we have to take into account the animals from which it sprang, for only its upright stance is human; everything else about it is animal, and indeed a combination of different animals. It is certain that the Mycenaeans took the idea from Crete, and that Minoans were led to their representation of it by the Egyptian hippopotamus goddess Ta-urt, who walks on her hind legs, though they soon abandoned her monstrous form. The creature has the elegant Cretan wasp-waist, with a belt; since the hippopotamus is not found in the Aegean, a different kind of being must be represented. Scholars have generally regarded the head and paws as those of a lion, though the ears are often elongated and are more like those of a dog. The white colour of the demons on the fragment of a fresco mentioned above indicates that they are female, as Ch. Bouloteis assumes; it need cause no surprise because iconographically they are derived from an Egyptian goddess. Furthermore, they, too, are the servants of goddesses, who are generally associated with women taking part in their cult. One cannot make the objection that they are sometimes huntresses, for it is well known that in Mycenaean frescoes women join in the hunt; one also thinks of Artemis and her attendant nymphs, devotees of the chase. On a honey-coloured cornelian in Berlin a demon of this kind has returned from a successful hunt, with two lions which she has killed hanging from a stick on her shoulder; this lentoid, which is damaged on the right, is indeed Late Mycenaean, but we know this creature

from the peak period of Mycenaean civilization. The Vapheio tholos tomb produced two agates, one which—shown here as an impression—has on it the demon by itself while the other has it repeated in heraldic fashion; in both representations they appear with their favourite attribute, the beaked jug, which was used in cults.

The Vapheio gems make it clear that on their heads the demons can have a horn or a lock of hair and, on their bodies, a beetle-like covering ; the latter is certainly not a skin with a belt round it, as was formerly assumed, for in that case it would be drawn close by the belt, and on the fresco fragment from Mycenae this area is marked off from the white bodies by its bright colours. It seems in fact to be taken from the insect world, specifically from butterflies and their larvae which, as we have shown, played an important part in the Minoan–Mycenaean vegetation cult; it is clear from the cult actions of the demons that they are connected with vegetation: on the lentoid from Vapheio they raise their jugs ceremonially above sacred branches placed over a cult place.

The demons' role in cult is shown most explicitly on the large gold ring from Tiryns, the largest and 'most Mycenaean' of the rings dealt with here. It came from a treasure which was buried towards the end of the second millennium, as is shown by the associated finds, which extend into the Sub-Mycenaean period; the ring cannot possibly be dated so late, since the style is totally different from that of a gold ring which was found in the Late Mycenaean necropolis at Perati in Attica, for whose date there is good evidence; more probably we are here dealing with an ancient theft from a royal tholos tomb of the peak of the Mycenaean period (late fifteenth or fourteenth century). The ceremonial rigidity which characterizes this gold relief— it brilliantly suited the subject—has its counterpart in the procession of women from Thebes (soon after 1400 BC); the formal nature of the proceedings is stressed by the ground-line over which the demons move with their jugs, and it is decorated with the sacral motif of half-rosettes. In front of them is an enthroned figure, dressed in a close-fitting garment reaching down to her feet, which are placed on a foot-stool—in Linear B texts the idiogram which has the same shape has beside it the symbols *ta-ra-nu*, i.e. *thranys*, as this piece of furniture is also called in later Greek. Some authorities who have tried to explain the scene are uncertain whether the enthroned figure is male or female; on the Agia Triada sarcophagus this costume is found on both men and women, though the torus-shaped head-dress, which recurs elsewhere on female figures and sphinxes, and the ample forms of the lower parts of the body, argue for a female being, either a goddess or a queen representing her. Behind the back of her throne is a heraldic creature—a hawk or a falcon—whose pose resembles that of the birds on the royal necklace from Shaft Grave V. Each demon holds in its right hand a ceremonial jug, and the seated figure holds a vessel of a kind familiar to us from Minoan sites and from Thera; the stand in front of her is also connected with the offering of libations; Valentin Müller rightly interpreted it as a libation table.

The four demons which have placed themselves in procession are, from what has been explained above, to be regarded as female; here, as on the agate from Vapheio, they are participating in the ritual of a vegetation cult, as is indicated by the jugs and by the branches (or are they young cypress-trees?) which stand between them. Similar branches can be seen on

305 Melian amygdaloid: stalking lion. Serpentine. Latter half of 7th century. 2.33 × 1.31 cm. Antikenabteilung, Staatliche Museen Preussischer Kulturbesitz, Berlin.

306-7 Melian amygdaloid: boar. Serpentine (Pl. 306) and impression. C. 600. 2.18 × 1.84 cm. Antikenabteilung, Staatliche Museen Preussischer Kulturbesitz, Berlin.

308 Argive quadrangular seal: archer and centaur, probably Herakles and Nessos. Impression from a serpentine. Latter half of 8th century. 2.2 × 2 cm. Bibliothèque Nationale, Paris.

309 Finger-ring: seated man, from Siphnos. Serpentine. Dimensions of seal 1.1 × 0.8 cm. National Museum, Athens.

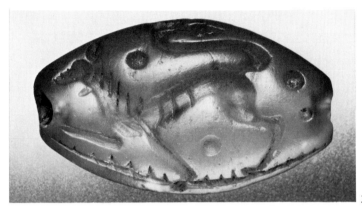

305

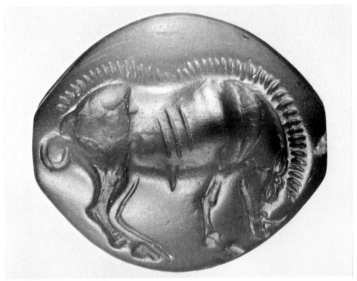

306

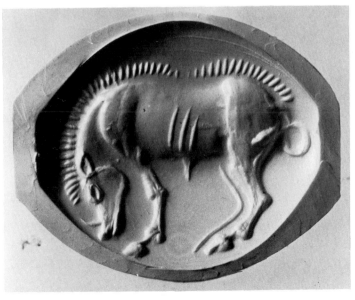

307

308

309

the undulating border-line above their heads, which delimits the realm of heaven, as on the gold ring from Mycenae. It is hard to explain the delicately carved pattern, which recurs on the dress of the enthroned figure; is it to be interpreted as the material of a canopy, or is it the heavens themselves? The latter alternative is supported by the moon and star which indicate the time of the libation; if this is right, the little 'drops' might indicate the intention of the cult: to produce rain, always a matter of great concern in Mediterranean lands.

303 Seal impressions on clay of the thirteenth century were found in the Lower City of Mycenae and in the palace of Pylos; they show the old motifs, though with an element of stylization. Compare the groups of lion and bull with the gems of the earlier period: without the characteristic horns the bulls would be scarcely recognizable; the horns form the only overlap between the two animals; the lion does not bite the neck of the bull, but only touches its body with its muzzle. The relationship of the two animals is undefined and organic composition has to a large extent been abandoned, as with animal pictures on Late Mycenaean vases. Some gems (not shown here) from the Perati cemetery in east Attica, which can be dated to the twelfth century, enable us to follow this tendency still further; alongside the drop in quality, one should also note the rarity of gold rings and gems in this cemetery, which, however, produced such a quantity of important pottery. Pottery was a local, independent product, the material for which was close to hand, whereas the complex process of gem-engraving and the working of precious stones and gold depended on the occupants of the royal palaces and their workshops, who organized trade with distant lands overseas (as the study of the ancient coastline has shown, Tiryns was once on the sea). The collapse of the Achaean monarchies in the twelfth century meant also the end of the palace workshops and of their outstanding tradition of gem-engraving.

Naturally, seals were used even during the 'Dark Ages' (1125-900 BC), above all in the sanctuaries which in many places (e.g. the Argive Heraion) took over the function of the palaces as places where the population could assemble. In these sanctuaries people used old seals, some of which were inherited from the Mycenaean period (a considerable number of them has been found in later levels), or else made new gems, following earlier examples as best they could. We must here 304 mention an amygdaloid from Melos, now in Berlin, on which a collapsing quadruped is so unskilfully engraved that no zoologist could identify it. This gem was dated to the Sub-Mycenaean but Ingo Pini has recently shown that it belongs to an Archaic group. The craftsmen of this group certainly imitated Bronze Age seals. They used again a rotating tool as part of their equipment, since a cornelian, on which this design is placed, could not have been made simply by shaping with an edged tool, but must have been worked by means of a bow-drill. At the start of the first millennium this technical aid, which had played an essential part in the development of engraving in the Aegean since the Middle Minoan period, fell out of use, and then only relatively soft materials such as limestone, serpentine (in general incorrectly called steatite) or ivory were carved or engraved. As a result gems for a long time showed a much more limited range of colour than those of the earlier period; the range now extended from white through yellowish-white to blackish-green, and it was not until the sixth century BC (outside the period here considered) that

Greek gem-engravers again used the drill and hard, brightly-coloured stones.

Geometric and Early Archaic Gems

In the early part of the first millennium, the so-called Island Gems, whose peak period falls in the seventh century BC, are the most important variety. They got their name in the last century when travellers to the Greek islands found an abundance of early gems there. Adolf Furtwängler succeeded in distinguishing them from Mycenaean stones; since many of them are amygdaloids and lentoids—thus repeating the most important Mycenaean forms—the distinction is possible only on the basis of technique and style. John Boardman treated the Island Gems in a monograph, in which he investigated several hundred of them. He also showed that the island of Melos was one of the main centres of production; a great number of stones were found there, and others can be assigned to Melian workshops on grounds of style. In the seventh century BC Melos also had important goldsmiths' workshops as did Rhodes. Melos lies midway between Crete and mainland Greece, and the Bronze Age tradition was never interrupted here; in recent years excavations have yielded some surprising Late Mycenaean finds. Like Crete, Rhodes and Thera, Melos was colonized by Dorians from the Peloponnese during the period of population movements at the end of the second millennium, and had its share in the rich development of the Early Archaic period.

An amygdaloid of pale green serpentine, now in Berlin, was 305 found at Thebes, but its style derives from Melos; it shows a lion in motion with its jaws open in a roar and its tail raised. Its lean body makes one think of the lions in pictures on pots of around 700 BC, but the stone can certainly not be dated so early, for the engravers of Island Gems long adhered to a Sub-Geometric style owing to the rudimentary nature of their tools—a style which vase-painters had long since left behind. The four circles which are placed as filling ornaments in the background around the lion correspond to the rosettes on Corinthian vases of the latter half of the seventh century BC.

While Melian engraving resumed its Mycenaean inheritance in format and subject-matter, the Argolid, the homeland of the Mycenaeans, was to a large extent free of this legacy. To judge by finds of seals at the Argive Heraion, whose style can be compared with that of Late Geometric Argive vases, Argos at that period was, alongside Melos, an important centre for the production of seals; but it did not favour round and oval shapes, preferring square and rectangular ones, and the humans, animals and mythical creatures are stylized in a comparable angular fashion (unless we are dealing with pure Geometric ornament). A quadrangular seal of black serpen- 308 tine—of which an impression is shown here—is an early representation of legend in Greek art: a man shoots an arrow from behind at a centaur, whose raised hands hold pine-branches, and as in the impression the archer holds his bow in his left hand it is this which clearly gives the 'correct' view. The man with the bow is apparently Herakles killing the centaur Nessos, who stretches his arms out on either side, so that the pine-branches (the normal weapons of centaurs) in his hand

are like twigs held by one begging for protection; a lizard is shown beside him as a herald of misfortune. This rectangular seal in the Bibliothèque Nationale in Paris is of unknown provenance, but from its style can be assigned to an Argive workshop of the early seventh century BC.

309 A rectangular seal worked in one piece with a ring of bright green serpentine, flecked with yellow, was found on the island of Siphnos; it is now in the National Museum in Athens, and is exceptional. It shows an enthroned male figure who, strangely, has only one arm and one leg; he appears to be holding a sceptre, and on the back of his throne perches what may be a bird. The carving of the ring is excellent, but the representation is awkward, and the Argive human figures in particular are far superior. It seems impossible to give an exact dating or place of production; the ring may have been made on one of the Greek islands some time in the seventh century BC.

 A serpentine amygdaloid—the last piece shown here—is, 306- once again, stylistically connected with Melos; we show the original and an impression. A boar whose neck and spine are covered with bristles lowers its head and tusks as if intending to attack—it could not raise its head higher, since in this pose the animal completely fills the convex surface of the oval stone, and so, filling ornament is unnecessary, as with the Melian lion. Unlike the lion, the boar's body is not cut up by geometric lines but is shaped organically. With this masterpiece of around 600 BC, now in Berlin, Greek engraving stood on the threshold of a development which at its height attained a level equal to that of Mycenaean gem-engraving.

Jewellery and Ornament

Gold and Silver Jewellery from Shaft Graves

Schliemann's finds of gold ornaments in the shaft graves of Mycenae have not been matched by later excavations, although many pieces from the fifteenth and fourteenth centuries have survived; even Grave Circle B (at the foot of the citadel, and somewhat earlier in date) is poor when compared with the other. To be sure, here too the dead already had gold headbands, but they were less lavish than those in Schliemann's shaft graves. For many of the ornaments it is hard to decide what was simply decoration for the dead and what was worn in life, but in general one can certainly follow Georg Karo, who interpreted sheet gold, often paper-thin and worked only on the front, as made for burial; even in the first millennium crowns for the dead were still made from thin sheet gold, though, as with metal vases, more solid ones were found, made to serve the needs of the living along with ones which were delicate and unusable.

We begin with the ornaments of the dead which, like the gold masks, can rightly be regarded as native Mycenaean, as opposed to numerous other imported objects for decoration. Around the skeletons of women and children in Shaft 312 Grave III Schliemann found 701 gold discs, and in the men's grave, V, over one hundred. They are circular, or slightly ovoid, cut from thin sheet gold with impressed motifs; their diameter varies around 6 cm, and a few of them have holes which show that they were sewn on to a backing, consisting of clothing or shrouds which were laid over the dead. It is questionable whether the other plaques were glued on; at the burial they may have been simply scattered over the corpse, just as nowadays those present at a burial throw in earth or flowers. Many motifs, such as the large ribbed shell, recur over a hundred times; others are less common. Purely ornamental motifs are popular, such as loops, spirals, whorls and concentric circles, combined in a graceful way; among these are 67 plaques with a highly stylized octopus whose tentacles run out into spirals, symmetrically arranged along the axes, and also two types of butterfly. The latter number 121 in all, and so this is the commonest motif. As an ornament the butterfly is well suited to these discs because of its axially symmetrical form, but this is not the sole explanation for its use; chrysalises are far less decorative, yet imitations of them in gold occur as individual beads on a necklace from Shaft Grave III, presumably as a grave-gift for one of the children buried in it. We have already noted the importance of the butterfly and its pupae in the Minoan–Mycenaean vegetation cult in connection with the gold rings that bear this theme, so it seems that religious as well as mere decorative considerations affected the design of these gold plaques.

The same is true of another kind of gift for the dead: little 315 objects cut from sheet gold, partly à jour; as on the discs, we find motifs such as the octopus, butterfly and shell, both in the round and as cut-outs; in both categories holes for threads can sometimes be seen. The way they are made shows that some of these miniature sheets may have been arranged to form necklaces (above left, and, in the centre, the cross decorated with spirals). In Shaft Grave V a funerary necklace with opposed falcons (which clearly belongs to this class) lay on the breast of one of the princes buried there; otherwise these sheets are found predominantly with the women and children

interred in Shaft Grave III. One of the most striking motifs is the tripartite façade of a cult structure; three other examples, beaten out with the aid of the same form, were found in Shaft Grave IV. This kind of sacred building, dealt with in chapter I (p. 50), came from Crete—as did the octopus; the one shown 64-5, here is in lively movement and is set obliquely, which makes it markedly different from the symmetrical Mycenaean one, although it may have been made at Mycenae—perhaps from a form imported from Crete. This variety has only seven tentacles instead of eight, though one should not deduce any deeper significance from this fact; however, such significance undoubtedly pertains to the cult façade and to several other motifs found among these miniature gold sheets.

Among the few female figures from the shaft graves are the 315 two pieces shown on either side of the cult building. One is a nude standing goddess in profile, round whose head three birds flutter; the other a seated woman, seen frontally and dressed in a flounced skirt. Though the poses are basically different, both figures hold their arms in front of their breasts in the same way. The first can hardly be interpreted other than as a goddess of Love, even though the name Aphrodite has not so far been found in Linear B texts; her sacred birds were sparrows, doves and geese, and to judge from the scale the last are the most likely candidates here. She corresponds in type to Astarte or Istar, who in the seventh century made a second entry into the Greek world from the Orient; Astarte figures, too, are found with the hands to the breasts. The same gesture made by the clothed, seated figure shows that the two are related. This may be the goddess of Love in another manifestation; her seated pose, without a throne (it should not be mistaken for standing) recalls the 'Aphrodite in the Gardens' on the gold ring from Mycenae. There she is surrounded by women and children, like the woman buried in Shaft Grave III. 276

On the other hand the bull's head with the double axe 315 between its horns (third row, left) occurs only in Shaft Grave IV, which also contained the large bull's-head rhyton. 127 Like the 'Aphrodite' figures and the cult building it is one of the motifs on miniature gold sheets which have their roots in cult, as do the various butterflies, some of which may be moths (first and third row, right). Unfortunately we do not know whether the goddess of Love was already 'sea-born' for the Mycenaeans; if she was, we might reckon that her attributes included the octopus and, above all, the shell, which in later 312 times were so often represented beside her. This goddess's range of activity is significant in ornaments of the dead, since the traditional festival of Adonis—known from the poems of Sappho onwards—shows that the goddess of Love was closely connected with life and death in nature. She was also the mistress of the precious unguents with which the dead were anointed.

Other motifs on miniature gold sheets are more of a heraldic 315 character, such as the sphinx (above, left), the griffin (second row, middle), and the leopards and deer arranged like coats of arms (second row, left and right); they indicate that the dead with whom they were buried had princely rank. Only one motif in our selection, the owl (second row, centre), did not come from Schliemann's shaft graves but from a tholos tomb near Kakovatos in the western Peloponnese. Gold owls were also found in other graves in that area, at Peristeria and near the palace of Nestor. They show that in the fifteenth century, too, it was customary to adorn the dead with miniature sheets

Fig. 29 Bronze pendants in the form of a pomegranate, from Thessaly. 8th century. Drawings by Imma Kilian-Dirlmeier.

of gold, but few of these have survived, since tholoi were normally plundered. Spyridon Marinatos believes that the owl—still a bird of death in modern Greece—is connected as a motif with the Pylians who came from Orchomenos and later took it to Athens, where it was linked to the city's goddess, Athena. In any case it is certain that, for all the uniformity of Mycenaean culture, the individual centres had their own traditions and symbols, for not a single owl is be found among the hundreds of gold offerings in the shaft graves.

311 The royal necklace from Shaft Grave V belongs to the category of miniature gold sheets. Because of their long tails the birds must be falcons rather than eagles, though their grouping in armorial pairs and the spirals on the necks of their averted heads—found also on griffins and sphinxes—warn us against any attempt to define the species too precisely. The two other necklaces were not indications of rank but were worn by the living. The little gold pomegranates from Shaft Grave III do not have just a front but are in the round, put together from two halves. They are the first examples of a favourite ornamental motif in Greek art, which constantly recurs in the 320-2 form of necklaces or pendants on ear-rings and other ornaments, and is also common in bronze.

fig. 29
317 Some rock-crystal heads of long, bronze decorative pins also have the form of pomegranates and poppy-heads. Since they were found in Shaft Grave III and in other Mycenaean graves they must have been a favourite form of ornament. The rock-crystal is sometimes cut to correspond to a natural fruit, but on occasion it is decorated with horizontal grooves or spirals—common in Minoan–Mycenaean art—or given some other abstract form. Georg Karo assumes that these pins were predominantly worn as hairpins. These durable objects decorated the hair of the living, but a diadem from Shaft above Grave IV must have adorned the head of someone who had already died. This headband is made of thin sheet gold and tapers at both ends; it is decorated with nine bosses, of which the central one, the largest, is flanked by smaller ones; the upper and lower borders are decorated with a zigzag, and at the ends (by the loops) with little arrays of spirals.

below An arm-band from the same grave bears seven whirling rosettes, unevenly spaced: the heart of each rosette is enclosed by a single beaded circle, but the outer border by a double one—only the one on the extreme right has a single circle as its outer border. This arm-band was an ornament for the dead, 310 but Shaft Grave IV, whence it comes, also yielded a band worn by a king on his upper arm, and this inalienable possession was buried with him. The solid circlet is decorated with a single

large sunflower, set on boldly curved leaves; the petals are gold while the heart, once silver, was fastened to a background of silvered gold by a bronze rivet. The inside of the circlet is flat, while the centre part of its exterior in convex; it is of gold, and is in places coated with silver—an indication that at that time the latter metal was more precious than gold. The flower and the circlet are in balance; the strange array of leaves between them supplies an attractive contrast. Originally the gold parts stood out from the silver surfaces—now, alas, oxidized—without jarring. Taken as a whole, this is a masterpiece, a jewel of timeless elegance.

Silver and gold are also combined on a pin which belonged 316 to a woman in Shaft Grave III. The thick pin itself is of silver and curved at the top, where it carries a gold relief, worked *à jour* and flat at the back. The careful workmanship and delicate engraving show that this was an object made for use—perhaps a precious hairpin. Ancient ornament was never self-sufficient, but well adapted to the part of the body it served to decorate—something which is particularly true of this piece. The figure represented, with palm-branches, flowers and fruit growing from her head, is a tree goddess, typical of Minoan–Mycenaean religion. In her outstretched arms she holds a long double chain which adorned the neck or hair of the woman who wore this pin; this is therefore an 'active' ornamental figure, such as frequently recurs in the long history of this branch of art. In the Classical and Hellenistic periods this role is given to Nikai or Erotes, but here to a vegetation goddess, who forms the bole of a magic tree bearing blossom and fruit at the same time. Since tree goddesses were exceptionally beautiful—Helen was one of them—this figure is particularly well suited to her task.

Finally, the gold ear-rings from Shaft Grave III were robust 313 ornaments, made to be seen from either side. Each of them consists of two 'crescents', fastened together at the inner edge and slightly open below. They are in open-work, the gaps being filled by four-pointed stars, which diminish in size towards the lobes of the ears; the same is true of the little gold balls—an early example of granulation—which occur here and there among the rays of the stars. The outer edges of the ear-rings are defined by a series of arcs—typical of Minoan–Mycenaean art—to which projections, another popular motif, are added. The whole effect is so typically Mycenaean that it is no good regarding these pieces as imports from outside the Aegean area—especially since no one can say from what source they might have come.

Geometric Ear-rings from Athens

From these Early Mycenaean ear-rings we make an abrupt 320-1 move forward to those from the 'Grave of a Rich Athenian Lady', found in 1967 by American excavators below the Areiopagos; the find was sensational, because until then there was nothing comparable from ninth-century Greece, and the associated pottery made it possible to date the find to the transitional period from Early to Middle Geometric (*c.* 850 BC). Evelyn L. Smithson, who published the contents of this grave, supposed that these ear-rings, decorated with granulation and filigree work, were made in Athens itself, but

310 Upper arm-band of a king, from Shaft Grave IV of Grave Circle A at Mycenae. Silver and gold. 16th century. Inner d. 9.3 cm, W. of band 2.2 cm. National Museum, Athens.

311 Mycenaean necklaces. The outer one, with antithetically arranged falcons, from Shaft Grave V of Grave Circle A at Mycenae; the middle one, from which hang pendants in the form of pomegranates, from Shaft Grave III of Grave Circle A at Mycenae; the third necklace, with stylized lilies, from the 'Aegina Treasure'. Gold. 16th century. National Museum, Athens.

312 Circular discs, from Grave Circle A at Mycenae. Gold-foil with impressed decoration: spirals, octopus (above, middle), moth (below, middle), shell (below, left). 16th century. D. approx. 6 cm. National Museum, Athens.

313 Ear-rings, from Shaft Grave III, Grave Circle A at Mycenae. Gold. 16th century. D. 7.5 cm. National Museum, Athens.

314 Funerary diadem and arm-band, from Shaft Grave IV of Grave Circle A at Mycenae. Gold leaf. 16th century. L. of diadem 41.5 cm, L. of arm-band 36.1 cm. National Museum, Athens.

315 Miniature sheets. In detail from left to right: sphinx, octopus (with seven tentacles), butterfly, heraldic leopards, little owl, griffin, heraldic stags, bull's head with double axe, cross with spiral pattern, butterfly (second type), dressed woman seated frontally, tripartite shrine façade (cf. Pl. 64), naked standing woman (Aphrodite) with birds fluttering around. From Grave Circle A at Mycenae (only the small owl on the left comes from Kakovatos). Gold-foil. 16th century. All slightly enlarged. National Museum, Athens.

316 Pin with tree goddess, from Shaft Grave III of Grave Circle A at Mycenae. Silver and gold. 16th century. L. of pin 21.5 cm. National Museum, Athens.

317 Decorative pins, from Shaft Grave III of Grave Circle A at Mycenae and from other Mycenaean sites. Silver or bronze with heads of rock-crystal. 16th-15th century. National Museum, Athens.

318 Necklace, from a Late Geometric grave at Spata (eastern Attica). Gold with inlays (now lost). 725-700 BC. L. 10 cm. National Museum, Athens.

319 Necklace and other ornaments, from Tekke near Knossos. Gold with rock-crystal. 8th century. Museum, Iraklion.

320-1 Ear-rings, from the 'Grave of a Rich Athenian Lady'. Gold with filigree work and granulation. C. 850 BC. L. 6.4 cm. Agora Museum, Athens.

322 Pin: 'Mistress of the Animals'; below: lobes in the form of pomegranates, from Rhodes. Gold with filigree and granulation. C. 650 BC. H. of plaque 3.7 cm, overall h. 6 cm. Antikenabteilung, Staatliche Museen Preussischer Kulturbesitz, Berlin.

323 Small decorative plaque: young centaur with his catch, above a rosette, from Rhodes. Gold relief. C. 650 BC. H. 4.3 cm. Antikenabteilung, Staatliche Museen Preussischer Kulturbesitz, Berlin.

324 Ear pendant with griffin heads, from Melos. Gold with granulation. 7th century. H. 6 cm. Antikenabteilung, Staatliche Museen Preussischer Kulturbesitz, Berlin.

325 Five small decorative plaques with *melissai* (goddesses with bee bodies), from Rhodes. Gold relief. Latter half of 7th century. H. 2.7 cm. Antikenabteilung, Staatliche Museen Preussischer Kulturbesitz, Berlin.

326 Rosette: in the middle a bird, on the petals of the rosette alternating griffins' heads and bees, some facing inwards, others outwards, from Melos. Gold with filigree and granulation. 7th century. D. 4.6 cm. National Museum, Athens.

310

311

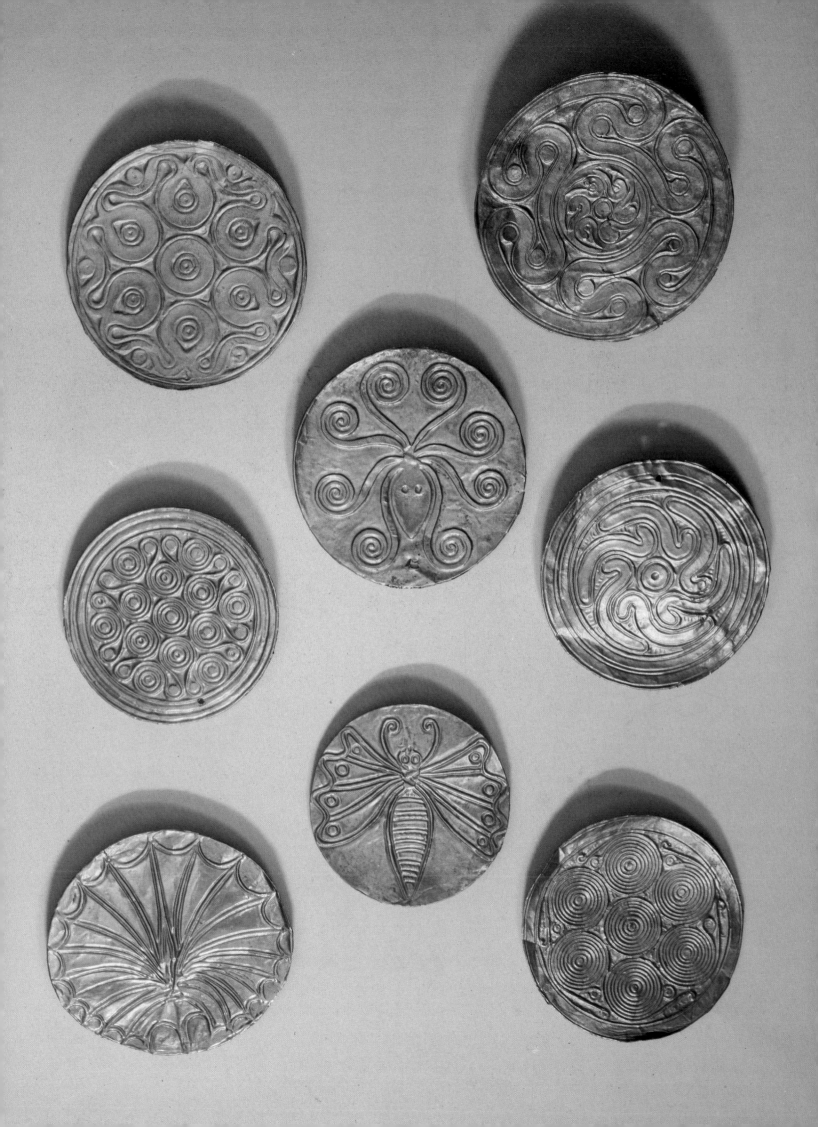

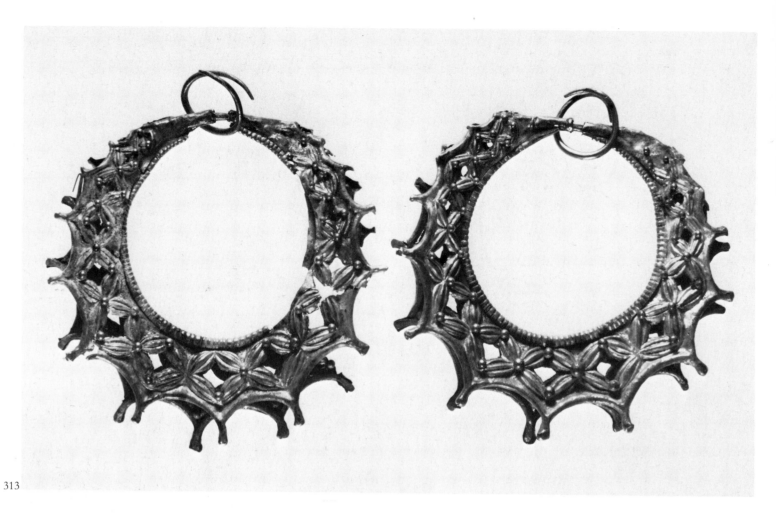

313

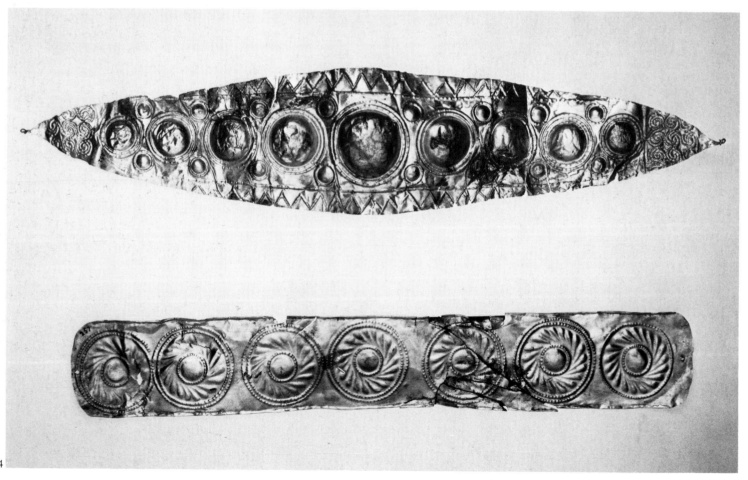

314

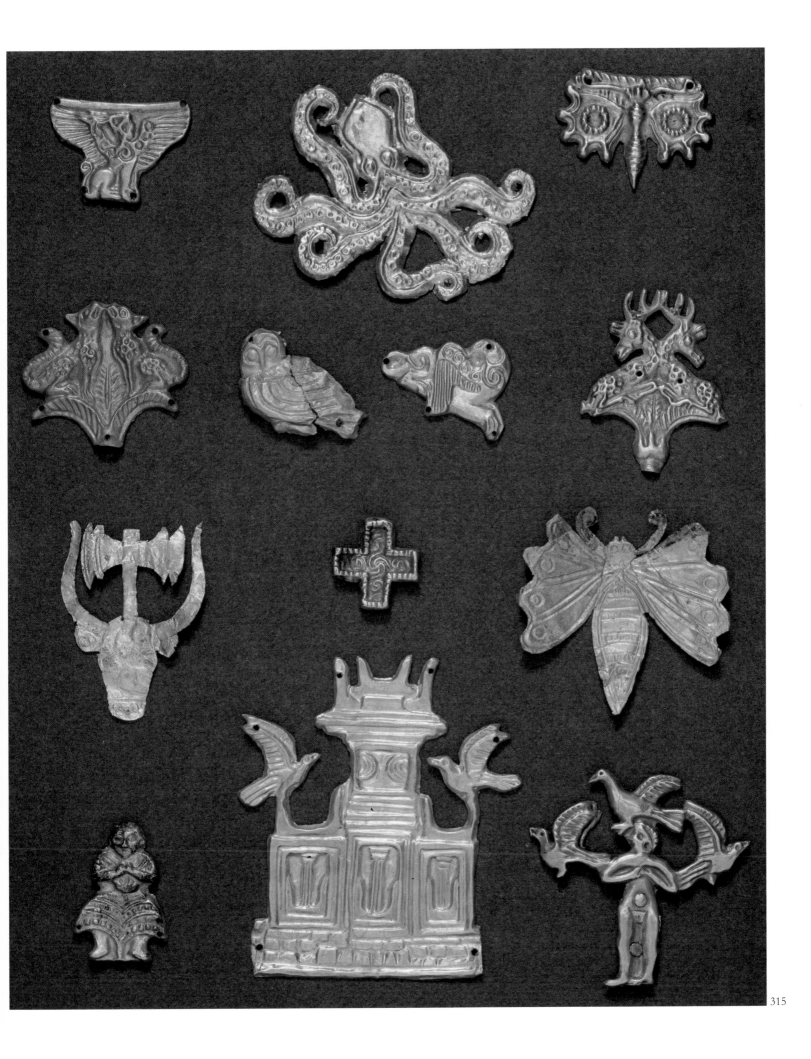

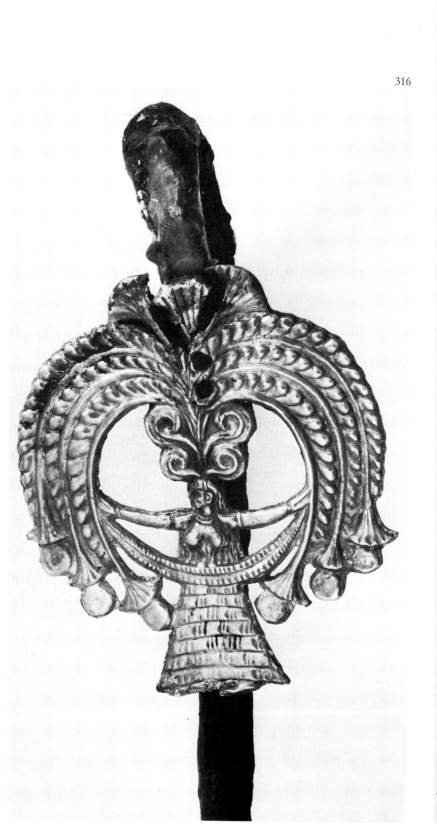

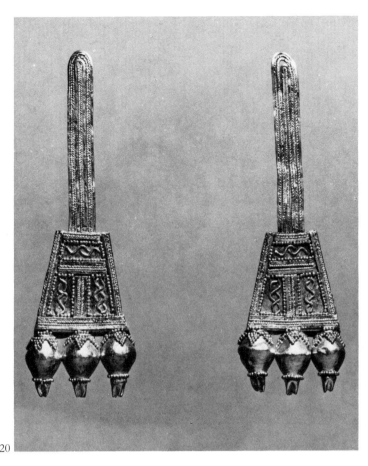

320

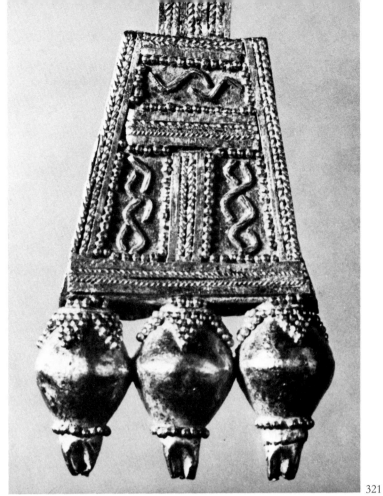

321

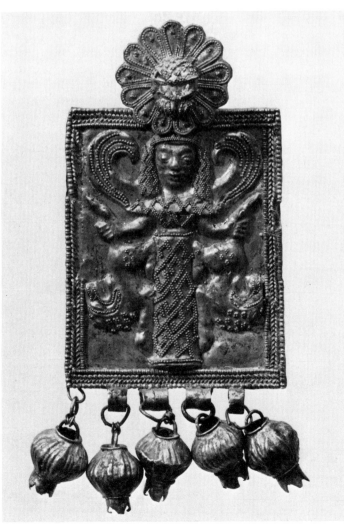

322

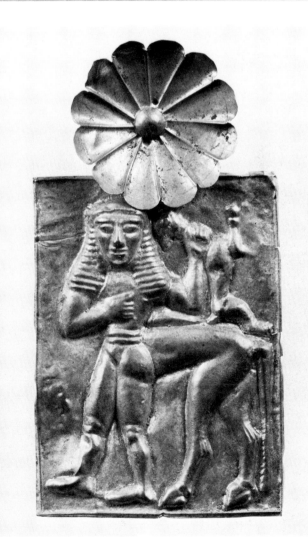

323

324

325

326

these objects presuppose a tradition of artistic goldwork which—unlike Attic pottery—cannot be traced back to the Mycenaean period; thus both alternatives—continuity from the Mycenaean period, or re-introduction from the Orient of the technique of filigree and granulation—lead to an impasse. The excavator was right to be cautious, and we must wait for new finds from the 'Dark Ages'. All the same, arguments for the first option can be put forward.

In Geometric Athens the connection with the Bronze Age was unbroken; the population remained the same, for though some immigrants arrived, the Dorians were warded off, and in no other place in Greece was the existence of the Mycenaean element so marked in the year's cycle of festivals as it was in Athens. The site of the grave on the Areiopagos also followed Mycenaean tradition, for this area was a Bronze Age burial-ground, in which the grave with the ivory pyxis was found. From the eleventh century onwards the Kerameikos was generally chosen for burials (see above, p. 147), and the fact that the 'Rich Athenian Lady' was buried on the Areiopagos may be linked to the idea that she traced her family back to the Mycenaean period. This might also explain why she was given expensive grave-gifts, of a character which was not normal in the Kerameikos. It is known that in antiquity grave rituals differed from one family to another—and not only in Greece. Ornaments of the kind we have here were doubtless worn in Athens, but were not generally put with their owner in the grave. The exceptional position of the 'Rich Athenian Lady' is in the last resort connected with the fact that she had held office as a priestess; in Athens the office of priestess of Athena Polias was always held by a member of the family of the Boutadai, which derived from the Attic kings of the Mycenaean period.

On the pendant, which is delicate though relatively long, there is in the upper part a small hole for a gold wire which went through the lobe of the ear, and traces of use can be found at this point. The upper part, made of plain and twisted gold wires set together with delicacy and precision—filigree work—is the supporting band, whose strands extend in an elaborate manner over the rear of the pendant (not illustrated here). The main stress falls on the trapezoidal central part, on the broad lower edge of which are three small pomegranates; the triangular leaves at their bases, with their corolla, are executed with fine granulation, which appears only on the front of the leaves, but all round the corolla. The three divisions on the front of the trapezium also have granulated borders; one division is horizontal, with two vertical ones beneath it; they are decorated with 'S'-shaped wires and small pieces of wire which in the vertical areas overlap in a guilloche pattern, while in the upper one two horizontal 'S' forms are juxtaposed. The divisions which are as broad as the spaces between them, form a 'T'; this, like part of the supporting band, is bounded by similar twisted gold wires.

The stylization is a credit to the Geometric style, which is shown to have been in no way confined to pottery; since 'S'-shaped elements appear in vase decoration only at a later date, the inspiration for them may have come from goldsmiths' work. In the present state of our knowledge we cannot say whether the braided decoration with the 'S' forms goes back to braided bands in Late Mycenaean art, but bronze ornaments, which in the centuries round the turn from the second millennium to the first virtually replaced gold and silver,

provide links for the pomegranates back into the second millennium.

Imma Kilian-Dirlmeier has published bronze pendants in Greece from the Mycenaean to the Late Geometric period and so made an important contribution to our knowledge of the continuity between the two periods; alongside the manifold pendants in birds' form, there are numerous bronze pomegranates, particularly in the rural districts of Thessaly and the Peloponnese. She writes: 'Despite substantial gaps in our finds, we may suppose that decorative pendants in the form of pomegranates enjoyed general popularity in Greece from the Mycenaean Age down to the Archaic period.'

In the eighth and seventh centuries BC quantities of gold ornaments were once again put into women's graves; compared to Mycenaean work the material is modest, but the craftsmanship is careful. One example is a necklace from a grave at Spata in eastern Attica. Each of the space-beads is decorated with two gold lozenges, while the centre-piece has an element shaped like an Amazon's shield (*pelta*); the inlays which once were present are now missing. Underneath hangs an array of small gold pendants, some of them attached directly and the others by means of little chains; they end in what appear to be pomegranate-flowers, for they are not sufficiently plump to be pomegranates, such as we know from numerous ornaments of that period, but do have the typical corolla at the end. Another pendant from Tekke near Knossos, now in the Iraklion Museum, has a rock-crystal in the shape of a half-moon, from which hang three crescents with discs; a further find from the same grave is a kind of cross in beaten gold, which ends above in two heads. To judge by associated finds, the necklace from Attica in the National Museum may have been made between *c.* 725 and *c.* 700 BC, and the pendant from Crete belongs also to the Geometric period. 318

319

Seventh-Century Gold Ornaments

We have to thank the workshops of two islands, Rhodes and Melos, for the fact that we can call the seventh century the heyday of Archaic Greek gold ornament. Melos has already been mentioned (p. 195) as a centre for the 'Island Gems' of that period. Both there and on Rhodes an original kind of ear-pendant, hitherto unknown, has been found: it consists of thick gold wire, bent double, with the ends turned over and ending in a knob with a small disc. The decoration of the ends varies; on an example from Melos in Berlin the ends are griffins' heads in the round—miniature work of the highest order; the eye-sockets, the spirals on the nape, the ornament on the neck, in front of the ear and at the base of the beak are granulated work, and the knob on the brow is also covered with granulation, so that it looks like a berry. The open beak of this favourite seventh-century motif is not pointed, as is that of the griffin on the big bronze cauldrons, but conical; this was done so that griffin should not damage the wearer's cheek. At his highest point the pendant has a loop, through which a wire could be introduced into the lobe of the ear—such a wire, decorated with a rosette, has survived on another example in Berlin. 324

The granulated rosette is one of the most characteristic 326

211

motifs of goldsmiths' work on Melos and Rhodes. A particularly well-preserved example from Melos is in the National Museum in Athens; this little masterpiece, only 4.6 cm wide, was the jewel on a band of perishable material worn on the head or arm, as has recently been shown by the Belgian scholar, Robert Laffineur. The six petals of the rosette and its heart are again decorated either with a rosette or with a star, in granulation; in the centre is a bird with outspread wings; on the surrounding petals are griffins' heads, like those on the Berlin piece, facing outwards, alternating with three bees, which are turned towards the centre; the latter have settled on the little rosettes, while the griffins grow out of the stars. The goldsmith has applied granulation to the body and feathers of the bird, to its head, and to the griffins' heads and the bees—only the wings of the bees are engraved, to make them seem as light as possible. Groups of granules are set round the edges of the whole rosette, set in threes round the griffins but in fours round the bees, on which there is less granulation; finally, the petals of the rosette have a border of twisted gold wire.

The bees are markedly larger in scale than the bird and the griffins, though one might say that the other creatures are reduced in size in favour of the bees, which are surely more in keeping with the flower. In any case the bee must have been especially important to the goldsmith, since in Rhodian ornament it even appears as a goddess. Five square gold plaques from Rhodes, now in Berlin, show goddesses with sickle-shaped wings and the body of a bee; each of them could have been fixed to a chain by three attachments at the top. Their arms are placed by their sides, with the forearms outstretched laterally; the hands are clenched, as if they held something. On examples of finer workmanship the objects could be rosette-petals, placed on either side, for this object is not granulated in the normal way but simply beaten out—something found also on other sheets and pendants with the bee goddess, most of which were made from the same form.

Modern scholars believe that this being, found only in Rhodian goldsmiths' work, is a manifestation of Artemis of Ephesos, though in truth it belongs not to Artemis but to the ancient Anatolian goddess, Kybele. In general the bee is rather to be placed among the entourage of mother-goddesses, such as Demeter and Rhea, and for that reason in Crete it was regarded as one of the nurses of the infant Zeus; this ancient Minoan myth must still have been alive in Crete in the seventh century, for bees are often used as decoration on Cretan vases. Finally, in the Greek oral tradition *melissai* (bees) was a general term for nymphs, whose characteristics as pure, nourishing

and prophetic beings were equated with those of bees. For this reason it seems unnecessary to look for a specific name for the bee goddess on Rhodian ornaments; she is simply a melissa, and since bees and nymphs are found in the plural, as far as the gold sheets are concerned it is best to speak of melissai. If these sheets were made primarily as ornaments for the dead—for which their thinness and lack of granulation might serve as arguments—they might supply another element for Greek beliefs about bees; people were convinced that bees emerged from the bodies of the dead, and therefore saw in these creatures symbols of immortality—a concept linked with the function of the butterfly, in the Minoan vegetation cult, referred to above (p. 176). One might therefore ask whether Cretan and Rhodian bees and melissai indicate a certain revival in the seventh century of Minoan–Mycenaean beliefs, in which insects played a more important role than they did later.

The goddess Artemis as 'Mistress of the Animals' is another favourite motif on Rhodian and Melian gold sheets. One of the earliest representations, from *c.* 650 BC, is on a pin from Rhodes in Berlin. It is among the examples of this class worked in relief, with granulations—i.e. it was thought of as an ornament for a living person. Beneath it dangle five pomegranates (originally there were six of them); above the goddess the granulated rosette with the lion's head masks the looped extension of the decorative plaque, whose rear part is flat. Artemis is seen in frontal view, holding by the tail two lions, who look up at her, snarling; their manes, like the goddess's hair, sickle-wings and chiton, are covered with skilfully applied granulation; despite the small scale—the plaque is only 3.7 cm high—the effect is monumental.

As a last example of the products of these workshops let us consider a plaque with a centaur, of which there is an example from Rhodes in Berlin. At the top is a large, ungranulated rosette; granulation is totally lacking on this piece. We know many centaurs from Late Geometric art onwards, but this one has no counterpart; the others are bearded, but this one is a kouros, its entirely human front part girt with a belt of a kind typical of seventh-century kouroi. The centaur's long hair with its horizontal waves falls on the chest, on which the right hand is placed; the raised left hand grasps a fawn. The upper part of the body is frontal, the human legs are in three-quarter view, while the elegant equine hind part, with its long, slender tail reaching to the ground, is shown in profile. Despite these changes of viewpoint, this figure, which together with its prey forms a compact group, is convincing. In spite of its small size it is monumental, like the 'Mistress of Animals'. This is the moment when Greek large-scale sculpture begins.

325

322

323

Ivory, Bone and Wood

Mycenaean Work

Ivory and ivory-working were known in the Near East long before the Mycenaeans concerned themselves with them. Since the Achaeans followed the Minoans in their commercial contacts, it is possible that they obtained from Syria direct knowledge of the material and the way to work it. In the Near East, it is assumed, works of this kind were produced by groups of itinerant craftsmen, who may have acted as intermediaries. Once the technique had been learned, it would have been necessary only for the raw material to be imported into Greece and worked in certain centres—in royal palaces or areas adjacent to them; the existence of workshops of this kind can be proved for the palaces of Knossos and Mycenae, and apparently also for Zakro in eastern Crete, Pylos and Thebes. In Mycenae workshops of this kind left traces of their activities outside the walls of the citadel; in the 'House of the Shields' and in the 'House of the Sphinxes' numerous remains of ivory-working have come to light—in the fill above them were not only finished works like the lid with sphinxes but also numerous pieces in varying stages of completion, which must have fallen from the upper floor when the house was burned at the end of the thirteenth century; it is assumed that some of them were exported. Many other examples show that craftsmen in ivory worked in the same place as wood-carvers and those who cut precious stones; all of them co-operated.

Trade in such valuable materials as ivory lay in the hands of the rulers, who obtained them from Oriental monarchs by exchanging goods and then commissioned work in these materials. Ivory was used for various purposes: as decoration on furniture, especially couches and thrones, on weapons, e.g. for the hilts and pommels of swords, for rectangular chests and round boxes, for carvings in the round and reliefs, ornaments, seals, and various everyday objects. The character of these pieces was far from uniform, and the style does not progress in the same kind of consecutive series, and cannot be subjected to the same kind of general survey, as is possible with pottery; as a result, it is difficult to date a lone example unless there are associated finds. Most of this ivory work was doubtless made between the fifteenth and thirteenth centuries; the important find-spots are Knossos and Zakro in Crete and Mycenae, Tiryns, Pylos and Thebes on the mainland; good examples were also found in Attica and in the Artemision on Delos. It is possible to describe and illustrate only a small selection of the material here.

327 Shaft Grave V at Mycenae contained the remains of a small rectangular wooden box, which is about 11 cm high; on each of two opposing sides were two appliqué dogs, sawn out of wood and carved; beneath each of them are set two horizontal strips of ivory. It has long been noted that the value of the ivory and of the carving contrasts with the rather clumsy carpentry of the box. From this one might well conclude that the carpenter and the carver were two different people; all the same, this casket, made in the sixteenth century, gives us an idea how relief work could be combined with ivory in the early days of Mycenae. The dogs are of two different breeds; the larger ones are mastiffs, the smaller terriers; they might be regarded as custodians of the valuable contents of the casket.

As regards weapons we can here mention only the large
Fig. 30 sword-pommel from Shaft Grave IV. It was covered with a

Fig. 30 Sword-pommel with whirligig of four lions, from Shaft Grave IV of Grave Circle A at Mycenae. Ivory. 16th century. Drawing after Karo, *Schachtgräber*, Pl. 77. National Museum, Athens.

thin, hemispherical covering of ivory, bearing in low relief a whorl of four lions, whose heads meet at the centre while their bodies, set to the left, are spread over the rest of the surface; in this way part of an object or weapon was given artistic treatment.

The circular bronze mirror, developed in the east, became a common article of use in the Mycenaean world in the fifteenth and fourteenth centuries BC; the ivory handle-end was ornamented with symmetrical reliefs, most delicately executed. One of our two examples was placed as a grave-gift for a woman buried in the so-called Tomb of Clytemnestra, one of the finest tholoi. Both handles show two female figures, seated 329-3 opposite one another above a set of palm-leaves. On one handle they look towards each other and shade themselves with sprigs of palm. On the other they are shown with their heads 330 bent forward, as if in a trance. The carving, where well preserved, and the motifs are unique; truly, these are works for a king or a queen.

By an exceptional stroke of good luck we have an ivory 328 group carved in the round—height, 7.8 cm—which was found on the citadel of Mycenae and must have come from a sanctuary. Two goddesses, closely embracing, kneel on the ground; the larger figure lays her arm round the shoulders of the smaller one who raises her hand to grasp the other's hand; the larger woman's narrow cloak—seen from the rear—goes from her shoulders behind her companion's back and hips, as if to show that the two are inseparable. Both wear dresses fastened closely at the waist, leaving the breasts exposed, and the folds of the flounced skirts are set close around their knees; their clothing is similar, but the differences in material are particularly clear when viewed from the rear. They look

straight ahead; between them moves a boy, who does not wear the women's flounced skirt but a close-fitting kilt, fastened round his waist; one of his hands reaches to his mother's breast, while with his other elbow he supports himself on the thigh of the younger woman. His profile can be seen in frontal and in rear view, while his mother looks past him.

Many suggestions have been offered as to the identity of these three figures, made around 1400 BC; the most likely is that they are Demeter and Kore (or their Mycenaean predecessors) and Demeter's child, the infant Ploutos (represented later in Classical art).

276 A gold ring from Mycenae bears the representation of a goddess seated on a rock who is approached by female worshippers; the conception is the same in another ivory
331 figure seated on a rock. Her legs are turned so as to be seen in side view, while her arms and torso are turned towards the spectator; head and raised forearms have not survived. Round her neck is a plain, segmented collar; her waist is closely girt, in Minoan fashion, and her breasts are visible. There is a roll around her waist, and the folds of her flounced skirt encircle her legs in generous curves down to her feet. The smooth areas beneath her hips and on the upper part of her body are in strong contrast to the rocky seat, which is marked out by angular divisions. We do not know which goddess is represented. This ivory relief (height, 8.5 cm) may be part of a larger work from the citadel of Mycenae, which was made c. 1400 BC and presumably had a religious subject.

The 'House of the Sphinxes', below the citadel, can be dated from pottery to the thirteenth century; it owes its name to an
332 ivory lid of a box (height 8.1 cm) on which two sphinxes confront each other in heraldic fashion. Above a zone of horns of consecration the two mythical creatures rest their front paws on the capital of a fluted column—like the lions of the Lion Gate; they stand chest to chest and look into each other's eyes. Each of them wears a leafy crown, and a head-piece from which a plume stretches far to the rear; where the wing joins the body there is spiral. The wings are outspread, with horizontal and lateral divisions, and two generous spirals meet below the creatures' chests; their forelegs are set close together on the base, but their hind legs still step forward, as if the two sphinxes were connected at this point.

Mycenaean sites have produced a series of carved ivory heads of warriors wearing boar's-tusk helmets, which may come from objects of furniture of some kind. The finest of
334 them is one from Mycenae, 7.3 cm high, which is shown here. At the top of the helmet is a ring—no doubt to be thought of as of bone—to which the crest could be attached; under it is a series of boars' tusks set in alternate directions in successive rows, the bottom row being somewhat wider than the others. Below the helmet can be seen a line of spiral locks of hair. The cheek-piece is drawn over the ear, whose upper part is visible, and fastened beneath the chin; it too is covered with small tusks in alternate rows. At the back the close-cut hair falls in layers down to the nape; the eyebrow is incised, while the pupil must have been inlaid in some different material; there is no beard or moustache. This is how young men looked in the Mycenaean period.

In the *Iliad* (X, 260 ff.) Homer mentions a boar's-tusk helmet which Odysseus wore when ambushing Dolon; it came from his grandfather Autolykos and had changed hands many times before it was given to Odysseus. The poet gives an exact description of it: 'And he set on his head a leather helmet; on the inside it was drawn tight by many thongs, and on the outside the white tusks of a gleaming-toothed boar were set well and with skill, this way and that, and in the middle a felt cap was fitted.'

In the eighth century Homer could never have known such a piece of armour from his own observation; he must have followed a detailed description from the Mycenaean period, perhaps already in verse.

The boar's-tusk helmet can also be seen on a relief plaque 333 from the Artemision on Delos. Behind the temple of Artemis was found a whole cache of Mycenaean carved ivories, which were cleared out on some occasion, but, consisting as it did of sacred objects, was not profaned but concealed in the sanctuary. On the plaque stands a warrior who with his strong arms grasps his spear in front of him, his head thrown back in a proud gesture; he wears a boar's-tusk helmet, crowned with a socket for the crest, and his large figure-of-eight Mycenaean shield hangs by his side. The representation—perhaps one of the latest examples—shows that this kind of helmet was still worn in the thirteenth century; by that time it may already have been a time-honoured piece of armour, which was abandoned shortly afterwards.

The ivory head found by Lord William Taylour in the 335 cult-room at Mycenae comes from a quite different context. About 6 cm wide, it is a work of great refinement, precision and sensitivity. There is a band round the flat-topped head; the hair, parted in the middle, is drawn down over the broad forehead and hangs in a loop above the ear; it is carefully worked into separate locks. Beneath the brows the wide eyes stare out in surprise. The neck is pierced at the front and side, no doubt to fix the head to a body of different material (wood?). There is a vast difference between this head with its noble features and the dark-painted clay figures of gods with their grim expressions.

The following carved reliefs have a more decorative character; they may have been made for chests, boxes or furniture. On an almost square plaque (length of side 7 cm) is a 336 reclining griffin carved in low relief; it is completely at rest, its paws set on the ground and its wing-tip reaching to the upper left-hand corner. There are spirals at the start of the wing, feathers on the main part, and a tassel-like projection on the head. The griffin's head is placed immediately under a flower, which grows out of the ground in front of it, and one has the impression that in an unhurried way it is inhaling the scent of the flower, looking as peaceful as if butter could not melt in its mouth; one has here no hint of the violent, roaring and lethal hunter which was the Mycenaean conception of such griffins.

A chamber tomb on the slope of the Areiopagos in Athens contained an ivory pyxis (heigth 16 cm; diameter 11.2 cm); 337-8 this precious grave-gift came to light with other copious finds, which indicate a date of c. 1400 BC. The pyxis is lavishly decorated with carving; from both sides winged griffins attack a herd of deer, the powerful creatures sweeping down like the winds of the storm, a shrub bending violently to one side by the blast of their passage. From the right a large griffin sweeps through the air in a 'flying gallop' and strikes its powerful claws into the neck of a deer, which lifts itself up, raises its head, and seeks in vain to escape; from the other side another griffin makes its attack, clapping its wings and dominating the

327 Small box with 'guardian dogs' in relief, from Shaft Grave V of Grave Circle A at Mycenae. Dogs and box of wood, the base of the animals of ivory. 16th century. H. 11 cm. National Museum, Athens.

328 Two kneeling goddesses (Demeter and Kore?), between them a child (Ploutos?), from the Acropolis at Mycenae. Ivory. Probably 14th century. H. 7.8 cm. National Museum, Athens.

329 Mirror-handle: two female figures with palm-leaf fans on top of a palm-tree, from Chamber Tomb 55 at Mycenae. Ivory. 15th-14th century. H. 17.1 cm, H. of the figured scene 7 cm. National Museum, Athens.

330 Mirror-handle (with bronze disc preserved): two female figures on top of a palm-tree, as if dreaming, from the 'Grave of Clytemnestra' at Mycenae. Ivory. 14th century. H. 16.5 cm, H. of the figured scene 5.5 cm. National Museum, Athens.

331 Goddess seated on a rock, from the Acropolis at Mycenae. Ivory relief. C.1400 BC. H. 8.2 cm. National Museum, Athens.

332 Box lid: heraldic sphinxes, from the 'House of the Sphinxes' at Mycenae. Ivory. 13th century. H. 8.1 cm. National Museum, Athens.

333 Relief plaque: warrior with figure-of-eight shield and boar's-tusk helmet, from the Artemision on Delos. Ivory. 14th century. H. 11.8 cm. Museum, Delos.

334 Relief head of a warrior with boar's-tusk helmet, from Chamber Tomb 27 at Mycenae. 14th century. H. 7.3 cm. National Museum, Athens.

335 Head from the cult centre at Mycenae. Ivory. 13th century. W. 6 cm. Museum, Nauplion.

336 Relief plaque with reclining griffin, from Chamber Tomb 88 at Mycenae. Ivory. 14th century. H. 7 cm. National Museum, Athens.

337-8 Pyxis: on the lid and wall (both illustrated here in drawings by P. de Jong, the wall rolled out) griffins attacking stags. In addition two small lions, seen from above, lying quietly. From a grave on the Areiopagos in Athens. Ivory. C. 1400 BC. H. 16 cm, D. 11.2 cm. Agora Museum, Athens.

339 Relief plaque: a lion attacking a bull, from Spata (eastern Attica). Ivory. 13th century. H. 6.5 cm. National Museum, Athens.

340 Comb: on the decorated strip reclining sphinxes, from Spata (eastern Attica). Ivory. 13th century. L. 14.5 cm. National Museum, Athens.

341 Sphinx, from the Athenian Acropolis. Ivory. 13th century. H. 7.2 cm. National Museum, Athens.

342 Round disc (pyxis lid?: cf. Pl. 337) with a rosette in the centre and volutes, in which are small rosettes, from a chamber tomb at Mycenae. Ivory. 15th-14th century. D. 6.2 cm. National Museum, Athens.

343 Miniature columns of various forms, from Mycenae. Ivory. 14th-13th century. National Museum, Athens.

344 Half-rosette motif, from Mycenae. Ivory. Probably 14th century. National Museum, Athens.

345 Statuette of a youth wearing a short chiton (arms and lower legs missing), from the Heraion on Samos. Wood, carved. Mid-7th century. Preserved H. 30 cm. Museum, Vathy, Samos.

346 Statuette of a demon, who carries a male figure, from the Heraion on Samos. Wood, carved. Latter half of 7th century. H. 21.9 cm. Museum, Vathy, Samos.

347 Group of Zeus and Hera as lovers, from the Heraion on Samos. Wood, carved. Late 7th century. H. 19.5 cm. Formerly Museum, Vathy, Samos, now lost.

348 Relief with the beheading of Medusa by Perseus, behind him his guardian goddess Athena, from the Heraion on Samos. Ivory. Latter half of 7th century. H. 10.6 cm. National Museum, Athens.

349-51 Statuette of Hera with high head-dress, reconstruction drawn by D. Ohly from the carved wood original, from the Heraion on Samos. Latter half of 7th century. H. 28 cm. Museum, Vathy, Samos.

352 Sphinx, from the Artemision at Ephesos. Ivory. Late 7th century. H. 28 cm. Museum, Istanbul.

353 Statuette of a god (Apollo) with a lion, from the sanctuary of Apollo at Delphi. Oriental work of 7th century. H. 24 cm. Museum, Delphi.

354 Plaque from dress-pin, from the sanctuary of Artemis Orthia at Sparta: winged 'Mistress of the Animals'. Ivory. Towards the mid-7th century. H. 5 cm. National Museum, Athens.

355 Protome of Artemis Orthia, from her sanctuary at Sparta. Bone carving. C. 600 BC. H. 10 cm. National Museum, Athens.

356 Lion tearing apart a calf, from the sanctuary of Artemis Orthia at Sparta. Ivory. Late 7th century. H. 3.8 cm, L. 8 cm. National Museum, Athens.

357 Comb with the Judgment of Paris: left, Paris sitting, Hera, Athena and Aphrodite approaching, from the sanctuary of Artemis Orthia at Sparta. Ivory. C. 620 BC. L. 8 cm. National Museum, Athens.

358 Segment-shaped plaque: Paris leading Helen on to a ship, from the sanctuary of Artemis Orthia at Sparta. Ivory. C. 620 BC. L. 24 cm. National Museum, Athens.

359 Head of a bearded man, in relief, from the sanctuary of Artemis Orthia at Sparta. Ivory. Towards the mid-7th century. H. 5.2 cm. National Museum, Athens.

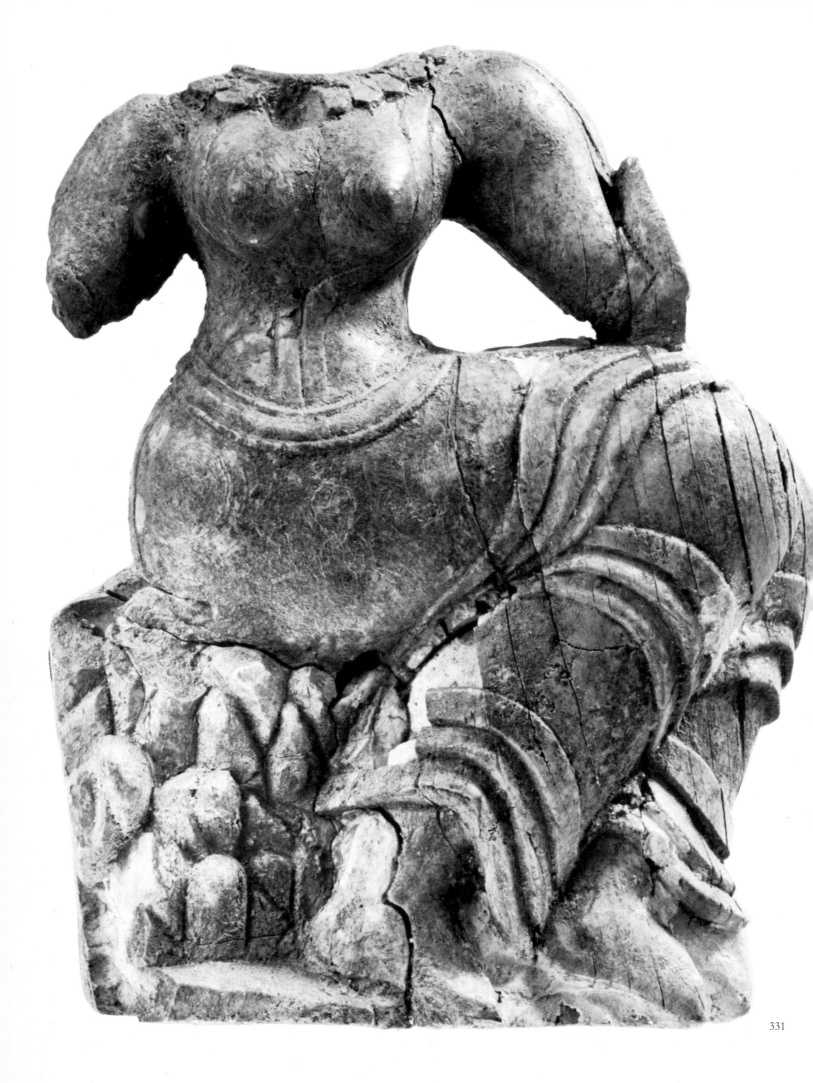

331

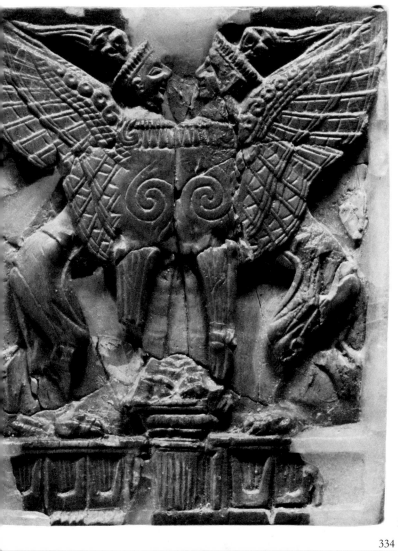

332 333

334 335

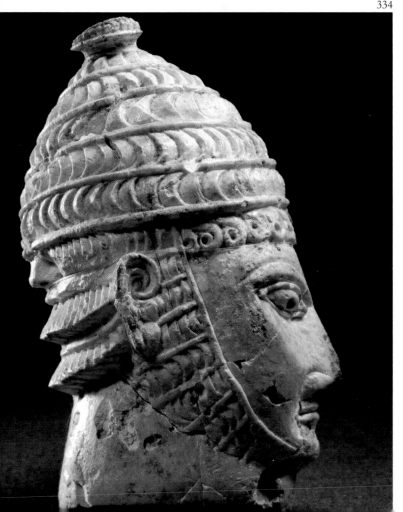

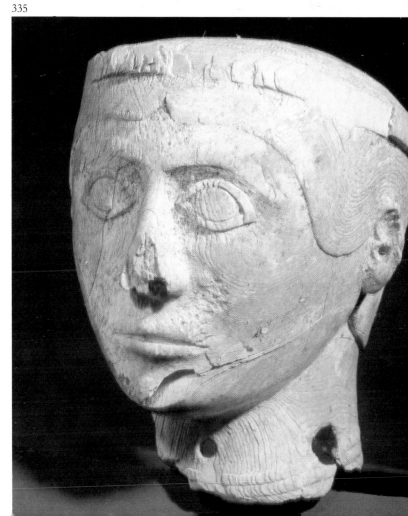

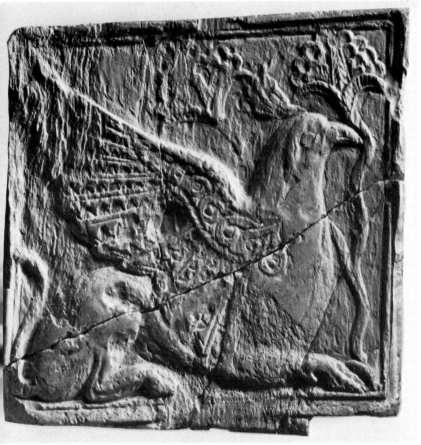

336

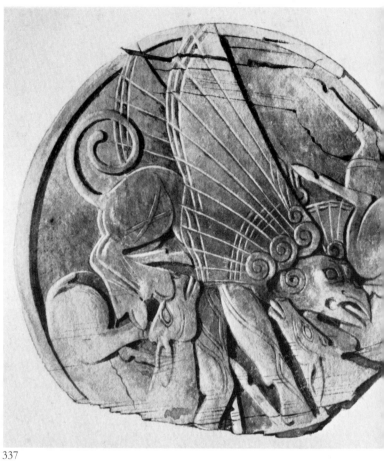

337

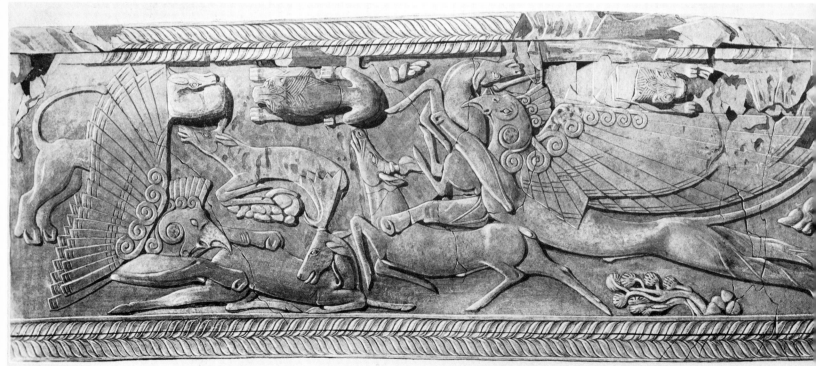

338

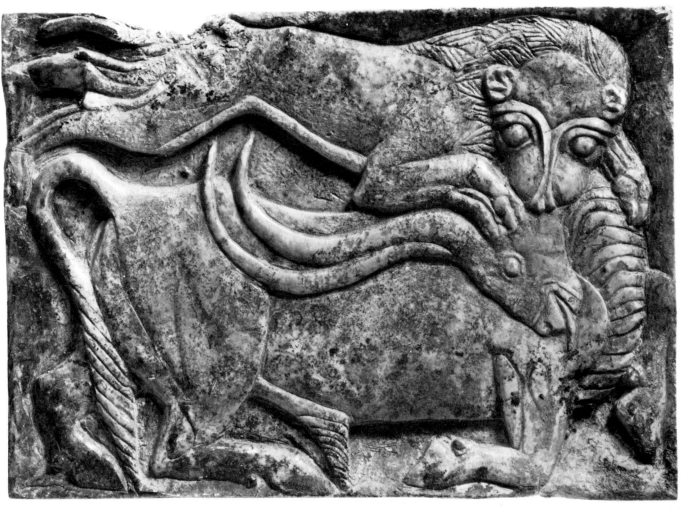

339

340

341

342

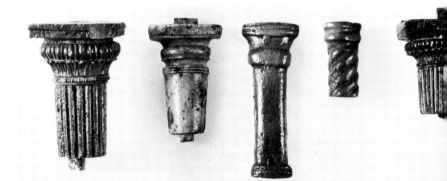

343

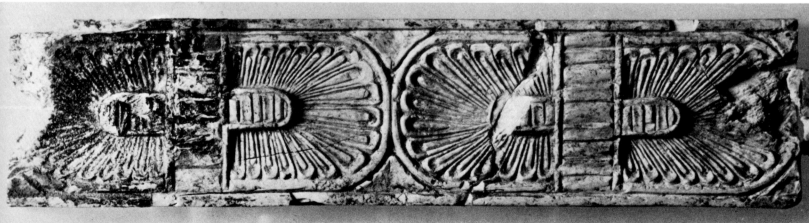

344

345

346

347

348

349

350

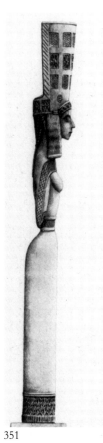

351

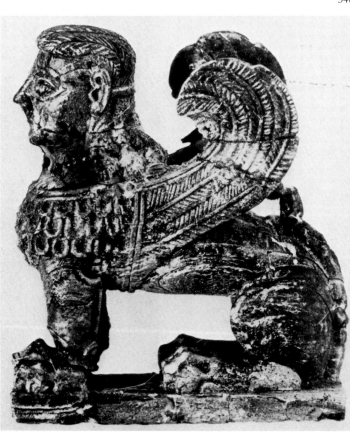

352

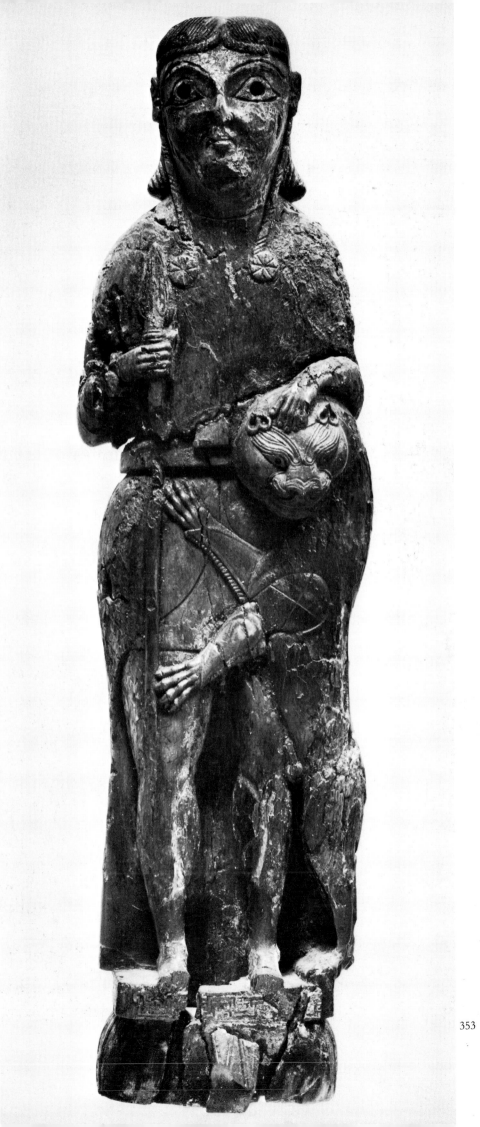

353

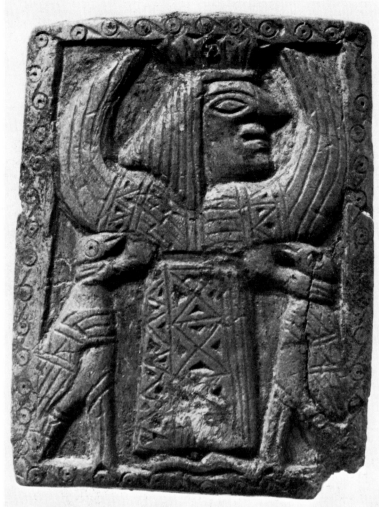

354

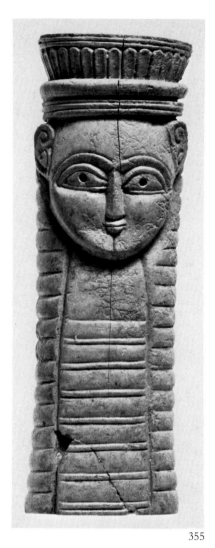

355

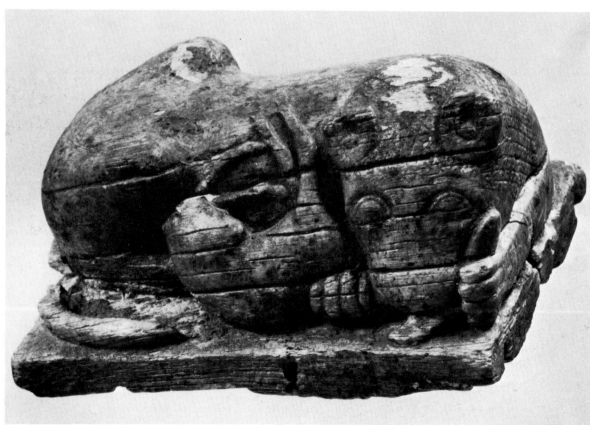

356

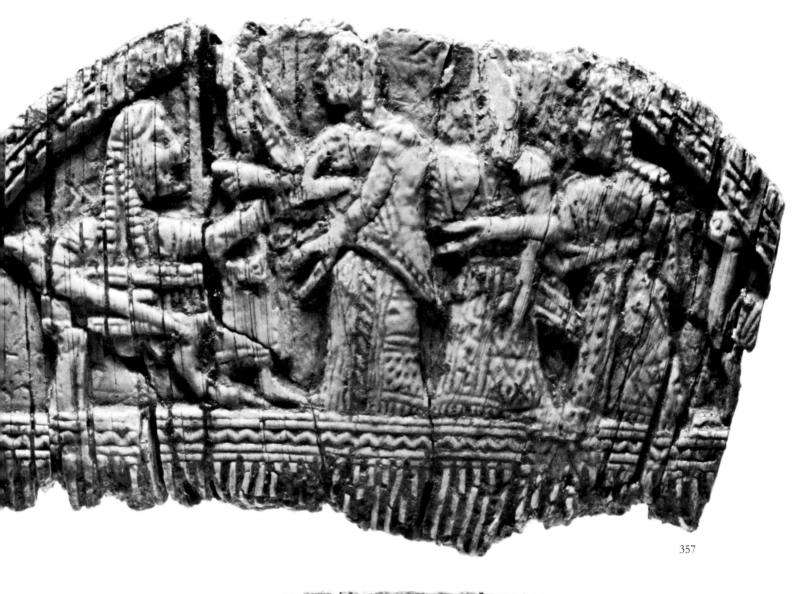

357

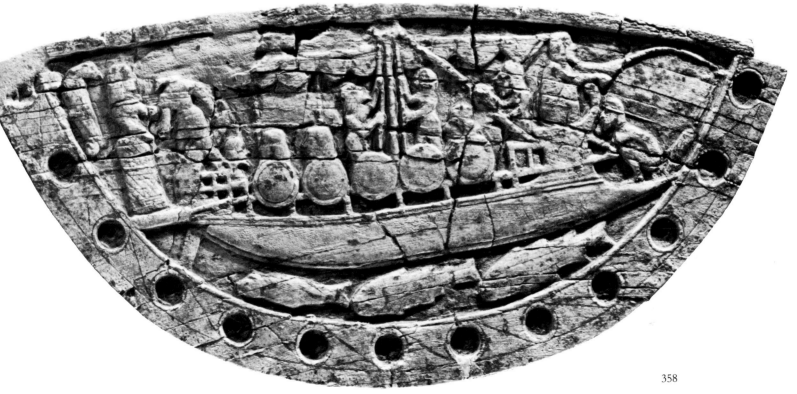

358

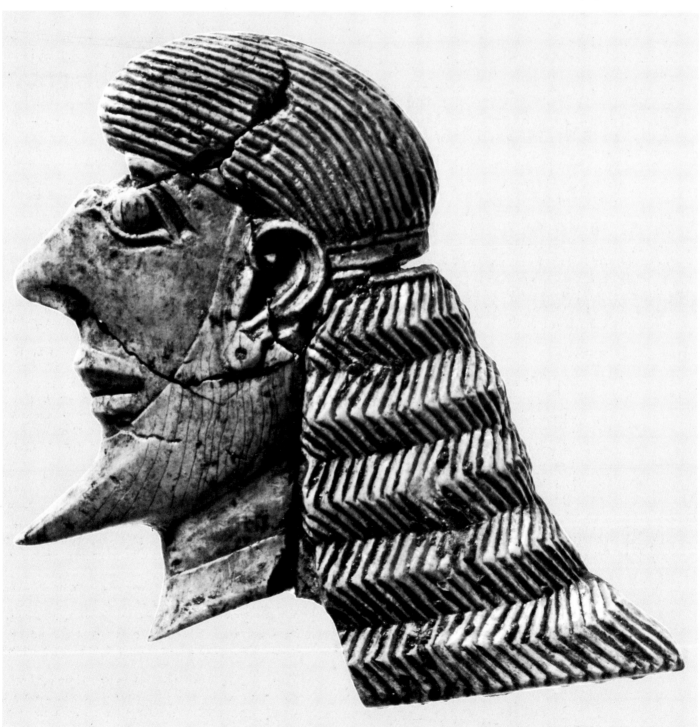

cowering herd. The griffins, with their pointed beaks, have tufts of feathers on their heads, which at the base are surrounded with spirals, and there are other spirals at the roots of the wings, which are spread out wide like a fan. On the lid another griffin attacks two hinds; it is like the left-hand one on the body of the pyxis except that its tail is even more closely coiled. On the body, above the turmoil, are two lions at rest; they are seen in rear view, facing each other, and serve as lug-handles. This grave, the largest and richest in the Agora, must have belonged to a member of one of the leading families.

339 From Spata in eastern Attica came a plaque (length 9.2 cm, height 6.5 cm) showing a bull attacked by a lion. The beast has leaped on to the bull's back and is taking a powerful bite at its neck; the bull turns its head back and is already collapsing. There is a contrast between the eager, glaring eyes of the predator and the dulled vision of the victim. Strong contrasts of line give this carving its charm; note the stress on the line of the lion's belly and, below it, the long curves of the horns and, in addition, the broad tail, divided into separate locks. The carved ivory is small in scale, but a monumental force emanates from it.

340 The comb (length 14.5 cm) was also found at Spata. Above, two decorated bands form the handle, below which the teeth are finely carved from the ivory; the upper band has in the middle a rosette, each of whose broad petals is enlivened by a small one inside it, and the rosette is flanked by two sphinxes looking towards the centre; in the lower band are three sphinxes, of which the left-hand one faces right, the other two to the left. The sphinxes have one wing spread out in front, the other to the rear, and from their heads long, wavy tufts curve out behind them; their paws are set firmly on the ground, and their tails are raised and curled over. The carving is fine,

though products of this kind were routine work. Also of excellent quality is the ivory disc with a large rosette in the middle, surrounded by a ring of smaller rosettes inscribed within volutes. 342

The ivory sphinx was found on the Acropolis at Athens. It rests its front paws on the capital of a decorative column, raising itself upright on its hind legs. Its female head has a low leaf-crown, beneath which the hair projects in ringlets; the eyes and mouth are large and full, the ears broad and heavy, the spirals on the wing accentuated, and the feathers coarsely articulated. One has the impression that the figure was from a piece of furniture, such as a throne, and designed to be seen from a distance. 341

Here and there in Minoan and Mycenaean palaces—for instance, at Mycenae and Pylos—models of buildings in different materials, including ivory, were found. The illustration shows a selection of ivory columns of this kind, some plain, others fluted and with a concave moulding at the top decorated with overhanging leaves. One thinks of the impressions left by fluted columns in the floor of the palace at Pylos (see p. 12). 343

A carved ivory from Mycenae also comes from an architectural context; we have already met the motif in Crete. It must have been employed—in limestone, painting or engraving—to represent something particularly venerable or sacred (cf. the frieze of half-rosettes from Knossos). 344

66

Eighth- and Seventh-Century Work

After the collapse of Mycenaean rule there were no more royal patrons, and warfare in the Near East disrupted the trade routes; the Mycenaean area, which had been so homogeneous, fragmented and during the 'Dark Ages' many areas must have been extremely poor. We do not know whether the art of working ivory survived, somehow or other, in one or two places, or if it had to be re-introduced from the East. It is only from the end of the eighth century that we have noteworthy evidence that the art had again reached a high level—this time, for grave offerings: consider the grave in the Kerameikos at Athens with its ivory figurines.

From the same period also come the first finds of wooden objects on Samos, with figures of men, demons and gods; the sanctuary of Hera on that island, beside the river Imbrasos, was adorned with a whole series of wooden statuettes, vessels and objects, which the river covered with a layer of mud, so preserving them. We show a small selection of these objects.

The first, from the late eighth century, is the remnant of a wooden stool, shown here according to a hypothetical reconstruction. The seat is still decorated in a Geometricizing style but the sides are given a horse's profile and on each of their external surfaces another horse is incised, with an ibex beneath it. Fig. 31

One should also mention a flat wooden plate with remarkable handles projecting at either side, whose curvature goes the opposite way to that of the plate; its diameter is 19.8 cm, and the underside is decorated with chessboard pattern. The incised work cannot be compared with Greek pottery, and the handles are un-Greek in form; the chessboard ornament makes Fig. 32

Fig. 31 Reconstruction of a wooden stool (drawing), from the Heraion on Samos. Late 8th century. Museum, Vathy, Samos.

one think of Phrygian works. A wooden aryballos in the form of a female head (height 8.7 cm) was also found on Samos. Only faint traces of the face have survived; the mass of hair has fared better, with abundant curls encircling the head, ending above the brow in small rounded locks, and so also the handles, which are attached above to the narrow plate-like mouth, and fixed at the back by volutes and palmette-like tongues. This aryballos is a typical Greek work of the second half of the seventh century. The quantity of wooden objects found on Samos suggests that many wooden artefacts have completely disappeared from other sites, where conditions were less favourable to preservation. On Samos we can also add the carved wooden statuettes.

Fig. 33

One of these statuettes is of a youth wearing a short chiton; round his waist is a belt with metal clasps, of a kind fashionable in the mid-seventh century. The greater part of his arms and legs is missing; the right arm was raised to the side. The neck, thick and strong, supports a heavy head, on which the mouth and one eye can still be made out; the hair is divided into strands and where it falls over the brow seems to finish in little curls, while its projection at the sides makes the face seem even broader than it actually is. The ears are pressed slightly forward by the mass of the hair, which is cut away above the shoulders and divided up in a way which we know from sculpture of the mid-seventh century.

345

The plump wooden demon (height 21.9 cm) with chubby cheeks like a child's, thick lips and wide-open eyes, is unusual; his penis, clearly large and erect, was made separately and

346

attached; on his left arm he carries a nude man, who has a cap on his head. We do not know what name the Samians gave to such a demon, nor what functions or powers they ascribed to him, but it is amazing what corporeality their carvings could achieve in the later seventh century when, as here, they were emulating a foreign—perhaps Egyptian—model.

Zeus and Hera, standing on a single base and carved in one piece, are shown, not at the consummation of the Sacred Marriage, but as lovers (height 19.5 cm). He grasps her breast with his right hand, while his left arm encircles her neck; their feet and lower bodies are turned towards each other, while their torsoes and heads are in frontal view. As often in the early period Zeus is beardless and dressed in a short garment; both wear low poloi on their heads. Between them a bird, seen in rear view, soars up; it is the cuckoo, in whose form Zeus tricked Hera in order to make love to her before their marriage without the knowledge of their parents (*Iliad*, XIV, 295 f.). This carving—now lost—was made towards the end of the seventh century, possibly on Samos, though definitely under Anatolian influence.

347

The ancient cult image of Hera on Samos, a board which was supposed to have fallen from heaven, had in the seventh century long since been replaced by a sculpted figure. Its loss increases the importance of a find which transmits to us a definite idea of the original. This is a wooden statuette of the goddess, 28 cm high, which was fixed to a base by a tenon. She wears a long garment, which conceals her feet; round her waist is a wide belt. The bottom hem of the garment, the belt, and the border of the wrap round her shoulders are decorated with the same kind of Geometric ornament; her breasts swell out slightly in front. But the most impressive element is the tall, ornamental head-dress, or rather *Pyleon*, which is left open at the back and makes the goddess's slender figure seem even taller. (*Pyleon* literally means gate-tower; for cult purposes such head-dresses were woven from grass.) On either side the hair falls in wide, curly locks, and at the back several plaits are bunched together. This carving may have been made soon after the middle of the seventh century.

349-5

Also from the Heraion on Samos comes an ivory relief showing Perseus beheading Medusa. His helper, the goddess Athena—most of this figure has broken off—touches his arm with the conventional gesture of support; she wears no helmet but simply a band round her hair; on the right the monstrous winged Gorgon, Medusa, with scales on her chest, is in the process of collapsing. She has glaring, petrifying eyes, a wide mouth with projecting tongue, curls of hair above her forehead and prominent cheeks. In the middle is the hero of the occasion, Perseus, in all his glory, with full hair falling to his shoulders and curls above his brow; his left hand grips one of the snakes which sprout from Medusa's head, while his right cuts through the monster's neck with a large sword. On his head is a pointed hat—the hat of Hades, which made him invisible, and which is the only element in the composition that overlaps the border; he does not look at Medusa, to avoid being turned into stone. To judge by its style, this work was produced at the end of the seventh century, though we cannot say whether it was made in Samos itself or in Sparta, or indeed somewhere else, for we have too few reliefs of this kind to be able to attribute them to different artistic schools.

348

The sphinx from the Artemision at Ephesus (height 28 cm) is a masterpiece made by an East Greek ivory-carver at the end

352

Fig. 32 Top and bottom of a wooden plate, from the Heraion on Samos. Phrygian? Drawings by the German excavation team, Samos, cf. Figs. 31 and 33. D. without handles 19.8 cm. Museum, Vathy, Samos.

Fig. 33 *Aryballos* (oil container) of wood in the form of a female head, from the Heraion on Samos. Drawings of the whole and sections. Later half of 7th century. Museum, Vathy, Samos.

of the seventh century. The lion's body has short, sturdy legs and scales on the chest, on which are set sickle-wings, with feathers arranged in herring-bone pattern; these lead the eye on to the female sphinx's head, which has a pointed, projecting nose, ornamentally stylized ears, and hair which at the top follows an even curve, with separate locks, but which is bound in at the back by a band. The proportions are are well balanced and every detail is exactly placed.

We know that the sanctuary of Apollo at Delphi was famous far beyond the Greek territory and that non-Greek rulers, such as Kroisos of Lydia, made enquiries of the oracle and rendered lavish offerings to the god. Some such Anatolian dedicator may have given the ivory figure which was found at Delphi (height 24 cm): a god, who holds a spear or sceptre in his left hand, has on his left side a rearing lion, whose legs are seen from the side and his head from the front. The animal only comes up to the god's waist, and so is subject to him; it is Apollo's sacred animal, which in the early period was often placed with him—e.g. on the Terrace of the Lions in the sanctuary of Apollo on Delos. In this ivory group the god places his hand on the lion's head, as if to subdue it. He wears a long cloak over a short chiton, has a belt round his waist, and is bare-headed; the hair on his flat-topped head, parted in the middle, falls down in front over his chest in two locks, which end in rosettes. The pupils were inlaid with a different material, while the eyebrows and lids were carved (and no doubt stressed by use of a different colour); his hands are unusually small. The lion's heart-shaped ears, eyes and the lines on its head are clearly demarcated, as are its claws. This is a seventh-century piece, which may have inspired Greek ivory-carvers in their own work.

Many bone or ivory objects were found in the sanctuary of Artemis Orthia at Sparta, where there must have been an extensive factory. The site produced this head in relief (height 5.2 cm), which must have been made by an outstanding Spartan artist. The wide-open eyes with their eyebrows, the nose projecting almost pertly, the clean-cut mouth with shaven lower lip, the jutting beard decorated with fine lines—all give us an idea of the delicacy and sureness of touch which a great artist here brought to his work. The ear is conceived as a whole; the hair is combed back from the forehead, gathered in by a cord, and then falls in articulated layers; These elements make a splendid frame to the whole. Though we cannot know the identity of this fine male head, the manner of execution allows it to be attributed to the mid-seventh century.

The same site also produced an ivory plaque from a dress-pin (height 5 cm) showing the 'Mistress of the Animals' with a leaf-crown on her head, sharp features, and ample hair falling in vertical locks; to indicate her supremacy she grasps two birds—perhaps ravens—by the neck. The lines of the relief are hard and angular; triangular depressions have been carved into the decoration of her garment, and the whole group is surrounded by a narrow border ornamented with dotted circles linked by tangents. This little object may have been made around the middle of the seventh century and represents the owner of the sanctuary, Artemis Orthia—as does the following piece, which is of bone (height 10 cm) and also shows her wearing a polos surrounded by tall leaves or tongues. Here, however, she is viewed frontally; her ears are set beside her broad forehead, though placed much too high; her straight nose and mouth are too small in proportion to the wide-open eyes, with pupils inlaid. The long neck and the hair on either side of it are given horizontal divisions; both look as though they could go on for ever. This protome, an impressive workmanlike piece, dates from around 600 BC.

An ivory group of a lion rending a deer or a calf was also found in this sanctuary. The base on which it rests is 8 cm long. The mighty beast lies on the animal it has caught, holding it with both front paws and biting its neck; one can see only the victim's body, on its back with its legs in the air. There is an impressive contrast here between the massive power of the lion and the utter feebleness of its victim.

From the Artemis sanctuary we also have the ivory comb with a representation of the Judgment of Paris described above (p. 83)—a subject especially meaningful on a woman's comb. Another piece with a common mythological theme (height 24 cm) shows the abduction of a woman by ship. On the left is the tall stern-structure of trellis-work, with the steering-oars below it; above is the principal figure, a man in armour, turning towards a woman boarding the ship; behind her on the frame is a bird, looking back. Warriors with round shields sit on the rowing-deck of the warship; below, fish swim to the left. On board above them men are busy with the sail; a bearded man sits on the high prow casting with a long fishing-rod, with which he draws up a fish, while another crouches on the pointed ram and relieves nature. The round depressings in the lower border were no doubt inlaid with a different material.

As with other related scenes, this can be interpreted as Paris taking Helen away by ship. This abduction was the central element in the legend; the departure of a captain from his wife or bride, suggested by some scholars, was not a theme worthy of representation in early Greek art. The work was made around 600 BC.

353

354

355

357

358

359

231

Sculpture

Mycenaean Period

On the island of Keos, beside the church of Ayia Irini on the shore of a deeply reaching bay, a team of archaeologists under the direction of J.L. Caskey uncovered a Bronze Age town. Close by the church was a building which the excavators called a temple. It is a long rectangular building, divided inside into several rooms. In one of these rooms they found, to their great surprise, many fragments of large terracotta sculptures. There were definitely nineteen figures and further fragments bring the total up to about twenty-four. They are of the free-standing type and range from half- to fully life-size. They are all of women represented in dancing poses. Below the tightly drawn-in waist they wear wide flaring skirts; above the bare breasts are exposed over a closely-fitting jacket. There are thick rings around the hips and neck. The arms jut out sideways, bent at the elbows so that the hands rest on the hips. One might think of these figures as dancing nymphs, the largest of them, in the excavator's opinion, may have been cult statues.

The surprising thing about them is their size: they tower above all pieces found on Crete and in the Aegean. They were made by potters from Keos on their own initiative employing self-invented, almost improvised means. In the still damp clay pieces of wood were inserted to give support, not as a firm interconnected framework, but loosely during the actual modelling. There was a vertical pole in the middle around which the skirt was laid ring upon ring in the manner that a pithos is made. Sometimes this pole reached up as far as the head. The shoulders might be supported by horizontal struts—where they are missing the shoulders tend to slope downwards more markedly—while the arms were strengthened by thinner pieces. In one case the wood is well enough preserved for its type to be ascertained: willow. These wooden supports remained inside during the firing and became red hot, so a particularly gentle prefiring was required.

In rare cases the upper and lower parts were worked separately and joined after firing, stone wedges being inserted to avoid any displacement. The skirts usually remained open underneath, but occasionally they were closed by clay plates.

The proportions of the parts and the inserted supports vary from one piece to another. The artist did not follow a canon but experimented and improvised. The sculptures are hand-made, not produced from moulds. The breasts were modelled on conical cups such as were in daily use. The clay of the core is very coarse, so over it a thinner slip of finely levigated clay was laid. This has mostly flaked off, whereas the core shows only a few cracks. In a few areas traces of colour have been preserved: white for the bare skin, yellow ochre for the garments and red for the neck-bands.

At first the excavators believed that they were dealing with twelfth-century terracottas. Later they realized that these works were much earlier, Early Mycenaean, or on the Cretan time-scale from the period of the late palaces. The temple was destroyed by an earthquake and the terracottas fell from some high place—perhaps from a wooden shelf or an upper storey—and broke; later some pieces were removed. One cannot classify these terracottas as Minoan, although the dress is of Cretan origin. Nor are they really Mycenaean, although they are contemporary with Early Mycenaean pottery. They remind one rather of the wall-paintings found on Thera of

women at a religious festival. The style of the terracottas is purely insular, one which at this time required the creation of such large-scale works. During the 'Dark Ages' the head of the sculpture K. 3.611 was stored separately in a round clay basis and obviously greatly revered. In the fourth century the god Dionysos was worshipped in the temple, as inscriptions show.

From Enkomi on Cyprus comes a statuette of a horned god, 55 cm high, which was excavated by P. Dikaios. It was in the central area of a sanctuary and seems to have been worshipped there for a long time, in fact from the beginning of the twelfth century to the early eleventh. Then the inhabitants abandoned the town, leaving behind their household goods and the image of their god.

The statuette is completely mould-made and shows the deity as a young man standing and leaning forward slightly, his left leg a little in front of the right. He is naked except for a close-fitting loin-cloth suspended from a thick belt at the waist. On his head he wears a thin fur cap with curly hair, from which two bull's horns project sideways. The left arm is bent at the elbow and laid on the breast; the right arm is outstretched, so that the palm of the hand faces downwards in a protecting gesture. The loin-cloth has a decorated hem; around the neck is a delicate necklace. In profile the nose seems to be a prolongation of the forehead. The eyes are wide open and the thin mouth has a slight smile. The ears are big and protrude sideways. Under the feet are preserved two plugs of metal, which probably served to attach the statuette to a base.

It is easy to see in this horned god Apollo Kereatas, who was worshipped in Arcadia as well as on Cyprus. Perhaps migrants from Arcadia brought the cult to Cyprus, as is suggested by the offerings found in the cult rooms at Enkomi: bulls' horns and skulls and also some small golden representations of them. The statuette was probably made by a Cypriot artist. Its style reflects a mixture of Mycenaean and Syrian influences, while its elaborate moulding technique suggests a long workshop tradition.

The statuette of a youth, 12 cm high and made of lead, was found in a tomb at Kampos in Lakonia. The youth wears a belt around his narrow waist and a triangular loincloth, with a penis-sheath very much in the Cretan style. He has a circlet around his head and his thick hair, which falls down his back in a broad tress, is segmented horizontally, in contrast to the Minoan fashion. He stands firmly on his feet, placed slightly apart, and holds out both hands with the palms downwards: indeed he appears to be looking at them. Since he was carrying something—but what?—he seems to resemble the bringers of offerings in wall-paintings. We should not, however, think of him as just a genre figure.

If one compares this youth with the god from Enkomi, the difference in proportions strikes one immediately. In one case the legs are long and muscled, the waist narrow and the form of the upper body triangular; in the other a continuous contour links the rather squat limbs and swelling chest. Both statuettes seem to be smiling, but the horned god has a definite look in his eyes.

In a Late Mycenaean sanctuary at Phylakopi on the island of Melos C. Renfrew found the clay statuette of a goddess illustrated here among other treasures such as male idols, some of which were imported from the East, and Mycenaean bull-shaped rhyta. The goddess is 16 cm high and damaged

234

(but since repaired) only below the neck and at the bottom on the right. The arms, which were both raised, are just stumps. The body was turned on a wheel and is shaped like a long tube, tapering a little towards the waist. The upper body protrudes all around. Neck, head, hair and arms are hand-made.

The clay is of a light reddish colour, while the painting varies from dark red to brownish black. Breasts and skirt are partly decorated with triangular and zigzag patterns and partly with patterns which end above in a wavy form. A wavy ring also appears over the chest and forms the upper border of the skirt. The neck is adorned with a necklace. The skirt carries, in added white on the dark bands, a ⋁⋀⋁ pattern above a ⋏⋏⋏ pattern and rows of little dots. The skirt has two wide bands at the waist and another roughly in the middle of the dress, a segmentation which probably represents the last remains of the Cretan flounced skirt.

The neck is rather long and the head is surprisingly both turned sideways and tilted upwards. The eyes look up at the sky. They are round, wide open and have eye-lashes all round. The eyebrows bulge in wide arcs, and are enlivened by stripes. Wavy hair, surrounded by rows of dots, frames the forehead and falls down in two long locks in front of and behind each ear. The ear itself is rendered plastically and given a painted spiral decoration. At the back the hair falls down in a thick tress which reaches to the hips.

The most remarkable thing about the statuette, however, is that there is a large, dark painted area on the face. It begins over the bridge of the nose between the brows, continues down the nose to the mouth, and encircles the chin. Here we should not speak of a weird impression, as with Lord William Taylour's idols from Mycenae. The dark parts seem rather to be intended to emphasize the modelling. The statuette is a strange mixture of highly stylized, nearly schematic features and more naturalistic elements such as the pose of the head and its gaze. At the same time the piece is rich and elegant in appearance. It is indeed the most impressive example of the late phase of Mycenaean art towards 1200 BC and can easily be compared with the best of the pottery at that date. This statuette must have been worshipped as a divine being, because of its appearance and the circumstances of the find.

K. Kilian, who excavated the Lower City of Tiryns, found a little sanctuary with several phases one on top of the other. In it was a bull-shaped rhyton, like those found at Phylakopi on Melos, which surely served a cult purpose. In addition there were several complete idols and fragments of others; two of them are illustrated here. Both are female figures with long drapery falling to their feet and have their arms raised in the gesture of epiphany; on one the hands are covered by the drapery, whereas on the other they protrude from the drapery, with the palms held to the front.

Each has a very long neck with a precious neck-band round it. In one case the necklace consists of rings of dots, with a large ornament hanging down on the breast; in the other case there are also two rings and a row of circles with dots which probably represent rosettes. Such rosettes can also be found on the lower and side hems of the garment, on the flat head-dress as well as on the bands which fall down on both sides of the lavish tresses that reach down to the buttocks. The breasts are modelled and emphasized by painted circles. The lips are thin and the mouth wide; in one case the figure seems to be smiling. The eyes are wide open in astonishment; they are drawn

as round discs with a surrounding circle. The eyebrows are arched, represented in one case by little lines, in the other by hatching, as on the goddess from Phylakopi. The ear is modelled, and also has a gloss slip line around it. In front of the ear is a painted sweeping curl. The idols from Tiryns, which are over 30 cm high, may belong to the Late Mycenaean period, c. 1100 BC.

After all these newly discovered statues of gods which reach up to half life-size, one may ask how the head of painted stucco, 16.8 cm high, which was found long ago at Mycenae, is to be explained. Previously it was taken for the head of a sphinx, but the new discoveries suggest that this too might be the head of a goddess, the largest yet found. A red band runs across the forehead, over which rises a flat blue head-dress, divided by vertical black lines. Short curly locks frame the forehead below the band. They are bluish-grey in colour, as are the arched eyebrows and the very naturalistic eyes. The closed mouth is red. Red markings are to be found inside the modelled ears, which lie close against the head, while the pattern of spots on the cheeks and chin is also done with red. Are these spots tattoos, or has the painter tried to use them to make the goddess more beautiful? A smaller elegant idol (height 29 cm) from Mycenae has similar patterns of spots on the cheeks. A further small idol from Mycenae has squares on the cheeks, repeating the patterns on the garments.

In any case this work is the sole large sculpture of a human head to have survived from the Mycenaean epoch.

Sub-Mycenaean Period

At Karphi on Mount Dikte on Crete a number of idols were found in a simple sanctuary. This is the place to which the native Cretan population retreated before the invading Dorians and where they still maintained for a time their traditional customs and religious rites (cf. p. 55). Not only the urban layout but also the idols are Sub-Minoan, produced between 1100 and 1000 BC. One of these idols, 67 cm high, is illustrated here.

The lower part has been turned on the wheel and formed like a pipe. In the middle on the lower part, however, is a semicircular cut-out, in which movable feet are set. The upper part of the figure is hand-formed and the female breasts modelled. The arms are held up in front in the gesture of epiphany. The head is surrounded by a diadem-like wreath, above which, in the middle, is set a pair of sacred horns. The neck is very long and plaits of hair fall far down the back. The mouth is slightly opened, the ears are modelled and round, and the hooked nose juts out sharply.

Of the same type is the head, 12 cm high, which was found at Asine in the south-eastern Argolid. It was wrongly spoken of by the excavators as the 'Lord of Asine'. It is actually a female head with the same characteristics as the statuettes from Karphi. The flat chignon ring around the head, the large protruding nose, the slightly opened mouth, the round ears and the hair plaits falling down the back, all compare well. Only the eyes are even more strongly modelled in the round. The ears are drilled, as on some other idols of the early period,

360 Statue of a dancing figure, from the Cycladic sanctuary at Agia Irini on Keos. Terracotta, with remains inside of willow wood as a support. 16th century. H. 99 cm. Keos.

361 Upper body of statue, from the same find-spot and in the same technique as the statue on Pl. 360. Terracotta. Keos.

362 Head of a statue like those in Pls. 360 and 361. Terracotta. Nearly life-size. The head was preserved during the centuries up to the 'Dark Ages' in the sanctuary at Agia Irini and was clearly venerated. Keos.

363 Women in an frenzied cult ceremony, from Thera. Fresco. 16th century. H. of figure 1.14 m. National Museum, Athens.

364 Statuette of a youth, from a tholos tomb at Kampos (Lakonia). Lead. 15th-14th century. H. 12 cm. National Museum, Athens.

365 Statuette of a horned god (perhaps Apollo Kereatas), from Enkomi (Cyprus). Bronze, solid cast. 12th century. H. 55 cm. Cyprus Museum, Nicosia.

366-8 Statuette of a goddess (idol), from the Late Mycenaean sanctuary of Phylakopi on Melos. Terracotta. Towards 1200 BC. H. 16 cm. Museum, Melos.

369, 372 Statuette of a goddess (idol), from a sanctuary in the Lower City at Tiryns. Terracotta. H. just over 30 cm. C. 1100 BC. Museum, Nauplion.

370-1 Statuette of a goddess (idol) with raised arms, from the same find-spot as Pl. 369. Terracotta. H. c. 30 cm. C. 1100 BC. Museum, Nauplion.

373 Female head probably of a goddess, from the Acropolis at Mycenae. Stucco, painted. C.1250 BC. H. 16.8 cm. National Museum, Athens.

374 Sub-Minoan idol, from Karphi (Crete). Terracotta. 11th century. H. 67 cm. Museum, Iraklion.

375 Head of a female idol, similar to that in Pl. 374, from Asine (Argolid). Terracotta. 11th century. H. 12 cm. Museum, Nauplion.

376 Statuette of a goddess (idol) with raised arms, from the cult centre at Mycenae. Terracotta. Late 13th century. Museum, Nauplion.

377 Centaur, front view, from Lefkandi (Euboea). Terracotta, hollow body, perhaps used as rhyton, as the firing hole at the front suggests. C. 900 BC. H. 36 cm. Museum, Eretria.

378 Stag from a Proto-Geometric grave in the Kerameikos at Athens. Terracotta. Hollow body, probably used as a rhyton, as the finish of the body shows. 10th century. H. 26.6 cm. Kerameikos Museum, Athens.

379 Centaur from Lefkandi, side view (cf. Pl. 377).

380-1 Hero (probably Herakles) and centaur. Bronze group, solid cast. Third quarter of 8th century. H. 11.3 cm. Metropolitan Museum of Art, New York.

382-4 Warrior on a chariot-box, from Olympia. Bronze, solid cast. Third quarter of 8th century. H. 13.6 cm. Museum, Olympia.

385 Hind suckling its young. Bronze, solid cast. Late 8th century. H. 7.2 cm. Museum of Arts, Boston.

386 Small standing horse. Bronze, solid cast. Late 8th century. H. 16 cm. Antikenabteilung, Staatliche Museen Preussischer Kulturbesitz, Berlin.

387 Miniature bulls, votive offerings, from Olympia. Bronze, solid cast. 8th century. Museum, Olympia.

388 Miniature horses, votive offerings, from Olympia. Bronze, solid cast. 8th century. Museum, Olympia.

389-91 Warrior and horse, from a tripod handle (reconstruction Pl. 391). Bronze utensil attachment, solid cast. Third quarter of 8th century. D. of handle 45.6 cm. Museum, Olympia (cf. tripod in Pl. 153).

392 Horse's head, from Olympia. Bronze, solid cast. Early 7th century. C. 2½ × actual size. Museum, Olympia.

393-6 Statuette of naked woman wearing a polos, from a Late Geometric grave (cf. Pl. 237) in the Kerameikos of Athens. Ivory. 735-720 BC. H. 24 cm. National Museum, Athens.

397-9 Head of Apollo Amyklaios, from his sanctuary at Sparta. Terracotta. C. 700 BC. H. 11.5 cm. National Museum, Athens.

400-1 Head of Artemis or Leto, from the same find-spot as Pls. 397-9. Terracotta. C.700 BC. Of the same size and style as the helmeted Amyklaios, which was possibly connected with Leto and Artemis in a group of three. The head of the second goddess would then be lost. National Museum, Athens.

402-4 Warrior. In his left hand, like the warrior in Pl. 389, holding perhaps a horse on a rein, brandishing in his hand a spear; from the Acropolis in Athens. Bronze, solid cast. Latter half of 8th century. H. 20.5 cm. National Museum, Athens.

405-6 Griffin's head from a cauldron (cf. Pl. 160), from the Heraion on Samos. Bronze sheet, embossed. Early 7th century. H. 18.1 cm. Museum, Vathy, Samos.

407-8 Griffin's head from a cauldron (cf. Pl. 164), from Olympia. Bronze, hollow cast. Second quarter of 7th century. H. 35.8 cm. Museum, Olympia.

409 Head and breast of a sphinx from Calydon, an akroterion of the Artemis temple. Terracotta. Second quarter of the 6th century. H. of head (with neck) 21.5 cm. National Museum, Athens.

410 Cycladic jug (of the same style as Pl. 261) with a griffin's head as spout. Clay. Mid-7th century. H. 41.5 cm. British Museum, London.

411 Sphinx, from Perachora near Corinth. Ivory. Probably third quarter of 7th century. H. 7.7 cm. National Museum, Athens.

412 Fragment of a relief pithos with mythical beast. Clay. Probably second quarter of 7th century. Kanellopoulos Museum, Athens.

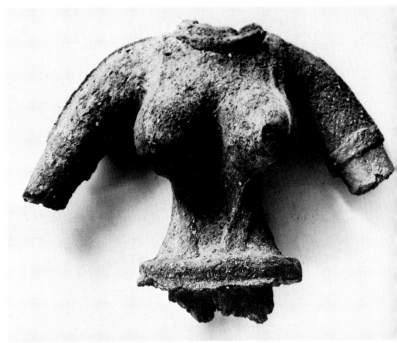

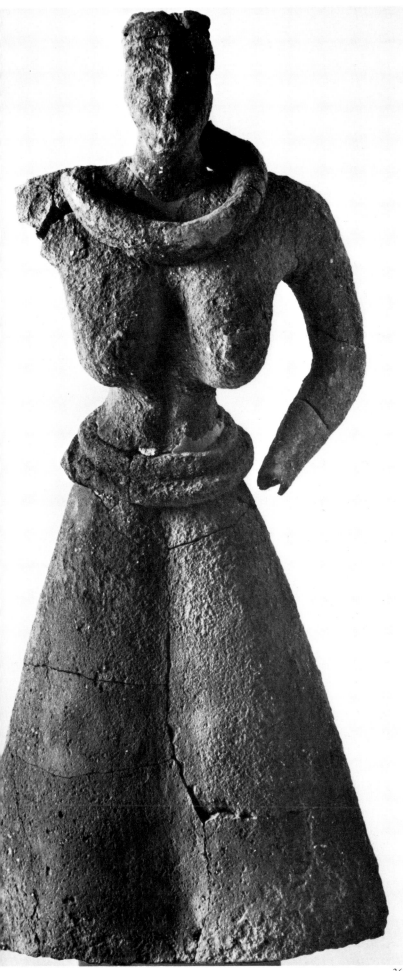

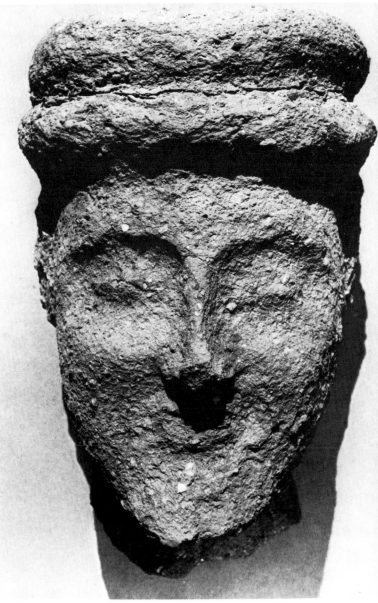

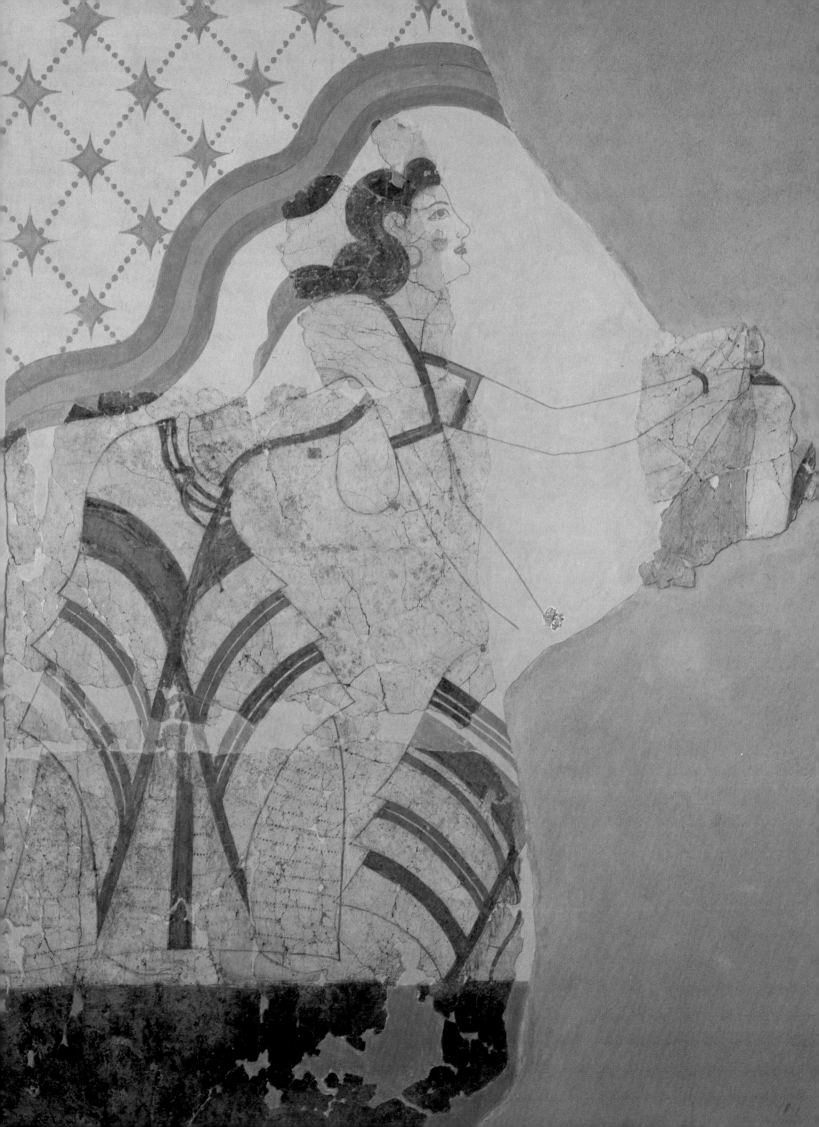

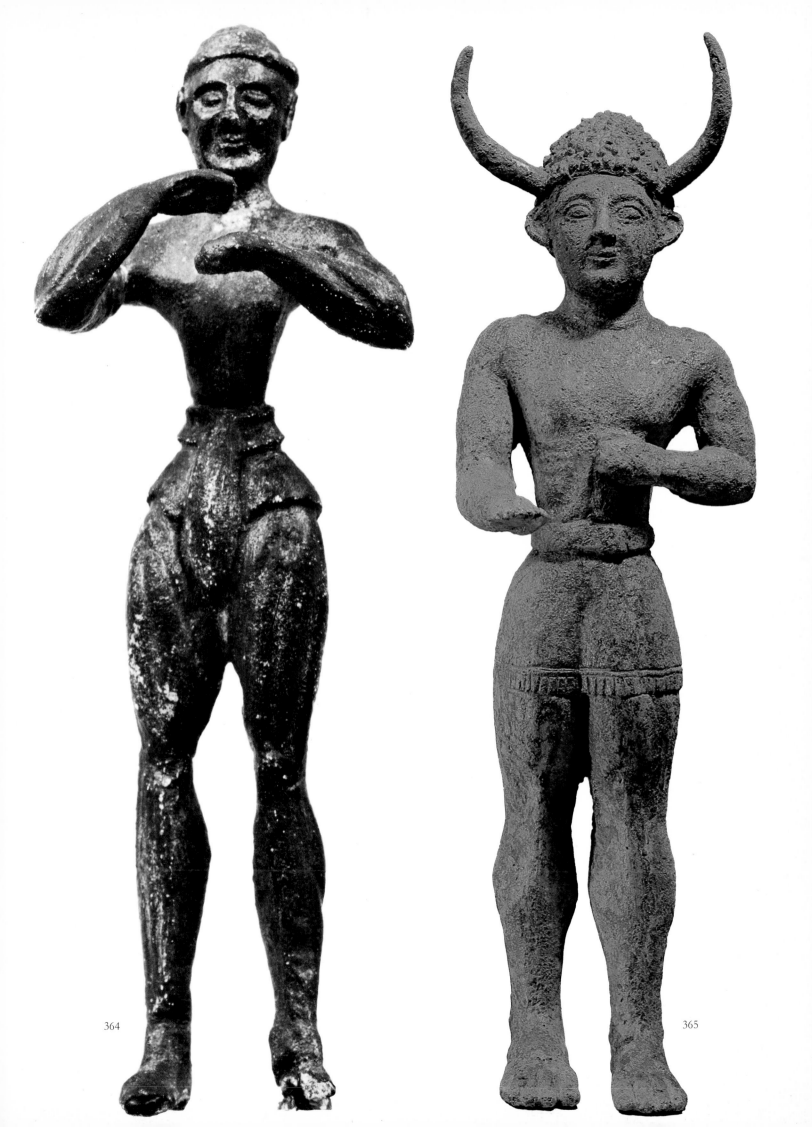

364

365

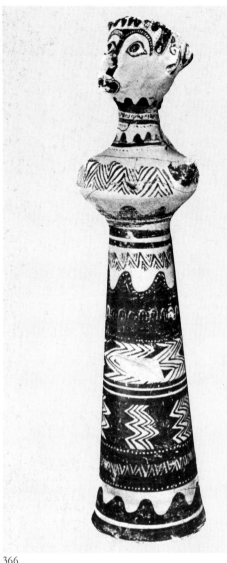

366

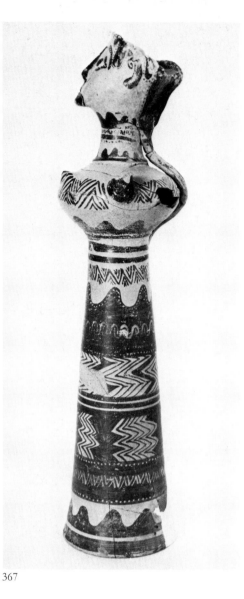

367

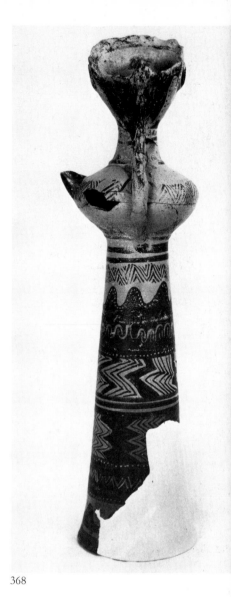

368

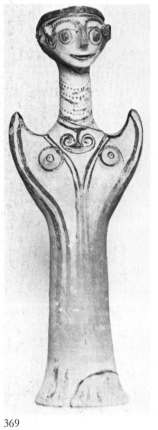

369

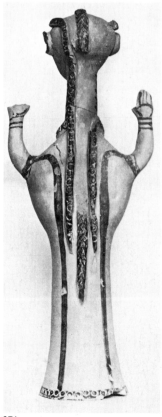

370

371

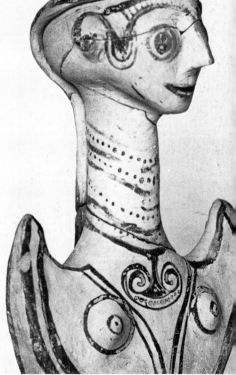

372

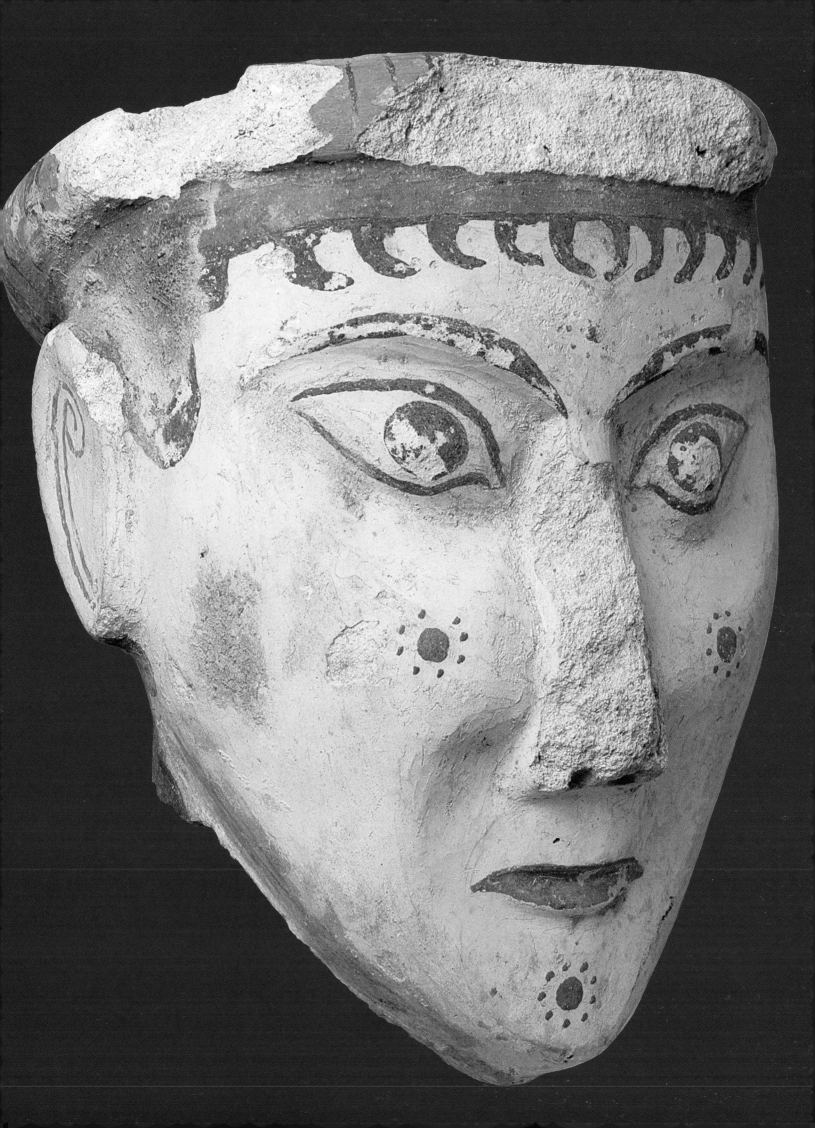

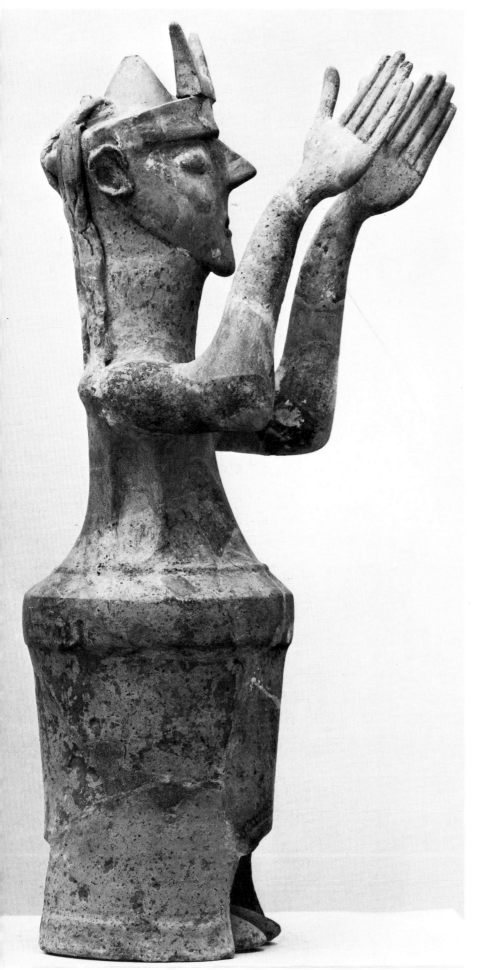
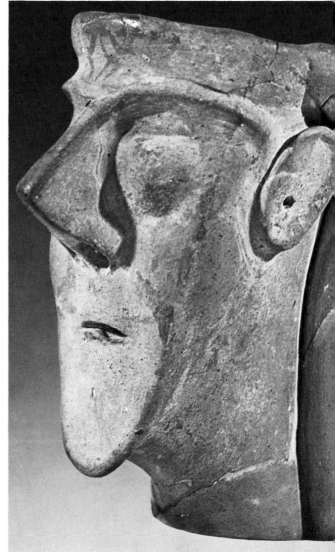

374 375

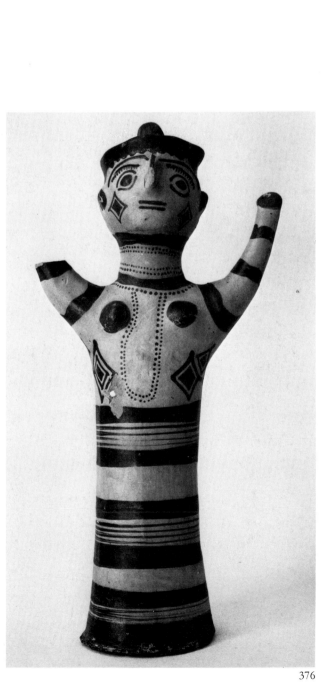

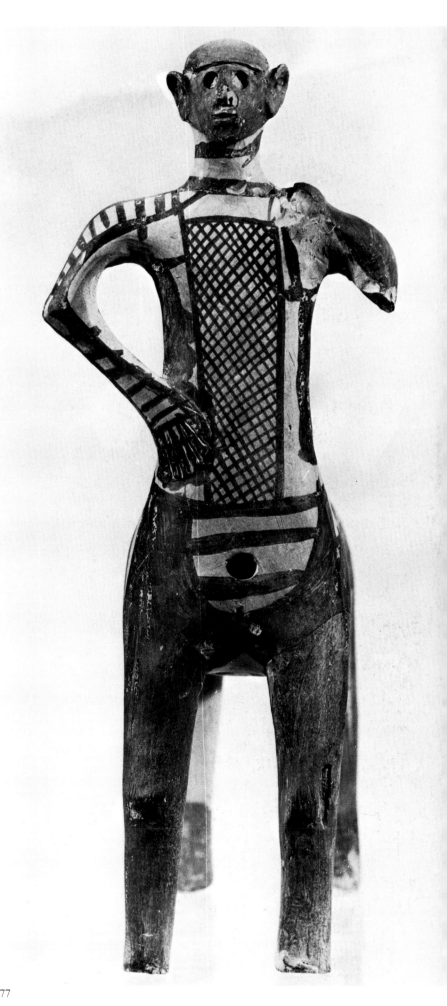

376 377

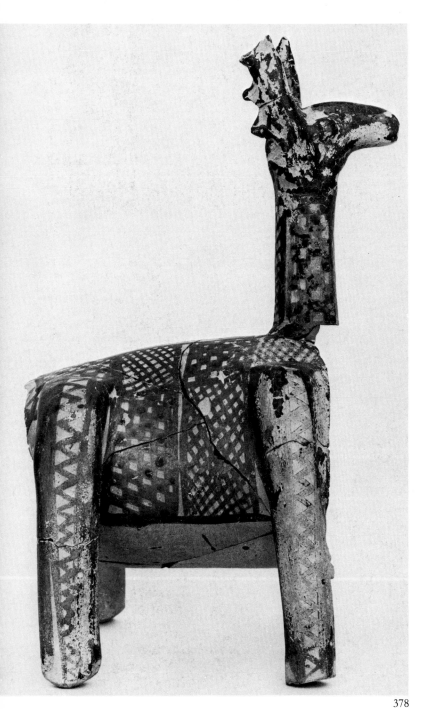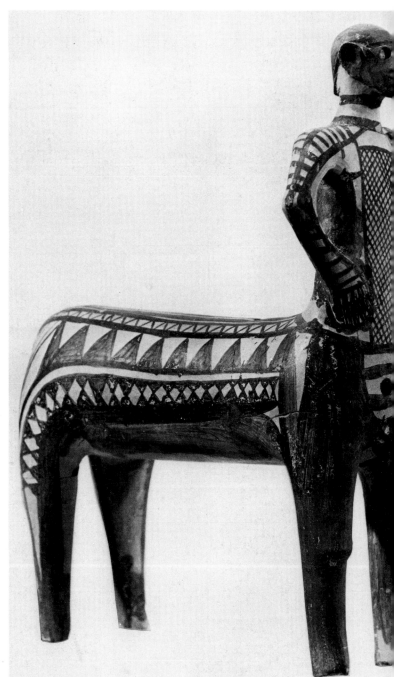

378 379

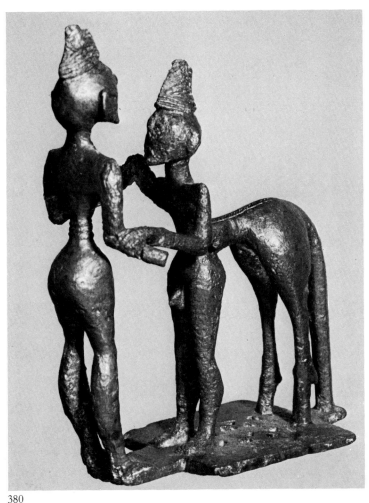

380

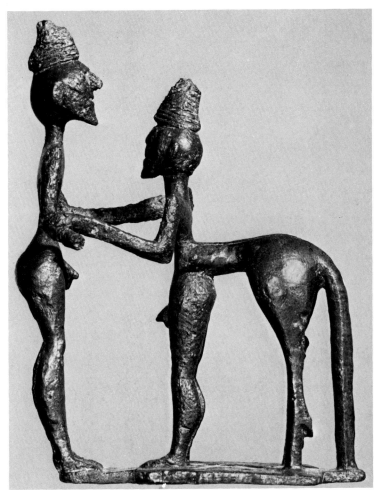

381

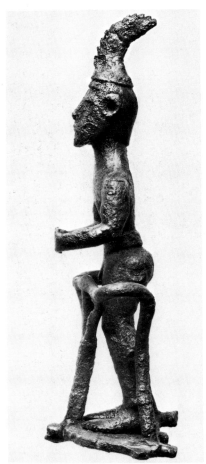

382

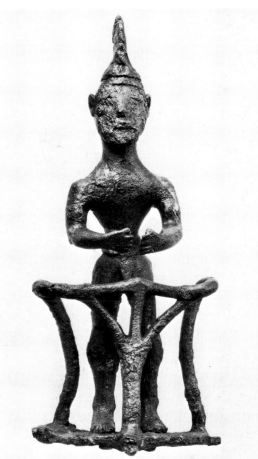

383

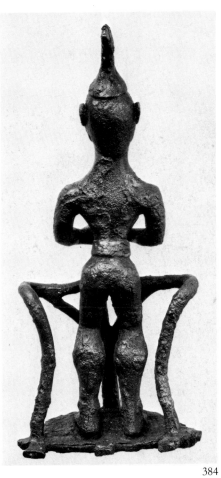

384

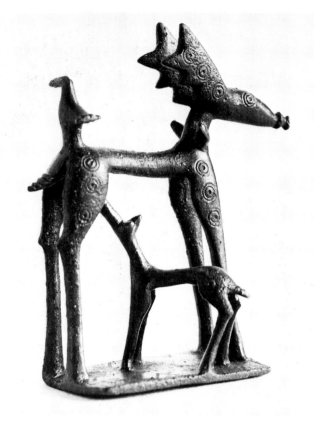

385

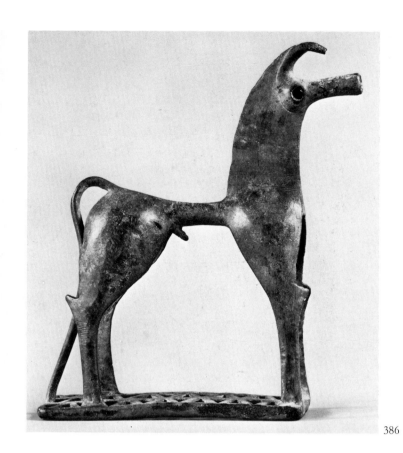

386

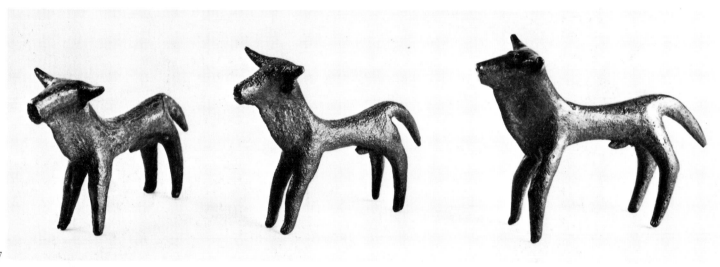

387

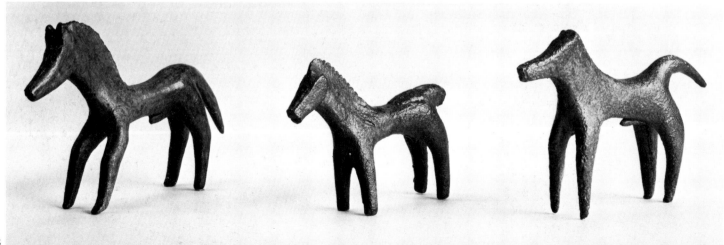

388

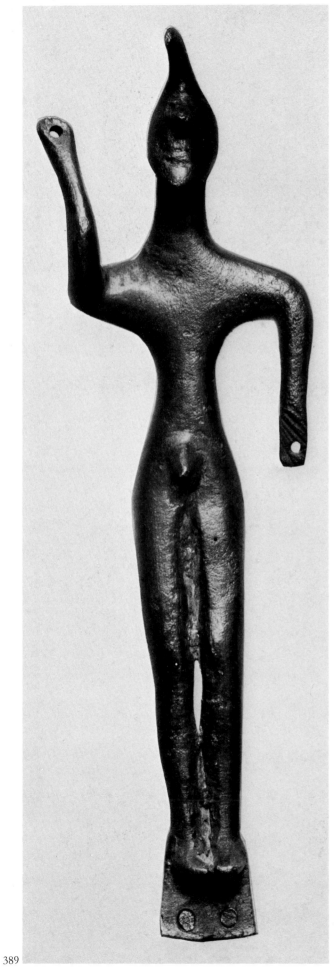

389

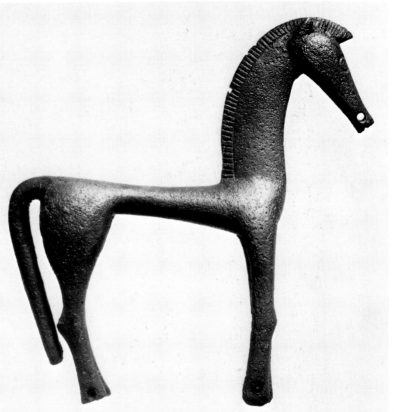

390

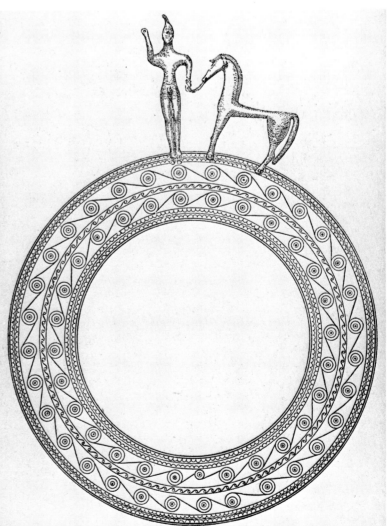

391

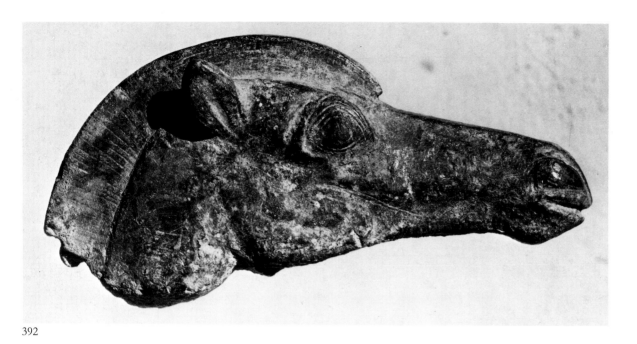

392

397

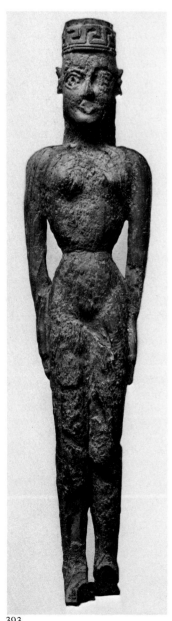

393

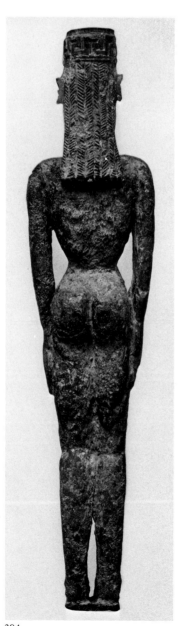

394

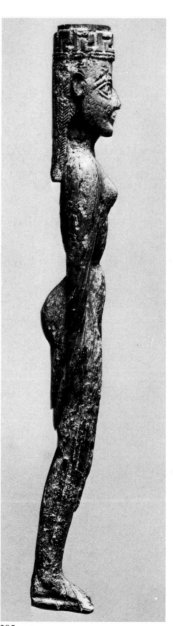

395

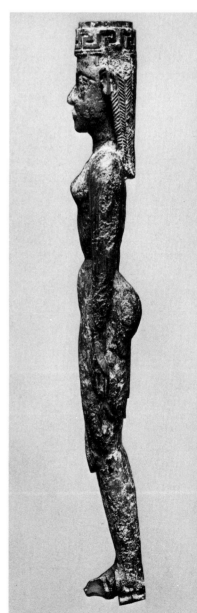

396

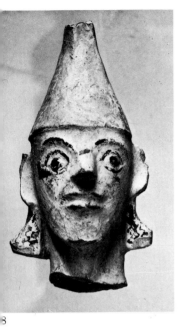

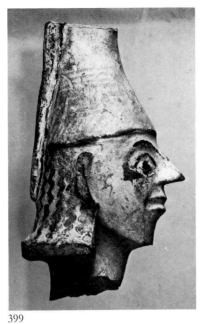

399

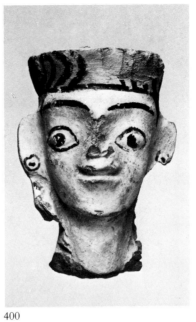

400

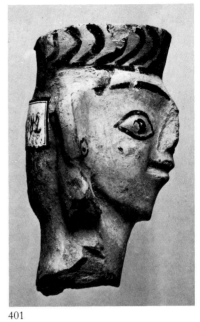

401

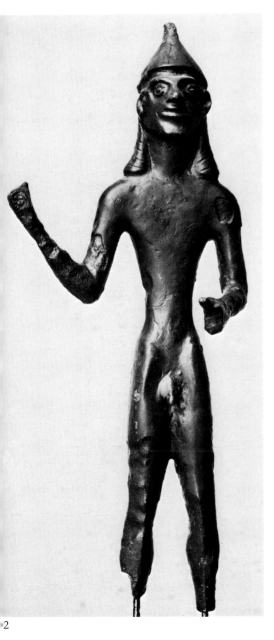

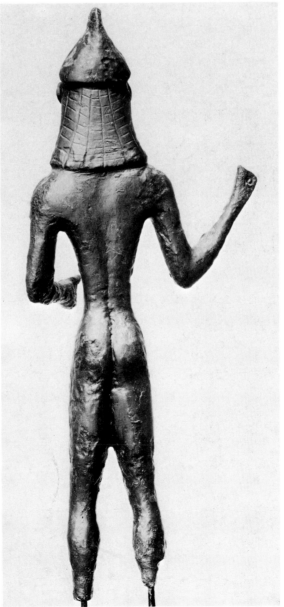

403

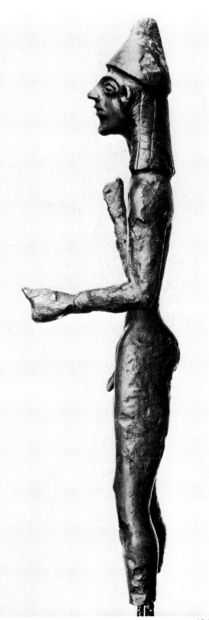

404

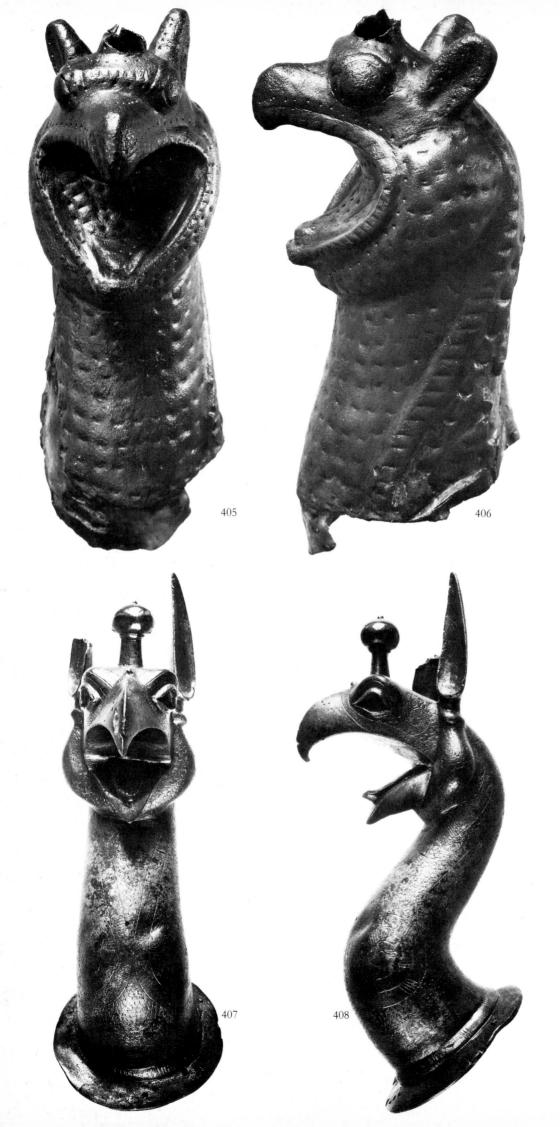

405 406

407 408

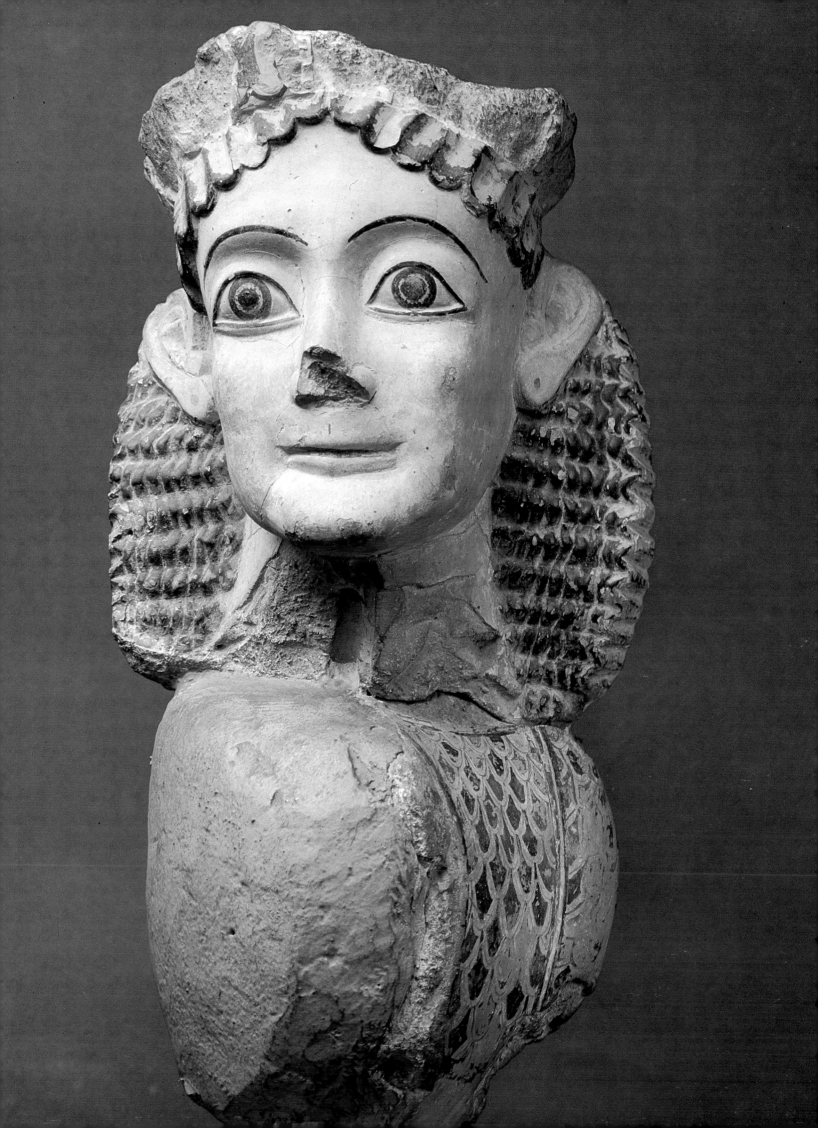

410

411

412

probably so that the gods could hear petitions and prayers. The date of the figure from Asine may be close to that of the Karphi goddess.

Proto-Geometric and Geometric Sculpture

Lefkandi in the middle of Euboea is a key point for development in the so-called 'Dark Ages'. The most recent Mycenaean settlement there probably lasted into the 'Dark Ages' and after it was abandoned a new community settled in its place. From finds in graves one can follow the course of developments continuously from the Sub-Mycenaean period onwards, from the second quarter of the eleventh century to the middle of the ninth. Lefkandi has yielded an important hydria from the middle phase of the Proto-Geometric period decorated both with the usual geometric patterns and with the figures of two archers, who stand opposite and shoot at each other.

378 Around 950 BC a period of Attic influence is detectable in the pottery. Two works from this period are a terracotta stag 7, 379 from Athens, whose stomach is a barrel-shaped vessel, and a remarkable terracotta sculpture from Euboea, the Lefkandi centaur. Below, it is horse—on the front legs the joints are visible—whereas the upper body is human. The right hand is supported on the hip, the left arm is bent as if it carried the centaurs' customary weapon. The chin is beardless, the mouth and nose are modelled, and the ears are large and slightly protruding. The deep eyes were inlaid with another material. Over the forehead is a horizontal groove, and the head is bald on the crown. It is possible that a helmet of another material, perhaps metal, was set on top, as is the case with the centaur of 380-1 the bronze group in New York. The horse's legs are completely covered with a dark gloss slip, and the creature's face is likewise dark. On the horse's rump triangles alternate with zigzag patterns, while horizontal hatching marks the right arm. A cross-hatched area lies like a shawl over the human upper body. The figure is hollow and the front bored as if the vessel served as a rhyton.

This terracotta centaur is unique for its time, an early forerunner of the terracotta and metal figurines of the following century. Yet it is so skilfully made that it can scarcely have stood alone, but must itself have had predecessors which have not been preserved or which will one day come to light. From this piece too it may be concluded that stories of centaurs, probably in epic form, were already so widely known in the tenth century, that such a representation could be made. This centaur may have carried a pine-trunk as a weapon over his shoulder—the left shoulder, for he is not involved in a battle, although the helmet (to be restored) on his head indicates belligerent intentions.

380-1 More than one hundred and fifty years later in date is the bronze group in New York. It was cast whole and has a height of 11.3 cm. The centaur and his adversary stand together on a fretwork base. Both are bearded and have helmets on their heads to signify the martial nature of their encounter. The size of the centaur's human opponent is intended to indicate that he will be the victor. He stabs the centaur in the left hip with a sword, the point of which still shows there. His outstretched arm rests on the centaur's shoulder. The centaur meanwhile is trying to push him away with his left arm, while holding his right arm bent for a blow, but what weapon he held is not known. The pine-branch which is normally reconstructed in drawings is not completely convincing. It must have been added after the casting. Similarly, the eyes of the centaur's opponent and conqueror would have been inlaid, probably giving him a terrifying visage.

The interpretation of this pair has long been in dispute. The victor is sometimes seen as Zeus, wrestling with the centaur-like Kronos or Typhon. But Kronos is not centaur-bodied and Typhon should have been snake-footed. So one has to see the victorious hero as Herakles in the act of overcoming a centaur. In other early representations, too, for example on the Boeotian fibula in Philadelphia, Herakles is depicted similarly with sword, belt and helmet.

The combatants' helmets sit unfastened on their heads, which are, except for their jutting noses and beards, spherical in shape; the modelled ears are barely indicated. In their bodies, strongly projecting features, such as the buttocks, calves and hind-quarters of the centaur, alternate with flat areas, as do the upper bodies, and with thin elements, such as the arms and the horse's trunk. Joints are especially emphasized. It is a self-conscious style that manifests itself here, one dependent on contrasts and almost mannered. Of the same type is a warrior 382-4 from Olympia who stands on a chariot-box, and a hind suckling its young, with a bird on its back. Just as the hind 385 already shows a rather mannered style, so too does the small bronze horse in Berlin, which is probably Corinthian. 386

Less distinct in style, but nevertheless still deliberately worked, are the small bronze bulls and horses from Olympia. 387-8 At Olympia countless figured votives were dedicated to Hera, Zeus and Pelops. They were found in the ashes of the offerings, and are mostly of bronze or more rarely of terracotta. They are for the most part completely artless, without style and therefore difficult to date. It is difficult to prove that they are older than the foundation year of the Olympic Games, 776 BC; primitiveness ought not to be confused with an early date. So far as they can be dated on stylistic grounds, they seem to belong to the period after 776 BC. For the most part they are utensil attachments in the form of figures: for example a little 390 bronze horse from a tripod cauldron, which was attached to the 389 large round handle together with a warrior holding the horse by the reins. Swelling, flat and thin forms are all found here, too, and the joints are again emphasized. The illustration shows 391 a reconstruction. It seems that the strict form of the utensil has influenced the modelling of the attachment.

If one compares the bronze horse's head from Olympia, 392 dated early in the seventh century, one notices what advances had by then been made. The large, finely rendered eyes, the alert ears, the strong jawbone and sensitive muzzle show that in spite of all the severity in conception this animal's head reflects considerable observation of nature. This horse has its nearest 410, 443 parallels on Cycladic vases and the relief pithos in Basle. On the whole, however, we still stand at the beginning as regards attribution of bronzes from this period to particular workshops.

An ivory female statuette, 24 cm high, was found in the 393-6 Kerameikos of Athens. It comes from a grave which from the pottery in it can be dated between 735 and 720 (Coldstream: Late Geometric IIa). Other ivory statuettes were discovered in the tomb, carved in a rather more old-fashioned style with the arms partly attached. Here, however, an artist was at work who

was fully in control of his craft. The hands are firmly laid along the legs, which are slightly bent forward, so that the pose seems undecided. The hips are narrow and the upper body triangular in the Late Geometric tradition. The breasts are slightly rounded and the bottom juts out strongly. The head rests on a delicate well-proportioned neck. The hair falls down the neck in vertical tresses which are bound diagonally. Over the high forehead sits the polos, still in a rather inorganic fashion like the helmet on the bronze sculptures. It is decorated with a meander in relief. The ears lie flat against the head and are level with the eyes, which are set wide apart, with lids and arched brows. The nose projects sharply and the mouth is slightly open.

402-4 This ivory statuette is slender and tall, whereas the bronze sculptures were short and squat. Of the same style, however, and of roughly the same date is the fully cast bronze statuette of a warrior from the Acropolis of Athens, 20.5 cm high. There is a helmet on his head, the top of which is bent forward, and he must have held a shield in his left hand, a spear in his right. The transitions are even more fluid here than in the ivory statuette. The hair falls down softly in a wide mass and is segmented by engraved vertical and horizontal lines; the nose again juts out sharply. The expression conveys alertness.

Both the following heads were found in the sanctuary of
397-401 Apollo at Amyklai, south of Sparta. One, 11.5 cm high, has a helmet, whose top is bent forward, while the crest falls down
397-9 the back. A painted meander runs around the helmet. The hair flows in a thick mass down the neck, where it ends as if cut, and is enlivened with vertical wavy lines. The ears stand out and the pointed nose juts out sharply. Large eyebrows frame the wide-open eyes; the mouth seems almost to be open too; the chin, which was probably set on an elongated neck, is receding. This head has rightly been spoken of as that of an early Apollo Amyklaios.

The woman's head found with it was at first considered to be
400-1 Mycenaean. From it, however, one can clearly observe the difference between the two worlds, the Mycenaean and the Geometric. If one ignores the polos that rests on the head, the less strongly arched eyebrows and the lack of thick hair at the back, one realizes that this female head is modelled in the same way as the male one. There are the same jutting-out ears, but here with painted ear-rings; the same nose, though only a stub of it is preserved, juts out just as sharply as the warrior's; there is the same mouth, the same receding chin and the same painting of the wide-open eyes. Indeed everything indicates that not only the same workshop but also the same master was responsible for both pieces. If, however, the helmeted head is
397-9 Apollo and the woman is associated with him, then it is fair enough to suppose that there was a further female figure, which has not been preserved, so that we would have Apollo, Leto and Artemis—the remains of a triad mentioned in the
415 *Iliad* (V, 445-8) and so often depicted as a triad in later art. This would be its earliest example, a Spartan creation around 700 BC.

Mythical Creatures

The eighth-century custom of offering bronze tripod cauldrons gave way in the seventh to a fashion of cauldrons with
160-3 conical stands. To the rims of these cauldrons were attached

Oriental protomes, displaying their wings and looking into the cauldron, and towering griffins' heads, which were unknown
164-5 in the East. These griffins are the first figured pieces which clearly differ in style from the traditional sculptures of the Geometric epoch. The custom of dedicating cauldrons continues through out the seventh century to the sixth and spreads as far as Etruria. A large number of them were found in the sanctuary of Hera on Samos and were clearly produced there. Some had hammered into them positioning marks in the early Ionic alphabet, a further indication that they were produced on Samos. They are at the same time the oldest evidence for writing on the island. The whole construction, the proportions of neck and head, and the setting of the eyes and ears on some pieces from Samos are so similar to the piece from the Barberini tomb at Praeneste that the question arises whether the Praeneste griffins were made in a Samian workshop, although there were, of course, other workshops which made such griffin cauldrons.

At first the griffin protomes on the cauldrons were hammered out of bronze sheets. The hollow bodies were filled with pitch. The eyes were sometimes worked separately: the glass for the eyes was melted in a small crucible and set in place with a locking pin and bolt. The head is crowned with a knob and the beak open with the tongue visible. Down the neck frequently runs a single tress which curls into a spiral at the
407-8 bottom. These griffins' heads were developed to a fair size and sometimes reached monumental proportions. It has been said that at last one can sense the beginning of Greek large-scale sculpture. Of colossal scale was the griffin cauldron which a certain Kolaios offered to the sanctuary of Hera on Samos as a tenth of his profits after a very lucrative journey to Tartessos in the West, as is reported by Herodotos (IV, 152).

In Cycladic pottery too such griffins' heads were imitated, as a jug in the British Museum shows (41.5 cm high). On the
410 shoulder of the jug there is to the left a lioness biting the throat of a stag, and to the right a horse grazing. The ornamentation is in part old-fashioned, but in part new and employed in different fashion. On the neck the hair tress ends in a palmette. Over the neck towers the griffin's head, a real innovation.

The artists of this era were still wrestling with the problem of how to represent monsters and mythical animals. On the fragment of a Cycladic relief pithos in the Kanellopoulos
412 Museum we see a winged mythical beast with a lion's head, and on its neck the spiral curls usual on a griffin. The paws are again those of a lion. The tail is only a stump and seems to be broken.

It is worth comparing the sphinx from Perachora, which is
411 only 7.7 cm high and may be dated approximately to the third quarter of the seventh century, with the sphinx from Calydon
409 which is probably from the second quarter of the sixth century. The Perachora sphinx is on a small scale—it was probably part of an utensil—and is carved from ivory, while the sphinx from Calydon is made of terracotta and was an akroterion figure from a building. Both were probably represented crouching. The spreading wings are not preserved on the work from Calydon, but on the ivory sculpture the plumage is incised with a compass in the form of semicircles; on the Calydon sphinx the plumage must have been rather more complex. The turn of the head is similar on both works. The hair of the ivory sphinx is divided into horizontal steps and covers the ears, but on the other piece the fine, wavy hair pushes the ears forward. On the

Perachora sphinx the forehead is low and there is a flat head-dress with crossing zigzags; on the other piece there are flat wavy curls which come out under the diadem and leave the high forehead visible, while below big, wide-open eyes shine out. Even if one supposes that the ivory was formerly coloured, the difference both in conception and in execution is enormous, even though they are separated chronologically by only a few decades. This shows how rapidly development proceeded.

Armour

13-14 From the Late Geometric tomb at Argos of the late eighth century comes a bronze panoply: a helmet, which is riveted together from several parts and is overshadowed by a high crest-holder, and body armour, which curves out like a bell below and has a collar above. The front and back sections of the body armour are made separately; the chest muscles and shoulder-blades are rendered in relief at the front and rear. In spite of the strict stylization the natural forms of the body have been taken into account. When one realizes that such armour must have been hammered out to exact measurements if it was to fit properly, one has to admit that such armourers must have been the forerunners of large-scale sculptors.

The Middle of the Seventh Century

415 The triad of Apollo, Leto and Artemis from Dreros on Crete is later than the supposed triad from Amyklai (cf. p. 269). It might be dated to the third quarter of the seventh century. The figures are in the technique called by the Greeks *sphyrelaton*, in which sheets were embossed over a core and the then riveted together, the inside being left hollow. The god (height *c*. 80 cm) stood in the middle, and the goddesses, half his size, on either side. At some points, for example at the back and on the thighs of the male deity, one can see where the sheets have been riveted together. The ears and genitals were worked separately, while the eyes of both god and goddesses were inlaid with some other material.

The goddesses are in rigid poses with their arms close by their sides, with small breasts, a polos on their heads, and their hair not falling down freely but cut in page-boy style. The pose of the god is, however, more relaxed. A belt probably ran round his hips and a band round his forehead. The straight hair is gathered at the back, while vertical lines run from the parting to the forehead where they end in small curls. The left arm was lowered, the right bent and stretched out in front. What either hand held is not known.

At one time these were the oldest evidence of the early period in which bronze statuettes were made in this manner, but further *sphyrelaton* figures, produced by Cretan artists, have been discovered at Olympia. Brigitte Seidel-Borell has prepared a full-length study which is due to be published. There are the remains of a triad of female statues, of which the largest is nearly life-size. The single embossed bronze sheets are riveted in just the technique described by Pausanias (III, 17,6). To judge from the well-preserved figure-engraving they were made by a Cretan artist in the second quarter of the seventh century. In the rendering of their richly decorated garments Greek and Oriental designs have been used; these were taken over from older offerings in the sanctuary at Olympia.

416-17 The bronze warrior statuette was found under the foundations of the Heraion at Olympia. It has been called Steiner's bronze after the man who first published it. Since the Heraion is known to have been built in a single phase around 600 BC, this bronze is of no help in dating the building. The warrior has a helmet, the peak of which curves forward. In his perforated raised right hand he carried a lance, but whether the pendant left hand held a shield is debatable. Around the waist is a tight broad belt. The left foot is slightly advanced. The face is small and the hair has a page-boy cut with horizontal waves.

This statuette has something unbalanced about it. It still adheres closely to traditional forms and fails to innovate. Nevertheless, it does contain some more advanced features and so it is only with reservation that one can call it Sub-Geometric. It may be placed in the second quarter of the seventh century.

418-19 The statuette of a youth from Delphi, which may belong around the middle of the seventh century, is like an escape from the long period of transition, when the Geometric tradition was on the wane and artists were struggling for new forms. The balance of plastic masses, the well-proportioned forms and the organic transitions immediately strike the eye. This piece, though only 20 cm high, nevertheless is related to large-scale works from the Cyclades. It is in a state of equipoise and therefore of tranquillity. The absolute symmetry of the pose is interrupted only by the slightly advanced left foot.

420-1 A female counterpart to the youth from Delphi—to be sure, a Boeotian and provincial one—is the bronze statuette in Baltimore. The woman has her left hand closed but her right hand open and stretched out in front. Her large eyes and wide-flowing hair, divided horizontally, can be compared with similar features on the Delphi youth.

422-5 Our next piece, an ivory youth uncovered by German excavators at the sanctuary of Hera on Samos, is a particularly precious carving. It was soon realized that it was part of a utensil, from a lyre or phorminx in fact, and that this youth once had a counterpart on the other arm of the instrument. The figure is just 15 cm high. At the top of his head is a round cavity for a peg in which the wood for holding the strings would have been fixed. Down his back runs a long grooved support, the remains of the arm of the lyre, which protected the youth's particularly narrow hips from damage. The youth is naked except for the belt, encircling his waist, which is richly 426 decorated, and for his shoes. His hair, hair-band, belt and shoes were certainly painted, as was customary on ivory works. Eyebrows, ear-rings and pubic hair were probably inlaid in a darker material; the large eyes probably contained semi-precious stones. In the hair-band over the forehead are preserved inlays of honey-coloured amber. His long hair is arranged in wavy tresses, caught together below in bunches, two down the back and one on each side of the head and on to his chest. His thighs are pressed tightly together and the lower part of the legs bent back so that his heels nearly touch his bottom.

At first it was thought that the youth was kneeling. But one does not kneel this way, and we have to thank E. Simon for the

413-14 Late Geometric armour, from a grave at Argos (cf. Pl. 183). Bronze sheet of *c.* 1 mm thickness, embossed. H. 47.4 cm. Museum, Argos.

415 The triad of Apollo, Leto and Artemis, from the temple of Apollo at Dreros (Crete). Bronze sheet, embossed, sphyrelaton technique. Third quarter of 7th century. H. of Apollo 80 cm. Museum, Iraklion.

416-17 Statuette of a warrior, from the foundations of the Heraion at Olympia. Bronze, solid cast. Second quarter of 7th century. H. 23.7 cm. National Museum, Athens.

418-19 Statuette of a kouros, from Delphi. Bronze, solid cast. Mid-7th century. H. 20 cm. Museum, Delphi.

420-1 Statuette of a kore. Bronze, solid cast. Mid-7th century. H. 18 cm. Walters Art Gallery, Baltimore.

422-5 Leaping dancer, from the arm of a lyre. Ivory. Last quarter of 7th century. H. 15 cm. Museum, Vathy, Samos.

426 Reconstruction (by D. Ohly) of the ivory lyre, which was decorated with the leaping dancer of Pls. 422-5 and a second dancer.

427-8 Apollo, votive offering of Mantiklos, from Thebes. Bronze, solid cast. 680-670 BC. H. 20.3 cm; H. of statuette, including the (lost) lower legs and feet, 28 cm. Museum of Fine Arts, Boston.

429 Bell-shaped idol (Artemis?), from Thebes. Terracotta. *C.* 700. H. 33 cm. Louvre, Paris.

430 Idol of Pallas Athena, from Gortyn (Crete). Terracotta. Towards the mid-7th century. H. without helmet 36.2 cm. Museum, Iraklion.

431 Statue of Artemis, votive offering of Naxian Nikandre. Naxian marble. *C.* 660. H. 1.75 m. National Museum, Athens.

432 Naked goddess with polos, a relief from a temple on the Acropolis at Gortyn (Crete). Limestone. Mid-7th century. H. 1.5 m. Museum, Iraklion.

433 Decoration of a doorway of a temple at Prinias (Crete): seated woman, stalking panther and, on both soffits, a standing woman. Limestone. Third quarter of 7th century. Museum, Iraklion.

434 One of two seated women in Pl. 433. Limestone. H., with restorations, 98 cm.

435 Ariadne on a Cycladic relief pithos. Clay. Second quarter of 7th century. Overall h. of vase 155 cm. Antikenmuseum, Basle.

436 Tondo with the head of a kouros *en face.* Bronze sheet, embossed. Mid-7th century. D. 35 cm. Charlottenburg Museum, Berlin.

437 Head of a female supporting figure, from Olympia. Bronze, hollow cast. Third quarter of 7th century. H. 8.7 cm. Badisches Landesmuseum, Karlsruhe.

438 Standing goddess, from unknown find-spot. Grey limestone. Mid-7th century. H., including 10 cm-high socle, 75 cm. Louvre, Paris, (until 1909 in the Museum of Auxerre, donated by the classicistic painter David).

439 Head and upper body of a woman unveiling, from the area near the temple of Athena, on the Acropolis of Mycenae. Metope or frieze? Limestone. Third quarter of 7th century. H. 40.2 cm. National Museum, Athens.

440 Head of Hera, from her cult statue in the temple at Olympia (cf. Pls. 85-7). Limestone. *C.* 600. H. 52 cm. Museum, Olympia.

441 Neck picture: goddess between lions (Hera?), with similar crown to that worn by Hera in Pl. 440, from a Cycladic relief pithos from Thebes. Clay. 680-670 BC. Overall h. of vase 1,2 m. National Museum, Athens.

442-3 Two details from Pl. 441: head of the goddess and of a hind from the shoulder frieze.

444 Reclining lion on a curved base, probably attached to the handle or rim of a Mycenaean vessel, found south of Grave Circle A at Mycenae. Solid gold. 15th century. Enlarged by about four times in the illustration. National Museum, Athens.

445-6 Lion waterspout, from Olympia. Limestone. *C.* 675. L. 79 cm. Museum, Olympia.

447-8 Reclining lion with oil-bowl, from Arkades (Crete). Clay. Third quarter of 7th century. L. 32.6 cm. Museum, Iraklion.

449 Colossal reclining lion on Keos. Marble. Latter half of 7th century. L. 9 m.

450-1 The lion terrace on Delos and a single lion from it (Pl. 451). Naxian marble. Late 7th century. L. of terrace 64 m.

452-3 Reclining lion, from the area near tomb of Menekrates. Limestone. End of 7th century. Base 121 × 41 cm. Museum, Corfu.

454-6 Kouros, from Attica. Island marble. Late 7th century. H., including 6 cm-high plinth, 1.99 m. Metropolitan Museum of Art, New York.

457-9 Head of the Dipylon Kouros; front and rear view. Island marble. Last quarter of 7th century. H. 44 cm. National Museum, Athens.

458 Ear of one of the kouroi, from Sounion. Island marble. *C.* 600 BC. National Museum, Athens.

460 Back of the head of the New York kouros (cf. Pls. 454-6).

461-3 Upper body (from front and rear) and hips of the colossal Apollo on the island of Delos. Naxian marble. Late 7th century.

464 Half-finished colossal statue in the marble quarry on the north of the island of Naxos. It is a bearded, fully draped male, with the right arm outstretched (Dionysos?). The photograph was taken shortly before the cement steps were built which now lead to the statue. L. 10.45 m.

465-9 The group of Kleobis and Biton, from the sanctuary of Apollo at Delphi. Island marble. Early 6th century. H. of kouros in Pl. 465, with restorations, but without base, 2.16 m. From this kouros: details of the frontal view of the head (Pl. 469), rear view of the upper body (Pl. 468) and profile view (Pl. 467). Museum, Delphi.

413

414

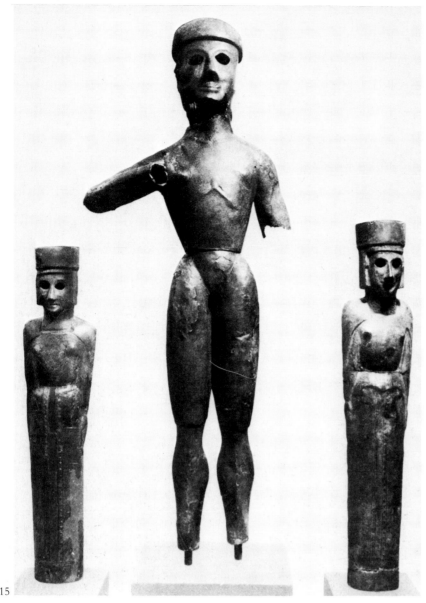

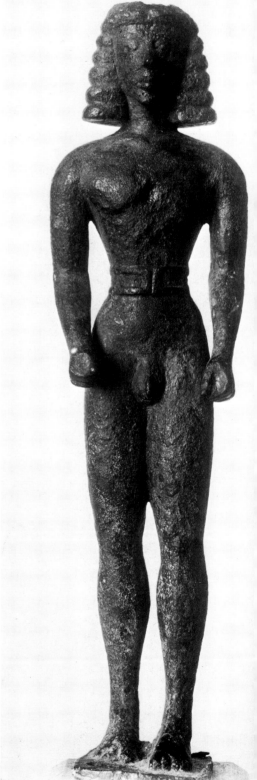

415

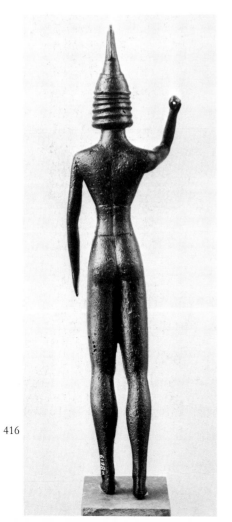

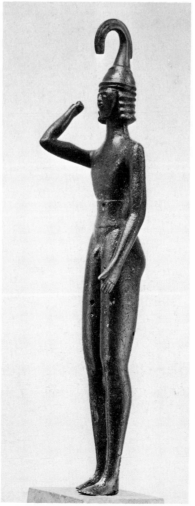

416

417

418

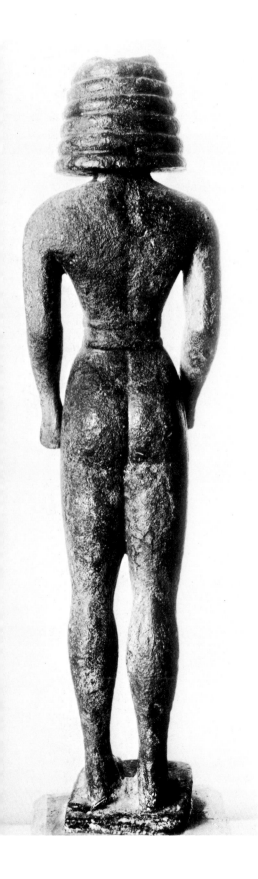

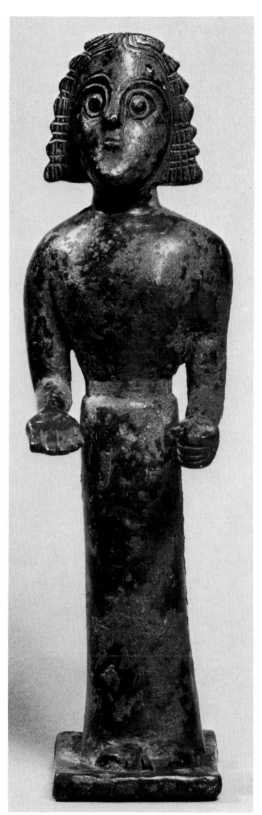

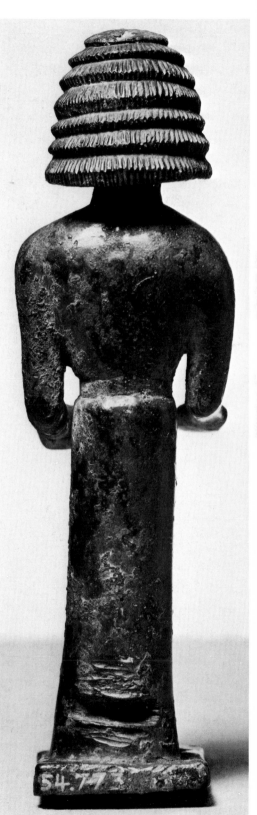

420

421

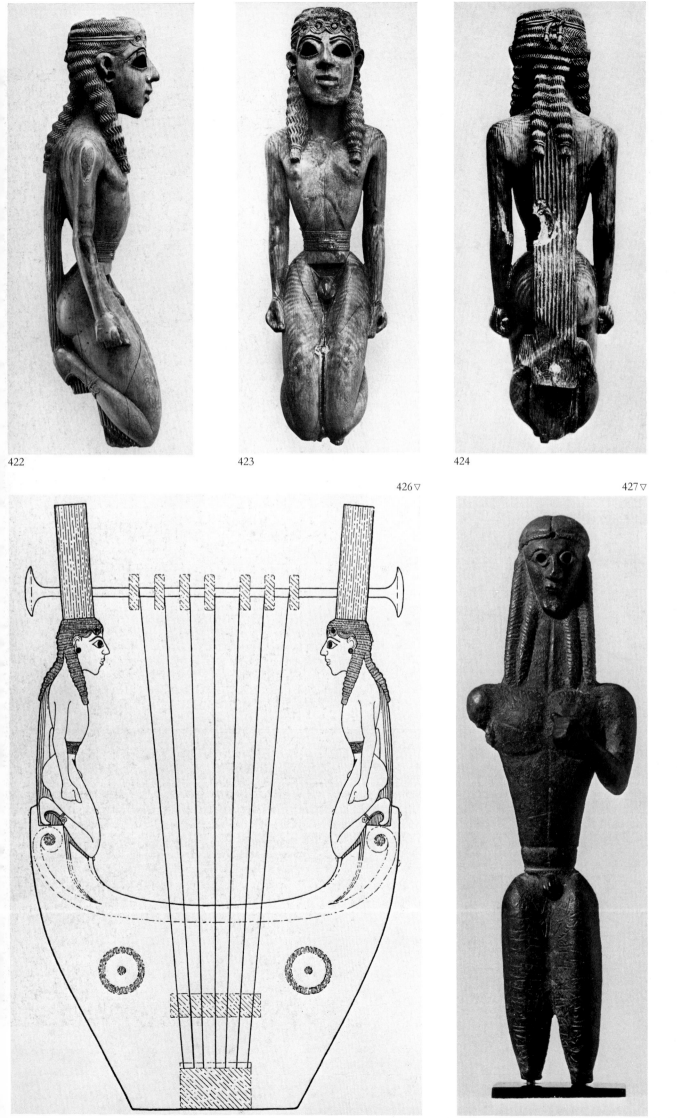

422 423 424 425

426 ▽ 427 ▽

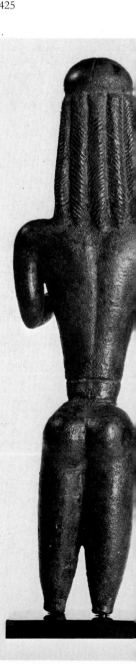

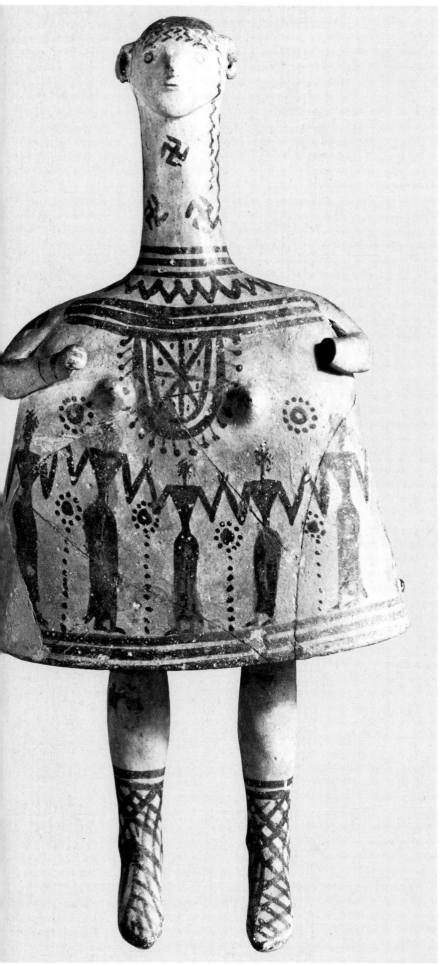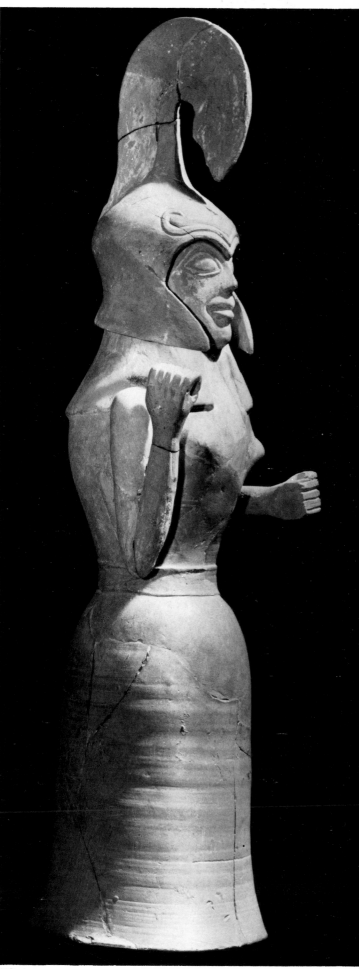

431

433

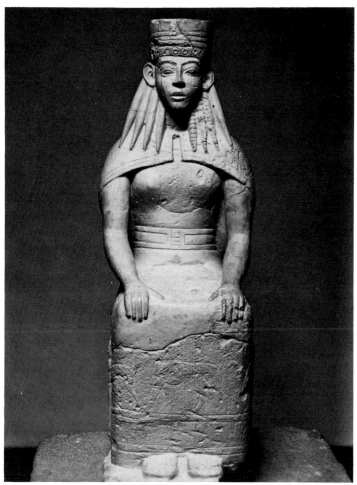

434

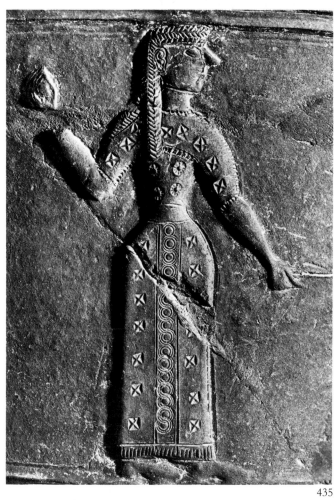

435

436

437

438

439

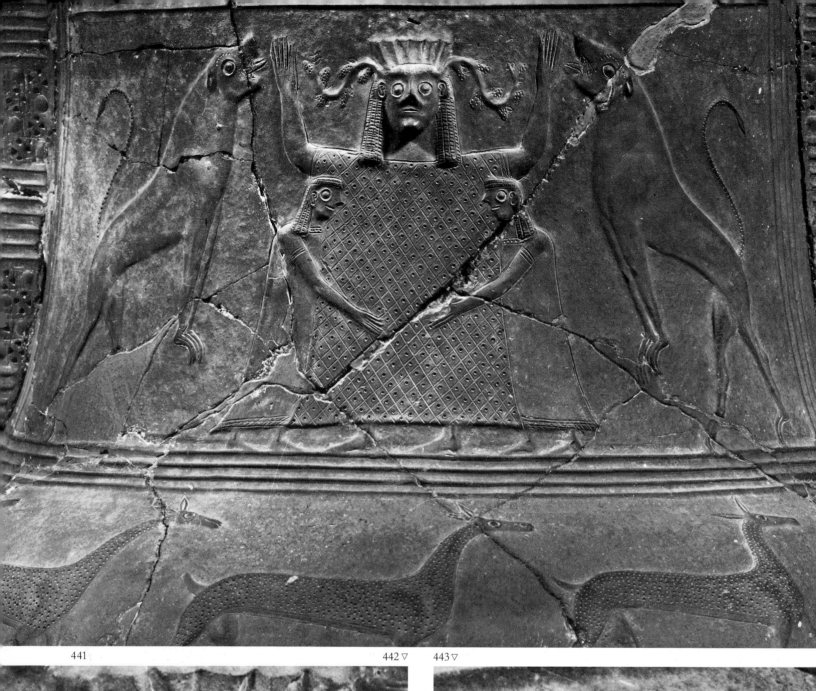

441

442 ▽

443 ▽

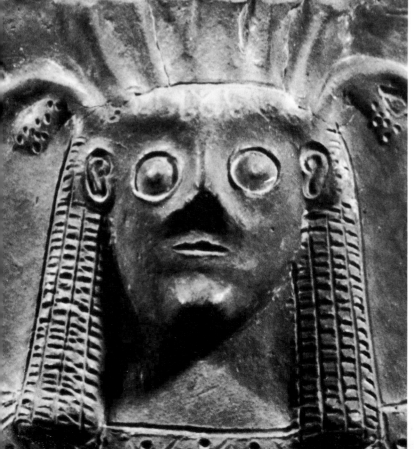

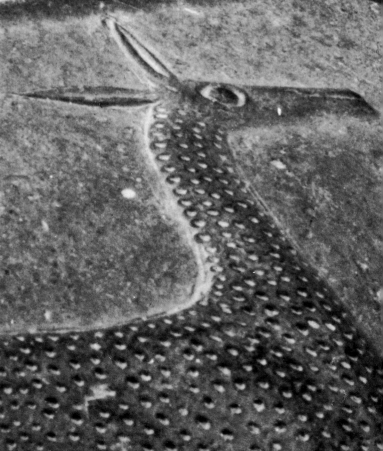

444

445

446

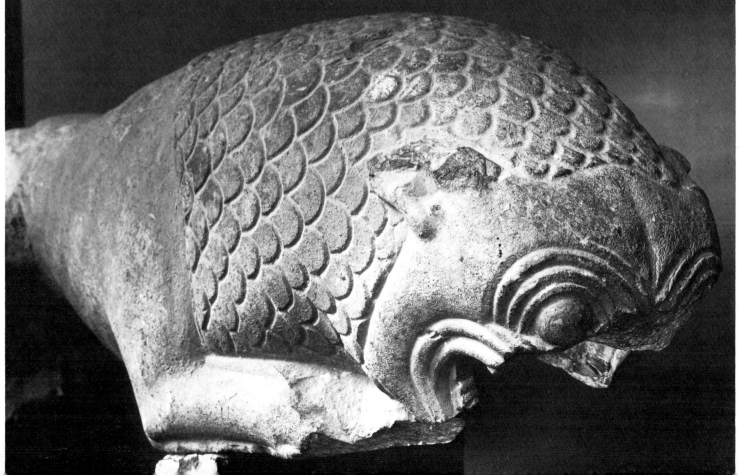

447

448

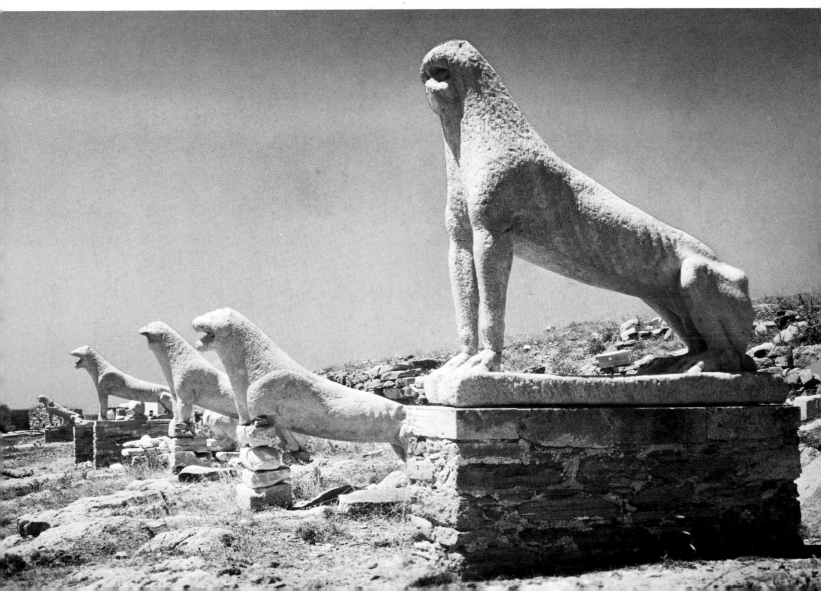

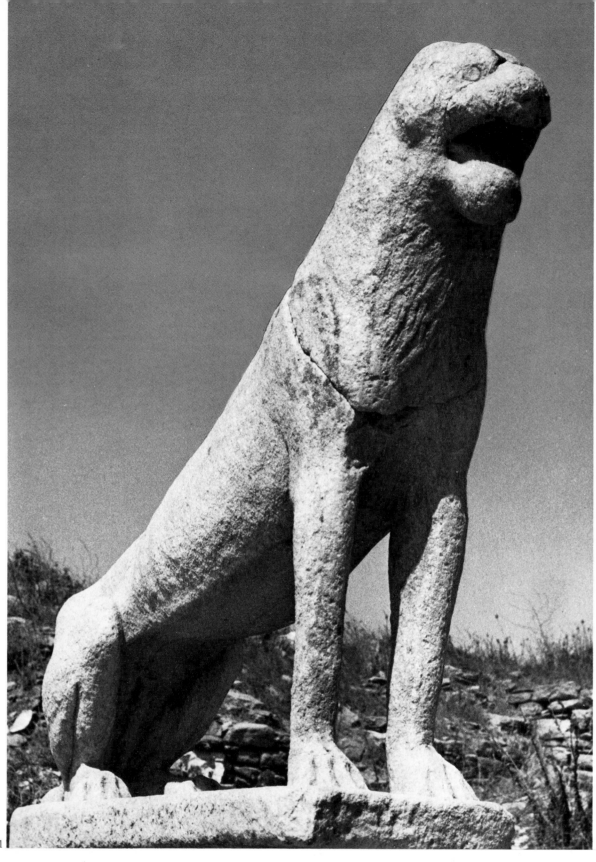

451

452

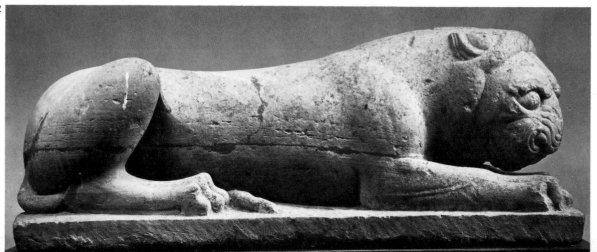

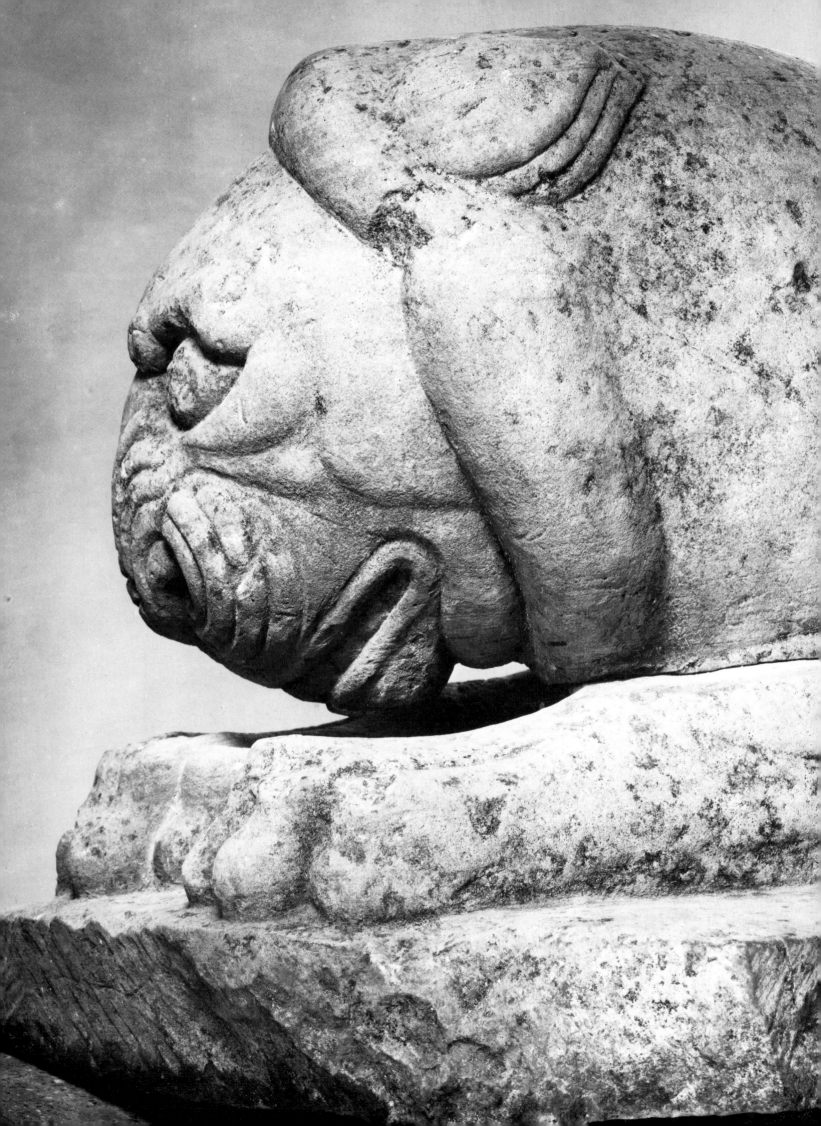

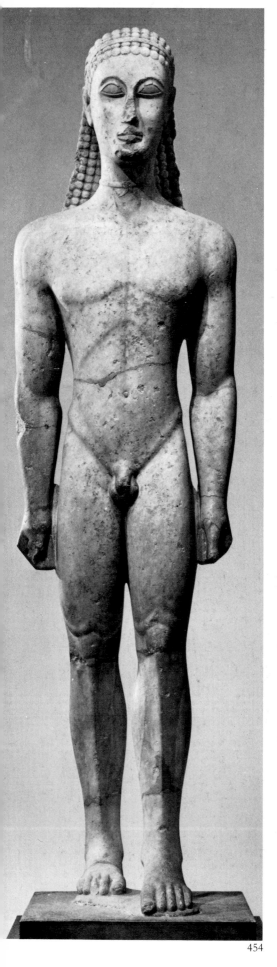
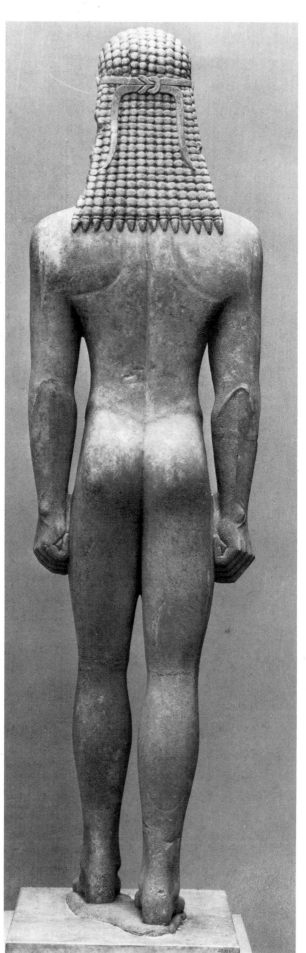
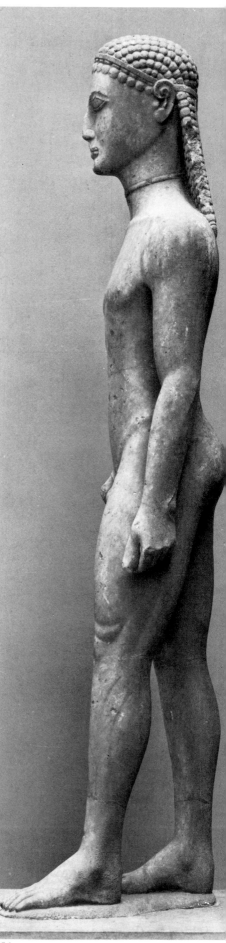

454 455 456

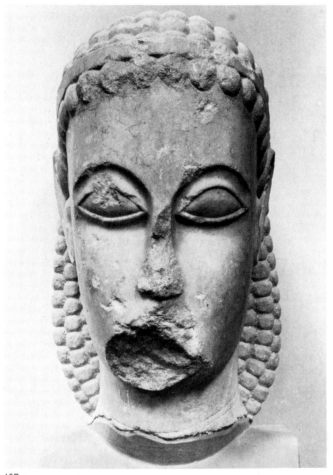

457

458

459

460

461

462

463

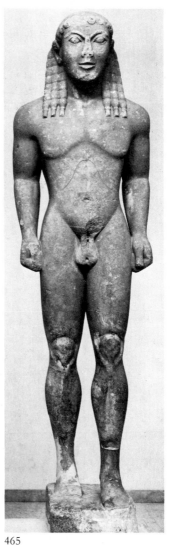

465

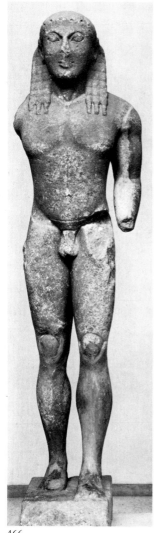

466

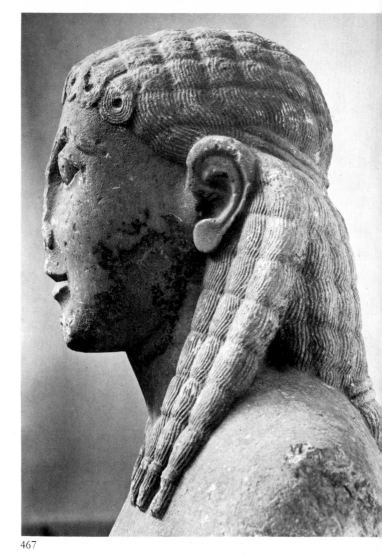

467

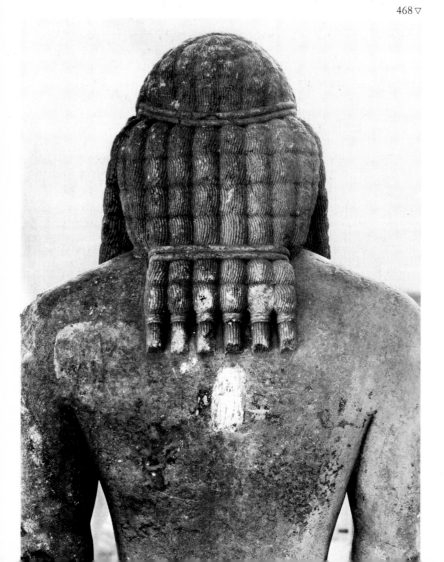

468 ▽

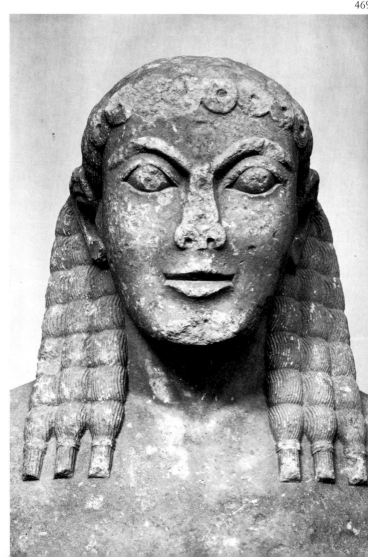

469

insight that this is a jumping dancer. Such jumping dancers used to dance in pairs to the sound of the phorminx. Both dancers were represented here on this very precious offering. Where the artist's home was we cannot yet say for sure, but Samos, Corinth and Sparta have all been suggested. The *bothros* (rubbish pit) in which the remains of the phorminx and other objects were found has been dated by its excavators between 625 and 600 BC.

Bronze Statuette of Apollo

We may now go back in time to look at a work which lies rather outside the mainstream of development, the 20 cm-high bronze statuette of Apollo which Mantiklos dedicated to that deity in Boeotian Thebes. On the thigh is the engraved dedication in *boustrophedon* fashion (i.e. like a plough making a turn): 'Mantiklos dedicated me to the far-darter of the silver bow as a tithe. But you, Phoibos, give some pleasing favour in return.' The inscription is formulated in imitation of epic phraseology. In spite of all the efforts of scholars, we do not know who this Mantiklos was; nor do we know the profit of which he offered a tenth part to the god; but we *do* know that he expected something from the god in return.

427-8

The statuette is constructed on the Geometric scheme of three nearly independent parts: the strong thighs with the round, protruding bottom (the calves are missing, but they would have incresed the elongation of this slim figure); the triangular torso—a broad belt would once have encircled the waist; and the head with its ample locks hanging down behind and in front. The head ovbiously bore a helmet, probably of the form usual for this date (cf. the Apollo Amyklaios). The eyes were inlaid with another material. The face had a sharply protruding nose and a painted chin. The neck is too long and has a vertical groove down the middle. The chest is adorned with a necklace. The left hand, now rather bent, was stretched out horizontally and probably held the bow mentioned in the inscription. The right hand did not lie along the body; what the god held in it is not known. This statuette is a rather eclectic work, which kept to older features and should probably be placed between 680 and 670 BC.

Bell-shaped Idols

429 In Boeotia around 700 BC bell-shaped clay female idols were produced, one of which is illustrated here. The head sits on a rather long neck. The drapery is short and stands out stiffly. The arms are either plastically rendered or painted. The breasts are in relief and have added paint; a piece of jewellery hangs on the chest and there is a necklace on the neck. The legs, in boots, are attached separately and are movable. The drapery bears in front a painted scene of women dancing. Such idols were suspended, a common practice with goddesses associated with the tree cult of the second millennium BC. E. Simon has explained these idols as representations of Artemis. In Pausanias' time (VIII, 23,6) in the second century AD, there was still a cult of 'suspended Artemis' in Arcadia. The clay idols may imitate wooden representations of the Boeotian Artemis which were hung on trees.

The Cretan clay idol from Gortyn fits into this tradition in a rather different way. The part of the drapery below the belt is turned on a wheel; the garment is tight around the waist, but below it swings out, bell-shaped. The torso, arms and head are hand-made. The helmet does not belong for sure; but since it fits exactly, and since the right hand is drilled and would have wielded a raised spear, while the left was bent to carry a shield, the figure is throught of as a Pallas Athena—and so the helmet really should belong to her armour. The statuette may be dated towards the middle of the seventh century BC.

430

Female Figures from the Middle to the End of the Seventh Century

The marble statue of Artemis which one Nikandre from Naxos dedicated on the island of Delos has a more plank-like than rounded body that is 1.5 m high and stands upright. The hips are encircled by a belt. The dress reaches to the feet and has a slight curve so that the tips of the feet are visible. A small base is cut from the same block as the statue. The arms lie flat along the body. The left hand is bored right through, the right only partly: they carried the bow and arrow, which were of metal. The face is badly worn. Long locks fall in individual strands over both shoulders and down the back of the neck.

431

The dedicator named herself in a long inscription which is engraved on the left side of the skirt in the boustrophedon manner. The inscription, whose epic language is very familiar, says in three hexameters: 'Nikandre dedicated me to the farshooter of arrows, the excellent daughter of Deinodikos of Naxos, sister of Deinomenes, wife of Phraxos.' We do not know the special reason which prompted this dedication but it must have been something extraordinary. First the dedication is by a woman and second it is the earliest preserved marble statue of the goddess. That the names of the father and husband are given is natural, but the name of the brother is added as well implies that he must have had an extremely high position and was known to everybody. The statue is difficult to date exactly. It may still belong to the second quarter of the seventh century.

Fig. 34

Besides Athena, the goddess of Love was worshipped on Crete, particularly at Gortyn. Her cult and with it the use of perfumed oils came from the Syrio-Phoenician region, the source of strong influences on Greek art. Many small votive plaques and figures and also large metope-like limestone reliefs depict the type of the goddess, who was worshipped on the Acropolis at Gortyn. Only the right-hand figure is completely preserved; the left-hand one is a cast of the right and the middle one is only partly preserved. A tall polos rests on her head, from which the hair, divided into strands, flows down. The hands lie along the body, which is represented completely naked, frontal and with the pubic area emphasized. The motif is thoroughly Oriental, but the execution is completely Cretan. This is not one of the fat female bodies that were loved in the Orient; instead we have slender elongated figures with their hands laid on the thighs, as here, or on the pubic area or the breast. After the Cycladic idols of the third millennium, it is not until this period, under Oriental influence, that the naked female figure is once again represented in stone, in a form which anticipated the later Greek ideal of beauty.

432

Fig. 34 Inscription on the left side of the dress on the statue of Artemis in Pl. 431, which Nikandre of Naxos dedicated on Delos. Drawing after Guarducci, *Epigrafia Greca* I, Rome (1967), 155, Fig. 38 c.

When dressed, such figures look much like the draped woman from the temple at Prinias on Crete, which was under the door lintel and had to be seen from below. She wears as well as her belted garment a short cape around the shoulders. Though she is seen completely frontally, the feet are turned in profile. One may also compare the seated woman above the lintel, whose polos should be imagined higher than in the illustration and whose right hand is clenched, as I. Beyer has pointed out. Her drapery was decorated with figured ornaments: a sphinx in low relief, a panther, and then a horse which was incised.

On the Cyclades, too, a new style with balanced proportions emerged, as the Ariadne on the Basle relief pithos indicates. Fighting with the young Athenias and Theseus against Minotaurus, she holds a stone in her raised right hand and in her left the thread. Her body is frontal to the viewer. The belted garment is embroidered with patterns; an ornamental band runs down the middle. The head and feet are again turned in profile.

We might compare here a terracotta relief. Two examples, one from the former Santangelo Collection now in the Naples museum, the other from the excavations of P. Zancani-Montuoro near Francavilla in southern Italy, come from the same matrix and complement each other. The head is missing (it is restored in the drawing), but the left arm showing the form of the drapery is preserved. On the drapery below the belt at the front are depicted figured scenes, divided by patterns of plaited bands. In the uppermost zone is a mythical theme, Ajax carrying from the battlefield the very tall body of Achilles with its splendid helmet-crest. Under this is a row of five girls, seen from the front and holding hands. Below this, four youths in similar poses march along—head and torso frontal, legs in profile. At the bottom are two antithetically arranged winged sphinxes with the usual tresses growing from their heads.

The relief was about 34 cm high, with restorations. It cannot be doubted that a female figure with so richly patterned a garment is a goddess, perhaps Athena, since this goddess was worshipped at the site near Francavilla. The finds come from Italy and it seems possible that this work was created in Magna Graecia towards the middle of the seventh century.

A grey limestone statuette (height 65 cm) which sits on a rectangular base came by way of the Auxerre Museum to the Louvre. We do not know its provenance, so the place of production and its attribution are disputed. Some suggest Crete, others the Argolid, Rhodes or even the Cyclades. This uncertainty is unfortunate, since we can speak of this piece as a work in which the different tendencies of the preceding decades—balanced proportions, compactness and concentrated expressive power—are almost fully manifest. The head is swaddled in hair, the locks curls over the forehead, and out of this frame the face, alert and intense, looks out. A cape covers the shoulders and arms, while the right hand with its long fingers reaches up to rest on the breast and the other hand lies against the thigh. The arms thus alleviate the caesura created by the wide belt. The large feet give the figure a firm stance, an effect increased by the dress which falls in a stiff mass, divided only by a row of square panels down the middle and a broad lower hem. The fine border at the neck and the bracelets are discreet. But how vivid the whole was made by colours, lost to us. There is both a quiet peace and a solemn sense of spiritual power in this fine piece, which has no equal. Whether it is a goddess or an adorant is disputed—and it is not perhaps so important to know. For if she is a girl praying, she seems to be filled with the goddess herself. This degree of unity and balance can have been reached only around the middle of the seventh century.

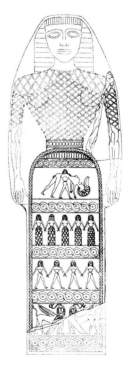

Fig. 35 Reconstruction (by P. Zancani-Montuoro) of a terracotta relief with a frontal standing goddess wearing a dress decorated with figures. West Greek, towards 650 BC. Original h. of figure *c.* 34 cm. The example from Francavilla illustrated here comes from the same matrix as the one in Naples illustrated in Schefold, *Sagenbilder* (1964), Pl. 32 b.

439 A fragment of a limestone relief was found near the temple of Athena in the citadel of Mycenae. It is 40.2 cm high and, along with the other reliefs discovered with it, served an architectural purpose. With caution it may perhaps be thought of as a metope from a Doric temple. The woman has a veil around her head. The neckline of her garment and belt are also visible. A double row of rounded curls lies horizontally over the forehead. It is the face of the Louvre statue again. The hair, however, is in two broad masses and is divided horizontally into many steps. Indeed in contrast to the Louvre statue a slightly later stage has now been reached, for the relief belongs to the third quarter of the seventh century, and may be the work of an Argive master.

437 Rather later and different in style is the small cast bronze female head in the Landesmuseum, Karlsruhe. It is said to come from Olympia, but this is not sure. The hole in the parting indicates that this head, only 8.7 cm high, comes from an utensil. A narrow band runs across the forehead while the hair falls straight and undivided. The face is full of a spiritual intensity that formerly must have been increased by the eyes, which were inlaid.

436 Of the same quality is a head in the Berlin-Charlottenburg Museum. It is embossed from a circular disc measuring 35 cm in diameter. Two rows of locks curl over the forehead and masses of hair in a step-like pattern fall upon the shoulder. The eyes were inserted in a different material. Scholars regard this head as being that of a maiden, but somehow I have always maintained that this is a young man at the height of beauty.

In 1878, in the course of the German excavations at
440 Olympia an over-life-sized female head (height 52 cm) of grey limestone was found. The style of this colossal work, which blends both majesty and charm, suggests a Spartan artist and a date around 600 BC or soon after. A band, which when the piece was found was still red, runs across the forehead. Below it, the wavy hair imparts a certain grace to the countenance. The hair was once a bright yellowish red. The almond-shaped eyes were also once painted: the incised circle of the iris can still be seen. The eyes are in fact tilted so that they look downwards, which suggests a high setting for the work. The mouth seems to wear a slight smile. The hair falls down the neck in a wide mass so that it pushes the ears forwards. Above the band it is combed backwards and is parted in the middle. The goddess wears a polos or, as it was called in Sparta, a pyleon. At the bottom there is a narrow woven band, and above, rising steeply, reeds surround the head like a crown. Out of the head-dress a tendril sprouts on the left—the one on the right has not been preserved. As long ago as 1935 P.
441-2 Wolters pointed to an important parallel, a Cycladic relief pithos on which a goddess stands with raised hands flanked by lions, while serving maids help to put a garment over her plank-like body. Out of her polos grows on both sides a lush branch from which hang grapes. This important parallel has often been overlooked by scholars.

The goddess on the pithos has with good reason been called Hera, while A. Furtwängler identified the head from Olympia as that of Hera's cult statue in her temple. Pausanias saw this
440 statue in the second century AD and described it briefly (V, 17,1): 'in the temple of Hera is a statue of Hera which sits on a throne, and nearby stands that of Zeus who wears a helmet on his head. They are simple works.' By 'simple works' it must be meant that they were archaic, but perhaps also that they were not made of gold and ivory. In any case the Hera in the temple was a seated figure. One wonders how such a seated statue could be fitted on the base preserved in the temple, which is 4.07 m wide and 1.3 m long. Perhaps the statue was set at an angle in three-quarter view. Certain asymmetries which have been detected in the head may support such a reconstruction.

The head has also been referred to as that of a colossal sphinx which stood in the open air. From time to time the theory is put forward either that this was the head of an enormous free-standing sphinx or that it was the remains of a relief figure from the temple of Hera. But could the surfaces of a soft limestone statue have been so well preserved if it had stood in the open air from the beginning? And can we believe that a temple of Hera with wooden columns and entablature could have had colossal stone pediment figures? We ought, therefore, to consider this head from Olympia as an enthroned Hera. Whether the Zeus, which Pausanias mentions as standing nearby, was contemporary or a later addition remains an open question.

Lions

With representations of lions we return once again to the Mycenaean period. Near Schliemann's Grave Circle A was 444 found a lion cast in gold. It is depicted here about four times its actual size. The animal lies in a quiet and relaxed pose on a curved plinth. The paws and belly rest on the ground; the tail is curled up high. The artist has indicated the mane with a few chisel strokes. Above, the head is turned towards the viewer, its eyes open and ears pricked.

The limestone lion from Olympia (79 cm long) is in a totally 445-6 different style. The contours are tense and sleek. Even the scaly mane is given a smooth outline. The lion is full of aggression and seems about to spring. The jaws are wide open and the eyes protrude fiercely under triple eyebrows. The belly 446 is drilled to take a pipe: this lion once served as a water-spout—the water would have gushed from its open jaws. The head is turned a little to the right which could indicate that the animal had a partner turned to the left. Perhaps both lions spouted water into a basin from opposite directions. The basin may perhaps have been situated on the hill of Kronos a little above the temple of Hera; from ancient times there was probably a spring on top. This lion was painted naturally in vivid colours which would have made it seem even more aggressive. It was made around 675 BC by a Peloponnesian artist.

In the seventh century each individual Greek region had its own type of lion. Here one should mention a terracotta lion 447-8 from ancient Arkades on Crete which served as a vessel for perfumed oil. The animal lies in a tense pose and holds a shallow basin in its front paws. The precious oil was poured out through a hole under the rim. The aggressiveness is still present, especially when seen from the front where the wide-open jaws, bared teeth and the many wrinkles over its eyes show.

The motif of the reclining lion holding a vessel had already been treated in Egypt and Palestine, but there can scarcely be

any stylistic link between such pieces and the Greek transformations of them. We may mention here an apt statement by C. Watzinger: 'In contrast to the lazy, motionless animals of Egyptian and Palestinian art, this lion is filled with an inner tension and power; it has become a restless predator with open jaws, whose liveliness is perhaps even a little too intense for such a simple motif as holding a cup.' The terracotta lion from Arkades on Crete was probably made by an artist from Arkades itself in the third quarter of the century.

In the second half of the seventh century Greek sculpture moves on partly to works of monumental scale and this applies to representations of lions as well. Such colossi lie especially
449 over tombs as a symbol or as a guardian. On the Island of Keos in a remote area about one and a half kilometres north-east of ancient Ioulis such a lion was hewn from a nearby rock. The spot is on a slope and so the nine-metre-long base on which the lion rests now has a slight inclination: once he lay flat on a tomb. His large eyes and the mane on his neck were no doubt originally painted.

450-1 The monumental lion terrace in the sanctuary of Apollo on Delos is the high point of such representations. The terrace on which they stand was 64 m long. There were at least nine lion statues set in a row, crouching with jaws open threateningly. The largest of them is 2.95 m long. They were provisionally re-erected by the excavators as far as their condition permitted. The lion was the sacred animal of Apollo and this terrace may have belonged to the Letoon, the sanctuary of his mother, who gave birth to him on Delos. Naxos had a great influence on Delos at that time; the lions on the terrace are the work of Naxian artists and were dedicated by individuals famous on Naxos.

To the end of the century also belongs the monumental lion
452-3 from Corfu, which was found in the neighbourhood of the tomb of Menekrates, but did not belong to it. Here all the forms are powerfully modelled. The lion lies lengthwise on a base 121 cm long and 41 cm wide. It is split lengthwise, for it was made in two parts—one can see the joint—which were dowelled inside with two pins. The beast looks heavy and massive as it lies there, its head turned slightly to one side. The deeply set eyes look out grimly over the slightly open jaws. The heart-shaped ears are set close against the head. The mane is a raised hump and was once painted, as was the whole statue. With this statue a zenith was reached which could not be surpassed. Corfu was a Corinthian colony and a Corinthian artist probably made this work.

Monumental Male Figures of the Late Seventh Century

From the last quarter of the seventh century comes the
457, 459 over-life-size head (44 cm high) which was found, built into the Double Gate (Dipylon) during the excavations of the Athenian Kerameikos. When ten years later his right hand came to light—it once lay against his thigh—it became clear that this was the head of a youth in the *kouros* pose, who stood quietly, his left leg slightly forward. Forty years later further fragments were found of the same excellent Cycladic marble in the excavations of the Athenian market (Agora), which ought

by reason of style and pose to belong: parts of the left hand, the right thigh and the shoulders, parts of the back, the right knee and the left buttock muscle. If these fragments should not belong to this statue, there must have been a second statue of a youth, in the same pose and style, cut of the same material and by the same sculptor.

The youth's head was once painted, as is shown by traces of paint on the hair-band which runs around it, and was covered by hair over the forehead (a second band surrounds the hair also). It can be seen too on the iris of the eyes. The hair, which is divided up like a honey-comb, but with large bumps, falls down the neck where it is gathered. Large eyebrows arch over 459 the almond-shaped eyes. The mouth is only partly preserved 457 and it remains uncertain whether it wore a slight smile. The ears are a mixture of ornamental modelling and observation of nature. A fine collar runs around the neck. This monumental head belongs to a grave statue *c.* 2.5 m high. It is a picture of the deceased without being a portrait. The portrait element lay in the name that was probably inscribed on the base.

The statue of a boyish youth now in the Metropolitan 454-6 Museum, New York, is complete with arms, torso and legs. It is 1.93 m high and was probably made by the same sculptor at a slightly later date. It is the oldest fully preserved statue in the kouros pose, a type which lasted over a century. The left leg is set slightly forward and the hands lie against the thighs because the brittleness of the marble imposed limitations on the sculptor. The hands are clenched and the thumbs point downwards. The muscles and joints are presented in an unusual mixture of abstract schemata and lively observation from nature. The neck is narrower and more boyish then that of the Dipylon head. The band round the hair, however, is the same. Whether there was another painted band on the forehead under the hair is uncertain. The mouth and chin are both preserved here; only the nose is broken. The ears are almost purely ornamental in form. The hair is arranged, as on the 460 Kerameikos head, in a honey-comb pattern, but it flows more freely and with a wider sweep down the back of the neck. The statue once stood close to the country estate of a nobleman, on the path to Anavyssos, near the modern estate of Melissourgos. A large part of the Vlastos Collection of vases comes from the ancient cemetery on this land.

On a nearby grave mound stood a funerary statue, 1.94 m high, of a youth who in the inscription on its associated base is named as Kroisos. The statue of Kroisos is eighty or ninety years later than the Dipylon head and it is interesting to compare the two. Both belonged to the same noble family. Kroisos was killed in the front rank of battle. What death the youth of the New York monument met we do not know, but it may be assumed that he died young.

On the terrace next to the Poseidon temple at Sounion there once stood several colossal statues of youths. The one now in the National Museum at Athens was much restored in face and 458 body, so we shall look only at one detail of the head. The sculpture is rather more developed than the Dipylon head and the New York youth, as can be seen from the wavy flow of the hair. Nevertheless, the ear still manifests that strange mixture of art and nature. Furthermore, the hair in the section between the two parts of the hair-band is given ornamental curls, while the hair and the band are rendered more naturally. In the Sounion colossi we are probably dealing with monumental votive statues.

461-3 A colossal statue of Apollo also stood in the open air on the island of Delos. The base is preserved and still lies at its original site. It measures 15.18 by 3.5 by 0.75 m. The inscription informs us that this statue was erected by 'the Naxians to Apollo'. A second inscription proudly explains: 'From the same stone is the statue and the base.' This colossus has resisted all attempts at removal, because of its enormous

461-2 weight. It is broken into different pieces. On the back are deeply etched lines showing spine and shoulder-blades. Locks of hair, curled up at the ends, fall down the back, while on the chest, as can be seen from the attachment holes, lay other locks which must have been worked in metal. Around the waist was a metal belt, as a further fragment of the waist and thighs

463 shows. A hand, 40 cm long, is still on Delos and a foot found its way to London.

How these colossi were transported from the quarry overland to the coast and from there placed on board ship

464 we do not know. On Naxos a large block still lies in a quarry. It was to have been a draped and bearded figure with outstretched right arm. The stone was probably flawed in some way, so it was left there. It is clear that these enormous pieces were transported in a semi-finished state and were only finished at the place of erection.

465-9 The statue group of Kleobis and Biton, which was dedicated at Delphi, probably belongs to the beginning of the sixth century. Herodotos (I, 31) tells the following story. When Solon was staying with King Kroisos in Lydia, Kroisos asked him whom he thought was the happiest person. He named first a certain Tellon, an Athenian, who had excellent sons, whose children were all alive, and who fell in a battle and was given a state funeral. As the second happiest, however, he named the brothers Kleobis and Biton. They were of Argive birth, had enough to live on and were of great strength. They were both

prize-winners. Their mother was a priestess of Hera. One day there was a feast of Hera at the sanctuary, to which she had to be brought on a cart. As the cattle were not back from the fields, the two youths took up the yoke and drew the cart bearing their mother the forty-five stades to the sanctuary. When they did that and were seen by participants at the feast, they were granted a fine end to life. Thereby the god showed that it was better for humans to die than to live. The assembled Argive men praised the strength of the youths, while the Argive women lauded the woman who had given birth to such sons. The mother, very happy about such praise and the deed, stood in front of the cult statue and asked the goddess to give her children, Kleobis and Biton, who were so greatly honoured, what was best for humans. When, after this prayer, they had made sacrifice and eaten, the two youths fell asleep in the sanctuary. They did not rise again, but there met their end. The Argives, however, made statues of them and dedicated them at Delphi as men who had proved themselves.

The names of both youths are cut on the rectangular base on which each figure stands; the reason for the dedication could also be read there, together with the name of the artist, which ended in —medes. The youths are naked and are in the kouros pose with clenched dists and left feet slightly forward. The pubic hair is rendered plastically, as are the eyebrows. The hair curls over the forehead and falls down over their soulders and neck. The bands cut into the luxuriant hair. The youths are not represented naked because they are athletic winners. Their strenght of body is indeed emphasized, but they wear their hair long, which was not usual in athletics. Furthermore, they wear boots —the contours were incised, the rest painted. These features recall their deed, the pulling of the cart, which they fulfilled at the feast of Hera. Their faces are beaming, filled with the blessed praises which they took with them into another life.

Conclusion

The Mycenaean palaces and their paintings were linked to a form of rule which had its predecessors in the East and in Crete, and which lasted in Greece only until the collapse of the twelfth century. Individual architectural elements such as the megaron, the column, the capital and polygonal masonry survived in a modified form, but if one considers how the forms chosen by the Achaeans differed from their prototypes, one must concede the latter's independent character, which was preserved almost unchanged from the fifteenth to the twelfth century. Only the ground-plans of the palaces are preserved, but their form has become immortal through the descriptions in Homer's *Odyssey*.

The Mycenaean grave stelai with low relief or painting are independent works, whose initial character can be seen in the awkwardness of certain representations; though intermediate examples are lacking, they find their continuation in Greek grave stelai from the Archaic to the Hellenistic period. As for Late Mycenaean painted sarcophagi with scenes of mourning for the dead, it is around three hundred years before there are similar representations on Geometric vases; though the pictures are similar, we have to do here with the survival of a custom, not an art form, and the Geometric depiction of the human figure is new.

Many rites in the cult of the gods were transmitted through the 'Dark Ages' in the same way as funerary customs. Cult areas without temples but with sacred trees, for which Minoan–Mycenaean engraving and painting give proof, also occured later. A cult place like the oldest one at Eleusis is unusual because of its isolated setting, and points forward to the later Eleusinian cult, but instead of princes and princesses holding the important sacred offices these were later occupied by priests and priestesses, who often traced their lineage back to Bronze Age ancestors. The ecstatic dance in vegetation cults finds its continuation in the dance in the worship of Dionysos who, as the Linear B tablets show, was honoured in Greece already in the second millennium; this is also true of Zeus, Hera, Poseidon, Athena, Ares, Hermes and many other divinities. The name of Aphrodite has not so far been read in the Mycenaean records, but it is exactly this goddess—given the epithet 'in the Gardens' in Athens—whose presence can be shown in Mycenaean art; another representation of a divinity which can be identified with certainty is that of Athena, who appears as a Palladion with a large figure-of-eight-shaped shield. The Mycenaean element is most strongly preserved in the cults of Athens.

The gold masks of dead rulers from the two grave circles at Mycenae found successors only on the outskirts of the Greek world. The Mycenaean masks differed from each other in a way which allows one to infer that their makers enjoyed a degree of freedom denied to those in Oriental cultures; furthermore, one can conclude that there were at Mycenae different workshops for gold masks, whose artists were in competition *(agon)*, a principle typical of later Greece.

Among metal vases the cup with high handles, the kantharos, was an old form in the Mycenaean period, and yet it points the way to the future, it became the vessel of Dionysos and of Greek heroes. Inlay work on metal vases and weapons was characteristically Mycenaean, and was followed on Cyprus, which was occupied by Achaeans; the technique had a further life in literature through the description of the Shield of Achilles in the *Iliad*, the unrivalled iconographic model down to the Byzantine period.

The Sub-Mycenaean type of brooch can be traced in unbroken succession down to the Archaic period, though with alterations of style. There is evidence for the bronze bowl with three attached legs—a Bronze Age form—from the Mycenaean epoch through the 'Dark Ages' down to the Geometric period, when it reached its heyday. The tripod stand for a bowl was especially favoured by the bronze industry of Cyprus, whose products also bridge the gap between the two millennia.

In pottery continuity between the Mycenaean and Geometric periods is particularly strong; although some shapes like the stirrup-jar die out—something which happens in all periods—the typical Mycenaean invention of shiny black gloss slip and, with it, the method of firing in special kilns, survived; this was particularly clear in Athens, where a remarkably rich quantity of material from the 'Dark Ages' has been found. However, the Proto-Geometric style of this period was not confined to Athens, but was a Greek *koine* (common style), which arose from the surprisingly uniform Sub-Mycenaean *koine*.

Already in 1900 Adolf Furtwängler in his work on Greek gems had recognized that in character Mycenaean engraving is Greek; although nowadays we know that it owes its origin to Minoan artists, Furtwängler's subtle observations retain their validity, since gems and gold rings were bespoke pieces, which expressed the aims of their owner. The narrative tendency of many Mycenaean gems recurs in the scenes of action in Early Archaic art, in painting and in metalwork; moreover, many Mycenaean gems were found in later contexts. The artists of the so-called 'Island Gems' imitated them; however, since technique declined with the end of the palace workshops—for about half a millennium in Greece there was no use of a bow-drill for hard stone—only relatively soft stone like serpentine was used for gems. On the other hand, pottery was not linked to royal trade and commissions.

283

The quantity of gold ornament, attested for us by Schliemann's shaft graves and by finds from partially plundered tholoi down to the fourteenth century, was never again equalled in Greece, but, leaving aside the poverty of the 'Dark Ages', the custom of giving the dead solid ornaments and also thin sheet gold, for instance in the form of diadems, still persisted; apart from these, there were individual motifs—for instance, pendants shaped like pomegranates, which can be traced from a gold chain from Shaft Grave III through Thessalian and Peloponnesian pendants down to Geometric ear-rings and Rhodian–Melian ornaments. It is a disputed point whether the ninth-century technique of granulation was introduced afresh from the East to Athens, or whether it survived from the Mycenaean period.

Like engraving, ivory-carving lost its princely patrons with the collapse of Mycenaean rule, and for a time disappeared; apparently the technique, together with the material, was taken over anew from the East in the eighth century. On the other hand wood-carving may have been widespread during the era of impoverishment; in the literary tradition the cult of many Greek gods originates in an image carved from wood: a *xoanon*. In contrast to Egypt, however, wooden objects, which undoubtedly existed in the Mycenaean period, have hardly survived in Greece; we must be all the more grateful to the fortunate chance that works in wood from the seventh century BC have come to light on the island of Samos.

As regards sculpture in the round, there are certain links from Mycenaean through Sub-Mycenaean to Geometric, though one cannot see how the Mycenaean inheritance had its effect because of the gaps in the evidence; pieces like the centaur from Lefkandi on Euboea are at present unique. In the Late Geometric period we find ivory-working already highly developed at Athens, and the same is true of Argos, Corinth, Sparta and other places—especially in the immediate vicinity of large sanctuaries—for the art of casting bronze. From the end of the eighth century the development of Greek sculpture is not straightforward. It is known that the various Greek areas and dialects first developed their specific characteristics in the post-Mycenaean period, just as the Romance languages developed after the collapse of Roman rule in the area where Latin had been the predominant tongue. The last Panhellenic style was Proto-Geometric, which derived from the Late Mycenaean *koine*; in pottery half a millennium went by before the Hellenistic world again had a *koine*, in the field of relief vases. Sculpture in the seventh century BC had regional differences, and progressive works stand alongside old-fashioned ones; around 600 BC the different currents coalesce into a single stream, though the various artistic areas were not entirely swamped.

In Mycenaean times, as in the Orientalizing period of the seventh century, one can see a preference for lions, sphinxes and griffins; these were taken over from the East on two separate occasions. In the second millennium, as in the first, Greek imagination gave them new life and made them beings which differ in character from their prototypes; the lion was no less a fabulous creature than the griffin or sphinx. In Mycenaean art its head is strikingly often seen from above, and so it is possible that the artists had seen lions' skins, which, together with elephants' tusks, ostrich eggs, precious stones and other luxury articles, were certainly imports from the East. When in Mycenaean art men fight with lions, as on the famous dagger-blade from the shaft graves, despite the realism in the method of representation these are not portrayals of lion-hunts in Greece, but scenes which border on the fabulous; in such instances one might almost already speak of myth, as in the seventh century.

By emphasizing some aspects of the wealth of material we hope to have stirred the reader to further reflection on what Mycenaean art and later Greek art have in common.

Bibliography

In the bibliography the following abbreviations are used:

AA	*Archäologischer Anzeiger*, Berlin (1889-1930)
AD	*Antike Denkmäler*, Berlin (1887-1930)
AGD	*Antike Gemmen in deutschen Sammlungen*, 4 vols., Munich and Wiesbaden (1968, 1969, 1970, 1975)
AJA	*American Journal of Archaeology*, New York (1897-)
AM	*Athenische Mitteilungen*, Deutsches Archäologisches Institut, Athens (1876-)
BCH	*Bulletin de Correspondance Hellénique*, Paris (1877-)
BOARDMAN, *Gems*	J. BOARDMAN, *Greek Gems and Finger Rings*, London (1970)
BORCHHARDT, *Helme*	J. BORCHHARDT, *Homerische Helme*, Mainz (1972)
BSA	*Annual of the British School at Athens*, London (1896-)
BUCHHOLZ and KARAGEORGHIS	H.G. BUCHHOLZ and V. KARAGEORGHIS, *Altägäis und Altkypros*, Tübingen (1971)
COLDSTREAM (1968)	J.N. COLDSTREAM, *Greek Geometric Pottery*, London (1968)
CVA	*Corpus Vasorum Antiquorum*, Union Académique Internationale
DAVIS (1977)	E. DAVIS, *The Vapheio Cups and Aegean Gold and Silver Ware*, New York (1971)
Deltion	*Deltion Archaiologikon*, Athens (1915-)
EAA	*Enciclopedia dell'Arte Antica*, Rome (1958-73)
Ephemeris	*Ephemeris Archaiologike*, 22 vols., Athens (1883-)
FITTSCHEN, *Sagendarstellungen*	K. FITTSCHEN, *Untersuchungen zum Beginn der Sagendarstellungen bei den Griechen*, Berlin (1969)
FURTWÄNGLER, *AG*	A. FURTWÄNGLER, *Die antiken Gemmen*, vols. I-III, Berlin (1900); reprinted Amsterdam and Osnabrück (1964)
FURUMARK, *Pottery*	A. FURUMARK, *The Mycenaean Pottery: Analysis and Classification*, Stockholm (1940)
GGA	*Göttingische Gelehrte Anzeigen*, Göttingen (1739-)
HAMPE, *Sagenbilder*	R. HAMPE, *Frühe griechische Sagenbilder in Böotien*, Athens (1936)
HERRMANN, *Olympia* (1972)	H.-V. HERMANN, *Olympia, Heiligtum und Wettkampfstätte*, Munich (1972)
HIGGINS (1961)	R.A. HIGGINS, *Greek and Roman Jewellery*, London (1961)
HOOD (1978)	S. HOOD, *The Arts in Prehistoric Greece*, Norwich (1978)
JDI	*Jahrbuch des Deutschen Archäologischen Instituts*, Berlin (1886-)
JHS	*Journal of Hellenic Studies*, London (1880-)
KARO, *Schachtgräber*	G. KARO, *Die Schachtgräber von Mykenai*, Munich (1930)
MARANGOU	E.-L. MARANGOU, *Lakonische Elfenbein- und Beinschnitzereien*, Tübingen (1969)
MARINATOS and HIRMER (1973)	SP. MARINATOS and M. HIRMER, *Kreta, Thera und das mykenische Hellas*, Munich (1973)
MdI	*Mitteilungen des Deutschen Archäologischen Instituts*, Berlin (1948-52)
Mon. Piot	*Monuments et mémoires Fondation Eugène Piot* (1899-1967)
MYLONAS, Kyklos B	G.E. MYLONAS, Ὁ Ταφικὸς Κύκλος τῶν Μυκηνῶν, Athens (1973)
ÖJh	*Jahreshefte des Österreichischen Archäologischen Instituts*, Vienna (1898-)
Op. Ath.	*Opuscula Atheniensia*, Lund (1953-)
POURSAT, *Ivoires*	J.-C. POURSAT, *Les Ivoires Mycéniens*, Paris (1977)
POURSAT, *Cat.*	J.-C. POURSAT, *Catalogue des Ivoires Mycéniens du Musée National d'Athènes*, Paris (1977)
RE	Paulys *Realencyclopädie der classischen Altertumswissenschaft*, Stuttgart (1894-1980)
Rev. Arch	*Revue Archéologique*, Paris (1860-)
SAKELLARIOU, *CMS*, vol. I	A. SAKELLARIOU, *Corpus der minoischen und mykenischen Siegel*, vol. I, Athens, Berlin (1964)
SCHEFOLD, *Sagenbilder* (1964)	K. SCHEFOLD, *Frühgriechische Sagenbilder*, Munich (1964)
SIMON and HIRMER	E. SIMON and M. and A. HIRMER, *Die griechischen Vasen*, Munich (1976 and 1981)
SIMON, *Götter*	E. SIMON, *Die Götter der Griechen*, Munich (1969 and 1980)
Stud. Med. Arch.	*Studies in Mediterranean Archaeology*, Lund (1962-)
WACE	A.J.B. WACE, *Mycenae*, Princeton (1949)
ZERVOS (1969)	CH. ZERVOS, *La Civilisation Hellénique*, vol. I, Paris (1969)

Architecture and Painting

Excavation of the old and new shaft graves

H. SCHLIEMANN, *Mykenae*, Leipzig (1878)

H. SCHLIEMANN, *Briefwechsel*, ed. by E. MEYER, vol. I (1842-75), Berlin (1953), vol. II (1876-90), Berlin (1958)

W. REICHEL, *Die Schachtgräber-Terrasse von Mykenai während Schliemanns Ausgrabung*, AD, vol. II, Pls. 46, 49

A. FURTWÄNGLER and G. LOESCHCKE, *Mykenische Vasen*, Berlin (1886)

KARO, *Schachtgräber*

G.E. MYLONAS and J. PAPADIMITRIOU, 'The Shaft Graves of Mycenae', in *Archaeology*, 5 (1952)

SP. MARINATOS, Περὶ τοὺς νέους βασιλικοὺς τάρους τῶν Μυκηνῶν«, Ἑταιρία Μακεδονικῶν σπουδῶν 9 (1953), pp. 54 ff.

G.E. MYLONAS, 'The New Grave Circle of Mycenae', in *Archaeology*, 8 (1955)

G.E. MYLONAS, *Grave Circle B of Mycenae*, Lund (1964)

MYLONAS, *Kyklos B*

E.T. VERMEULE, *The Art of the Shaft Graves*, Cincinnati (1975)

Mycenaean culture, general

G. KARO, 'Mykenische Kultur', in *RE* Suppl., VI (1935), pp. 584 ff.

C.W. BLEGEN, *The Mycenaean Age*, Cincinnati (1962)

E.T. VERMEULE, *Greece in the Bronze Age*, Chicago (1964)

L.A. STELLA, *La civiltà micenea nei documenti contemporanei*, Rome (1965)

G.E. MYLONAS, *Mycenae and the Mycenaean Age*, Princeton (1966)

D. LEVI, 'Continuità della tradizione nell'arte greca arcaica', in *Atti e memorie del 1. Congresso internazionale di Micenologia*, Rome (1968), pp. 185 ff.

MARINATOS and HIRMER (1973)

J.T. HOOKER, *Mycenaean Greece*, London and Boston (1976)

HOOD (1978)

Mycenaean palaces, general

CH. TSOUNTAS and I. MANATT, *The Mycenaean Age; a Study of the Monuments and Culture of pre-Homeric Greece*, (1897), reprinted Chicago (1969), pp. 44 ff.

J.W. GRAHAM, 'Mycenaean Architecture', in *Archaeology*, 13 (1960), pp. 46 ff.

Mycenae

WACE, *Mycenae. An Archaeological History and Guide*, Princeton (1949)

G.E. MYLONAS, *Ancient Mycenae*, London (1957)

H. WACE and C. WILLIAMS, *Mycenae, Guide*, Meriden (1963)

A.J.B. WACE and F.H. STUBBINGS, *A Companion to Homer*, London (1963), pp. 387 ff.

SP. E. JACOVIDES, 'The Present State of Research at the Citadel of Mycenae', in *Bulletin of the Institute of Classical Studies of the University of London*, 14 (1977)

2-4, 8-9 Tiryns

H. SCHLIEMANN and W. DÖRPFELD, *Tiryns*, Leipzig (1886)

Tiryns, Die Ergebnisse der Ausgrabungen des Instituts, Augsburg (1930); vol. III, K. Müller, *Die Architektur der Burg und des Palastes*

Pylos 1, 6-7

C.W. BLEGEN and M. RAWSON, *A Guide to the Palace of Nestor*, Cincinnati (1962)

C.W. BLEGEN and M. RAWSON, *The Palace of Nestor at Pylos in Western Messenia. The Buildings and their Contents*, Princeton (1966)

Gla 13

SP. E. JACOVIDES, *Archaeologica Homerica* E 204 ff.

Water supply

Mycenae

G. KARO, *AJA*, 38 (1934), 123 ff.

SP. E. JACOVIDES, *Archaeologica Homerica* E 192 f.

Tiryns

SP. E. JACOVIDES, *Archaeologica Homerica* E 179

Athens

O. BRONEER, *Hesperia*, 8 (1939), pp. 317 ff.

SP. E. JACOVIDES, Ἡ Μυκεναϊκὴ Ἀκρόπολις τῶν Ἀθηνῶν, Athens (1962)

SP. E. JACOVIDES, *Archaeologica Homerica* E 200 f.

Road system 14

H. STEFFEN, *Karten von Mykenai*, Berlin (1884)

Wall at the Isthmus

O. BRONEER, *Hesperia*, 24 (1955), p. 124; 35 (1966), pp. 346 ff.

SP. E. JACOVIDES, *Archaeologica Homerica* E 211

Mycenaean Painting

Mycenae: House of the Oil-Merchant

M. VERDELIS, *Archaeology*, 14 (1961), pp. 12 ff.

Mycenae: the palace 29-30
32-3,
WACE, pp. 69 ff., Pls. 87-91

G.E. MYLONAS, *Mycenae and the Mycenaean Age*, Princeton (1966), pp. 58 ff.

G. RODENWALDT, *Der Fries des Megarons von Mykenai*, Halle (1921)

G. RODENWALDT, 'Die Fussböden des Megarons von Mykenai', in *JDI*, 34 (1919), pp. 87 ff.

Tiryns 16-17
22, 24
G. RODENWALDT, Tyrins II. *Die Fresken des Palastes*, (1912), 37, 39
pp. 69 ff.

CH. BOULOTES, 'Zur Deutung des Freskenfragments Nr. 103 aus der Tirynther Frauenprozession', in *Archäologisches Korrespondenzblatt*, 9 (1979), pp. 59 ff.

Pylos 18, 21
27-8,
M. LANG, *The Palace of Nestor at Pylos in Western Messenia II. The* 34-6,
Frescoes, (1969)

E.S. Hirsch, *Painted Decoration on the Floors of Bronze Age Structures*, Göteborg (1977)

15 Thebes

H. Reusch, *Die zeichnerische Rekonstruktion des Frauenfrieses im böotischen Theben*, Berlin (1956)

Vivara

M. Marazzi and S. Tusa, 'La Parola del Passato', in *Rivista di studi classici*, 171 (1976), pp. 473 ff.

5, 363 Thera (Akrotiri)

Marinatos and Hirmer (1973), Pl. XL above: river scene; Pl. XL below and Pl. XLI: approach of fleet; Pl. XLII: sortie of Mycenaean warriors

Sp. Marinatos, *Thera*, vol. VI, Athens (1974), Col. Pls. 7 (warrior); 8 (river); 9 (fleet); 4 (cabin)

P.M. Warren, *JHS*, 99 (1979), 115 ff.

Sp. E. Jacovides, *AJA*, 83 (1979), 101 f.

Tholos tombs, general

O. Pelon, *Tholoi, tumuli et cercles funéraires*, Paris (1976)

51 Orchomenos

H. Schliemann, *Orchomenos*, Leipzig (1881)

Marinatos and Hirmer (1973), Pls. 182, 183

46-50 Treasury of Atreus

F. Thiersch, 'Die Tholos des Atreus zu Mykenai', in *AM*, 4 (1879), pp. 177 ff.

Wace, 119 ff., Figs. 49-51, 74

G.E. Mylonas, *Mycenae and the Mycenaean Age*, Princeton (1966), pp. 120 ff., Figs. 112-14

Marinatos and Hirmer (1973), Figs. 170-3

52 Carved grave stelai

G.E. Mylonas, 'The Figured Mycenaean Stelai', in *AJA*, 55 (1951), 134 ff.

54-6 The Agia Triada sarcophagus

R. Paribeni, *Monumenti Antichi*, 19 (1908-9), pp. 1 ff.

M.P. Nilsson, *Minoan–Mycenaean Religion*, 2nd. ed., Lund (1950), pp. 426 ff.

P. Nauert, *Antike Kunst*, 8 (1965), pp. 91 ff.

Chr. Long, 'The Aya Triada Sarkophagus', in *Stud. Med. Arch.*, 41 (1974)

E. Simon, *RE* Suppl., XV (1978), Pt. III, p. 1417 *s.v.* Zeus

57-61 Mycenaean sarcophagi

E.T. Vermeule, *Greece in the Bronze Age*, Chicago and London (1964, 1972), pp. 210 ff.

Ergon, (1971), p. 15, Figs. 12, 13

B. Rutkowski, 'Minoan Sacred Emblems', in *Antichità Cretesi*, vol. I, Pl. XXIV

E.T. Vermeule, 'Painted Mycenaean Larnakes', in *JHS*, 85 (1965), pp. 123 ff.

Antike Kunstwerke aus der Sammlung Ludwig I, Basle (1979), p. 16, No. 2 with Figs. A, B, C

Pillar cult

Simon, *Götter*, pp. 61 ff.

The Lion Gate at Mycenae 62-3

Wace, pp. 49 ff., Pls. 72, 73, 74a

St. Hiller, *Antike Welt*, 4 (1973), pp. 21 ff.

R. Lullies and M. Hirmer, *Griechische Plastik*, 4th ed., Munich (1979), Fig. 1

Shrines 64-5

N. Platon, 'Der minoische Palast von Kato Zakro', in *du*, Jan. (1967), 52 f.

B. Rutkowski, *Cult places in the Aegean World*, Wroclaw, Warsaw, Cracow and Gdansk (1972)

Rhyton from Kato Zakro: Marinatos and Hirmer (1973), Pls. 108-10

R. Hägg, 'Mykenische Kultstätten in archäologischem Material', in *Op. Ath.*, 8 (1968), 39 ff.

J.W. Shaw, 'Evidence for the Minoan Tripartite Shrine', in *AJA*, 82 (1978), 429 ff.

J.N. Coldstream, *Deities in Aegean Art before and after the Dark Age*, Bedford College, University of London (1976)

The cult centre at Mycenae 70-7, 335

W.D. Talour, 'Mycenae 1968', in *Antiquity*, 43 (1969), pp. 91 ff.

W.D. Taylour, 'New Light on Mycenaean Religion', in *Antiquity*, 44 (1970), pp. 270 ff.

G.E. Mylonas, Τὸ θρησκευτικὸν κέντρον τῶν Μυκηνῶν, Athens (1972)

G.E. Mylonas, Μυκηναϊκὴ θρησκεία Πράγματα δι τῆς ᾿Ακαδεμίας ᾿Αθηνῶν, 39 (1977)

The shrine at Eleusis

G.E. Mylonas, *The Hymn to Demeter and her Sanctuary at Eleusis*, St. Louis (1942)

G.E. Mylonas, *Eleusis and the Eleusinian Mysteries*, Princeton (1961)

N.J. Richardson, *The Homeric Hymn to Demeter*, Oxford (1974)

Building in the Geometric period, general

H. Drerup, *Archaeologica Homerica* O, pp. 1 ff.

St. Sinos, *Die vorklassischen Hausformen in der Ägäis*, Mainz (1971)

A.E. Kalpaxis, *Fr“harchaische Baukunst in Griechenland und Klein-asien*, Athens (1976)

Old Smyrna

J.M. Cook, 'Old Smyrna', in *BSA*, 53-4 (1958-9), p. 15, Fig. 3

Fortifications: R.V. Nicholls, in *BSA*, 53-4 (1958-9), pp. 36 ff.

Eretria (Daphnephorion)

P. Auberson, *Antike Kunst*, 17 (1974), pp. 60 ff.

84 **Granaries**

E.L. SMITHSON, 'The Tomb of a Rich Athenian Lady', in *Hesperia*, 37 (1968), pp. 77 ff.

Temples

S.D. MARKMAN, *Studies Presented to D.M. Robinson*, vol. I, Washington (1951), pp. 259 ff.

P. VERZONE, *Studies Presented to D.M. Robinson*, vol. I, Washington (1951), pp. 272 ff.

H. DRERUP, 'Architektur und Toreutik', in *MDI*, 5 (1952), pp. 7 ff.

85-7 **Olympia**

W. DÖRPFELD, *Altolympia*, 2 vols., Berlin (1935)

Corrected plan: A. MALLWITZ, 'Das Heraion von Olympia und seine Vorgänger', in *JDI*, 81 (1966), pp. 310 ff.

88-9 **Bronze fitting for columns**

R. HAMPE, *AA*, (1938), pp. 360 ff.

Inner columns: A.E. KALPAXIS, *AM*, 90 (1975), pp. 83 ff.

170 **Bronze sheet: griffin with young**

R. HAMPE and U. JANTZEN, *1. Olympia-Bericht*, (1937), Pls. 34, 35

R. HAMPE, *Pantheon*, (1941), p. 101, Fig. 8

90 **Disc akroterion**

Olympia, V (1881), Pl. 34; Olympia text vol. II, pp. 190 f.; plates vol. II, Pl. 115

N. YALOURIS, *AM*, 87 (1972), pp. 85 ff., Pls. 37-44, Suppl. Pls. 1-3

Painting from 800-600 BC

91 **Pinax in a private collection**

R. HAMPE, in: *Charites, Studien zur Altertumswissenschaft (Festschrift für Ernst Langlotz)*, Bonn (1952), pp. 104 ff.

92 **Fibula in London with Herakles and the Hydra**

R. HAMPE, *Die Gleichnisse Homers und die Bildkunst seiner Zeit*, Tübingen (1952), Pl. 18, Fig. 18a

SCHEFOLD, *Sagenbilder* (1964), Pl. 6a

93-4, 149 **Fibula in Philadelphia**

W.N. BATES, *AJA*, 15 (1911), pp. 1 f.

HAMPE, *Sagenbilder* (1936), p. 14, Pl. 8

95-6 **Terracotta shield from Tiryns, Museum, Nauplion**

D. v. BOTHMER, *Amazons in Greek Art*, Oxford (1957), 16, Pl. 1a-b

SCHEFOLD, *Sagenbilder* (1964), Pl. 7b

97 **Eleusis amphora**

G.E. MYLONAS, Ὁ πρωτοαττικὸς ἀμφορεὺς τῆς Ἐλευσῖνος, Athens (1957)

SCHEFOLD, *Sagenbilder* (1964), Col. Pl. I, 16

SIMON and HIRMER, Pl. IV, 15

Krater from Argos 98

BCH, 77 (1953), 265, Fig. 58

J.M. COOK, *JHS*, 73 (1953), 116, Fig. 5

P. COURBIN, *BCH*, 79 (1955), pp. 1 ff., Pl. 1

SCHEFOLD, *Sagenbilder* (1964), Pl. 15

Plate from Praisos 99-10

E. PFUHL, *Malerei und Zeichnung der Griechen*, Munich (1923), vol. I, § 98, p. 102, Fig. 57

Nessos amphora 101, 1

J.D. BEAZLEY, *The Development of Attic Black-Figure*, Berkeley-Los Angeles (1951), 14-18, 21, 38, 49

SCHEFOLD, *Sagenbilder* (1964), Pl. 59

SIMON and HIRMER, Pls. 44-6

Chigi jug 102

H. PAYNE, *Protokorinthische Vasenmalerei*, Berlin (1933); reprinted Mainz (1974), pp. 14 f., Pls. 27 ff.

SIMON and HIRMER, Pl. VII, 25, 26

Euphorbos plate 103

SCHEFOLD, *Sagenbilder* (1964), Pl. 75

SIMON and HIRMER, Pl. 31

Gorgon plate 104

SIMON and HIRMER, Pl. 32

Thermon metopes 105-1

AD, vol. II, Pls. 49-52 A

SCHEFOLD, *Sagenbilder* (1964), Pls. 18-21

Grave stele from Prinias 111-1

A. LEBESSI, Οἱ στῆλες τοῦ πρινιά, Athens (1976), B 11

A. LEBESSI, 'Monumento funerario del VII sec. a.C. a Creta', in *Antichità Cretesi*, vol. II, p. 122, Fig. 2

Mythological scenes, general

HAMPE, *Sagenbilder* (1936)

SCHEFOLD, *Sagenbilder* (1964)

FITTSCHEN, *Sagendarstellungen*

R. KANNICHT, *Wort und Bild, Symposium des Fachbereichs der Altertums- und Kulturwissenschaften zum 500-jährigen Jubiläum der Universität Tübingen*, Munich (1977), 279-96

Krateriskos from Samos 113

AM, 74 (1959), 58 Suppl. Pl. 114, 1 (H. Walter)

Fragment of an Attic krater 114

K. KÜBLER, *Altattische Malerei*, Tübingen (1950), Fig. 89

Bronze sheet with Kaineus 115, 1

R. HAMPE and U. JANTZEN, *1. Olympia-Bericht*, (1937), pp. 85 ff., Pl. 28

R. HAMPE, *Die Antike*, 15 (1939), 39 ff.

Shipwreck of Odysseus

Attic jug, Museum antiker Kleinkunst, Munich:
R. HAMPE, *Die Gleichnisse Homers und die Bildkunst seiner Zeit*, Tübingen (1952), pp. 26 ff., Pls. 7-11

SCHEFOLD, *Sagenbilder* (1964), Pl. 8

123 **Bronze fitting with Cassandra, from the Heraion at Argos**

HAMPE, *Sagenbilder* (1936), p. 81, Pl. 41

G.M.A. RICHTER, *Korai*, London (1968), Fig. 103

348 **Perseus on an ivory relief from Samos**

AM, 60-1 (1935-6), p. 288, 5; Pl. 99, 2 (R. Hampe)

SCHEFOLD, *Sagenbilder* (1964), p. 33, Pl. 17

B. FREYER-SCHAUENBURG, *Elfenbeine aus dem samischen Heraion*, Hamburg (1966), pp. 30 ff., Pl. 6a

357 **Ivory comb from Sparta**

R. HAMPE, 'Das Parisurteil auf dem Elfenbeinkamm aus Sparta', in *Festschrift für B. Schweitzer*, Stuttgart (1954), pp. 77 ff., Pls. 11-12

MARANGOU, pp. 108 f., Pl. 78a

Hero cult in dromoi

C.W. BLEGEN, 'Post-Mycenaean Deposits in Chamber Tombs', in *Ephemeris* (1973), pp. 377 ff., conclusion pp. 388 f.

Hero cult of Agamemnon

J.M. COOK, 'The Cult of Agamemnon at Mycenae' in Ἑταιρία Μακεδονικῶν σπουδῶν, 9 (1953), pp. 112 ff.

16-20 **Relief pithos in Mykonos**

M. ERVIN, *Deltion*, 18 (1963 [1964]), Meletai pp. 37 ff.

G. DAUX, *BCH*, 86 (1962), p. 855, Pl. 29

SCHEFOLD, *Sagenbilder* (1964), Pls. 34 f.

Metalwork

Masks

124 **'Agamemnon'** from Shaft Grave V, Mycenae. National Museum, Athens. (The Museum inventory numbers are identical with Karo's.) H. 26 cm

H. SCHLIEMANN, *Mykenae*, Leipzig (1878), pp. 357 f., Fig. 474

KARO, *Schachtgräber*, No. 624, Pl. 52

G. KRIEN-KUMMROW, *EAA*, vol. IV (1961), pp. 904 f., Fig. 1074 f. *s.v.* Maschera

MARINATOS and HIRMER (1973), Pl. 184

G. KOPCKE, *AM*, 91 (1976), pp. 6 ff., Pl. 2, 2 (instead of 259 Shaft Grave IV read: 624 Shaft Grave V)

125 **Electrum mask** from Grave Gamma of Grave Circle B at Mycenae. National Museum, Athens, 8709. H. 21.5 cm

MYLONAS, *Kyklos B* 76, No. 362, Pl. 60, 1

MARINATOS and HIRMER (1973), Pl. 189

G. KOPCKE, *AM*, 91 (1976), pp. 4 ff., Pl. 1, 1

Metal vessels, general

E. SIMON, *EAA*, vol. VII (1966), pp. 924 ff., *s.v.* Toreutica BUCHHOLZ and KARAGEORGHIS, pp. 84 ff.

DAVIS (1977)

HOOD (1978), pp. 153 ff.

Lion's-head rhyton from Shaft Grave IV, Mycenae. National 126 Museum, Athens. H. 20 cm

KARO, *Schachtgräber*, No. 273, Pls. pp. 117 f.

MARINATOS and HIRMER (1973), Pls. 198, LIII

DAVIS (1977), pp. 179 ff., No. 62, Figs. 146, 147

HOOD (1978), p. 162 f., Fig. 156

Bull's-head rhyton from Shaft Grave IV, Mycenae. National 127 Museum, Athens. H. with horns *c.* 30 cm

KARO, *Schachtgräber*, No. 384, Pls. 119 ff.

MARINATOS and HIRMER (1973), Pl. 197

DAVIS (1977), pp. 187 ff., No. 64, Figs. 151, 152

HOOD (1978), p. 163, Fig. 157

Funnel-shaped rhyton from Shaft Grave IV, Mycenae. National 130-1 Museum, Athens. Preserved h. 22.9 cm, D. of mouth 11.1-11.3 cm

KARO, *Schachtgräber*, Nos 477, 481, 504, Pl. 122

W. ST. SMITH, *Interconnections in the Ancient Near East*, New Haven and London (1965), pp. 63 ff., 84 ff.

MARINATOS and HIRMER (1973), Pl. 196

A. SAKELLARIOU, *Rev. Arch.*, (1975), p. 196, Fig. 1

DAVIS (1977), pp. 227 ff., No. 87, Figs. 179, 180

HOOD (1978), pp. 160 ff., Figs. 154 f.

Electrum cup from Shaft Grave IV, Mycenae. National Museum, 129 Athens. H. 15.5 cm, D. 17 cm

KARO, *Schachtgräber*, No. 390, Pls. 112 f.

MARINATOS and HIRMER (1973), Pl. 208

A. SAKELLARIOU, *Antike Kunst*, 17 (1974), pp. 10 f.

DAVIS (1977), pp. 208 ff., No. 83, Figs. 165, 166

HOOD (1978), pp. 157 f., Fig. 150

Silver jug from Shaft Grave V, Mycenae. National Museum, 132 Athens. H. 34.5 cm

KARO, *Schachtgräber*, No. 855, Pl. 134

MARINATOS and HIRMER (1973), Pl. 217

DAVIS (1977), pp. 149 ff., No. 43, Fig. 120. Ibid. 152, Fig. 121 for the bronze piece from Knossos, Museum, Iraklion, 843, which is compared; see also HOOD (1978), p. 170, Fig. 168

Gold kantharos from Kalamata. National Museum, Athens, 7381. 133 H. 9.7 cm, D. 12.2 cm

DAVIS (1977), pp. 305 ff., No. 134, Figs. 248, 249. There the handle ornaments in the form of spirals are clearly visible. For the parallels not illustrated here: two silver kantharoi from the Tôd Treasure (Upper Egypt). Cairo Museum, 70590, 70591

DAVIS (1977), pp. 175., Figs. 53, 52

Gold kantharos from Shaft Grave IV, Mycenae. National Museum, Athens

289

KARO, *Schachtgräber*, No. 440, Pl. 108. MARINATOS and HIRMER (1973), Pl. 214 below

DAVIS (1977), pp. 175 f., No. 60, Fig. 143

128 **Gold cup** from Peristeria. Museum, Pylos. H. 13.5 cm, D. 19.5 cm

SP. MARINATOS, *Praktika*, (1965), p. 117, Pls. 135a, b, 138a, b

DAVIS (1977), pp. 251 ff., No. 99, Fig. 196

The similar example from Shaft Grave V, Mycenae: KARO, *Schachtgräber*, No. 629, Pl. 125. MARINATOS and HIRMER (1973), Pl. 216 above

134-40 **Pair of gold cups** from Vapheio. National Museum, Athens, 1758 (dramatic scene); 1759 (idyllic scene). H. 7.9 cm, D. 10.7 cm

CH. TSOUNTAS, *Ephemeris* (1889), Pl. 9

MARINATOS and HIRMER (1973), Pls. 200 ff.

BUCHHOLZ and KARAGEORGHIS, Nos 1104, 1105

W. SCHIERING, *Antike Welt*, 2 (1971), pp. 3 ff.

DAVIS (1977), pp. 1 ff., 256 ff., Nos 103, 104, Figs. 1 ff.

HOOD (1978), pp. 166 f., Figs. 160 ff.

141 **Three bronze vessels** from Chamber Tomb 2, Dendra. National Museum, Athens

Jug: H. 31 cm, D. 20.5 cm

A.W. PERSSON, *The Royal Tombs at Dendra near Midea*, Lund (1931), 92, No. 2, Pl. 31, 3.

Companion-piece from the Panoply tomb: N.M. VERDELIS, *AM*, 82 (1967), pp. 48 ff., No. 9, Fig. 13 f., Pls. 24, 26

BUCHHOLZ and KARAGEORGHIS, No. 115a (with further parallels)

P. ASTRÖM, 'The Cuirass Tomb and Other Finds at Dendra', in *Stud. Med. Arch.*, 4 (1977), pp. 52 ff., No. 9, Pls. 25, 27, 1

Bowl: H. 14.3 cm, D. 21 cm

A.W. PERSSON, *The Royal Tombs at Dendra near Midea*, (1931), p. 94, No. 6, Pl. 31, 4; the spirals on the rim ibid. 95, Fig. 68

Parallel for the knob handle: BUCHHOLZ and KARAGEORGHIS, No. 1109 ff. Lamp: L. 10.6 cm

A.W. PERSSON, *The Royal Tombs at Dendra near Midea*, Lund (1931), p. 95, No. 13, Pl. 32,4 middle

A.W. PERSSON, *New Tombs at Dendra near Midea*, (1942), pp. 102 ff.

Parallels for the shape in stone and clay: BUCHHOLZ and KARAGEORGHIS, No. 1126

FURUMARK, *Pottery*, p. 641, form 96, No. 321

142 **Gift-bearers with Minoan–Mycenaean metal vessels** on tomb paintings from Egyptian Thebes (15th century BC), general:

J. VERCOUTTER, *L'Egypte et le monde Egéen préhellénique*, Paris (1956)

W.ST. SMITH, *Interconnections in the Ancient Near East*, New Haven and London (1965), Fig. 90

The following characteristic vase forms and decoration on these frescoes should be noted: 'Vapheio jug': VERCOUTTER, Pls. 35, 231-3; SMITH, Fig. 90

Bull's-head rhyta: VERCOUTTER, Pls. 40, 41, 42; Smith, Fig. 92

Lion's-head rhyta: VERCOUTTER, Pls. 37, 38

Funnel-shaped rhyta: VERCOUTTER, Pls. 42, 43

Decoration with inlaid boukrania: VERCOUTTER, Pls. 35, 231, 234

Silver cup with inlaid boukrania from Enkomi. Cyprus Museum, 144 Nicosia, 4.207. H. 6 cm, D. 15.7 cm

C. F.-A. SCHAEFFER, *Enkomi-Alasia*, vol. I, Paris (1952), pp. 380 ff., Pl. 116, Col. Pls. C, D

V. KARAGEORGHIS, *Treasures in the Cyprus Museum*, Nicosia (1962), Pl. 40, 3

BUCHHOLZ and KARAGEORGHIS, No. 1684

DAVIS (1977), pp. 314 ff., No. 140, Fig. 255

Parallel from Midea: National Museum, Athens, 7336. H. 5.5 cm, D. 15.7 cm

DAVIS (1977), pp. 284 ff., No. 120, Fig. 231

Silver cup with inlaid bearded heads from Chamber Tomb 24, 143 Mycenae. National Museum, Athens, 2489. H. 6 cm, D. 16.2 cm

CH. TSOUNTAS, *Ephemeris* (1888), Pl. 7, 2

BUCHHOLZ and KARAGEORGHIS, No. 1108

MARINATOS and HIRMER (1973), Pl. 218 above

DAVIS (1977), pp. 297 ff., No. 130, Fig. 243. A new technical examination ought to be made of this piece to see if no niello was really used, as Davis suggests, p. 299 f.

Heads from a similar cup from the palace at Pylos: National Museum, Athens, 7842, 7843. MARINATOS and HIRMER (1973), Pl. 226 below. DAVIS (1977), pp. 308 ff., No. 136, Fig. 251. HOOD (1978), 168, Fig. 164. On these heads' beards and the similar fashion in the 7th century BC see SP. MARINATOS, *Archaeologica Homerica* B 23, Figs. 9a-c

Sceptre from Kourion, Cyprus Museum, Nicosia, J 99. H. 16.5 cm 145

V. KARAGEORGHIS, *Treasures in the Cyprus Museum*, Nicosia (1962), Pl. 40, 1

BUCHHOLZ and KARAGEORGHIS, No. 1788

HOOD (1978), p. 207, Fig. 208; ibid. on the enamel technique

On the technique of the Shield of Achilles: K. FITTSCHEN, *Archaeologia Homerica* N 6

On the Armour of Agamemnon: H.W. CATLING, *Archaeologia Homerica* E 79

Metals and metalwork in the 'Dark Ages', general

V.R. d'A. DESBOROUGH, *The Greek Dark Ages*, London (1972), pp. 294 ff.

On the development of the dress-pin, ibid., pp. 295 ff.; the fibulae pp. 300 ff.; the weapons pp. 306 ff.

Sub-Mycenaean fibula. Antikenmuseum, University, Heidelberg, 146 70/4. L. 9.8 cm

R. HAMPE, *Neuerwerbungen 1957-1970*, Mainz (1971), No. 119, Pl. 80

Bronze fibulae of this type found in the graves of men and women; see C.G. STYRENIUS, *Submycenaean Studies*, Lund (1967), 47

147-8 Two Early Geometric dress-pins. Antikenmuseum, University, Heidelberg, 58/3 and 58/4. L. 22.1 cm, 24.4 cm

R. HAMPE, *Neuerwerbungen 1957-1970*, Mainz (1971), No. 120, Pl. 80. Ibid., reference to P. JACOBSTHAL, *Greek Pins*, Oxford (1956), pp. 3 ff. and N.M. VERDELIS, *AM* 78 (1963), pp. 32 ff., 62, Fig. 12, Suppl. Pls. 12, 1-4, 13, 4-7. The nearest parallel comes from the Argolid

150 Boeotian bronze fibula catch-plate. Antikenmuseum, University, Heidelberg, 62/10. D. of centre 6.9 cm

R. HAMPE, *Neuerwerbungen 1957-70*, Mainz (1971), No. 126, Pls. 93 (entire fibula), 97 (plate)

4, 149 Fibula in Philadelphia

W.N. BATES, *AJA*, 15 (1911), pp. 1 f.

HAMPE, *Sagenbilder* (1936), p. 14, Pl. 8

Tripod plate from Pylos

M. VENTRIS and J. CHADWICK, *Documents in Mycenaean Greek*, 2nd ed., Cambridge (1973), p. 336, No. 236, Pl. IIIb and additional commentary 498 f.

Geometric tripods, general

A. FURTWÄNGLER, *Olympia*, vol. IV, Berlin (1890), pp. 71 ff. The reconstructions illustrated there (Pl. 34) and repeated in more recent literature must now be replaced by the graphic and material reconstruction of M. MAASS (see below)

S. BENTON, *BSA*, 35 (1934/5), pp. 74 ff.

B. SCHWEITZER, *Die geometrische Kunst Griechenlands*, Tübingen (1969), pp. 178 ff.

HERRMANN, *Olympia* (1972), pp. 76 ff.

M. MAASS, 'Die geometrischen Dreifüsse von Olympia', in *Olympische Forschungen*, vol. X, Berlin (1978). Ibid. 5 f. a collection of the literature on Mycenaean and Proto-Geometric tripods

151 Completely preserved bronze tripod. Olympia, B 1240. H. 65 cm

HERRMANN, *Olympia* (1972), Pl. 14

M. MAASS, 'Die geometrischen Dreifüsse von Olympia', in *Olympische Forschungen*, vol. X, Berlin (1978), p. 7, Pl. 1

154-5 'Ridged leg tripod', reconstruction and original fragment. Olympia, B 1255

M. MAASS, 'Die geometrischen Dreifüsse von Olympia', in *Olympische Forschungen*, vol. X, Berlin (1978), pp. 49 ff., No. 176 a-h, Fig. 2. 'The greatest cast tripod known'. The height was, according to Maass, over 2 m. 'The overall weight is certainly no less than 100 kg' (Maass 52). The association of the open-work handles to this type of tripod, ibid. pp. 51 f.

3, 156 Hammered tripod. Olympia (reconstruction), and original fragment Olympia, Br. 6247. H. with handles 154.5 cm

M. MAASS, 'Die geometrischen Dreifüsse von Olympia', in *Olympische Forschungen*, vol. X, Berlin (1978), p. 179, Pl. 48, No. 201

The tripod was made in 1972-3 from copper plate in Athens and Olympia, under the direction of M. Maass, to whom we are grateful for the photograph illustrated here.

Tripods with wheels on Ithaca: S. BENTON, *BSA*, 35 (1934-5), pp. 56 ff., Pl. 15

Wheels on Cypriot stands: BUCHHOLZ and KARAGEORGHIS, Nos 1685, 1686

'Ridged leg tripod' fragment with competitors and lions. 157-8 Olympia, B 1730. H. 46.7 cm

M. MAASS, 'Die geometrischen Dreifüsse von Olympia', in *Olympische Forschungen*, vol. X, Berlin (1978), p. 174, No. 179, with bibliography. Good reproductions of all the fragments: HERRMANN, *Olympia* (1972), Pl. 16c; ZERVOS (1969), Fig. 221

Representation of a griffin cauldron on a chased tripod leg. 159 Olympia. H. of the whole sheet 78 cm

R. HAMPE and U. JANTZEN, *1. Olympia-Bericht* (1937), 71, 85, Pl. 17 right

F. WILLEMSEN, 'Dreifusskessel von Olympia', in *Olympische Forschungen*, vol. III, Berlin (1957), p. 157 f., Pl. 92 right. The griffin cauldron is in the upper panel; then follows (not illustrated here) a crab, a bird and a snake each in its own panel

Six bronze griffin protomes from the same cauldron. Private 164-5 collection, formerly in the Count Franz zu Erbach Collection. H. of heads 19.5-20 cm

U. JANTZEN, *AA*, (1966), pp. 123 ff., Figs. 1-12

H. A. CAHN, *Art of the Ancients*, André Emmerich Gallery, New York (1968), No. 2

H.-V. HERRMANN, *Die Kessel der orientalisierenden Zeit*, Pt. 2; 'Kesselprotomen und Stabdreifüsse', in *Olympische Forschungen*, vol. XI, Berlin (1979), p. 105, n. 20. Ibid. for parallels from Samos

On Samian griffins and miscasts: U. JANTZEN, *Griechische Greifenkessel*, 405-6 Berlin (1955), and the supplement in *AM*, 73 (1958), pp. 26 ff. as well as the publication of the Erbach griffins quoted above

Greek cauldron attachment in the form of winged creatures, from 161-2 the Acropolis. National Museum, Athens, 6519

H.-V. HERRMANN, *Die Kessel der orientalisierenden Zeit*, Pt. 1, 'Kesselattaschen und Reliefuntersätze', in *Olympische Forschungen*, vol. VI, Berlin (1966), p. 101, Pl. 38

Greek cauldron attachment as above. Museum, Delphi, 1666 163

H.-V. HERRMANN, *Die Kessel der orientalisierenden Zeit*, Pt. 1, 'Kesselattaschen und Reliefuntersätze', in *Olympische Forschungen*, vol. VI, Berlin (1966), p. 100, Pl. 35

On cauldron attachments see also U. JANTZEN, *Griechische Greifenkessel*, Berlin (1955), and the supplement 'Assurattaschen' from Samos, *Antike Kunst*, 10 (1967), pp. 91 ff.

On the Oriental prototypes: E. AKURGAL, *Die Kunst Anatoliens*, Berlin (1961), pp. 35 ff. Idem, *Orient und Okzident*, Baden-Baden (1966), pp. 192 f. (*The Birth of Greek Art: the Mediterranean and the Near East.* Transl. Wayne Dynes, London 1969)

Oriental incense-burner stands used as cauldron stands in Greece: H. KYRIELEIS, *Marburger Winckelmannprogramm 1966*, Marburg (1967), pp. 20 ff.

Griffin cauldron on a rod tripod from Salamis. Cyprus Museum, 166 Nicosia. H. with iron tripod stand 1.25 m

V. KARAGEORGHIS, *Salamis in Cyprus*, Norwich (1969), pp. 89 f., Pl. 1, Fig. 40

H.-V. HERRMANN, *Die Kessel der orientalisierenden Zeit*, Pt. 2, 'Kesselprotomen und Stabdreifüsse', in *Olympische Forschungen*, vol. XI,

Berlin (1979), pp. 137, 146: 'If comparisons are to be drawn at all, their style most strongly resembles late griffin protomes from Italy... This is a special form which combines skilfully elements of the protome cauldron with attachments.'

Cretan Bronze reliefs, general

E. KUNZE, *Kretische Bronzereliefs*, Stuttgart (1931)

J. BOARDMAN, *The Cretan Collection in Oxford: the Dictaean Cave and Iron Age Crete*, Oxford (1961), pp. 48 f.

F. CANCIANI, *Bronzi orientali e orientalizzanti a Creta nell' VIII e VII sec. a. C.,* Rome (1970)

J. BOARDMAN, Exhibition catalogue *Dädalische Kunst auf Kreta im 7. Jh. v. Chr.*, Hamburg (1970), pp. 14 ff.

H. HOFFMANN, *Early Cretan Armorers*, Mainz (1972)

167-8 Bronze tondo from the Idaean cave. Museum, Iraklion. D. 56 cm

E. KUNZE, *Kretische Bronzereliefs*, No. 2, Pl. 3 (without the central protome, which is restored from the tondo Kunze, No. 10, Pl. 26)

F. CANCIANI, *Bronzi orientali...*, Rome (1970), p. 20, No. 2, with bibliography

R. HAMPE, 'Kretische Löwenschale des siebten Jahrhunderts v. Chr.', in *Sitzungsberichte der Heidelberger Akademie der Wissenschaften*, Heidelberg (1969), p. 22, Pl. 17, 1

Bronze sheet from Kato Syme. Museum, Iraklion

A. LEBESSI, *Praktika* (1975), pp. 322 ff.; idem, 'A. Sanctuary of Hermes and Aphrodite in Crete', in *Expedition*, 18, No. 3, Spring 1976, pp. 1 ff., Figs, 1, 2, 6, 7

169 Bronze sheet of the same type. Paris, Louvre, Br. 93. H. 18 cm

A. de RIDDER, *Bronzes antiques du Louvre*, vol. I, Paris (1913), p. 20, Pl. 11

Exhibition catalogue *Dädalische Kunst auf Kreta im 7. Jh. v. Chr.*, Hamburg (1970), 41 f., B2, Pl. 12

H. HOFFMANN, *Early Cretan Armorers*, Mainz (1972), Pl. 49,2

W. SCHIERING, *Funde aus Kreta*, Göttingen (1976), pp. 214 ff., Fig. 80

On the Cretan custom of stealing boys the most important ancient source is Strabo 10, 4, 21 after Ephoros; cf. F. JACOBY, *Die Fragmente der griechischen Historiker*, Pt. 2 A, No. 70, fr. 149, pp. 88 f.; cf. below under Figs. 189-92

115, 171 Bronze relief with Kaineus. Olympia. W. 33 cm, H. 22.5 cm

R. HAMPE and U. JANTZEN, *1. Olympia-Bericht*, (1937), pp. 85 ff., Pl. 28 Schefold, *Sagenbilder* (1964), p. 38, Pl. 27c

170 Bronze sheet, griffin with young. Olympia. H. and W. 79.5 cm each

R. HAMPE and U. JANTZEN, *1. Olympia-Bericht*, (1937), pp. 90 ff., Pls. 34, 35

HERRMANN, *Olympia* (1972), Pl. 25

Arms

Mycenaean swords and daggers, general

KARO, *Schachtgräber*, pp. 194 ff.

A. M. SNODGRASS, *Arms and Armour of the Greeks*, London (1967), pp. 14-34

Sword from Skopelos. National Museum, Athens. L. of handle **172** and pommel 24 cm, D. of pommel 13.8 cm

G. BAKALAKIS, *6. Internat. Kongress für Archäologie*, Berlin 1939 (1940), pp. 309 ff., Pl. 17

BUCHHOLZ and KARAGEORGHIS, No. 689

MARINATOS and HIRMER (1973), Pls. 192-3

HOOD (1978), pp. 182 f., Figs. 181 f.

Dagger-blade with spirals from Shaft Grave V, Mycenae. Natio- **173** nal Museum, Athens. L. 24.3 cm

KARO, *Schachtgräber*, No. 744, Pl. 91 f.

BUCHHOLZ and KARAGEORGHIS, No. 685

MARINATOS and HIRMER (1973), Pl. 194 middle

Dagger-blade with leopards chasing ducks from Shaft Grave V, **174** Mycenae. National Museum, Athens. L. 16 cm

KARO, *Schachtgräber*, No. 765, Pl. 93 f.

BUCHHOLZ and KARAGEORGHIS, No. 681

MARINATOS and HIRMER (1973), Pls. XLIX, LI, both above

HOOD (1978), pp. 180 f., Pl. 179

Leopard as the Pharaoh's companion: O. KELLER, *Thiere des classischen Alterthums in culturgeschichtlicher Beziehung*, Innsbruck (1887), pp. 154 f.

E. SIMON, *Antike Kunst*, 15 (1972), pp. 21 f.

Dagger-blade with lion hunt from Shaft Grave IV, Mycenae. **175-6** National Museum, Athens. L. 23.8 cm

KARO, *Schachtgräber*, No. 394, Pls. 93 f.

BUCHHOLZ and KARAGEORGHIS, No. 682

MARINATOS and HIRMER (1973), Pls. XLIX middle, L

HOOD (1978), pp. 179 f., Fig. 178

Dagger with leopards from a tholos tomb near Pylos. National **177** Museum, Athens. L. 32 cm

MARINATOS and HIRMER (1973), Pl. III middle, 195 middle and below

BUCHHOLZ and KARAGEORGHIS, No. 684

HOOD (1978), pp. 180 f., Fig. 180

Dagger-blade from Thera. National Museum, Copenhagen **178**

G. PERROT and CH. CHIPIEZ, *Histoire de l'art*, vol. VI, Paris (1894), p. 974, Fig. 550

KARO, *Schachtgräber*, p. 314

Mycenaean and Sub-Mycenaean armour, general

KARO, *Schachtgräber*, pp. 210 ff.

V. R. d'A. DESBOROUGH, *The Last Mycenaeans and their Successors. An Archaeological Survey c. 1200–c. 1000 BC*, Oxford (1964, reprinted 1966), pp. 61 ff.

P.C. GUIDA, 'Le armi difensive dei Micenei nelle figurazioni', in *Incunabula Graeca*, 56 (1973)

Summary of literature: E. SLENCZKA, *Archaeologia Homerica* E 223-E227. On armour in the Homeric poems: R. Hampe, in Reclams Universalbibliothek 249, transl. of Homer, *Iliad*, Stuttgart (1979), pp. 534 ff.

179 **Armour** from Grave 12 (the Cuirass Tomb) from Dendra. Museum, Nauplion

N.M. VERDELIS, *AM*, 82 (1967), pp. 8 ff., Suppl. Pls. 2, 2, 4-17, 21

BUCHHOLZ and KARAGEORGHIS, No. 712

BORCHHARDT, *Helme*, pp. 30 f.

P. ASTRÖM, 'The Cuirass Tomb and Other Finds at Dendra', in *Stud. Med. Arch.*, 4 (1977)

H.W. CATLING, *Archaeologia Homerica* E 96 f., Pl. E7

Boar's-tusk helmet

BORCHHARDT, *Helme*, pp. 18 ff., 30 f., 47 ff. Idem, *Archaeologia Homerica* E 57 f.

181 **Greaves from Kallithea.** Museum, Patras. L. 25.5 cm

N. YALOURIS, *AM*, 75 (1960), pp. 43 ff., Pl. 28

N.M. VERDELIS, *AM*, 82 (1967), pp. 37 ff.

H.W. CATLING, *Archaeologia Homerica* E 153 f.

On fastening: G. v. MERHART, *Geschnürte Schienen*, pp. 37, 38. *Bericht der Römisch-Germanischen Kommission* (1956-7), pp. 91 ff. — CATLING, *Archaeologia Homerica* E 154, disputes the idea that the ornament was imitated from the fastening of the greaves

Typological analogies in Central Europe: H. MÜLLER-KARPE, *Germania*, 40 (1962), pp. 255 ff.

Greaves from Enkomi. Cyprus Museum, Nicosia

H.W. CATLING, 'A Bronze Greave from a 13th-Century BC Tomb at Enkomi', in *Op. Ath.* 2 (1955), pp. 21 ff. Idem, *Archaeologia Homerica* E 154 f.

Greaves, Olympia B 6950: K. KILIAN, *Germania*, 51 (1973), pp. 528 ff., Pl. 42

Archaeologia Homerica Pl. E 15d. Although no greaves have been found which date between this greave of the 7th century and the Mycenaean greaves referred to above, one may presume an 'uninterrupted tradition' because of their similarities. (CATLING, *Archaeologia Homerica* E 161)

Mycenaean shields, general

H. BORCHHARDT, *Archaeologia Homerica* E 1-E 56; the half-cylindrical shield E 25-E 27, the figure-of-eight shield E 6-E 24. They are all known only from representations, such as on the dagger-blade Pl. 175. The author rebuts Matz (E 10, note 67) on this piece, who regarded it as Minoan. Her observations in the Ledermuseum, Offenbach, E 8-E 9. Geometric and 'Boeotian' shields: E 17-E 24. Boeotian shield in the hoplitodromos at Plataea: J. JÜTHNER, *Die athletischen Leibesübungen der Griechen*, vol. II, Vienna (1968), p. 122

The figure-of-eight shields in the Regia of Forum Romanum: U.W. SCHOLZ, *Studien zum altitalischen und altrömischen Marskult und Marsmythos*, Heidelberg (1970), pp. 28 ff.

180 **Helmet from near Knossos.** Museum, Iraklion. H. 38.6 cm

BUCHHOLZ and KARAGEORGHIS, No. 710

MARINATOS and HIRMER (1973), Pl. 117 below

BORCHHARDT, *Helme*, pp. 55 f. Idem, *Archaeologia Homerica* E 65 f., Pl. E 3d

182 **Sub-Mycenaean metal fitting on helmet from Tiryns.** Museum, Nauplion. H. 34 cm

V.R. d'A. DESBOROUGH, *The Greek Dark Ages*, London (1972), p. 73, Pl. 11

BORCHHARDT, *Helme*, pp. 43 f., Pls. 8, 4 and 5. Idem, *Archaeologia Homerica* E 68, Pl. E 4a

Geometric armour. Museum, Argos 183

P. COURBIN, *BCH*, 81 (1957), pp. 340 ff.

H.W. CATLING, *Archaeologia Homerica* E 116 ff., E 130, Pl. E 8

Helmet from the same grave. Museum, Argos 183

P. COURBIN, *BCH*, 81 (1957), pp. 356 ff., Pls. 1 ff.

BORCHHARDT, *Helme*, pp. 63 ff., Pls. 33, 1-3. Idem, *Archaeologia Homerica* E 69 f., Pl. E 4b

Earliest Corinthian helmet. Museum, Olympia 185-6

R. HAMPE and U. JANTZEN, *1. Olympia-Bericht*, (1937), p. 52, Pl. 7

E. KUNZE, *7. Olympia-Bericht*, (1961), pp. 56 ff.

J. BORCHHARDT, *Archaeologia Homerica* E 72

Illyrian helmet. Museum, Olympia 187-8

R. HAMPE and U. JANTZEN, *1. Olympia-Bericht*, (1937), p. 52, Pl. 10

Derivation of this type from the early Greek conical helmet: E. KUNZE, *6. Olympia-Bericht*, (1958), pp. 125 ff. On this see BORCHHARDT, *Helme*, pp. 66 f. Idem, *Archaeologia Homerica* E 72

On the Greek origin cf. also B. SHEFTON and P. FOSTER, *Greek Arms and Armour*, The Greek Museum, University of Newcastle-upon-Tyne (1978), 6 f. relating to No. 566

Cretan helmets. Norbert Schimmel Collection, New York

H. HOFFMANN, *Early Cretan Armorers*, Mainz (1972), pp. 1 ff.

Helmet with winged demons of which only the engraving of 190-1
one side is shown:

H. HOFFMANN, *Early Cretan Armorers*, Mainz (1972), pp. 2 ff., 34 ff., Pls. 1-6, 3. H. 21 cm

Helmet with horse on either side and inscription 'Synenitos': 189

H. HOFFMANN, *Early Cretan Armorers*, Mainz (1972), p. 4, Pls. 8-10.

H. 24.5 cm. On the inscriptions on these weapons from Arkades: A.E. RAUBITSCHEK in H. HOFFMANN, *Early Cretan Armorers*, Mainz (1972), p. 15 f. G. NEUMANN, *Zeitschrift für vergleichende Sprachforschung*, 88 (1974), pp. 32 ff.

For the interpretation of the weapons from Arkades as 'prizes' for the Pyrrhic dance: E. SIMON, *Studi Etruschi*, 46 (1978), p. 143, n. 32. The most important source is again Ephoros in Strabo 10.4,20: F. JACOBY, *Die Fragmente der griechischen Historiker*, Pt. 2 A, No. 70, fr. 149, p. 88

Ephoros describes mock fights which Cretan youths performed to the music of flutes and lyre, during which wounds were received in contrast to Xenophon's account, Anabasis VI, 1

Cretan 'mitrai' 192

H. HOFFMANN, *Early Cretan Armorers*, Mainz (1972), pp. 9 ff., Pls. 30 ff.

The Mitra shown here belongs because of its decoration, style and inscription to the helmet Fig. 189. Norbert Schimmel Collection, New York. H. HOFFMANN, *Early Cretan Armorers*, Mainz (1972), p. 10, Pls. 31, 32. D. 24.2 cm

H. BRANDENBURG, *Archaeologia Homerica* E 135 ff., Pl. E 11a

193-4 Bronze strip from Arcadia. National Museum, Athens, 16514. L. 42 cm, H. 8.5 cm

S. KAROUZOU, *Deltion*, 16 (1960), pp. 63 ff., Pls. 28 A-33

J. BOARDMAN, in *Studies in honour of C.F.C. Hawkes*, London (1971), pp. 124 ff., Fig. 21, Pl. 11 (no belt)

H. BRANDENBURG, *Archaeologia Homerica* E 131, n. 920

195-6 Back-piece of corselet from the Alpheios near Olympia. Museum, Olympia.

A. FURTWÄNGLER, *Olympia*, vol. IV, Berlin (1890), pp. 154 ff. Pl. 59 (drawing, which is repeated here)

Kunstwerke der Antike, Auktion 40, Münzen und Medaillen AG, Basle (1969), No. 140, Pls. 55 f. and colour frontispiece

H. HOFFMANN, *Early Cretan Armorers*, Mainz (1972), 50, Pl. 25a-c (the best illustration until now)

Stone vessels

Mycenaean stone vases, general

J.A. SAKELLARAKIS, 'Mycenaean Stone Vases', in *Studi micenei ed egeoanatolici*, 17, Rome (1976), pp. 173-87

Early Neolithic forerunners in Cyprus: BUCHHOLZ and KARAGEORGHIS, Nos 1657-61

Early Cycladic marble vases: BUCHHOLZ and KARAGEORGHIS, Nos 1132-9

Minoan stone vases: P. WARREN, *Minoan Stone Vases*, Cambridge (1969)

197 Rock-crystal duck from Grave Circle B at Mycenae. National Museum, Athens, 8638. L. 13.2 cm

Mylonas, *Kyklos B* 203, Pls. 183-5

BUCHHOLZ and KARAGEORGHIS, No. 1156

MARINATOS and HIRMER (1973), Pl. 235 below

J.A. SAKELLARAKIS, 'Mycenaean Stone Vases', in *Studi micenei ed egeoanatolici*, 17, Rome (1976), pp. 176 f., Pl. 1, 1

The vase comes from Grave Omikron, a female interment, which is contemporary with the older shaft graves from Grave Circle A

On vases in the shape of ducks or boats with ducks' heads: J.A. SAKELLARAKIS, *Ephemeris*, (1971), pp. 188 ff.

198 Two globular stone vases from Mycenae. National Museum, Athens, 2371, 7389

J.A. SAKELLARAKIS, 'Mycenaean Stone Vases', in *Studi micenei ed egeoanatolici*, 17, Rome (1976), pp. 178, 180, Pls. 3, 6 and 7, 19. The neck of neither vase is preserved; because of their small size, probably perfume vessels

198 Alabaster libation jug from Chamber Tomb 102, Mycenae. National Museum, Athens, 4920

J.A. SAKELLARAKIS, 'Mycenaean Stone Vases', in *Studi micenei ed egeoanatolici*, 17, Rome (1976), p. 185, Pls. 12, 34

199-200 Alabaster vase with three handles from Shaft Grave IV, Mycenae. National Museum, Athens. H. 24.3 cm

KARO, *Schachtgräber*, No. 389, Pl. 138 f.

MARINATOS and HIRMER (1973), Pl. 237

J.A. SAKELLARAKIS, 'Mycenaean Stone Vases', in *Studi micenei ed egeoanatolici*, 17, Rome (1976), 177, Pl. 1, 2

Alabaster lamp with a low foot from the Lion Tomb at Mycenae. 201 National Museum, Athens, 2921

J.A. SAKELLARAKIS, 'Mycenaean Stone Vases', in *Studi micenei ed egeoanatolici*, 17, Rome (1976), p. 187, Pls. 14, 38 with further examples. The protuberances on the rim acted as handles

Marble lamps of the 7th century BC, general

J.D. BEAZLEY, *JHS*, 60 (1940), 22-49, Pls. 5-7

J. BOARDMAN, *The Cretan Collection*, Oxford (1961), pp. 123 ff.

Cycladic marble lamp from Selinus. 202-3 Museum, Palermo, 270. W. of front 21.7 cm, H. 7.2 cm

J.D. BEAZLEY, *JHS*, 60 (1940), pp. 24 ff., Fig. 2 f., Pls. 6, 1-3

E. LANGLOTZ and M. HIRMER, *Die Kunst der Westgriechen*, Munich (1963), Pl. 2

Pottery

Mycenaean pottery, general

A. FURTWÄNGLER and G. LOESCHCKE, *Mykenische Tongefässe*, Berlin (1879)

FURUMARK, *Pottery*

A. FURUMARK, *The Chronology of Mycenaean Pottery*, Stockholm (1941)

E. SLENCZKA, 'Figürlich bemalte mykenische Keramik aus Tiryns', in *Tiryns*, vol. VII, Mainz (1974)

HOOD (1978), pp. 40 ff.

A short general survey is L.W. TAYLOUR, *The Mycenaeans*, Ancient Peoples and Places 39, London (1964), pp. 45 ff.

Definition of the Mycenaean style as 'a successful fusion of mainland and Minoan styles': E.T. VERMEULE, *The Art of the Shaft Graves of Mycenae*, Cincinnati (1975), p. 12

Minyan pottery, general 204

H. SCHLIEMANN, *Orchomenos*, Leipzig (1881)

C.W. BLEGEN and A.J.B. WACE, 'Middle Helladic Tombs', in *Symbolae Osloenses*, 9 (1930), pp. 28 ff. (based on the excavations at Korakou and Zygouries, which Blegen published in 1921 and 1928)

H. GOLDMAN, *Excavations at Eutresis in Boeotia*, Cambridge (1931)

F. BIANCOFIORE, *EAA*, V (1963), pp. 40 ff. *s.v.* Minii, Vasi

BUCHHOLZ and KARAGEORGHIS, Nos 876-84

Mylonas, *Kyklos B*, 270 ff., Pls. 214 ff. and summary 408

Kamares ware, general

A.A. ZOIS, *Der Kamares-Stil: Wesen und Werden*, Tübingen (1968)

BUCHHOLZ and KARAGEORGHIS, Nos 887-97

G. WALBERG, *Kamares. A Study of the Character of Palatial Middle Minoan Pottery*, Uppsala (1976)

On the development of the potter's wheel and the survival of slower wheels

A. RIETH, *5000 Jahre Töpferscheibe*, Constance (1960)

R. HAMPE and A. WINTER, *Bei den Töpfern und Töpferinnen in Kreta, Messenien und Zypern*, Mainz (1962; reprinted 1976)

Gloss slip, general

A. WINTER, in E. SIMON, *Führer durch die Antikenabteilung des Martin-von-Wagner-Museums der Universität Würzburg*, Mainz (1975), pp. 282 ff.

A. WINTER, *Die antike Glanztonkeramik*, Mainz (1978)

205 **Jug from Shaft Grave VI**, Mycenae. National Museum, Athens. H. 36.5 cm

KARO, *Schachtgräber*, No. 945, Pl. 175

FURUMARK, *Pottery, passim*. Because the shaft-grave pottery is relatively well dated, it is especially important for Furumark's classification, which is particularly well exemplified in this piece:
Ivy leaves: Fig. 35, motif 12, No. 5
Semicircles: Fig. 58, motif 44, No. 1
Spirals: Fig. 59, motif 46, No. 32

206 **Jug from Shaft Grave I**, Mycenae. National Museum, Athens. H. 33 cm

KARO, *Schachtgräber*, No. 199, Pl. 169

MARINATOS and HIRMER (1973), Pl. 253

207 **Storage jar from Kakovatos**. National Museum, Athens. H. 78 cm

K. MÜLLER, *AM*, 34 (1909), pp. 304 f., Pl. 16

MARINATOS and HIRMER (1973), Pl. 251

DAVIS (1977), p. 12, Fig. 26

HOOD (1978), p. 38, Fig. 16

For the so called 'Marine style' cf. recently PH. P. BETANCOURT, 'Marine Life Pottery from the Aegean', in *Archaeology*, 30 (1977), pp. 38 ff. On the connection of the 'Marine style' to the 'Palace style': W.-D. NIEMEIER, Die Palaststil-Keramik von Knossos. Thesis, Mannheim (1975). The author kindly granted me access to his unpublished manuscript. Provisionally: *Temple University Aegaean Symposium*, 4, Philadelphia (1979), pp. 18 ff. (W.-D. NIEMEIER)

208 **'Depas' with helmets** from the harbour of Knossos. Museum, Iraklion, 10058. H. 97 cm

ST. ALEXIOU, *Antiquity*, 28 (1954), p. 211, Pl. 8

BUCHHOLZ and KARAGEORGHIS, No. 938

BORCHHARDT, *Helme*, pp. 49 f.

MARINATOS and HIRMER (1973), Pl. 94 (incorrect height; cf. ALEXIOU and BUCHHOLZ and KARAGEORGHIS)

209 **Libation jug** from the harbour of Knossos. Museum, Iraklion, 9540. H. 49.5 cm

ALEXIOU, *Kretika Chronika*, 6 (1952), pp. 25 ff., Col. Pl. A

BUCHHOLZ and KARAGEORGHIS, No. 919

MARINATOS and HIRMER (1973), Pl. 95

Striped jug. Museum, Nauplion 211

The jug is not a unique piece, but belongs to a large series. For parallels:
C.W. BLEGEN, *Prosymna*, vol. II, Cambridge (1973), Pl. 150, No. 1049 and Pl. 472, Nos 926, 927. SP. MARINATOS, *Praktika*, (1966), Pl. 95b. G.E. MYLONAS, *Mycenae and the Mycenaean Age*, Princeton (1966), Pl. 149a

Krater from Enkomi. Cyprus Museum, Nicosia. H. 37.5 cm 210

E. SJÖQVIST, *Swedish Cyprus Expedition*, vol. I, Stockholm (1934), Pls. 120, 3, 4

M.P. NILSSON, *Geschichte der griechischen Religion*, vol. I, 3rd ed., Munich (1967), pp. 366 ff., Pl. 25, 1

BUCHHOLZ and KARAGEORGHIS, No. 1621

P. DIKAIOS, *Enkomi*, vol. II, Mainz (1971), pp. 918 ff.

E. SLENCZKA, *Tiryns*, vol. VII, Mainz (1974), p. 122 No. 4, Pl. 42, 4

E. SIMON, *RE* Suppl., XV (1978), pp. 1418 f. *s.v.* Zeus, Archäologische Zeugnisse

On copper ingots cf. BUCHHOLZ and KARAGEORGHIS, Nos 739 ff.

On the octopus cf. the too far-reaching conclusions of J. WIESNER, *JDI*, 74 (1959), pp. 35 ff.

Recent excavations in Mycenaean Attica

SP.E. JACOVIDES, *Perati*, vols. I, II, Athens (1969-70)

G.E. MYLONAS Τὸ δυτικὸν νεκροταφεῖον τῆς Ἐλευσῖνος, Athens (1975)

To the same, too sceptically interpreted find belong the following four pieces:

Spouted amphora from Koropi (Attica). Römisch-Germanisches 212 Zentralmuseum, Mainz, 0.17970. H. 33.3 cm

A. BÜSING-KOLBE, *CVA Mainz, Zentralmuseum*, vol. I, Munich (1977), Pls. 1, 3, 4

High-stemmed cup with octopus. Römisch-Germanisches 214 Zentralmuseum, Mainz, 0.17972. H. 19.4 cm

CVA Mainz, Zentralmuseum, vol. I, Munich (1977), Pls. 2, 2

For chronology cf. FURUMARK, *Pottery*, 61, Fig. 17, No. 257 = III A 2 late. According to Furumark the shape is to be found in the Argolid, on the Cyclades, on Rhodes and in Attica. The octopus can be compared with FURUMARK, *Pottery*, p. 305, Fig. 49, Nos 16, 17

Low-stemmed cup ('skyphos'). Römisch-Germanisches Zentral- 213 museum, Mainz, 0.17973. H. 8.8 cm

CVA Mainz, Zentralmuseum, vol. I, Munich (1977), Pls. 2, 3

On the shape cf. FURUMARK, *Pottery*, 60, Fig. 16, No. 254

Chariot with charioteers. Römisch-Germanisches Zentralmu- 216 seum, Mainz, 0.17975. H. 11.4 cm

CVA Mainz, Zentralmuseum, vol. I, Munich (1977), Pls. 2, 6, 7

Comparable in theme is the chariot group from Prosymna, BUCHHOLZ and KARAGEORGHIS, No. 1248c, with another example. Preservation and quality of the piece in Mainz are remarkable. The same applies to the following terracotta.

215 **Chariot (charioteer** missing**).** Römisch-Germanisches Zentralmuseum, Mainz, 0.17974. H. 10.8 cm

CVA Mainz, Zentralmuseum, vol. I, Munich (1977), Pls. 2, 4, 5

For the pinned wheels, I know no parallel. The lekanis from Perati (Pl. 221) shows that such fittings can be presumed. For the type of the wheel, cf. representations of chariots on Mycenaean pottery; H.W. CATLING, *AJA,* 72 (1968), pp. 42 ff. On terracotta chariots cf. also E. FRENCH, *BSA,* 66 (1971), pp. 176 f.

217 Mycenaean idols, general

E. FRENCH, 'The Development of Mycenaean Terracotta Figurines', in *BSA,* 66 (1971), pp. 101-87 (summary pp. 174 ff.), Pls. 13-29

On their interpretation: SP.E. JACOVIDES, *Perati,* vol. II, Athens (1970), pp. 266 f., with reference to Mylonas

Our Pl. 217 unfortunately does not show any idols from the back; cf. Buchholz and Karageorghis, Nos 1258b-1262b. As French notes, the idols are from the beginning Mycenaean

Stirrup-jars in Linear B (ka-ra-re-we)

M. VENTRIS and J. CHADWICK, *Documents in Mycenaean Greek,* 2nd ed., Cambridge (1973), p. 328, with additional commentary by Householder

Late Mycenaean octopus stirrup-jars, general

FURUMARK, *Pottery,* pp. 565 ff.

V.R. d'A. DESBOROUGH, *The Last Mycenaeans and their Successors,* Oxford (1964, reprinted 1966), *passim,* frontispiece and Pl. 6; also pp. 149 ff. on the numerous and for the most part unpublished examples in the Naxos Museum

218 **Octopus stirrup-jar from Perati.** H. 21.5 cm (the height in BUCHHOLZ and KARAGEORGHIS, No. 1034, and Desborough, Pl. 6d, differs from JACOVIDES, which is given here)

SP.E. JACOVIDES, *Perati,* vol. I, Athens (1969), p. 251, No. 261, Pl. 73; II (1970), p. 184, Fig. 70; ibid, Pl. II (a colour plate). On the octopus, ibid. pp. 142 ff.; on rosettes pp. 125 f.; on fish pp. 140 ff. On the 'Close style': FURUMARK, *Pottery,* pp. 550 ff. V.R. d'A. DESBOROUGH, *The Last Mycenaeans and their Successors,* Oxford (1964, reprinted 1966), *passim*

219 **Octopus stirrup-jar from Pitane,** Museum, Istanbul, 2276. H. 20 cm

V.R. d'A. DESBOROUGH, *The Last Mycenaeans and their Successors,* Oxford (1964, reprinted 1966), pp. 161, 228

BUCHHOLZ and KARAGEORGHIS, No. 1032, with bibliography

Very similar is a jug from Kalymnos in the British Museum, London A 1015. P.P. KAHANE, *Antike Kunst,* 16 (1973), p. 122, Fig. 6

220 **Stirrup-jar from Rhodes.** British Museum, A 931, London.

E.J. FORSDYKE, *Prehistoric Aegaean Pottery, Catalogue of the Greek and Etruscan Vases in the British Museum,* vol. I, 1, London (1925), p. 169, Fig. 230, Pl. 13

221 **Lekanis with women mourning from Perati.** H. 16.2 cm, D. 23.7-23.9 cm, D. of the miniature cups (one restored) 7.1 cm

SP.E. JACOVIDES, 'A Mycenaean Mourning Custom', in *AJA,* 70 (1966), pp. 43 ff., Pl. 15. Idem, *Perati,* vol. I, Athens (1969), p. 172,

No. 63, pp. 68 ff.; *Perati,* vol. II, Athens (1970), pp. 267 f. The counterpart from Grave IIIa: *Perati,* vol. I, pp. 400 ff., Pl. 178. Also the remaining Late Mycenaean parallels are discussed there

For absolute chronology of Phase I at Perati, in which this vessel belongs (1190-1160 BC): *Perati,* vol. II, pp. 407 ff., 467 f.

Pyxis in Philadelphia 222

The Museum *Journal,* University of Pennsylvania, 23 (1932), pp. 55 ff., Figs. 1-3

FURUMARK, *Pottery,* p. 586, form 5, No. 12, 3

Late Mycenaean pyxides: SP.E. JACOVIDES, *Perati,* vol. II, Athens (1970), pp. 258 ff. On metopal decoration on vases from Perati: SP.E. JACOVIDES, *Perati,* vol. II, Athens (1970), pp. 135 f. Attic red-figured pyxides with bronze handle: S.R. ROBERTS, *The Attic Pyxis,* Chicago (1978), Pls. 90, 3; 91, 1, etc.

'Warrior Vase' from Mycenae. National Museum, Athens, 1426. 223-4 H. *c.* 40 cm

BUCHHOLZ and KARAGEORGHIS, No. 1025, with extensive bibliography

MARINATOS and HIRMER (1973), Pls. 256, 257

E. SLENCZKA, *Tiryns,* vol. VII, Mainz (1974), p. 144, No. I

BORCHHARDT, *Helme,* pp. 37 f. Idem, *Archaeologica Homerica* E 66 ff.

Pottery of the 'Dark Ages', general

C.-G. STYRENIUS, *Submycenaean Studies,* Lund (1967)

A.M. SNODGRASS, *The Dark Age of Greece,* Edinburgh (1971)

V.R. d'A. DESBOROUGH, *The Greek Dark Ages,* London (1972) pp. 29 ff.

On the problem of continuity:

K. NICOLAOU, 'On the Origins of Greek Geometric Pottery and Questions of Continuity', in *Symposium on the Dark Ages in Greece,* Hunter College, New York (1977), pp. 21 ff. Ibid., further important contributions on the 'Dark Ages', also by G. KOPCKE on the figured style before, during and after this time (pp. 32 ff.)

North-western Greek pottery from Tiryns

K. KILIAN, *Atti della XX riunione scientifica dell'Istituto Italiano di Preistoria in Basilicata 1976,* Florence (1978), pp. 311 ff.

Proto-Geometric pottery, general

K. KÜBLER and W. KRAIKER, *Kerameikos,* vol. I, Berlin (1939)

K. KÜBLER, *Kerameikos,* vol. IV, Berlin (1943)

N.M. VERDELIS, Ὁ πρωτογεωμετρικὸς ῥυθμὸς τῆς Θεσσαλίας, Athens (1958)

C.G. STYRENIUS, *Submycenaean Studies,* Lund (1967), pp. 87 ff.

COLDSTREAM (1968), pp. 8 ff.

V.R. d'A. DESBOROUGH, *The Greek Dark Ages,* London (1972), a book in which the earlier research of the author on this—his special concern—is collected

Small clay chest. Kerameikos Museum, Athens, 924. H. with lid 225 11.5 cm, L. 10.9 cm, W. 8.5 cm

K. KÜBLER, *Kerameikos,* vol. IV, Berlin (1943), p. 32, Pl. 3

226 **Attic Proto-Geometric vases: amphora and cup.** University, Mainz, 40, 41. H. 13.8 cm, 8.7 cm

R. HAMPE and E. SIMON, *CVA Mainz, University*, vol. I, Munich (1959), Pl. 1

Geometric pottery, general

P.P. KAHANE, 'Entwicklungsphasen der attisch-geometrischen Keramik', in *AJA*, 44 (1940), 464-82

C. COURBIN, *La céramique géométrique de l'Argolide*, Paris (1966)

COLDSTREAM (1968), Idem, *Geometric Greece*, London (1977)

ZERVOS (1969), pp. 88 ff.

B. SCHWEITZER, *Die geometrische Kunst Griechenlands*, Cologne (1969)

227 **Rhodian Geometric krater.** Grave 82 from Kamiros. Museum, Rhodes, 14734. H. 33.5 cm

B. SCHWEITZER, *Die geometrische Kunst Griechenlands*, Cologne (1969), pp. 89 f., 95, Pl. 87

On the plastic grooves on the foot: COLDSTREAM (1968), p. 282; on the Sub-Proto-Geometric concentric circles in Rhodian pottery, ibid., 285. Schweitzer's dating of the vase seems, therefore, too late

Theran Geometric amphora. National Museum, Athens, 824b. H. 51 cm

H. DRAGENDORFF, *Thera*, vol. II, Berlin (1903), p. 135, No. 3, Fig. 314

COLDSTREAM (1968), p. 187, n. 1

29-30 **Attic Middle Geometric miniature krater.** National Museum, Athens, 18020. H. 12.2 cm, D. 11 cm

S. KAROUSOU, *CVA Athens, National Museum*, (1931), fasc. 2, Pl. 9

B. SCHWEITZER, *Die geometrische Kunst Griechenlands*, Cologne (1969), p. 30, Pls. 17, 18

The dating in the second half of the 9th century BC is convincing, but the definition 'cup' is incorrect. A cup ought to have a thin lip for drinking, the vase, however, has the thick rim of a krater

231-2 **Attic Geometric 'horse pyxis'.** National Museum, Athens, 18132, from the Empedokles Collection

For this type cf. COLDSTREAM (1968), pp. 47 f.

SIMON and HIRMER, Pl. 10

The decoration of the bottom (rosette with small swastikas) is also to be found on the following pyxides in the Kerameikos: K. KÜBLER, *Kerameikos*, vol. V 1, Berlin (1954), p. 181, Pl. 64 (inv. 275, 338, 775)

233 **Attic Geometric kantharos.** Museum antiker Kleinkunst, Munich, 8501. H. with handle 19.6 cm

R. LULLIES, *CVA, Museum Antiker Kleinkunst, Munich*, vol. 4, Munich (1956), Pls. 120, 1; 121, 1

SIMON and HIRMER, Pl. 6 above

234 **Attic Geometric tripod stand.** Kerameikos Museum, Athens, 340. H. 22.5 cm

K. KÜBLER, *Kerameikos*, vol. V 1, Berlin (1954), p. 258; Grave 71, Pl. 69

Mourning. Main panel of the 'Prothesis Amphora'. National 235 Museum, Athens, 804. H. of entire vase 1.62 m

COLDSTREAM (1968), p. 29, No. 1 and pp. 33 ff., 45, Pl. 6

ZERVOS (1969), Figs. 60, 63

M. ANDRONIKOS, *Archaeologia Homerica* W 47, Pl. W 1

SIMON and HIRMER, pp. 30 f., Pl. 4, 5

Attic Geometric amphora. National Museum, Athens, 18062 236

F. VILLARD, *Mon. Piot*, 49 (1957), pp. 31 ff., Figs. 14 ff.

COLDSTREAM (1968), p. 42 ff., No. 6 (Hirschfeld Painter)

G. AHLBERG, *Prothesis and Ekphora in Greek Geometric Art*, Göteborg (1971), Pl. 24

Attic Geometric jug from the 'Tomb of the Ivories'. National 237 Museum, Athens, 771

HAMPE, *Sagenbilder* (1936), Pl. 32 (lid)

P.P. KAHANE, *AJA*, 44 (1940), p. 478, notes 62, 482

COLDSTREAM (1968), 83

On the ivory figurines from the same tomb cf. Figs. 393-6

Argive Geometric pyxis from Asine. Museum, Nauplion, 4232. 238 H. 20.5 cm, D. 40 cm

COLDSTREAM (1968), p. 142, n. 14 (Fence Workshop); comparable Corinthian pyxis shapes, ibid. p. 106, Pl. 20g.

ZERVOS (1969), Fig. 102

Argive Geometric fragment, women in ring dance and jumping 239 dancers, from the Heraion at Argos. National Museum, Athens. H. 9 cm

P. COURBIN, *La céramique géométrique de l'Argolide*, Paris (1966), pp. 159, 447, 490 ff., Pl. 147

M. WEGNER, *Archaeologia Homerica* U 74 No. 53, Pl. U 6d

On the subject: U. TÖLLE, *Frühgriechische Reigentänze*, Waldsassen (1964); E. SIMON, *Antike Kunst*, 21 (1978), pp. 66 ff. About a dozen representations of ring dances on Argive Geometric pottery have been found in the Heraion at Argos; cf. Tölle, ibid. p. 44, Nos 92-103. The fragment with jumping dancers illustrated here: No. 101. The Argive rendering of the scene of women with long girdles influenced the Euboean representations, cf. L. KAHIL, in *Studies in Honour of A.D. Trendall*, Sydney (1979), 98, Pl. 27

Women in ring dance on an Argive Geometric krater. 240 Museum, Argos, C 229; from the grave with the panoply, Pl. 183

P. COURBIN, *La céramique géométrique de l'Argolide*, Paris (1966), Pl. 40

COLDSTREAM (1968), p. 140, No. I (Dance Painter); instead of *BCH*, 83 read 81

Attic Late Geometric drinking-cup with interior frieze. 241

Erlenmeyer Collection, Basle. H. 5.5 cm, D. 13.3 cm

B. BORELL, *Attisch geometrische Schalen. Eine spätgeometrische Keramikgattung und ihre Beziehungen zum Orient*, Mainz (1978), p. 19, No. 68, Pls. 28, 29

Proto-Attic painting, general

J.M. COOK, *BSA*, 35 (1934-5), pp. 165 ff.; idem, *BSA*, 42 (1947), pp. 139 ff.; idem, *EAA*, vol. VI, (1965), pp. 495 ff. *s.v.* Protoattici, Vasi

K. KÜBLER, *Altattische Malerei*, Tübingen (1950). Idem, *Kerameikos*, vol. VI, Pl. 2, Berlin (1970)

R. HAMPE, *Ein frühattischer Grabfund*, Mainz (1960)

E.T.H. BRANN, *The Athenian Agora*, vol. VIII, Princeton (1962), Nos 381 ff.

242 **Proto-Attic jug**, Agora Museum, Athens, P 12178. H. 23 cm

E.T.H. BRANN, *The Athenian Agora*, vol. VIII, Princeton (1962), No. 492, Pl. 30: 'Early to Middle Proto-Attic'

243-4 **Two Proto-Attic cauldrons.** University, Mainz, 153, 154. H. to the upper rim of the cauldron 108 and 109 cm. Capacity 37 and 38 litres. Upper d. 46, 45.5 cm, lower d. of stand 28.6, 31.3 cm

R. HAMPE and E. SIMON, *CVA, Mainz, University*, vol. I, Munich (1959), Pls. 8-23

R. HAMPE, *Ein frühattischer Grabfund*, Mainz (1960), pp. 3 ff., Pls. 6, 7 (reconstruction); Pls. 1-5, 8-20 (fragments)

For the plastic flowers on the handles: R. HAMPE, *Ein frühattischer Grabfund*, Mainz (1960), p. 58. For the frieze and the opening of the *Iliad*, ibid. pp. 66 ff.

Attribution of the stand with lozenge shape cut-outs to the Analatos Painter: R. HAMPE, *Ein frühattischer Grabfund*, Mainz (1960), pp. 62 ff.

247 **Boeotian Late Geometric jug** from Thebes. Martin-von-Wagner-Museum, Würzburg. L. 61 cm, H. 50.8 cm

HAMPE, *Sagenbilder* (1936), p. 27 V 36

F. CANCIANI, *JdI*, 80 (1965), p. 27, No. 12

COLDSTREAM (1968), p. 201, No. 13

A. RUCKERT, 'Frühe Keramik Böetiens', in *Antike Kunst*, suppl. fasc. 10 (1976), p. 78

245-6 **Boeotian amphora with 'Mistress of the Animals'** from the neighbourhood of Thebes. National Museum, Athens 5893. H. 87 cm

SIMON and HIRMER, Pl. 16 f., with extensive bibliography

Pottery of Archaic Corinth, general

H. PAYNE, *Necrocorinthia*, Oxford (1931; reprinted College Park, Maryland 1971)

H. PAYNE, *Protokorinthische Vasenmalerei*, Berlin (1933; reprinted Mainz 1974). More recent literature collected by K. WALLENSTEIN, *CVA Tübingen*, vol. I, Munich (1973), p. 38 and F. Hölscher, *CVA Würzburg*, vol. I, Munich (1975) 36

252 **Two Proto-Corinthian vessels with stripes: skyphos and aryballos**

Martin-von-Wagner-Museum, Würzburg, 5049 and 5695. H. 8.6 cm, 6.7 cm

Skyphos: F. CANCIANI, *AA*, (1968), pp. 130 f., Fig. 10

F. HÖLSCHER, *CVA Würzburg*, vol. I, Munich (1975), Pls. 30, 3, 4

Aryballos: unpublished

249 **Large Proto-Corinthian jug.** Martin-von-Wagner-Museum, Würzburg. L. 756 cm, H. 33.1 cm

F. HÖLSCHER, *CVA Würzburg*, vol. I, Munich (1975), Pl. 29 with bibliography and pieces for comparison

Fragmentary jug with broad base (lekythos-oinochoe), Proto- 248 Corinthian. Metropolitan Museum of Art, New York, 23. 160.18. Present height 9.2 cm

R. HAMPE, *Ein frühattischer Grabfund*, Mainz (1960), pp. 55 ff., Figs. 40 ff.

G.F. PINNEY and B.S. RIDGWAY, *Aspects of Ancient Greece*, Allentown Art Museum (1979), pp. 120 f., with detailed discussion (J. McCALLUM)

Polychrome olpe ('Chigi jug') 102

H. PAYNE, *Protokorinthische Vasenmalerei*, Berlin (1933; reprinted Mainz 1974), pp. 14 f., Pls. 27 ff.

SIMON and HIRMER, Pls. VII, 25, 26

Proto-Corinthian lekythos ('pointed aryballos'). Antikenmuseum, 250 University, Heidelberg, 67/6. H. 11.6 cm

R. HAMPE, *Neuerwerbungen 1957-70*, Mainz (1971), No. 36, Pl. 20 (D. Michel)

Proto-Corinthian jug with scale pattern. Antikenmuseum, 251 University, Heidelberg, 69/4. H. with handle 29.8 cm

R. HAMPE, *Neuerwerbungen 1957-70*, Mainz (1971), No. 37, Pl. 21 and frontispiece (coloured)

Early Corinthian pyxis. Martin-von-Wagner-Museum, Würz- 257 burg. L. 120 cm, H. 15.9 cm

H. PAYNE, *Necrocorinthia*, Oxford (1931), No. 862, Pl. 28, 1

E. SIMON, *Führer durch die Antikenabteilung des Martin-von-Wagner-Museums der Universität Würzburg*, Mainz (1975), p. 70, Pl. 11 (F. HÖLSCHER)

Cretan cauldron with griffin protomes from Arkades. Museum, 253-4 Iraklion.

D. LEVI, *Annuario Scuola Archeologica Atene*, 10-12 (1927-29 [1931]), pp. 32 ff., Figs. 420a-d from Grave 50, No. 18a

R. HAMPE, 'Kretische Löwenschale des siebten Jahrhunderts v. Chr.', *Sitzungsberichte der Heidelberger Akademie der Wissenschaften*, Heidelberg (1969), pp. 11 f., Pls. 13, 2; 14; 15

Cretan bowl with lion. Antikenmuseum, University, Heidelberg, 255-6 59-1. H. 4.3 cm, D. of the vessel 13.1 cm

Publication with explanation concerning the function: R. HAMPE, 'Kretische Löwenschale des siebten Jahrhunderts v. Chr.', in *Sitzungsberichte der Heidelberger Akademie der Wissenschaften*, Heidelberg (1969)

R. HAMPE, *Neuerwerbungen 1957-70*, Mainz (1971), No. 31, Pl. 17

Amphora in 'Linear Island style'. Royal Palace, Stockholm 261 S. Wide, *JdI*, 12 (1897), pp. 195 ff., Pl. 17

SIMON and HIRMER, Pl. 20

On the style: H. PAYNE, *JHS*, 46 (1926), pp. 204 ff.

Chiot chalice. Martin-von-Wagner-Museum, Würzburg. L. 128 cm, 258 H. 15.8 cm, D. 20.5 cm

F. HÖLSCHER, *CVA Würzburg*, vol. I, Munich (1975), Pl. 22

SIMON and HIRMER, Pl. 33

Cycladic plate, Bellerophon and Chimaera, 'Naxian' school. 260 Museum, Thasos, 2085. D. 28 cm

BCH, 83 (1959), p. 781, Pl. 11

BCH, 84 (1960), pp. 247 ff., Pls. 4-6

N. YALOURIS, *Pegasus: The Art of the Legend*, Westerham Press (1975), No. 8 (coloured)

On the origin of the 'Melian school': J. BOARDMAN, *Island Gems*, London (1963), pp.100 f. D. PAPASTAMOS, *Melische Amphoren*, Münster (1970). I have given up the scepticism I expressed in SIMON and HIRMER, 47

259 **Attic black-figured olpe:** Hermes between spinxes. British Museum, London B 32

J.D. BEAZLEY, *Attic Black-Figure Vase-Painters*, Oxford (1956), pp. 11, 16 (close to the Gorgon Painter)

R. HAMPE, *Ein frühattischer Grabfund*, Mainz (1960), p. 65, Fig. 43

Engraving

Mycenaean engraving, general

FURTWÄNGLER, *AG*, vol. III, pp. 13 ff.

A. SAKELLARIOU, 'Die mykenische Siegelglyptik', in *Stud. Med. Arch.*, 9 (1964)

BOARDMAN, *Gems*, pp. 46 ff.; on the shaft graves esp. pp. 54 ff.

BUCHHOLZ and KARAGEORGHIS, pp. 112 ff.

F. MATZ (ed.), 'Die kretisch-mykenische Glyptik und ihre gegenwärtigen Probleme', in *Tagungsberichte Bad Godesberg*, Boppard (1974)

HOOD (1978), pp. 209 ff.

Rhyton-bearer with lentoid gems around his wrist

MARINATOS and HIRMER (1973), Pl. XV

262 **Disc-shaped amethyst: bearded head,** from Grave Gamma of Grave Circle B at Mycenae. National Museum, Athens, 8708. D. 1 cm

SAKELLARIOU, *CMS*, vol. I, No. 5

BOARDMAN, *Gems*, Pl. 44

MARINATOS and HIRMER (1973), Pl. 235 above

HOOD (1978), p. 224, Fig. 226, with Cretan parallel Fig. 227

263 **Amygdaloid 'talismanic' cornelian:** vessel and twigs, from Grave Mu of Grave Circle B at Mycenae. National Museum, Athens, 8672. D. 1.75 × 1.4 cm

SAKELLARIOU, *CMS*, vol. I, No. 6. The 'talismanic' gem from Vapheio, ibid. No. 261

On the 'talismanic' style: BOARDMAN, *Gems*, pp. 42 ff., 54 ff.

265 **Gold ring: battle,** from Shaft Grave IV, Mycenae. National Museum, Athens (the museum numbers are not given since they are identical with Karo's). D. (for rings always only the bezel) 3.5 × 2.1 cm

KARO, *Schachtgräber*, No. 241, Pl. 24

SAKELLARIOU, *CMS*, vol. I, No. 16

BUCHHOLZ and KARAGEORGHIS, No. 1383

MARINATOS and HIRMER (1973), Pl. 230 above

Minoan fight scenes: D. LEVI, *Annuario Scuola Italiana Atene*, 8-9 (1925-6), p. 123, Nos 114 f., Figs. 130 f.

Gold ring: hunt, from Shaft Grave IV, Mycenae. National Museum, 266 Athens. D. 3.45 × 2.1 cm

KARO, *Schachtgräber*, No. 240, Pl. 24

SAKELLARIOU, *CMS*, vol. I, No. 15

E.T. VERMEULE, *The Art of the Shaft Graves of Mycenae*, Cincinnati (1975), pp. 45 f., Fig. 60

Lentoid cornelian: chariot, from the tholos tomb at Vapheio. 264 National Museum, Athens, 1770. D. 3.1 cm

CH. TSOUNTAS, *Ephemeris*, (1889), p. 164, Pl. 10, 1

SAKELLARIOU, *CMS*, vol. I, No. 229

BOARDMAN, *Gems*, Pl. 163; the lost lentoid, ibid. Pl. 186

MARINATOS and HIRMER (1973), Pl. 234 above

On the subject: J. WIESNER, *Archaeologia Homerica* (1968), F 36 ff. Ibid. F 47a, d the two Cretan examples

Lentoid amethyst: suckling hind, from Shaft Grave III, Myce- 267 nae. National Museum, Athens. D. 1.8 cm

KARO, *Schachtgräber*, No. 117, Fig. 15, Pl. 24

SAKELLARIOU, *CMS*, vol. I, No. 13

Tagungsbericht Bad Godesberg (1974), p. 140, Fig. 49 (lecture by A. SAKELLARIOU)

Gold flattened cylinder seal: man and lion, from Shaft 269 Grave III, Mycenae. National Museum, Athens. D. 2 × 1.5 cm

KARO, *Schachtgräber*, No. 33, Pl. 24

SAKELLARIOU, *CMS*, vol. I, No. 9

On the problem of Mycenaean representations of lions: BOARDMAN, *Gems*, pp. 58 f.

Gold flattened cylinder: wounded lion, from Shaft Grave III, 268 Mycenae. National Museum, Athens. D. 2.5 × 1.5 cm

KARO, *Schachtgräber*, No. 34, Pl. 24

SAKELLARIOU, *CMS*, vol. I, No. 10

Lentoid onyx: lion and bull, from the tholos tomb at Midea in 271-2 the Argolid. National Museum, Athens, 7332. D. 4 cm

A.W. PERSSON, *The Royal Tombs at Dendra near Midea* (1931), p. 32, No. 3a, Pl. 19.4

SAKELLARIOU, *CMS*, vol. I, No. 185

BOARDMAN, *Gems*, p. 57, Fig. 129

MARINATOS and HIRMER (1973), Pl. 233 middle

Lentoid agate: lion and bull, from the tholos tomb at Vapheio. 273 National Museum, Athens, 1774. D. 2.81 cm

CH. TSOUNTAS, *Ephemeris*, (1889), 166, Pls. 10, 18

SAKELLARIOU, *CMS*, vol. I, No. 252

BOARDMAN, *Gems*, Pl. 159

Lentoid agate: lion and bullock, from a tholos tomb at Rutsi near 274 Pylos. National Museum, Athens, 8329. D. 2.5 cm

MARINATOS in SAKELLARIOU, *CMS*, vol. I, No. 278

MARINATOS and HIRMER (1973), Pl. 232 below right

270 Gold flattened cylinder seal: duel, from Shaft Grave III, Mycenae. National Museum, Athens. D. 1.8 × 1.2 cm

KARO, *Schachtgräber*, No. 35, Pl. 24

SAKELLARIOU, *CMS*, vol. I, No. 11

MARINATOS and HIRMER (1973), Pl. 230 middle

276 Gold ring: cult scene with women and children, from the treasure of Mycenae. National Museum, Athens, 992. D. 3.4 × 2.5 cm

SAKELLARIOU, *CMS*, vol. I, No. 17

SIMON, *Götter*, pp. 181 ff., Fig. 164

BOARDMAN, *Gems*, Pl. 149

On the mulberry-tree: *RE*, vol. XIV 2 (1930), pp. 2331 ff. (STEIER), with ancient sources

275 Lentoid cornelian: flower offering, from the tholos tomb at Rutsi near Pylos. National Museum, Athens, 8323. D. 1.7 cm

MARINATOS in SAKELLARIOU, *CMS*, vol. I, No. 279

MARINATOS and HIRMER (1973), Pl. 232 middle

277-80 Four gold rings from Chamber Tomb 91, Mycenae. National Museum, Athens. Treatment of the whole find: SAKELLARIOU, *CMS*, vol. I, Nos 126-9

Dating to the 15th century and stylistic attribution to two workshops: J.A. SAKELLARAKIS, *Tagungsbericht Bad Godesberg* (1974), pp. 115 ff.

278 Ring with sphinx. National Museum, Athens, 3182. D. 2.1 × 1.1 cm

SAKELLARIOU, *CMS*, vol. I, No. 129

MARINATOS and HIRMER (1973), Pl. 228 below left

277 Ring with enthroned figure and griffin. National Museum, Athens, 3181. D. 1.9 × 1.2 cm

SAKELLARIOU, *CMS*, vol. I, No. 128

MARINATOS and HIRMER (1973), Pl. 228 below right

279 Ring with praying women. National Museum, Athens, 3180. D. 2.55 × 1.5 cm.

SAKELLARIOU, *CMS*, vol. I, No. 127

BOARDMAN, *Gems*, Pl. 150

MARINATOS and HIRMER (1973), Pl. 228 below right

280 Ring with vegetation cult. National Museum, Athens, 3179. D. 3 × 1.8 cm

SAKELLARIOU, *CMS*, vol. I, No. 126

MARINATOS and HIRMER (1973), Pl. 228 middle right

285 Lentoid jasper: priest and griffin, from the tholos tomb at Vapheio. National Museum, Athens, 1761. D. 2.25 cm

CH. TSOUNTAS, *Ephemeris*, (1889), p. 167, Pls. 10, 32

SAKELLARIOU, *CMS*, vol. I, No. 223

BOARDMAN, *Gems*, Pl. 160

MARINATOS and HIRMER (1973), Pl. 234 above right

281 Electrum ring: antithetically arranged griffins, from Chamber Tomb 68, Mycenae. National Museum, Athens, 2970. D. 3 × 1.7 cm

HIGGINS (1961), Pl. 7 A

SAKELLARIOU, *CMS*, vol. I, No. 102

MARINATOS and HIRMER (1973), Pl. 228 above

Gold ring: vegetation cult, from the tholos tomb at Vapheio. 282 National Museum, Athens, 1801. D. 2.15 × 1.38 cm

SAKELLARIOU, *CMS*, vol. I, No. 219

BOARDMAN, *Gems*, Pl. 154; cf. also p. 53, Fig. 125 (ring from Archanes)

Minoan-Mycenaean vegetation cult

MARTIN P. NILSSON, *Geschichte der griechischen Religion*, vol. I, Munich (1955), pp. 322 ff.

Gold ring: dances in the vegetation cult, so-called ring of 287-8 **Nestor,** from Kakovatos. Ashmolean Museum, Oxford, 1938. 1130

A. EVANS, '"The Ring of Nestor", A Glimpse into the Minoan Afterworld', in *JHS*, 45 (1925), pp. 43 ff.

M.P. NILSSON, *The Minoan-Mycenaean Religion and its Survival in Greek Religion*, Lund (1927), pp. 549 ff.

J.A. SAKELLARAKIS, 'Über die Echtheit des sogenannten Nestor-rings', in *Akten des 3. kretologischen Kongresses in Rethymnon (September 1971)*, Athens (1973), pp. 303 ff., Pls. 85 ff.

Since the ring was included in the standard museum publication, V.E.G. KENNA, *Cretan Seals*, Oxford (1960), p. 154, Pl. 20, among the 'gemmae dubitandae', and since an expert like F. Matz declared it fake, it will certainly take some time until Sakellarakis's defense is generally accepted. It seems to me, however, conclusive. I am grateful to colleagues in Oxford, M. Vickers and J. Boardman, who enabled me to study the original. It urgently needs redrawing since its condemnation rests on the inaccurate drawing which unfortunately has had to be reproduced here

Amygdaloid agate: reclining lion, from the tholos tomb at 283-4 Vapheio. National Museum, Athens, 1790. D. 2.45 × 1.4 cm

CH. TSOUNTAS, *Ephemeris* (1889), Pls. 10, 27

SAKELLARIOU, *CMS*, vol. I, No, 244

MARINATOS and HIRMER (1973), Pl. 234 middle

Lentoid agate: female rider on sea-monster, from the Lower 286 City at Mycenae, perhaps from the 'tomb of Clytemnestra'. National Museum, Athens, 8718. D. 2.7 cm

SAKELLARIOU, *CMS*, vol. I, No. 167

BOARDMAN, *Gems*, p. 57, Fig. 128

HOOD (1978), p. 223, Fig. 225

Lentoid jasper: collapsing bull, from the tholos tomb at Vapheio. 289 National Museum, Athens, 1767. D. 1.85 cm

CH. TSOUNTAS, *Ephemeris* (1889), p. 166, Pls. 10, 14

SAKELLARIOU, *CMS*, vol. I, No. 234

Lentoid sardonyx: two reclining bulls, from the tholos tomb at 292 Rutsi near Pylos. National Museum, Athens, 8326. D. 2.8 cm

MARINATOS in: SAKELLARIOU, *CMS*, vol. I, No. 275

Lentoid agate: two reclining bulls, from the tholos tomb at 291 Vapheio. National Museum, Athens, 1764. D. 2.23 cm

SAKELLARIOU, *CMS*, vol. I, No. 241; ibid. No. 240: a sardonyx with the same subject; for this cf. BOARDMAN, *Gems*, Pl. 158

MARINATOS and HIRMER (1973), Pl. 234 middle

290 **Lentoid agate: two reclining cattle heraldically arranged,** from the tholos tomb at Vapheio. National Museum, Athens, 1771. D. 2. 25 cm

SAKELLARIOU, *CMS*, vol. I, No. 239

293 **Lentoid sardonyx: cow trying to lick its hind hoof,** from the tholos tomb at Vapheio. National Museum, Athens, 1771. D. 2 cm

SAKELLARIOU, *CMS*, vol. I, No. 235

294-5 **Seal impression on the disc on top of a clay stirrup-jar:** cow in similar pose as the previous one, from the 'House of the Oil-Merchant' at Mycenae. National Museum, Athens, 7626. D. 2 × 1.5 cm

SAKELLARIOU, *CMS*, vol. I, No. 160

301-2 **Three-sided agate prism with curved surfaces: a) reclining ibexes; b) lion and ibex,** from a Chamber Tomb (10) at Midea, Argolid. National Museum, Athens, 8754. D. 2.4 cm

SAKELLARIOU, *CMS*, vol. I, No. 193

300 **Gold ring: youth and ibex in a tree sanctuary,** from Chamber Tomb 84, Mycenae. National Museum, Athens, 3148. D. 3 × 1.95 cm

HIGGINS (1961), Pl. 7 B

SAKELLARIOU, *CMS*, vol. I, No. 119

BOARDMAN, *Gems*, Pl. 148

MARINATOS and HIRMER (1973), Pl. 228 above left

Minoan-Mycenaean Ta-urt demons, general

FURTWÄNGLER, *AG*, vol. III 39

M.A.V. GILL, *AM*, 79 (1964), pp. 1 ff.

BOARDMANN, *Gems*, p. 53

298 **Lentoid cornelian: demon returns with two dead lions from the hunt,** from Crete. Antikenabteilung Staatliche Museen Preussischer Kulturbesitz, Berlin, FG 11. D. 2 cm

M.A.V. GILL, *AM* 79 (1964), 20, No. 41, Suppl. Pl. 4, 7

E. ZWIERLEIN-DIEHL, *AGD*, vol. II, Munich (1969), No. 28, Pl. 7

297 **Amygdaloid agate: demon with jug,** from the tholos tomb at Vapheio. National Museum, Athens, 1797. D. 1.89 × 1.3 cm

SAKELLARIOU, *CMS*, vol. I, No. 232

The amygdaloid is one of the less well-known examples with the representation set upright

296 **Lentoid agate: two demons with jugs at a cult place,** from the tholos tomb at Vapheio. National Museum, Athens, 1776. D. 1.95 cm

SAKELLARIOU, *CMS*, vol. I, No. 231

BOARDMAN, *Gems*, Pl. 166

MARINATOS and HIRMER (1973), Pl. 234 below left

HOOD (1978), p. 227, Fig. 230

299 **Gold ring from the Treasure of Tiryns: enthroned woman and four demons with jugs.** National Museum, Athens, 6208. D. 5.7 × 3.5 cm

V. MÜLLER, 'Der Dämonenring von Tiryns', in *JdI*, 42 (1927) pp. 1 ff.; ibid. 8 on the offerings stand

G. KARO, *AM*, 55 (1930), pp. 119 ff., Pls. 2, 1; 3, 2; Suppl. Pl. 3, 2

SAKELLARIOU, *CMS*, vol. I, No. 179

M.A.V. GILL, *AM*, 79 (1964), p. 18, No. 26

BUCHHOLZ and KARAGEORGHIS, No. 1381b

MARINATOS and HIRMER (1973), Pl. 229 above

Minoan chalice: A. SAKELLARIOU, *Festschrift E. Grumach*, Berlin (1967), pp. 289 ff.

Frieze of women from Thebes

H. REUSCH, *Die zeichnerische Rekonstruktion des Frauenfrieses im böotischen Theben*, Berlin (1956). Additional information and new comments in: CH. BOULOTES, Studien zu ägäischen Prozessionen des 2. Jahrtausends v. Chr. (thesis, Würzburg, 1980)

Seal impression in clay: lion and bull, from the palace at Pylos. **303** National Museum, Athens, 8527. D. 2.8 × 2 cm

SAKELLARIOU, *CMS*, vol. I, No. 310; ibid. No. 308, impression with Linear B script

C.W. BLEGEN and M. RAWSON, *The Palace of Nestor in Western Messenia*, vol. I, Princeton (1966), p. 59

Gems from the end of the Bronze Age, general

BOARDMAN, *Gems*, pp. 59 ff.

Amygdaloid cornelian: four-legged animal (fawn?), from **304** Melos. Antikenabteilung, Staatliche Museen Preussischer Kulturbesitz, Berlin, FG 86. D. 1.95 × 1.23 cm

E. ZWIERLEIN-DIEHL, *AGD*, vol. II, Munich (1969), No. 59, Pl. 15

A. GREIFENHAGEN, 'Schmuckarbeiten', in *Edelmetall*, vol. II, Berlin (1975), Pls. 53, 5, 6

I. PINI, Marburger Winckelmann – Programm 1975-6, Marburg (1976), p. 1 ff., No. 14

Amygdaloid, serpentine ('steatite'): stalking lion, from **305** Thebes, Melian. Antikenabteilung, Staatliche Museen Preussischer Kulturbesitz, Berlin, FG 95. D. 2.33 × 1.31 cm

J. BOARDMAN, *Island Gems*, London (1963), p. 34, No. 71

E. ZWIERLEIN-DIEHL, *AGD*, vol. II, Munich (1969), No. 108, Pl. 26

Quadrangular seal, serpentine ('steatite'): archer and centaur, **308** **probably Herakles and Nessos.** Bibliothèque Nationale, Cabinet des Médailles, Paris, M 5837. D. 2.2 × 2 cm

J. BOARDMAN, *Island Gems*, London (1963), p. 120, No. C 13

FITTSCHEN, *Sagendarstellungen*, p. 112, SB 3

BOARDMAN, *Gems*, Pl. 208 right

Finger-ring, serpentine ('steatite'), from Siphnos. National **309** Museum, Athens, 1095. D. (of the seal) 1.1 × 0.8 cm

J. BOARDMAN, *Island Gems*, London (1963), 82, No. 351, Pl. 13

Amygdaloid, serpentine ('steatite'): boar. Antikenabteilung, **306-7** Staatliche Museen Preussischer Kulturbesitz, Berlin, AG 92. D. 2.18 × 1.84 cm

J. BOARDMAN, *Island Gems*, London (1963), 23, No. 2, Pl. 1

E. ZWIERLEIN-DIEHL, *AGD*, vol. II, Munich (1969), No. 115, Pl. 272

Mycenaean gems in later contexts

J. BOARDMAN, *Island Gems* (1963), 110

J.A. SAKELLARAKIS, 'Kretisch-mykenische Siegel in griechischen Heiligtümern', in: U. JANTZEN (ed.), *Forschungen in griechischen Heiligtümern*

Jewellery

Mycenaean and Geometric gold and silver jewellery, general

HIGGINS (1961), pp. 68 ff. (Late Minoan and Mycenaean); pp. 90 ff. (Dark Ages); pp. 95 ff. (Geometric and Orientalizing)

E. BIELEFELD, *Archaeologia Homerica* C (1968)

HOOD (1978), pp. 197 ff.

Mycenaean and Geometric bronze pendants

I. KILIAN-DIRLMEIER, 'Anhänger in Griechenland in der mykenischen bis zur spätgeometrischen Zeit', in *Prähistorische Bronzefunde*, vol. XI 2, Munich (1979)

Bronze jewellery should be looked at in closer relation to that of gold and silver than is usual, because many shapes are shared. The bronze pins of the 'Dark Ages' which were more practical than decorative, are treated under Pl. 146 with metalwork. From there the Boeotian fibulae developed, which were certainly display pieces. The dividing line between the practical and the luxurious was, therefore, very narrow

Terminology and technique

M. ROSENBERG, *Geschichte der Goldschmiedekunst auf technischer Grundlage*, vol. III: *Granulation*, Frankfurt am Main (1918)

H. HOFFMANN and P.F. DAVIDSON, *Greek Gold. Jewellery from the Age of Alexander*, Mainz (1965). Edited by M.V. Saldern. New observations on granulation

H. HOFFMANN and V. v. CLAER, *Antiker Gold- und Silberschmuck im Museum für Kunst und Gewerbe Hamburg*, Mainz (1968). Glossary pp. 219 ff., *s.v.* Decorative wire, Granulation. In modern times one generally thinks of filigree as a technique with perforations, but in antiquity filigree work was mainly set on a base, as our Pls. 320-2 and 326 show

Jewellery from the shaft graves at Mycenae, general

KARO, *Schachtgräber*, pp. 173 ff., 181 ff., 258 ff.

BUCHHOLZ and KARAGEORGHIS, Nos 1297 ff.

E.T. VERMEULE, *The Art of the Shaft Graves of Mycenae*, Cincinnati (1975), pp. 23 ff.

HOOD (1978), pp. 197 ff.

312 **Circular gold discs from Grave Circle A at Mycenae.** National Museum, Athens. All with a d. of approximately 6 cm

KARO, *Schachtgräber*, pp. 183 ff.

MARINATOS and HIRMER (1973), Pl. 224

Our Pl. 312 contains only a selection of the motifs

From Shaft Grave III: KARO, *Schachtgräber*, No. 2 (butterfly); No. 4 (butterfly); Nos 6, 8, 9 (shell, called by Karo a fan-palm leaf, though the shape of the shell is clear and verified elsewhere, whereas palmette motifs are stylized in a different fashion); Nos 11-14, 16, 20 (ornaments); No. 18 (octopus)

From Shaft Grave V: KARO, *Schachtgräber*, Nos 640-6, 647, 655. Golden necklace with butterfly cocoons from Shaft Grave III (not illustrated here)

KARO, *Schachtgräber*, No. 78, Pl. 22

Miniature gold sheets from Grave Circle A at Mycenae. 315 National Museum, Athens

KARO, *Schachtgräber*, pp. 189 ff.

MARINATOS and HIRMER (1973), Pls. 226 f.

HOOD (1978), pp. 203 ff., Fig. 203

Cult façade: KARO, *Schachtgräber*, Nos 26, 242-4, Pls. 27, 18 (from Graves III and IV)

BUCHHOLZ and KARAGEORGHIS, No. 1303

MARINATOS and HIRMER (1973), Pl. 227 middle

A similar cult façade of gold tinsel was found in the tholos tomb at Volos of the fourteenth century: J.A. SAKELLARAKIS, *The Mycenaean Collection of the National Museum, Athens* (1971), 86 Inv. 5609 with Fig.

Octopus lying diagonally with seven tentacles: KARO, *Schachtgräber*, Nos 39, 40, Pl. 26 (Grave III)

MARINATOS and HIRMER (1973), Pl. 226 above

Naked standing goddess: KARO, *Schachtgräber*, Nos 27, 28, Pl. 27 (Grave III)

MARINATOS and HIRMER (1973), Pl. 227 middle

SIMON, *Götter*, p. 239, Fig. 225 f.

Draped seated woman: KARO, *Schachtgräber*, No. 36, Pl. 27 (Grave III)

MARINATOS and HIRMER (1973), Pls. 227 (below right and left)

The figure does not stand, as Karo says, but sits or rather crouches on the ground, as is indicated by the shortness of her dress and the pose of her legs. The representation of the face from the front is very unusual. Marinatos did not decide whether it is a divine or a mortal person

Bull's head with double axe between its horns (only from Shaft Grave IV):

KARO, *Schachtgräber*, Nos 353, 354, Pl. 44

The miniature sheet was earlier used in the reconstruction of the bull's-head rhyton with a double axe, also found there (Pl. 127) but it has now been removed

Two types of butterfly from Grave III: KARO, *Schachtgräber*, No. 51, Pl. 26 (with thin abdomen); No. 49, Pl. 27 (with thick abdomen, moth?)

Sphinx: KARO, *Schachtgräber*, No. 48, Pl. 26 (Grave III)

Griffin: KARO, *Schachtgräber*, No. 47, Pl. 26 (Grave III)

Heraldic leopards: KARO, *Schachtgräber*, No. 50, Pl. 26 (Grave III)

HIGGINS (1961), Pl. 5 B

Heraldic stags: KARO, *Schachtgräber*, Nos 45, 46, Pl. 26 (Grave III)

HIGGINS (1961), Pl. c.f. 5 C

Cross with spiral pattern as pendants: KARO, *Schachtgräber*, No. 52, Pl. 27 (Grave III)

A 'foreign body', not from Grave Circle A, is mentioned under the miniature sheet on Pl. 315

Small screech-owl of gold-foil from Kakovatos. National Museum, Athens

K. MÜLLER, *AM*, 34 (1909), 271, Pls. 13, 27

MARINATOS and HIRMER (1973), Pl. 225 below left

SP. MARINATOS, *AM*, 83 (1968), pp. 170 ff.

311 **Gold necklace as funerary jewellery of a king,** with antithetical falcons, from Shaft Grave V, Mycenae. National Museum, Athens

KARO, *Schachtgräber*, No. 689, Fig. 48, Pl. 6

MARINATOS and HIRMER (1973), Pl. 227 above. There labelled as falcons, whereas Karo speaks of 'paired eagles'. Cf. KARO, *Schachtgräber*, No. 44, Pl. 26 (from Grave III), not illustrated here: the same motif as on the miniature sheet

311 **Gold necklace with plastic pomegranates** from Shaft Grave III, Mycenae. National Museum, Athens

KARO, *Schachtgräber*, No. 77, Pl. 22

HIGGINS (1961), Pl. 6 B

E. BIELEFELD, *Archaeologia Homerica* C 19

The third gold necklace on our Pl. 311 has near parallels in the 'Aegina treasure' and has a counterpart in the necklace pieces from Shaft Grave Omikron of Grave Circle B

HIGGINS (1961), p. 77 with Pl. 8 E speaks of 'palm leaves', but they are, because of the daintiness of the motif, probably rather simplified lily blooms. On the 'Aegina treasure' cf. BUCHHOLZ and KARAGEORGHIS, Nos 1106, 1305, with bibliography; see also R. HIGGINS, *The Aegina Treasure. An Archaeological Mystery*, London (1979), Nos 32, 33

317 **Decorative pins (mostly silver) with rock-crystal heads** from Shaft Grave III, Mycenae. National Museum, Athens

KARO, *Schachtgräber*, Nos 102-4, Pl. 31

E. BIELEFELD, *Archaeologia Homerica*, Pl. C, IVe

BUCHHOLZ and KARAGEORGHIS, Nos 1297, 1298

HOOD (1978), p. 200, Fig. 198, 2, 3

The other pins and heads in our Pl. 317 come from other find-spots and demonstrate the popularity of this jewellery in the 16th and 15th centuries BC.

314 **Gold funerary diadem** from Shaft Grave IV, Mycenae. National Museum, Athens. L. 41.5 cm, W. 8.1 cm

KARO, *Schachtgräber*, p. 232, Pl. 36

E. BIELEFELD, *Archaeologia Homerica*, Pl. C, VId

314 **Gold funerary arm-band** from Shaft Grave IV, Mycenae. National Museum, Athens. L. 36.1 cm, W. 5.5 cm

KARO, *Schachtgräber*, No. 257, Pl. 43

310 **Upper arm-band of gold and silver belonging to a king,** from Shaft Grave IV, Mycenae. National Museum, Athens. Inner D. 9.3 cm, W. of band 2.1-2.2 cm

KARO, *Schachtgräber*, No. 263, Pl. 42

MARINATOS and HIRMER (1973), Pl. 223 above

HOOD (1978), p. 202, Fig. 202

Pin of silver and gold with a tree goddess from Shaft Grave III, 316 Mycenae. National Museum, Athens. L. of pin 21.5 cm, H. of decoration 6.7 cm

KARO, *Schachtgräber*, No. 75, Pl. 30

HIGGINS (1961), Pl. 6 A

MARINATOS and HIRMER (1973), Pl. 222 left

HOOD (1978), p. 200, Fig. 199

Helen as tree goddess: M.P. NILSSON, *Geschichte der griechischen Religion*, vol. I, Munich (1955), 315

Gold ear-rings from Shaft Grave III, Mycenae. National Museum, 313 Athens. D. 7.5 cm

KARO, *Schachtgräber*, No. 61, Pls. 20, 32

HIGGINS (1961), Pl. 5 D

MARINATOS and HIRMER (1973), Pl. 223 below

HOOD (1978), p. 201, Fig. 200: 'Probably Cretan work of Late Minoan I A' and not Near Eastern as other scholars have maintained, eg. E. BIELEFELD, *Archaeologia Homerica* C 19 f.

Geometric ear pendants of gold with filigree and granulation, 320 from the 'Grave of the Rich Athenian Lady' on the Areiopagos. Agora Museum, Athens. L. 6.4 cm

E.L. SMITHSON, *Hesperia*, 37 (1968), pp. 112 ff., Nos 77a, b, Pls. 30, 32

H.A. THOMPSON and R.E. WYCHERLEY, *Agora*, vol. XIV, Princeton (1972) 14, Pl. 22

On the Boutades (Eteoboutades), from among whom came the priestess of Athena Polias: J.K. DAVIES, *Athenian Propertied Families*, Oxford (1971), pp. 169 ff. The long gold band, on which hung the trapezium-shaped pendant, was bent together on both examples at the time of the burial. See SMITHSON, *Hesperia*, 37 (1968), p. 114. This recalls the custom of making dedications at sanctuaries, such as helmets (cf. Pl. 187), useless by bending or 'killing' them

Bronze pendants in form of pomegranates

I. KILIAN-DIRLMEIER, 'Anhänger in Griechenland von der mykenischen bis zur spätgeometrischen Zeit', in *Prähistorische Bronzefunde*, vol. XI 2, Munich (1979), Pl. 35; quotation on p. 126

Gold necklace with inlays from Grave 3, Spata (eastern 318 **Attica).** National Museum, Athens, 2604. L. 10 cm

HIGGINS (1969), p. 99, Pl. 33 F

Gold necklace with pendants from Tekke near Knossos. 319 Museum, Iraklion

HIGGINS (1961), pp. 109 f., Pl. 16

Gold workshop on Melos

J. BOARDMAN, *Island Gems, A Study of Greek Seals of the Geometric and early Archaic periods*, London (1963), pp. 100 f.

Gold workshop on Rhodes

HIGGINS (1961), pp. 105 ff.

R. LAFFINEUR, 'L'orfèvrerie Rhodienne orientalisante', Ecole française d'Athènes, in *Travaux et Mémoires*, vol. XXI, Paris (1978)

324 **Gold ear pendant from Melos.** Antikenabteilung, Staatliche Museen Preussischer Kulturbesitz, Berlin, Misc. 1845. GI 141. H. 6 cm, H. of griffin's head 1.6 cm

HIGGINS (1961), p. 107, Fig. 17

A. GREIFENHAGEN, *Schmuckarbeiten in Edelmetall*, vol. II, Berlin (1975), Pls. 38, 7, 8

R. LAFFINEUR, 'L'orfèvrerie Rhodienne orientalisante', Ecole française d'Athènes, in *Travaux et Mémoires*, vol. XXI, Paris (1978), No. 203, Pl. 23, 4

326 **Gold rosette with granulation from Melos.** National Museum, Athens. D. 4.6 cm

R. LAFFINEUR, 'L'orfèvrerie Rhodienne orientalisante', Ecole française d'Athènes, in *Travaux et Mémoires*, vol. XXI, Paris (1978), No. 120, Pl. 15, 5. Forty-two further examples are gathered there, of which the piece illustrated here is the richest and finest. On the development of these rosettes: LAFFINEUR, ibid. pp. 105 ff.; cf. also HIGGINS (1961), p. 105

325 **Small gold plaques with bee-shaped goddesses from Rhodes**

Antikenabteilung, Staatliche Museen Preussischer Kulturbesitz, Berlin, Misc. 8946. H. 2.7 cm, W. 2.5 cm

A. GREIFENHAGEN, *Schmuckarbeiten in Edelmetall*, vol. I, Berlin (1970), Pl. 9, 6

R. LAFFINEUR, 'L'orfèvrerie Rhodienne orientalisante', Ecole française d'Athènes, in *Travaux et Mémoires*, vol. XXI, Paris (1978), No. 6, Pl. 2, 3. On the interpretation see pp. 51 ff.; the various arguments are also assembled by S. de MARINIS, *EAA*, vol. IV (1961), pp. 993 f. *s.v.* Melissa

Conflation of bees and nymphs: Van der KOLF, *RE*, vol. XV 1 (1931), pp. 525 f. *s.v.* Melissa No. 3. On the bees in the myth of the birth of Zeus see pp. 526 f.

Bees on Cretan vases of the seventh century: E. PFUHL, *Malerei und Zeichnung der Griechen*, vol. III, Munich (1923), Fig. 39

322 **Gold pin with the 'Mistress of the Animals' from Rhodes**

Antikenabteilung, Staatliche Museen Preussischer Kulturbesitz, Berlin Misc. 8943. H. 3.7 cm (plate), overall h. 6 cm, W. 3 cm

A. GREIFENHAGEN, *Schmuckarbeiten in Edelmetall*, vol. I, Berlin (1970), Pls. 9, 1; 5, 7

R. LAFFINEUR, L'orfèvrerie Rhodienne orientalisante', Ecole française d'Athènes, in *Travaux et Mémoires*, vol. XXI, Paris (1978), No. 3, Pls. 1, 3; on the type pp. 33 ff.

323 **Gold plaque with centaur from Rhodes** (one of two similar sheets). Antikenabteilung, Staatliche Museen Preussischer Kulturbesitz, Berlin, Misc. 8945. H. 4.3 cm, W. 3.2 cm

HIGGINS (1961), Pl. 18 C

A. GREIFENHAGEN, *Schmuckarbeiten in Edelmetall*, vol. I, Berlin (1970), Pls. 9, 2-4

R. LAFFINEUR, 'L'orfèvrerie Rhodienne orientalisante', Ecole française d'Athènes, in *Travaux et Mémoires*, vol. XXI, Paris (1978), No. 5, Pls. 2, 1; on the type pp. 66 ff.

Ivory, bone and wood

General

J.A. SAKELLARAKIS, Τὸ ἐλεφαντόδοντο καὶ ἡ κατεργασία του στὰ Μυκηναϊκὰ χρόνια, with German translation pp. 87 ff., Athens (1979)

POURSAT, *Cat.*

POURSAT, *Ivoires*

Small wooden box from Shaft Grave V 327

KARO, *Schachtgräber*, Nos 812, 813, Pl. 145

B. SCHWEITZER, *AM*, 55 (1930), pp. 107 ff. Suppl. Pl. 29

POURSAT, *Cat.*, No. 215, Pl. 18

Twisting lion on a sword pommel

KARO, *Schachtgräber*, No. 295, Pls. 75-7

POURSAT, *Cat.*, No. 208, Pl. 17

Mirror-handle from Mycenae, Chamber Tomb 55 329

J. SCHÄFER, *AM*, 73 (1958), pp. 78 f., No. c, Fig. 3

POURSAT, *Cat.*, No. 300, Pl. 32

Mirror-handle from 'The Grave of Clytemnestra' 330

A.J.B. WACE, *BSA*, 25 (1921-23), p. 369, No. 1, Pl. 59 A

MARINATOS and HIRMER (1973), Fig. 245

J. SCHÄFER, *AM*, 73 (1958), p. 79, Suppl. Pl. 60, 1

Ivory group from Mycenae 328

WACE, pp. 83-4, Pls. 101-3

H. WACE, *Ivories from Mycenae I: 'The Ivory Trio...'*

MARINATOS and HIRMER (1973), Figs. 242-3

SIMON, *Götter*, pp. 94 f., Figs. 90-1

POURSAT, *Cat.*, No. 49, Pl. 4

Relief of a seated goddess 331

H. KANTOR, *Archaeology*, 13 (1965), Fig. 23

MARINATOS and HIRMER (1973), Fig. 241

Ivory lid from the 'House of the Sphinxes' 332

A.J.B. WACE, *BSA*, 49 (1954), p. 240, Pl. 38c

R. HAMPE, *Gymnasium*, 63 (1956), 16, Pl. 11

POURSAT, *Cat.*, No. 138, Pl. 12

Head of a warrior from Mycenae 334

MARINATOS and HIRMER (1973), Fig. 238

POURSAT, *Cat.*, No. 288, Pl. 27

Relief with a warrior from Delos 333

BCH, 71-2 (1947-8), pp. 156 ff., Pl. 25

R. HAMPE, *Gymnasium*, 63 (1956), 12, Pl. 10

POURSAT, *Ivoires*, Pl. 14, 1

Sculpture

71-3, 376 Mycenae: idols found by Lord William Taylour
Antiquity, 43 (1969), pp. 91 ff.; 44 (1970), pp. 270 ff.

Sub-Mycenaean

374 Karphi

MARINATOS and HIRMER (1973), Pls. 142-3

BSA, 38 (1937/8), p. 76, Pl. 31

ST. ALEXIOU, *Kretika Chronika*, 12 (1958), pp. 192 ff.

375 Asine

O. FRÖDIN and A.W. PERSSON, *Asine*, 1922-30, Stockholm (1938), p. 307, Fig. 211

Geometric sculpture

378 Terracotta vessel in shape of a stag, Athens

K. KÜBLER, *Kerameikos*, vol. IV, Berlin (1943), 20, Pl. 26

R. LULLIES and M. HIRMER, *Griechische Plastik*, 4th ed., Munich (1979), Fig. 2

Archers on a Proto-Geometric hydria, Lefkandi, vol. I (1979), Pl. 106, Tomb 51

377, 379 Centaur, Lefkandi

V.R. d'A. DESBOROUGH, *The Dark Ages*, London (1972), p. 200, Pl. 46; *BSA*, 65 (1970), pp. 21 ff., Pl. 8

Lefkandi, vol. I (1979), Pls. 169, 216e, 217, 252, 254

380-1 Centaur group, New York

HAMPE, *Sagenbilder* (1936), Pl. 30

SCHEFOLD, *Sagenbilder* (1964), Fig. 4a

FITTSCHEN, *Sagendarstellungen*, p. 111, SB 1 with bibliography, Fig. 16

N. HIMMELMANN, *Bemerkungen zur geometrischen Plastik*, Berlin (1964), Figs. 39-41

382-4 Bronze charioteer, Olympia

E. KUNZE, *4. Olympia-Bericht*, (1944), pp. 110 ff., Fig. 41, Pl. 35

N. HIMMELMANN, *Bemerkungen zur geometrischen Plastik*, Berlin (1964), Figs. 39-41

385 Hind with its young

HAMPE, *Sagenbilder* (1936), Pl. 30, 2

R. HAMPE, *Die Gleichnisse Homers und die Bildkunst seiner Zeit*, Tübingen (1952), Pl. 17a

386 Small bronze horse in Berlin

A. NEUGEBAUER, *Die minoischen und archaisch-griechischen Bronzen der Staatlichen Museen zu Berlin*, (1931), Pl. 3, No. 6

C. BLÜMEL, *Sport der Hellenen*, Berlin (1936), 13, No. 20

G. RODENWALDT, *Olympia*, Berlin (1937), 21, Fig. 7

R. LULLIES and M. HIRMER, *Griechische Plastik*, 4th ed., Munich (1979), Fig. 7 below

H.-V. HERMANN, *JDI*, 79 (1964), pp. 17 ff. 30 f., Fig. 14

Round handle from a tripod with warrior and horse, Olympia 389-9

R. HAMPE and U. JANTZEN, *1. Olympia-Bericht*, (1937), pp. 66, 67

R. HAMPE, *Die Antike*, 15 (1939), p. 35, Figs. 18, 19

E. KUNZE, *Neue Meisterwerke griechischer Kunst aus Olympia*, Munich (1948), p. 9

HERRMANN, *Olympia* (1972), p. 74, Fig. 43

Bronze horse's head, Olympia 392

Olympia, vol. IV, No. 956, Pl. 56

7. Olympia-Bericht (1961), p. 192, Fig. 104

Ivory statuette from Kerameikos Grave XIII, Athens 393-6

TH. HOMOLLE, *BCH*, 15 (1891), pp. 441 f.

A. BRUECKNER and E. PERNICE, *AM*, 18 (1893), pp. 127 ff., 129 f.

G. PERROT, *BCH*, 19 (1895), pp. 273 ff., 277-81, Figs. 8-12, Pl. IX

E. KUNZE, *AM*, 55 (1930), pp. 141 ff., 147 ff., with earlier dating to period around 800, even as early as the last quarter of the 9th century

HAMPE, *Sagenbilder* (1936), pp. 38, 'last quarter of the 8th century'

E. KUNZE, rev. by R. HAMPE, 'Frühe griechische Sagenbilder', in *GGA* (1937), pp. 298 ff. 'I'm fairly sure in suggesting the second quarter of the century.'

R.S. YOUNG, *Hesperia*, Suppl. II (1939), p. 211

P.P. KAHANE, *AJA*, 44 (1940), pp. 478 f., 482

E. KUNZE, *4. Olympia-Bericht*, (1944), 112 with note 2 'Spätgeometrische Phase in zwei Stufen (750-c. 700)'

S. BENTON, *JHS*, 70 (1950), p. 21, n. 65, 'Dating—last quarter of the 8th century'.

J.M. DAVISON, *Yale Classical Studies*, 16 (1961), pp. 115 f.

COLDSTREAM (1968), p. 361 'third quarter of 8th century'; ibid. p. 83 'Late Geometric IIa' (735-720 BC; ibid. 330)

R. LULLIES and M. HIRMER, *Griechische Plastik*, 4th ed., Munich (1979), Fig. 3

Bronze statuette of a warrior, Acropolis, Athens 402-4

A. de RIDDER, *Catalogue des Bronzes trouvés sur l'Acropole d'Athènes*, Athens (1896), No. 702

E. KUNZE, *AM*, 55 (1930), pp. 156 ff., Suppl. Pls. 44-5

R. LULLIES and M. HIRMER, *Griechische Plastik*, Munich (1979), Fig. 8

Helmeted female head, terracotta, Amyklai 397-4

E. KUNZE, *AM*, 55 (1930), pp. 155 ff., Suppl. Pls. 42, 43

K.A. PFEIFF, *Apollon. Die Wandlungen seines Bildes in der griechischen Kunst*, Frankfurt-am-Main (1943), pp. 20 ff., Pl. 1a, b

SIMON, *Götter*, p. 127, Fig. 114

R. LULLIES and M. HIRMER, *Griechische Plastik*, Munich (1979), Fig. 7 above

Mythical beasts

405-6 Chased griffin protomes, Samos

U. JANTZEN, 'Ein Nachtrag', in *AM*, 73 (1958), pp. 26 ff.

407-8 Cast griffin protomes, Olympia

H.-V. HERRMANN, *Olympische Forschungen*, vol. XI (1979), Pl. 44 G, 73

R. LULLIES and M. HIRMER, *Griechische Plastik*, 2nd ed., Munich (1960), Fig. 5

410 Griffin protome as spout of jug, Cyclades

E. PFUHL, *Malerei und Zeichnung der Griechen*, Munich (1923), p. III, Fig. 97

A. LANE, *Greek Pottery*, 3rd ed., London (1971), Pl. 15

SIMON and HIRMER, Pl. 21

412 Fragment of a Cycladic relief pithos in the Kanellopoulos Museum, Athens

M. BROUSCARI, *BCH*, 99 (1975), p. 387 Fig. 1

411 Ivory sphinx, Perachora

Perachora, vol. II (1930-3), p. 403, A I, Pl. 171

E. HOMANN-WEDEKING, *Die Anfänge der griechischen Grossplastik*, Berlin (1950), p. 32, Fig. 16

409 Terracotta sphinx, Calydon

F. POULSEN and K. RHOMAIOS, *Erster vorläufiger Bericht über die dänisch-griechischen Ausgrabungen von Kalydon*, Copenhagen (1927), Pls. 36, 37

E. DYGGVE, *Das Laphrion*, Copenhagen (1948), Figs. 191-3

K.A. RHOMAIOS, *Kalydon*, Athens (1951), pp. 39 ff.

13-14 Armour from Argos

P. COURBIN, *BCH*, 81 (1957), pp. 339 ff., Pls. I-IV

415 Cult statues, Dreros

G.M.A. RICHTER, *Kouroi*, London (1960), Figs. 12-13

SIMON, *Götter*, 125, Fig. 119

G.M.A. RICHTER, *Korai. Archaic Greek youths. A Study of the Development of the kouros type in Greek Sculpture*, London (1968), No. 16, Figs. 70-5

I. BEYER, *Die Tempel von Dreros und Prinias A*, Freiburg (1976), Pl. 47, 1-3; Apollon, Pl. 48, 1-3 goddesses

16-17 Steiner's bronze

P. STEINER, *AM*, 31 (1906), pp. 219 ff., Pl. 18

A. FURTWÄNGLER, *Kleine Schriften*, vol. I, pp. 446 ff.

E. KUNZE, *AM*, 55 (1930), pp. 159 f., Fig. 2

HERRMANN, *Olympia*, (1972), Fig. 26c

18-19 Bronze youth from Delphi

G.M.A. RICHTER, *Kouroi*, London (1960), Figs. 14-16

E. HOMANN-WEDEKING, *Die Anfänge der griechischen Grossplastik*, Berlin (1950), 69, Fig. 23

Boeotian female statuette 420-1

G.M.A. RICHTER, *Korai*, London (1968), No. 14, Figs. 60-2

Ivory lyre 422-6

D. OHLY, *AM*, 74 (1959), pp. 48 ff.

E. SIMON, *Antike Kunst*, 21 (1978), pp. 66 ff., Pl. 17

Apollo statuette dedicated by Mantiklos 427-8

W. FRÖHNER, Mon. Piot 2 (1895), pp. 137 ff., Pl. 15

K.A. PFEIFF, *Apollon. Die Wandlung seines Bildes in der griechischen Kunst*, Frankfurt-am-Main (1943), pp. 23 f., Pl. 2, Fig. 1 and appx.

F.R. GRACE, *Archaic Sculpture in Boeotia*, Cambridge, Mass. (1939), 49 f., Fig. 65

G.M.A. RICHTER, *Kouroi, Archaic Greek Youths. A Study of the Development of the kouros type in Greek Sculpture*, London (1960), Figs. 9-11

SIMON, *Götter*, Fig. 117-18

R. LULLIES and M. HIRMER, *Griechische Plastik*, 4th ed., Munich (1979), Fig. 10

Bell-shaped idols

SIMON, *Götter*, pp. 168 f.

Bell-shaped idol from Boeotia 429

F.R. GRACE, *Archaic Sculpture in Boeotia*, Cambridge, Mass. (1939), 12, Fig. 6

ZERVOS (1969), Fig. 106

Cretan idol of Athena from Gortyn 430

G. RIZZA and V. SANTA MARIA SCRINARI, *Il Santuario sull'Acropoli di Gortina*, vol. I, Rome (1968), No. 59, Pl. XI

Female sculpture from second half of seventh century

Nikandre's Artemis, Delos 431

G.M.A. RICHTER, *Korai*, London (1968), No. 1, Figs. 25-8

Limestone relief with naked goddesses from Gortyn 432

G. RIZZA and V. SANTA MARIA SCRINARI, *Il Santuario sull'Acropoli di Gortina*, vol. I, Rome (1968), No. 9, Pl. IV

Door lintels from Prinias 433-4

L. PERNIER, *AJA*, 38 (1934), pp. 171 ff.

I. BEYER, *Die Tempel von Dreros und Prinias A*, Freiburg (1976)

Basle relief pithos with Ariadne 435

E. BERGER, *Cibablätter*, July-August (1962)

F. ECKSTEIN, *Atlantis*, (1964), 169

SCHEFOLD, *Sagenbilder* (1964), Pl. 25a

Terracotta reliefs from Naples and Francavilla

A. LEVI, *Terracotte Figurate*, Florence (1922), No. 171, Fig. 130

R. HAMPE, *Sagenbilder* (1936), pp. 72 f., Pl. 35, 1

P. ZANCANI MONTUORO, *Atti e memorie della Società Magna Grecia*, NS. XI-XII (1970-1), pp. 67 ff.

438 Female statuette in the Louvre

M. COLLIGNON, *Rev. Arch.*, 11 (1903), pp. 153 ff. Pl. 10

G.M.A. RICHTER, *Korai*, London (1968), Figs. 76-9, No. 48

R. LULLIES and M. HIRMER, *Griechische Plastik*, 4th ed., Munich (1979), Pl. 11

439 Limestone relief from the citadel of Mycenae. Preserved h. 40 cm

G.M.A. RICHTER, *Korai*, London (1968), No. 19, Fig. 84

R. LULLIES and M. HIRMER, *Griechische Plastik*, Munich (1979), Fig. 15

436 Bronze tondo with head in centre in Berlin

U. GEHRIG, A. GREIFENHAGEN and N. KUNISCH, *Führer durch die Antikenabteilung*, Berlin (1969), p. 171, Pl. 7

437 Bronze female head in Karlsruhe

Dädalische Kunst auf Kreta im 7. Jh. v. Chr., Mainz (1970), Pl. 21 (Cat. B 10)

Badisches Landesmuseum, *Bildkatalog* (1968), Fig. C 28

440 Head of Hera from Olympia

G. TREU, *Die Bildwerke in Olympia*, pp. 1 ff. Pl. 1

P. WOLTERS, in: *Festschrift für H. Wölfflin*, Dresden (1935), pp. 168 ff.

G.M.A. RICHTER, *Korai*, London (1968), Figs. 118-21

SIMON, *Götter*, p. 56, Fig. 50

R. LULLIES and M. HIRMER, *Griechische Plastik*, 4th ed., Munich (1979), Fig. 19

HERRMANN, *Olympia*, (1972), Pl. 29

441-3 Cycladic relief pithos with Hera

SCHEFOLD, *Sagenbilder* (1964), Pl. 12

SIMON, *Götter*, p. 57, Fig. 51

Lions, general

K. GABELMANN, *Studien zum frühgriechischen Löwenbild*, Berlin (1965)

444 Gold lion from Mycenae

MARINATOS and HIRMER (1973), Pl. 221 above

H. SCHLIEMANN, *Mykenae*, Leipzig (1878), 410, Fig. 532

H. THOMAS, *BSA*, (1938-9), pp. 77, V, Pl. 28d, Fig. 2; L. of lion 3.1 cm

445-6 Limestone lion from Olympia

F. CROME, *Mnemosynon Theodor Wiegand*, Munich (1938), pp. 47 ff. Pls. 7, 9, 10

Terracotta lion from Arkades — 447-8

R. HAMPE, *Kretische Löwenschale des siebten Jahrhunderts v. Chr.* Sitzungsberichte der Heidelberger Akademie der Wissenschaften, Heidelberg (1969), 22, Pls. 7, 8, 9

Limestone lion on Keos — 449

P.O. BRØNSTED, *Reisen und Untersuchungen in Griechenland*, vol. I, Paris (1826-30), Pl. XI

L. ROSS, *Reisen auf den griechischen Inseln*, vol. I, Stuttgart and Tübingen (1840-52), p. 130

L. SAVIGNONI, *Ephemeris*, (1898), Pl. 14

G. WELTER, *AA*, (1954), pp. 78 ff., Figs. 18-20

DÖRIG, *AM*, 76 (1961), Suppl. Pls. 47, 48

H. GABELMANN, *Studien zum frühgriechischen Löwenbild*, Berlin (1965), pp. 54 f., No. 43, Pl. 7, 1

J.B. HARTMANN and K. PARLASCA, *Antike Motive bei Thorvaldsen*, Tübingen (1979), p. 103, Pl. 45, 1

Lion terrace on Delos — 450-1

Delos, vol. XXV (1959), pp. 26 ff.

E. HOMANN-WEDEKING, *Die Anfänge der griechischen Grossplastik*, Berlin (1950), 73, Fig. 27

Funerary lion from Corfu — 452-3

F. CROME, *Mnemosynon Theodor Wiegand*, Munich (1938), pp. 47 ff., Pls. 11-16

R. LULLIES and M. HIRMER, *Griechische Plastik*, 4th ed., Munich (1979), Figs. 12-13

Monumental male figures from the late seventh century

Dipylon head — 457, 4

G.M.A. RICHTER, *Kouroi, Archaic Greek Youths. A Study of the Development of the kouros type in Greek Sculpture*, London (1960), No. 6, Figs. 50-3, Pls. 63-4

E. BUSCHOR, *Frühgriechische Jünglinge*, Munich (1950), Figs. 11-14

E.B. HARRISON, *Hesperia*, 24 (1955), pp. 290 ff.

New York youth — 454-6

G.M.A. RICHTER, *Kouroi, Archaic Greek Youths. A Study of the Development of the kouros type in Greek Sculpture*, London (1960), No. 1, Figs. 25-32, 60-62

E. BUCHSOR, *Frühgriechische Jünglinge*, Munich (1950), Figs. 15-21

R. LULLIES and M. HIRMER, *Griechische Plastik*, 4th ed., Munich (1979), Figs. 16-17

Statue of Kroisos

G.M.A. RICHTER, *Kouroi, Archaic Greek Youths. A Study of the Development of the kouros type in Greek Sculpture*, London (1960), No. 136, Figs. 395-8, 400, 401

E. BUSCHOR, *Frühgriechische Jünglinge*, Munich (1950), Figs. 124-6

R. LULLIES and M. HIRMER, *Griechische Plastik*, Munich (1979), Figs. 50-1

458 Colossus from Sounion

E. BUSCHOR, *Frühgriechische Jünglinge*, Munich (1950), Figs. 22-8

461-3 Colossal Apollo from Delos

E. BUSCHOR, *Frühgriechische Jünglinge*, Munich (1950), Figs. 29, 30

E. HOMANN-WEDEKING, *Die Anfänge der griechischen Grossplastik*, Berlin (1950), 76, Figs. 30-2

R. PFEIFFER, *Journal of the Warburg and Courtauld Institutes, vol. XV*, Nos 1-2 (1952), pp. 20 ff.

G.M.A. RICHTER, *Kouroi, Archaic Greek Youths. A Study of the Development of the kouros type in Greek Sculpture*, London (1960), No. 15, Figs. 87-90

464 Colossal statue in a quarry on Naxos

L. ROSS, *Reisen auf den griechischen Inseln*, vol. I, Stuttgart and Tübingen, (1840-52), pp. 38 f., Fig. between pp. 34 and 35

Kleobis and Biton 465-9

TH. HOMOLLE, *Fouilles de Delphes*, vol. IV (1909), pp. 5 ff., Pls. 1-2

A. v. PREMERSTEIN, *ÖJH*, 13 (1910), pp. 41 ff.

G. DAUX, *BCH*, 61 (1937), pp. 61 ff.

P. de la CÔSTE-MESSELIÈRE, *BCH*, 77 (1953), pp. 177 f.

E. BUSCHOR, *Frühgriechische Jünglinge*, Munich (1950), Figs. 39-42

G.M.A. RICHTER, *Kouroi*, London (1960), No. 12, A-B, Figs. 78-83, 91, 92

R. LULLIES and M. HIRMER, *Griechische Plastik*, Munich (1979), Fig. 18

Glossary

Names of deities and mythological figures are not included; for geographical information see the general map on p. 10 and the detailed map Fig. 9; Pl. or Fig. refers to a plate or an illustration in the text which shows an object of the type under consideration (for example a vase or a gem); an asterisk indicates that the following item is discussed elsewhere in the glossary.

Dates are not exact, only approximate; they are all BC.

Achaeans:	inhabitants of the *Helladic mainland since early in the second millennium; from the middle of the fifteenth century also in Crete (Knossos); they spoke an early form of Mycenaean Greek which is preserved in the *Linear B texts.
Agalma:	a 'pleasing gift' or votive offering of figural or non-figural form.
Agon:	competition.
Agora:	assembly place, market.
Amphora:	closed vessel with two handles (Pls. 212, 226 left, 228, 246, 261).
Amygdaloid:	almond-shaped gem (Pls. 263, 283).
Anax:	pronounced wanax in Mycenaean Greek; title of the ruler who resided in a *palace (Anaktoron).
Aniconic:	non-figural; in the case of Minoan gems also a term for representations of heads without faces (Pls. 282, 288).
Apotropaic:	averting evil.
Archaic art:	Greek art from the early seventh century to the early fifth century. The first half of this period is dominated by the *Orientalizing style.
Architrave:	horizontal beam below the roof, originally wooden.
Artemision:	sanctuary of Artemis.
Aryballos:	small round oil-vessel (Pl. 252, right), sometimes also of figural form (Fig. 33).
Athenian art:	*Attic art.
Attic art:	art of Attica, generally includes the art of Athens, its capital. *Mycenaean Attic art: Pls. 212-16, 336-41; Proto-Attic style: Pls. 243-4; Archaic Attic art: Pls. 454-60.
Boeotian shield:	*shields.

Bothros:	rubbish pit in a sanctuary, in which the old votive offerings were buried.
Boar's-tusk helmet:	*helmets.
Boukrania:	cow's or bull's head seen frontally (Pl. 144).
Bronze Age:	period between 3000 and 1100, which in the Aegean includes cultures which partly overlap both chronologically and geographically, viz. *Helladic, *Cycladic, *Minoan, *Mycenaean.
Catch-plate fibula:	safety-pin in which the catch is hammered out into a large ornamental plate; this is usually engraved (Pls. 93, 94, 150).
Cella:	main room of a temple, where the cult statue stood.
Cenotaph:	sepulchral monument to a person who is buried elsewhere.
Centaur:	hybrid creature, part horse, part man, either with human upper body (Pl. 101) or with a complete human body and a horse's rear (Pls. 115, 380).
Circular shield:	*shields.
Chimaera:	mythical creature, part lion, part goat and part snake (Pl. 260).
Chiton:	garment (Pl. 345).
'Chlareus':	globular jug with false mouth, to which are attached two handles, the resultant form reminding one of a stirrup (hence stirrup-jar); the real mouth with its narrow spout is positioned asymmetrically on the shoulder (Pls. 218-220). The vessel varies from the small to the relatively large and contained oil, especially perfumed oil. The name is taken from the *Linear B texts, in which the vessel is called ka-ra-re-we.
'Close style':	style of decoration typical of late *Mycenaean pottery in the twelfth century (Pl. 218).
Conical helmet:	*helmets.
Corinthian art:	the leading style in seventh-century Greece; the important contribution of Corinthian artists led to the dissolution of the *Geometric style. Proto-Corinthian c. 720, the earliest *Orientalizing style in Greece (Pls. 248, 252). In the last quarter of the seventh century the Early Corinthian style (Pl. 257)

	emerged after a Transitional Phase (Pls. 250, 251); around 600 Middle Corinthian begins; Late Corinthian is outside the ambit of this book.
Corinthian helmet:	*helmets.
Cycladic style:	native style of the Cyclades in the third and second millennia.
Cyclopean walls:	walls made of undressed stones, usually large (Pls. 8, 9, 12, 14); this typically Mycenaean technique is continued in the polygonal wall in which the stones are, however, dressed.
'Dark Ages':	the period between 1125 and 900.
Depas:	name of a vessel which is called *di-pa* in the *Linear B texts. In later Greek usually a drinking vessel, in Mycenaean Greek also used of a type of storage vessel with a varying number of handles or without any at all, as the ideograms next to di-pa indicate (Fig. 27). In this book it is used of vessels with three handles (Pl. 208) or with three rows of handles (Pl. 207). Occasionally this shape is called an *amphora, but this is unsuitable, for amphorae always have only two handles (*stamnos).
Disc akroterion:	large disc-shaped ornament on top of the gable end of a building (Pl. 90).
Discoid:	disc-shaped *Minoan gem (Pl. 262).
Dromos:	passage way, entrance to a *tholos tomb (Pls. 46, 48).
Electrum:	a natural alloy of silver and gold, used for masks (Pl. 125), vessels (Pl. 129) and *inlay work.
Enamel:	multicoloured glass melted into cells (cloisons); rare in the Bronze Age Aegean (Pl. 145).
Eteocretans:	'genuine Cretans', descendants of the old *Minoan population; they lived in mountain refuges.
Figure-of-eight shields:	*shields.
Filigree:	ornamental wire, often twisted, frequently used in jewellery settings (Pls. 321, 322, 326).
Flattened cylinder seal:	piece of jewellery which, because it is bored, can be threaded (Pls. 268-70).
Flutes:	vertical grooves decorating columns.
Geometric style:	style of Greek art in the first three (to four) centuries after the collapse of the Mycenaean culture; it is divided chronologically into: Proto-Geometric 1050-900 (Pls. 225, 226) Early Geometric 900-850 Middle Geometric 850-760 (Pls. 227, 229) Late Geometric 760-700 (Pls. 231-7). Out of the Proto-Geometric *koine there developed, parallel to Athenian, various local Geometric styles, such as Euboean (Pl. 377), Argive (Pls. 95, 96, 238-40, 308), Cretan (Pls. 78, 79), Theran (Pl. 228), Rhodian (Pl. 227) and Boeotian (Pl. 247).
Gloss slip:	a technique invented by Mycenaean potters either for completely covering or just for painting pottery, which continued throughout antiquity. The colour of the gloss slip (reddish to blackish brown) is produced by firing in the kiln (Pls. 211, 227, 240, 252).
Gold tinsel:	very thin sheet gold used for funerary ornaments (Pls. 312, 315).
Granulation:	delicate technique in which small gold grains are applied ornamentally on pieces of gold jewellery; already known in Mycenaean art (Pl. 313), attested in Athens in the ninth century and widely spread in seventh century Rhodian gold-working (Pls. 322, 324, 326).
Grave Circle A:	circular enclosure containing shaft graves on the Acropolis of Mycenae, south of the Lion Gate, excavated by Schliemann in 1876; sixteenth century.
Grave Circle B:	circular enclosure with both shaft graves and other forms, at the foot of the Acropolis of Mycenae, excavated by Papadimitriou and Mylonas in 1952-4; sixteenth century, partly earlier than Grave Circle A.
Griffin:	hybrid creature, lion with bird's head; *protome cauldron (Pls. 70, 336-8, 405-8).
Half-rosette:	*rosette.
Helladic:	term for the culture of the Greek mainland from the middle of the third millennium to *c.* 1100; it is divided chronologically into: Early Helladic 2500-1900 Middle Helladic 1900-1580 Late Helladic 1580-1100 The *Achaean migration occurred probably during the Middle Helladic period, to which time part of *Grave Circle B at Mycenae belongs. Its characteristic pottery is matt painted and *Minyan (Pl. 204); the Late Helladic period is contemporary with the *Mycenaean.
Helmets:	Boar's-tusk helmet (Pls. 179, 333, 334), a special form of zone helmet (Pl. 208); conical helmet or 'Illyrian' (Pls. 183, 184, 187, 188); Corinthian helmet (Pls. 185, 186); Cretan helmet (Pl. 189).
Heraion:	sanctuary of Hera (Pls. 85-7).
Hoplite:	heavily armed warrior.
Hydria:	three-handled water jar, already known in the *Helladic period.
Idol:	statue or statuette of a god or demon (Pls. 71-2, 366-72).
Inlay work:	inlays of different coloured metals on vessels (Pls. 127, 143-4) and weapons (Pls. 174-8), usually in a setting of *niello; probably invented on the Mycenaean mainland.
Kamares style:	style of decorating pottery in Middle Minoan Crete (*Minoan), called after a site in the Ida Mountains where it was first found; mainly produced in the palace workshops of Phaistos.

311

Kantharos:	drinking vessel with two handles which rise above the rim, known in the second and first millennia (Pls. 133, 233).
Keres:	demons of death, fates.
Koine:	'common language', in art a common style.
Kotyle:	two-handled drinking-cup, also called *sky-phos (Pl. 252).
Krater:	large open vessel for mixing wine and water (Pls. 210, 223, 227).
Krateriskos:	small *krater.
Lekanis:	bowl (Pls. 141 left, 221).
Lekythos:	oil-flask of elongated form, as opposed to the spherical *aryballos (Pl. 250).
Lentoid:	lens-shaped gem (Pls. 264, 267, 271-5).
Letoon:	sanctuary of Leto.
Linear A:	*Minoan syllabic script.
Linear B:	*Mycenaean syllabic script (Fig. 27).
'Marine style':	style of *Minoan pottery in Late Minoan I (1550-1450) which also spread to the Mycenaean mainland (Pl. 207).
Megaron:	public room in the Mycenaean *palace (Pls. 1, 7).
Metope:	decorative panel between *triglyphs (Pls. 105-8).
Minoan:	term for the culture of the island of Crete in the third and second millennia, it is divided chronologically into: Early Helladic 2800-2000 Middle Helladic 2000-1550 Late Helladic 1550-1100 Each of these periods is in turn divided into three phases; Middle Minoan is roughly contemporary with Middle Helladic, Late Minoan with Late Helladic (*Mycenaean).
Minyans:	inhabitants of Orchomenos in Boeotia.
Minyan:	term for Middle *Helladic pottery.
Mitra:	half-moon shaped bronze guard for the abdomen (Pl. 192).
Mycenaean:	term for the culture of the Greek mainland in the Late *Helladic period; it is divided chronologically into: Mycenaean I 1580-1500 ('Shaft Grave period') Mycenaean II 1500-1425 Mycenaean III 1425-1100. The last, very long period is further subdivided into A, B and C; and even further divided by pottery styles. Mycenaean art is a mixture of *Helladic and *Minoan elements (E. Vermeule: 'a successful fusion').
Niello:	amalgam of several metals (silver, copper, lead) and sulphur, used for inlays; the Greek term was perhaps *kyanos*, but this word is also translated as 'glass flux'.

Opisthodomos:	rear room of a temple.
Orientalizing style:	style of Greek art in the seventh century. Just as in the *Mycenaean culture, strong influences came from the Orient to the Aegean; it has in each Greek area its own particular character, the earliest is the *Corinthian (Proto-Corinthian) and then *Proto-Attic; independent Orientalizing styles were also developed on Chios (Pl. 258), the Cyclades (Pls. 116-20, 260-1, 410) and Crete (Pls. 253-6, 432-4). Melos excelled in gem-cutting (Pls. 305-7), Rhodes in gold-working (Pl. 322-6).
Orthostats:	vertical slabs.
Palace:	residence of the *Anax, not only the centre of political administration, but also of artistic activities, when valuable materials like gold, silver, ivory and precious stones were being used.
'Palace style':	style of decoration on *Mycenaean and *Minoan pottery of the fifteenth century, which developed partly from the *Marine style' (Pls. 208-9).
Palmette:	ornament in the shape of a fan of long leaves.
Pelta:	half-moon shaped shield, carried by Amazons (Pl. 95), as with the *figure-of-eight shield it was a favourite ornamental motif (Pl. 318).
Peplos:	thick woollen garment, often worn over a *chiton, appears at the same time as the pins with which it was held together at the shoulders (Pl. 147), during the *'Dark Ages', and is rightly connected with the Dorian invasion.
Phorminx:	stringed instrument.
Pinax:	votive plaque made of clay (Pl. 91) or wood.
Pithos:	large storage vessel.
Polos:	cylindrical crown or head-dress worn by deities and mortals in their service (Pl. 434).
Pomegranate:	pendants of this shape occurred in *Mycenaean jewellery (Pl. 311) and in Athenian (Pl. 321) and Thessalian (Fig. 29) Geometric jewellery, as well as in that of the Orientalizing period (Pl. 322); pomegranate buds were also used (Pl. 318).
Potnia Theron:	'Mistress of the Animals', goddess with an animal in either hand (Pls. 167, 322, 354).
Pronaos:	room at the front of a temple.
Propylaea, propylon:	gateway (Pl. 4).
Prothesis:	ceremonial laying out of the dead on a bier, accompanied by mourning women (Pls. 235-6).
Proto-Attic style:	*Orientalizing style at Athens and in Attica, parallel to Proto-Corinthian (*Corinthian style).

Proto-Corinthian style:	*Corinthian art.
Proto-Geometric style:	*Geometric style.
Protome:	head and neck of a human figure, animal or mythical creature.
Protome cauldron:	most important form of cauldron in the *Orientalizing style, with protomes of *griffins and/or lions around the rim (Pls. 160, 164, 165). Stood on a conical stand (Pls. 113, 159) or a rod-tripod (Pl. 166).
Pyxis:	box with lid, for jewellery and toilet articles; cylindrical (Pl. 222) or globular in shape (Pl. 257).
Rhyton:	libation vessel; funnel-shaped (Pls. 130-1), like an elongated oval (Pl. 67) or in the form of a *protome of an animal (Pls. 126-7).
Rosette:	ornament in the form of a round flower, popular in *Minoan art (Pl. 53-6), *Mycenaean (Pls. 51, 340, 342) and in the *Orientalizing style (Pls. 251, 257, 305), mostly as a filling ornament. The Minoan–Mycenaean half-rosette is a mixture of *palmettes and rosettes (Pls. 66, 344).
Shields:	figure-of-eight shield (Pls. 38, 175, 270, 333), from which developed the Boeotian shield (Pl. 236); in the Mycenaean period large rectangular tower-shields were also used (Pls. 175, 265); the circular shield belongs to the armour of the Archaic *hoplite (Pl. 102-3).
Siren:	hybrid creature, bird with human head (Pls. 257).
Skyphos:	two-handled drinking-cup, also called *kotyle.
Sphinx:	hybrid creature, lion with human head (Pls. 250, 332).
Sphyrelaton:	statue or statuette made from hammered sheets of metal (Pl. 415).
Spiral:	important *Minoan and *Mycenaean ornament (Pls. 37, 51, 52, 67, 338, 342).
Stamnos:	name of a vessel, occasionally used for the form here called a *depas.
Stele, grave stele:	upright slab marking a grave, sometimes decorated in relief (Pl. 52).
Stirrup-jar:	*'Chlareus'.
Stylobate:	stone platform with steps on which the colonnade of a temple stands (Pl. 86).
Sub-Mycenaean:	style after the end of *Mycenaean III C, c. 1100-1050. It is followed by the *Proto-Geometric style.
Talismanic style:	style of *Minoan gems with strongly simplified forms (Pl. 263); 1700-1450, contemporary with other styles.
Ta-urt:	Egyptian hippopotamus goddess whose form influenced the Minoan–Mycenaean demons (Pls. 33, 296-9).
Telesterion:	initiation hall at Eleusis (Fig. 11).
Temenos:	enclosed sacred area.
Tholos tomb:	domed like the 'Treasury of Atreus' (Pls. 46-50).
Toreutic:	art of chasing metal.
Tree goddess:	goddess of the *vegetation cult (Pl. 316).
Triglyphs:	together with the *metopes they form the frieze of a Doric temple.
Tripod:	cauldron with three legs and two ring-handles, which is called a ti-ri-po in the Linear B texts (Fig. 27). It belongs among the shapes which were taken over from the second millennium into the first (Pls. 151-3).
Tower shield:	*shield.
Vapheio handle:	called after the shape of handle used on the famous bull-catching cups from Vapheio (Pls. 134-40), already found in the Middle Minoan period and in the shaft graves (Pl. 129), as well as in Egyptian wall-paintings representing Aegean offering bearers (Pl. 142).
Vegetation cult:	cult in which the blooming and fading of the vegetation is celebrated with ecstatic rites (Pls. 282, 288); *tree goddess.
Whirl rosette:	*rosette in which the leaves are arranged so as to create a swirling pattern (Pl. 134, below).
Xoanon:	wooden *idol of a god.
Zone helmet:	*helmets.

Index

315

This book was printed in Switzerland by
Imprimeries Réunies SA, Lausanne

Filmsetting: Atelier ep SA, Lausanne
Photoengraving: E. Kreienbühl & Co. AG,
Lucerne
Binding: Schlatter AG, Berne
Production: Franz Stadelmann and Oscar Ribes